James Barry's Murals
at the Royal Society of Arts:
Envisioning a New Public Art

James Barry's Murals
at the Royal Society of Arts:
Envisioning a New Public Art

WILLIAM L. PRESSLY

CORK UNIVERSITY PRESS

First published in 2014 by Cork University Press
Youngline Industrial Estate, Pouladuff Road, Togher, Cork, Ireland

Text © William L. Pressly
Images © held by the owners

British Library Cataloguing in Publication Data

A CIP catalogue record for this book is available from the British Library.

ISBN 978-1-78205-108-4

Book design and typesetting, Anú Design, Tara
Printed by Gutenberg Press, Malta

For the next generations

David, William and Caitlin

Contents

Illustrations

Fig. 10 Pierre Lombart after Francis Cleyn, *Dancing Around the Statue of Ceres*. Engraving, 298mm x 195mm. From Book I of *Georgics* in Virgil/Ogilby, London 1654. Beinecke Rare Book and Manuscript Library, Yale University, New Haven

Fig. 11 Nicolas Poussin, *A Dance to the Music of Time*, *c.* 1637–9. Oil on canvas, 848mm x 1076mm. © By kind permission of the Trustees of the Wallace Collection, London

Fig. 12 Detail of *A Grecian Harvest-home*, 1774–84. Royal Society of Arts, London

Fig. 13 James Barry, *The Diagorides Victors at Olympia*, 1792. Etching and engraving, 419mm x 924mm. British Museum, London

Fig. 14 James Barry, *Study for 'Crowning the Victors at Olympia'*, *c.* 1777–80. Pen and brown ink with black chalk over pencil, 342mm x 1095mm. Victoria and Albert Museum, London

Fig. 15 James Barry, *Ticket of Admission for Horace's 'Carmen Seculare'*, 1779. Etching, 170mm x 127mm. Collection of William L. Pressly

Fig. 16 James Barry, *The Thames or the Triumph of Navigation*, 1792. Etching and engraving, 415mm x 505mm. British Museum, London

Fig. 17 Wenceslaus Hollar, *The Long View of London from Bankside*, 1647. Etching (6 plates in 7 sections), 473mm x 2364mm. British Museum, London

Fig. 18 Detail of John Rocque's *A Plan of the Cities of London and Westminster, and Borough of Southwark*, 1746. Engraving by John Pine. Yale Center for British Art, Paul Mellon Collection, New Haven

Fig. 19 Spiridione Roma, *The East-Indian Provinces Paying Homage to Britannia*, 1778. Oil on canvas. © The British Library Board, Foster 245

Fig. 20 S.F. Ravenet after Francis Hayman, *The Triumph of Britannia*, 1765. Engraving, 381mm x 518mm. British Museum, London

Fig. 21 James Barry, *Study for 'The Triumph of the Thames'*, *c.* 1777–80. Pen and ink with red chalk, 314mm x 480mm. Art Institute of Chicago, Chicago

Fig. 22 James Barry, *The Society for the Encouragement of Arts &c. in the Distribution of Their Annual Premiums*, 1792. Etching and engraving, 419mm x 508mm. British Museum, London

Fig. 23 Thomas Malton, *View from Scotland Yard*, 15 December 1795. Etching and aquatint, 213mm x 312mm. Plate 27 in vol. 1 of Thomas Malton's *A Picturesque Tour Through the Cities of London and Westminster*, London 1792. Yale Center for British Art, Paul Mellon Collection, New Haven

Fig. 24 James Barry, *King George III and Queen Charlotte*, 1792. Etching and engraving, 422mm x 516mm. British Museum, London

Fig. 25 James Barry, *Study for 'George III Recommending a Law for the Independence of the Administrators of Justice'*, *c.* 1784–8. Pen and brown ink over black chalk, 298mm x 165mm. Jupp R.A. Catalogues, © Royal Academy of Arts, London (Photographer: Prudence Cuming Associates Limited)

Fig. 26 Benjamin West, *Portrait of George III*, 1779. Oil on canvas, 2553mm x 1829mm. Royal Collection Trust/ © Her Majesty Queen Elizabeth II 2014

Fig. 27 Benjamin West, *William Penn's Treaty with the Indians*, 1771–72. Oil on canvas, 1917mm x 2738mm. Pennsylvania Academy of the Fine Arts, Philadelphia. Gift of Mrs. Sarah Harrison (Courtesy of the Joseph Harrison Jr. Collection)

Fig. 28 James Barry, *Elysium and Tartarus or the State of Final Retribution*, 1792. Etching and engraving, 419mm x 924mm. © The Trustees of the British Museum, London

Fig. 29 J. Collyer after James Barry, *Universal History*, late 1770s (?). Etching, 174mm x 104mm (image). Collection of William L. Pressly

Fig. 30 James Barry, *The Education of Achilles*, *c.* 1772. Oil on canvas, 1029mm x 1289mm. Yale Center for British Art, Paul Mellon Collection, New Haven

Fig. 52 Detail of James Barry's *The Birth of Pandora, c. 1791–1804.* © Manchester City Art Galleries

Fig. 53 James Barry, *Passive Obedience, c.* 1802–05. Pen and brown ink with grey wash and black chalk, 427mm x 584mm. Art Museum, Princeton University/Art Resource, NY

Fig. 54 James Barry, *Minerva Turning from Scenes of Destruction and Violence to Religion and the Arts, c.* 1805. Etching, 197mm x 121mm. British Museum, London

Fig. 55 William Blake, *Joseph of Arimathea Among the Rocks of Albion,* 1773–*c.* 1810. Engraving, 229mm x 118mm. British Museum, London

Fig. 56 William Blake, *Urizen on the Atlantic.* Relief-etching, colour-printed, 234mm x 168mm. Plate 10 of *Europe: A Prophecy,* Lambeth, London, 1794. Yale Center for British Art, Paul Mellon Collection, New Haven

Fig. 57 Anonymous, *Babel and Bethel: Or, The Pope in his Colours,* 1679. Broadsheet, letterpress and engraving, 174mm x 294mm (image), 464mm x 365mm (sheet). British Museum, London

Fig. 58 William Blake, *Los fleeing with his Daughters.* Relief-etching, colour-printed, 232mm x 165mm. Plate 15 of *Europe: A Prophecy,* 1794. Yale Center for British Art, Paul Mellon Collection, New Haven

Fig. 59 Detail of *Crowning the Victors at Olympia,* 1777–84. Royal Society of Arts, London

Fig. 60 James Barry, *Edmund Burke and James Barry as Ulysses, and a Companion Fleeing from the Cave of Polyphemus, c.* 1776. Oil on canvas, 1270mm x 1008mm. © Crawford Art Gallery, Cork

Fig. 61 James Barry, *Self-portrait as Timanthes, c.* 1780 and 1803. Oil on canvas, 760mm x 630mm. National Gallery of Ireland Collection, Photo © National Gallery of Ireland

Fig. 62 Giovanni Cesare Testa, after Pietro Testa, *Christ Trampling the Serpent, c.* 1650–55. Engraving, 21cm x 25cm (trimmed). British Museum, London

Fig. 63 James Barry, *Lord Baltimore and the Group of Legislators,* 28 February 1793. Etching and engraving, 743mm x 472mm. Tate Images

Fig. 64 James Barry, *Detail of the Diagorides Victors,* 1795. Etching and engraving, 743mm x 474mm. © The Trustees of the British Museum, London

Fig. 65 James Barry, *Reserved Knowledge,* 1795. Etching and engraving, 745mm x 478mm. Tate Images

Fig. 66 James Barry, *The Glorious Sextumvirate,* 1795. Etching and engraving, 743mm x 474mm. Tate Images

Fig. 67 James Barry, *Queen Isabella, Las Casas and Magellan,* 1800. Etching and engraving, 713mm x 150mm. © The Trustees of the British Museum, London

Fig. 68 James Barry, *Divine Justice, c.* 1802. Etching and engraving, 753mm x 505mm. British Museum, London

Fig. 69 James Barry, *The Angelic Guards, c.* 1802. Etching and engraving, 743mm x 502mm. © The Trustees of the British Museum, London

Fig. 70 James Barry, *Scientists and Philosophers, c.* 1800–05. Etching and engraving, 337mm x 328mm. Tate Images

Fig. 71 James Barry, *Pensive Sages, c.* 1800. Etching, 81mm x 124mm. Collection of William L. Pressly

Fig. 72 James Barry, *Blessed Exegesis, c.* 1800. Etching and aquatint, 63.5mm x 89mm. Collection of William L. Pressly

Fig. 73 Detail of *Elysium and Tartarus* from an A.C. Cooper photograph taken in the 1950s. Collection of William L. Pressly

Fig. 74 Detail of *The Triumph of the Thames.* Royal Society of Arts, London

Preface

By providing a fuller account of James Barry's intentions in the creation of his murals at the Royal Society of Arts, this book has allowed me to take care of unfinished business. When I published *The Life and Art of James Barry* in 1981 and the Tate Gallery exhibition catalogue *James Barry: The Artist as Hero* in 1983, I knew that my treatment of his murals was inadequate. The reasons for this were twofold. First of all, I was not the only one captivated by his series. David Allan, then the librarian at the Society, had already staked his claim to a book on these works, and I respected his priority. Secondly, there was the mandate to publish or perish. My work on Barry's entire career needed to be turned into a book as soon as possible, although the exploration of his murals had only barely begun. At that point I thought it sufficient to have pointed the way to a Christian reading of them, and having planted the seeds, I moved on to other interests.

When new works by Barry came to light, I was happy to insert them into his *oeuvre*, but I was not contemplating a return to any extensive projects on his art. Then Tom Dunne and Peter Murray drew me, extremely reluctantly, back into Barry studies with their proposal for an exhibition at the Crawford Art Gallery in Cork commemorating the 2006 bicentennial of his death. Diving back into this material induced me to take up again the exploration of the murals. David Allan's book eventually appeared in 2005, but he confined himself to producing keys that match up with the figures in the artist's own descriptions.

Since Barry's murals are the most important series of history paintings in Great Britain, a book exploring their meaning and purpose forms a major building block in the study of British art. Had the artist died in 1784, after first completing the series, my job would have been made considerably easier, but his constant revisions in terms of seventeen prints and later alterations to the murals themselves has complicated the analysis. Not all of Barry's adjustments are of equal interest, but because my reading has proven controversial, I have been unwilling to edit the record. My solution has been to confine the majority of Barry's later emendations to two appendices in order to help the reader avoid becoming bogged down in detail. In this way, the book remains authoritatively comprehensive without falling into the trap of obscuring the forest for the trees.

Titles of Barry's works are at times problematic. In some cases he provided in different contexts varying titles, and in other cases neglected to ascribe any. He presumably felt the standardisation of titles to be more limiting than useful. For each mural I have recorded the title that Barry gave it

in his 1783 *An Account of a Series of Pictures*, which has freed me to make minor adjustments when providing my own. The 1792 series of prints reproducing the murals presents its own set of problems. In my print catalogue in *The Life and Art of James Barry*, in order to avoid confusion I gave each print the title of the painting it reproduced, but in this book I have honoured the title Barry engraved in the print's margin. Thus the print after the mural *Crowning the Victors at Olympia* is here entitled *The Diagorides Victors at Olympia*. To complicate matters further, Barry never got around to supplying titles in the margins of his large print details, and in the case of the three small prints discussed in appendix one, he not only did not bother to entitle them but he also did not provide any descriptive texts. In these instances, the titles are entirely my own.

One of my larger goals in writing this book is to bolster the place held by history painters in British art. The only history painter to date to have gained a full measure of respect is William Blake, and this largely because he is perceived as a man apart. Even the inventive Henry Fuseli is now sometimes regarded as being merely a poseur, looking only to exploit a market niche. In this context, this book should be seen in relationship to some of my earlier studies. *The French Revolution as Blasphemy: Johan Zoffany's Paintings of the Massacre at Paris, August 10, 1792* (1999) explores Zoffany's attempts to create a suitable genre for depicting scenes of contemporary horror, and *The Artist as Original Genius: Shakespeare's 'Fine Frenzy' in Late-eighteenth-century British Art* (2007) examines how the first generation of British history painters fashioned for themselves a new identity that inspired them to challenge the Continental old masters. *James Barry's Murals at the Royal Society of Arts*, in its turn, argues for a new type of history painting in line with the artist's assertion that there is no honour in repeating past formulas.

This book's objective is to situate Barry's murals within their historical context. Part one, its longest section, offers a detailed accounting of the paintings' ostensible content. Beginning in part two, the book argues for the presence of a deeper hidden meaning. The artist went far beyond a didactic presentation of 'universal truths' intended for moral instruction to provide instead an initiation into a 'secret wisdom' that was intended utterly to transform his audience. In so doing, he also transformed the role of the history painter, whom he saw as occupying civilisation's most prominent and important position. Although Barry wrote a book to accompany his murals, his text deliberately abstained from addressing the paintings' deepest issues, which raises the thorny question: How then is the audience meant to discern content? Given the likelihood that he would have shared his meaning with some of his friends, there must have been a few contemporaries who knew the deeper purpose, but for anyone to have revealed it, given the prevailing extremes of anti-Catholic prejudice, would have led to the murals' destruction. Knowledge of this deeper interpretive level died with the artist and his confidants. But the murals themselves lived on, and in the final analysis a work of art has to speak for itself. Never has a series in a prominent public venue been so dependent on, and demanding of, a sophisticated response from its audience. Indeed, the act of uncovering the series' content is part of its meaning.

Although Barry first exhibited his series in 1783, this book marks the first time in 230 years that a full public accounting of his concealed intentions has been published. Given this focus, I have not emphasised stylistic concerns. (In many cases I have already discussed formal and technical aspects of the works in earlier publications.) Instead, this book should be seen as a study in iconology, particularly as the term is used by Erwin Panofsky, who, in distinguishing between simple iconography and iconology, gave this classic definition: 'It [intrinsic meaning or content as interpreted by iconology] is apprehended by ascertaining those underlying principles which reveal the basic attitude of a nation, a period, a class, a religious or philosophical persuasion – unconsciously qualified by one personality and condensed into one work' (*Studies in Iconology: Humanistic Themes in the Art of the Renaissance*

[New York: Oxford University Press, 1939], p. 7). Barry's subject matter is often unique: his treatment of Orpheus is unprecedented; *A Grecian Harvest-home* and *Crowning the Victors at Olympia* have no parallel; and I also am unaware of any earlier painting of Elysium and Tartarus containing portraits of the deceased from all historical periods. Within this original content, I have been at pains to document and describe his use of traditional iconographic motifs, followed by an explanation of their deeper meaning within their historical context.

I appreciate that in some instances my interpretation of a detail as an iconographic reference could, when seen in isolation, be challenged as being merely coincidental. As will be shown, however, when all four of the classical subjects fit into a consistent pattern, coincidence is no longer in play. Only Barry's second deeper meaning provides a coherent intellectual structure to what is otherwise a decidedly disjointed narrative. In addition, while Barry's meaning is crypto-Catholic, his message should not be viewed as another narrow, sectarian salvo in the wars of religion. In accordance with the root meaning of 'catholic', he saw his message as a call to a universal Church. In his mind his vision was inclusive rather than partisan. What fascinates is how long his intentions have remained concealed and how personal and complex are their meanings.

Recognition of the Christian message in *James Barry's Murals at the Royal Society of Arts* helps to enrich our understanding of the role Christianity played in Enlightenment thought. Because of Barry's emphasis in the murals on the civilisation of ancient Greece, he is sometimes cast as the poster boy for a neoclassicism that valued a classical ethos over a Christian one, but nothing could be further from the truth. Barry saw Christianity and classical culture as being inextricably intertwined. In addition, the artist even saw the medium of history painting itself, the closest simulation in this fallen world of our heavenly natures, as partaking of divinity.

For at least the last two generations, many art historians have been fighting to distance themselves from the once standard model of the artist as an original genius who produces artwork for what are essentially passive viewers. However, Barry embraced this model with a vengeance. Indeed, he is one of those artists of the Romantic period who helped create this narrative. With this in mind, one needs to avoid the error of committing the 'intentional fallacy', which would equate the meaning of his murals with his intentions (like all great art, these works cannot be reduced to such a facile formula). Yet it is important to understand the main outline of what he hoped to achieve. Up to this time, his programme has not been comprehended at even a rudimentary level. Uncovering more of the artist's intentions will not explain or exhaust the murals' meanings, but it will prove an important step in establishing a deeper and more informed relationship between the paintings and the viewer.

The study of British art of the eighteenth and nineteenth centuries has prospered in recent years in its focus on defining overarching ideologies that have helped shape and determine our understanding of art and artists of this period. But such framing structures can obscure as well as reveal. Barry has some big ideas of his own that do not necessarily correspond to the terms of our current discourse. The comprehension of Blake's art has always required a proficient knowledge of visual sources and arcane texts. As this book demonstrates, this is also true of Barry's work. Indeed, in terms of imaginative myth-making, Barry led the way for Blake. My analysis of Barry's remarkable achievement takes its cue from Samuel Johnson's response on first seeing the murals: 'Whatever the hand has done, the mind has done its part' (Hill [ed.], *Bowswell's Life of Johnson*, vol. 4, p. 224). In detailing what the mind has accomplished, content has been paramount. Given how little understood this series has been, I trust no special pleading is required to justify such an emphasis. My hope is that this book will mark a significant development in the series' reception history by reimagining our experience of the murals, enabling Barry scholarship to proceed from a more enlightened perspective.

Over the years I have incurred a great many debts to individuals and institutions. Two of my

colleagues, Tom Dunne and Richard Spear, have been extraordinary not only in their many thoughtful responses to the manuscript but also in their support and encouragement in seeing this project through to completion. Indeed, Tom's efforts proved crucial in making possible this present publication. Both he and Richard deserve a place in Barry's Elysium. I would like to thank as well other readers of the manuscript who have offered numerous helpful suggestions: Meredith Gill, June Hargrove, Michael Kidson, Ronald Paulson and, of course, my wife Nancy, who over the years has contributed so much. Among those individuals who have provided assistance, I would like to thank Susan Bennett, David Bindman, Tony Colantuono, Diane de Grazia, Aneta Georgievska-Shine, Quint Gregory, Elizabeth Marlowe, Suzanne May, Charles McClendon, Timothy McLoughlin, Pearl and Seymour Moscowitz, Patrick Noon, Edward Nygren, Jorgelina Orfila, Hella and Rudi Preiesberger, Sally Promey, Penelope Treadwell and Marjorie Venit. The many opportunities I had at the University of Maryland to exchange ideas with my students and colleagues in multiple disciplines also proved invaluable in widening my scope and purpose.

Institutions have also played an important role in assisting me in my research. Among those I would like to thank are Peter Murray and Colleen O'Sullivan at the Crawford Art Gallery, Cork; the staffs at the Yale Center for British Art and the Beinecke Rare Book Library in New Haven and at the Paul Mellon Centre for Studies in British Art, London; Paoli Ranieri at the Villa Madama, Rome; and Valeria Samaolo at the Museo Archeologico Nazionale in Naples. Obviously, the Royal Society of Arts (RSA) deserves a place of its own. The Society was unfailingly responsive in giving me access to the murals and to archival materials, and I am extremely grateful to Matthew Taylor, the RSA's chief executive, and to Rob Baker and Evelyn Watson for their help and encouragement.

Given that I have worked for so many years on Barry, unsurprisingly throughout the book there are echoes of previous publications. In some instances I owned the copyright, but in the case of my article on Barry's painting *The Birth of Pandora*, I would like to thank Robin Simon, the editor of *The British Art Journal*, for permission to reprint extensive portions of this essay.

For providing me with time to complete this work, I am deeply indebted to the University of Maryland for its unstinting support. Its funding, including two General Research Board Grants, a sabbatical, and a year of paid research leave made this book possible. I would also like to thank the Paul Mellon Centre for Studies in British Art for its Mellon Senior Fellowship (spring semester, 2005) and the Yale Center for British Art for its residency fellowship (March 2010).

Working on Barry has turned out – a surprise to me – to be a lifelong pursuit. This book is the capstone to the years I have spent working on him. I deeply regret that my two early mentors – Robert Rosenblum and Charles Ryskamp, to whom I am greatly indebted – did not live to see this work completed. Over the last decade, many friends and family members had to listen to my thoughts on Barry, and I am particularly grateful to our son David for his patience with, and enthusiasm for, this project. We are all glad that these murals are now beginning to get the attention they deserve, and it is only fitting that Cork University Press, from the artist's hometown, is the book's publisher. Maria O'Donovan, editor, and Mike Collins, publications director, and their staffs have also done a superb job in helping to make these paintings accessible, giving Barry his largest audience yet.

Introduction

The history painter's sacred calling

In spring 1777, when he was only thirty-five years old, the Irish artist James Barry began work in London on six murals, which he entitled *A Series of Pictures on Human Culture*,[1] for the Great Room of the Society of Arts (the institution was granted the prefix 'Royal' in 1908). Writing in 1842, over a half century after the series' completion in 1784, the astute art historian Anna Jameson gave an assessment that is as true today as it was then: 'The six great pictures painted by Barry, for the Society of Arts, in the Adelphi, are almost unknown to the public at large; and though so easily accessible, there are but few people in London, even among those who take an interest in art, to whom they are familiar. Yet … they are up to this time the greatest historical works of the English school.'[2] No other major series of paintings in a venue accessible to the public has been as misunderstood as this one. By illuminating for the first time the full extent of the paintings' scope and ambition, this book aims to bring this neglected series into the mainstream of discussions on British art of the Romantic period.

A Series of Pictures on Human Culture consists of six paintings, 361cm high, which provide an almost continuous band around the walls of the Society's Great Room. The first three paintings depict the progress of Greek civilisation, opening with Orpheus instructing his primitive companions on how to lift themselves out of barbarism. The second mural shows a later agrarian stage of civilisation, with the Greeks, in a pastoral setting, celebrating a harvest thanksgiving. These two pictures on the west-side wall are 462cm wide, and they prepare the viewer for the grand climax of Greek civilisation in a painting showing the victors at the Olympic Games that extends along the entirety of the north wall for 1278cm. The east side wall again features two 361cm x 462cm canvases, both of which focus on aspects of contemporary England. The first is an allegorical composition celebrating Britain's global

commercial expansion, whereas the second features, in an idealised setting, the Society's awarding of its prizes. Another almost 42-foot (1280cm) mural stretching across the south wall closes the series with depictions of the elect in Elysium and the damned in Tartarus. The artist fills Elysium with portraits of specific individuals, although he only depicts generalised vices in the much smaller portion of the picture reserved for hell. Barry conceived the four classical subjects as early as his student years in Rome in the late 1760s, adding the two pictures on the east wall to his series when the Society of Arts became the venue. The murals belong to the genre of history painting, which, as traditionally defined by Renaissance academic theory, was art's highest category. History painting's subject matter was drawn from such 'universal' sources as the Bible, classical mythology and history, epic poetry, and the lofty symbols of allegory, all of which were depicted in an idealising style that transformed common nature. Addressed to the public realm, such heroic and high-minded works were intended to promote public welfare and virtue.

Barry saw this opportunity to create his series of history paintings as a crucial step in the education and advancement of his countrymen in terms of improving both their character and their reputation. In 1775 he had offered his own ennobling definition of history painting's significance: 'History painting and sculpture should be the main views of every people desirous of gaining honour by the arts. These are the tests by which the national character will be tried in after ages, and by which it has been, as is now, tried by the natives of other countries.'[3] Before Barry created his murals, how indeed should Britain's national character be judged, particularly in its capital city, which was the bellwether for the nation? At this time, London was one of the world's pre-eminent cities. Only Tokyo had a larger population, and London was second to none in commercial dominance. Yet despite its robust economic expansion, in some cultural matters it remained conspicuously behind many of its Continental neighbours. In painting, in particular, there was an appreciable gap in the achievements it could boast. The foundations for a great national school were being laid in the areas of genre painting (William Hogarth and Joseph Wright of Derby), portraiture (Sir Joshua Reynolds, Thomas Gainsborough and George Romney), landscape (Richard Wilson and Thomas Gainsborough) and sporting art (George Stubbs), but if one looks to the highest category of painting as defined by the academic canon – history painting – British prospects were poor indeed. The Royal Academy was founded in 1768 to help remedy this deficiency in the most exalted of categories, but there was little patronage or promise for the cultivation of high art. Italy, France, Spain, Germany, Holland and Flanders could boast an impressive number of ambitious historical cycles adorning the walls and ceilings of many of their churches and palaces. London could point to its ceiling by Sir Peter Paul Rubens in Whitehall and Sir James Thornhill's work in the dome of St Paul's Cathedral and at Greenwich Hospital, but such productions were, in the case of Rubens, too few and far between when compared to the number of Continental cycles or, as in the case of Thornhill, of inferior quality.

For supporters of British culture, all was not entirely amiss. One could point with pride to excellence in literature: Shakespeare, Milton and Spenser were often seen as a trinity that helped illuminate and nourish a brilliant literary heritage. Furthermore, one could argue that dominance in one cultural area automatically precluded dominance in another. From the vantage point of Scotland, William Duff, writing in 1767, made the case that poetry and painting flourished under different conditions, the former reaching its full powers under a system that promotes liberty and public spirit and the latter when wealth is concentrated in the hands of a few: 'Eloquence will always be exerted in its utmost power under a Democratical form of government, during the reign of Liberty and public Spirit; Painting and Architecture will in general attain their highest degree of improvement, in the most advanced state of society, under the irradiations of Monarchical splendor, aided by the countenance and encouragement of the great and opulent.'[4] The conclusion is obvious: London, Great

Britain's cultural centre, is conducive to the production of great writing but not great painting. This is more a matter for congratulation than concern; for what people would want to live in a nation where a few, as in France, have a monopoly on power? Painting, after all, smacked of effeminacy in its sensual appeal to the eye, and the British are made of sterner stuff. Besides, no less a cultural icon than Samuel Johnson had already proclaimed 'The chief glory of every people arises from its authours [*sic*]'.[5] Seen in this context, Barry's 1775 assertion concerning the importance of history painting and sculpture was made in defiance of Johnson's edict.[6] The artist's mission was to establish history painting on British soil by altering how the British perceived the role history painting should play within its culture, elevating it to occupy the premier position in its own civilisation's progress. In making such a bold pronouncement in favour of the elevated status of the visual arts, he was determinedly swimming against the tide.

For Barry, the debate over which of the arts should play the most consequential role went beyond an academic exercise concerning their supposed relationship to various political and social institutions. Text and images were in competition in terms of a much more important arena, that of religion. Which medium better performed a sacral function? Which gave the closer access to God's will? Benedict Anderson argues for the importance of written languages in nourishing mankind's relationship to the divine, a position that Johnson would have endorsed. In Western civilisation before the rise of nationalism, the idea of Christendom, as a great sacral culture provided a strong bonding identity, and this culture was 'imaginable largely through the medium of a sacred language and written script'.[7] In the case of Christendom this 'truth-language' was Church Latin.[8] This concept of a sacred language strengthened enormously the privileged position of the papacy: 'The astonishing power of the papacy in its noonday is only comprehensible in terms of a trans-European Latin-writing clerisy, *and* a conception of the world, shared by virtually everyone, that the bilingual intelligentsia, by mediating between vernacular and Latin, mediated between earth and heaven.'[9] However, by the eighteenth century Latin was everywhere in steep decline as vernacular languages were replacing it in most spheres of life: 'the fall of Latin exemplified a larger process in which the sacred communities integrated by old sacred languages were gradually fragmented, pluralized, and territorialized.'[10] But in Protestant, iconoclastic cultures, vernacular languages, such as English, in their turn became powerful conveyors of faith, with texts, in particular the sacred word of God in the Bible, offering the most direct access to divinity.

For Barry, too, texts were of great importance. With the exception of the group portrait *The Distribution of Premiums*, texts underlie all of his murals. He employs a wide variety of them, including ancient and modern authors such as Horace, Lucretius, Virgil, James Thomson, Gilbert West, Pindar and Sir John Denham, whereas *Elysium and Tartarus* is populated with a vast array of men of letters. In particular, Bishop William Warburton's eighteenth-century treatise *The Divine Legation of Moses* provided Barry with the key by which to unlock a syncretic reading of ancient texts. The bishop pointed the way to an interpretation of Virgil's writings that gave Barry his overarching organising principle. Given the number and range of his textual sources, in one sense the artist's underlying text is the Western classical tradition. Yet another primary textual source is the Bible, even if Barry chose not to acknowledge openly its fundamental presence. He also wrote a lengthy book to accompany his images. In some ways, all of these literary sources provide remedial texts to point the audience in the right direction in order to understand his history paintings' underlying meaning and purpose.

Although texts are essential to understanding Barry's series, they play a supportive, rather than a leading, role. For the iconophilic artist, visual imagery was the sacred language that best gave mankind access to the supernatural world, because he fervently believed in the power of images, with history painting being its grandest expression. Pictorial forms are the repository of immutable truths

that act more forcibly on the human mind and spirit than any other medium. Ultimately, the most profound 'text' of all is the imagery of the murals themselves, through which the artist has created a mega-narrative all his own.

Barry maintained that the word 'language' itself was woefully inadequate when applied to the visual arts: 'But the art of painting is debased by the complaisance of calling it a language. It is a mode of communication as much superior to language, as the image of any thing in a looking-glass is more satisfactory and superior to any mere account of the same thing in words.'[11] The history painter actually composes in the discourse of divinity: visual imagery is literally the Word made flesh (John 1:14), or, more accurately, a mimetic simulation. However, the simulation, because it presents imagery in the form of a more perfect, idealised nature, is superior to ordinary reality. Its shelf life, unlike a language such as Latin, has no expiration date. In this context, Protestant iconoclasm is further proof of its alienation from divinity. Protestant culture is overly concerned with the Bible's text, literally the word, in contrast to Catholicism's emphasis on the visual, the Word made flesh, or, more literally, ideas understood as images.[12] From Barry's perspective, history painting is the one means of expression that can be understood by all peoples at all times in a polyglot world. The idea of a united Christendom on a global scale lies at the heart of the Great Room's reliance on this supposedly eternal and universal medium. For Barry, visual imagery at its highest level was inseparable from religion, because it best expressed the mind of God. Because mankind was created in God's image, it is only in works such as the *Belvedere Torso*, Raphael's Vatican *Stanze*, Michelangelo's Sistine Chapel and Barry's Great Room, or so he would have it, that one can most fully experience divinity. In endorsing the biblical proposition that we are made in the image of the creator, Barry, like so many others, ended by reshaping the world to fit his own image. But his reconfiguration is an imaginative construct of a high order. His images are not intended as mechanical renderings of reality, the shadows of things, but are meant to convey instead a substantive, spiritual vision. Only the sublime content and idealising style of high art speak to mankind at the most profound levels. If history painting and sculpture are the highest forms of expression, it naturally follows that history painters and sculptors should hold society's most eminent and influential position. No painter of the Romantic period perceived a higher status for the artist than did Barry, who saw the history painter functioning as a supreme political and spiritual leader, a high priest who reveals core principles and how best to achieve them.

Initiating a new public art

If the history painter were to be considered as supreme, then the traditional forms of patronage could no longer apply. Customarily, the patron was closely involved in any large mural programme, appointing an adviser or advisers to create a template and to supervise its execution. But, as will be shown, Barry's agreement with the Society of Arts was unprecedented. For the first time in the history of Western art, the patron of a large, impressive interior turned over complete control to the artist commissioned to decorate it. Barry, and Barry alone, formulated the series' subject matter. Furthermore, the Society of Arts has always been generous in allowing the public access to its murals, thereby enabling Barry to continue to speak directly to the general public without mediation. He envisioned his series of paintings as participating in a discourse concerning national priorities, a new public sphere which has been ably defined by Jürgen Habermas in his book *The Structural Transformation of the Public Sphere: An Inquiry into a Category of Bourgeois Society*. Habermas maintains that in the eighteenth century the formation of a bourgeois public sphere created new forms of political discourse in the capitalist economies of major urban centres. As a result, the new phenomenon of public opinion played an

increasingly important role. Such forums as newspapers, journals and coffee houses gave private individuals opportunities in which to debate public issues. Through the prestigious space afforded him in the Great Room of the Society of Arts, Barry was able to participate aggressively in the public debate of private citizens, a debate that extended well beyond the Society's membership. He was not just concerned with the Society's specific goals and aspirations, other than that, in a general sense, both were interested in helping to shape issues upon which the common good depended. Rather than reinforce or celebrate its agendas, he wished to transcend them, addressing his message to mankind as a whole.

Barry also identified with classical precedent in describing how meaning in his paintings should be transmitted. He looked back to the frescoes adorning the colonnade or stoai in the market place at Athens as an antique prototype. Available to all, these images prompted discussion among those who gathered there, leading eventually to the founding of a school of philosophy, led by Zeno, bearing the name Stoics after their regular meeting place. Barry compared the Great Room to Athens' colonnade: 'it was my wish, when I began the work, to make pictures for the *porch* … where some future Zeno might find a useful text, which, with his amplification, would be a means of inciting his hearers to the pursuit of true patriotism and true glory, the exertions of active, genuine virtue.'[13] The artist envisioned his murals as forming an integral part of a democratic gathering place that would instigate philosophical reflection, thereby inspiring the creation of another important new philosophy. But, again, one must distinguish between visual texts and written ones: pictorial narratives are part of a more elevated discourse than are written documents or the spoken word that helps transmit their ideas.

Although Barry's paintings form part of a public discourse, one of their fundamental purposes has gone unperceived: the artist intended his murals as an initiation into sacred mysteries, a resurrection in modern times of the mystery cults of the ancient world. For him, the only two mysteries of consequence were those of Eleusis and of the rites of Christian Communion. In addition, he saw their underlying meaning as being closely aligned, each manifesting a similar religious revelation, beyond rational understanding, of God's secret knowledge. In his creation of an esoteric and erudite programme and in his reliance on an imaginative and syncretic exploration of classical myths and Christian dogma, Barry opened up a new approach to art in Britain, of which at least one artist was to take full advantage. William Blake, who is usually thought to be *sui generis*, was strongly indebted to the Irish artist's example.

In exploring the content of Barry's epic, this book follows a chronological and thematic organisation that is also responsive to the artist's use of different media. Part one analyses the murals' surface, or apparent, narratives, as the artist presented them in his exhibitions of 1783 and 1784 (there is little change in content between these two exhibitions). This is the level at which the series has been approached for 230 years. In this regard, 'surface' should in no way be seen to imply 'superficial': the reading of the ostensible narrative is itself richly complex and rewarding. The fact that part one is the book's longest indicates just how elaborate and extensive is such an analysis. Barry's own descriptive texts, which are mainly concerned with helping the viewer comprehend the surface level, by necessity accompany this examination despite their length. His text for his last painting, *Elysium and Tartarus*, is so long that it has been subdivided into more easily digestible portions. The three sections on the classical world, the modern world, and the state of final retribution represent the past, the present, and the future, but all the works are meant to be continually discussed and analysed in the present. *Elysium* does not enshrine a pantheon of the great in a remote region removed from earthly concerns, but rather its figures and the inscribed books and scrolls they are holding are intended to establish an ongoing dialogue with the viewer. Barry published his own prints after the murals in 1792, and these prints, which offer variations on the original content, are integrated into the discussions of

the paintings in part one. Part one's title, *The Murals' First Incarnation*, refers to the series' 1783–84 appearance as being only the first of the forms it was to take, as the artist continued to make adjustments, large and small, for the remainder of his career.[14] In addition, another of the meanings of the word 'incarnation', in which it is seen to embody divinity in earthly form, foreshadows the discussion of the murals in part two.

Part two starts anew with the murals as they appeared in 1783 and 1784, this time discerning a sophisticated, hidden subtext available only to those who can comprehend the 'divine' rhetoric of history painting. In addition, this section places this hidden message within the context of some of Barry's other pictures, including his largest easel painting, *The Birth of Pandora*, demonstrating that his Adelphi series forms part of a unifying vision encompassing his entire career. These two projects, the Adelphi series and *Pandora*, are integrally linked: the murals provide the model for the best political and social system, while *The Birth of Pandora*, drawing on the same sources, deals more exclusively with religious matters. Both projects were conceived when the artist was a student in Rome, *Pandora* having grown out of his study of Raphael's Cupid and Psyche frescoes in the Villa Farnesina, and the Adelphi series out of his meditations in front of Raphael's Vatican *Stanze*. As already stated, Barry's reading of the *Aeneid*, as interpreted by Bishop Warburton, informed his approach to these frescoes. When he first conceived the outline of his plan, he could not have anticipated where his paintings might eventually appear. Consequently, he later introduced his two modern subjects, *Commerce or the Triumph of the Thames* and *The Distribution of Premiums in the Society of Arts*, to accommodate this specific venue. Although he never managed to integrate these two murals fully into his original plan, they do comment on, and add to, his overarching design. In the discussion of Barry's hidden meaning, however, their role is minimal. But even in his classical subjects, the political, social, economic and religious institutions that interest him the most are British rather than Greek. Or, more accurately stated, what interests him the most are those values and structures of Greek civilisation that should be applied to modern Britain. His is a utopian vision in that he applies a system of classical Greek culture that exists more in his imagination than it ever did in reality to a future civic order that is equally impossible of achievement. He wages a battle over defining and rescuing the 'soul' of the British nation. In contesting how its history should be interpreted, he offers his version of a Catholic narrative to which Britannia must be receptive if she is to reclaim her former virtue and sanctity. Unsurprisingly, Catholic Ireland figures prominently in defining those values for which the British should strive. Barry's initiation, however, is about more than the duties of citizenship and the optimal structuring of political, social and religious institutions. The call to the active life is only one part of the equation. Of greater importance is his call to the contemplative life. His pilgrimage is also a spiritual journey in search of a primal wholeness, the rapturous obtainment of the Platonic ideal.

After completing his murals in 1784, Barry lived for another twenty-two years, during which time he continued to fine-tune his message, making it more intelligible, rethinking certain aspects, emphasising others, and making it responsive to such major contemporary developments as the French Revolution and the Irish rebellion of 1798. In order not to impede the flow of the narrative, I have placed his many revisions to his content in the medium of prints in appendix one, and the majority of his changes to the murals themselves in appendix two. His efforts to amend and to add to his subject matter were often his way of making more discernible the hidden message to which his audience had remained oblivious. The artist's Irish roots underlie much of his vision of a more perfect society, and part three explores how in 1801 he devised an ambitious plan to commemorate and comment on the Act of Union between Great Britain and Ireland.

The Conclusion is in three sections. The first section helps to situate Barry's achievement in relationship to similar projects by his contemporaries, thereby bringing into focus the innovative

nature of his own programme. After briefly introducing the major projects of Benjamin West and John Francis Rigaud, the section concludes with a more extended analysis of Barry's relationship to Blake. The second section examines his 'official' self-portrait as Timanthes that he initially introduced into *Crowning the Victors at Olympia*, which is one of the more creative statements on artistic identity made in the Romantic period. The third section closes with a review of the artist's intent, his approach to his audience, and his carefully crafted persona. This book will reveal Barry's series as an epic pilgrimage in which the viewer is led into a profound, transforming experience. At heart, the Great Room is like the *cella* of a temple or the interior of a cave, where the artist as high priest initiates the acolyte into a rite of passage resembling that of the Eleusinian Mysteries.

The conventions of high art encouraged artists to challenge viewers to study and meditate on their works in an effort to uncover ever deeper layers of meaning. But Barry's concealment of his content goes far beyond normal practice as far more was at stake. He realised that if his meaning were readily apparent, the Society would have thrown out both him and his murals. Part of his message was stingingly inflammatory, offering a scathing critique of modern British society. Even his life could have been in danger, or so he thought, given his unshakable belief that martyrdom was a fate commonly awarded great men. But another reason for disguising his meaning was still more important: the series formed an initiation into profound religious mysteries, and by definition such experiences involved secret rites available only to the initiated. The artist faced a dilemma in which he was torn between revealing and concealing his message. By making the path to understanding long and arduous, his hope was that the process of discovery itself would eventually convince those who persevered. Because visual imagery is a medium more powerful than mere words, it is the more persuasive of the two. Barry's sublime 'vocabulary' ensured, at least in his mind, acceptance. Once the secret mysteries at the murals' core were grasped, there would be no going back. Since, for the artist, the mysteries themselves derived from divine revelation, once understood they could no longer be denied or ignored.

PART 1

THE MURALS'
FIRST INCARNATION

A Painter's Progress:
the Exhibitions of 1783 and 1784

The painter and the patron

Like so many of the British school who ambitiously chose to become history painters, Barry came from a more remote cultural area, where, outside the major artistic centres, he could more easily imagine a career unencumbered by the oppressive heritage of an omnipresent past. Born in Cork, Ireland, on 11 October 1741, to a Roman Catholic mother and a Protestant father, his first language may well have been Gaelic, a language, however, which he presumably never learned to read or write.[1] Perhaps as early as 1760, Barry travelled to Dublin,[2] where within three years he submitted his painting *The Baptism of the King of Cashel by St Patrick* for an exhibition held by the Dublin Society for the Encouragement of Arts, Manufactures and Commerce, for which he won a premium. In Ireland's capital he met the statesman and aesthetician Edmund Burke, who, taking the young man under his wing, secured for him a position in London with James 'Athenian' Stuart. Then, along with his kinsman William Burke, Edmund supported Barry's training on the Continent for five-and-a-half years from November 1765 to spring 1771 – study that took the artist first to Paris for ten months and then to Rome for three-and-a-half years, along with brief stays in other Italian cities.

On his return to London in 1771, Barry lost little time in establishing himself as a history painter. His *Temptation of Adam* (National Gallery of Ireland, Dublin) was on display at the spring exhibition of the Royal Academy even before he had arrived back in the capital. In 1772 he exhibited three more history paintings, and in November of that year the Royal Academy elected him an associate member, followed by election to full academician in February 1773, the fastest advancement of any painter in

its history. Barry continued to exhibit annually at the Academy up until 1776, but he believed the time was ripe for a native history painter to make a major statement. As he later wrote, beginning in the Renaissance, artists had been slowly acquiring the means to execute grand designs, and now all that was lacking was the soulful intelligence necessary to animate their hard-won technical skills: 'the preparatory times of the art, when little component particulars bounded the prospect, as they succeeded each other, are long since passed away. We are now at the close of the eighteenth century, the whole of the art is called for, the animating soul is necessary, and if mind or intellect be wanting, care, expense, and curious decoration of mere trifles can avail nothing.'[3]

What were Barry's credentials for addressing the public in the noble format of history painting? The artist was an autodidact, and like so many of the self-educated, he was opinionated and obstinate in his beliefs. Intellectually curious, he was widely read, not only borrowing books from his friends but also building up a considerable personal library.[4] Although intrigued by ancient cultures, he did not read Greek and had only a rudimentary knowledge of Latin,[5] but because of his stays in Paris and Rome, he was proficient in French and Italian. He was Roman Catholic, his friend and biographer Dr Edward Fryer having described him as being a staunch believer but in his own fashion: 'Although no man's rule of faith could be more invariable and steady than Mr. Barry's, and to the principal doctrines of the Roman Catholic Religion [he] was rivetted, even to a degree which many of his protestant friends justly thought bigoted, yet was he a Catholic after his own way'.[6] Fryer went on to characterise him as yearning for 'an Universal Church' in which 'a general reconciliation might take place between the Catholic and Protestant churches'.[7] Although the artist passionately supported reconciliation in the public arena, his biographer's observation of his having been 'justly thought bigoted' refers as much to his character as it does to his beliefs. The artist was paranoid, self-aggrandising and inflexible, seeing himself as championing truth and justice in a world in which the powerful would have liked nothing better than to silence his voice. At one point, Barry accused members of the Royal Academy of having robbed his house of cash in an effort to derail his work,[8] and over the course of his life he even worried about the possibility of assassination.[9] Those feelings of rage that accompanied his exalted sense of purpose, harnessed to a keen intellect, helped drive his scholarly erudition.

Although Barry felt he was more than ready to undertake a major series of paintings, there still was the problem of finding a site suitable for history painting on a grand scale. In this the experience of the artist differed from that of the writer, and Barry was also acutely aware of the gulf separating Italian culture from that of the English. He singled out painting cycles in Rome for his antecedents when pointing out that painters, unlike writers, were dependent upon having a specific site for their field of operation: 'Raffaelle, M. Angelo, and Carrache, could not have produced their great works, without the Sistine Chapel, the Vatican, and the Farnese Palaces: whereas Milton's poem required neither a palace nor a prince, and is as much within the purchase of the mechanic, as of the sovereign.'[10] England's churches and palaces had unfortunately not provided suitable places for history painting. The commitment to artistic patronage by the Church, the state and the nobility that had supported the grand cycles to be found on the Continent was largely absent.

Barry had wasted no time in trying to secure a proper venue for history painting. In the appendix to his 1783 description of the Adelphi paintings, he gave the following account of the project's genesis:

Immediately upon my connection with the Royal Academy, in a conversation at one of our dinners, where we chatted a good deal about the concerns of the Art, I made a proposal, that, as his Majesty had given us a palace (Old Somerset House) with a chapel belonging to it, it would become us jointly to undertake the decorating this chapel with pictures; that it afforded a good opportunity of convincing the public of the possibility of ornamenting places of religious worship with such pictures as might be useful, and could possibly give no

offence in a protestant country; that, probably this example would be followed in other chapels and churches; that it would be opening a new and noble scene of action, would not only be highly ornamental to the country, but would be absolutely necessary for the future labour of the many pupils whom the Academy was breeding up … Sir Joshua Reynolds proposed, as an amendment, that, instead of Somerset chapel, we had better undertake St. Paul's cathedral, which was agreed to.[11]

The voting would seem to have taken place at the time Barry was formally enrolled as a full academician at the meeting held on 19 August 1773.[12] Reynolds, in conjunction with Benjamin West and Thomas Newton, the bishop of Bristol and dean of St Paul's, had already begun to explore the possibility of five Royal Academicians (the number was soon expanded to six) to each contribute a large picture to the cathedral. As Sir Joshua wrote to Thomas, 2nd Baron Grantham, on 20 July 1773, this project, like Barry's, was directly related to the promotion of history painting in order to bring British practice more in line with Continental ones: 'We are upon a scheme at present to adorn St. Pauls Church with Pictures … We think this will be a means of introducing a general fashon for Churches to have Altar Pieces, and that St. Pauls will lead the fashon in Pictures, as St. Jamess does for dress, It will certainly be in vain to make Historical Painters if there is no means found out for employing them.'[13] The project, however, was squelched by Dr Richard Terrick, bishop of London, who is reported to have played the anti-Catholic card: 'I will never suffer the doors of the metropolitan church to be opened for the introduction of popery into it.'[14] Inspired by the Royal Academy's proposal to decorate St Paul's, the Society of Arts approached the Academy with its own proposal to ornament its Great Room. Although this negotiation collapsed because of the academicians' indifference, from this failed effort came the pioneering partnership between Barry and the Society in the creation of a monumental cycle of history paintings in the heart of London.

The Society of Arts (its full name was the Society for the Encouragement of Arts, Manufactures and Commerce) was typical of a number of democratic institutions that grew out of Enlightenment aspirations in eighteenth- and nineteenth-century Europe and America. Within ten years of its founding in 1754, its membership had grown to over two thousand, including such notables as Samuel Johnson and Benjamin Franklin and the artists William Hogarth and Reynolds. Its goals were to foster practical and beneficial improvements in multiple fields of endeavour by sponsoring premiums to be awarded for innovation and excellence. As its founder William Shipley, a drawing master, stated in his proposal of 8 June 1753, what was needed was an organisation that could judiciously dispense these awards:

That whoever shall make the most considerable Progress in any Branch of beneficial Knowledge, or exhibit the most compleat Performance of mechanick Skill; whoever shall contrive the best Expedient or execute the happiest Project for the Comfort, the Embellishment, the Interest, or in Time of Danger, for the Defence of *Great Britain*, may receive a Reward suitable to the Merit of his Services. Such a Scheme … it is hoped may prove an effectual Means to embolden Enterprize, to enlarge Science, to refine Art, to improve our Manufactures, and extend our Commerce; in a Word, to render *Great Britain* the School of Instruction, as it is already the Centre of Traffick to the whole World.[15]

What was most remarkable about the Society's membership and purpose was its inclusiveness. Its membership was noteworthy for its social flexibility, extending from commoners to aristocrats, from craftsmen to professionals. Within a decade, women composed a tenth of the membership, and the indiscriminate mix of occupations included manufacturers, merchants, bankers medical doctors, clergymen, military officers, government officials, tradesmen, lawyers and artisans, as well

Fig. 1 Benedict Pastorini, *View of the South Front of the New Buildings Called Adelphi*, 1770. Engraving, 422mm x 810mm. Plate 1 in vol. 3 of *The Works in Architecture of Robert and James Adam, Esquires*, London, 1822. Beinecke Rare Book and Manuscript Library, Yale University, New Haven

as representatives of the various branches of the liberal arts. By the early 1760s, the Committee of Premiums, for practical purposes, had been divided into six standing committees reflecting the major fields of interest: the polite arts, agriculture, mechanics, manufactures, chemistry, and the colonies and trade.[16] Again given the pragmatic and inclusive nature of the Society's intent, the definition of the visual arts ranged from low to high, promoting both improvements in mechanical execution as well as in the advancement of art as an intellectual activity focusing on general principles. This dichotomy, based on academic hierarchies, was also reflected in the types of premiums: one might receive a medal (an honorary token of esteem) or money (a more practical prize but one associated with sordid financial gain). In his painting showing the Society's distribution of premiums, Barry depicts only the former.

In 1774 the Society moved into a new building designed for it by the distinguished architect Robert Adam, a structure it still inhabits today. The land formed part of the ambitious development that the Adam brothers, Robert, James and William, were undertaking on an approximately 3½-acre site to rehabilitate the rundown Durham House estate that ran from behind the buildings on the south side of the Strand down the steep slope to the edge of the Thames.[17] The Adam brothers christened their venture the Adelphi, the Greek name for brothers, and hoped to attract a fashionable clientele for their apartments above and to attract the government for the rental of vaulted storage spaces below. Benedict Pastorini's engraving of 1780 shows the impressive river front with the entrances to the Adelphi arches supporting a central building whose partial façade, punctuated by eight central pilasters and four pilasters at each end, housed eleven apartments. The ends of separate buildings at either side project forward to anchor this unified composition. The street above the arches bore the name Adelphi Terrace, while the other streets were given family names. In the print, on the east side

Fig. 2 Thomas Malton, *John Street, Adelphi*, 21 December, 1795. Etching and Aquatint, 304mm x 227mm. Plate 30 in vol. 1 of Thomas Malton's *A Picturesque Tour Through the Cities of London and Westminster*, London 1792. Yale Center for British Art, Paul Mellon Collection, New Haven

JOHN STREET, ADELPHI

Published Dec.r 21.st 1795. by T. Malton.

at the right, one sees Adam Street's south end. The street on the left side is Robert Street, named in honour of the project's principal architect. John Street, named after the eldest brother, who was still in Scotland, was another important thoroughfare, running parallel to Adelphi Terrace on the north side of the central block of apartments. While most of the Adelphi buildings were torn down from 1936 to 1938, the major streets have retained their names, although John Street has been renamed John Adam Street and now runs all the way to Villiers, having subsumed Duke Street.[18] The Society's principal building is on the north side of John Adam Street (no. 8) near its east end. Thomas Malton's 1795 print shows its stately facade within its confined, urban setting. As with so many of the other Adelphi structures, the ground floor provides an imposing foundation, but instead of pilasters, Adam employed attached columns supporting an entablature, emphasising the building's temple-like nature. One enters this 'temple' through the central entrance on the ground floor to climb steps to the left to the first-floor landing. Turning one's back to the decorative Palladian window in the centre of the façade, one then proceeds through the doors in the centre of the south wall of the Society's Great

Fig. 3 *Society for the Encouragement of Arts, &c.*, 1 July 1809. Etching by Augustus Pugin and Thomas Rowlandson, and aquatint by J. Bluck, 232mm x 260mm. Plate 71 in vol. 3 of R. Ackermann's *Microcosm of London* [1808].

Room, a grand space that was used as an assembly room, particularly for the awarding of premiums. Thomas Rowlandson's aquatint gives a sense of this room's original appearance, with its oval skylight, its light, decorative, classical moulding, and its orientation toward the president's chair on the north wall.

The Society immediately addressed the question as how best to decorate its impressive new interior. Since displays of the works submitted by its premium winners could be mounted in the Model Room on the ground floor directly beneath the Great Room, the Great Room itself required permanent decoration befitting its use for general meetings and ceremonial occasions. The Society hatched an ambitious scheme, involving twelve paintings in all, three on each wall, and only two of which would be by the same artist, Sir Joshua Reynolds, the president of the Royal Academy. Valentine Green produced a watercolour charting what was intended. All four walls were to have a strong central focus. The long south wall, where one entered, had a large central door over which was a vertical oval, 213cm x 152cm, with the allegorical subject *Time Introducing Genius to Fame*. The sketch shows an actual clock incorporated into the composition. Opposite was to be a horizontal oval, 152cm x 244cm, titled *Liberality Rewarding Merit*. Appropriately, the president would be sitting beneath this allegory when the awards were dispensed to the winners, and an architectural frame behind the dais firmly defined the wall's centre. Each of the short walls had a fireplace at its centre, over which were to be portraits of the first and the current president: that of Lord Folkestone, the first president, was destined for the west wall, and that of Lord Romney, the second and then current president, for the east wall (these works have subsequently exchanged positions). These strong, central elements provided the support for what would be the room's dominating feature, the large historical compositions flanking them. Eight works, each by a different artist illustrating a scene from English

JAMES BARRY'S MURALS AT THE ROYAL SOCIETY OF ARTS

Fig. 4 Valentine Green, *Plan for Decorating the Great Room*, 1774. Pen and ink with watercolor, 372mm x 418mm. Royal Society of Arts, London

history and each measuring 361cm x 274cm, would indeed offer an impressive showcase of British talent. Hogarth had on a lesser scale initiated a similar venture at the Foundling Hospital, whereby four artists (Hogarth, Francis Hayman, Joseph Highmore and James Wills) each contributed a biblical subject to decorate the hospital's Court Room. In addition, Hayman on his own had undertaken a room of four large canvases of contemporary English subjects at Vauxhall Gardens (for an engraving after one of these pictures see fig. 20).

The Society's biggest challenge was to have its proposed programme executed with as little expense as possible. In his decoration for the Foundling Hospital, Hogarth was able to persuade his colleagues to donate their works to this charitable institution, and just the year before the completion of the Society's own building, as we have seen, six Royal Academicians had approached St Paul's Cathedral with an offer to paint and contribute altarpieces that would obviously help promote their careers as painters of high-minded compositions. The Society now undertook to approach these same six painters – Reynolds, Angelica Kauffmann, Benjamin West, J.B. Cipriani, Nathaniel Dance and Barry – to undertake the painting of its large historical pieces, rounding out their number to eight by adding two prominent non-academicians, John Hamilton Mortimer and Joseph Wright of Derby. George Romney and Edward Penny were nominated to execute the allegorical designs. The portraits of the presidents over the fireplaces were a separate transaction, and indeed Reynolds had already executed his portrait of Lord Romney in 1770, two years before the new premises had been negotiated. To

decorate St Paul's would have been distinction enough, but the Society realised that in its case it had also to offer a financial incentive, proposing that it would subsidise an exhibition of the works once completed up to the sum of £300, the profits of which could be split among the artists. In their meeting of 5 April 1774, the artists voted to reject the offer, sending the reply, 'the mode of Raising Money by Exhibition would be disreputable to them and from the Nature of their Engagements with their respective Societies they are Sorry they Cannot comply with the present proposals of the Society'.[19]

On 5 March 1777, after almost three years had lapsed, Barry approached the Society on his own, proposing that for its interior he single-handedly execute a historical cycle on a grand scale. He asked only that he be allowed to choose his own subjects, a highly unusual request, and that the Society cover the expenses for canvas, colours, and models.[20] The Society accepted his offer, and the artist began work in earnest by late July of that same year.[21] But he did not have an entirely free hand in decorating the space in which he was to work. In 1776 Reynolds' portrait of Lord Romney, the Society's then president, had been joined by Thomas Gainsborough's posthumous portrait of Lord Folkestone, the Society's first president, with the first positioned over the fireplace on the east wall and the latter over the fireplace on the west wall opposite it. Although forced to work around these images, Barry never considered them as permanent features, hoping that he could eventually persuade the Society to allow him to replace them with works of his own.

An unprecedented alliance

Barry's opportunity to create a grand historical cycle without supervision in an important London interior is remarkable, and the Society's patronage in allowing the artist to create his own programme was unprecedented. It was indeed unthinkable before a time when the idea of original genius was beginning to be held in the highest esteem. Books, such as William Duff's *An Essay on Original Genius* of 1767, helped prepare the way:

To explore unbeaten tracks, and make new discoveries in the regions of Science; to invent the designs, and perfect the productions of Art, is the province of Genius alone. These ends are the objects to which it constantly aspires; and the attainment of these ends can only fall within the compass of the few enlightened, penetrating, and capacious minds, that seem destined by Providence for enlarging the sphere of human knowledge and human happiness.[22]

Barry seizes his moment to become a pioneering intellect who not only enlarges the sphere of human knowledge and human happiness but also takes it for his subject matter, having written that his purpose was 'to illustrate one great maxim of moral truth, viz. that the obtaining of happiness, as well individual as public, depends upon cultivating the human faculties'.[23]

This new type of opportunity demanded a new type of art. In his written introduction to his series, Barry states that there was no honour in repeating past formulas. Biblical subject matter in particular had been repeated to the point of sterility:

With respect to historical painting, people will not now give us credit for common-place matter, of which, for a century past, there has been more than enough all over Europe; many subjects have been long since exhausted, by the accumulated ingenuity and industry of our predecessors on the Continent ... There are many subjects of the New Testament, which have been already so hackneyed, that a moment's inspection will convince us, there is hardly any thing admissible into them, which has not been executed over and over again; and, consequently,

prints and drawings of them within every man's reach; so that for the same reason that mere mechanical artists will run after these kind of subjects, a Poussin, a Le Sueur, and all who possess a mind and genius adequate to their art, would wish to avoid them … The majesty of historical art requires not only novelty, but a novelty full of comprehension and importance.[24]

Barry's content is indeed novel. The following diagram shows his paintings' positions on the walls, although Barry of course was never permitted to replace the existing portraits by Reynolds and Gainsborough with his intended portraits of the king and queen.

Although Barry's content was indeed unprecedented in terms of a large mural series, one could, however, point to Hogarth as a precursor in some respects. Although Hogarth operated on a different, less exalted level of painting, and on a different scale, that of canvases suitable for an easel, he did pioneer the idea of an artist creating his own complex narratives, independent of any patron or adviser, within a series of six or eight pictures. Barry would have been offended by such a comparison; in contrast to Hogarth, he was a practitioner of high art. Yet Hogarth had prepared the way for him not just to construct an ambitious programme on his own but also to envision that programme in highly personal terms. Both Hogarth and Barry were insisting on conventions that had applied to

Diagram 1: The intended 1783 disposition of the paintings in the Great Room
1. *Orpheus*; 2. *A Grecian Harvest-home*; 3. *Crowning the Victors at Olympia*; 4. *The Triumph of the Thames*; 5. *The Distribution of Premiums at the Society of Arts*; 6. *Elysium and Tartarus*; 7. *Portrait of King George III* (space originally occupied by Gainsborough's *Portrait of Lord Folkestone*; at present this portrait has been exchanged with the one by Reynolds); 8. *Portrait of Queen Charlotte* (space originally occupied by Reynolds' *Portrait of Lord Romney*)

writers rather than to painters. When comparing an author, such as Milton, to artists, such as Raphael, Michelangelo and Carracci, Barry argued the writer was traditionally freer to create his or her own narrative without interference. In an era that can still exalt the idea of original genius, one often forgets the once-accepted nature of the contract between the artist and his or her patron. Such a sophisticated programme as Raphael's Vatican *Stanze* was the product of several advisers, and furthermore one imagines Raphael welcomed such scholarly input rather than chaffed under its 'restrictions'.

Although it is impossible to be certain of the exact nature of Barry's original programme for his Adelphi series, its content evolved over time. When he approached the Society in March 1777, he deliberately withheld specifics about his subject matter, but when he wrote to Sir George Savile on 19 April of that same year, he offered a tantalising glimpse of his intentions in what is his earliest recorded vision for the Great Room:

I have begun it, and my intention is to carry the painting uninterruptedly round the room (as has been done in the great rooms at the Vatican and Farnese galleries) by which the expense of frames will be saved to the society. And though I mean to ground the whole work upon one idea, viz. Human Culture, I shall yet divide it into different subjects expressive of the different periods of that culture. In one I take the story of Orpheus reclaiming mankind from a savage state, as it is glanced at by Horace. This story has been often painted in another way, and from attending more to the letter of allegorical and poetical metaphors than to the spirit of them, hitherto I think very ineffectually; as, however it might do in words, a man encircled with beasts, tygers, birds, &c. playing with ten fingers upon an instrument of four or seven strings, is a subject little susceptible of either expression or improvement, and gives us but an imperfect idea of the undertaking of that legislator, poet, and musician. In the second subject I take that point of time at the olympic games, when the Hellanodics are distributing the rewards to the conquerors in those several contests, by which the Grecians were formed to such an admirable pitch of mental and bodily vigour. This picture occupies that whole side of the room behind the president's chair, and is forty-two feet by twelve. The two pictures next, which are fifteen feet by twelve, are, one, – the contest and matching the competitors, and the other Prodicus reading to that assembly his performance of the choice of Hercules, Aetion the painter, and a number of other ingenious men, producing their several performances. I shall have an opportunity of enriching the work with the portraits of many of my contemporaries of worth, which posterity will thank me for. The three other pictures that remain, I shall dedicate to matters of more recent discovery, and more immediately relating to the abilities of our own people.[25]

A number of interesting points emerge. First of all, since Barry envisioned that the paintings on the side walls would be 15 feet (457cm) wide, their present width, he intended to substitute his own separate works for Reynolds' and Gainsborough's portraits rather than divide the spaces they occupied between the murals he specifically names. Thus presumably he already had in mind placing over the fireplaces the portraits of the king and queen he was later to engrave.

Barry's comments to Savile also reveal that from the beginning he envisioned *Crowning the Victors at Olympia* as the primary focal point of the series. Not only was it the first work one saw on entering the room, but it also appears to have initially been the only work to stretch across the entire breadth of one of the two long walls. In his appendix to his 1783 *Account*, he writes that his plan was from the beginning intended to far outstrip the Society's own scheme as proposed to the ten artists in 1774, with 'one of my pictures being almost equal to all which had been originally proposed'.[26] This picture would have been *Crowning*, and while Barry's claim that it is almost equal to the original ten is an exaggeration, it again underscores how much emphasis he placed on this work.

In his accounting Barry identifies *Crowning the Victors* as the second picture in the series. However, two pictures which are to be viewed as extensions of this central scene were to flank it.

No. 2A, *The Contest and Matching the Competitors*, would have occupied the place now given to *A Grecian Harvest-home*, while no. 2C *Ingenious Men Producing their Performances*, would have occupied the space now allotted to *The Triumph of the Thames*. Two painted statues frame *Crowning the Victors*: Hercules on the left, Minerva on the right. The flanking pictures amplify the two qualities they represent, the 'admirable pitch of mental and bodily vigour'. *The Contest*, which would have been adjacent to Hercules, extols bodily vigour, whereas mental vigour is detailed in the image adjacent to Minerva. For the latter painting, two figures are singled out, neither of whom were later introduced into *Crowning*: the first is the writer Prodicus, who reaped fame for his recitations at the Olympic Games and whose most celebrated creation was *The Choice of Hercules Between Virtue and Vice*, and the second is the painter Aetion, who, when he exhibited at the Olympics his picture of Alexander the Great celebrating his wedding with Roxana, was awarded the hand of the chief judge's daughter.[27] Other great men would have accompanied Prodicus and Aetion, with, as in Raphael's frescoes in the Vatican *Stanze*, portraits of the artist's contemporaries standing in for their likenesses. Barry himself, of course, would have been Aetion.

Barry's last sentence in his description to Savile is frustratingly terse: 'The three other pictures that remain, I shall dedicate to matters of more recent discovery, and more immediately relating to the abilities of our own people.'[28] Perhaps he had not fully settled on the precise nature of the subjects of

Diagram 2: Hypothetical reconstruction of first plan for the murals in the Great Room
1. *Orpheus*; 2a *The Contest at Olympia*; 2b *The Crowning of the Victors at Olympia*; 2c *Ingenious Men at Olympia*; 3. *The Triumph of the Thames* (?); 4. *The Distribution of Premiums* (?); 5. *Elysium and Tartarus* (?); 6. *Portrait of King George III*; 7. *Portrait of Queen Charlotte*; 8. An allegorical subject? (Conjectured interval between the two large paintings on the south wall)

the three canvases, and he, in any case, did not want to invite discussion of their content. Perhaps, at least in some form, *The Triumph of the Thames* and *The Distribution of Premiums* were among this number. Then, too, because the British dominate the cast of characters in *Elysium and Tartarus* and because, as we shall see, this image is so crucial to the conception of the entire series, it was likely the third subject would be 'immediately relating to the abilities of our own people'. It is clear, though, that two of these three pictures would have occupied the 42-foot (1280cm) south wall, since *Ingenious Men* had already accounted for one of the two major spaces on the east wall. Each of the pictures on the south wall would either have measured 366cm x 640cm or, more likely, a tenth, much narrower, painting would have occupied the central position, echoing the same configuration found on the two side walls. In his description to Savile, Barry had not bothered to mention the portraits intended for the centres of the side walls, thus another modest subject over the entrance door between the two large compositions might also have gone unmentioned. The preceding diagram offers a possible scenario, although admittedly some of the paintings are highly speculative.

Whatever the original configuration, *Crowning the Victors at Olympia* would have reigned supreme, not only being the only 42-foot (1280cm) picture but also being accompanied by paintings that would have extended it on either side. Any interpretation of the Great Room's murals must take into account this image's importance in placement and meaning – this climax of classical civilisation is literally front and centre. The argument will be made in part two, 'The Hidden Agenda', as to why Barry placed such emphasis on this particular painting.

In his same letter to Savile of 19 April 1777, Barry went on to propose that a subscription be raised on his behalf, which, by providing him with £100 per annum, would allow him to devote himself full-time to this project. He reasoned that if an exhibition were held, as the Society had suggested in its original 1774 proposal, he could pay back the public-spirited subscribers under the assumption that the work would take only about two years. He bluntly added, 'If the exhibition produces nothing, or that the society should neglect to make one, you will then lose your money; but a public work will be completed'.[29]

No subscription was raised, and Barry was left to his own devices. Edward Fryer reported him as having frequently stated that he began this series with only sixteen shillings in his pocket.[30] He relied in part on sales from the prints he was creating in the late 1770s, but mainly on a penny-pinching lifestyle. Years later Miss Corkings, then the young daughter of the Society's registrar, told the history painter Benjamin Robert Haydon, 'He had tea boiled in a quart pot, and a penny roll for breakfast, dined in porridge Island, & had milk for supper, all of which was prepared in the rooms of the House.'[31] The artist Edward Dayes maintained that through careful budgeting he subsisted on just four pence a day while contracting a debt of several hundred pounds.[32] Even if these accounts are exaggerated, his willingness to sacrifice to make this project a reality was remarkable.

By the time of the Society's summer recess of 1779, Barry was so far advanced that a moving gallery was ordered for him to fix and finish his paintings, and at the same time he was given the key to the Great Room.[33] From that time on, Barry jealously guarded the murals from prying eyes. No was allowed to enter the Great Room without his permission. On resuming its meetings in October, the Society opted to hold them in the Committee Room, and when it did use the room again in 1780 and 1781, the paintings were covered. When Samuel More, the Society's secretary, tried to gain admittance in the performance of his duties, Barry is said to have retorted, 'Sir, I bring in my two-penny loaf, my cheese, and my pot of porter, every morning, that I may not be interrupted until dusk, when I leave off.'[34]

The artist allowed only a select few to see his work in progress. On 26 October 1779 he hosted a party of four women, composed of his friends and neighbours: Elizabeth Burney, the second wife of Charles Burney, who was to appear in *The Triumph of the Thames*, two of Charles' daughters, Charlotte

and Susan Burney, by his deceased first wife, and Ms Kirwan, one of the daughters of the Irish scientist Richard Kirwan. This privileged group visited both the studio in his house, which was located at 29 Suffolk Street, a relatively short distance from the Society, as well as the Great Room. Susan recorded the visit in her letter journal, and because her account offers the only detailed description of the murals in progress, it will be quoted at length in the appropriate chapters in this book. Susan's entry begins,

Last Monday eveg. [25 October 1779] Edward [her cousin Edward Francis Burney] called, & found Miss Kirwan [either Maria Theresa or 'Bessy'] here, & Mr. Barry, the painter, who came to fix a day for my Mother &c to see a great work wch. he is now about [the Burneys lived just two short blocks from the artist in Sir Isaac Newton's former house on the east side of St Martin's Street near Leicester Square], – The next Morng. was settled for it, & accordingly my Mother, Charlotte, & yours went Tuesday to Miss Kirwan's, & thence were conducted by Mr. Barry to his House [29 Suffolk Street], wch. is next door to theirs – there we saw a representation of Elysium, & another of Tartarus wch. he is now at work on – Thence he carried us to the Great Room belonging to the Society for Encouraging Arts & Sciences in John St Adelphi, where we saw those pieces which he has more finished, tho' no part of his design is yet compleatly executed. The Progress of Society & Cultivation is his subject, which is comprized in 6 distinct pieces. The Room for which it is intended is a very large one, & when it is compleatly finished he designs to exhibit it–[35]

It is noteworthy that her cousin Edward, who was then nineteen years old and studying to become an artist in the Royal Academy schools and who lodged with the Burney family, was not among the company. No fellow artist, no matter how non-threatening, was welcomed: Benjamin Robert Haydon quotes Miss Corkings as saying, 'She remembered Burke & Johnson calling once, but no Artist. She really believed he would have shot any one who would have dared.' Miss Corkings also confirmed that 'his Violence was dreadful, his oaths horrid, & his temper like insanity,' but 'when coaxed to talk, his conversation was sublime.'[36]

On 30 January 1782 Barry told the Society that the project was almost at an end and that he would be ready to exhibit the murals by April of that year. On 6 and 13 February he read a paper at the Society's meetings in which he reviewed their arrangement and reminded the members that up until that time he had only received £45 to pay his models. Then on 6 March Barry informed the Society that he would not be ready to exhibit that year. One week later, on 13 March, the Society voted the artist £50 as a token of its appreciation and confirmed that he would be granted two exhibitions, each not to exceed eight weeks, and that £87 be allotted to cover expenses. The artist never made personal use of the money awarded to him, instructing that it be used instead to help cover printing costs for his book on the murals and advertisements for the first exhibition,[37] which opened on 28 April 1783. The murals were exhibited again in 1784 after they had been entirely completed with the exception of introducing the head of the Prince of Wales in The Distribution, the prince having not yet sat to the artist.

Raphael as forerunner: when the centre no longer holds

For an influential predecessor for his series, Barry frequently cites Raphael. Painting's most important function is its address to the mind, and in that regard Raphael is unsurpassed:

The principal merit of Painting as well as of Poetry, is its address to the mind; here it is that those Arts are sisters, the fable or subject, both of the one and the other, being but a vehicle in which are conveyed those sentiments by which the mind is elevated, the understanding improved, and the heart softened. It is in this address to the

mind, in the sublimity, elegance and propriety of the ideas, and in the wise and judicious selection of sublime, elegant and happily corresponding forms in the personages, characters, expressions, &c. that the Roman school has been acknowledged superior, not alone to the Hollanders and Flemings, but to the other schools of Italy also; and it is in these that Raffael is justly distinguished as the foremost man in the Roman school.[38]

When evoking the name of Raphael, Barry is referring to his Vatican frescoes, and on one occasion he makes an explicit comparison, saying he had attempted to produce 'an extensive subject, not very dissimilar to that of Raffael's in the Vatican.'[39] First for Pope Julius II, then for his successor Leo X, Raphael executed a remarkable series of frescoes. Barry profits from all of these works, but, like critics in general, he singles out for special praise the first room on which Raphael worked, the *Stanza della Segnatura*, remarking on its 'four great pictures, representing Theology, or the Dispute of the Sacrament; Philosophy, or the School of Athens; Jurisprudence, an Allegorical picture; and Mount Parnassus, or Poetry'.[40] In citing these 'four great pictures,' Barry chooses to ignore the subsidiary images, such as the ceiling decoration and the smaller panels beneath the major designs. But in an effort to present this interior as a more unified space than it is in reality, he also distorts the room's actual appearance. *The Disputa*, *The School of Athens* and *Mount Parnassus* dominate their respective walls, but because of a disruptive window embrasure, Raphael placed three principal scenes on the wall opposite *Parnassus*. In Barry's description, Jurisprudence refers to two frescoes, *The Emperor Justinian Handing the Pandects to Trebonianus* on the left, and *Pope Gregory IX Handing the Decretals to St Raimund of Peñaforte* on the right. Above are the allegorical figures of the three cardinal virtues. Even without Barry's efforts to integrate the 'four' major pictures more closely, the *Stanza della Segnatura* impresses and captivates. As a model, it is well chosen: he wants his works to exhibit the same breadth of intellect, encompassing and integrating a large field of knowledge, particularly in regards to the humanistic blending of the ancients and moderns, of pagan antiquity with Christianity.

In order to highlight his own difficulties, Barry was quick to point out Raphael's advantages:

Every body knows that Raffael enjoyed all the advantages the heart of man could wish for, and had a fair opportunity of putting forth all his strength, in a country which afforded a continual occasion for the exercise of his abilities; his profession was considered as not less necessary than ornamental, and his great work of the *Camera della Senatura* [sic] was carried on under the auspices of those two great and distinguished encouragers of the art, Julius the Second, and Leo the Tenth; he was assisted in this work by the counsels (such as they were) of the great luminaries of that age, [Pietro] Bembo, [Baldassare] Castiglione, [Cardinal Bernado Dovizi] Bibbiena, &c.[41]

Raphael had both important patrons and well-informed advisers, even if Barry chooses to downplay the significance of the advisers' role. Yet he felt he had an edge on his old-master rival in that, from his point of view, Raphael had not fully absorbed the beauty and sublimity to be found in antique statues.[42]

While Raphael's reputation is in no danger from Barry's challenge, the Irish artist draws attention in his work, though not in his text, to a compositional difference in their choice of format. Raphael's images rely on an impressive centrality. An exalted, symmetrical architecture frames *The School of Athens*, whose principal protagonists, Plato and Aristotle, share the exact centre. In *Parnassus*, Apollo is at centre stage, and on the wall opposite an elevated Prudence occupies the centre, with Fortitude and Temperance flanking her, each on a lower register. *The Disputa*'s meaning is intricately wedded to the centrality of its composition, where God the Father, Christ, the Holy Spirit and the host on the altar are all aligned on the central axis. In addition, the composition's vanishing point coincides

with the host. Such an organisation expresses a world view that confidently proclaims immutable, fixed truths reflecting a universal order. By way of contrast, in his series, Barry positions Orpheus slightly off-centre to the left; he places the dancers in *A Grecian Harvest-home* to the right; and in *Crowning the Victors at Olympia* he positions the sons bearing their father at the Olympic Games to the right. While in his preparatory drawing he had placed Father Thames at the centre (see fig. 21), in the mural he shifts the river god to the left. In the middle of *The Distribution of Premiums* two groups compete for attention, and even in *Elysium and Tartarus*, where eternal verities should reign, the composition's foreground is decidedly askew. Barry's is a world that is fragmented and destabilised, lacking Raphael's confidently assertive symmetry and hierarchical disposition. In Raphael's frescoes, although repeated viewing and study reveal ever deeper layers of meaning, these layers are in accord with the surface narrative that they enrich and harmonise. In Barry's murals, as we will see, beneath the surface reading of the progress of classical civilisation is a parallel but different narrative. His world is out of joint. The compositions of his pictures reflect this skewed situation, but if their message is carefully attended to, he believes it is possible for the British nation to regain its purposeful cohesion.

A contemporary precedent: charting the progress of civilisation at Merly House

While Barry cites such old masters as Raphael as his model, he also states that he wishes to break new ground in his subject matter. His efforts to chart the progress of mankind from a primitive state to a sophisticated one, however, were already part of his culture's preoccupations, an interest driven as much by the opening up of the world through global exploration as it was by a more scientific approach to the reconstruction of the history of Western civilisation. In the visual arts, he had already been anticipated by the elaborate decorative scheme, executed in stucco in 1772, for the library at Merly House, the home of Ralph Willett. Although it is unlikely that Barry saw this room in Dorset, given his interest in Willett's subject, 'the Rise and Progress of Knowledge',[43] it is likely he was aware of Willett's book, *A Description of the Library at Merly in the County of Dorset*, which was published in 1776, the year before he undertook his own project.

In his book, Willett describes in detail the content of his 'outline of human nature, in its progress

Fig. 5 *The General Arrangement of the Ceiling at Merly House.* Engraving (3 plates): left- and right-hand plates, Ralph Willett, *inv.* [designed by], William Collins, *fec.* [made by], and Ryley, *sculp.* [engraved by]; central plate, same except James Record, *sculp.* Combined measurement, 324mm x 1320mm. From Ralph Willett's *A Description of the Library at Merly in the County of Dorset*, 1785. Beinecke Rare Book and Manuscript Library, Yale University, New Haven

from barbarism to perfection'.[44] The room itself, which was destroyed early in the nineteenth century, measured 701cm x 2560cm, and the following account is concerned only with the principal designs on the coved ceiling, although the walls contained additional images. For Willett, religion forms the basis of civilisation by instilling fear in mankind for wrongdoing, supplying the power elites with a convenient fiction that could be used for purposes of social control. Consequently, a religious figure anchors the middle of each side: Zoraster and Mahomet (or Mohammed) at the short ends, and Moses and Christ on the long sides, with Christ given the most prominent position opposite the windows. Next Willett honours four influential policymakers, who helped establish laws making civil society possible. These four occupy the ends of the long sides, and they stand in as well for the Four Continents: King Alfred (Europe), Confucius (Asia), Osiris (Africa) and the Inca chief, Manco Capac (America).

These stabilising leaders prepare the way for the arts: 'Religion and human Policy must have exerted their Influence long before Refinement and Elegance could be thought of'.[45] Although the arts and sciences offer a high point of civilisation's progress, they are allotted more confined spaces, with the allegorical figures of Painting, Sculpture, Geography and Astronomy inhabiting boxes flanking Christ and Moses. In the case of Painting and Sculpture, both figures are shown at work on images celebrating the ruler Alexander the Great, suggesting that art's principal function is to support and enhance authority. The money that had enabled Willett to buy Merly and create his lavish new home was derived from the estates he had inherited in the West Indian islands. He celebrated these sugar-cane plantations, made profitable by slavery, by introducing the sugar-cane's decorative stalks in the corners of the coved ceiling.

The religious figures, earthly governors, the personifications of the arts and sciences, and the references to an imperial economy literally provide a frame for five scenes that occupy the flat surface of the ceiling's centre. These scenes chart the stages of society's progress from primitivism to refinement. Contemporary societies, newly explored by Captain Cook and Joseph Banks, represent what are considered to be society's early stages. At the south end is 'the unpleasant Image of savage Life',[46] represented by a scene from Patagonia. The next scene, also an oval but at the opposite end, shows Otaheite (Tahiti), where society has advanced in religion, governance and the arts. For the last three stages, Willett looks to Western civilisation as it unfolds chronologically. To the south in the square frame, Egypt is represented at the moment Sesostris directs the adornment of Thebes. Then in the square on the north side one sees Phidias showing Pericles the plans for the Propylæa while surrounded by other prominent Athenians.

The largest scene is the central oval reserved for civilisation's fifth and climactic stage, where Britannia introduces George III into the Temple of Fame with a topographically imperfect cityscape of London . The other Englishmen whom George III greets are drawn from the previous two centuries. To the far left is Inigo Jones conversing with John Locke, who impolitely ignores Jones' plan of Whitehall Palace to point out to him Christopher Wren's great achievement of St Paul's Cathedral. In the group in front, a pensive Milton, who, as Willett acknowledges, may be purposefully ignoring the king,[47] leans on Sir Francis Bacon's chair, while Bacon listens to Sir Isaac Newton. Sir Francis Drake holds 'a Chart of the great Discoveries made by him in his Circumnavigation of the Globe',[48] a scroll that opens with the words, 'NEW ALBION', and next to him is his supporter, the Elizabethan statesman Lord Burghley. So small a company necessarily excludes many of the deserving, but the most surprising absence is William Shakespeare, Willett having resisted his contemporaries' deification of the national bard. Willett, in any case, was more interested in Britain's imperial expansion. This brave new world beginning in Elizabethan England and continuing in the ongoing voyages of discovery will lead not just England but also in time the more benighted cultures of Tahiti and the Americas to greater

Fig. 6 *Britannia*. Engraving, Ralph Willett, *inv*., William Collins, *fec*., William Sharp, *sculp*., 439mm x 650mm. From Ralph Willett's *A Description of the Library at Merly in the County of Dorset*, London 1785. Beinecke Rare Book and Manuscript Library, Yale University, New Haven

excellence. The trophies adorning the arcade represent such modern inventions as 'Clocks, Sea Compasses, Barometers, [Newton's] Prisms, the Torricellian Tube [which established the principle of the barometer], &c.',[49] discoveries that in many cases aid exploration in the service of imperial dominance.

Willett anticipates Barry in his choice of subject matter. The main outline of civilisation's progress from a primitive to a refined state ending in an allegorical representation of a celebrated elite is present in both. But there are significant differences. Fundamentally, they are poles apart in their conception of the roles played by religion and by art in human affairs. In addition, while both stress the important role Britain plays in embodying civilised values and their dissemination through global expansion, in his approach Barry is not as aggressively chauvinistic as is Willett. For Willett, England, having built on the inheritance of ancient Egypt and classical Greece, stands at civilisation's apex. She is now poised to help (or, more accurately, to exploit) those contemporary societies that have remained in varying degrees of 'primitive' isolation. Barry is more focused on seeing Britain achieve her full potential with crucial lessons still to be learned. As an Irish Catholic who knows all too well the abuses of colonial power, he has far more sympathy than Willett for the need for fair and equal treatment for all. In terms of his cast of characters, Barry includes some of his predecessor's choices, most notably Confucius and Manco Capac in *Elysium*, but he seems to have gone out of his way not to emphasise them, barely acknowledging their presence in either their placement in his mural or in his descriptive text.

The similarities between the underlying concept of the library at Merly House and that of the Great Room are intriguing – this was a theme whose time had come. Yet their dissimilarity in terms of how their conception is related to their execution is of even greater interest. William Collins, who

executed in stucco the grand panorama of world history on the library's ceiling, placed himself in the work's central oval holding his mortar board and peering over the balustrade into the Temple of Fame. But even this marginalised placement is too generous. At heart, the creator of this programme is the patron. It is the traditional model, where the artist follows closely his assigned instructions.

Reaching a wider audience: writings and the small-print series of 1792

As noted in the introduction, Barry envisioned the Great Room as a gathering place where his murals would instigate philosophical reflection, much as the marketplace frescoes in Athens had inspired Zeno and his followers to create a new school of philosophy. Yet in the absence of an enquiring and skilled interlocutor, a modern-day Zeno, the artist felt that the murals' visual imagery required an accompanying written narrative. Consequently, he obligingly wrote a 221-page book, *An Account of a Series of Pictures, in the Great Room of the Society of Arts, Manufactures, and Commerce, at the Adelphi*, describing the paintings' content. Any examination of the series should begin with the artist's statement as to his intentions, and in this present book, the discussion of each painting opens with his commentary. Despite its length, the artist makes clear his account is more discursive than definitive: 'my intention being only to collect the materials for a book, not to make one'.[50] He adds, 'my endeavours have extended no further than simply to point out, in a homely, painter-like, and very cursory way, some few of the leading ideas that occurred to me upon the variety of matter the subject of the work afforded: if haply those ideas should merit it, others will polish and dress them out for my advantage, in a manner that it would ill-become me to attempt'.[51] Thus he still cites the need for others to supply their own written accounts, and in this regard he elsewhere points to Continental precedent:

The higher exertions of art, as in Raffael, &c. require, for the developing of all their beauties, not only some degree of information in the spectator, but also that he consider them with some attention and study; and these artists were particularly happy in this respect, as there were a great many people, both in Italy and France, with much leisure and ease of mind, who particularly delighted in these studies, and who, by their ingenious explanations, were a kind of useful and very agreeable medium between the artists and the public.[52]

Such commentaries can 'explain' pictures only up to a point, since in the final analysis paintings cannot be verbalised. One would value having the instructions supplied to Raphael when he composed his frescoes, but no one would see them as substitutes for the works themselves.

Barry gives two reasons for having written a text in the first place, both of which address the need to reach out to an audience beyond the Society's walls. In the first instance, he wrote from 'a desire to gratify the curiosity of an amiable friend, who has it not in his power to see them'.[53] Presumably he not only had in mind this friend, who may have been Irish, but also the large absent audience to be found on the Continent and in America. Secondly, he says he wrote the book as a diversion while anxiously awaiting the Society's decision on whether or not it would permit an exhibition of his work. With or without a formal exhibition, a text was required if the public was to appreciate more fully the series' content. For Barry to initiate the composing of such an account during a time of 'very disagreeable surprise' underscores how much his paranoid perceptions motivated his conduct: the message of the paintings themselves was already steeped in a combative vision at odds with the dominant culture, and his having executed their description at a time of anxiety and stress was hardly fortuitous.

If the murals were at a disadvantage without a text, a text without the images is even more restricting. A second major vehicle for the dissemination of his ideas beyond the Society's walls is

the series of prints he executed after the six murals, to which he added a seventh plate showing the intended paintings over the two fireplaces. In 1784, having completed the paintings, he could begin to contemplate in earnest executing the prints after them. In his 1784 appendix, which accompanied the second exhibition, he writes, 'As to the above-mentioned prints after my pictures, I have to inform the public, that in order to preserve the drawing and characters to my own satisfaction, I shall at least execute a great part of the etchings myself, the inferior and more laborious part will be executed by others'.[54] This division of labour never did take place, Barry again seeing the engravings through from beginning to end. Even allowing for a fallow period after the intensive labour of executing the murals, the prints were a long time in coming. Barry inscribed the prints with the date 1 May 1791, but in truth he did not release them for circulation until 23rd April of the following year.[55] Thus, although from 1777 to 1784 he spent seven years conceiving and executing the paintings, he took another eight years before the prints were ready for distribution.

Barry had enthusiastically turned to printmaking in 1776, producing in that year a sizable volume of work for which he was printmaker, publisher and, apparently, sole distributor. Artists such as Angelica Kauffmann, John Hamilton Mortimer and Barry's close friend, the Scotsman Alexander Runciman, offered examples of other painters of historical subjects who had turned to printmaking, but in the scale of his activity Barry soon outstripped his predecessors.[56] By 1778 he had executed around fourteen prints on a variety of subjects,[57] the sale of the majority of which helped, even if in a small way, to finance the Adelphi undertaking. At this time, the concept of what Adam von Bartsch at the beginning of the nineteenth century was to term the 'painter-etcher' was already emerging, because a new appreciation for prints created by artists from their own designs was beginning to make itself felt. One should not minimise as a prime motivation for Barry's turning printmaker the intense satisfaction he must have derived from working with copper plates, acid, etching needles and burins. He is remarkable for the experimentation with which he pursued a variety of media. In this regard, he belongs to an elite few: among painters in late-eighteenth-century England only Thomas Gainsborough and Barry's friend, George Stubbs, showed a comparable creativity in the exploration of printmaking, with William Blake, who had apprenticed as an engraver, occupying a niche of his own.

None of the prints after the murals reproduce the paintings exactly. Although they all are creative variations on the original theme, the prints after the two largest paintings, *Crowning the Victors* and *Elysium and Tartarus*, are in a category of their own. Measuring approximately 366cm x 1280cm, the murals were unsuitable for printmaking. As Barry points out, the size of the largest double elephant paper and the glass covering it when framed restricted the print to a length of 91cm. If the proportions of the large murals were to be maintained, the image's height would then measure only 254mm. In these two instances, a new compositional format was required. Barry chose to alter the other images as well, not out of dissatisfaction with their composition, 'but merely to give an additional value to the prints, which they could not otherwise receive'.[58] As a result, the prints required a text of their own that Barry supplied in later publications, and they initiate their own dialogue with the pictures. Although these prints deserve to be studied in their own right, in this book they are incorporated into the discussion of the individual paintings, being used more for the light they shed on the murals.

The prints' lack of a tight, 'professional' finish and their refusal to reproduce the paintings with an exacting precision dismayed some of the artist's contemporaries. Henry Fuseli gleefully reported after Barry's death that he, 'after the most heroic perseverance, produced a set of prints, though not absolute caricatures of the work, [that was] sufficiently ludicrous to glut the wish of his most decided enemy'.[59] J.T. Smith later reported that one subscriber, who is surely Arthur Young, the celebrated writer on agriculture who appears in *The Distribution of Premiums*, was so dumbfounded by the

prints' 'coarseness of execution' that he forfeited the sum that he had already paid rather than pay the remainder:

Mr. Young, a particular friend of his, considering Barry's intended prints from his pictures in the Adelphi to be a national series which ought to be encouraged by the public, went to his house in Castle-street, Oxford-market, and paid half the subscription-money to ensure a set. When they were pronounced finished, he called to pay the remainder, and receive his prints; but, upon his expressing himself with some surprise as to their coarseness of execution, Barry asked him, if he knew what it was he *did* expect? – 'More finished engravings,' replied Mr Young; who, after experiencing farther rudeness from the artist, took his departure, observing that he was very welcome to keep the money he had already received.[60]

For better or for worse, for those who did not visit the Great Room the prints were, until the invention of photography, the face shown to the larger public. Even for those who do encounter the murals themselves, they add intriguing new dimensions.

THE
CLASSICAL WORLD

CHAPTER TWO

Orpheus

Title in 1783 *Account*: ORPHEUS

Barry, 1783, in *Works*, vol. 2, pp. 324–6:

The story of Orpheus has been often painted, but by foolishly realizing a poetical metaphor, whatever there was valuable in it, has been hitherto overlooked. Instead of treating it as a mere musical business, as a man with so many fingers operating on an instrument of so many strings, and surrounded with such auditors as trees, birds, and wild beasts; it has been my wish rather to represent him as he really was, the founder of Grecian theology, uniting in the same character, the legislator, the divine, the philosopher, and the poet, as well as the musician. I have therefore placed him in a wild and savage country, surrounded by people as savage as their soil, to whom he (as a messenger from the gods, and under all the energies of enthusiasm) is pouring forth those songs of instruction which he accompanies in the closes with the music of his lyre.

By the action of Orpheus, I have endeavoured that the song may appear the principal, and the music of the lyre but as an accompaniment and accessory, which to me seems not only more verisimilar on such an occasion, but also to be the true and natural way of explaining all those passages in the ancient writers, where such extraordinary effects have been ascribed to music. Those who, like the ancients, would operate upon the mind, must look for something more substantial than sonatas, or mere inarticulate tune, which generally reaches no farther than the ear.

> Hail, golden lyre! whose heav'n-invented string
> To Phœbus, and the black-hair'd Nine belongs;
> Who in sweet chorus round their tuneful king,
> Mix with thy sounding chords their sacred songs.
> Ev'n Mars, stern god of violence and war,

Pl. 1 James Barry, *Orpheus*, 1777–84. Oil on canvas, 360cm x 462cm. Royal Society of Arts, London

Soothes with thy lulling strains his furious breast,

And driving from his heart each bloody care,

His pointed lance consigns to peaceful rest.

Nor less enraptur'd, each immortal mind

Owns the soft influence of enchanting song,

When in melodious symphony combin'd,

Thy son Latona, and the tuneful throng

Of muses, *skill'd in wisdom's deepest lore*,

The subtle powers of verse and harmony explore.

 1 Pyth. Ode.

The hearers of Orpheus, who are in what is called the state of nature, a state far short of the golden age and happiness some have unwisely imagined, as has been eloquently shewn by Lucretius (Lib. v.) and much more happily by our own admirable Thomson, (see Autumn) are most of them armed with clubs, and clad in the spoils of wild beasts, with courage and strength, to subdue lions and tygers, but without wisdom and skill, to prevent frequent retaliation on themselves and their more feeble offspring. At some distance on the other side of a river, is a woman milking a goat, and two children sitting in the entrance of their habitation, a cave, where they are but poorly fenced against a lion, who discovers them as he is prowling about for prey; a little farther in the distance, are two horses, one run down by a tyger, by which I wished to point out, that the want of human culture is an evil which extends (even beyond our own species) to all those animals which were intended for domestication, and which have no other defence but in the wisdom and industry of man. In the woman with the dead fawn over her shoulder, and leaning on her male companion, I wished to glance at a matter often observed by travellers, which is, that the value and estimation of women increase according to the growth and cultivation of society; and that amongst savage nations, they are in a condition little better than beasts of burthen, all offices of fatigue and labour, every thing, war and hunting excepted, being generally reserved for them.

As Orpheus taught the use of letters, the theogony or generation of the gods, and the worship that was due to them, I have placed before him papers, the mundane egg, &c. a lamb bound, a fire kindled, and other materials of sacrifice, to which his song may be supposed preparatory: considerably behind, in the extreme distance, appears Ceres, as just lighting on the world. These circumstances lead us into the second picture, which consists of some of the religious rites established by those doctrinal songs of Orpheus.

The 1792 print

Orpheus Instructing a Savage People in Theology & the Arts of Social Life

For states of the print and full inscriptions, see Pressly, no. 17. ('The Catalogue of Prints' is in *The Life and Art of James Barry*, pp. 263–81)
Barry, 1793, in *Works*, vol. 2, p. 422:

As to the first subject, it being identically the same, both in the print and the picture, the printed account applies equally to both. Orpheus, the messenger of the gods, by the united charms of poetry and music, is impressing on the savage Thracians those lessons of *Theology* and *Morality* which substitute the ardour for TRUTH and JUSTICE in the place of selfish *Fraud* and *Violence*, and consequently afford the true sold basis for social institutions. In the foreground, on a little elevation serving for an altar, is a lamb bound, the sacred fire and other preparations for a sacrifice of atonement.

Fig. 7 James Barry, *Orpheus Instructing a Savage People in Theology & the Arts of Social Life*, 1792. Etching and engraving, 415mm x 505mm. British Museum, London

Barry's conception of Orpheus' significance is closely tied to contemporary writings. To give one example, in his book *Polymetis*, first published in 1747, Joseph Spence gives the following account of Orpheus on his appearance in Elysium in Book 6 of Virgil's *Aeneid*:

There is not any of the happy spirits, represented in this picture [i.e., Virgil's description of entering Elysium], that we know by name; except Orpheus. He appears in a long dress, falling down to his feet; that robe of dignity, which was given to musicians in the first ages of the world, in honour of their high character: which in those times comprehended not only the science of music, but that of poetry, moral philosophy, and legislature. The giving rules of life to particulars, or laws to any nation, is too apt to carry a severe air with it; and to deter people, from what you would have them follow: the wise men therefore of those days united the two arts of music and poetry, to that of instructing mankind: and, by that means, softened the severity of their instructions; and insinuated them into the hearts, as well as the minds, of their rough hearers.[1]

Along similar lines, Robert Wood in his 1767 account of Homer relates how music and poetry worked together to form the basis for instruction in primitive societies:

Indeed all instruction, civil and religious, was wrapt up in Melody and Verse [he inserts here the following footnote: 'See Aristotle's Politics for singing and writing']; and the Priest, who was a Lawgiver, was also a Poet and Musician. This is agreeable to that rude state of society, which we have described, when civilization was addressed more to the passions than the understanding, and men were to be first tamed, in order to their being taught.[2]

In his print reproducing the painting, Barry quotes four lines from Horace's *Art of Poetry* as translated by Philip Francis.

> The wood-born Race of Men when Orpheus tam'd,
> From Acorns and from mutual Blood reclaim'd,
> This Priest divine was fabled to assuage
> The Tiger's Fierceness, and the Lion's Rage.[3]

Horace is the *locus classicus* for the concept of Orpheus as a civiliser. Francis' footnote to the first line of the Latin text is even more relevant to the artist's meaning: 'Poets were the first Priests, Philosophers, and Legislators. Orpheus is called the sacred Interpreter of the Gods, because he composed Hymns in Honour of them, and instructed Mankind in the Ceremonies of Religion.'[4]

Orpheus' performance is no mincing lyric. As Wood says, it is addressed to the passions, or in Barry's words he is under 'the energies of enthusiasm'.[5] The transformation of a savage race requires transfixing sublimity. In the painting Orpheus wears the poet's laurel crown, but the print conveys his mesmerising power even more forcibly by supplying a flame-like lock of hair evoking inspired thought. In addition, his hand, with its more emphatic pointing gesture, is silhouetted against the sky, now breaking entirely free of the background terrain. In both works, a cloud discreetly adjacent to his head connects him with heavenly divinity.

Barry hints at the content of Orpheus' message. Beside him in the painting is a partially unfurled

Fig. 8 Detail of *Orpheus* 1777–84. Royal Society of Arts, London

scroll showing a man's head with an egg in his mouth. In the print the top of the head can be seen: here the figure wears a feathered headdress. Barry's reference in his text to 'the mundane egg' is hardly adequate in conveying the scroll's purpose. One can sympathise with the newspaper reviewer who praised the painting but added the caveat, 'The Adjuncts, and emblematic Parts are all apposite and in Point – In but one Instance or two can they be charged as being recondite, and enigmatical'.[6] The artist forces the viewer/reader to seek out a fuller explanation, and in this regard a passage from John Smith's *Choir Gaur* of 1771 helps elucidate his meaning:

What the Egyptians in their Cosmogony called Cneph, was symbolically represented in the shape of a Man, of a dark-blue complexion, holding a Girdle and a Sceptre, with a royal plume on his head, and thrusting forth an Egg out of his mouth; from whence proceeded another God, whom they named Phtha, and the Greeks Vulcan. The reason of which hieroglyphic is thus given: Because this intellectual being is difficult to be found out, hidden and invisible; and because he is the giver of life, and King of all things; and because he is moved in an intellectual, and spiritual manner, which is signified by the Feathers on his head. The Egg which proceeds from the mouth of this God, is interpreted to be the world. Vid. Ancient Hist. vol. I. p. 27. It is proper to observe, that Orpheus, among other eastern learning, seems to have first introduced among the Greeks, the doctrine of the Mundane-Egg.[7]

This hieroglyph then contains Orpheus' theogony. There is an intriguing interplay between the curve of the god's ear and the inner curve of the scroll itself, as if they were complementary pieces of a larger,

Pl. 1 James Barry, *Orpheus*, 1777–84.
Oil on canvas, 360cm x 462cm.
Royal Society of Arts, London

integrated whole. The scroll, too, changes direction: at its centre it moves out in a counterclockwise direction, only to reverse to a clockwise one. The artist would seem to be suggesting that there is no easy way to unfurl the universe's secrets.

Music is an essential element in conveying the power of words, but Barry makes clear that the content is more important than the accompaniment. In quoting lines from Pindar's 'First Pythian Ode' as translated by Gilbert West, he italicised the phrase 'skill'd in wisdom's deepest lore' in order to emphasise the intellectual and philosophical wellsprings from which these sacred songs draw.[8] Yet despite his disparagement of music as requiring 'something more substantial than sonatas, or mere inarticulate tune, which generally reaches no farther than the ear', most of the remainder of his murals draw on its animating presence. In the following mural, *A Grecian Harvest-home*, musicians perform for the dancers; trumpets blare in *Crowning the Victors*; Burney plays an organ while floating down the Thames in *The Triumph of the Thames*; and the final painting has as its accompaniment no less than the music of the heavenly spheres, along with numerous lyres.

For man in the state of nature Barry gives as his textual sources the fifth book of Lucretius' *On the Nature of Things* and *Autumn* in James Thomson's epic *The Seasons*, which had first been published in 1730. Classical literature offered two competing models for understanding the primeval past, Lucretius being the best-known spokesman for one, Hesiod for the other.[9] Hesiod envisioned five ages of man, which overall charted a decline from a golden age of primal innocence to mankind's present condition of moral depravity. Lucretius, on the other hand, saw man's beginnings as harsh and brutish, with humanity gradually progressing toward a higher civilised state, a progression that, however, had its own pitfalls and setbacks. Barry, as had Thomson, drew extensively on Lucretius' imagery of man's savage state. Like Lucretius' account, his painting is not intended as a snapshot of one moment in time. Rather he portrays progressive stages, and the movement is from left to right. The group at the left is in shadow, the one on the right in light.[10] At the far right of the painting, a man raises both hands, and as he is the only figure other than Orpheus to look heavenward, he is the onlooker who has achieved the greatest spiritual enlightenment.

The group at the left beneath the trees, which suggest the edge of a forest, is entirely male, representing Horace's 'wood-born Race' that, in the words of Lucretius, 'wander'd about like wild Beasts'.[11] These nomadic hunters were at first naked, although they soon learned to clothe themselves with animal pelts, and they were without laws or civil society:

As yet they knew nothing of Fire to dress their Food, nor the Use of Skins, or how to cover their Bodies with the Spoils of Beasts; but inhabited the Groves, the hollow Mountains and the Woods, and hid their naked Bodies among the Shrubs; this they did to avoid the Rains and the Blasts of Wind. They had no Regard to the common Good; they had no Order among them, or the Use of Laws; every Man seized for his own what Fortune gave into his Power; every one consulted his own Safety, and took care of himself.[12]

Their diet was plain fare: 'They commonly refreshed their Bodies with Acorns among the Oaks, and with those wild Apples which you see ripen in Winter.'[13] A sprig with acorns appears in both the painting and the print, albeit in different places. Barry was hardly alone in stressing Lucretius' association of primitive man with an acorn diet. Virgil had followed Lucretius' lead in the *Georgics*, when he commented,

> Yet that's the proper Time to thrash the Wood
> For Mast of Oak, your Father's homely Food.
> (Virgil/Dryden, *Georgics I*, lines 409–10)

Thomson as well fastened on this unappetising detail:

> And still the sad barbarian, roving, mix'd
> With beasts of prey; or for his acorn-meal
> Fought the fierce tusky boar: a shivering wretch!
> (Thomson, *Autumn*, lines 57–9)

Lucretius' brute savages had some redeeming qualities, not yet having been softened by an easier lifestyle: 'And the first Race of Men were much hardier upon the Earth, as 'twas fit they should, for the hard Earth bore them. They were built within upon larger and more solid Bones, and their Limbs were strained with stronger Nerves; nor did they easily feel the Inclemency of Heat or Cold, or were affected with the Strangeness of their Food, or any Weakness of Body.'[14] Barry's figures are strong and robust, embodying the nobility of Greco-Roman types. Two of the figures on the left, with their pelts and clubs, have characteristics of Hercules, and the one with the lion's pelt extending over his head would have made an appropriate model for the statue of Hercules in the print after *Crowning the Victors at Olympia* (see Fig. 13), where, unlike the statue in the painting, he wears this fierce headpiece. The man standing next to him with a shepherd's crook denotes a more advanced state of civilisation, where animal husbandry, as in the middle distance, has been introduced, but he, too, wears a lion's pelt, the head of which can be seen just beneath his right elbow.

The figures at the left struggle to absorb Orpheus' message, and two of them are in poses that suggest a moment of epiphany. The Herculean figure at the left with his back to the viewer is based on the figure of the prominent soldier in the Vatican fresco *Constantine Addressing his Troops*. The tilt of his head in the print reproducing the painting (see fig. 7) is even closer to the original source. Raphael's soldier looks at the vision of the cross, a moment of revelation, just as Barry's muscular primitive looks at Orpheus in his moment of spiritual awakening. The figure seated beneath him stares at his hands as if seeing them for the first time. He literally is grasping his potential in an image that draws on a rich and complex textual and visual tradition celebrating the hand as the embodiment of 'the distinctive attributes of recorder of knowledge, creativity, and skill'.[15]

The group of figures to the right shows a more advanced stage of development, where men and women intermingle. In the earlier, more savage stage, Lucretius describes brutish and casual couplings: 'Their Amours were consummated in the Woods; either the Ladies were urged on by mutual Heat, or they were overcome by the superior Force and raging Fire of their Gallants, or were softned by Presents, a Dish of Acorns, of Apples, or of choice Pears.'[16] Later, however, they evolved to a more civilised condition:

But when they began to build Huts, and provided themselves with Skins and Fire; when One to One was joined for Life together, and the chaste sweet Delights of constant Love were now first felt, and they saw a lovely Train of Children of their own; then this hardy Race first began to soften; for being used to Fire, their tender Bodies could not bear so well the Cold of the open Air; and Love impaired their Strength, and the Children, by their little Arts of Fondness, easily softned the haughty Temper of their Parents: Then those who lived near together began to cultivate a Friendship, and agreed not to hurt or injure one another.[17]

On the right in the painting, men and women have paired up, marking the beginnings of family life. Thanks to Susan Burney's journal entry, recorded soon after the artist's guided tour of 26 October 1779, we know that even Orpheus' wife Eurydice is included among the onlookers: '– the subject of the first Painting is Orpheus playing on his Lyre, not to attract Beasts, Trees, or stones, as Mr. B. is

desirous of setting allegory aside as far as it is in his Power, but to <u>humanize</u> the savage Inhabitants of Thrace, who are crowding round him & listening wth. the most earnest attention – <u>Euridice</u> is among these – but is as yet but faintly sketched.'[18] She is possibly the woman thoughtfully resting her chin on her hand sitting beside the nursing mother. Another Herculean male, now clad in a pelt with the animal's head serving as a hood, echoes the figure on the other side. Concerning this figure and his mate, Burney remarks, 'there is a great deal of Invention & Fancy in this Piece, & indeed in all the others, everything tending to explain & develop his subject – A Fierce Man clothed in the skin of a Beast is followed by a trembling Female who carries a faun at her Back wch. He is supposed to have lately killed, to point out that in a state of Nature the most ignoble services are expected from Women.'[19] In the print this man sheds the headpiece as well as the lion's fierce claws dangling below his arm. Lucretius makes a point of the abandoning of furs for woven garments as another important step in the progress of civilisation, an advancement colourfully evoked by Thomson in his lines,

> Tore from his limbs the blood-polluted fur,
> And wrapt them in the woolly vestment warm …
> (Thomson, *Autumn*, lines 89–90)

While the man in the print has not shed his animal skin entirely, presumably Barry chose to de-emphasise his fierce qualities better to reinforce his point that the group on the right has advanced culturally beyond that on the left.

In the middle distance, reflecting the division of labour by gender and age, a woman and an older child tend to the domesticated animals. The woman milks a goat; the girl approaches with grain; and to the left a small child plays with a dog. Lucretius writes at length of the benefits of domestication:

And therefore many kind of Animals must needs be extinct, nor could they all by Propagation continue their Species … And there are many that, from their Usefulness to Mankind, have recommended themselves to our Defence … But the watchful and faithful Race of Dogs, all Beasts of Burden, the Flocks and Herds, all These, my *Memmius* [Gaius Memmius, to whom the work is dedicated], are committed to the Care of Man. These fly swiftly from the Rage of wild Beasts; they love a quiet Life; and depend upon us for their Fill of Provision, without any Labour of their own.[20]

In the background of the painting and print, a lion threatens, while another has run to earth an unprotected horse. This last detail is not only in keeping with Lucretius' account but it also pays homage to the artist George Stubbs, a friend of Barry who was known for his paintings of lions attacking horses. Barry, though, stays closer to the Hellenistic sculpture than he does to any of Stubbs' paintings. This is the last detail in the painting on which Burney comments, following closely the artist's own explanation: 'A Lion at a distance is marking as prey some savages who appear creeping from a cave, in another place a Tyger is tearing a Horse, all tending to point out the universal Evils attending the want of cultivation, or union of civil society.'[21] In the print, swans glide through the water. Interestingly, this detail occurs in the frontispiece to Book V of the 1743 edition of Lucretius' work, and in Barry's case, he may have intended the pair to allude to Orpheus' inspired poetry, since the ancients consecrated the swan 'to Apollo and the Muses'.[22]

OPPOSITE PAGE: **Detail from Pl. 1** James Barry, *Orpheus*, 1777–84. Oil on canvas, 360cm x 462cm. Royal Society of Arts, London

Detail from Pl. 1 James Barry, *Orpheus*, 1777–84. Oil on canvas, 360cm x 462cm. Royal Society of Arts, London

The human habitation in the middle ground is still a cave, a crude, natural shelter that men have in common with beasts. Man-made structures, however, are beginning to appear. At the right of the milking woman and a small flock, a protective fence has been erected. The forked trees supporting a beam do not seem to serve a practical purpose: presumably they were introduced to suggest the first tentative steps toward evolving the post-and-lintel system.

Barry's comment that 'considerably behind, in the extreme distance, appears Ceres, as just lighting on the world' is intended, as he says, as a segue into the next picture showing an agrarian society. The goddess, however, appears in neither the painting nor the print. However, in the print a large bird, presumably an eagle, appears above the mountains, but more as a bird of prey than as a heavenly messenger. The artist may have intended when he wrote his text to place Ceres in the painting, or he subsequently removed her. In any event, the goddess is better evoked without being personified in the image, where a single allegorical figure would be out of place.

Civilisation's most advanced stage appears in the right foreground, where materials for sacrifice are gathered. The smoking censer is the first indication that these primitives have mastered the use of fire, and the golden-handled knife resting on the bowl beside the bound lamb, which bleats while eyeing the viewer, is a far more sophisticated accessory than the men's crude clubs. But it is not so much the objects as the concept itself of sacrifice and atonement that marks a signal advance in mankind's cultural progression. In emphasising and applauding Orpheus' establishment of religious rites, Barry departs from Lucretius' text. The Latin author railed against the superstitious appeal to the supernatural, arguing instead for the rational exploration of natural laws that would give mankind needed tranquillity: 'Nor can there be any Piety for a Wretch with his Head veiled, to be ever turning himself about towards a Stone, to creep to every Altar, to throw himself flat upon the Ground, to spread his Arms before the Shrines of the *Gods*, to sprinkle the Altars abundantly with the Blood of Beasts, and to heap Vows upon Vows.'[23] Barry wilfully overlooks Lucretius' condemnation of animal sacrifice. In contrast, he insists on Orpheus' sacred undertaking to plant worshipful piety in the hearts of men.

CHAPTER THREE

A Grecian Harvest-home

Title in 1783 *Account*: *A Grecian Harvest-home, or Thanksgiving to the Rural Deities, CERES, BACCHUS*, &c.

Barry, 1783, in *Works*, vol. 2, pp. 326–7:

In the fore-ground are young men and women, dancing round a double terminal figure of Sylvanus and Pan, the former with his lap filled with the fruits of the earth, &c. [J]ust behind them are two oxen with a load of corn, a thrashing-floor, &c. [O]n one side is just coming in, the father or master of the feast, with a fillet round his head, a white staff, or sceptre, and his aged wife, &c.: in the other corner is a basket of melons, carrots, cabbage, &c. rakes, plough, &c. and a group of inferior rustics drinking, &c. If this part should be thought less amiable, more disorderly and mean than the rest, it is what I wished to mark. – In the top of the picture, Ceres, Bacchus, Pan, &c. are looking down (see Georgic, book i.) with benignity and satisfaction, on the innocent festivity of their happy votaries; behind them is a limb of the zodiac, with the signs of Leo, Virgo, and Libra, which mark this season of the year.

In the distance is a farm-house, binding corn, bees, &c. male and female employments, courtship, marriage, and a number of little children every-where. In short, I have endeavoured to introduce whatever could best point out a state of happiness, simplicity, and fecundity, in which, though not attended with much eclat, yet, perhaps, the duty we owe to God, to our neighbour, and ourselves, is much better attended to in this, than in any other stage of our progress; and it is but a stage of our progress, at which we cannot stop, as I have endeavoured to exemplify by the group of contending figures, in the middle distance, where there are men wrestling; one of the lookers-on has a discus under his arm, &c.; on the other side, the aged men are sitting and lying along, discoursing and enjoying the view of those athletic sports, in which they can no longer mix; and which (as we are informed by the ancients) gave rise to those wide and admirable national institutions, the Olympian, Isthmian, and Nemean games of the Grecians, which make the subject of the next picture.

Pl. 2 James Barry, *A Grecian Harvest-home*, 1777–84. Oil on canvas, 360cm x 462cm in. Royal Society of Arts, London

The 1792 print

A Grecian Harvest-home

For states of the print, see Pressly, no. 18.

Inscriptions in margin: upper centre: 'A Grecian Harvest Home'; far left: 'vos, o clarissima –'; left of centre: 'Ye Deities who Fields and Plains protect [/] Who rule the Seasons and the Year direct'; centre: 'Bacchus and Fostring Ceres Pow'rs Divine [/] Who gave us Corn for Mast for Water Wine. Dryden's Virgil.'; far right: '3d.'; bottom left: 'Painted Engraved & Publish'd by Jams. Barry R.A. Professor of Painting to the Royal Academy May. 1st. 17['7' reversed] 91'

Barry, 1793, in *Works*, vol. 2, p. 422:

In the second subject, where the mast or acorns give place to the chearful gifts of Ceres and Bacchus, the print and the picture are circumstantially the same. I have indeed in the group of figures which are dancing round the double terminal figure of Faunus and Sylvanus, by removing them a little to the right side, made room for introducing, in a more conspicuous way, the master of the feast, who with his aged wife is sitting in a patriarchal manner, enjoying the festivity and happiness of their virtuous and vigorous descendents.

Barry bases his vision of an Arcadian past, a golden moment of harmony and peaceful cultivation, largely on Virgil's *Georgics*, the Roman poet's four books on wise husbandry. He cites Virgil's *First*

Fig. 9 James Barry, *A Grecian Harvest-home*, 1792. Etching and engraving, 415mm x 505mm. British Museum, London

Book of the Georgics in his *Account*, and in the margin of the print he gives four lines from Dryden's translation, the lines which, following a brief introduction, open the song. Yet because Dryden, who was unconcerned with providing a literal translation, did not do full justice to this invocation, Barry also provides the Latin phrase 'vos, o clarissima –', that begins the song's opening sentence (line 5), which in its entirety translates, 'O ye most radiant lights of the firmament, that guide through heaven the gliding year'.[1]

Because Virgil's *Georgics* provides the primary underlying text, Barry's 'Grecian' harvest-home has a decidedly Roman flavour. Ceres and Bacchus are the primary deities: they take pride of place in the cluster of gods at the upper-left. At the left, Bacchus, his thyrsus beside him, pensively looks down, and Ceres, with stalks of grain in her hair, leans over to sprinkle kernels upon the ground while cradling a sheaf of grain. Above Bacchus in the upper-left corner sits Pan, his appearance not quite as vulgar as that shown on the herm. At the far right of this group of divinities is the two-faced Janus, whose month January begins the year. He holds a sickle, the symbol of Saturn, but since Janus received Saturn after Jupiter had expelled him from Greece, this conflation of the two gods is presumably deliberate. Saturn's joining of Janus began the golden age in Italy, the type of joyful time the artist depicts below. The youthful figure, who appears to hold a primitive ploughshare between Janus/Saturn and Ceres, is perhaps Pallas Athene, whom Virgil invokes as 'Thou Founder of the Plough and Plough-man's Toyl' (Virgil/Dryden, *Georgics I*, line 24), but seated next to Ceres, she is more likely her daughter, Proserpine, who plays a critical role in the celebration of the seasons. Despite the three signs named by Barry, the limb of the zodiac in the painting contains only Leo (23 July) and Virgo (23 August), with Libra (23 September) appearing in the print.[2]

The double terminal figure represents the more rustic deities Sylvanus and Pan. Virgil calls on Pan at the beginning of the *Georgics* (Virgil/Dryden, *Georgics I*, lines 20–22), and he had already linked him with Sylvanus in his *Tenth Pastoral*:

> *Sylvanus* came: his Brows a Country Crown
> Of Fennel, and of nodding Lillies, drown.
> Great *Pan* arriv'd; and we beheld him too,
> His cheeks and Temples of Vermilion Hue.
> (Virgil/Dryden, *Pastoral* or *Eclogue X*, lines 37–40)

Because Pan, an Arcadian god protective of herdsmen, hunters and country folk, also appears in the heavens behind Bacchus, perhaps this repetition induced Barry in his description of the print to substitute the name Faunus for Pan; although this change does not alter the work's content, the two often being associated, the change does tilt it even more toward a Roman bias.

The painting's primary focus is on the dance around the herm. An expression of thanksgiving to the divine, it denotes Greek civilisation as a culture of piety. The primary set of engravings adorning late-seventeenth-century editions of Dryden's translation shows two separate dances, one around a statue of Ceres, and an even wilder celebration in front of a statue of Bacchus.[3] In keeping with the rural nature of his thanksgiving, Barry's musicians at upper right play a pipe and, in the print, a tambourine. The numerous paintings of village festivals and kermises by such Flemish artists as David Teniers and Rubens would have been well known to Barry. One newspaper critic even wrote concerning *A Grecian Harvest-home* that the 'Rustics gamboling round a Wooden God' were degrading in their commonness, lowering the tone of the series as a whole.[4] Despite the rustic nature of the setting and the critic's comments, there is an elegance and dignity to Barry's circle of dancers that has more in common with such grand-manner sources as Poussin's paintings than with

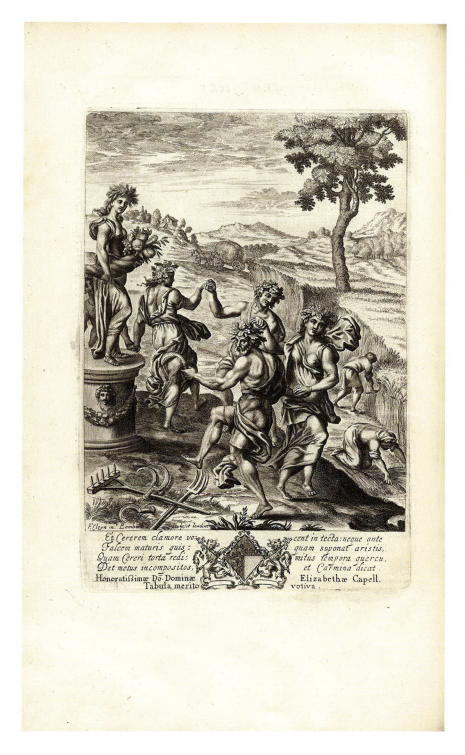

Fig. 10 Pierre Lombart after Francis Cleyn, *Dancing Around the Statue of Ceres*. Engraving, 298mm x 195mm. From Book I of *Georgics* in Virgil/Ogilby, London 1654. Beinecke Rare Book and Manuscript Library, Yale University, New Haven

the tradition of boisterous Flemish peasants or the gyrating dancers in the illustration to Virgil. Poussin's *A Dance to the Music of Time*, for example, with its garlanded, double-headed herm and stately dancers overseen by airborne deities, more strongly influenced his conception. At the right of Poussin's work, Time himself plays the musical accompaniment, another wise Orpheus-like figure whose tune is one of universal harmony.

In addition to the dancers, many of the elements populating Barry's canvas are present in the *Georgics*. At the left is a fruit-bearing limb, perhaps one that has been grafted onto the more rugged, blasted stock. The large tree at the right supports a vine, and some of the animals Virgil mentions are present, such as the oxen, the ass, the distant horse, the rooster (in the print) and the bee hives (also seen only in the print). While the prominent peacock does not appear in Virgil's text, its role as Juno's

Pl. 2 James Barry,
A Grecian Harvest-home,
1777–84. Oil on canvas,
360cm × 462cm in.
Royal Society of Arts, London

Fig. 11 Nicolas Poussin, *A Dance to the Music of Time*, c. 1637–9. Oil on canvas, 848mm x 1076mm. © By kind permission of the Trustees of the Wallace Collection, London

bird helps explain its inclusion. What are not present are the wild animals that haunt the background of *Orpheus*. As Virgil remarks in *The Second Book of the Georgics*:

> Our Land is from the Land of Tygers freed,
> Nor nourishes the Lyon's angry Seed;
> (Virgil/Dryden, *Georgics II*, lines 207–8)

Although the social construct of men and women pairing off into families was beginning to take shape in *Orpheus*, in *A Grecian Harvest-home* Barry incorporates the institution of marriage, with his early biographer, Edward Fryer, providing the textual gloss: 'A marriage procession is advancing from a distant temple; and the joy of the accompanying figures expresses the happiness arising on such occasions, the labourers even suspending their work to hail the happy pair'.[5] Two torchbearers lead this procession, while figures playing a lyre and a tambourine immediately follow the bride and groom. Barry also takes pains to distinguish between 'male and female employments'. Like Virgil, he emphasises the importance of women as weavers.

> The Wife and Husband equally conspire,
> To work by Night, and rake the Winter Fire:
> He sharpens Torches in the glim'ring Room,
> She shoots the flying Shuttle through the Loom:
> (Virgil/Dryden, *Georgics I*, lines 389–92)

Fig. 12 Detail of *A Grecian Harvest-home*, 1774–84. Royal Society of Arts, London

In a seventeenth-century set of illustrations to Virgil's *Georgics*, the plate illustrating these lines shows a winter interior where adults work by firelight. The foremost figure in the group is a woman spinning thread on a distaff, while a companion works a loom.[6] In the background of his painting, Barry shows a young woman sitting in front of a shed where a young swain approaches and bows to her. She holds a distaff in her hand, as does the woman watching the dancers glimpsed just to the right of the double herm.

Barry's males display a wider range of social types than do his women. In the lower left corner, he places a group of drinking, inferior rustics, identified by Susan Burney as slaves.[7] Scattered about them are agrarian implements that have replaced the clubs found in the previous picture. Throughout the series the artist introduces similar brutish, minor characters, representatives of a debased lower or servant class who, as is traditional, tend to be swarthier than their 'betters'.

Behind the heads of the oxen stands a male celebrant whose hands are raised as he snaps his fingers in time with the music. On his head he wears a brown liberty cap with electric-blue stripes and a bright-blue headband. There was already a precedent for including a freedman wearing a Phrygian cap in an illustration to Dryden's Virgil, where an onlooker at the left watches soil being tested,[8] but one suspects, given Barry's strong republican sympathies,[9] that his use of the cap had political

overtones that were not in the mind of the earlier illustrator. In republican Rome, the cap, which had been worn by freedmen, came as well to symbolise freedom from tyranny. In employing this cap, Barry may have anticipated the French, who, during the French Revolution, were soon to revive a red version of this classical symbol as the *bonnet rouge*.

In his text Barry describes as entering from the right 'the father or master of the feast, with a fillet round his head, a white staff, or sceptre, and his aged wife'. The headband, like the staff, is a sign of venerable respect. In the *Georgics*, Virgil adorns his poet narrator with a holy fillet as would befit a priest:

> Ye sacred Muses, with whose Beauty fir'd,
> My Soul is ravish'd, and my Brain inspir'd:
> Whose Priest I am, whose holy Fillets wear;
> (Virgil/Dryden, *Georgics II*, lines 673–5)

The patriarch makes his entrance at the far right, but he is difficult to see as only a portion of his profile is visible (not visible in the reproduction). Wearing a red robe, he holds up an instructive finger. Behind him Barry shows the head of his aged wife, uncut by the frame and wearing a white hood. In describing the print, the artist mentions that he purposefully moved the dancing figures to the right (that is, to the right on the copperplate, to the left in the printed image) in order to feature more prominently this presiding couple, who are now shown holding hands to the right of the dancers. He describes them as enjoying the happy festivity, and to a certain extent they have usurped the role which in the commentary to the painting had been assigned to the celestial deities.

Barry envisions a progression from barbarism to 'a state of happiness, simplicity, and fecundity', which sadly cannot be maintained as civilisation advances to a higher stage, but one filled with strife. In Virgil, as in Georgian England, the possibility of these two states, that of rural simplicity and that of the bustling world of commerce and discourse, existed simultaneously, and Virgil's theme of retirement to rustic pleasures echoes throughout English literature of this period.[10] Virgil's narrator himself fondly yearns for bucolic felicity:

> My next Desire is, void of Care and Strife,
> To lead a soft, secure, inglorious Life.
> A Country Cottage near a Crystal Flood,
> A winding Vally, and a lofty Wood.
> Some God conduct me to the sacred Shades,
> Where Bacchanals are sung by *Spartan* Maids.
> (Virgil/Dryden, *Georgics II*, lines 688–93)

While rural retirement may be an option for those wearied by the larger world, Virgil, too, sees this agrarian society as, in its essence, representing an earlier, happier time that has to a large degree been lost:

> Such was the life the frugal *Sabines* led;
> So *Remus* and his Brother God were bred:
> From whom th' austere *Etrurian* Virtue rose,
> And this rude life our homely Fathers chose.
> (Virgil/Dryden, *Georgics II*, lines 777–80)

Detail from Pl. 2 James Barry, *A Grecian Harvest-home,* 1774–84. Royal Society of Arts, London

Detail from Pl. 2 James Barry, *A Grecian Harvest-home*, 1774–84. Royal Society of Arts, London

Like Virgil, Barry wistfully looks to an imagined world of lost innocence. In his introduction to the print after this painting published in the 1808 posthumous edition, Fryer described the dancers in terms of Milton's *L'Allegro*:

In the foreground is a double terminal figure of Sylvanus and Pan, with their proper attributes; round which, young men and women, in beautiful forms, and lightly habited, are dancing to the music of a rural pipe and tabor, and seem, in the language of the poet, to

> '_____ trip it as they go
> On the light fantastic toe'.[11]

Yet the ominous break in the chain of dancers, more evident in the painting than in the print, foreshadows the disruption of rural harmony, and the pensive, melancholy expression of the prominent female dancer as eloquently recalls *Il Penseroso* as *L'Allegro*. The woman with the distaff to the right of the herm (see fig. 12) is on one level the Fate Clotho, a sobering reminder that, just as this thread will eventually be cut, so too will the pleasures of this happy stage of civilisation pass all too quickly as will life itself. Fryer, the earliest commentator other than the artist himself, describes the time of day in *A Grecian Harvest-home*: 'as most of the persons represented are employed in rural sports, the evening is chosen, as the most proper time for such relaxation from the labours of the field.'[12] An evening, autumnal scene again underscores the sweet sadness and elegiac nature of this blissful moment, which will soon disappear along with the setting sun.[13]

Virgil mentions wrestling as one of the virtuous rural sports (Virgil/Dryden, *Georgics II*, line 775), and for Barry such activity, particularly when, as here, sport is accompanied by reflective, wiser, older men, foreshadows the subject of the next painting. After commenting on the mural's overall agrarian content, Susan Burney focused on these old men and youthful athletes, although the horse racers she mentions did not survive into the final conception:

The second Piece represents Mankind in a much higher state of Civilization – it contains a Corn-rick, a Haystack, a Plough yoked with oxen, & many implements of Husbandry – He lays his scene in Greece – some beautiful women are dancing – Old People seated on the grass conversing – Athletics [this word is possibly 'Athleties' but 'Athletes' is intended] practising wrestling, 2 youths on Horseback run[n]ing a race.'[14]

For Barry such competitive challenges will lead to a higher stage of civilisation, but one that is gained at no little cost. The harmony of rural life will be lost in the more demanding and stressful society to come.

CHAPTER FOUR

Crowning the Victors at Olympia

Title in 1783 *Account*: *Crowning the Victors at OLYMPIA*

Barry, 1783, in *Works*, vol. 2, pp. 328-31:

I have taken the point of time, when the Victors in the several games pass in procession before the Hellanodicks or judges, where they are crowned with olive, in the presence of all the Grecians. The three judges are seated on a throne, which is ornamented with medallions of their great legislators, Solon, Lycurgus, &c. under which come trophies of the victories of Salamis, Marathon, and Thermopyle, which are not improper objects of commemoration for such a place.

As the Greek chronology was regulated by those games, one of the judges with his hand stretched out, is declaring the Olympiad, and the name, family, and country of the conqueror. At the foot of the throne, on one side of the table, on which are placed the chaplets of olive, and palm branches, there sits a figure, who is just going to write down in a scroll of parchment, what the hellanodick is proclaiming; this scroll appears to be a register of the Olympiads; and names of the conquerors which were set down together; near this table an inferior hellanodick is crowning the victor in the foot-race, and putting into his hand the branch of palm; the next figure is a foot-racer, who ran armed with a helmet, spear, and shield; the next is a pancratiast, and the victor at the cestus; then comes the horse and the chariot. In the chariot is Hiero of Syracuse; the person who leads the chorus, is Pindar; the old man on the shoulders of the boxer, and pancratist, is Diagoras of Rhodes, who having been often in his younger days celebrated for his victories in those games, has now, in his advanced age, the additional felicity of enjoying the fruit of the virtuous education he had given his children, he being

Pl. 3 James Barry, *Crowning the Victors at Olympia*, 1777–84. Oil on canvas, 360cm x 1278cm. Royal Society of Arts, London

carried round the stadium, on the shoulders of his two victorious sons, amidst the acclamations of the people of Greece. Cicero, Plutarch, and other great men, have taken notice of this incident, and one of them mentions the saying of a Spartan on this occasion, which strongly marks the great estimation in which those victories were held. Pindar's 7th Olympic ode is inscribed to this Diagoras. The spectators for the most part consist of all those celebrated characters of Greece, who lived nearly about that time, and might have been present on the occasion; the rearing up of the horse, which comes next after the boxer, has by opening that line of figures, furnished me with an opportunity of introducing Pericles, whom I wished to represent in an action of some energy, speaking to Cimon; and there were many differences, and matters of importance between them; near him are Socrates, Anaxagoras, Euripides, &c. who may be supposed to be entertained with the wisdom and eloquence of the speaker, whilst the profligate Aristophanes is appearing just behind him, attentive to nothing but the immoderate length of Pericles's head, at which he is ridiculously pointing and laughing, verifying what the wise man has long ago observed. 'He that cometh to seek after knowledge, with a mind to scorn and censure, shall be sure to find matter for his humour, but no matter for his instruction.' But my dislike of this base character, has, I fear, withheld me from bringing in enough of his head, to impress the idea of his likeness to the bust from whence it was taken; if so, he may do for any other wretch of this class, and there will be found no want of them upon similar occasions, in all times. When I painted this figure of Pericles, I knew of no bust of him remaining, and had nothing to follow but that description of him in Plutarch, which amounts to little more than the circumstance of the great length of his head; and the late Lord Chatham being just then dead, and there being a striking resemblance in the character and fortunes of those two great men, I was determined to melt them into one figure, and keeping the length of the one in the upper part of the head, to introduce in the features below the resemblance of the other. Not long since, Henry Banks, Esq. gave me a small copy of a medallion of Pericles, and Aspasia, the original of which was lately found at Rome, and is in the hands of that amiable man, and excellent artist, [Gavin] Hamilton the painter, of whose skill and great professional abilities, his country ought to make a better use than keeping him raking in *cavas* [quarries], let what would be found in them.

The man with the bandage over one eye, who is strewing flowers, and congratulating the armed foot-racer, shews this to be a contest of glory, and not of rancour; just behind the man who is registering the Olympiads, is Herodotus, with his history of Greece in his hand, and near him, and further in the picture, is one in white, with his finger on his lips, and that system in his hand, which was held by the Pythagoreans, and has been since revived by Copernicus; near him stands Hippocrates, Democritus, &c. [B]ehind the stadium is the altis, where the statues of the Victors were placed, and the temple of Jupiter Olympius. In the distance, is the town of Elis, and the river Alpheus. The basso-relievo, on the chariot of Hiero, is the contest between Neptune and Minerva, for the naming and patronage of Athens. At one end of the picture is a statue of Minerva at the other, a statue of Hercules treading down Envy, which are comprehensive exemplars of that strength of body, and strength of mind, which were the two great objects of Grecian education. In the Minerva I have followed the original passage in Homer, and Pausanias's description of her statue by Phidias: not to mention other matters, it is not a little surprising to find that circumstances so proper, and so truly terrific, of the rim of serpents rolling round the Egis, omitted in all the statues I have seen of her except one which is in the Capitol at Rome, though this statue is in the other, and more essential respects, of no great worth, as the majesty, grandeur, and style of proportions of Minerva, are her particular characteristics, and not merely her helmet and Egis. There is a fine head of Minerva, in the possession of the Earl of Shelburne, which is conceived and executed in a masterly and truly Grecian manner. As to the Hercules treading down envy, on the other side, Horace observes, that this was Hercules's last labour, and cost him his life before it could be effected; by-the-bye, it is no doubt a good and a wise distribution, that Envy should continually haunt and persecute the greatest characters; though for the time, it may give them uneasiness, yet it tends on the one hand to make them more perfect, by obliging them to weed out whatever may be faulty, and occasions them on the other, to keep their good qualities in that state of continued unrelaxed exertion, from which the world derives greater benefit, and themselves in the end, still greater glory. On the

basement of this statue of Hercules, sits Timanthus the painter, with his picture, which is mentioned by Pliny, &c. of the Cyclops and Satyrs; as there is no portrait of Timanthus remaining, (from a vanity not uncommon amongst artists) I shall take the liberty to supply him with my own. Gilbert West has prefixed to his elegant and spirited translation of some of Pindar's odes, a dissertation on the Olympic Games, where those who may be in want of it, will find much information respecting this favourite, and so very celebrated institution, of the most truly illustrious people that ever graced the records of mankind.

The 1792 print

The Diagorides Victors at Olympia

For states and full inscriptions, see Pressly, no. 19.
Barry, 1793, in *Works*, vol. 2, pp. 422–4:

In the third subject, where the famous family of the Diagorides are victors at Olympia, the printed account to the picture can lead to no error in considering the print, as the inessential circumstances altered or omitted, in order to obtain a greater magnitude in the figures, are not taken notice of in that account. Philolaus the Pythagorean, with his solar system (since revived by Copernicus) standing near the Hellanodicks or judges, who are seated upon a throne, ornamented with the victories of Marathon, Salamis, and Thermopyle, is the same in the picture and print, as also the foot racer, on whom one of the Hellanodicks is tying on the crown, the armed racer, the victor at the Cestus, and the Pancratiast triumphantly carrying their father Diagoras, the horse and Hiero driving the chariot of four horses, surrounded by the chorus, which Pindar leads. In the second line of figures, which is discovered by the rearing up of the horse, appear Socrates, Euripides, and the others who are attending to the conversation of Pericles with Cimon – also the two statues of mental and bodily vigour in which the subject terminates. These two statues of Minerva and Hercules, the temple of Jupiter in the altis, and the procession approaching the altar, with the victims for a sacrifice, bring the mind naturally to

Fig. 13 James Barry, *The Diagorides Victors at Olympia*, 1792. Etching and engraving, 419mm x 924mm. British Museum, London

the contemplation of those numberless blessings which society derives, and can only derive from the exercise of religious worship. The Greeks, the most belligerent of all people, who were divided into so many distinct polities, with such rivalships, strife, and animosities, to embitter and to increase their estrangement from each other, were, notwithstanding, from the influence of religion, obliged every four years to lay aside all manner of hostility, and declare a general armistice or truce for the peaceful, fraternal celebration of those sacred games. At the numerous and great sacrifices which the different people of Greece held themselves obliged to perform at the common altar of Jupiter during the festival, occasion was continually offered to the mentors of their several countries to break out with the admirable and amiable Fenelon. [At this point, Barry quotes a passage in French from Fénelon's *Les Aventures de Télémaque*. The following is Tobias Smollett's 1776 translation of Mentor's speech: 'O ye kings and commanders, here assembled! your several nations for the future will be but one, under different names and governors. Thus it is, that the just gods, who formed and love the human race, would have them united in an everlasting bond of perfect amity and concord. All mankind are but one family dispersed over the face of the whole earth, and all nations are brethren, and ought to love one another as such. May shame and infamy overtake those impious wretches who seek a cruel unnatural glory, by shedding the blood of their brethren, which they ought to regard as their own. War, it is true, is sometimes necessary: but it reflects disgrace on human nature, that it should be unavoidable on certain occasions. O ye kings! do not say that it is desirable for the sake of acquiring glory; for true glory cannot exist independent of humanity' (François de Salignanc de la Mothe Fénelon, *The Adventures of Telemachus, the Son of Ulysses*, trans. into English by Tobias Smollett, intro. and notes by Leslie A. Chilton, ed. O.M. Brack, Jr. (Athens, Georgia and London: University of Georgia Press, 1997)], pp. 132–3).]

As discussed in chapter one, from the beginning Barry envisioned *Crowning the Victors at Olympia* as the primary focal point for the series. In his letter of 19 April 1777 to Sir George Savile, where he outlined his earliest recorded vision for the Great Room, this mural was paramount.[1] In this first conception, the picture *Orpheus* was to lead directly into the subject matter of the Olympic Games, to which he planned to devote three paintings covering half of the wall space then available to him. In the spot that *A Grecian Harvest-home* came to occupy he first conceived a work showing the contests in progress. Then came the 42-foot (1280cm) painting showing the crowning of the victors, and flanking it on the east wall, opposite *The Contest*, was a work to be devoted to creative men, among whom would be featured Prodicus and Aetion, presumably along with Herodotus.[2] For his conception's textual source, Barry cites Gilbert West's book *Odes of Pindar, with Several Other Pieces in Prose and Verse, Translated from the Greek. To which is Added a Dissertation on the Olympick Games*, a work first published in 1749, with new editions appearing in 1753 and 1766. West's primary subject is Pindar's poetry, but as he explains, in order to appreciate it one must first understand its context:

There is still another Prejudice against *Pindar*, which may rise in the Minds of those People, who are not thoroughly acquainted with ancient History, and who may therefore be apt to think meanly of *Odes*, inscribed to a Set of *Conquerors*, whom possibly they may look upon only as so many *Prize Fighters* and *Jockeys*. To obviate this Prejudice, I have prefixed to my Translation of *Pindar's Odes* a *Dissertation* on the *Olympick Games*: in which the Reader will see what kind of Persons these *Conquerors* were, and what was the Nature of those famous *Games*.[3]

Along with these athletes, West's account sanctioned the inclusion of intellectual and artistic performers:

And as the several Parts of this great Institution drew to *Olympia* an infinite Multitude of People from all Parts, so did that numerous Assembly invite thither the Men of the greatest Eminency in all the Arts of Peace; such as Historians, Orators, Philosophers, Poets, and Painters; who perceiving that the most compendious Way to Fame

lay through *Olympia*, were there induced to exhibit their best Performances, at the Time of the Celebration of the *Olympick Games*. To this Assembly *Herodotus* read his History, to this Assembly *Aëion*, a celebrated Painter, shewed his famous Picture of the Marriage of *Alexander* and *Roxana*; and for this Assembly *Hippias* the *Elean*, a *Sophist*, *Prodicus* the *Cean*, *Anaximenes* the *Chian*, *Polus* of *Agrigentum*, and many other Sophists, Historians, and Orators, composed Discourses and Harangues; …[4]

Barry, however, was to drop the idea of flanking images devoted to the Olympic Games. In the case of creative, intellectual figures, he squeezed philosophers, scientists and statesmen into the main composition. His work *Elysium and Tartarus* would also be able to absorb and honour a large contingent of great men from the classical past. Interestingly, however, Prodicus and Aetion never found a home within the series.

With fewer figures than the equally large *Elysium and Tartarus* and with the organising principle of a grand procession, *Crowning the Victors* has a bold effect. At either end, framing the composition are painted statues in front of paired fluted columns of the masculine Doric order. As Edward Croft-Murray points out, 'Barry has here gone back to the old processional type of wall painting, closed at either end by flanking statues – one thinks immediately of Ricci's *Triumph of Bacchus* for the staircase of Burlington House'.[5] At the left is Hercules, representing virtue and physical excellence, and at the right Minerva, representing wisdom. In the case of Minerva, Barry follows the type embodied in Phidias' celebrated statue in the Parthenon, but in the case of Hercules, who is shown trampling the Serpent of Envy, his conception is a visualisation of an ode by Horace in which the Greek god triumphs over the envy of others, their earlier disparagements turning after his death into praise.[6]

In Barry's painting, Pindar, seen in the procession playing his lyre beneath the pillar at the left, is the only figure to wear a laurel crown, as the athlete being crowned at the right is presented instead with a chaplet in which the leaves are turned in the opposite direction. Barry had already quoted portions of Pindar's *First Pythian Ode* in his text to *Orpheus*, and in *Crowning the Victors* the poet holds the golden lyre he had hailed in his opening line to this poem. Here Pindar is to be seen as another Orpheus, the inspired poet, philosopher and theologian, who comprehends and elevates the society in which he lives. Barry also purposefully contrasts Pindar's regal bearing and resplendent attire with the crude appearance of the horn blowers following him. While the poet, followed by a chorus of boys, accompanies his musical instrument with the sublimity of sacred song, the players of wind instruments are unable to give voice to their thoughts and feelings.

The setting is the stadium at Olympia. Three principal judges are seated at the right. One of the lesser judges awards the honours to the first of four champions who approach on foot. The last two of these victors carry their father Diagoras, a former victor, on their shoulders. In the latter part of the procession, seen on the left, are the winners of horse and chariot races. The procession itself continues around one of the stadium pillars, inscribed with the Greek word 'ΑΡΙΣΤΕΥΕ', which West had translated as courage.[7]

While the procession moves from left to right, the expected direction in Western art, Barry begins his description with the right-hand side. Although there are three primary judges, the central figure dominates, magisterially pointing with his right hand while he grips with his left hand his staff, which leans against his shoulder. The impressive marble base of the judges' throne has ornate relief carvings. Along the bottom are palm trees, between which are smoking altars flanked by amphorae. Each tree supports a shield with the names in Greek of three major military victories, which, from left to right, are Marathon (490 BC), Thermopylae (480 BC), and Salamis (480 BC). In contrast to the others, this last was a naval victory, and Barry introduces a ship's prow behind the palm supporting the shield. Winged Victories holding wreaths gracefully ascend to the front of the throne decorated with a

cartouche presumably intended for an inscription. Above the Victories are facing portrait medallions of Solon, the great lawgiver of Athens, and Lycurgus, of Sparta. In Barry's account, their names are followed by an etcetera, and there is an unseen medallion that continues on the throne behind the column. Since a similar arrangement is presumably to be found on the other side of the throne, there are still more opportunities for naming.

The scribe at the foot of the throne, pausing in his recording of the information concerning the victors, looks up at the judge. Sculptures of graceful women (presumably more Victories) form the supports for the table at which he works, and the long scroll unwinds over a tablet he uses as a support. West describes the moment when each victor is recognised: 'The *Conquerors* being summoned by Proclamation, marched in Order to the Tribunal of the *Hellanodicks*, where a *Herald* taking the *Crowns* of *Olive* from the Table, placed one upon the Head of each of the *Conquerors*; and giving into their Hands *Branches* of *Palm*, led them in that Equipage along the *Stadium*, preceded by *Trumpets*, proclaiming at the same Time with a loud Voice, their Names, the Names of their Fathers, and their Countries.'[8] Barry, following West's lead, writes of the victors being crowned with olive. but in the painting the crowns appear closer to laurel, an even more common classical symbol of victory, and one that also celebrates Apollonian creativity.[9] West offers an explanation, based on Plutarch, of the meaning of the palms: they represent, 'the unsuppressive Vigour of their [the victors'] Minds and Bodies, evidenced in their getting the better of their *Antagonists*; and surmounting all Opposition, like those Plants, whose Property it was, according to the Opinion of the Ancients, to rise and flourish under the greatest Weights, and against all Endeavours to bend or keep them down.'[10]

The cluster of victors nearest the judges consists of the winner in the foot-race, who is receiving a palm and chaplet from an inferior judge, followed by the armed foot-racer, whom a bandaged opponent congratulates. The two victorious sons of Diagoras are winners of the cestus, or boxing, and of the pancratium, consisting of boxing and wrestling. Martin Kemp makes the observation that, when taken together, the four young victors, all of whom wear little more than a scarf around their loins, 'are entirely conscious demonstrations of the painter's anatomical prowess, using a serially turning technique invented by Leonardo.'[11] Kemp feels Barry could have learned this technique from Dr William Hunter, the anatomist who was a friend and who had planned to publish Leonardo's anatomical drawings at Windsor. The four athletes gracefully rotate from a full-frontal position to one in profile, and their movement becomes increasingly less pronounced until it comes to rest in this stationary profile figure. Barry, too, emphasises these athletes' physical beauty, a visual testament to the Greek ideal uniting beauty and intellectual knowledge.

J.J. Winckelmann had written in his *Thoughts on the Imitation of Greek Works in Painting and Sculpture* of 1755, '*To be like the God-like Diagoras*, was the fondest wish of every youth'.[12] Pindar's *Seventh Olympick Ode* celebrating Diagoras' victory in the cestus was held 'in such Esteem among the Ancients, that it was deposited in a Temple of *Minerva*, written in Letters of Gold'.[13] Fittingly for the painting's theme, physical prowess is reverenced within a temple for the goddess of wisdom. Barry, however, does not show Diagoras' moment of victory but that of two of his sons. Although he compresses the action by introducing the showering of flowers on the victors upon their approach to the judges, he chooses the following moment as described by West:

This venerable *Conqueror* [Diagoras the Rhodian] is said to have accompanied his two Sons, *Acusilaus* and *Damagetus*, to the *Olympick Games*, in which the young Men coming off victorious, *Acusilaus* in the *Cæstus*, and *Damagetus* in the *Pancratium*, took their Father on their Shoulders, and carried him as it were in Triumph along the *Stadium*, amid the Shouts and Acclamations of the Spectators; who poured Flowers on him as he passed, and hailed him happy in being the Father of such Sons.[14]

Pl. 3 James Barry, *Crowning the Victors at Olympia*, 1777–84. Oil on canvas, 360cm x 1278cm. Royal Society of Arts, London

This moment was so central to the painting's meaning that Barry entitled his 1792 print after the painting *The Diagorides Victors at Olympia*.

In his notes to Pindar's ode West offers an even lengthier account of this moment, one which is indebted to *The Dictionary Historical and Critical of Mr. Peter Bayle*:

Mr. *Bayle* in his Dictionary has an Article upon this *Diagoras*, in which he relates from *Pausanias* a famous Story of him, *viz.* That *Diagoras* having attended his Two Sons *Damagetus* and *Acusilaus* to the *Olympick* Games, and both the young Men having been proclaimed Conquerors, he was carried on the Shoulders of his Two victorious Sons through the midst of that great Assembly of the *Greeks*, who showered down Flowers upon him as he passed along, congratulating him upon the Glory of his Sons. Some Authors (adds Mr. *Bayle*) say, he was so transported upon this Ocassion, that he died of Joy. But this Account he rejects as false, for Reasons which may be seen at large in the Notes upon this Article. *Tully* and *Plutarch*, alluding to this Story of *Diagoras*, add, that a *Spartan* coming up to him said, 'Now die, *Diagoras*, for thou canst not climb to Heaven.' Which Mr. *Bayle* paraphrases in this Manner: 'You are arrived, *Diagoras*, at the highest Pitch of Glory you can aspire to, for you must not flatter yourself, that if you lived longer you should ascend to Heaven. Die then, that you may not run the Risk of a Fall.' Which is certainly the meaning of this famous Saying of the *Spartan*.[15]

This Spartan, an old man in shadow who stands on tiptoe in his red-strap sandals, grasps Diagoras' right hand while showering him with flowers with his left.

Diagoras had three sons who won Olympic crowns,[16] although only two of them are shown supporting him on their shoulders. The young man to the left of this group is surely the third son, who, while throwing flowers with one hand, touches his brother's hand with the other.[17] Diagoras' grandson Pisidorus also was to be an Olympic victor,[18] and the boy at the right of the group is he, Barry asserting in his description to the print detail of 1795 that three generations are present in his sculpturesque grouping of the Diagorides:

These Diagorides afford a subject of such peculiar felicity for a group in sculpture, that I have often complimented myself by supposing that there must have been (notwithstanding the silence of Pausanias) something like this of mine set up in the Altis at Olympia; the characters of the men in their different stages of life – father, sons, and grandsons, such a race of heroes, where the naked occurred with such peculiar propriety, and so gloriously connected with ethics, and with all the duties of the good citizen, that I can recollect nothing remaining of the ancients, where the subject matter is more exemplary, more impregnated with that unction, spirit, and *venustas* [graces], which are the inseparable characteristics of Grecian genius.[19]

This 'race of heroes' is not based on an exceptional gene pool but rather on the inculcation of the highest ethical standards, the promotion of virtuous conduct to which all can aspire.

In the procession on the painting's left half first appears the rider on horseback, his steed rearing up, the horse's nostrils flaring, as he holds a pose worthy of an equestrian statue. He is followed by Hiero of Syracuse, who rides in a chariot that accords with West's description: 'These *Chariots*, by some Figures of them upon ancient Medals, *&c.* seem to have been very low, open behind, but closed up before and on the Sides, with a Kind of *Parapet*, which was sometimes enriched with various Sorts of Ornaments. There does not appear to have been any *Seat* for the *Driver*, who is therefore always represented *standing*, and leaning forward to the *Horses*.'[20] Appearing in relief on the side of

OPPOSITE PAGE: **Detail from Pl. 3** James Barry, *Crowning the Victors at Olympia*, 1777–84. Oil on canvas, 360cm x 1278cm. Royal Society of Arts, London

the chariot is the fable of the founding of Athens; when Neptune and Minerva competed to see who could produce the better gift, thereby awarding him or her the rule of the city. Neptune is beside the horse that his trident has summoned up, whereas Minerva, the winner, holds a branch of the olive tree, a symbol of peace and plenty, which is her gift to the citizens.

Barry introduces himself seated beside the statue of Hercules in the character of Timanthes holding a recreation of one of the Greek artist's paintings, a self-portrait that will be discussed at length in the conclusion. Next to him a figure, who appears to be female, bends over to pick up flowers from a basket to shower upon the victors. The artist, who is smaller in scale than the surrounding figures, unfortunately juxtaposes himself with this flower retriever's large rear posterior. If this figure is indeed a woman, as seems likely, she is another member of the Diagorides family.[21] At a later date, because of the distinguished accomplishments of her father and brothers, Aristopateira, the daughter of Diagoras, became the first woman allowed to attend the Olympic Games in order to witness her son Pisadorus' participation.[22] Additional celebrants throw flowers on the other side of Heiro's chariot, and this group is led by a young man striking a large tambourine with swinging bells tied to it on short cords.

Interspersed among the victorious athletes are a select number of distinguished spectators. Behind the scribe registering the Olympiads is the historian Herodotus, who is most famous for his histories of the Greco-Persian wars, battles from which are commemorated on the throne. Herodotus is in shadow, head on hand, and the scroll with his name rests at the feet of the judges, his right hand lightly touching it. The historian is surrounded by three other figures excluding the scribe, all of whom disappear in the print's more concentrated format.

A highlighted line of spectators recedes between the lesser judges and the scribe. The first is named in the description of the print after the painting as the Greek philosopher Philolaus, with a scroll depicting his speculation on the solar system. He is followed by the Greek physician Hippocrates and the melancholy philosopher Democritus, who is also known as the laughing philosopher; here his slight smile exposes his bottom row of teeth. After naming this third figure, Barry concludes with another etcetera. It seems unlikely that he simply became bored with naming the participants, but, as in the case of the medallions of lawgivers decorating the judges' platform, he invites the viewer to project his or her own list of worthies, forcing one to interact with the painting rather than passively receiving the artist's choices.

Between the rearing horse and the group of Diagorides victors appears another cluster of celebrated intellectuals, all drawn from Athens' glorious past. The most prominent, with his left arm raised, is the Athenian statesman Pericles, to whom Barry has given Lord Chatham's features. He is in conversation with Cimon, the general and statesman who had been his opponent. Between them are two heads, and the older of the two is perhaps the philosopher Anaxagoras, who looks to Pericles, one of his pupils. The Athenian comedic playwright, Aristophanes, is seen between Pericles' head and upraised arm, mocking the head's inordinate length.

The first figure in the group to the right of Pericles is presumably the playwright Euripides, who, unlike his neighbor Aristophanes, is known for his tragedies. At the far right of this group stands a pensive Socrates, with his arms folded beneath his toga. The boy next to him, unidentified in the artist's text, is surely Plato, Socrates' most famous pupil. While the primary focus of the painting is on the Diagorides victors, Socrates is at the painting's exact centre. Within this celebration of physical prowess, a philosopher is given pride of place. The small figures seen on the stadium's seats over his head appear like extensions of his own thoughts, with the two seated men directly above him studying intensely an open scroll.

Whatever the athletes have accomplished, intellectual endeavours are not slighted. While only a

few artistic figures appear among the historians, philosophers, scientists, and statesmen, one should not forget the poet Pindar's prominence as well as that of the painter Timanthes. In the 1792 print, Barry introduces brushes and a palette beside Timanthes, but of greater interest is the scroll beneath the palette, which is an indication of the artist's intellectual role. Two distinct sets of garments and travelling paraphernalia beside the statue of Minerva in the opposite corner from Timanthes also may be intended to balance mental with physical excellence. The uppermost one consists of a green cloak with helmet, bow, chest armour, and shield, which are the accoutrements of a warrior athlete. Beneath it is a red cloak with a jug, cloth bag, crooked staff and a black broad-brimmed hat with a white band, which are accoutrements more closely associated with an intellectual pilgrim, particularly the hat, which is related to melancholy genius.[23] Given their positioning in the corner opposite Timanthes, these last items may well belong to him.

The drama unfolds in the stadium with framing columns and statues superimposed at either end. Beyond the rising tiers of seats can be seen the imposing Temple of Jupiter surmounted by a gilded statue of Victory. The walls enclosing the Altis, or sacred precinct, are punctuated with statues of former victors. In the distance beyond the wall to the right of the Temple of Jupiter can be seen a smaller domed structure, the front of which is flanked by two large plinths, each supporting a statue of a charioteer. The town of Elis near the River Alpheus appears to the right above the line of spectators that begins with Philolaus. The radiant sky proclaims this a golden age, a high-water mark in the advance of civilisation.

The stimulus of glory, both in the physical and mental realms, has produced an advanced culture. Despite the strife of competition, there is still a strong sense of community: public rather than private interests are being served. The sacrificial procession proceeding toward the temple gives witness of the importance of religion and ritual within this highly structured system. In putting the Olympic Games into a larger perspective, West may just as well have been describing an organization such as the Society for the Encouragement of Arts, Manufactures, and Commerce:

From what has been said of the *Utility* of the *Olympick Games*, we may draw this general Inference:

That even the *Sports* and *Diversions* of a People may be turned to the Advantage of the Publick. Or rather,

That a wise and prudent Governor of a State may dispose the People to such Sports and Diversions, as may render them more serviceable to the Publick; and that by impartially bestowing a few *honorary Prizes* upon those, who should be found to excell in any *Contest* he shall think proper to appoint, he may excite in the Husbandman, the Manufacturer, and the Mechanick, as well as in the Soldier, and the Sailor, and Men of superior Orders and Professions, such an Emulation, as may tend to promote Industry, encourage Trade, improve the Knowledge and Wisdom of Mankind, and consequently make his Country victorious in War, and in Peace opulent, virtuous, and happy.[24]

Barry's mural not only celebrates an earlier stage of a healthy, productive society, but also offers a blueprint for how the love of glory can be channelled to promote public virtue in the present day.

Early accounts: a preparatory drawing and an eyewitness report

The sole surviving drawing for the painting's composition as a whole differs from the mural in a few significant details. Because its proportions are not wide enough to accommodate the 366cm x 1280cm space, presumably at this point the artist was unconcerned with blocking the intended statues into the drawing. Of greater interest is his confining the intellectual and creative figures primarily to the space

Fig. 14 James Barry, *Study for 'Crowning the Victors at Olympia'*, c. 1777–80. Pen and brown ink with black chalk over pencil, 342mm x 1095mm. Victoria and Albert Museum, London

left of centre, allowing for a resonating gap at the right between the enthroned judges and the lesser judge, bridged only by the table. Such a rendering makes the enthroned judges even more remote and superior in their isolation. At this time he also delineates five prominent figures in the group near the centre. The gesticulating figure at the left, just behind the head of the rearing horse, would be Pericles, who is dominating the conversation that he is having with Cimon, who faces him. There is a head between these two statesmen, and to the right of this group is a fourth figure, who raises his hand in astonishment as he looks at Diagoras being showered with flowers by the Spartan. Next comes the most prominent of these five onlookers. He is shown full length holding two disk-like shapes of unequal size. Perhaps he is holding scrolls, and if this is the case, the most likely identification is Herodotus, who, in the final design, has been moved to the far right beneath the judges' throne. At this point Socrates was not then among the chosen. Perhaps because Barry was intending to give Socrates a place of prominence in *Elysium*, he was not yet considering him as a candidate for inclusion in *Crowning*. Once added, Socrates became the sole figure to twice appear in the series in a significant way.[25]

On the composition's left-hand side, the Three Graces, a symbol of the arts, are depicted on the side of Hiero's chariot rather than the contest between Minerva and Neptune. Absent at this point are the figures of Barry, as Timanthes, and the bent-over flower gatherer. The boy chorus has also not yet been introduced. Still, all in all, the primary composition and conception are in place.

As the earliest surviving description of the mural, Susan Burney's 1779 account deserves quotation in full:

The 3d. Piece, wch covers one entire side of the Room, (the Figures are almost all as large as life) represents the celebration of the Olympic Games – the Period chosen by Mr. Barry is that during which Greece was perhaps at its highest point of Elevation – at the time of Cymon's recall from banishment & when Pericles so successfully encouraged & protected arts & sciences in Athens. At one end of the Piece set the Judges & distributors of the Prizes, on a kind of throne, on wch. are sculptur'd Medallions of Lycurgus & Solon, & Trophies hanging of the Victories gain'd at Marathon, Salamin [*sic*], &c – a Foot racer is receiving an Olive Wreath from the hands of an Old Man – The Victor at the Horse Race is a beautiful Greek youth, who appears just reining in a very fine

OPPOSITE PAGE: Detail from Pl. 3 James Barry, *Crowning the Victors at Olympia*, 1777–84. Oil on canvas, 360cm x 1278cm. Royal Society of Arts, London

Horse – & at the most distant end of the Piece is Hiero Tyrant of Syracuse in a superb Char, preceded by Pindar wth. his Lyre supposed to be singing a celebrated Ode in honour of his Patron's Victory. – A very fine figure, representing the Eloquent Pericles is a very conspicuous object in the Piece, near him stands Cymon whom he appears to be addressing, but whose figure is somewhat concealed by the Horse Racer – Many celebrated Greeks stand in a groupe behind there, among which Aristophanes appears pointing in derision at the length of Pericles Head, wch. it seems from the descriptions wch. remain of him was very extraordinary. Pythagoras wth. <u>his finger on his Mouth</u> &c. There are I believe above a hundred figures in this piece – all in some action, & those design'd for particular Persons characteristically employed – Mr. Barry has copied from real Portraits of all those whose resemblance still exist either from painting or Marbles. – Whether He may not have committed some anachronisms I am not able to determine – however it is really a very interesting Performance, & to <u>we fair sex</u> appeared extremely well executed – [26]

As in the case of the preliminary drawing, Burney's account does not mention the flanking statues or Barry's self-portrait, but such omissions may be due to the brevity of her description. Possibly, though, Barry had not yet introduced himself as Timanthes, as this is a detail that Burney would have been less likely to have overlooked. With feigned humility, his self-portrait is on a slightly smaller scale than the other figures, and the artist may have chosen to introduce himself at a later date.

While one can speculate on whether or not Burney's omissions indicate the absence of a particular detail, there is no denying that she overlooked the painting's primary focus – Diagoras atop the impressive grouping of semi-naked athletes, which forms the mural's central narrative and focus. Her self-deprecating conclusion – 'to <u>we fair sex</u> appeared extremely well executed', which alludes to women's supposed insufficiencies as critics – is not altogether convincing, and one suspects her wry summation was prompted by the mural's focus on these exposed male physiques about which she deliberately chose to remain silent (her comment on 'a beautiful Greek youth' refers to the clothed horse racer). Her silence in this instance suggests how problematic nudity, so common in the work of the Continental old masters, remained for an English audience.[27]

Burney's account also differs from Barry's in the identification of one of the scientists. She identifies as Pythagoras the figure at the right placing the thumb of his right hand to his mouth. Possibly she was accurately reporting the artist's comments in front of the painting. However, by the time he published his *Account*, Barry described this figure more generally as one of the Pythagoreans, and only in the description of the print was he more specific, identifying him as Philolaus. Apparently, Pythagoras morphed into Philolaus, one of his followers. The reason for this transformation is to be found in the inclusion of the scroll he is holding outlining the solar system with the planets correctly revolving around the sun – a proposition that Philolaus had helped refine – rather than with the sun and planets revolving around the earth. Although overall Pythagoras was by far the greater of the two, in the end it was more important to highlight the ancients' precocity in anticipating modern astronomy. The thumb Pythagoras/Philolaus holds to his mouth is also telling. This meditative gesture is associated with silence and secrecy invoked by the Egyptian god Harpocrates. Thus the fundamental truths imparted by scientists and philosophers are ultimately enshrouded in mystery, a concept that is in keeping with one of Barry's overall themes in the series: wisdom is not easily attained.

Barry and Baretti: reviving classical sacred games in modern London

Barry's subject matter was a departure from the conventional repertoire of history painting, but he was not alone in his attempt to 'recreate' classical games in London at this time. His close friend, Giuseppe

Baretti, was doing the same thing in another venue.[28] Baretti had hit on the idea of commissioning music for performances of Horace's *Carmen Seculare*,[29] which the Latin poet had composed for the Secular Games held by the Emperor Augustus in Rome in 17 BC. The meaning of 'secular' in this context requires explanation, because this festival, which over a three-day period consisted of sacrifices, performances and athletic competitions, was profoundly sacred in nature. Baretti himself offers clarification:

Carmen Seculare means a Poem, or a Song, made at the beginning of a *Seculum*; that is, of a Century, to hail it in auspiciously. It was the custom of the Romans to celebrate the foundation of their city at the beginning of every century by a great festival; in which, among a variety of games and diversions, a Song was introduced, made in honour of Apollo and Diana, the tutelar Deities of their town, to implore a continuance of their favour and protection. The Song was sung in a temple dedicated to those Deities, by seven and twenty boys, and as many girls, all born of their noblest families.

The recurrence of a new century happened to fall in the reign of Augustus, who built a temple on the Palatine-Hill for the purpose of that festival, and ordered Horace to compose the Song.[30]

Baretti required time to find a suitable composer, finally settling on the Frenchman François-André Danican Philidor, with the London performances being held at the Freemasons' Hall on 26 February and 5 and 12 March 1779. Thus during those years that Barry was considering his recreation of the Greek Olympic Games, Baretti was considering his of the Roman Secular Games, and the two friends surely discussed at length their related projects, each fuelling the passion of the other and sharpening their perceptions of the value of these recreations to modern culture.

Barry was even directly involved in Baretti's project, executing for his friend the ticket of admission. Horace's poet opens with the injunction, 'STAND off, ye Vulgar', and Barry's image is remarkable for its compression of the foreground, denying the viewer easy access and thereby keeping him or her at a respectful distance. The poet himself is the administering 'priest', his inscribed bust is backed by a slanting architectural feature bearing the print's title, beyond which is seen a simplified version of the Pantheon and in the distance the Temple of Apollo on the Palatine Hill. Above in the clouds the primary deities addressed in the poem, Diana and Apollo, are portrayed in intense concentration; they are not so much Horace's inspiration as they are the poet's creation, appearing like a thought balloon above his head. One is again reminded of the hymn's opening stanza, which bears the title '*The* POET *to the* PEOPLE':

> STAND off, ye Vulgar, nor profane,
> With bold, unhallow'd Sounds, this festal Scene:
> In Hymns, inspir'd by Truth divine,
> I Priest of the melodious Nine,
> To Youths and Virgins sing the mystic Strain.[31]

Higher still in Barry's print is Apollo's sun chariot, with four women, representations of Hours or of the Seasons, harnessing the horses. The women in relief on the chariot itself (only four can be seen) may be intended for the Nine Muses. Barry's print is an image of Horace as a potent cultural hero, not just a celebrant at a sacred festival but a shaper of mystic values that the profane hold in awe.

Barry also links the Secular Games with his depiction of the Olympic Games. In the case of the ticket of admission, the image is framed in the same palm fronds, references to eternity, that not only permeate the mural but also originally surmounted each of the pictures in the Great Room (see fig.

Fig. 15 James Barry, *Ticket of Admission for Horace's 'Carmen Seculare'*, 1779. Etching, 170mm x 127mm. Collection of William L. Pressly

3), an important decorative motif that did not survive nineteenth-century alterations.[32] Furthermore, in the mural the chorus of young boys accompanying Pindar on his lyre harks back to Horace's hymn. The viewer witnesses here Barry's version of Baretti's and Philidor's boy chorus performing Horace's sacred song in the Freemasons' Hall. Both Baretti's version of the Secular Games and Barry's of the Olympic Games have something to teach the modern audience about communal values and the important role played by creative men in advancing civilisation's highest goals.

Amalgamating the Olympic Games with Athens' Panathenaic Festival

Although Barry included elements of the Roman Secular Games in his mural of the Greek Olympic Games, his concept of Olympia is far more indebted to his knowledge of classical Athens. One should recall that the foundation for his understanding of classical art and civilisation began in earnest in London before his departure for Italy, when he was employed by James 'Athenian' Stuart, who, born in 1713, was almost thirty years his senior. Before travelling to Athens, Stuart had spent eight years in Italy. Stuart and his colleague, Nicholas Revett, had arrived in Athens in March 1751, where they worked on recording the ancient remains until their premature departure due to political unrest in September 1753. Their first volume, *The Antiquities of Athens Measured and Delineated by James Stuart, F.R.S. and F.S.A., and Nicholas Revett, Painters and Architects*, adorned with numerous engravings, appeared in 1762. Barry's arrival in London in 1764 came at a time when Stuart was still deeply immersed in this project, the later two volumes in fact not being published until after his death in 1788. Barry's passionate interest in the Parthenon in particular remained with him throughout his career. At the end of his life, he was still exploring its sculptural decorations, attempting to acquire copies of Jacques Carrey's 1674 drawings of the temple's sculpture, executed not long before the devastating gunpowder explosion in 1687. In preparation for his own account of the Parthenon sculptures,[33] he also read Sir George Wheler's and Dr Jacques Spon's descriptions of the temple, which, derived from a visit they had made in 1676, are the last ones to be published before the temple's centre was blown asunder.[34] Although both Stuart and Barry saw Athenian civilisation as the fountainhead, at the same time neither disparaged the Italian culture that they felt had been so deeply influenced by it.

The Olympic Games were the most important of four Panhellenic games, the three others being the Delphian, Isthmian and Nemean. However, the Great Panathenaic Festival, which was held in Athens every four years, was unofficially on the same level.[35] Spread over a number of days, this festival consisted of athletic, equestrian and musical contests followed by its grand procession. All of these games (and there were numerous other minor ones throughout Greece) were centred on religious worship, the athletic contests being performed in the gods' honour.[36] Underlying the procession depicted by Barry in *Crowning the Victors at Olympia* is more than a hint of the Panathenaic Procession as depicted in the sculpture of the Parthenon; in his mural, the procession at Olympia is to a degree conflated with that of Athens. The direction of the procession from west to east is the same as that of the Parthenon frieze, where the twin processions both begin at the south-west corner, one moving eastward along the south side to turn the corner to end in the centre of the east side, and the other proceeding along the west side to turn eastward along the north side to end again above the centre of the eastern entrance. Barry's rearing horseman also echoes elements of the graceful cavalcade in the Parthenon frieze, even if the horse's attenuated foreleg and the rider's long, wavy hair are Barry's own invention. Then, too, Barry gives Pericles, the instigator of the building of the Parthenon, a prominent position, and Pericles' pointing upward directs one's attention to the procession accompanying the sacrificial bull, another recurring motif contained in the Parthenon frieze. Finally, Minerva appears twice in the mural, most prominently in the 'statue' on the right, where she is in full armour as Minerva Polias, the same type as in Phidias' grand statue in the *cella* of the Parthenon. Furthermore, this is how she appeared when she sprang from the head of Jupiter, which is the subject of the sculpture on the Parthenon's eastern pediment. In this sense, the goddess is born of the sublime thoughts of the supreme deity. Her other appearance in the mural is on the side of Hiero's chariot, where, as we have seen, the subject is the naming of Athens, which is the same subject of the sculptural decoration on the Parthenon's western pediment. With these multiple allusions to the Parthenon, Barry associates *Crowning the Victors at Olympia* with the grandeur and noble solemnity of Periclean Athens.

Enriching the work with contemporary portraits

The creative men who populate the Olympic Games were not limited just to the ancients. From its inception, Barry saw this large mural as affording opportunities for including portraits of his contemporaries. When he wrote to Sir George Savile on 19 April 1777, he mentioned his intention of 'enriching the work [i.e., all three murals which were then to be devoted to the Olympic Games] with the portraits of many of my contemporaries of worth, which posterity will thank me for'.[37] The custom of introducing oneself into a historical composition, as Barry did in the case of Timanthes, was a well-established Renaissance practice, and in expanding such associations to include others, the artist could again point to Raphael's work as offering a celebrated precedent; commentators had long recognised that a fresco, such as *The School of Athens*, contained a number of classical figures who have been given the features of an appropriate contemporary.

Two days after Christmas 1777, Barry wrote to William Pitt, earl of Chatham, identifying three of his contemporaries that he hoped to introduce into the mural in the role of judges at the Olympic Games:

I am engaged in an extensive work of Painting for the Society for the encouragement of Arts, Manufactures & Commerce which is now far advanced. My views (the periods of human Culture) having naturally led me to take up for one of the subjects, the several victors receiving their crowns at Olympia, & the time I have fixed on being about the 86th Olympiad affords me an opportunity of bringing in some of the greatest Characters of Greece. As I can also with great propriety introduce the portraits of three or four similar Characters of my own time, my earnest wish is to avail myself of the advantage of your Lordship's portrait, Lord Cambden's [Charles Pratt, then Baron Camden, who became Earl Camden in 1786] & Sir George Saville's as three of the Hellanodicks or Judges in those Games. If your Lordship could afford me an hour to this end, it will compleat my scheme & posterity will thank you for such a condescension as you will naturally be the first object of their research; and the work in general must unavoidably attract their attention, as it is very large (this single picture being 42 feet in length) & will be in the possession of an extensive Society founded upon the views of national advancement.[38]

At this point, Barry's incorporation of contemporaries was limited to otherwise anonymous judges in the mural, and was intended to honour and promote liberal politicians. A little over three months after he wrote this letter, Pitt dramatically collapsed in the House of Commons after giving a speech defending the American colonies, dying on 11 May 1778. He was the only contemporary figure that Barry ultimately introduced into his mural other than himself, assigning Chatham the more prominent role of Pericles instead of that of one of the judges. Savile found a home in *The Distribution of Premiums*, whereas Lord Camden, who may never have responded to Barry's overture, did not appear in any of the murals.

In 1793, ten years after his series had first been exhibited to the public, Barry felt compelled to defend his introduction of Chatham as Pericles:

The other objection [made by a critic] … is notwithstanding equally unsound, viz. in the picture of Olympia, where Pericles was found to resemble the late Lord Chatham, a little reflexion soon convinced him that this was no Anachronism, since it was still Pericles, who upon the supposition that there was no portrait of him remaining, might, for any thing he could say to the contrary, have been as well taken from Lord Chatham as from the model of the academy, or any other person whom I should employ: and in the number of the spectators at those games from the different parts of Greece, one of them might resemble General Paoli, or one of the Hellanodicks or judges might have a face resembling Lord Mansfield, and another the Lords Thurlow,

Wedderburn, or Camden, without the least infraction of any propriety, but the contrary, as something might be gained and nothing lost by such a procedure; it would be quite a different thing, and a great absurdity, introducing any of them in their own persons with the parapharnalia of a Lord of Parliament, a Lord Chancellor, or a Chief Justice, as Raffael has done with the pope and his court in the Heliodorus and other ancient subjects.[39]

In demonstrating that he had avoided Raphael's anachronistic 'mistake' of interjecting contemporary figures as themselves into a historical composition, as in *The Expulsion of Heliodorus*, Barry neglects to say he was following in Raphael's footsteps entirely in terms of the Italian master's methods in a work such as *The School of Athens*. Of greater interest is the number of new names he has added to his list of those worthy of inclusion. General Paoli was a celebrated freedom fighter who had fought for Corsica's independence.[40] Lord Mansfield, whose support for the Catholic Relief Act had led to the burning of his house at the height of the Gordon Riots, stands alone as a candidate for one judge, while Charles Pratt, Earl Camden, now has to compete with two others, Lord Thurlow and Alexander Wedderburn, Lord Loughborough, for consideration for the second judge. Yet the fact remains that Barry chose not to introduce any of his contemporaries into the mural other than Lord Chatham; it was enough for him to speculate in his text on appropriate candidates, thereby stimulating discussion and expanding the number of possibilities without having to act on such choices.

THE
MODERN WORLD

PROLOGUE

BARRY'S TWO MODERN SUBJECTS highlighting British culture, *Commerce, or the Triumph of the Thames* and *The Distribution of Premiums in the Society of Arts*, occupy the east wall. Each is an anomaly: *The Triumph of the Thames* is a full-blown allegory, whereas *The Distribution of Premiums* is a heroic group portrait. In addition, the movement of the *Thames* is from right to left, a change of direction that reverses, even collides with, the progression found in the pictures of the stages of Greek civilisation. The artist signals that the series has abruptly changed gears.

Barry's letter to Sir George Savile of 19 April 1777 is the earliest statement that remains of how he first conceived of the Great Room's decoration. After describing the first four pictures of a then planned seven works, he tersely remarked on the remaining three in a single sentence: 'The three other pictures that remain, I shall dedicate to matters of more recent discovery, and more immediately relating to the abilities of our own people.'[1] In this proposal of 1777, the series was to begin on the west wall with *Orpheus*, as it does in the design as completed. Stretching across the entire length of the north wall was the third picture, *Crowning the Victors*, which, as we have seen, was to be flanked by two smaller paintings with scenes devoted to other aspects of the Olympic Games. In this plan, the first of the modern subjects would have been on the east wall opposite *Orpheus*, while the long wall opposite *Crowning the Victors* would have contained the remaining two pictures. In the final conception, in place of the first four paintings, three of which were devoted to a single stage in the evolution of Greek society, Barry chose to execute three works, each depicting a different stage of Greek civilisation. In place of the three paintings concerning modern subjects, he chose to depict only two. Yet because *Elysium* has modern figures who were recently deceased (one was even still alive at the time of the painting's execution) and because its inhabitants address concerns relevant to modern Britain, it may well have been intended from the beginning as the third picture.

Why was the artist so succinct in alluding to the content of the pictures devoted to contemporary subject matter? Since he was writing to Savile with regard to his appearing as one of the judges in *Crowning the Victors*, it is understandable that he would lavish attention on this painting. At the same time, however, he was also trying to enlist Savile's support for a scheme that would help finance the entire project. In this regard, it seems strange that after devoting space to all four of the proposed classical subjects, he would have so abruptly dismissed the three modern ones. One explanation is that the grand panorama of society's progress from infancy to maturity and the blueprint for achieving this progression was already in place in the classical series. Although the modern subjects are pertinent to an English audience in terms of time and place, the grand view of civilisation's stages from barbarism to agrarian harmony to competitive excellence had already been sketched. Yet *The Triumph of the*

Thames and *The Distribution of Premiums* are more than just fillers before the grand climax of *Elysium and Tartarus*. They make sophisticated and complex arguments about the contributions the British were making toward cultural progress.

Barry had conceived the subject of the Society's distribution of premiums at least as early as 28 October 1778,[2] but, as observed by Susan Burney, he was in the following year contemplating dropping this picture in order to substitute another mural of the Thames in its place: '– the two Pieces which are design'd to follow this [i.e., *Crowning the Victors*] are to represent the <u>Triumph of the Thames</u> – the first of them at the time of the Spanish Armada – the 2d. about the time of the present King's accession – however of these I have a very imperfect idea, & Mr. Barry has not even sketch'd out his design.'[3] Thus, according to this report, at this point he was considering two images of the Thames, one concerned with the events surrounding 1588 and the other with 1760. The progression in the two murals would have been from past to present, from the beginnings of Britain's global empire to its triumphant realisation, from war to peace. In any event, he abandoned this alternate conception, retaining such Elizabethan figures as Sir Walter Raleigh and Sir Francis Drake in his allegorical image of Britain's contemporary maritime progress.

As these images immediately follow the classical narrative, they pose the question as to the ways in which British civilisation was adding to past excellence. Barry specifically mentions 'matters of more recent discovery', and according to the well-worn arguments concerning the Battle of the Ancients and Moderns, it was commonplace to grant modern civilisation superiority in terms of technological advancements. One of the modern world's achievements, one in which the British had extensively participated, was in the art of navigation. In this context, one should recall that Barry was to entitle his print after the first of his modern paintings, *The Triumph of Navigation*. Astronomy, too, was another area of progress that was to be celebrated in Barry's proposed royal portraits (see chapter seven) and in his later addition of the Naval Pillar into *The Triumph of the Thames* (see appendix two). Improvements in navigation were essential in promoting maritime commerce on a global scale, far outstripping what had been possible in classical times. For an island nation this emphasis on far-flung commerce nicely harmonised with 'matters … more immediately relating to the abilities of our own people'.[4]

While the progress made in commercial ventures is to be seen as a triumph of the moderns over the ancients, the values celebrated in *Crowning the Victors* still remain the standard guide for civilisation's fostering of excellence. The world of commerce, like that of the sacred, classical games, awards those who compete. Ambition, rivalry, self-interest are how the game is played, yet these intense, fracturing incentives are to be seen within a larger framework that provides a social cohesion that holds together these fragmenting impulses. In the case of commerce, James Thomson gave poetic voice to this vision of a 'social commerce' that unites, rather than divides or oppresses, a liberty-loving world. In *The Castle of Indolence*, the narrator describes how the Knight of Arts and Industry travelled westward from the classical Mediterranean world to inspire Britain's inhabitants:

> Then towns he quicken'd by mechanic arts,
> And bade the fervent city glow with toil;
> Bade social commerce raise renowned marts,

Join land to land, and marry soil to soil,
Unite the poles, and without bloody spoil
Bring home of either *Ind* the gorgeous stores;
Or, should despotick rage the world embroil,
Bade tyrants tremble on remotest shores,
While o'er th'encircling deep BRITANNIA'S thunder roars.

 (*The Castle of Indolence* (London, 1748), canto ii, stanza xx)

In *Triumph of the Thames*, Barry offers his own unifying vision of commerce's salutary effects, one that celebrates the peaceful and benevolent benefits of this Pax Britannia that joins land to land from pole to pole. Only later in his 1801 addition of the Naval Pillar at the right of the painting does he allude to the necessity of Britannia's martial powers in maintaining this nurturing social order. When properly understood, Barry's image will enable a modern, fragmented, commercial society to grasp a unifying vision proclaiming that the whole is greater than the parts. The painting's leftward movement can now be seen as not putting the contemporary world on a collision course with the classical tradition that preceded it, but rather having it advance to join this earlier progress: one must go back to essentials in order to go forward.

The Distribution of Premiums in the Society of Arts should also be seen in relationship to the classical series. It shows a modern institution involved in many of the activities already commemorated in *Crowning the Victors*. It may be a poor substitute for the inclusive cultural scene unfolding in the classical mural, in which all segments of society – political, religious, physical, intellectual and artistic – unite to honour excellence, but it is a beginning. The traditional sources of patronage provided by the court and aristocracy were to be replaced with that provided by private institutions, which, in Barry's scenario, were better equipped to address public concerns rather than the specialised interests of individuals. In this light, the Society for the Encouragement of Arts, Manufactures, and Commerce points the way for returning to the full dimensions of a healthy society, but it is no coincidence that its own award-granting ceremonies actually took place beneath *Crowning the Victors*, the Great Room's principal focus, rather than beneath its own mural *The Distribution of Premiums*. The classical model, even though expanded upon by the modern scenes on the east wall, remains paramount.

At the beginning of the eighteenth century, James Thornhill had undertaken a major decorative programme just outside London at Greenwich, a project which has echoes in Barry's work. In 1694, following the naval battle at La Hogue two years earlier, Queen Mary had conceived the idea of converting the site of a royal palace at Greenwich to a hospital for seamen along the lines of that erected for soldiers at Chelsea by Charles II. As part of this grand scheme, Thornhill, along with assistants, began his decoration for the Painted Hall in the newly constructed Royal Hospital in 1707, which was a work he did not complete until 1727. On entering Thornhill's sequence of rooms, one passes through the vestibule with its cupola containing a painted compass and the Four Winds. Next comes the grand Great Hall with its ceiling decoration featuring William and Mary, in which the king presents 'PEACE and LIBERTY to *Europe*'[5] while surrounded by a host of allegorical figures. Next in the ceiling of the Upper Hall appears Queen Anne with her husband, Prince George of Denmark, within a circular frame, again surrounded by numerous allegorical figures, the most prominent of

whom is Neptune offering his trident, or command of the seas, to the royal couple. The primary design on the end wall of the Upper Hall, the wall that faces the Great Hall and concludes the space's long axis, shows King George I and his family posed within another elaborate allegorical programme.

Given that this was a hospital for seamen, it is unsurprising that Thornhill's decorative programme emphasises throughout maritime commerce and power. In his painted narrative, the navy plays a major role in making possible the peaceable pursuits of trade and commerce with the accompanying increase of public wealth. Because of this emphasis on maritime matters, there are a number of points of similarity between Thornhill's conception and Barry's, including such details as an emphasis on Mercury, personifications of the Four Continents, the foregrounding of the Thames, and the presence of the dome of St Paul's Cathedral as a symbol of London. This symbolism is standard fare, and of greater interest is how both artists emphasise the arts and science of navigation. Thornhill even includes portraits of those scientists and astronomers whose work furthered maritime exploration, a group that includes the Dane Tycho Brahe, Copernicus, Sir Isaac Newton, 'an old Philosopher', who is presumably Galileo,[6] shown looking at some of Newton's calculations, and, on the other side of the Painted Hall ceiling, Rev. John Flamsteed and his follower Thomas Weston. But the differences in the two artists' conceptions are even more telling. Thornhill, concerned with bolstering the legitimacy of the Protestant Succession after the Glorious Revolution of 1688, embarked on glorifying the succeeding reigns of William and Mary, Queen Anne and George I, which was hardly a radical agenda for a royal institution. By way of contrast, in *The Triumph of the Thames* the role monarchy plays in Britain's progress gives way entirely to the celebration of London's cult of commerce.

CHAPTER FIVE

The Triumph of the Thames

Title in 1783 *Account*: *Commerce, or the Triumph of the THAMES*

Barry, 1783, in *Works*, vol. 2, pp. 332–5:

The practice of personifying rivers, and representing them by a genius, or intelligence, adapted to their peculiar circumstances, is as ancient as the arts of poetry, painting, and sculpture. It has therefore been my endeavour to represent Father Thames, as of a venerable, majestic, and gracious aspect, steering himself with one hand, and holding in the other the mariner's compass: from the use of which modern navigation has arrived at a certainty, importance, and magnitude, superior to any thing known in the ancient world; it connects places the most remote from each other; and Europe, Asia, Africa, and America, are thus brought together pouring their several productions into the lap of the Thames. Sir John Denham, in his celebrated eulogium upon our *Hero*, has expressed this with great happiness:

> Nor are his blessings to his banks confin'd,
> But free, and common, as the sea or wind;
> When he to boast, or to disperse his stores
> Full of the tributes of his grateful shores,
> Visits the world and in his flying tow'rs
> Brings home to us, and makes both Indies our's;
> Finds wealth where 'tis, bestows it where it wants,
> Cities in deserts, woods in cities plants,
> So that to us, no thing, no place is strange,
> While his fair bosom is the world's exchange.

Pl. 4 James Barry, *Commerce, or the Triumph of the Thames*, 1777–84 and 1801. Oil on canvas, 360cm x 462cm. Royal Society of Arts, London

The Thames is carried along by our great navigators, Sir Francis Drake, Sir Walter Raleigh, Sebastian Cabot, and the late Captain Cooke of amiable memory, in the character of Tritons; over-head is Mercury, or commerce, summoning the nations together, and in the rear are Nereids carrying several articles of our manufactures and commerce of Manchester, Birmingham, &c.; if some of those Nereids appear more sportive than industrious, and others still more wanton than sportive, the picture has the more variety and, I am sorry to add, the greater resemblance to the truth; for it must be allowed, that if through the means of an extensive commerce, we are furnished with incentives to ingenuity and industry, this ingenuity and industry are but too frequently found to be employed in the procuring and fabricating such commercial matters as are subversive of the very foundations of virtue and happiness. Our females (of whom there are at least as many born as males) are totally, shamefully, and cruelly neglected, in the appropriation of trades and employments; this is a source of infinite and most extensive mischief: and even of the males, the disproportion between those who are well and ill employed in this country, is not as it will be when our legislators shall be as eagerly intent upon preventing evil, as our ancestors have been in furthering party views, and obtaining state emoluments. Perhaps the mere punishment of vice is not the only or the best method of introducing virtue: however, I have touched this matter lightly, as there is reason to think that the evil will soon cure itself. In the distance is a view of the chalky cliffs of the coast of England, ships, &c.

As music is naturally connected with matters of joy and triumph, and that according to all necessary propriety, the retinue of the Thames could not appear without an artist in this way, I was happy to find that there was no necessity for my co-operating with those who seem inclined to disgrace our country by recurring to foreigners, whilst we can boast a native, so eminently distinguished for his musical abilities, as doctor Burney, whom I have introduced here, behind Drake, and Raleigh, with a –. When we reflect upon the expense and attention which our people so eagerly bestow upon Italian operas, and other foreign musical entertainments, in a language unintelligible to the many, and even but ill understood by the few, one is almost tempted to think that our musical feelings are very superior to those of the Italians, since we appear to the full, in as much ecstasy from the mere sensation of hearing only, as the people of Italy are from the joint operation of their ears and their understandings. 'Tis odd enough, that on the banks of the Tyber and the Arno, music should necessarily require words for an exponent, and to be enforced by the language that was intelligible and familiar to all; whilst we, on the banks of the Thames, from our superior sensibility and greater quickness of apprehension, should stand in no need of any such requisition. But the philosophical critics will not allow us to reason after this manner; they will say that this very extraordinary relish is, for the most part, affectation; and it is possible they may call it by its right name. But if ever the musical genius of our islands should be suffered to emerge, and that it may be rationally hoped that we too should, in our turn, have our ears and out hearts equally affected by the sterling vigour and persuasive sentiments of our own poetry, clothed in all the harmony, majesty, and eloquent melting sensibility of those co-operating tones, which form the proper colouring, and give the last finish, perfection, and energy to that vehicle of our sentiments, language; if ever these things are likely to come to pass, it must be under the auspices of such a leader as doctor Burney, whose plan was for establishing a national school of music not long since, at the Foundling Hospital, which, to all rational people, seemed so useful and practicable; but after being unanimously voted by the governors, was set aside by the cabal of a few fanatics only. We might expect every thing under such a director, whose admirable History of Music [the first volume of four was published in 1776] shews a mind capacious and excursive, that has left nothing unexplored from which his art might derive perfection, and appears no less fraught with elegant observation and a vigorous display of the spirit and beauties of our poetry, which his animated translations manifest, than for every kind of agreeable and useful information respecting his own very pleasing art.

The 1792 print

The Thames or the Triumph of Navigation

For states and full inscriptions, see Pressly, no. 20.

Barry, 1793, in *Works*, vol. 2, p. 424:

The fourth subject, the Triumph of the Thames, is the same in the print and picture, where the four quarters of the globe, summoned together by Mercury, or Commerce, are exchanging their several productions for those of the Thames, who is carried along by our great navigators, Cook, Raleigh, and Drake. Europe is bringing its fruits and wine; Asia its silk and cotton; America its furs, and (God be praised for it) the great and general attention that has been so recently turned to the African part of our trade, shews that this limb of my subject was not ill hit off, where the poor African himself, which is the commodity we have hitherto trafficked for, was represented manacled with a halter about his neck, throwing his eyes to heaven for relief.

Fig. 16 James Barry, *The Thames or the Triumph of Navigation*, 1792. Etching and engraving, 415mm x 505mm. British Museum, London

The first three paintings in the series outlining the progress of classical civilisation were not substantially altered after their completion in 1784, but *Commerce, or the Triumph of the Thames* underwent a major change in 1801 with the addition of the large, imposing Naval Pillar at the right. The print of 1792 helps recapture the impact of the original composition, and the pre-Naval Pillar painting is discussed in this section.

For his first painting devoted to the modern period Barry focused on the theme of the importance of commerce to civilisation's advancement. Mercury, the god of commerce, flies overhead, his caduceus,

in part a symbol of peace, in one hand, his herald's trumpet in the other. England is shown taking the lead in the civilising influence of commercial endeavours as its maritime trade reaches out to the world's four corners. The river god Thames, holding his paddle more like a sceptre than a steering oar and leading a waterborne procession of British manufactures, approaches the Four Continents: Europe with his jar overflowing with grapes, America balancing a basket of furs, Asia adorned with exotic jewellery, and directly behind Europe a manacled Africa, a victim of the slave trade. The theme of the River Thames and of London (more particularly the City of London, whose coat of arms adorns the Thames' shell-throne) as working together to form the world's leading commercial centre was already well established when Barry conceived his triumphant design.

The cult of commerce and envisioning a marine triumph

In the middle of the first century AD, the Romans, building on an earlier settlement, named the town they constructed on the north bank of the Thames Londinium, which from its beginning was a major port. Later, however, this settlement expanded, and one needs to distinguish between the City of London and the city of London. The City constitutes the original boundaries of the Roman and medieval town, some of whose walls still form its boundaries today. Yet by the eighteenth century the greater metropolis encompassed a much larger territory. From the time of the Saxons, Westminster had become the centre for the national government. In the eighteenth century between Westminster and the City, the fashionable West End in the County of Middlesex was also expanding and flourishing, and on the south bank of the Thames was the long-established Borough of Southwark. Together these components comprised the city of London, and Parliament's policies, decided on at Westminster, played their role in the nurturing of Britain's commercial empire. Yet within this larger whole, the City maintained its separate status. Governed by its own lord mayor, its sheriffs and aldermen, it exercised an unusual degree of political autonomy from the court and Parliament. Unlike the landed aristocracy who controlled Parliament, the City's power was derived from financial institutions and from the trade and commerce that they made possible.

In 1711 the prominent essayist Joseph Addison took great pride in London's empowering commercial success, which operated on a global scale: 'There is no Place in the Town which I so much love to frequent as the *Royal-Exchange*. It gives me a secret Satisfaction, and, in some measure, gratifies my Vanity, as I am an *Englishman*, to see so rich an Assembly of Country-men and Foreigners consulting together upon the private Business of Mankind, and making this Metropolis a kind of *Emporium* for the whole Earth.'[1] England's capital pulsated with extremes. Along with enormous wealth and exotic commodities drawn from the earth's four corners, there was a constant assault on one's senses of cacophonous noise, noxious odours from omnipresent filth, and the unsightly squalor of the poor, along with crime, official corruption, the state-sanctioned violence of public hangings, excessive gambling and drinking, the sex trade, and the threat of fire and disease. While William Hogarth and other eighteenth-century artists captured numerous aspects of this tumultuous, multifaceted world, there were abundant paintings, sculptures and graphics that turned to more sanitised allegories that could celebrate London's imposing stature, in particular its claim to dominance in the global marketplace.[2]

Even the supposedly semi-objective views and maps of the city were adorned with aggrandising vignettes that championed London's powerful international role. Much of the iconography that Barry employs is already present in Wenceslaus Hollar's *Long View of London from Bankside* of 1647. The coat of arms of the City surmounts the cartouche at upper centre inscribed 'LONDON', conflating the City with the larger metropolis. On the plinth at the left is the female personification of the city

Fig. 17 Wenceslaus Hollar, *The Long View of London from Bankside*, 1647. Etching (6 plates in 7 sections) 473mm x 2364mm. British Museum, London

as Justice, with the dedication, 'AD LONDINVM ...' ('To London ...'), but the poem beneath opens 'Nympho Britannarium ...' ('The Nymph Britannia'), a conflation of London with Britannia, the two in this context often being seen as virtually interchangeable given the capital city's unchallenged status in terms of its political, economic, cultural and demographic supremacy. London is additionally linked with the Thames, which reclines on the right-hand plinth. The river, which introduces London/ Britannia to the larger world, plays a dominant role in the design itself, threading its way across the entire composition. As in Barry's picture, a mariner's compass is prominently displayed, in this case at lower right amidst the paraphernalia adorning Thames' plinth. Overhead fly Mercury, the god of commerce, and Fame with her trumpet, along with representations of the Four Continents, which, from left to right, are Africa, Europe, Asia and America.

The decorative, allegorical programme for John Rocque's monumental plan of London, one of the great achievements of the mid-eighteenth century, offers another insight into the visual vocabulary for depicting the city. Rocque published in June 1747 a twenty-four-sheet map of the metropolis, which, measuring an impressive 198cm by almost 400cm, was based on an exhaustive new survey.[3] Inspired in part by Loius Bretez's *Plan de Paris*, composed of twenty sheets and published a little over a decade earlier, Rocque included three decorative cartouches along the map's bottom edge. At the left, a cartouche, which is surmounted by a compass flanked by winds and a putto with the equipment required by a surveyor, gives technical information such as scale. A larger, central cartouche is inscribed with London, Westminster and Southwark, flanked by a river god (Thames) and a river goddess (perhaps a female version of Oceanus or one of his daughters, the Oceanides, representing the large expanse of water into which the Thames flows, as the putto beside her holds up a conch shell). At the right of the map's lower margin, the City of London receives a separate, elaborate tribute, where the appealing innocence of the putti or infant boys was presumably intended to counter some of the crassness of the commercialism they represent. In the centre is the City wearing a castellated crown and resting his right arm on the City's coat of arms, while cradling the staff with a liberty cap that not only extols the City's liberties but also refers to one of Britannia's most common attributes. The City, as so often is the case, is partnered with the river god Thames, who again grasps a steering oar. They are flanked on one side by Plenty, with his cornucopia spilling out coins, and on the other by Mercury, who holds a sack of money along with his caduceus. The Four Continents are arranged beneath, with the personification of Africa on his own to the viewer's right. To the left, in front of the stern of an imposing ship, are Europe securing a bale, Asia swinging a censer, and America holding a jaguar's hide.[4] English oak leaves and an olive branch, symbolising peace, decorate the base. At the centre of the scalloped shell, which frames the whole, is the shell's pearl, which in this instance consists of the names of the lord mayor and supporting aldermen. Unlike Bretez's undertaking, which had Louis XV's support, Rocque relied on the City's civic pride rather than on the monarch.

Fig. 18 Detail of John Rocque's *A Plan of the Cities of London and Westminster, and Borough of Southwark*, 1746. Engraving by John Pine. Yale Center for British Art, Paul Mellon Collection, New Haven

In his rendering, Barry focuses primarily on the Thames, acknowledging London only in the inclusion of the City's coat of arms on the back of Father Thames' shell-throne. By focusing on the Thames rather than the metropolis, he was able to avoid the messy reality of London's complex and tumultuous world, washing away its sins in the cleansing waters of the river (another leap of faith in a

Pl. 4 James Barry, *Commerce, or the Triumph of the Thames,* 1777–84 and 1801. Oil on canvas, 360cm x 462cm. Royal Society of Arts, London

polluted world) and of the oceans themselves. But this elision, in which the river stands for the whole, is also a commonplace in poetry. In his text, Barry quotes lines from Sir John Denham's *Cooper's Hill*, published as early as 1642, in which from his vantage point atop the hill the poet muses on the river's grandeur in dispensing wealth on a global scale.

> My eye descending from the Hill, surveys
> Where *Thames* amongst the wanton Vallies strays.
> *Thames*, the most lov'd of all the Ocean Sons,
> By his old Sire to his embraces runs,
> Hasting to pay his tribute to the Sea,
> Like mortal Life to meet Eternity.
> [...]
> Nor are his Blessings to his banks confin'd,
> But free, and common, as the Sea or Wind;
> When he to boast or to disperse his stores
> Full of the tributes of his grateful shores,
> Visits the World, and in his flying towers
> Brings home to us, and makes both *Indies* ours;
> Finds wealth where 'tis, bestows it where it wants,
> Cities in deserts, Woods in Cities plants.
> So that to us no thing, no place is strange,
> While his fair bosom is the World[']s exchange.
> (Sir John Denham, *Cooper's Hill* (London, 1709), pp. 10–11)

This theme is sounded repeatedly in the eighteenth century, but Alexander Pope's echoing of Denham's lines hits a more altruistic note in foreseeing a less one-sided distribution of the wealth generated by English commerce:

> The time shall come, when free as seas or wind
> Unbounded *Thames* shall flow for all mankind,
> Whole nations enter with each swelling tyde,
> And Seas but join the regions they divide;
> [...]
> Oh stretch thy reign, fair Peace! from shore to shore,
> Till conquest cease, and slav'ry be no more:
> (Alexander Pope, *Windsor-Forest*, 4th edn. (London, 1720), p. 31)

Despite his choice of lines to quote in his text, Barry's conception is more in tune with Pope's vision of shared prosperity than with Denham's more jingoistic bias.[5]

In *A Grecian Harvest-home*, Barry honours rustic innocence, where the Virgilian labour of the husbandman is an important and necessary stage of mankind's development. In the modern world, he celebrates commerce, moving from a rural to an urban setting. This movement is in line with his view that competition leads to even greater achievements, even as, at the same time, it also leads to greater stress, but one suspects that he does not see country and city as necessarily antagonistic. In the contemporary world, each has timeless virtues, and like Thomson in his *Seasons*, there is ample opportunity to celebrate both. While heaping adulation on rural retirement, Thomson also does not hesitate to join the alternate chorus:

JAMES BARRY'S MURALS AT THE ROYAL SOCIETY OF ARTS

THEN COMMERCE brought into the public walk
The busy Merchant; the big ware-house built;
Rais'd the strong crane; choak'd up the loaded street
With foreign plenty; and on thee, thou THAMES,
Large, gentle, deep, majestic, king of floods!
Than whom no river heaves a fuller tide,
Seiz'd for his grand resort.

<div style="text-align: right">(James Thomson, Autumn (London, 1730), lines 129–135)</div>

Barry, like Thomson, is prepared, despite his attachment to rural bliss, to sing the praises of London's commerce and of the majestic Thames, which makes it all possible.

The artist's focus on the Thames without an accompanying personification of London also allowed him to masculinise his image, because London's personification is almost always female (Rocque found it necessary to present his male allegorical figure as an infant). One of commerce's primary pitfalls was its tendency to degenerate into luxury, a vice that was associated with effeminacy, and Barry's view of a progressive commerce demands a manly presence. He would have been aware of Spiridione Roma's ceiling painting *The East-Indian Provinces Paying Homage to Britannia*, which, executed in 1778 for the East India Company in its Leadenhall Street headquarters, represents what he wished to

Fig. 19 Spiridione Roma, *The East-Indian Provinces Paying Homage to Britannia*, 1778. Oil on canvas. © The British Library Board, Foster 245

avoid. The description of Roma's painting opens, 'The principal figure represents Britannia seated on a rock, to signify the firmness and stability of the empire'.[6] Beneath a bare-breasted Britannia, wearing a pink gown with blue highlights, is a contented British lion. The river god is the Ganges pouring out his riches, while the figure of Calcutta offers a basket that can barely contain its numerous strings of pearls. Commerce, in the form of Mercury, oversees this one-sided trade, and he is surrounded by figures and objects signifying China, Persia, Bengal, Madras and Bombay. For Barry, this image offers the warning that while commerce promotes prosperity (or at least Britannia's prosperity), it can also lead to debilitating luxury. Roma shows Britannia captivated by a pearl necklace; the British lion beside her is in danger of turning into a domesticated cat; and her teetering position on the towering rock hardly looks firm or stable despite the descriptive text's insistence to the contrary. For Barry, a commerce of 'ingenuity and industry' is to be promoted, rather than one that fosters the subversive and debilitating indolence exhibited by some of the Nereids. If these latter tendencies are not kept in check, the British could end up like their foppish French neighbours just across the channel.

Barry's conception, reverting to an old form, is rooted in a rich visual tradition that features the marine triumphs of such gods and goddesses as Neptune and Venus. He was also on intimate terms with Raphael's fresco *The Triumph of Galatea*, a particularly noteworthy example of this genre

Fig. 20 S.F. Ravenet after Francis Hayman, *The Triumph of Britannia*, 1765. Engraving, 381mm x 518mm. British Museum, London

in the Villa Farnesina, where he had spent a great deal of time during his student years in Rome. Closer to home was the large painting by Francis Hayman, *The Triumph of Britannia*, in Vauxhall Gardens, now known only from the print after it. Hayman's canvas, completed in 1762, was one of four commemorating British successes in the Seven Years War that were on display at Vauxhall Gardens, the pleasure ground across the river from Westminster. According to the margin of the print reproducing it, it measured 366cm x 457cm, the same size as Barry's canvas. Hayman commemorates Admiral Sir Edward Hawke's decisive victory at Quiberon Bay off the coast of France on 20 November 1759. In this allegory, he intermingles admirals with wanton Nereids, even if the naval heroes are introduced in the form of oval portraits. Neptune holds the reins, but he is only Britannia's charioteer,[7] and even over the roar of the guns from the ships in the background, one can hear the inspiring refrain from Thomson's poem as set to music by Thomas Arne in 1740: 'Rule Britannia! Britannia rule the waves.' Hayman's image is in line with Thornhill's conception of the importance of maritime dominance in laying the foundation for Britain's imperial ambitions. In extolling in his mural peaceful commerce rather than war, Barry is implicitly critical of Hayman's jingoistic conception.

One of Barry's preparatory drawings survives, and while it is similar in content to the mural, it conveys a different mood. In the drawing, a reclining Thames, modelled on the classical river gods so prominently displayed in Rome, sets a languid, relaxed tone in the composition's centre. With the Continents on the left and the dolphin's tail on the right, the composition curls up at the ends, offering a framing enclosure. Mercury, off-centre to the right, helps balance this self-contained design. In the mural as exhibited in 1783 and 1784, the composition's primary focus dramatically shifts to the left, as a more erect Thames, now also influenced by Michelangelo's Adam in *The Creation of Adam* on the Sistine ceiling, dominates his companions. As noted earlier, the composition in moving from right to left reverses the direction of the earlier murals, with the painting now greatly accelerating toward the classical subjects.

Fig. 21 James Barry, *Study for 'The Triumph of the Thames'*, c. 1777–80. Pen and ink with red chalk, 314mm x 480mm. Art Institute of Chicago, Chicago

In alluding to the Battle of the Ancients and the Moderns in terms of this clash of directions, Barry, although stressing in his earlier murals the ancients' peerlessness in wisdom and creativity, asserts in the *Triumph* the moderns' superiority in technological advancements. In his text he singles out the mariner's compass, 'from the use of which modern navigation has arrived at a certainty, importance, and magnitude, superior to any thing known in the ancient world'.[8] Barry, of course, was hardly the first to make this assertion. Even the rudder that Thames holds in his right hand alludes to navigation,[9] and the artist entitled his 1792 print *The Thames, or the Triumph of Navigation*. In the mural, the compass also establishes the viewer's bearings, indicating that one is facing toward the north-west.[10] Thus the river god has already progressed to the Strait of Dover in order better to encounter the Four Continents. This orientation makes clear as well that the sun, which illuminates the clouds behind Thames' head, is setting. In this case (the sun, as will be seen, in the neighbouring *Distribution* is rising), Barry is intent not on showing a new beginning but on showing the modern world as a later epoch that builds on, rather than supplants, the classical past.

Although there are exceptions, the Four Continents were most commonly portrayed as females, but, as he had done by omitting a personification of London, Barry masculinises his depiction. In the preparatory drawing, where one of the Four Continents is cut by the frame, he had not bothered to differentiate their heads, as the three that are shown simply mirror Thames' appearance. In the mural, Europe, holding a jar filled with grapes and decorated with a relief of the rape of Europa, occupies the lower-left corner. Above him stands America, with a basket of furs on his head. More frequently, the personification of America was associated with some aspect of South America, but here Barry chooses North America as seen through its involvement in the English fur trade. Further to the right is Asia, who, although adorned with a pearl earring and gold chains, proffers to the Thames a piece of cloth or silk that downplays the potential opulence of this trade. Africa, partially cut by the frame, is by far the least prominent of the figures. With a rope around his neck, tears streaming down his face, and his manacled hands clasped in prayer, he represents the horrors of slavery within the global economy.

England's success does not stem solely from the invention of sophisticated technologies: the Thames is propelled by the courage of her seamen and explorers, men such as Sir Walter Raleigh, Sir Francis Drake and Captain James Cook, who have led the way in opening the world to Britain's fleets.[11] In his text, Barry lists Sebastian Cabot as one of those to be included. Cabot was an odd choice in that his father, John Cabot, was the more important explorer, but Sebastian did open up English trade with Russia. Barry, too, may have been influenced by his earlier plan to show a version of the triumph of the Thames around the time of the Spanish Armada, and Sebastian, although he died in 1557, thirty-one years before the Armada's defeat, was closer in time than his father, who had died in 1498. Drake, on the other hand, played an important role in this fight, as well as having accomplished much as an explorer. Although Raleigh did not participate in the fight against the Spanish Armada, his involvement in the settlement of English colonies in North America and his vivid writing of his adventures on a South American expedition in 1595, along with other voyages, ensured his place among this company. In addition, given Barry's belief that great men often suffered death at the hands of the enemies that their talent had engendered, Raleigh's beheading at the Tower of London in 1618 would have offered further proof of his worthiness for inclusion. Barry decided on introducing Cook only after his death in Hawaii had been reported in London, and Cook's inclusion presumably bumped Sebastian Cabot from the mural.

Barry's incorporation of these intrepid seamen within an allegorical composition may have passed muster, but his introduction of his good friend Charles Burney, the father, among others, of Susan, Charlotte and Fanny, and who was still very much alive, earned him nothing but ridicule. Burney did

Detail from Pl. 4 James Barry, *Commerce, or the Triumph of the Thames*, 1777–84 and 1801. Oil on canvas, 360cm x 462cm. Royal Society of Arts, London

not sit to the artist, but instead Barry used Reynolds' portrait with Burney in his doctoral robes as his model, which was a work that had been exhibited at the Royal Academy in 1781. Presumably, his friend was as surprised as everyone else to find himself amidst a bevy of naked Nereids 'playing on a harpsichord, a new kind of water-music'.[12] The discrepancy between the real and the ideal is made all the more disconcerting as Burney is accompanied by a marine Orpheus, who, situated behind Raleigh, plays a dolphin-tail lyre. Both Barry's mixture of historical personages with allegorical figures and his compositional device of the chain of Nereids owe a debt to Rubens' *The Disembarkation of Marie de' Medici*, executed for his series of paintings at the Luxembourg Palace in Paris (the paintings are now in the Louvre). Rubens' mixture, however, had provoked controversy, and Barry even copied into his commonplace book Du Bos' criticism: 'But the Nereids and tritons whom Rubens has represented sounding their Shells in ye Harbour to Express ye Joy with wch this maritime town received the new Queen make to my fancy at Least a very preposterous appearance as i [*sic*] am sensible that none of these marine Deities assisted at the Ceremony[.] this Fiction Destroys part of ye Effect wch the Imitation would have produced in my mind'.[13] Reynolds, however, in *Discourse VII*, delivered on 10 December 1776, sanctioned Rubens' decision:

Under this head of balancing and choosing the greater reason, or of two evils taking the least, we may consider the conduct of Rubens in the Luxembourg gallery, where he has mixed allegorical figures with representations of real personages, which must be acknowledged to be a fault; yet, if the Artist considered himself as engaged to furnish this gallery with a rich, various, and splendid ornament, this could not be done, at least in an equal degree, without peopling the air and water with these allegorical figures: he therefore accomplished all that he purposed. In this case all lesser considerations, which tend to obstruct the great end of the work, must yield and give way.[14]

Yet Barry even ventured beyond Rubens in placing Burney in the water next to the Nereids, and he ultimately paid a high price for his breach of decorum.

In the mural, there are nine Nereids and a mother with her child; whereas in the 1792 print, the mother and child have disappeared but the nine Nereids remain. These Nereids are the industrial and commercial equivalent of the Nine Muses representing the arts who accompany Apollo on Mount Parnassus. In his text, the artist uses them as well to digress on the role women should play in modern society, another departure from the standard classical discourse. Writing for the *Public Advertiser* on 13 May 1783, one critic enthused over the 'wanton' Nereid in the foreground: 'The prostrate Nereid floating with her Face upwards, is, without Exception, one of the most beautiful Female Figures we ever saw.'[15] The inspiration for this figure is Rev. Matthew William Peters' controversial painting *Lydia*, which is an erotic, engaging image of a reclining, bare-breasted woman in her bed, but Barry transforms her into a timeless beauty, one that celebrates, at the same time it chastises, women's seductive power that can ameliorate and temper male aggression.

Just and equal laws: commerce's larger moral dimension

Commerce alone, as seen in the tragic instance of the slave trade, does not guarantee a just and moral society. When addressing Barry's picture in his *A Poetical Epistle to James Barry, Esq.* of 1805, Francis Burroughs only sees the problems that commerce can bring. Tellingly he feminises commerce in order to emphasise luxury as a prevailing vice, and he goes on savagely to condemn the trading in human flesh:

Thy triumphs, *Thames*, our artist next portrays,
So sweetly sung, in Denham's tuneful lays,
Where, Commerce, proudly, spreads her swelling sail,
And, all the luxuries of life prevail.
Happy, for Britain, had she never known,
The ills, that still from luxury have flown;
Happy, for her, – far happier had it been,
Had Afric, ne'er, her flag triumphant seen.
See! – the sad negro, fetter'd and in chains,
With eyes to Heav'n uprais'd, to Heav'n complains,
His eyes, alone, express his inward pain,
His hands are bound, and supplicate in vain.
Happy, – had Britain's sons abstain'd from blood,
And learn'd 'the luxury of doing good;'
Had, that vile trade, in human flesh, ne'er stain'd
The laurels, her victorious fleets have gain'd.
(Francis Burroughs, *A Poetical Epistle to James Barry, Esq.*)

In his mural, Barry aligns himself visually with the anti-slavery movement by adopting the pose of the kneeling black in Josiah Wedgwood's well-known medallion, designed by William Hackwood, 'Am I not a Man and a Brother?'[16] Furthermore, in the 1792 print he gives Africa a three-feathered crown that echoes the emblem for the Prince of Wales in the margin to his print after *The Distribution of Premiums* (see fig. 22), suggesting perhaps that the prince could form part of the solution.

But questions remain. How can commerce best achieve its constructive potential rather than be allowed to degenerate into corruption and vice? In his *Letter to the Dilettanti Society*, the artist argues that there is something inherently positive in the pursuit of improving manufactures and commerce:

the silent, baneful operations of this great evil of corruption, the prolific parent of so many others, have been in some degree resisted and counteracted by that extensive pursuit of improvement in all the various branches and articles of manufactures and commerce, which has given occasion for so much rectitude, amenity, and polish of the right kind, and have imprinted on the minds of the good people of England a deep sense of the value of excellence. What wisdom, and how much is comprised in that beautiful allegory of the ancients, in making Ceres the cause and parent of legislation! How admirably and gracefully does it extend to every species of honest, commendable industry, to manufactures, to arts, and to commerce!

But more importantly he recognises that good intentions are not enough. In order to nurture the advantages of productivity, Barry concludes by arguing that just and equal laws are a necessary requirement:

it [the allegorical idea of Ceres] supposes (and most truly) that we even cannot, for any time, or in any tolerable degree, enjoy those gifts of God, without disposing ourselves to merit and preserve them by just and equal laws; and even, to consider it on the other side, that whenever we have the justice and magnanimity to submit ourselves to the guidance of those laws, we shall not be long before those fruits and blessings of industry are showered down upon us; and further, that under certain degrees of brutal violence, injustice, pressures, and partialities, either these blessings will never be given to us, or they will fly from us and be withdrawn, whenever we have rendered ourselves thus unworthy of the Divine favour.[17]

As already stated, Africa is an example of where the conditions of trade have gone horribly wrong – where 'just and equal laws' do not apply. In the painting and in the print, Africa looks not heavenward, as Burroughs would have it, but beseechingly toward Mercury or Commerce. The cause of his distress, properly guided, can also provide the cure.

Directly on the heels of the passage from *A Letter to the Dilettanti Society* quoted above, Barry does not, however, address the issue of African slavery. His thoughts instead turn to Ireland:

This allegory of Ceres will explain pertinently enough any difference that may be found in our two islands; for, on the supposition that the spirit of influence and corruption is equally extended in Ireland as it is here, and that the pursuit of improvement in manufactures and commerce is less, this will easily and very naturally account for any difference of manners in the people of the two countries … [E]ither a salutary reform must soon take place, to the annihilation of influence and corruption; or manufactures, and the commerce with those manufactures, must sink from our prospect.[18]

Barry goes on to quote Edmund Burke addressing the discontents that were to lead to the Irish rebellion of 1798, but the punitive legislation and unfavourable trade laws that help create this situation were of long standing, aptly applying to the mural of 1777–84.

From its inception Barry intended *Commerce or The Triumph of the Thames* as a statement on free trade that could be applied to the case of Ireland. In his painting *Elysium and Tartarus*, he gives a prominent place to William Molyneux, the author of the 1698 book, *The Case of Ireland's Being Bound by Acts of Parliament in England, Stated*, which argues that the English Parliament treats Ireland like a colonial possession rather than as a sister kingdom. As his description to *Elysium* in his *Account* will demonstrate, Barry was familiar with the preface to the book's 1770 edition, published by John Almon, who was also the publisher of his own 1776 print *The Phœnix or the Resurrection of Freedom*. This unsigned preface complains that, although the English were promoting liberty elsewhere, they were vigorously suppressing Irish independence and restraining its trade:

At a Time when *England* was diffusing the Blessings of Liberty, to a prodigious national Expence, amongst the most remote People of the Continent, it must be a matter of just Surprize to the *Irish*, that far from receiving Assistance from *English* Legislature, towards repairing the Damages they had sustained, they saw their Independence as a Kingdom, unjustly violated, their Trade wantonly restrained, and Mr. *Molineux's* modest dispassionate irrefragable Proof of the Rights and Liberties of his native Country, profanely burned by the Hands of the common Hangman.[19]

Barry's picture of 1777–84 in many ways looks to this preface, written in the context of the Irish problem, as stating the fundamental truths that he illustrates. At heart, as Molyneux wrote, the triumphant Thames represents a generous people: 'That it has not been the general Sense of the People of *England* to oppress *Ireland*, is most certain; the *English* breathe a Spirit of Freedom, they are naturally brave, generous, and just; they would endeavour to make all Mankind free…[W]ould the *English* Nation oppress the *Irish*? It is to the weak or wicked Councils of *English* Ministers that these Articles must be charged.'[20] In this interpretation, unfettered commerce will promote the general welfare: 'Commerce … and the Desire of thereby procuring the Comforts of Life, are the ruling Principles of the present Age … nothing should give a Superiority to one People over another in Trade, but superior Honesty, Industry and Skill.'[21]

The fact remains that the necessary laws to ensure justice and fair play are not yet in place. Equally, there are no wise judges to oversee their beneficent effects. Again, *Crowning the Victors at Olympia*

Detail from Pl. 4 James Barry, *Commerce, or the Triumph of the Thames*, 1777–84 and 1801. Oil on canvas, 360cm x 462cm. Royal Society of Arts, London

points the way to a society that is not dependent on goodwill alone to engender freedom but to a society that has the framework in place to ensure fair and equal representation, the only true guarantee of excellence. In *The Triumph of the Thames*, both the Thames and Mercury look attentively across to *Crowning the Victors at Olympia*. Even if the modern world has surpassed the ancients in its pursuit of commerce, there is still a great deal for it to learn from its classical predecessors, including those core principles that best serve the progress of human culture.

OPPOSITE PAGE: **Detail from Pl. 4** James Barry, *Commerce, or the Triumph of the Thames*, 1777–84 and 1801. Oil on canvas, 360cm x 462cm. Royal Society of Arts, London

CHAPTER SIX

The Distribution of Premiums in the Society of Arts

Title in 1783 *Account*: *The Disbribution of Premiums in the Society of Arts, &c.*

Barry, 1793, in *Works*, vol. 2, pp. 337–59:

The distribution of premiums in a society, founded for the patriotic and truly noble purposes of raising up and perfecting those useful and ingenious arts in their own country, for which in many they were formerly obliged to have recourse to foreign nations, forms an idea picturesque and ethical in itself, and makes a limb of my general subject, not ill suited to the other parts. [Barry inserts a footnote, quoting passages from the Parisian newspaper *Nouvelle de la République des Lettres et des Arts* of 1 July 1781, demonstrating that, despite being at war with France and Spain, England was also exporting beneficial ideas promoting human happiness in the example of institutions such as the Society of Arts.]

The sitting figure in the corner of the picture, who holds the instrument of the institution in his hand, is Mr. Shipley, whose zeal for whatever is of public benefit, was very instrumental in the first framing of this society. One of the two farmers, who are producing specimens of corn to Lord Romney, the president, is Arthur Young, Esq. the very knowing and ingenious author of the Farmer's Tours, &c. [Young had published extensively on agriculture, including *A Six Months' Tour Through the North of England* (4 vols., 1769), *The Farmer's Tour Through the East of England* (4 vols., 1771), and *A Tour in Ireland* (1780).] Near him is Mr. More, secretary to the society; on one side of Lord Romney is the Hon. Mr. Marsham, V. P. on the other, and between him and his royal highness the Prince of Wales, who is habited in the robes of the Garter, is Salisbury Brereton, Esq. V.P.: towards the centre of the picture is a distinguished example of female excellence, Mrs. Montagu, who is earnestly

Pl. 5 James Barry, *The Distribution of Premiums in the Society of Arts*, 1777–84 and 1801. Oil on canvas, 360cm x 462cm. Royal Society of Arts, London

recommending the ingenuity and industry of a young female, whose work she is producing; around her stand the late Duchess of Northumberland, the Earl of Percy, V.P. Joshua Steele, Esq. the ingenious author of that admirable treatise on the Melody of English speech [*An Essay Towards Establishing the Melody and Measure of Speech* (1775)], Sir George Saville, V.P., Dr. Hurd, bishop of Worcester, Soame Jennings, and James Harris, Esqrs.; of Lady Betty Germaine, Mr. More, after long delaying me, could not get any picture. Near Mrs. Montagu stand the two beautiful Duchesses of Rutland and Devonshire; and if I have been able to preserve one half of those winning graces in my picture, which I have so often admired in the amiable originals, the world will have no reason to be dissatisfied with what has been done. Between them I have placed that venerable sage, Dr. Samuel Johnson, who is pointing out this example of Mrs. Montagu, as a matter well worthy their graces' most serious attention and imitation. My admiration of the genius and abilities of this great master of morality, Dr. Johnson, cannot be more than it is; but my estimation of his literary abilities is next to nothing, when compared with my reverence for his consistent, manly, and well spent life – so long a writer, in such a town as London, and through many vicissitudes, without ever being betrayed into a single meanness, that at this day he might be ashamed to avow; and above all which extraordinary stretch of virtue that induced him to be so singularly active in assisting and bringing forward all his competitors of worth and ability, particularly at that period of their reputation, when it was easy for him to have crushed them, if he had been so inclined. In the history of the arts, we find but a few examples of the practice of this (apparently very difficult) virtue; Raffael, at Rome, was in this, as in other things, noble, generous, and becoming; the admirable, candid, and conscientious procedure of the Carraches, at Bologna, assisting and bringing forward the Guidos, the Domenichinos, the Lanfrancs, &c. and perhaps one or two other examples, is all we have to boast; but we everywhere meet with those who are all virtue, candour, and amiability, out of their profession, where there is not rivalship, though they scruple not to practise every baseness and treachery within, when it can be done with sufficient concealment; and that the complaints of the injured may be made to appear nothing more that the barkings of envy, and mere professional clamour.

Further on is his Grace the Duke of Richmond, V.P. and near him is my former friend and patron Edmund Burke, Esq.: to the conversation of this truly great man, I am proud to acknowledge that I owe the best part of my education. Providence threw me early in his way; and if my talents and capacity had been better, the public might have derived much satisfaction and some credit from the pains he bestowed upon me: it was he that maintained me whilst I was abroad, during my studies; and he did not discontinue his very salutary attentions until my return, when it might be supposed I could no longer stand in need of any of them. Further on is Edward Hooper and Keane Fitzgerald, Esqrs. and vice-presidents: his Grace the Duke of Northumberland, the Earl of Radnor, William Locke, Esq. and Dr. Hunter, are looking at some drawings by a youth, who had obtained the premium of the silver pallet; behind him is a boy with a port-folio under his arm, in whose countenance and action I wished to mark dejection and envy, as he is attending to the praises they are bestowing on the successful boy; the clergyman behind is Dr. Stephen Hales, V.P. author of Vegetable Statics, &c. [*Vegetable Staticks* (1727)] a man, by the testimony of all that know him, not less eminent for his piety and virtue, than for his ingenuity and great philosophical acquisitions; behind him is the late Lord Radnor, V.P. and Lord Folkstone, who was the first president of the society. The society having lately elected general Elliot into their presidency [General Sir George Eliott, Lord Heathfield, was elected a vice president in 1782], I shall, if possible, endeavour to find a place for him in this picture: the public are much indebted to this glorious character, and I am very sorry not to be able to discharge my part of this debt, in a manner more adequate to my own wishes. [Here he regrets not having been able to include General Paoli in *Crowning the Victors*.] I am also not a little mortified at being obliged (from the same cause, want of room) to omit a very interesting matter in comparative anatomy, which it was my intention to have introduced in the hands of that hero in the science, Mr. John Hunter: how fortunate, or rather how providential, that a genius, indefatigable and penetrating like his, should have met with in his brother the doctor, just such another to form and give it a direction; and that the same exertions which give being to a virtuous affection amongst individuals, will be also productive of advantage to the public, to the

arts, and to knowledge in general. In the back-ground appears part of the water-front of Somerset-House, St. Paul's, &c. It was my original intention to bring in a much greater number of portraits, as we have many other illustrious living characters, whose likeness posterity will enquire after; for notwithstanding the common cant of decrying living worth, we have still amongst us, poets worthy of every muse; the sock and the buskin are still worn, without any diminution of their lustre. The philosophic dignity, the eloquence, and the impartial, manly spirit of some late writers of history, have given the last finish to the national character in this way; and while the researches of Boyle [who appears in *Elysium*] have any credit amongst the lovers of philosophy, what has been lately added is not likely to be overlooked. Criticism and philological knowledge were, perhaps, never treated with better ability, than by writers of our own time. What an acquisition has knowledge and literature lately received from those great luminaries that have blazed out in Scotland. Even our women, what encomiast could exceed in speaking of the perfections of many of them …

[Barry laments Mrs Anna Letitia Barbauld having been forced to bury her talents in rural retirement in the production of 'twopenny books for children', but he hopes that she will soon not limit her abilities to 'the wise and virtuous culture of a few children', because 'talents, like her's, belong to the country at large and to the age, and cannot, in justice, be monopolized or converted into private property'. He reiterates how too many of the wealthy indulge in vices, such as whoring, gambling, leisure pursuits, expensive fashions and conspicuous consumption instead of supporting 'people of genius and abilities'. Barry continues to digress, discussing how the social elite, unlike artists, cannot be of direct service to the community, but they can, through the wise dispensation of patronage, occupy 'a sphere of action not less glorious and interesting to mankind'. In terms of celestial explorers, he wonders how many Herschels could be promoted; in terms of terrestrial explorers, how many Captain Cooks; and in terms of the arts, how many Thomas Chattertons 'might be rescued from destruction, in whom we see revived the spirit of a Homer, a Pindar, a Raffael'. He even grumbles about the funds squandered on musical extravaganzas, probably having in mind the great Handel concert, and it is perhaps no coincidence that this mural is the only one in the series lacking any musical accompaniment. He gives as his prime example of a monarch's patronage of a man of genius Queen Isabella's pawning of her jewels to support Christopher Columbus' explorations, an event he was to commemorate in a later print detail to *Elysium* (see fig. 67). He remarks that human nature makes the powerful all too susceptible to flattery, too often permitting cunning artists of limited abilities to win out over the true genius, who may consequently not only 'be retarded and obstructed in the exercise of his talents' but 'may even be borne down and perish'. Barry points out how the arts have thrived in Italy thanks to the patronage 'of an Agostino Ghigi (the banker who built the Roman palace and gardens known as the Farnesina), a Federigo Gonzaga (the ruler of Mantua), of the Medicean (the Florentine family), the Farnese (ducal family of Parma, whose Farnese Palace is one of the glories of Rome), and other illustrious families'. While cities such as Rome, Florence, and Bologna have benefitted from this inheritance, the English nobility and gentry, on the other hand, have housed their collections of ancient art, for which they have spent considerable sums, in their country estates away from public view. In England, the professors of medicine, such as Sir Hans Sloane (1660–1753), whose collection formed the nucleus of the British Museum, or Doctor Richard Mead (1673–1754), the famous collector and patron of books and paintings, including commissions from Watteau, have exhibited the most public spirit in terms of promoting the arts. In this category, Barry concludes with thanks to Dr William Hunter 'for the great assistance my pictures have received from the use of his most extensive and invaluable collection'.]

But not to wander too far from my subject, we possess many illustrious characters, with whose portraits I should have been happy to ennoble my work, but circumstanced as I was, I found to my sorrow, that waiting the leisure of so many people, would bring with it too great a delay and expense, not of time only, but of somewhat

OPPOSITE PAGE: **Detail from Pl. 5** James Barry, *The Distribution of Premiums in the Society of Arts*, 1777–84 and 1801. Oil on canvas, 360cm x 462cm. Royal Society of Arts, London

else which I was less able to afford; even with the few that I have painted, this picture has cost me more time than all the rest of the work …

In the corners of the pictures are specimens of cotton, indigo, &c. for the cultivation of which, particularly in the colonies in America, the Society had at different times given premiums and bounties to a very considerable amount: there are also gun-barrels of white tough iron, maps, charts, madder, cochineal, a gun-harpoon for striking whales with more certainty and less danger, English carpets, and large paper of a loose and spongy quality, proper for copperplate printing, which is, and has long been a very great desideratum, as our engravers (whose works are now a considerable article of commerce) are for the most part obliged to make use of French grand aigle and colombiez, at six times the price of what paper of the same quality might be manufactured for in England.

As the Society have given premiums for history, painting, and sculpture, I have introduced a picture and a statue in the back-ground; the picture, of which part only is seen, is the fall of Lucifer, a design which I made about five years since, when the Royal Academy had selected six of us to paint each a picture for St. Paul's cathedral; the statue is the Grecian Mother, who dying, and attentive only to the safety of her child, is putting it back from her breast, after which it is striving …

[Barry writes a lengthy conclusion elaborating on the 'practice of giving premiums in the polite arts'. His main theme is to undercut the role played by the Society of Arts, elevating instead that of the Royal Academy. The awarding of prizes in the inferior categories of the arts undermines the foundation of high art: 'the rage for inveigling a great number of young people into those arts, by the distribution of lesser premiums and bounties for the inferior branches, is of all other causes the most likely to bring about the speedy destruction of whatever is valuable in the arts, particularly in that of painting.' Juvenile premiums should be 'annihilated', and the prize should be awarded only to mature competitors, 'at the end rather than at the beginning of the race', which is a metaphor that again recalls the winners at the Olympic Games. A society that had the national interest at heart should 'furnish one good premium every second or rather every third year, and the decision ought to be left to the judgment of the Royal Academy, who ought to be sworn for that purpose; and the work whether picture or statue, might be bestowed if sacred, to some parish church; if profane, to some public hall; by this means they would really encourage in the art, what ought to be encouraged; they would oblige, they would increase their influence, and consequently their power of being serviceable to the country'.

Looking to the Continent to bolster his claim concerning the detrimental effects of quantity of students over quality, Barry argues that the deluge of 'the great numbers bred up in … public academies [in France and Italy]' has led to 'the speedy destruction of the arts'. Quoting statistics supplied to him on Parisian schools, he argues that the high number of art students has diluted and corrupted the pool of the truly talented: 'What is worst of all in these public institutions, is the great majority of base, uneducated, indigent people who avail themselves of the mechanical culture which academies afford gratis; such artists must necessarily destroy and contaminate every thing valuable, and reduce this liberal art, this sister of poetry and child of philosophy, to a mere trade.' He points out that there are also positive lessons to be learned from the French, who provide artists engaged in exalted subject matter with lodgings in the Louvre Palace, where they are surrounded by ample means to carry on their work. In addition, royal patronage makes possible the production of numerous large pictures. Barry challenges the English public to provide the conditions for the arts to flourish on this side of the channel: 'The King has done much, the artists have done much, but the public have done nothing; his Majesty not only brought the Royal Academy into existence, but he bestowed upon it the palace of Somerset House; like another Cosmo, he most graciously placed himself at their head, and generously out of his pocket, made good all the deficiencies of their income, which for some time was very considerable.' If the public's representative, Parliament, gave the trifling sum of £3,000 annually, the Academy's decline could be stopped by restoring history painting and heroic sculpture as its primary focus. Not only could more casts of Grecian sculpture and books for the library be obtained, but important new spaces could be added, including apartments for the professor of painting, a post then held by Barry himself, not to mention an increase in salaries. Barry concludes with his vision for the

nation of the advantages offered by a reformed Royal Academy, a vision in which the Society of Arts and other such institutions would play the role of handmaiden.]

This institution [a reformed Royal Academy] would be to a man devoted to glory, a sheet anchor, and secure moorings against those boisterous tempests of faction and intrigue, which will inevitably follow the exertions of the artist, whose abilities are best calculated to advance the art and the reputation of the country; every thing would soon wear a very different aspect; our education in the eighteenth century, and the vigour derived from the freedom and admirable frame of our government, would bring the Grecian spirit back again into the world; our churches, our public halls, and great houses, are for the most part empty or very incongruously supplied; the Society of Arts might, as I observed before, hold out their premiums to the most formed artists, they might make public donations; and other societies, corporations and respectable individuals, would follow their example.

The 1792 print

The Society for the Encouragement of ARTS &c. in the Distribution of their Annual Premiums

For states of the print and full inscriptions, see Pressly, no. 21.
Barry, 1793, in *Works*, vol. 2, pp. 424–5:

In the fifth subject, the distribution of premiums in the Society for the Encouragement of Arts, there is no difference of arrangement between the print and the picture. His Royal Highness the Prince of Wales, by whose

Fig. 22 James Barry, *The Society for the Encouragement of Arts &c. in the Distribution of Their Annual Premiums*, 1792. Etching and engraving, 419mm x 508mm. British Museum, London

Pl. 5 James Barry,
*The Distribution of Premiums
in the Society of Arts*, 1777–84
and 1801. Oil on canvas,
360cm x 462cm.
Royal Society of Arts, London

goodness and gracious condescension in sitting to me, I was enabled, after more than five years delay, to resume and finish the pictures in the great room, and consequently to discharge my engagement with the subscribers, by finishing and publishing the prints: his Royal Highness, in the nobleness of whose disposition the country may indeed felicitate itself, is habited in the robes of the garter, standing near the worthy president, Lord Romney, who is employed in that most important national concern, the advancement of agriculture, by presenting the society's medal to Arthur Young, Esq. the ingenious disseminator of so much useful knowledge on that subject. Next to Lord Romney is Mr. Moore, the secretary; the Hon. Mr. Marsham and Joshua Steele, vice-presidents: between the president and his Royal Highness, is Salisbury Brereton, Esq. vice-president; on the other side of his Royal Highness is the late Duchess of Northumberland, to whose attention Mrs. Montagu is recommending the ingenious labours of a young female: next the Duchess is the present Duke of Northumberland (then Lord Percy) Sir George Saville, vice-presidents, and Dr. Hurd, Bishop of Worcester: Soame Jennings and James Harris are on the side of Mrs. Montagu, and between the beautiful Duchesses of Rutland and Devonshire, is Dr. Samuel Johnson of ever venerable memory: next her Grace of Devonshire is the Right Hon. Edmund Burke, Esq. the Duke of Richmond, Edward Hooper and Keane Fitzgerald, Esqrs. and vice-presidents: higher up is the Reverend Dr. Stephen Hales, Lord Folkstone, and the late Earl of Radnor. The group below consists of the Duke of Northumberland, the Earl of Radnor, the late Dr. William Hunter and William Locke, Esq. conversing about the drawings which a youth is producing: on the other side before the farmers sits William Shipley, Esq. holding the Instrument of institution of the society in his hand.

This mural, one of the eighteenth-century's finest examples of a heroic group portrait, differs from the other works in the series. In the *Distribution of Premiums*, Barry employs brighter colours, befitting portraiture, than he does in the more sober historical or allegorical compositions that portray an idealised world removed from the flashier, transient concerns of contemporary life. Yet rather than replicate the Great Room itself, he provides an aggrandising extension, a space with a large pier anchoring the middle of the composition, on one side of which one glimpses an impressive rotunda, while on the other a terrace offering a view of two London buildings, the artist's version of the Royal Academy in the new Somerset House and St Paul's Cathedral.

Barry first mentions undertaking the subject matter of this mural in a letter of 28 October 1778, when he wrote to the Society that he had begun a painting of its annual distribution of rewards. He asked the assembly to select in order of preference between forty and fifty 'of such of your members as it may be most agreeable to the wishes of the Society to transmit to posterity in this work'.[1] After some indecision on whether or not Barry's offer should be accepted, the Society agreed to the motion that the 'presidency' and Mr Shipley, its founder, were proper persons to have their portraits introduced into the paintings.[2] On 9 December the presidency was defined as including 'the Original President and Vice Presidents and such of their Successors in office as far as may be complied with'.[3] Samuel More, the Society's secretary, was instructed to assist the artist in every way possible in procuring portraits of the appropriate deceased and living members. Lady members were also voted as worthy of inclusion, and on 16 December 1778, some seven weeks after his initial letter, it was agreed that Barry should be officially notified of the Society's decisions.

In his *Account* of 1783, Barry complains that 'this picture has cost me more time than all the rest of the work', and even allowing for exaggeration, it clearly offered challenges in terms of whom to include and how to secure sittings. When he gave the Burney entourage a tour of the Great Room on 26 October 1779, almost a year to the day after he had first approached the Society concerning his intentions to paint its membership, the canvas had yet to be mounted on the wall. Of even greater import, Susan Burney writes, as we have seen, that he intended for the east wall two paintings of the triumph of the Thames, omitting any mention of a group portrait of the Society's members. At

this time, Barry at the very least must have been toying with the idea of replacing *The Distribution of Premiums* with another allegorical composition devoted to the Thames presumably because of the frustration that he was experiencing over assembling his cast of characters. Substituting another allegorical composition would also have harmonised the two modern subjects, but in the end he persevered with his grand group portrait. Perhaps because posthumous images were hard to acquire and less than satisfactory as models, he ultimately included only two deceased vice presidents, Rev. Dr Stephen Hales, one of the original vice presidents, and the 1st Earl of Radnor, while all of the then living vice presidents were presented.[4] Yet even at the time of the first and second exhibitions of the murals in 1783 and 1784, this painting remained unfinished, Barry being unable to supply a satisfactory head to the Prince of Wales' body until 1790, after the prince had finally sat to him on two occasions.[5]

Barry's text for this mural goes far beyond cataloguing the actors and the picture's details, expounding at length on how premiums should be constituted on a national basis in order to produce the best results. He advocates a hierarchical structure of private institutions, at the top of which would be the Royal Academy. While a portion of a building representing the Academy appears in Barry's painting, without his essay one would not be able to divine his full intentions. Yet the subject matter of the painting does hint at the artist's proposition. He demotes the importance of the Society of Arts's role within a national scope in two ways. First, only two gold medals are featured, one for agriculture and one for a young woman's textile, without any premium displayed for art. As we have already seen, the painting in the Great Room that focuses the most intently on the handing out of prizes is *Crowning the Victors at Olympia*, beneath which the Society's president would have distributed the institution's awards. The second indication that the Society's awards are of lesser stature is that women predominate in the central group. While for the artist and his contemporaries women have an important role to play in the progress of civilisation, their position is not primary, and by highlighting them here, Barry signals the secondary position occupied by the Society itself. In 1808 Edward Edwards pointed out what he felt was a major structural flaw in Barry's arrangement, oblivious to the fact that the skewed nature of the emphasis is part of the message:

The fifth picture, which he has denominated the 'Distribution of the Premiums in the Society of Arts,' is by its composition not very expressive of the subject, for the principal group is not disposed in the principal part of the picture, but on one side [i.e., the left-hand side containing the Society's founder, its current president, and the Prince of Wales]; while the center is occupied by the representation of some ladies of high rank, whose portraits he has introduced more for the sake of flattering their personal charms, than from any other apparent motive.[6]

While Barry's emphasis on women as the central focus can be seen as deflating the Society's pretensions within a national context, their presence is also meant to draw a sharp distinction between the classical past and the present. As we have seen, *Crowning the Victors* establishes the essential blueprint for society's best chance for advancement, but the modern world does have some contributions to make to this grand design. *The Triumph of the Thames* promotes commerce, an area in which the ancients had not excelled, whereas *The Distribution of Premiums* honours the ameliorating effects of women's participation in society, again a departure from classical norms. Then, too, just as the text accompanying the *Thames* contains references to the advantageous role women could play in society, the *Distribution* continues the theme of commercial advancement. The figures on the terrace in the right background look out onto the Thames, even if the 'flying towers' are represented by a single, less than impressive, mast and sail at the far right. The Royal Academy, situated on the Strand rather than the river front, occupied only a small portion of Somerset House, whose primary function was

to serve the navy administration and branches of the Excise. Fittingly in this regard, the frieze on the classical building representing the Royal Academy is of another marine procession. Beneath and in front of the building appears what is presumably a family grouping, where the mother looks through a telescope while one of her two sons climbs the railing. Her husband, a naval officer, supports her as she peers down the Thames toward the larger world, again underscoring that military dominance must accompany commercial expansion. The scene faces east, and, with the sun rising in the distance, one feels confidence in the prospects for this burgeoning international trade: Britannia indeed rules the waves.

Barry employs a tripartite structure in organising his composition with the left-hand group extending to the Prince of Wales. The viewer enters at lower left with the seated figure of William Shipley, the Society's founder, who holds the plan for the institution's founding in 1754. At this time, Shipley occupied a more prominent position in the mural, because Barry did not introduce the old man holding a gold medal for improvements in coinage until 1801. The founder's gaze, directed into the left distance, links the design with *Crowning the Victors*, signalling the importance of classical institutions in inspiring his own conception. As Barry states in his description to the print, the principal activity of the left-hand cluster revolves around Lord Romney presenting a gold medal to Arthur Young for his advancement of agriculture. As the Society's president, Romney wears a hat and is resplendently attired in peer's robes. Barry intends his audience to compare his portrait of the president with Reynolds', which originally hung beside it. Young, who stands at the far left, is linked by the colour and style of his topcoat to the anonymous farmer holding the bag of grain. Looking out at the viewer, Romney directs one's attention to the farmer's sack with his left hand while holding up the gold medal in his right. Next to Young is Samuel More holding a quill pen poised above a book as befitting the Society's secretary. However, in the course of the work, Barry quarrelled with More over delays in the payment of funds, even publicly denouncing him for 'so uncivil, absurd, and indelicate an interference'.[7] In the etching reproducing this mural, More, now positioned in the background to the left of Lord Romney, is shown with the quill gripped between his teeth, which is a gesture that associates him with the figure in *Tartarus* symbolising character assassination. In the mural, Charles Marsham, Lord Romney's son, stands between More and his father, with the antiquarian Owen Salusbury Brereton struggling to be seen between Romney and the Prince of Wales. The cotton bale beneath the prince's right foot links agriculture with commerce, cotton being a major import. Then, too, by including the prince's coat of arms in the margin of his print reproducing this painting, he in effect dedicates it to him. At this same time, he also took the opportunity of the prince's sitting to him to create a heroic allegorical portrait of the Prince of Wales as St George slaying the dragon (Crawford Art Gallery, Cork).[8] The imagery in St George's shield associates the prince with Shakespeare's Prince Hal, the dissipated heir apparent who went on to become one of England's greatest kings. Thus, for Barry, the prince's presence is about his potential, his promise of leading Britain to a glorious future.

Above this group in the background is seen part of a grand interior, one that echoes the impressive architecture found in Raphael's *School of Athens*. This rotunda houses machinery that had earlier won the Society's premiums, furthering the country's Enlightenment aspirations. The impressive silhouettes of such items as a hydraulic machine, a crane, a loom, a winnowing machine, part of a mine ventilator, and a jack are seen behind and above the assembly.[9] These are the kinds of technological innovations, works that are literally mechanical in nature, that the Society's system of premiums, in Barry's opinion, is best suited to promote.

OPPOSITE PAGE: **Detail from Pl. 5** James Barry, *The Distribution of Premiums in the Society of Arts*, 1777–84 and 1801. Oil on canvas, 360cm x 462cm. Royal Society of Arts, London

The mural's central portion, dominated by women, is itself subdivided so that no emphatic centre dominates the composition. On the left, the primary narrative features Elizabeth Montagu presenting to the Duchess of Northumberland a young woman who has won a gold medal for a large piece of cloth (possibly shot silk) with shimmering pink highlights. The medal itself is held by a still younger girl, who is inspired to follow her example. Barry includes Elizabeth Percy, Duchess of Northumberland, even though she had died in 1776, basing his portrait on one by Reynolds. Behind her is Joshua Steele, who is partially obscured by the later addition of the head of the Prince of Wales and whom Barry singled out for his study of speech as music. Beside the duchess stands her son, Hugh Percy, then generally known as Earl Percy and later to become the 2nd Duke of Northumberland, dressed in his officer's uniform. Next to him, holding up a portion of the winner's cloth, is the liberal politician Sir George Savile. Standing on a step or honorific dais, Savile's head is elevated above the others. Next to him, sharing this elevated position, is Dr Richard Hurd, bishop of Worcester, one of the few male figures in the mural who was not a member of the Society. Barry may have wished to honour Hurd as the author of *Letters on Chivalry and Romance* (1762), with its emphasis on the power of the imagination, but Hurd's literary friendships also stood him in good stead. He was close to William Mason and Thomas Gray, both of whom Barry placed in *Elysium* despite the former's still being alive. In addition, Hurd was closely associated, both as a friend and co-author, with his fellow bishop William Warburton, on whom, it will be argued in part two, Barry relied heavily in conceiving the overall narrative of the Great Room.

The right-hand portion of the central group features the two duchesses, Mary Isabella Manners, Duchess of Rutland, and Georgiana Cavendish, Duchess of Devonshire. Born less than a year apart, in 1777 they turned twenty-one and twenty respectively. Neither was a member of the Society of Arts, but Barry includes them front and centre as examples of two beautiful women who had begun to use their social position as prominent hostesses to advance the Whig political agenda. Positioned just below the relief of Venus, the Duchess of Rutland is herself a contemporary Venus, whose long sash doubles for the goddess' cestus. The two duchesses hold hands in a gesture of friendship that underscores women's role in fostering social bonding in a male-dominated world that at times can be divisive. The head of a beautiful, unidentified female, possibly intended as an idealised portrait of Fanny Burney,[10] is seen over the Duchess of Rutland's right shoulder, a placement that allows one to read this group of beauties, which also includes the Duchess of Devonshire, as the Three Graces.

Behind and between the duchesses is Samuel Johnson, who, resting his left hand on the Duchess of Devonshire's hand, points with his right to the example of Elizabeth Montagu in an effort to encourage the young duchesses to emulate the older woman's more aggressive participation in cultural affairs.[11] Although Barry pays tribute in his text to Johnson's achievement as a man of letters, he is intent in the painting on honouring him for another aspect that the text emphasises, his generosity of spirit in promoting others.

The older woman in widow's attire to the right of the Duchess of Devonshire is unidentified, but she is presumably Lady Elizabeth [Betty] Germain, whom Barry mentions having wanted to include. Lady Betty had died in 1769, and, although again not a member of the Society, would have deserved inclusion as an influential supporter of political discourse and of the arts, having maintained a close relationship with Jonathan Swift.

On the left-hand side of this central group are bust portraits of Soame Jenyns and James Harris (a portion of an unidentified male head is to the left of Jenyns). Jenyns, at least, had been elected to membership of the Society in 1761, although up to this time he had never paid his subscription, and Harris was another non-member. Barry, as he had done with Dr Hurd, includes these two men for their achievements. Jenyns was an active participant in Montagu's 'bluestocking' assemblies, and, like

Bishops Butler and Warburton, had written a defence of Christianity against deism, publishing *A View of the Internal Evidence of the Christian Religion* in 1776. Harris presumably won inclusion for his work as a philosopher and classicist.

The right-hand side of the mural consists of all-male figures grouped within a right-angle triangle, the main portion of which is devoted to matters concerning art. The three figures at the top were all deceased at the time Barry undertook this project. At the apex stands Jacob, Viscount Folkestone, the Society's first president, wearing a hat denoting his high office. Next to him is William, the 1st Earl of Radnor, a vice president, who had died in 1776. Below them to the left is Rev. Dr Stephen Hales, another vice president, who had died in 1761. Hales had played an important role in the establishment of the Society: not only was he a founding member but he had also introduced Shipley to Lords Folkestone and Romney, who were critical for the fledgling Society's success.[12] Yet Barry's text is more concerned with acknowledging Hales' scientific achievements, specifically mentioning *Vegetable Staticks* of 1727, which was the first of an impressive series of scientific investigations in a number of fields.

Charles Lennox, 3rd Duke of Richmond, dominates the row of five figures standing at floor level. Dressed in peer's robes, Richmond commandingly points to the drawing held up by an artist who apparently had unsuccessfully competed for a premium. Behind Richmond to the left is Edmund Burke. While Burke was only an ordinary member, he, like Johnson, deserved inclusion for his eminence (both Burke and Johnson at the time had allowed their memberships to expire). He had also played a major role in Barry's career as an early mentor and guardian angel, but the fact that he is somewhat marginalised here and cast in shadow indicates the current strained nature of the relationship between the artist and his former sponsor. To Richmond's right, Edward Hooper holds a corner of the drawing,[13] with Keane Fitzgerald, another vice president, standing next to him.

The seated figures in the bottom row scrutinise the work produced by the boy kneeling at the left, who had won the premium of the silver palette and who reaches for other of his drawings in the portfolio on the ground. William Lock[14] holds up the drawing for the inspection of the Dukes of Northumberland and Radnor. Northumberland[15] props his left leg on a harpoon gun, while a stack of gun barrels fills out the right lower corner (the tea urn and at least the inscriptions on the scrolls were added in 1801). Seated above the drawing, Dr William Hunter makes a point with an anatomical figure, thereby establishing the close relationship between science and art, showing how empirical observation based on close scrutiny of nature is the necessary precondition for achieving high-minded idealisation or nature perfected.

When it comes to something as serious as art, Barry shows no medals. The right-hand corner is not so much about the awarding of prizes as it is about the careful examination and discussion centred around works of art. As with the girl who admires the young woman's achievement, a boy behind William Lock looks back at the attention afforded the winner. Yet Barry's characterisation of the boy's emulation in this instance strikes a negative chord: 'I wished to mark dejection and envy, as he is attending to the praises they are bestowing on the successful boy.'[16] High art, unlike the minor arts, is a dangerous pursuit, where competition leads not so much to healthy emulation as it does to destructive envy, which consumes not only those who experience it but also poisons the paths of those at whom it is directed. The profile of the artist at the far right who is showing his work to the Duke of Richmond resembles Barry's later rendering of the evil Iachimo in his painting *Iachimo Emerging from the Chest in Imogen's Chamber* (Royal Dublin Society), suggesting that this mature artist belongs to that type of untrustworthy painter about whom Barry was so concerned. If this is the case, the duke's commanding gesture suggests he is not fooled and is literally sending this artist manqué back to the drawing board.

While items having to do with manufactures, agriculture and commerce are featured in the rotunda at the left, the remainder of the background is largely concerned with issues surrounding high art. On the central pier, Barry hangs a version of his projected canvas of the Fall of Satan, which he had proposed executing for St Paul's Cathedral. Beneath it he renders in reverse his painting *Venus Anadyomene* as an oval relief. Together they cover the major categories of the sublime and beautiful that Burke had so eloquently detailed in his book of 1757. Next to Venus, he positions a sculpture in the round, which is his recreation of the classical painting by Aristides of Thebes as described by Pliny showing the dying Grecian mother pushing away her child lest it imbibe blood from her breast. This motif proved particularly popular in Baroque plague pictures. In 1778 Colin Morison, a Scottish cicerone in Rome, had exhibited at the Royal Academy a now lost marble group showing 'the dying mother preventing her child from sucking the blood of her wounded breast'.[17] Barry, who had known Morison in Rome,[18] may have intended his painted version as a critique of this effort, another example of emulation as aggressive competition. This dramatic subject was also an important touchstone for other of Barry's colleagues. In his aphorisms, Henry Fuseli cited this subject – 'the half-slain mother, shuddering lest the infant should suck the blood from her palsied nipple' – in his list of those works of the ancients that express 'the heights and depths of the sublime'.[19] Even if high art is not central to the Society's mission, it is central to national advancement: consequently, the composition's centre features examples of what should be the nation's primary concern. Despite the fact that *The Fall of Satan* is a Christian subject, these images are intended to 'bring the Grecian spirit back again into the world', that is, the ennobling spirit of the grand style.

Beyond the terrace in the background on the right, Barry shows only his rendition of Somerset House and St Paul's Cathedral. Thomas Malton's 1795 view down the Thames gives a sense of the actual

VIEW from SCOTLAND YARD

Published Dec.r 15th 1795 by T. Malton

Fig. 23 Thomas Malton, *View from Scotland Yard*, 15 December 1795. Etching and aquatint, 213mm x 312mm. Plate 27 in vol. 1 of Thomas Malton's *A Picturesque Tour Through the Cities of London and Westminster*, London 1792. Yale Center for British Art, Paul Mellon Collection, New Haven

relationship of these buildings to one another. In Malton's aquatint, the York Water Tower anchors the left-hand side, beyond which is seen the Adelphi with its imposing terrace. The next large structure, again fronting the river, is Somerset House, and much farther in the distance is St Paul's, near which is Blackfriars Bridge spanning the river. The terrace in Barry's mural refers to, rather than accurately portrays, the Adelphi terrace, and it, along with Somerset House and St Paul's, are roughly aligned as they would appear in reality even if their positions relative to one another have been telescoped.[20] By elevating the terrace, the artist goes out of his way to keep out the chaos of the city, focusing only on the two buildings beyond the Society's river frontage that should play key roles in the promotion of high art. In his description, he writes at length about how the Royal Academy should be reformed in order to live up to its potential, and St Paul's is a reminder of the role that the Church should play in promoting painting and sculpture. By placing his projected painting of the Fall of Satan, which had originally been intended for St Paul's, on the central pier in the mural, Barry offers a reminder to what up until now has been lost because of ecclesiastical reluctance to support the arts.

Barry links his plea for the advancement of high art with the concept that, in furthering this noble cause, London will be building on the classical tradition, a tradition that is its rightful inheritance. The city's name itself goes back to its Roman christening as Londinium. Barry was hardly alone in seeing modern London as a new Rome.[21] To give but two examples, around 1746 Antonio Joli painted *Capriccio with a View of the Thames and St Paul's* (Metropolitan Museum of Art, New York), which shows a river view through a fanciful classical structure sporting statues of antique Romans in its niches. Giovanni Battista Piranesi executed a print, published in London on 10 March 1766, showing the construction of Blackfriars Bridge as an aggrandised classical structure worthy of comparison with Rome's great engineering feats. Flanking a Romanised version of London's coat of arms in the margin, Piranesi inscribed 'SPQL', substituting the traditional lettering of 'SPQR' (*Senatus Populusque Romanus* or 'the Senate and the People of Rome') with a London version. As Rome falls into genteel decay, London with a new vigour rises to take its place, but this classical tradition in its broader sense is ultimately a Greco-Roman one. It is no accident that Barry ignored William Chambers' Palladian design with strong French overtones for Somerset House to give instead a thoroughly Greek interpretation of this building, even if he supplied this temple of art with a second story. The background of *The Distribution of Premiums* speaks directly to the national concern of promoting an art rooted in the Grecian spirit, which, as the cornerstone of the Greco-Roman tradition, is part of London's own fabric. In having the mural open onto the east, Barry requires the viewer to turn his or her back on the residences of the king and court and on the Houses of Parliament, concentrating instead on such private institutions as the Society of Arts and the Royal Academy, as well as a progressive, independent clergy, which are the true promoters of a dynamic new spirit that is at heart a revival of classical values.

A BILL for the Independency of the Judges.

J. Barry inv.

- 2.ᵈ -

CHAPTER SEVEN

The Royal Portraits: Proposed Fireplace Additions of 1783 and 1792

Barry, 1783, in *Works*, vol. 2, pp. 335–7:

There are two portraits over the fire-places, one by Sir Joshua Reynolds, of that best and most amiable of men, Lord Romney: the other by Mr. Gainsborough, of the deceased Lord Folkstone, who appears from the character he has left behind him, to have been animated by the same noble virtue and public spirit, so observable in his grandson the present Earl of Radnor. These two portraits it was my wish, after once exhibiting of them, to have by the next year removed into the committee-room, as the portraits of those two presidents make part of the composition of my next picture, which is that of the Society. This would enable me to complete my own scheme for the decoration of the room, by introducing such portraits of their majesties, the King and Queen, as would co-operate with the rest of my work. My intention would be to paint his Majesty looking on the solar system, as completed by the discovery of the fortunate Mr. Herschell, who might be pointing out the situation of the Georgium Sidus; and the Queen employed in one of those amiable acts of real female worth, in which her Majesty is so very distinguished, and which will ever be followed by the love and veneration of the wise and good. To this end I would beg of the Society, that they would be so good as to request their Presidency to recommend this petition, and intreat their Majesties' most gracious compliance. Their Majesties have long and successfully cultivated those amiable virtues, which form the main pillar of my work, and the King loves the art,

and has for some time past been the *only* patron and encourager of the great line of history, which in this age and country stands so much in need of support and countenance. [Barry continues at length to complain of the obstacles put in his way as a history painter.]

The two royal portraits were intended to hang over the fireplaces on the west and east walls, supplanting the portraits of the Society's two presidents by Reynolds and Gainsborough. One presumes that this substitution had not been made earlier, because there had been resistance to their removal from the beginning. Barry's publication of his intent on the occasion of the first exhibition of the murals would have been calculated to overcome this obstacle. One suspects, though, that he was not altogether displeased that they were still in place during the first exhibition, as their presence invited comparisons with his own portraits of the two presidents, a comparison that in the case of Reynolds' painting was decidedly in his favour.

The intended portrait of George III was to be positioned between *Orpheus* and *A Grecian Harvest-home*, that of Queen Charlotte between *The Triumph of the Thames* and *The Distribution of Premiums*. Barry placed his textual description of what he intended at the end of the section devoted to the *Thames* and just preceding the *Distribution*. Thus, the discussion of both portraits is placed squarely in the modern world. On 5 May 1783 the *Morning Chronicle* wrote, 'The wishes of Barry the painter are reported to have been attended to with the most ready benignity; their Majesties and the Prince of Wales all being *to sit* for their portraits; which, when finished, will be the completion of his plan'.[1] Sadly, however, the report was in error. Barry never did get to complete his plan for the Great Room as he had hoped.

In his description, Barry praises the king as a lover of art and as 'the *only* patron and encourager of the great line of history [painting]', a reference to George's generous support of Benjamin West. But the portrait was to focus on a different form of patronage, the king's encouragement of William Herschel. On 13 March 1781 Herschel, the organist to the Octagon Chapel at Bath, spotted in a telescope made by himself a new 'comet' that soon proved to be a planet. Until that time only five planets in addition to Earth were known – Mercury, Venus, Mars, Jupiter and Saturn – all of which were visible to the naked eye and had been known from prehistory. Thus Herschel's discovery created a considerable stir, and before the end of the year he had received the Copley Medal and had been made a Fellow of the Royal Society. George III granted him an annual salary that he might pursue astronomy without distractions, and in gratitude for this and other favours Herschel named the planet Georgium Sidus. The classical appellation Uranus, however, was soon to supplant this choice as the planet's official name. Barry intended to show the king looking at a celestial chart or model of the solar system. The painting would have harmonised with the left-hand portion of *Elysium*, where an angel expounds on a solar system to a prestigious group of astronomers and scientists, and to the right-hand portion of *Crowning the Victors*, where a Pythagorean holds a chart of the solar system. Again the artist focuses on the superior technological innovations of the modern world as the kind of patronage that can best be supported by individuals like the king or institutions like the Society of Arts itself.

The description of the queen's portrait is vaguer, but she, too, would not be shown in regal splendour as in a court portrait but engaged in some worthwhile and enlightening activity. Her 'amiable acts of real female worth' would have harmonised with the type of activities performed by the women in *The Distribution of Premiums*, which was directly adjacent. Nine years later, in 1792, when Barry published his print showing the intended portraits of the king and queen, he had altered his content.

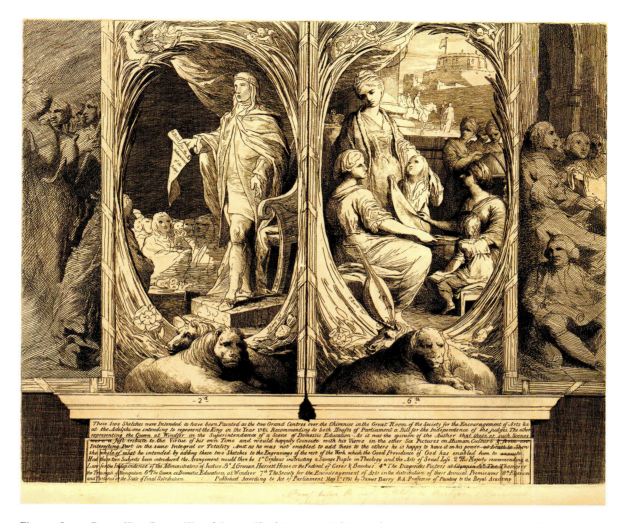

Fig. 24 James Barry, *King George III and Queen Charlotte*, 1792. Etching and engraving, 422mm x 516mm. British Museum, London

King George III and Queen Charlotte

For states and full inscriptions, see Pressly, no. 23.
Inscription in print's margin:

These two Sketches were Intended to have been Painted as the two Grand Centres over the Chimnies in the Great Room of the Society for the Encouragement of Arts &c at the Adelphi: one intending to represent the King in the year 1761 Recommending to both Houses of Parliament a Bill for the Independence of the judges. The other representing the Queen at Windsor in the Superintendence of a Scene of Domestic Education. As it was the opinion of the Author that these or such Scenes were a Just tribute to the Virtue of his own Time and would happily Coincide with his Views in the other six Pictures on Human Culture & form an Interesting Part in the same Integral or Totality And as he was not enabled to add these to the others he is happy to have it in his power at Least to Shew the whole of what he intended by adding these two Sketches to the Engravings of the rest of the Work which the good Providence of God has enabled him to execute.

Barry, 1793, in *Works*, vol. 2, p. 436:

The two designs of the King and Queen which have been added gratis to the other engravings, coincide happily enough with the rest of the work, since in the order of things, the independence and security of those who are appointed for the administration of justice, is the next thing which must be thought of, when Orpheus had

persuaded his savages to associate into a civil polity; and what can afford a surer prospect of success to those who mean to become candidates for public esteem and honourable reward, either in the world at large, or in the Society for the Encouragement of Arts, than the solid foundation of early domestic culture, and industrious useful application, which is held out in the exemplary gracious specimen which makes the subject of the sketch of domestic education at Windsor. These two designs would have come admirably over the chimnies in the great room; the supporters of the lion and unicorn, and the palms forming an arch in the top where they intersect, might be all painted on a gold ground, which would unite and make it a kind of massive repository, from whence issued the framework and festoons of palm, which encompass the other pictures all round the room, and the subjects being painted in their proper colours, which would appear with great eclat as scenes catching the eye through those seeming apertures of carved work.

On the left, flanked by *Orpheus* and *A Grecian Harvest-home*, is the intended second painting in the series of eight, *His Majesty Recommending a Law for the Independence of the Administrators of Justice*, and on the right, flanked by the *Thames* and *Distribution*, is the sixth painting, *The Queen or Domestic Education at Windsor*. Barry has changed dramatically his conception of the portrait of the king: reverting back two decades, it is now a question of the legal system rather than the solar system. The event depicted is George III, less than a year into his reign, presenting a bill for the independence of the judges to both Houses of Parliament. The king gave his speech on 3 March 1761 from the throne in the House of Lords, to which chamber the members of the House of Commons had been summoned. Traditionally, the judges of the common-law courts had vacated their offices on the death of the sovereign, although Queen Anne had at the beginning of the eighteenth century ensured that they at least could continue for another six months after the demise of the Crown. The Act, inaugurated on 3 March 1761, went much further, divorcing their tenure from such considerations. Barry's source for this address was presumably William Blackstone's *Commentaries on the Laws of England*, the first volume of which was published in 1765:

And now, by the noble improvements of that law in the statue of I Geo. III. c. 23. enacted at the earnest recommendation of the king himself from the throne, the judges are continued in their offices during their good behaviour, notwithstanding any demise of the crown (which was formerly held immediately to vacate their seats) and their full salaries are absolutely secured to them during the continuance of their commissions: his majesty having been pleased to declare, that 'he looked upon the independence and uprightness of the judges, as essential to the impartial administration of justice; as one of the best securities of the rights and liberties of his subjects; and as most conducive to the honour of the crown'.[2]

In imagining this scene, Barry does not limit himself to reportage, providing instead a more majestic vision. In a preparatory drawing, he suggests the woven frame of one of the Armada tapestries hanging on the wall, but in the print he deletes such intrusive details. He also reduces the gilded canopy and Cloth of Estate above the throne to a hanging swag of drapery, closer to the conventions of portraiture. The members of the House of Commons, who would be standing below the bar, seem to be the ones crowded around the king. The mace of the House of Lords lies on the table, while the sergeant-at-arms of the House of Commons cradles its mace in his arms. In the print the figure wearing bands between him and the king is presumably one of the judges affected by the legislation (possibly William Murray, Baron Mansfield, later 1st Earl of Mansfield, who was a chief justice in 1761). The profile of the imposing figure at the left, with its pointed, hooked nose, recalls that of William Pitt, the Earl of Chatham, then a prominent leader of the House of Commons and a man of whom Barry in 1778 had executed an admiring print.[3]

Fig. 25 James Barry, *Study for 'George III Recommending a Law for the Independence of the Administrators of Justice'*, *c.* 1784–8. Pen and brown ink over black chalk, 298mm x 165mm. Jupp R.A. Catalogues, © Royal Academy of Arts, London (Photographer: Prudence Cuming Associates Limited)

Fig. 26 Benjamin West, *Portrait of George III*, 1779. Oil on canvas, 2553mm x 1829mm. Royal Collection Trust/© Her Majesty Queen Elizabeth II 2014

As the artist points out in his 1793 description, the scene continues the story being told in its left-hand neighbour, where Orpheus discourses on issues concerning civil polity. It is related as well to its other neighbour, as the youthful king wears a classical fillet, associating him with the old patriarch at the far right of *A Grecian Harvest-home* as seen in the print (see fig. 9). Barry envisions George III as a leader in the Greek mode rather than as an autocratic monarch, although it remains to be seen if he will earn the laurel crown that the angels are holding for him at the upper left. As in *Crowning the Victors* and *Elysium and Tartarus*, an angel here and two in the portrait of the queen prepare to shower the royal couple with flowers.

Barry's royal portraits are in dialogue with the images of the king and queen painted by Benjamin West, which he had exhibited at the Royal Academy in 1780. West had already portrayed George holding a scrolled paper. Yet the paper in West's portrait is inscribed with the disposition of his troops. Barry's choice of subject, by way of contrast, returns to an earlier, more promising moment at the beginning of the king's reign, depicting him as a young man concerned with ensuring justice for his subjects rather than as a portly despot intent on keeping track of those forces on land and sea employed to crush liberty both at home and abroad.

Barry's portrait of the queen follows the same well-worn formula West used in his painting,

showing her standing on a carpet beside a column on a tall plinth, her crown resting at its base. He, too, places Windsor Castle in the background, but in showing the queen as an engaged mother, he brings her children, who in West's painting inhabit the middle ground, to the fore, emphasising the importance of education. In keeping with her husband's portrait, which depicts him in 1761, he gives her a youthful appearance, even at the expense of consistency, as her first child, the Prince of Wales, was not born until 1762, and here she is surrounded by seven more of her numerous offspring. Indeed, by 1792 the queen had been delivered of all of her fifteen children, nine of whom were boys (two had died as toddlers) and six of whom were girls. Ignoring her propensity to produce males, Barry shows a predominance of females in accordance with his belief that women were best suited to master the social graces and, when properly educated, could best benefit a male-dominated society by ameliorating its tendency to be ruinously combative and competitive. The arts that are being taught are music (represented by the lyre), literature (represented by the book), and science and geography (represented by the globe), but the most important is art itself, as the central group focuses on a drawing executed by one of the older girls, who holds a porte-crayon. While the queen pursues this noble purpose, the king in the facing portrait works to the same end by establishing an independent judiciary that can curb ruthless corruption and arbitrary power. In Barry's portrait of the queen, the king also appears in the background on horseback, where a standing figure doffs his hat in greeting, but the artist renders George as a domestic, rather than a martial or overbearing, figure.

The painted oval frames of the royal portraits continue the motif of palm leaves seen in the other paintings and in the actual frames with their bound fronds. At the base appear the royal lion and unicorn with the Tudor rose on the left and the Scottish thistle on the right. As Barry writes, these painted gold frames are to be seen as forming 'a kind of massive repository',[4] which germinates the palms in the framework of the murals and the festoons extending around the walls' upper border. These royal exempla form the centres from which eternal values are nourished and spring forth.

THE STATE OF
FINAL RETRIBUTION

CHAPTER EIGHT

Elysium and Tartarus or the State of Final Retribution

Title in 1783 *Account*: *Elizium, or the State of final Retribution*

In order to make manageable and accessible a picture with so much detail, this chapter is divided into fourteen primary sections, which, where appropriate, are accompanied by the artist's explanatory text.[1] The sequence follows Barry's ordering. The first eleven sections explore *Elysium*, with the twelfth devoted to *Tartarus*. To avoid redundancy, the thirteenth section on the 1792 print does not reprint Barry's description, but those portions of his text that provide additional information are quoted in the earlier relevant discussions. The final section provides Susan Burney's overview of the mural in its planning stages. She is the only contemporary to hint that the painting exhibits a Catholic sensibility.

Great and good men of all ages and nations

Barry, 1783, in *Works*, vol. 2, pp. 360–1:

Although it is indisputably true, that it exceeds the highest reach of human comprehension to form an adequate conception of the nature and degree of that beatitude, which hereafter will be the final reward of virtue; yet it is also true, that the arts which depend on the imagination, though short and imperfect, may nevertheless be very innocently and very usefully employed on this subject, from which the fear of erring ought not to deter us from

Pl. 6 James Barry, *Elysium and Tartarus or the State of Final Retribution*, 1777–84, 1798 and 1801. Oil on canvas, 360cm x 1278cm. Royal Society of Arts, London

the desire of being serviceable. If what shall be done be subservient to the views of piety and virtue; if no one be misled into vain or vicious ideas, it will be sufficient; the error will not be regarded, which is only in the fable or vehicle, and not in the moral.

As in a work of this kind the want of force and useful operation on the spectator, would be a most essential error, so I have studiously avoided every tendency toward those too refined and over spiritualized notions, which would exclude all organs of sensation, limbs, features, dress, and indeed all form whatever; the bulk of the world will never trouble themselves with such platonic, useless niceties, which to them would probably be attended with more mischief than benefit; for my own part I have preferred the example of a Virgil, a Fenelon, and a Milton, and think it not only more picturesque, but much better and wiser to lay (if I can) the foundation of sublimity and useful moral, upon those more popular opinions which have been, and ever will be inseparably annexed to the various pursuits of active life.

In this concluding picture (which occupies the whole side of the room, and is of the same length with that of the Victors at Olympia, viz., forty-two feet [1280cm] each) it was my wish to bring together in Elysium, those great and good men of all ages and nations, who were cultivators and benefactors of mankind; it forms a kind of apotheosis, or more properly a beatification of those useful qualities which were pursued through the whole work.

Barry clusters his figures into a number of prominent groupings, five of these extending from left to right across the foreground. The first consists of scientists and philosophers, who pursue knowledge and truth. The core of the second honours the Glorious Sextumvirate who, often at the sacrifice of their own lives, courageously opposed tyrannical rule. The third features legislators who strove to set up just laws and governments that would no longer require the sacrifices of the adjacent group. In his preamble Barry divides the elect into 'cultivators and benefactors'.[2] Although the emphasis is overwhelmingly on the former, the latter compose the fourth foreground group of illustrious patrons. The fifth and last of the foreground groups consists of theologians and supporters of peace. All these clusters lay the foundation that supports the work of the creative figures above them, where poets, writers, and artists occupy the high ground on the rising banks of clouds. Barry portrays all these members of the elect as continuing to participate in the pursuit of knowledge and excellence. Given the intense concentration of these figures, eternity barely seems time enough in which to achieve full comprehension.

Barry was criticised for having modelled so many of his figures on well-known portraits. One newspaper critic complained, 'The portraits of Sir Isaac Newton, Mr. Locke, Mr. Pope, etc., are copied servilely from the frontispieces of books, & placed in Heaven in the very attitude given them by the booksellers'.[3] Payne Knight bemoaned his lack of practical skill that would have delivered his figures 'from all those local and temporary peculiarities of dress and decorations with which the fluctuating caprice of fashion had loaded them'.[4] Although Payne Knight held up Raphael as an artist who had avoided this pitfall, Barry's retention of period attire follows Raphael's example in works such as *Parnassus* and *The Disputa*. He merits praise rather than damnation for the skilful way in which he has marshalled these figures into an organic whole.

Barry's assertion that he is celebrating the great and good men of all ages and nations is inaccurate even by eighteenth-century standards. There are only three non-Western figures, and even this small number is not prominently displayed and is barely mentioned in the text. Even within a European context, the overwhelming emphasis is on the ancients and the moderns, with only a few figures being drawn from the intervening medieval period. As for the medieval and modern figures, their selection shows a skewed demographic. England outstrips all other nationalities, with Italy and France a distant second and third. As we have seen, given his attempt through his book and prints to address a wider

audience, Barry's public is international, but he is mindful that he is addressing in particular his countrymen. The bias in his selection is a result of his concern for this primary audience rather than the result of a myopic chauvinism.

The biggest surprise in terms of the artist's selection is the absence of figures from the Bible. He offers an explanation in his description to the 1792 print: 'As to whatever is more perfect in these several ways (as Moses, the prophets, and such sacred characters) the imagination will naturally carry them into the spaces where particulars are not seen, nearer the Divinity, or into those great groups at a distance immersed in glory.'[5] Thus he argues their exclusion is a matter of respect, as they are closer to God's glory. Such a rationalisation allows him to dispense with having to render idealised portraits of men whose likenesses have not survived. In his exclusion of biblical characters, Barry also is better able to maintain the fiction offered in the painting's title. This, after all, is a mural of Elysium and Tartarus – not of heaven and hell. As we shall see, the need to maintain this fiction forms part of the series' hidden meaning. Despite the injunction on biblical characters, there are still numerous Christians within the ranks of the post-classical figures, and the mural resonates as well with Roman Catholic intimations, as is the case with Barry's use of the word 'beatification' in his description and the cherubim swinging censers in the upper-left corner.

Characterising virtue and picturing divinity

Barry, 1783, in *Works*, vol. 2, pp. 361–3:

On one side, this picture is separated from that of the society, by palm-trees, a large pedestal, and a figure of a pelican feeding its young with its own blood, which not unaptly typifies the generous labours of those personages in the picture, who had worn themselves out in the service of mankind. On the pedestal I shall inscribe a motto which, with the alteration of a word or two, is taken from the conclusion of the speech of Virtue to young Hercules in Xenophon's Memorabilia. 'They are the favourites of God, whose lives have been actually virtuous, cherished by their friends, honoured by their country, they remain not buried in oblivion, but a glorious reputation makes them flourish eternally in the memory of all men.' But this I am afraid is too long, and I should be thankful to any one who will help me to a better, many others have occurred to me, and have been pointed out by my friends: there is a passage in Thomson which comes near what I wish, viz.

> 'All else is perished! Virtue sole survives,
> Immortal, never-failing friend of man.'

But what I am dissatisfied with is, that this virtue is not sufficiently described so as to distinguish it from what is often mistakenly considered as such. Some men can content themselves with merely rendering inflexible and impartial justice to all with whom they have any intercourse: and others think it sufficient to live innocently, under the correct regulations of discretion and prudence, free from all stain, offence and guilt: but these and all such are without the pale of the true and approved heroic, or christian virtue, which lives not for itself but for the good of others.

Behind those palms near the top of the picture, are indistinctly seen, as immerst and lost in the blaze of light, cherubims [*sic*] veiled with their wings, in the act of adoration, and incensing something not seen above them and out of the picture, from whence the light and glory proceeds, and is diffused over the whole. This method of introducing the awful idea of God into the picture by his effects, rather than by any attempt to delineate him by a form, appears to me not only more proper, but more elevated than representing him by the figure of an old man

with a globe in his hand, as Raffael had done in his Dispute of the Sacrament, between whom and the saints that surround him, there is very little perceivable difference. In the interior and distant part of the picture are many figures, most of them females, absorbed in glory; as they are not particularly distinguished, they may stand for that species of character which forms the bond of society, and is the solace of domestic life. If one may believe (and why not?) that the reward hereafter to be bestowed upon the good and amiable private man or woman, will be proportionate to the grateful satisfactions that their complacency, benevolence, and affectionate friendships afford in this life, it will be very great indeed. Though the unambitious and reserved nature of this character shuns general remark, yet when men call to their recollection the real, unalloyed comforts and satisfactions they have derived from their connexions in life, no small part of them will be found owing to their intimacy with this character. It has been, and is, my happiness to know some of them, who are full of active good, though so unambitiously employed as to make no noise; every man must find some, and no one can ever forget or cease to love those they have known.

The pelican is shown feeding its young with blood drawn from its own breast. This well-established motif could be given a secular interpretation, as in this eighteenth-century account: 'the Pelican nourishing her young, is an emblematical device, moral and instructive, which denotes, the love of parents to their children, or that of a sovereign to his subjects.'[6] But its origins are as a Christian allegory, in which the legend of the pelican feeding its young with its own blood first occurs in the bestiary by the anonymous Physiologus. In this context it is read as a reference to Christ on the cross shedding his blood for mankind, and is also commonly used as a symbol of charity. In this regard it is relevant that Barry inscribed 'Beneficence' on the plinth in the drawing preparatory to the print. The London viewers of Barry's painting would presumably also have been familiar with the prominent use of this image in the nearby St Mary Abchurch in the City, where it is featured in Grinling Gibbons' carved reredos, as well as in the weathervane by Robert Bird.[7] Furthermore, the overarching palms in Barry's painting frame the pelican as if it were positioned before a Gothic arch through which can be seen the leg, arm and shoulder of a striding angel swinging a gold censer. The line between the secular and the sacred is fine indeed.

The mottoes Barry proposes, but ultimately rejects, are from an ancient and a modern source, Xenophon and James Thomson. From Xenophon, he adapts Virtue's speech to the youthful Hercules, which in English translation reads: 'Thus by my means they [the virtuous] are favour'd by the Gods, cherish'd by their Friends, honour'd by their Country, and when their fatal Hour arrives, they remain not bury'd in oblivion, but a glorious Reputation makes them flourish eternally in the memory of all Men'.[8] Tellingly in his paraphrase he turns 'Gods' into 'God'. To his 1792 print after this mural, he appended a longer and more accurate quote from Thomson's *Winter*: 'All now are vanish'd! Virtue sole survives, Immortal never failing friend of man, His guide to happiness on high.'[9]

Having denigrated Raphael's conception of God in *The Disputa*, Barry places the Deity outside the frame, revealing in this instance a more Protestant than Catholic sensibility. He also takes pains to differentiate the golden light in this canvas from that found in *Crowning the Victors* opposite. Rather than illuminating a static golden age, here the beams pulsate with dynamic energy.

Cast primarily in a supportive role, Barry's women are benevolent, affectionate and lacking in ambition. Only Sappho and the Sicyonian Maid hold their own amidst the elect with the other identified female, 'Petrarch's Laura', playing the role of supportive muse. Barry had rejected the quotes he mentions precisely because they failed to make the distinction between 'feminine', passive virtue and the 'masculine' principle of aggressive intellectual inquiry, which is fundamental to his conception. With the exception of the Judging Angel, all of the most imposing angels are men. Those angels who intermingle and instruct the elect are all non-threatening females or children. The celestial hierarchy continues to reflect the terrestrial one.

Pl. 6 James Barry, *Elysium and Tartarus or the State of Final Retribution*, 1777–84, 1798 and 1801. Oil on canvas, 360cm x 1278cm. Royal Society of Arts, London

Scientists and philosophers

Barry, 1783, in *Works*, vol. 2, pp. 363–4:

The figure lying down with a pen in one hand, and nearest the eye of the spectator, is Roger Bacon, an English Franciscan Monk, with his Opus Majus in the other; near him is Archimedes, Descartes, and Thales who first taught astronomy to the Greeks, with a celestial sphere, divided into five zones, the constellation of the Ursa Minor, which was the foundation of navigation, and a diagram for explaining the doctrine of eclipses, which he first discovered; in the hand of Descartes is a geometrical work on which they are attentive, where I have introduced that problem of the Cylinder, Sphere, and Cone, as the ultimatum of ancient Geometry, which Cicero tells us he had discovered on the tomb of Archimedes; opposed to this is another problem of Descartes; behind him is Sir Francis Bacon, Nicholas Copernicus, Galileo, and Sir Isaac Newton, who with two angels, are looking at a solar system, which the inferior angel is uncovering, whilst the superior, with one finger over a comet in its aphelion [the point of the comet's orbit most distant from the sun], and the other pointing up, may be supposed to explain some piece of divine wisdom, which her admiring hearers had been before unacquainted with: not only in this group, but through the whole picture, I have endeavoured to make the particular happiness of each class and order of men to consist greatly in the pursuit of their favourite studies, in which they may now be supposed to enjoy a more clear and distinct view of that adorable wisdom and infinite œconomy which, in proportion to the intelligence with which they are observed, will be every where manifest through all the works of God. Near the inferior angel is that great and good man Christopher Columbus, of Genoa, holding in his hand a chart of that Western world he had discovered …

In deploying men about a sphere in intense discussion, Barry was again inspired by imagery in the *Stanza della Segnatura*. In 1541 Pope Paul III had commissioned Perino del Vaga to undertake further decorations in this celebrated room. The artist introduced simulated bronze reliefs to the *basamento* beneath Raphael's frescoes. The 'relief' directly beneath Raphael's figure of Democritus in *The School of Athens* shows a group of sages holding an intense discussion over a terrestrial globe in the centre foreground, a fitting companion to the celestial globe held by Zoraster in the fresco above.[10] To the left of this fresco of wise men grouped about a sphere is a narrower simulated bronze plaque by Perino showing an allegorical figure of philosophy as a hooded ancient in a reflective, melancholy pose with one foot planted on a globe and the other on a pile of books.

Barry's characterisation of scientists and philosophers pursuing their favourite studies reminds one of the phrase, *Ars longa, vita brevis* (art is long, life is short), the Latin translation of Hippocrates' famous saying. In context, Hippocrates' meaning is that one lifetime is too short a span in which to master an art. Now for all eternity these great minds can pursue knowledge, but even in this setting, the angels unveil only that which is appropriate. The participants in the upper tier are Sir Francis Bacon, Copernicus, Galileo and Newton. The two Englishmen are foremost, both of whom have their hands raised in the moment of revelation. In the lower tier Thales and Archimedes, holding a compass, flank Descartes, as the two ancients ponder his more recent discoveries.

To the right of this group reclines the pensive figure of Roger Bacon, holding a quill pen as if still ready to record new thoughts. It is significant that Barry should open his list of the elite with this contemplative and melancholy friar: his appearance suggests that the continuing exploration on the part of these thinkers is spiritual as well as intellectual. In this context, the phrase that is most

OPPOSITE PAGE: **Detail from Pl. 6** James Barry, *Elysium and Tartarus or the State of Final Retribution*, 1777–84, 1798 and 1801. Oil on canvas, 360cm x 1278cm. Royal Society of Arts, London

appropriate is St Paul's verse, 'For now we see through a glass, darkly; but then face to face: now I know in part; but then shall I know even as also I am known' (1 Corinthians 13:12). Christopher Columbus, a more earthbound but no less adventurous an explorer, appears on the group's margins.

The discoursing angel, colourfully attired and with resplendent wings, points with one hand to a banded, glowing sphere on which one sees a ringed Saturn and a smaller planet, both of which are flanked by tiny moons, while pointing upward with the other. Beside her stands a lesser angel, who, as pointed out by John Manning, resembles the youthful angelic spirit of the Duchess of Devonshire, whose portrait appears in the adjacent *Distribution of Premiums*.[11] Later in the large print detail *Lord Baltimore and the Group of Legislators* (see fig. 63), Mary, Queen of Scots, will be similarly honoured, when the artist introduces her as an overhead angel.

Cluster with the Glorious Sextumvirate

Barry, 1783, in *Works*, vol. 2, pp. 364–8:

… the group of sitting figures next to him, is the glorious Sextumvirate of Epaminondas, Socrates, Cato the younger, and the elder Brutus [Lucius Junius Brutus], and Sir Thomas More, [and Marcus Junius Brutus,] which Dr. Swift has so happily brought together in his account of the island Glubbdubdribb, and to which he says all ages of the world have not been able to add a Seventh. But if a most uniform sincere detestation of all hypocricy, violence, injustice, and meanness of every kind, with a zeal the most honest, most ardent, and most manly in the cause of every virtue, private and public, could authorize me to add a Seventh, Swift himself should be the man; for who had ever employed the united efforts of eloquence, wit, panegyric, and satire, with more purity, and with a more happy success than he has done, particularly in his Gulliver?

[In the next paragraph Barry compares the 'social and innocent primeval simplicity' of Swift's Houyhnhnms to Fenelon's Betica and the Quaker settlers in Pennsylvania. He praises at length Swift's judgement, arguing that 'Socrates would join him in what he has ridiculed; Epictetus, Antoninus, and above all, the gospel, will be found to condemn and reprobate where Swift has censured.' The artist cites Samuel Johnson's approval of Swift's having laid the foundation 'for the constitutional spirit which has lately exerted itself with such happy success in Ireland', leading Barry to conclude that his intention had been to add 'Dr. Swift as a seventh to this group' had he been in possession of his portrait in time.]

I have put in the lap of M. Brutus (who is leaning on the shoulder of Sir Thomas More) that book it so well became him to write upon the all-sufficiency of Virtue; Cicero mentions it, in the fifth book of his Tusculum Disputations, where he is treating the same subject himself, learnedly and eloquently, no doubt; but, notwithstanding, who does not regret the loss of Brutus's work, who was more than a mere talker, and whose whole heart and soul was altogether of apiece with his subject; near M. Brutus is William Molyneux, of the kingdom of Ireland, with the case of his country in his hand. This book, though written with an almost unexampled precision, force, and integrity, was in King William's time (to whom it was addressed) burnt by the hands of the common hang-man, to the great infamy of the faction who then predominated.

It must, however, be acknowledged, that the Roman Catholics, in Ireland, had led the way, in the vindication of those rights of their common country; as they had, some years before, prevailed with king James to give his assent to an act entitled, *An Act for declaring that the Parliament of England cannot bind Ireland, and against Writs of Errors and Repeals out of Ireland into England*. But the happy adjustment of these matters was reserved for a more liberal philosophic age, when all occasions of disunion, strife, dependence, and desolation should be for ever banished, together with those mischievous horrors of Popery which gave rise to them. The general co-operation of the otherwise jarring interests of the united Cantons of Switzerland, affords a beautiful specimen

of those numberless permanent blessings which may be derived from a Society founded on moderation, confidence, equal law and justice; where men are not permitted to legalize their fears and suspicions, whether real or pretended, and where John is no more privileged to bind his neighbour Peter, and to exclude him from any advantages than Peter is to tie up John. We may now fairly hope that Ireland will at last, permit itself to be free; and that the great majority of the natives of that country (and the majority and the country are synonymous terms) will no longer have the bitter mortification of being prescribed the enjoyments of those constitutional rights (derived from the virtue of their ancestors, under the Henry's, John's, &c.) Which, 'tis to be expected, will now be generously and wisely held out, even to aliens. The basis of our islands will be firm and wide, not alone in proportion to the increase and the number of our people, but to (what is of still more importance) the high, generous, and manly spirit of those people, utterly estranged from whatever is abject and servile.

Behind Columbus is Lord Shaftesbury, John Locke, Zeno, Aristotle, and Plato; in the opening between this group and the next, is Dr. William Harvey, with his work on the Circulation of the blood; and sitting below him is the Honourable Robert Boyle, holding a retort …

Jonathan Swift introduces the Glorious Sextumvirate in his book *Gulliver's Travels*, where Gulliver relates how, when on the Island of Blubbdubdrib, he had requested the summoning up of the dead: 'I had the Honour to have much Conversation with [Marcus Junius] *Brutus*; and was told that his Ancestors *Junius, Socrates, Epaminondas, Cato* the Younger, Sir *Thomas More* and himself were perpetually together: a *Sextumvirate* to which all the Ages of the World cannot add a Seventh.'[12] These six men had all died in the defence of liberty and just principles. Barry gives Brutus, Gulliver's informant, a prominent position at the right. Brutus, one of the conspirators who slew Julius Caesar when he attempted to overturn the Roman Republic, threw himself on his own sword rather than surrender to Marc Antony. His right hand rests on the shoulder of the writer and statesman Sir Thomas More, who was executed after he refused to accommodate Henry VIII in his conflict with the papacy.

Next to More is the broad-headed Cato the Younger. Barry had already included Cato's query, '*laudandaque velle, sit satis*', on the title page of his 1783 book devoted to this series, thereby giving him a place of honour. This Latin quotation is taken from Lucan's *Pharsalia*, which in Nicholas Rowe's eighteenth-century translation reads, 'If Truth and Justice with Uprightness dwell, / And Honesty consist in meaning well?'[13] In creating this series, Barry saw himself as a modern Cato, appropriating characteristics that had been ascribed to the classical hero:

> To think he was not for himself design'd,
> But born to be of Use to all Mankind.
> […]
> On universal Good his Thoughts were bent,
> Nor knew what Gain, or Self-affection meant;
> And while his Benefits the Public share,
> *Cato* was always last in *Cato*'s Care.[14]

Barry, however, identified with how Cato had lived his life, not the manner in which he departed it. Like Marcus Junius Brutus, an opponent of Caesar, Cato stabbed himself rather than fall into his enemies' hands.

Next to Cato is Lucius Junius Brutus, who established the Roman Republic on overthrowing the royal Tarquin family in the sixth century BC, who condemned his own sons to death when they plotted to restore the Tarquins, and who died in battle fighting against their return. Socrates, the Greek philosopher who unjustly tried and executed, is beside him, counting off philosophical propositions

with his hands, in a manner reminiscent of Raphael's portrayal in his celebrated fresco *The School of Athens*. In this context, Barry, unlike Swift, made a distinction between those who had been killed or executed for their support of liberty and those who had killed themselves to avoid falling into the hands of their oppressors. He remarked on 'the fatal imperfection' of Cato's philosophy, which allowed him rashly to take his own life, going on to say that he would like to think 'something like this imperfection of stoicism, was the subject on which Socrates was discoursing'.[15] Because he had already given Socrates a prominent position in *Crowning the Victors at Olympia*, Barry shows only a portion of his head here, but he is still the dominant figure, as the others respectfully attend to his discourse.

Finally, anchoring the left-hand side appears Epaminondas, the Theban general and statesman who died in battle fighting for liberty. Barry's conception, with the skin-tight tunic and the languid, twisted right arm ending in the hand's upturned palm, is indebted to Michelangelo's sculpture in the Medici Chapel in Florence of Lorenzo de' Medici (not to be confused with his grandfather, whom Barry included in the ranks of illustrious patrons). In Epaminondas' hand lies the strap of his shield, on the front of which Barry later inscribed the general's battle plan for his great victory over the Spartans at Leuctra.

Behind this group from left to right stand an unidentified ancient, the moral philosopher Anthony Ashley Cooper, 3rd Earl Shaftesbury, the philosopher John Locke, a vestal virgin, Zeno, the founder of the Stoic school of philosophy who also used for instruction the pictures in the stoa of the Temple of Minerva,[16] Aristotle, wearing a richly patterned toga of gold and blues and Plato, the student to Socrates and teacher of Aristotle. Barry's audience would certainly have recalled the juxtaposition of Aristotle and Plato as the principal, central figures in *The School of Athens*, but rather than repeat Raphael's formula, Barry focuses on the student–teacher aspect of their relationship, with the student now ready to address the legislators, whom he faces. Beside Plato is a bald-headed man, followed by the physician William Harvey. Barry borrowed a number of his portraits from the engravings in Thomas Birch's *The Heads of Illustrious Persons of Great Britain* (London, 1747 and 1752), and in Harvey's case he also transferred the accompanying tablet showing the circulatory system to his own design, where it appears in the physician's uplifted scroll.[17] Beneath Harvey, looking out at the viewer, is the Irish physicist and chemist Robert Boyle.

Barry had cited Swift as the seventh man he would have liked to have added to the Sextumvirate, and the artist's own panegyric makes clear that an important reason for his inclusion was more specifically Swift's writings exposing England's unfair exploitation of Ireland. Swift, who had been born in Dublin, to which he returned to become dean of St Patrick's, had vociferously opposed England's domination of Irish interests, and Barry evokes this legacy as well as his more general satire on mankind's follies. But Barry's explanation that he could not find a likeness in time in order to introduce Swift at this point (Swift appears instead in the group of writers and poets) rings hollow. One suspects such a portrait would not have been difficult to locate, but Swift's absence allowed Barry to introduce instead William Molyneux, who, though never explicitly said to be the seventh man, is seated on the same level as the Glorious Sextumvirate, directly adjacent to Marcus Brutus.

The fingers of Molyneux's right hand curl over his book decorated with an Irish harp, only a portion of which is visible. On the book Barry inscribed a condensed version of its full title *The Case of Ireland's Being Bound by Acts of Parliament in England, Stated*, which was first published in 1698, and he derived the portrait, with its serious demeanour and downturned mouth, from the engraved frontispiece to the 1725 edition. In his book, Molyneux decried the Irish Parliament's subordination to the Parliament at Westminster, which did not hesitate to sacrifice Irish interests for England's benefit. Of course the Irish Parliament, limited as it was to the Protestant oligarchy, did not represent the

nation, and through an iniquitous penal code it actively suppressed the majority of the population. But Molyneux's arguments against the English Parliament's unfair dominance, which treated Ireland as a colonial possession rather than as a sister kingdom, reverberated with Irish supporters of liberty of all religious persuasions long after 1698. Molyneux argued that history and precedent supported the legislative independence of the Irish Parliament, but, more importantly for the future, he maintained that representative government was a natural right, an argument that was indebted to the writings of his friend John Locke, who appears near him in Barry's design.

In his description of this painting, Barry focuses on the reception of Molyneux's book, describing it as having been burned by the common hangman. His source is the preface to the 1770 edition of *The Case of Ireland's Being Bound*, where this story, for which no historical documentation exists, is recounted as fact: 'it must be a matter of just Surprize to the *Irish*, that … they saw their Independence as a Kingdom, unjustly violated, their Trade wantonly restrained, and Mr. *Molineux's* modest dispassionate irrefragable Proof of the Rights and Liberties of his native Country, profanely burned by the Hands of the common Hangman.'[18] The preface goes on to describe how the ills befalling both the Irish and the Americans were the products of corrupt administrations rather than an expression of the English people themselves, who are characterised as 'naturally brave, generous, and just'.[19] It also portrays Ireland as a nation where 'Religious Biggotry is losing its Force',[20] thereby espousing liberty for Catholics as well as Protestants. Barry would have been sympathetic to the preface's application of Molyneux's message to contemporary events, and he was soon to forge a personal relationship with John Almon, the book's publisher. In 1776 Almon, an ardent supporter of the radical politician John Wilkes, published the artist's print *The Phœnix or the Resurrection of Freedom*, a work whose political message was so inflammatory that Barry omitted his own name. The publisher and the artist obviously were in agreement in seeing the English government as corrupt and egregiously oppressive, even if Barry was the more cautious of the two in publicly expressing his convictions.

During the time Barry was completing his murals, Ireland was winning major concessions from the English government, which, engaged in a war with the American colonies, was more amenable to addressing Irish grievances, particularly in light of the Protestants having raised armed regiments of volunteers. On 16 April 1782, the Irish statesman Henry Grattan gave his celebrated speech on the triumph of Irish independence: 'I found Ireland on her knees, I watched over her with a paternal solicitude; I have traced her progress from injuries to arms, and from arms to liberty. Spirit of Swift! spirit of Molyneux! your genius has prevailed! Ireland is now a Nation!'[21] While Grattan's celebration proved premature, Barry's hope, as expressed in his description of a free Ireland that included Catholic participation, was not entirely far-fetched. He calls upon the same twin spirits of Swift and Molyneux, while, with sly discretion, introducing the latter to the group of the Glorious Sextumvirate as the seventh man. Even if Molyneux, unlike the others, had not died for liberty, his book had suffered martyrdom, having been burnt (at least according to one account) by the common hangman. But rather than face the Sextumvirate, Molyneux steadfastly gazes at the group of legislators, ardently desiring for Ireland the just laws embodied there.

In order to avoid controversy as much as possible, Barry, as we have seen, deflects criticism by evoking Swift's authority. Swift and his Glorious Sextumvirate provide a point of **departure** for ruminations on Irish matters and then to the subtle introduction of Molyneux as the seventh man. But by choosing Swift's Glorious Sextumvirate, the artist also is able surreptitiously to introduce another controversial agenda. Five of the six figures are ancients, but the one modern participant, Sir Thomas More, is intended as a rebuke to Henry VIII, whose break with the Roman Catholic Church Thomas More, at the cost of his life, had so steadfastly resisted. In his description of 1783, it was enough simply to include More in Swift's list of martyrs, but presumably frustrated by his audience's

lack of perspicacity in reading between the lines, Barry makes explicit his detestation for Henry and his daughter Elizabeth in his text for his 1792 print. In a digression growing out of his discussion of Charles I, he refers to 'those two monsters of savage cruelty, and baneful malignant hypocrisy, Henry the Eighth and Elizabeth', citing specifically in Henry's case 'the insulting mock trial which preceded the murder of that graceful ornament to his country, Sir Thomas More and his worthy companion [Bishop John] Fisher'.[22] This is the true meaning underlying More's inclusion in the mural, and a few pages later in a footnote, Barry quotes at length from Cresacre More's hagiographic biography of his great grandfather, *The Life of Sir Thomas More, Kt. Lord High Chancellour of England under K. Henry the Eighth*.[23] More's own words are used to demonstrate that statutes of præmunire and the diligence of men, such as Henry Chichele and More himself, provided ample safeguards against unwarranted papal encroachments. Those who would raise an outcry against papal authority are guilty of 'a mere bugbear, introduced out of compliment to vulgar antiquated prejudices'.[24]

With Henry and his break with the Roman Catholic Church, English history went horribly wrong. To those who were paying attention, the message was clear: for the country to get back on track, it must return to its Catholic roots and in the process accept its Irish subjects as equals.

Legislators and wise rulers

Barry, 1783, in *Works*, vol. 2, pp. 368–9:

… the next group, at which Aristotle and Locke are looking, and Plato pointing, are legislators, where king Alfred the Great, the deliverer of his country, the founder of its navy, its laws, juries, arts, and letters [at this point Barry places a footnote containing Latin verses inscribed beneath a statue of Fame holding a medallion of Alfred which is to be found on the Wiltshire estate of the Earl of Radnor] with his Dom book in one hand, is leaning ['with a kind of exultation' (text to 1792 print, p. 426)] with the other on the shoulder of that greatest and best of lawgivers, William Penn, who, in an age of the highest illiberality and intolerance. did establish a code of laws, and a government in Pensylvania, which happily subsisted until the late troubles [the American Revolution], and may be of service to future ages, as a most perfect model of equal and impartial privilege and justice, of christian meekness, forbearance, and brotherly affection, and consequently of the most finished, truest, and most useful national policy, particularly amongst people who may be unfortunately divided in matters of religion. When the heart is perfectly in obedience, when it is divested of pride, of selfishness, and of malice, the understanding is in no danger of losing its way; William Penn is a good instance of this; it is also very remarkable, and at the same time very humiliating, that neither the great Locke, nor the still greater Milton, could so sufficiently divest themselves of party rancour, as to tolerate even upon paper to the same extent that our amiable legislator did in the government he actually established. Two of those laws (vis. all believers in a God tolerated, and all believers in Christianity, of whatever denomination, and however they may explain themselves, equally admitted to a participation in the government) I have inscribed in the code he is shewing to Lycurgus, Solon, Numa, and Zaleucus. On the other side of Penn is Minos, Trajan, Antoninus. Peter the Great of Russia, Edward the Black Prince, Henry the Fourth of France, and Andrea Doria of Genoa.

The legislators form the mural's foremost group. The main cascade of flowers is reserved for them. On the right King Alfred, holding his Doom Book in his left hand, rests his right hand on William Penn's

OPPOSITE PAGE: Detail from Pl. 6 James Barry, *Elysium and Tartarus or the State of Final Retribution*, 1777–84, 1798 and 1801. Oil on canvas, 360cm x 1278cm. Royal Society of Arts, London

Fig. 27 Benjamin West, *William Penn's Treaty with the Indians*, 1771–72. Oil on canvas, 1917mm x 2738mm. Courtesy of the Pennsylvania Academy of the Fine Arts, Philadelphia. Gift of Mrs. Sarah Harrison. (The Joseph Harrison Jr. Collection)

shoulder. Alfred's Doom Book, in contrast to William the Conqueror's Domesday Book surveying English lands, set forth a code of laws. Not the least of Alfred's achievements was the creation of the jury system, another reference, as we will see, to his bond with William Penn. Atop his crown lies a wreath, some parts of which are composed of water plants, a reference to his having laid the foundations for Britannia's ruling the waves. A hand suspends above his head a third crown, a golden wreath representative of eternity. Alfred is unusual for an English king in that as a youth, after travelling to Rome, Pope Leo III anointed him with the royal unction on hearing of his brother King Ethelred's death. In this instance the suggestion of his wearing a triple crown may be intended to reinforce his close association with the papacy and its three-tiered crown or tiara. In the 1792 print after the painting (see fig. 28), Alfred's position becomes even more dominant: close to the centre, he stands on the same vertical axis as Homer, who forms the composition's apex.

Beside Alfred is an angelic boy who holds a large harp, not unlike Ossian's seen in the clouds above. These Celtic harps contrast with Homer's and Alcaeus' classical versions. The only other figure with a musical instrument is Milton, who holds a lute. In addition, Barry does not bother to introduce a single musician or composer into the mural: it is left instead to these Orphic rulers and poets to make inspiring music, which the artist sees as more of an appeal to the mind than the ear.

For the figure of William Penn, Barry's visual source was Benjamin West's painting *William Penn's Treaty with the Indians when he Founded the Province of Pennsylvania*, which he would have seen when it was exhibited at the Royal Academy in 1772. Yet because he reverses Penn's pose, he presumably relied more heavily on the 1775 engraving after West's picture, which also reverses the composition. Thomas Penn, the founder's son, had commissioned West's painting in 1771 in an effort to improve his own troubled relationship with the province by celebrating its earlier exemplary (and largely mythic) founding.[25] In 1680 Penn, a convert to Quakerism, petitioned Charles II for a grant of land in America as recompense for a debt owed his deceased father, becoming on 4 March 1681 the seigneur and

ruler of the province he named Pennsylvania in his father's honour. For his colony (he sailed for Philadelphia, the City of Brotherly Love, on 1 September 1682), he wrote a remarkably enlightened constitution and set of laws. Voltaire's account, translated into English in 1733, was the best known of several paeans to Penn's progressive statesmanship:

The first step he took was to enter into an alliance with his *American* neighbours; and this is the only treaty between those people and the Christians that was not ratified by an oath, and was never infring'd. The new sovereign was at the same time the legislator of *Pensilvania*, and enacted very wise and prudent laws, none of which has ever been chang'd since his time. The first is, to injure no person upon a religious account, and to consider as brethren all those who believe in one God.

He had no sooner settled his government, but several *American* merchants came and peopled his colony. The natives of the country instead of flying into the woods, cultivated by insensible degrees a friendship with the peaceable Quakers. They lov'd these foreigners as much as they detested the other Christians who had conquer'd and laid waste *America*. In little time, a great number of these savages (falsely so call'd) charm'd with the mild and gentle disposition of their neighbours, came in crowds to *William Pen*, and besought him to admit them into the number of his vassals. 'Twas very rare and uncommon for a sovereign to be *Thee'd* and *Thou'd* by the meanest of his subjects, who never took their hats off when they came into his presence; and as singular for a government to be without one priest in it, and for a people to be without arms, either offensive or defensive; for a body of citizens to be absolutely undistinguish'd but by the publick employments, and for neighbours not to entertain the least jealousy one against the other.

William Pen might glory in having brought down upon earth the so much boasted golden age, which in all probability never existed but in *Pensilvania*.[26]

West inscribes the plaque above the arched entrance to Penn's house 'W. P. / 1681', and Penn himself and an Indian chief frame this archway, as if they were twin pillars supporting this new community. Furthermore, the disposition of the feathers rising from this pensive Indian's headdress resembles paint brushes, prefiguring the young West who is said to have first learned from the Indians how to paint and who now records this scene for posterity.[27]

West shows Penn taller than he actually was, and using a likeness of him as an older man, he shows him more portly than he had been in 1682. He also gives him contemporaneous eighteenth-century Quaker dress. Although Barry follows West's lead in these details, including his retention of the broad-brimmed hat even when Penn is in the company of royalty, his is not a passive retelling of West's characterisation. He, too, had pursued a relationship with Penn's family, having in the course of working on the murals developed the acquaintance of Lady Juliana, Thomas Penn's much younger and more dynamic wife.[28] Barry not only was an enthusiastic admirer of Quaker values, but the fact that Penn's conversion to this faith had taken place in Cork would only have increased his appreciation and sense of kinship.

In Benjamin West's conception, Penn gestures with one hand to the unfurling parchment of the treaty, while with the other to the unfurling bolt of cloth being held up by one of the sailors. The French author Abbé Raynal had written, 'The price he [Penn] gave to the savages [for their land] is not known',[29] but West, in choosing to focus on bolts of cloth, emphasises the advantages of trade and commerce, with the Delaware river on the left supplying the gateway to the ports of Europe. Barry, too, would have approved this endorsement of commerce as the key to the peaceful and prosperous coexistence of the races. As in *Orpheus*, cloth supplants animal skins in the advancement of civilisation, even if the Indians already possess intricately embroidered clothing. This, too, is an entirely pacific trade: there are no weapons on the part of the Europeans, while the natives have laid down their bows

and arrows except the young boy at right, who embodies the qualities of a lithe hunter rather than that of a warrior.

Barry, however, picks up where West leaves off. Voltaire stressed two aspects of Penn's establishment of a golden age: his treaty with the Indians, with its magnanimous treatment of native Americans, and his toleration of all religions that believe in one God. West's painting addresses the first of these concerns, Barry's the second. The scroll Barry's Penn holds is inscribed, 'Pensylvania / 33 Ch. 2d.' Given that this is a gathering of lawgivers, 'Pensylvania' presumably refers to Penn's code of laws, *The Frame of the Government of the Province of Pennsilvania in America: Together with Certain Laws Agreed Upon in England*, which was published in 1682. Penn proudly displays this code to Lycurgus, a reference that harks back to yet another Frenchman, Montesquieu, who in a book first published in 1748 wrote, 'A character so extraordinary in the institutions of Greece, has shewn itself lately in the dregs and corruption of our modern times. A very honest legislator has formed a people to whom probity seems as natural as bravery to the Spartans. Mr. Pen is a real Lycurgus.'[30]

Together with West's painting, to which it alludes in terms of Penn's pose and appearance, Barry completes Voltaire's vision of Penn's accomplishments. West's work was intended in part to strengthen the son's hand in refurbishing his image as proprietor of this province. When Barry painted his Penn, the colony was no more, having been subsumed into the United States of America, but William Penn's golden age of Voltaire's telling remains the standard, challenging both Americans and Europeans to adopt fully his principles.

The second line of the inscription on the scroll, '33 Ch. 2d.', is more difficult to explicate. In *The Frame of the Government* there is nothing noteworthy about item 33, nor does it have a second part.[31] Perhaps it alludes to a citation in the most comprehensive book on Penn up to Barry's time, *A Collection of the Works of William Penn* (1726), which in its first volume on page 33 no. 2 gives a portion of Penn's defence during his 1670 trial at the Old Bailey in London for having preached to an unlawful assembly: 'Their [i.e. the court's] Treatment of the Prisoners was not more *Unchristian* than *Inhumane*. History can scarce tell us of one *Heathen Roman*, that ever was so ignoble to his Captive: What! *To Accuse*, and not *Hear them*; *to threaten to Bore their Tongues, Gag and Stop their Mouths, Fetter their Legs, meerly for defending themselves, and that by the Ancient Fundamental Laws of* England *too?*'[32] If the first line in the scroll, 'Pensylvania', links Penn to Lycurgus, the second line may be intended to link him to his other companion, King Alfred, who, as we have seen, holds in effect in his hand '*the Ancient Fundamental Laws of* England', including the right to trial by jury.

In addition to the classical legislators Lycurgus, Solon, Numa and Zaleucus, Barry introduces Russia's Peter the Great conversing with England's Black Prince, Edward III's eldest son, who, like King Alfred, was extolled as a symbol of English liberty. Next, Henry IV of France, who in the print is shown holding 'in his hand his favourite scheme for the pacification of Europe [the Edict of Nantes of 1598]',[33] faces the Genoese admiral and statesman Andrea Doria, who, after expelling the French at the time of Francis I, had re-established Genoa as a republic. Positioned between them is an unidentified figure, presumably another classical antecedent, and to the right of this threesome is a figure in shadow who faces the angel strewing flowers.

Illustrious patrons

Barry, 1783, in *Works*, vol. 2, pp. 369–70:

I have introduced also those patrons of men of genius, Lorenzo de Medicis, Louis XIV. Alexander the Great,

Charles I. Jean Baptist Colbert, Leo X. Francis I. and the illustrious Lord Arundel. It is admitted that some of those great men may have had exceptionable parts in their characters; but they were great men, and they were intentionally the instruments of great good to their several countries, which they have immortalized by their munificence, and the encouragement they gave to arts and letters, by wisely employing the greatest characters that came within their reach.

Barry lists the patrons in order of their appearance. In a row to the left of the prominent angelic guard are Lorenzo de' Medici, Louis XIV and Alexander the Great. They look toward the group on the other side of the angel, where Charles I faces Francis I, with Colbert and Pope Leo X in between, this last figure subsequently having been replaced in 1798 with Cassiodorus and a monk. Further to the right, Lord Arundel, whose head comes up to Francis' shoulder, is literally lesser to the others. as he looks back up at Charles I.

Alexander the Great, the sole classical figure, is present because of his celebrated association with Apelles, an association in which the painter was considered an equal. Three rulers represent the Renaissance: Lorenzo de' Medici (Florence), Pope Leo X (Rome), and Francis I (kingdom of France). As for the seventeenth century, though separated, Louis XIV has his minister Colbert, while Arundel, the founder of an impressive art collection including antique statuary, accompanies Charles I, who was both the patron of Rubens and Van Dyck and the creator of an unrivalled collection of old masters. Although Barry honours Charles for his sponsorship of the arts, his audience would again be acutely aware of his historical role. Other than Alfred, he is the only English monarch included in *Elysium*, and Barry intends his presence to invoke what he perceived as his martyrdom for his steadfast support of the Church. The inclusion of a Puritan minister in *Tartarus* holding a scroll inscribed 'Solemn / League & Covenant' testifies to the artist's passionate contempt for Charles' political opposition.

Barry, too, makes clear that some of these men had 'exceptionable parts in their characters', that is, parts with which one might want to take exception, but even if they were not always 'good' men, in their support of arts and letters they effected great results. This raises the question as to which system of government, an absolutist one or a republican one, leads to the greatest cultural advancements. As for these patrons, while they made good use of the unrestricted opportunities presented to them, the design of the mural as a whole argues for a government of just laws as the best foundation for the nourishing of creativity.

Angels and theologians: Christian symbolism at the mural's core

Barry, 1783, in *Works*, vol. 2, pp. 370:

Just before this group, on the range of rocks which separate Elysium from the infernal regions, I have placed the angelic guards. See Milton, Book IV. v. 549. Immediately before this in the most advanced part and entrance of the picture, is an archangel weighing something, which is not seen, as the scales come below the frame; the preponderation of the balance towards Tartarus, may, however, account for the emotion and expression of the angel's countenance turned towards the spectator; by the upper parts of the wings of an angel, and fiend, which appear to surround the scales below, I have endeavoured to impress the mind with, &c. [The following is the description for the 1792 print: 'The most advanced figure is the angelic minister of divine justice weighing *good* and *evil*, and with her hand raised and face turned away, appearing shocked at the preponderancy of evil, co-operating with the expression of the interior angel on the side of the light scale, who may be supposed the disappointed guardian: whilst the tip of a fiend's wing appearing on the side of the heavy scale, gives sufficient

indications how the matter terminates' (Barry, 1793, in *Works*, vol. 2, p. 430).] Behind this figure, or instrument of Divine justice (if I may use such a term) there is another angel, of a different class and character, who is explaining something to my two favourite writers upon the analogy between religion and nature, Pascal and Bishop Butler [to their left is Origen, who Barry does not mention by name until he describes his 1801 addition of Bossuet (see 'Changes to the murals, 1801', in appendix 2)]. Behind Francis I and Lord Arundel are those children of peace and moderation, Hugo Grotius, Father Paul, Pope Adrian, &c. enjoying that unanimity which the selfishness and party-strife of others would not permit them to enjoy here below [the 'etc.' encompasses Johan van Oldenbarneveldt, as made clear by Barry's description of the 1792 print].

Barry's rendering of the afterlife, as already noted, has a decidedly Christian flavour in terms of the cherubim at the upper left who surround God's throne, and the vast angelic choir ranged behind them. For his conception of the angelic guards on the mural's right-hand side, the artist relies on Milton, rather than the Bible itself, for his textual source, citing the English poet's description of Heaven's influence:

> … it was a Rock
> Of alabaster, pil'd up to the clouds,
> Conspicuous far, winding with one ascent
> Accessible from earth, one entrance high;
> The rest was craggy cliff, that overhung
> Still as it rose, impossible to climb.
> Betwixt these rocky pillars Gabriel sat,
> Chief of th' angelic guards, awaiting night; …
> (John Milton, *Paradise Lost. A Poem, in Twelve Books*, Bk 4, lines 543–50)

In the first conception of 1783–84, Barry included only one colossal angel at the cliff's edge (the others were added later). The massive seated angel grasping the large spear between his legs must be, given Barry's citation of Milton's line 549, no other than Gabriel himself. The 1792 print after the painting makes him an even more dominating presence. Gabriel's broad, barrel chest links him to the depiction of the equally impressive Hercules, who, armed with a huge club rather than a spear, occupies the left-hand side of *Crowning the Victors*.

Gabriel looks down at the Judging Angel, a colossal figure who anchors the mural's bottom centre. This archangel wears a white tunic, over which is a crimson garment with gold trim fastened by a large gold brooch. Beneath her dark hair piled high, one sees her grim, shaded features next to which is her large, expressively poised left hand.[34] In classical accounts, on entering the underworld one encounters Minos, who passes judgement on each individual's ultimate fate. Minos had been accorded this honour because of his brilliance, when he had been king of Crete, as a lawgiver, wise ruler and judge. Barry, too, honoured Minos by placing him among the group of legislators, but in choosing an archangel as the judge of individual souls, he again adopts a Christian perspective. The Last Judgement is often employed on the west-end of cathedrals, where, on entering or exiting the building's main entrance, one would pass under the figure of St Michael holding a pair of scales. In the mural, Gabriel, given his armour and his special bond with the Judging Angel, has more than a hint of St Michael in his characterisation. Although Barry assigns the task of judging to a female archangel, the Christian sentiment remains. In his mural, this judgement, too, occurs over the room's entrance and exit, each visitor having to undergo this trial each time he or she hurries past. Few may feel that they measure up, and the fact that the scale inclines toward *Tartarus* is cause for alarm.

Another detail associated with the Judging Angel, the introduction of a guardian angel vying with a devil over a soul, although an old iconographic motif, had such strong Roman Catholic connotations in the eighteenth century that Barry declined to elaborate, concluding his description with an etcetera. By inserting only the tips of the wings of these two spirits, the artist makes his reference discreet. The guardian-angel's wings can be glimpsed directly above the entrance (his head and clasped hands are shown in the print), while only the tip of one of the devil's bat wings can be seen further to the right, projecting above the frame like a shark's fin. Continuing to the right, one sees vipers swimming eagerly toward their newfound prey.

Stepping back, one sees that the mural's overall structure refers to the Christian Last Judgement. In this format, Christ is at the centre, with the blessed on the left (Christ's right-hand side) and the damned on the right (his left-hand side). In this regard the dominating figure of Gabriel in Barry's mural alludes also to Christ. The symbolism of the Last Judgement is modified and manipulated but present nonetheless.

Grouped above the Judging Angel are three pre-eminent theologians: Origen, a prominent Greek father of the early Church, who points with his finger to his temple; Blaise Pascal, the French religious philosopher who was a supporter of Jansenism; and Bishop Butler, who is closest to the archangel and on the painting's central axis (Barry did not introduce the overarching figure of Bossuet until 1801). While these three theologians, placed as they are in the centre foreground, occupy a position of importance within the composition, in his text Barry gives only the briefest of mentions of Butler and Pascal, and neglects to mention Origen at all. As often is the case, what is most important goes unspoken; in the section on hidden meanings, Butler's role will be more fully explored.

The artist's selection makes clear that his concept of religion is not a populist one. Rather, his thinkers are elitist, their message a difficult one for the general public to appreciate in all its complexity. Thus religion, which engages with the most fundamental questions, is for Barry an intellectual exercise to a degree far beyond what the Church normally promulgates; the exercise of reason over blind faith is necessary to religious inquiry, even if reason alone cannot fully answer life's most profound questions. Given the choice of theologians, there is a strong Neoplatonic bias to the artist's approach as well. The angel who is addressing these three men, unlike the angel discussing with the scientists and philosophers at the far left, has turned her back on the viewer, her revealed knowledge being literally beyond the viewer's comprehension. Her companion, the angel resting her head and hands on her shoulder, is as respectfully pensive as her auditors.

The figures categorised as the 'children of peace and moderation' are found on the right-hand edge of *Elysium*, far removed from the three theologians. Pope Adrian is seen from behind. While there have been six Pope Adrians, Barry presumably intends this figure as Adrian IV, the only Englishman to occupy the papacy. Lacking a portrait of this medieval figure, who served from 1154 until his death in 1159, Barry shows him facing inward, his receding profile in dark shadow. Not the least interesting of the controversies in which Adrian was embroiled concerns his negotiations with Henry II of England over who should control Ireland. Henry sought papal approval for his plan to conquer the island, but Adrian countered that, based on the Donation of Constantine (a document which will be discussed in chapter 6) dominion ultimately rested with the pope himself, an assertion that the artist would have enthusiastically endorsed. To the left of Adrian is Hugo Grotius, Dutch jurist and statesman known for his conciliatory and moderate views on religion and his formative studies on international law. To the right is an anxious Johan van Oldenbarneveldt, the Dutch statesman who after dedicating his life to the struggle for political independence and religious toleration, was executed by his enemies on trumped-up charges of treason. Next to him is Fr Paul Sarpi, the Venetian patriot and scientist who on behalf of the Venetian republic opposed the temporal power of the pope.

Detail from Pl. 6 James Barry, *Elysium and Tartarus or the State of Final Retribution*, 1777–84, 1798 and 1801. Oil on canvas, 360cm x 1278cm. Royal Society of Arts, London

Poets and writers

Barry, 1783, in *Works*, vol. 2, pp. 370–2:

In the top of the picture, and near the centre, sits Homer, who, with his head raised, and turned towards that part from whence the glory proceeds, is now singing to his lyre, somewhat in strains which Plato would not have condemned, in which he is accompanied by a choir of angels behind him. On his right hand, sits Milton, with a more modern instrument in his lap. Shakspeare sits next to Milton, in a careless easy action, with loose papers flung negligently about him. Spenser and Chaucer are next. Behind Sappho, who is near Chaucer, with a pen in her hand, &c. sits the poet Alcæus, who was so much admired by the ancients, though his writings are lost, yet fortunately there is a head of him remaining, and from the noble and spirited account Horace gives of his abilities, I have found a companion for him, very much of his own cast, in our ancient bard Ossian, with whom he is talking; as to the merit of Ossian's poetry, whether it was better or worse, or of the same lofty, impetuous, fierce character, with that of the Runic and Islandic bards, is now difficult to determine; but if we may be allowed to estimate him by the Fingal, Temora, &c. which the ingenious Mr. Macpherson has published in his name, it is certain he would do honour to any company to which he might introduce him. I agree, however, with the learned and very ingenious Mr. Shaw [see William Shaw, *An Enquiry into the Authenticity of the Poems Ascribed to Ossian* (London, 1781)], that Ossian, whatever his abilities may have been as a bard, was an Irish bard; what he has so clearly and so forcibly urged, from his own knowledge, added to the united testimony of all the ancient writers of our islands, from Beda down to Cambden, puts this matter beyond all dispute. I have accordingly given Ossian the Irish harp, and the lank black hair, and open unreserved countenance peculiar to his country; near him is another group, consisting of Menander, Moliere, Congreve, – Brama, Confucius, Mango Capac, &c. [For a discussion of these last three, see the following section, 'The rest of the world: a trio of non-Western legislators'.]

Next to Homer, on the other side, sits the great Archbishop of Cambray, with that first of all human productions, his inestimable poem of Telemachus; Virgil is standing between, and leaning on the archbishop's shoulder. The next figures are Tasso, Ariosto, and Dante, the last of whom, with his hands on the shoulders of his two descendants, is leaning forward, attending to Homer.

As to Ariosto, I am happy to say, that he is now our own, since, from the spirited and masterly translation of him, by the ingenious Mr. Hoole [John Hoole's translation, *Jerusalem Deliver'd: An Heroic Poem*, which went through numerous editions, was first published in 1763]; we also are now enabled to enjoy that copious, unbounded fancy, that eloquent sensibility, and felicity of expression, which have long been an inexhaustible fund of delight to the people of Italy. Behind Dante, sits Petrarch, with his hand locked in that of Laura; and between them, and further in the picture, is Giovanni Boccaccio, &c.

In the second range of figures, just over Edward the Black Prince, and Peter the Great of Russia, I have brought together Doctor Swift, Erasmus, and Cervantes; near them is Pope, Dryden, Addison, and Richardson, the author of Clarissa; behind Dryden and Pope is Sterne, Gray, Mason, Goldsmith, Thomson, and Henry Fielding; …

The blind Homer 'sees' fully the radiant glory. Significantly his lyre occupies the exact central axis of the canvas. Milton, who, cradling a lute in his lap, also has the potential to produce divine harmonies, is in a position of honour placed next to him on his right, but this does not necessarily mean Milton has outstripped Shakespeare, who is next in line. Milton looks to, and is inspired by Homer, a representative of the classical tradition, while Barry is careful to define Shakespeare as his own man, somewhat apart from academic rules and regulations. Next in line comes Chaucer, behind whom is a minor, unidentified bearded figure. Sappho is Barry's sole female writer, just as she had been Raphael's

in his *Parnassus*. However, her traditional admirer Alcaeus only has eyes for Ossian, who towers over his companions.

To the left of Ossian, Barry groups a number of playwrights but only names three writers of comedies: the classical Greek writer Menander, the Frenchman Molière, and the Englishman William Congreve, who had been educated in Ireland. In the text, the dash stands in for the rest, but the text for the print makes their identification clear. In the same line as Congreve, who is on the left-hand side of this group, are two more Englishmen, Ben Jonson and Thomas Otway. The Roman playwright Terence, who was influenced by Menander, is appropriately in the same line with him and Molière. The French tragedians Racine and Corneille are above. Between Corneille and Ossian's harp is the head of another bearded, unidentified classical figure.

More curious is Barry's curt listing of Brahma, Confucius and Manco Capac. In the painting, they are far removed from the cluster of playwrights, inhabiting an area of their own. Consequently, they receive here their own section, which follows this one.

In his description, Barry then begins to enumerate the figures on Homer's left-hand side. Virgil touches Fénelon's shoulder. Farther to the right, Dante acknowledges his literary descendants by placing his hands on the backs of both Tasso and Ariosto. Tasso, reflecting on the book before him, rests his head on his right hand. Directly behind him is a beardless classical figure holding a scroll. Perhaps this is Horace, whose bust profile in Barry's ticket of admission for Baretti (see fig. 15) is similar.

Behind Dante come two more famous Italian writers. Petrarch, with finger pointing upward, communes with his beloved Laura. Between the couple stands Petrarch's friend Boccaccio, who faces a group of four tall and enchanting young women, a group that presumably is the etcetera of Barry's text. Within this cluster, a pointing angel directs the attention of the foremost female back to Boccaccio. Just as Petrarch is accompanied by Laura, his inspiring muse, this beautiful, shy woman is presumably Boccaccio's Fiammetta. Dante's Beatrice must also be another of these unidentified, flesh-and-blood muses, who are awarded a place in *Elysium* along with the poets and writers their love helped to transform.

Beneath Homer is another cluster of writers. Cervantes, the sole Spaniard among the identified elite, is prominently featured at the left, where he is admired by Jonathan Swift, for whom Barry had claimed no portrait had earlier been available, by Erasmus, the Dutch scholar and reformer and friend of Thomas More, and by Laurence Sterne, who had been born in Ireland. In profile above and to the viewer's right of Sterne are William Mason and Thomas Gray, two English poets and close friends who naturally form a pair. Gray had died more than a decade earlier, in 1771, but in including Mason as his companion, Barry inadvertently placed a living figure (Mason did not die until 1797) among the dead. With his usual stubbornness, Barry retained Mason in his print of 1792, presumably comforted by the idea that it would become accurate soon enough; he was, after all, creating a greater truth – these two poets belonged together in eternity. The English Catholic Alexander Pope, in his familiar pose of melancholy genius, this time borrowed from the engraving after J.B. van Loo's portrait,[35] holds a prominent position next to Cervantes, and the three heads continuing to the viewer's right depict Dryden, Addison and Samuel Richardson (the anchoring fourth figure is Moses Mendelssohn, who was not added until 1798). Above, Oliver Goldsmith, who was from an Irish Protestant family, faces Henry Fielding, with James Thomson between them.

The rest of the world: a trio of non-Western legislators

At the end of his description of the cluster of playwrights in 'Poets and writers', Barry appends the names 'Brama, Confucius, Mango Capac, &c.' In his description to the 1792 print, he elaborates only

slightly: 'in the continuation of this line of figures are angels presenting, and as it were, interceding for Bruhma [*sic*], Confucius, Mango [*sic*] Capac, and such legislators and founders of polities whose information was inadequate to the purity of their intentions.'[36] The three non-Western principals are grouped together in the bank of clouds behind and above the Glorious Sextumvirate. Barry places Brahma, the Hindu deity in whom he sees a human progenitor, in the lead beside an interceding angel. Dark-skinned, bearded and wearing an earring and necklace, Brahma holds out a scroll toward the eternal light. Next comes a respectful Confucius wearing an Asian crown-like hat. Behind him can be seen the feathered headdress of the legendary Inca ruler Manco Capac. The South American presence later becomes more pronounced when in 1801 Barry adds Bishop Las Casas to the left of the group and a reclining Dominican friar talking to an Indian at the right.

In front of this group, just to the right of the wings of the angels discoursing over the celestial globe, are two unidentified dark-skinned men. The one to the left, his body bowed in despair and his head in his hand, precedes his companion, who holds up his hands in a gesture that repeats that of the black slave representing Africa in *The Triumph of the Thames*. In these figures Barry would seem to be introducing two Africans to complement the Asian and American participants in an effort to reference the Four Continents, Europe of course having already been represented in abundance. As suggested earlier, Barry, in wishing to avoid too great a similarity with Ralph Willett's more ecumenical cast of characters, downplays the inclusion of alien cultures, even if his response is far more sympathetic than was Willett's exploitative one. Even so, the fact remains that the non-Western world receives only the briefest of mentions. For the artist, there is only one truth, and by and large it is a Western monopoly.

Artists

Barry, 1783, in *Works*, vol. 2, pp. 372–92:

… near Richardson is Hogarth, Inigo Jones, Wren, and Vandyke: every body knows that this last-mentioned great artist had it much at heart to execute some great historical work, which should remain as a monument of his abilities; with this view he went to France, where he found N. Poussin employed at the Louvre; he then returned to England, and proposed to his royal patron, to paint the procession of the knights of the garter, for the sum of 80,000*l*. and though it has been often regretted, that this work was never carried into execution, yet the lovers of art will have some consolation to find that it is not totally lost, as Vandyke's original design, which was painted in chiar-oscuro, and is in the possession of the Earl of Northington, is now engraving by my very ingenious and long esteemed friend, Mr. Cooper, whose great professional talents it sincerely rejoices me to see thus happily exerted. In this part of the picture where I have introduced many artists of my own profession, it was my wish to glance at the dispute between the ancient Greeks and old Italian painters for pre-eminence, a question which has been much controverted; the learned for the most part have inclined to the ancients, whilst the contrary opinion is adopted by the greatest number of those who were more conversant with modern art. [Barry devotes almost twelve pages to this discussion. Although he comes out in favour of modern art, the mural gives priority to the ancients.]
[…]
Next to Vandyk is Rubens, who with his hand on the shoulder of the modest and ingenious Le Sueur, is pushing him forward amongst the artists of greater consequence; Le Brun is behind him. The next figures are Julio Romano, Dominichino, and Annibal Carrache, who are talking with Phidias, the Greek sculptor and architect, with the bald head, and with a ground plan of the Temple of Minerva at Athens under his arm; near him are two Greek painters, Nicholas Poussin and the Sicyonian Maid with the shade of her Lover, which gave a

beginning to the art; near her is Callimachus the Greek sculptor, with his invention of the Corinthian capital, and behind him sits Pamphilus, who is known by some treatises he had written, and who is exultingly calling upon the moderns to produce any man equal to his disciple Apelles, who is painting; on the off-side of Apelles, is Corregio, in whose action I wished to express a kind of negative upon the offer which Titian is making to Raffael, or Parmegiano, of his Pallet, or colouring, to be added to the several particulars in which they excelled; for it is certain that as no painter of Italy has possessed the beauty, sublimity, and knowledge discoverable in the antique, the union of all their good qualities would still be essentially defective, and not amount to the idea of perfect painting. Behind Raffael stand Michael Angelo, and Lionardo da Vinci, those two great and venerable trunks, from whence all the branches of modern art have derived much of sap and nutriment; behind them are Ghiberti, Donatello, Masaccio, Brunelleschi, Albert Durer, Giotto, and Cimabue.

Notwithstanding Hogarth's merit does undoubtedly entitle him to an honourable place amongst the artists, and that his little compositions considered as so many dramatic representations, abounding with humour, character, and extensive observations on the various incidents of low, faulty, and vicious life, are very ingeniously brought together, and frequently tell their own story with more facility than is often found in many of the elevated and more noble inventions of Raffael, and other great men; yet it must be honestly confessed, that in what is called knowledge of the figure, foreigners have justly observed, that Hogarth is often so raw, and uninformed, as hardly to deserve the name of an artist. But this capital defect is not often perceivable, as examples of the naked and of elevated nature but rarely occur in his subjects, which are for the most part filled with characters that in their nature tend to deformity; besides, his figures are small, and the junctures, and other difficulties of drawing that might occur in their limbs, are artfully concealed with their cloaths, rags, &c. But what would atone for all his defects, even if they were twice told, is his admirable fund of invention, ever inexhaustible in its resources; and his satire, which is always sharp and pertinent, and often highly moral, was (except in a few instances, where he weakly and meanly suffered his integrity to give way to his envy) seldom or never employed in a dishonest or unmanly way.

[Barry next embarks on an extensive digression on the state of contemporary English art, discussing the uses and abuses of satire and the lack of support for native painters of genius.]

[…]

Behind Phidias, I have introduced Giles Hussey, a name that never occurs to me without fresh grief, shame, and horror, at the mean, wretched cabal of mechanics, for they deserve not the name of artists; and their still meaner runners and assistants, that could have co-operated to cheat such an artist out of the exercise of abilities, which were so admirably calculated to have raised this country to an immortal reputation, and for the highest species of excellence. Why will the great, who can have no interest but in the glory of the country? why will they suffer any dirty, whispering, medium to interfere between them and such characters as Mr. Hussey, who appears to have been no less amiable as a man, than he was admirable as an artist? [Barry continues his discussion of Hussey, who for him is an alter ego.]

[…]

My friends at Bologna will blame me for omitting our Lodovico, for whom I had such fondness; Agostino also, Guercino, and Guido; but I was tired, and resolved to content myself with Dominichino, and his master Annibal. It is very remarkable that this great man Annibal Carrache, who came to such a place as Rome, and so shortly after the death of M. Angelo, should have been so far overlooked, even by that court, as never to have been employed about any papal work, and had the additional mortification of seeing all court-favour, employment, and even the honour of knighthood, flung away upon such a reptile as Gioseffo d'Arpino; however, let no man be discouraged, Annibal Carrache is, notwithstanding all this, the glory of his age; whilst the Pope, the Court, and the Cavalier d'Arpino, are rotting in oblivion.

Barry segues from his discussion of English writers into one concerning artists of the English school.

Then, after a lengthy debate about the respective merits of the ancients versus the moderns, he continues with his choices for the great seventeenth-century painters. He turns next to the identification of classical Greek artists, among whom he places Poussin as that modern most closely attuned to the spirit of antiquity. Next comes a discussion of artists of the High Renaissance, which is followed by an account of their antecedents. Finally, Barry comes full circle by closing with the Catholic, English painter Giles Hussey. The following account takes its organisation more from the mural itself than from Barry's discursive description of it.

Of the artists, Barry awards Apelles the most exalted position, showing him at work on a large canvas. Not too far from his side is seen the only other figure before a canvas on an easel, that of a gesturing angel, an indication that the close examination of art proves as spiritually revealing as the study of the spheres or the contents of books. In the print, the angel and her canvas have disappeared, and Apelles' canvas is now seen from the back. The handle of Apelles' brush is aligned with the outer circumference of the cosmic sphere behind him. Attuned to the spiritual forces animating the universe, he, too, is seen as a creator or, at the very least, an interpreter of entire cosmic systems.[37] While Homer is at the composition's apex, Apelles is at the outer limits of the universe's frontiers, positioned to explore its awesome sublimity. In the mural behind Apelles' easel are unidentified figures, the foremost of which appears to be a red-haired youth at work on a portfolio in front of him while three others look on. Perhaps this is a future genius yet unborn, his red hair signifying Celtic origins. At the bottom corner of Apelles' easel, the Sicyonian artist Pamphilus, who had been his teacher, holds up a scroll containing his treatises on art, while gesturing toward his pupil and challenging anyone to equal him. Visible on the scroll are intricate diagrams, again demonstrating how closely aligned art is with science.

In the upper row of figures lined up to the left of Apelles are artists of the trecento and quattrocento, who prepared the way for the Renaissance masters. Starting at the far left is a group of four: Cimabue, Giotto, Dürer, whose face is obscured, and Brunelleschi, who faces the others. Next comes an imposing Masaccio, who turns toward Donatello and Ghiberti. Of the moderns, Michelangelo, Leonardo and Raphael form a glorious triumvirate to which, since their time, all the world has not yet been able to add a fourth. Of these three, Raphael is to the fore, while Michelangelo rests his hand on Raphael's shoulder and Leonardo points to him. As his choice for the greatest artist since Apelles, Barry, basing his image on Raphael's self-portrait in *The School of Athens*, also has Raphael engage the viewer by looking out at his public. Barry pays homage as well to Raphael in one of the composition's prominent details: the angel over King Alfred's head, with its unusual wings and bowed arms holding flowers, makes reference to the zephyr in *The Wedding of Cupid and Psyche* in the Villa Farnesina, Rome. Slightly farther back are three more Italians artists: Titian offers his palette to Pamigianino, while Correggio is countering with philosophical arguments as to why colouring alone is insufficient in achieving greatness.

The row of artists beneath the upper tier begins with seventeenth-century masters and concludes with the classical Greeks, leading one back up to Apelles. At the upper left is Van Dyck, followed by a more prominent Rubens, to whom Van Dyck owed so much. Rubens pushes forward Le Sueur, who clutches a portfolio, while Le Brun stands between them. Next Giulio Romano points over his shoulder to Domenichino and Annibale Carracci, who holds a porte-crayon and portfolio. In his description, Barry points out how indebted he was to the Bolognese school by naming four more artists (Ludovico and Agostino Carracci, Guercino and Guido Reni) that he had left out, presumably not because of fatigue, as he claimed, but because of the inappropriateness of overweighting the mural in favour of this school. One might think he would have been more concerned about not having introduced an artist such as Rembrandt, who, in eighteenth-century England, already enjoyed a lustrous reputation.

Domenichino and Carracci heed the Greek sculptor Phidias, who points back up to Apelles. (In 1798 Barry painted over Phidias' design when he introduced Cassiodorus.) Beneath Phidias' hand are two

unspecified classical Greek artists who represent those antique masters whose names and faces have been lost to time. Next to them is Poussin, who also points to Apelles, signalling that of the moderns he is a true follower of the classical ethos. Following Poussin is the Sicyonian maid, who is credited with having invented the art of painting. Distraught that her lover was soon to depart on a sea voyage, she carefully traced the shadow of his profile cast on the wall by a lamp as he lay sleeping. Her father, a potter, then cast the image in his kiln, giving her a permanent reminder of her soon-to-be absent lover. In the mural, she holds the tablet representing mankind's first painting. Love is the motivating force that led to its creation, and the maid looks up to Apelles, who is realising the potential of what she had begun. On the other side of the tablet is Callimachus, his drawing, which Barry mentions, presumably having been lost with the later addition of one of the angelic guards. This line of ancients concludes with Pamphilus, who, as we have seen, emphatically directs our attention to Apelles.

The ranks of the artists extend even to the left of the three monumental angels, and it is with these figures that Barry first began his commentary. Inigo Jones appears directly beneath the writer Samuel Richardson. Next to Jones is his fellow architect Christopher Wren, to whom Jones holds up a large sheet of paper presumably containing one of his architectural designs. Hogarth is farther to the right, directly beneath Henry Fielding. Van Dyck comes next in Barry's account, but he is far removed, positioned on the other side of the imposing archangels and having been almost overtaken by them. One needs to recall that Barry added two of these archangels in a later campaign, an addition that would have required him to alter parts of his original arrangement, thereby rendering the 1783 description out of date. The English school continues to the right of the archangels with Giles Hussey, who, with porte-crayon in hand, shows one of his drawings to no less than an admiring angel. (Reynolds above and to the left of Hussey was added later.) Barry sees himself as carrying on Hussey's unfinished legacy, which his forerunner had been prevented from completing because of the conspiracies ranged against him. In assuming Hussey's mantle, Barry not only takes on for himself the task of introducing high art to England but also of confronting the envy that his greatness will inevitably engender.

The System of Systems

Barry, 1783, in *Works*, vol. 2, pp. 392–3:

In the top of this part of the picture, I have attempted to glance at what astronomers call the System of Systems; where the fixed stars, considered as so many suns, each with his several planets, are revolving round the *Great Cause* of all things. As in my apprehension too much has been ascribed to the properties of *inert matter*, it was my wish to represent every thing here as effected by *intelligence*; accordingly each system is carried along in this revolution by an angel; the points of the fingers form the poles or axes on which each sphere diurnally turns, if the expression be allowed me, and the situation of the hands gives the polar inclination, obliquity, &c. I have introduced angels incensing, &c. to mark the reference to the Deity still stronger. Though there is but a small portion of this great circle seen, yet I should hope there is enough to hint the idea to a man of any fancy.

In referring to the system of systems, Barry invokes the cosmology of the Pythagorean school, particularly as recorded in Plato's *Timaeus*, in which each cosmic body is propelled by pure spirit, a mental energy that, in a Christianised context, is easily symbolised by an angel. This Platonic concept emphasises as well the ordered, stable nature of the cosmos, stressing such 'perfect' forms as spheres and the celestial harmony (the music of the spheres) produced by their movement through the universe. Raphael's design for the cupola mosaic in the Chigi Chapel in S. Maria del Popolo in

Detail from Pl. 6 James Barry, *Elysium and Tartarus or the State of Final Retribution*, 1777–84, 1798 and 1801. Oil on canvas, 360cm x 1278cm. Royal Society of Arts, London

Rome, executed in 1516 by Luigi de Pace, offers a helpful Renaissance visualisation of this system told in a classical vocabulary that has been Christianised. At the top of the cupola, seen framed in a fictive oculus, is a welcoming and commanding God the Father. The encircling trapezoid sections show the various spheres that rotate around him in a counterclockwise direction, the same direction followed by the angels holding solar systems in Barry's mural. Raphael's rendition of the seven planetary spheres along with the stars begins at the right of the chapel with the personification of the moon as Diana; followed by Mercury; then the sphere of the fixed stars, which is positioned directly above the entrance and behind the viewer as he or she enters, since the stars occupy the cosmos's most distant point; next comes Venus; then Apollo, personifying the sun; Mars; Jupiter, who is given pride of place facing the viewer on entering the chapel; and finally Saturn. A large angel oversees each of the eight images, signifying that these material forms are imbued with, and directed by, a divine spirit. The images on the cupola also are seen to revolve around the earth, the vantage point of the chapel's viewer. Thus the earth, as the cosmos' centre, enjoys a privileged position, and the viewer also enjoys a special bond with the figure of God in the central mosaic above.

Although the dominant strand of the Pythagorean school argued, as in Raphael's design, for a geocentric cosmos, there were some classical proponents of the system of systems that proposed instead a heliocentric one. Painting his mural in the eighteenth century, well after the Copernican revolution had definitively established the heliocentric hypothesis, Barry modified his system of systems to reflect this structure. Returning to his facing mural *Crowning the Victors at Olympia*, one should recall that Barry had included Philolaus rather than Pythagoras in order to show a heliocentric universe on the scroll the philosopher is holding. This scroll depicts the earth's solar system in terms that an eighteenth-century astronomer, with only a few reservations, could find acceptable: not only do the planets revolve around the sun (the orbits are more circular, as conjectured in antiquity, than elliptical), but the moon orbits the earth, and Saturn is shown with rings. Once again Barry depicts the ancients as having already grasped the fundamentals of the universe's design.

The heliocentric system also aided Barry thematically in his conception of *Elysium*. God is the ultimate sun; all revolves around him, and his energising light represents a spiritual force that pulses through and animates all of creation. Milton again offers a reference point in having the multitude of angels sing their sacred song to God, who is conceived of as an omnipotent Fountain of Light that remains invisible and inaccessible because of his overwhelming brightness.

> Thee Father first they sung Omnipotent,
> Immutable, Immortal, Infinite,
> Eternal King; thee Author of all being,
> Fountain of Light, thyself invisible
> Amidst the glorious brightness where thou sit'st
> Thron'd inaccessible, …
> (*Paradise Lost*, III, lines 372–7)

Another striking facet of the artist's design is his delight in suggesting the imposing immensity of the cosmos. Rising from the upper right behind the dangling legs of the angelic guard, portions of eleven gliding angels, each supporting an individual solar system, can be seen before they disappear from view above Milton. The space between them is also charged with motion, as the orbit of a comet appears rising up between the two right-hand globes from behind the male angel's head, to appear itself between the second supporting angel's left shoulder and the globe she is holding. By showing only this small portion of the encircling angels with their rotating spheres, Barry suggests the vast

enormity of the whole. In leaving Raphael's tight, earth-centred construction far behind, he suggests the cosmic grandeur and sublimity of the system of systems, with its sweet harmonies eternally bathed in a transforming Neoplatonic light.

Tartarus

Barry, 1783, in *Works*, vol. 2, pp. 393–404:

We now come to that corner where I have endeavoured to give some little idea of the place of final punishment or Tartarus. I have introduced a kind of landscape distant view of a dreary continent, a volcano vomiting out flames and men, a sea and cataract of fire coming forward and tumbling into a dark gulph, where the eye is lost, and from whence issue clouds of smoke, and two large hands, one of which holds a fire-fork, and the other is pulling down two women by the hair, who make part of a group of large figures, which are bound together by serpents, and consists of a warrior, a glutton, a spendthrift, a detractor, a miser, and an ambitious man. [The print's description adds that the latter is 'emaciated with the miseries of luxury and ambition, and bedizened with those insignia of star and garter, which are not always the reward of honest endeavours' (pp. 430–1).] As the order of the garter is considered as the most honourable of all the honours of knighthood, I thought it likely to be the most intelligible characteristic of vanity, or this vice of ambition, more especially as only the lower limbs of the figure appeared. The *gamester*, or spendthrift, is under the *miser*, with a fiend wound about his neck, who by the hour-glass it is holding before him, as a kind of second conscience, is goading him on to the recollection of the time he had neglected and misused: it is not necessary to suppose, that the cards and dice he has in his hand, had been used fraudulently; no, I have taken it upon the lightest estimate; it will be sufficient if his crime amounted to nothing more than the wasting and destroying that time upon trifles, which was given him to be employed in active virtue … Be it ever remembered that the highest authority affirms, that the use and increase of the talent will be exacted from us, and not merely its preservation.

As to the warrior, I am ready to admit that wars and the spilling of human blood, may be sometimes necessary, justifiable, and perhaps even praise-worthy; but it is so much oftener otherwise, that we may presume it to be the case in this instance; and, without further remark, pass on to that detestable species of mischief in which we so much abound, the *Anonymous Detractor*, with his horrid face, appearing under an innocent placid-looking mask, a dagger in one hand, and falsehood and scandal in the other, under the guise and signature of a lover of merit, truth, and justice. This will serve as a kind of genus, including all the several species of these horrid assassins, from the volunteer who writes to gratify his own occasional spleen, rage, and envy, to the hireling who follows this business in an orderly professional way, and is ready to stretch his talents from a letter to a private house, to an essay in the newspaper, from that to a pamphlet, from prose to verse, to bemire or bedizen, just as his employer shall direct; these are of different degrees of skill, may be hired at all prices, and can adapt a few terms of art and common-place topics of praise, censure, or abuse, to all ranks and professions. Many painters used formerly to keep open house for them, and as far as I can learn, this practice is not yet totally laid aside […] I well know, that whatever excellence ensures a man credit with posterity, will infallibly raise him steady and deadly enemies amongst his rivals and co[n]temporaries; and that they will be more industrious to misrepresent and abuse, than his friends will be to justify him. But I would gladly have dispensed with the honour of all this; to be relieved from the mischief of it. I have reason to believe that it has greatly contributed to shorten as well as to embitter the life of my poor father, an honest, plain man, who at a distance from this great metropolis, and unskilled in its ways, naturally concluded, that his son was the most worthless of all our artists, or so much unusual labour and pains would not have been employed to prove it. Thus people who employ anonymous writers, may perpetrate any fraud or wickedness with impunity, when they confine their attack to the man who

cannot afford to avail himself of the protection of the laws.

[Barry continues for another six pages on the problem of art criticism. One partial remedy would be to require these anonymous villains to sign their names to their pieces. The Italian and French writers on art and artists did so (he names Vasari, Borghini, Dolci, Bellori, Fréart, Félibien, the Marquis Malvasia, the Cavalier Ridolfi, du Fresnoy and Roger de Piles). But even signed criticism can mislead, as in the case of writers who undeservedly praise those painters who are their friends. Barry is particularly incensed at unwarranted encomiums given to portraitists. He mentions in particular a portrait of George I by Jervoise (Charles Jervas) that he had seen at Northumberland House and speculates how a critic such as Alexander Pope could defend any praise he might accord to such an inferior production. The generalised accolades of hireling scribblers help portrait painters in their vying for position, but they also divert the public's attention from the higher, and more important, categories of art. After all, 'our posterity will concern themselves no more about the differences between the Hudson's, the Vanderbank's, the Closterman's, the Kneller's, the Jervoise's, the Richardson's, and the other unimportant triflers of the next age (if there should be any such) than we do about those of the last'.]
[…]

Floating down this fiery cataract are many figures, three of whom represent the abuses of power. An enraged king tearing his hair, and beating his head with that ensign of command he had so ill employed [in the print, he gnaws on the sceptre]; his beard and antique dress were intended to intimate, that he had been absolute, and lived in times prior to the actual and understood limitations of monarchy. The second is one of those Popes who had endeavoured, through the influence of his ecclesiastical character, to grasp at that earthly power and dominion, which was absolutely disclaimed by the Divine Author of our faith, as utterly repugnant to the doctrines and practice he had laid down for his followers; I have, accordingly, made that world, which was the object of his ambition, the instrument of his punishment, and represented him with a fiery terraqueous globe on his shoulders, preaching in the flame, like another Phlegyas [who in hell was made continually anxious by a huge stone suspended over his head]. His proper counterpart, the wretch on his left, holds that execrable engine of hypocrisy, injustice, and cruelty, the *Solemn League and Covenant*, a species of Croisade [crusade], more equally subversive of peace and good government; and much more savage, destructive, and odious in its consequences. The History of mankind can shew nothing more horrid than the aspect of religion, as it has been exhibited by those gloomy intolerant miscreants: they might be allowed, with impunity, to arrogate to themselves the title of Saints, and monopolize Heaven, and confine it to what limits they pleased. But that they should set up legal pretensions to the exclusive sole proprietorship of the Earth also, and rake together for their own peculiar use, all the little gratifications and enjoyments of it, and should dare to make use of force, to burn and destroy in consequence. Atheists might well deny a Providence, if a hell had not been prepared for such complicated, such finished wickedness.

I am, however, happy in believing, that this group is likely to be of the least use of any in the picture; for kings are, at present, so circumscribed by laws, that they can scarcely have any faults but those in common with their subjects. The Papacy, for some time past, has been liable to few or no objections of any moment; and until ignorance and barbarism return again, but little annoyance can be apprehended from that quarter: [in his description of the print he provides a lengthy discussion of the issue of praemunire in England] and some of the descendants of the fifth monarchy-men and covenanters, may be numbered amongst the most disinterested friends of equal laws and liberty, both civil and religious. However, these figures may serve as scare-crows, and help to remind us how necessary it may be to watch and pray, not against these only, but against the encroachments of all descriptions of men, since all equally love to place themselves in power, and to have others in dependance upon them; and, in truth, they are not much more blameable and vicious, who attempt these things, than the others are, who, from causes not less reprehensible, have suffered them to take place, by either wilfully or inattentively neglecting to provide the necessary bounds and restraints.

The dark, fiery regions of *Tartarus* – a visualisation of Milton's oxymoron 'of darkness visible' –

occupies the far right corner. Directly adjacent to *Tartarus* is *Orpheus*, the painting with which the series opens, but the viewer has not come full circle. A thin ridge forming the right-hand side of the cavernous mouth blocks any further movement to the right. The development through the series is linear, with *Elysium and Tartarus* providing closure. The space in this mural is also more conceptual than rational. Despite the juxtaposition of the two regions, *Elysium* is to be thought of as an ethereal cloudscape above the earth, whereas *Tartarus'* vast chambers extend not only backward into the distance but downward as well. The primary group of the damned, who represent abstractions (such as gluttony) rather than identifiable individuals, are spewed outward and down with the cataracts of the fiery lake spilling into a bottomless pit. In the distance to the left of the sharp, two-pronged fork can be seen bodies, highlighted from below by the lake of fire, plummeting into the inferno.

The principal group of figures that dominates the scene in terms of scale is Barry's own updating of the traditional seven deadly sins. Starting at the upper right one sees the emaciated gartered leg of what he describes as the Ambitious Man, who represents the sin of Pride. To the left is the miser clutching his bag of money, a reference to Avarice or Greed. Beneath him to the left is the Spendthrift, who is an imaginative reincarnation of Sloth: this figure's main crime is to have wasted his time upon trifles. To the right of the Spendthrift and below the aristocratic leg is Anonymous Scandal, wearing the mask of deceit and holding a dagger. For Barry, this sin stands out from the rest as in his descriptive text he pours out pages describing how he has been venomously attacked by his detractors. The driving motivation for Anonymous Scandal is, of course, the sin of Envy. The Laocoön-like figure of the warrior represents Anger, while Gluttony is the only one of the seven deadly sins whose name Barry chose not to alter. In the preparatory drawing for the print, he inscribed on this figure's cloak 'Monopolies &', indicating that the excessive appetites it encompasses extend to more than just overeating. At the bottom of this cascading group are the two women being pulled by their hair. In this instance Barry never bothers to mention their crime, but they represent Lust. Here again women are relegated to a secondary role; just as in *Elysium*, their role is defined primarily in terms of their relationship to men. Their crime is having evoked lust in the male, and the second woman behind the first suggests women's supposed two-faced duplicity.

Above this group are three types of menacing animals: a dragon with sharp teeth, a forked tongue and bat-like wings; a lion that roars forth flames and lightning; and a swarm of serpents. This selection is presumably derived from the Psalms, where the righteous man is given dominion over these three destructive, terrifying creatures, a dominion not granted to the sinner who is at their mercy: 'Thou shalt tread upon the lion and adder: the young lion and the dragon shalt thou trample under feet' (Psalms 91:13). The large, crossed, dangling feet of the uppermost angelic guard protect the virtuous but not the tormented damned. Serpents, of course, are not limited just to this upper register, appearing everywhere throughout this hellish scene.

Beneath the figures evoking the seven deadly sins, Barry places at the lower right abusers of political power. To the left is the Enraged King, an absolute monarch who tyrannised his subjects. Despite the king's 'antique dress', this bearded, pudding-faced man may date no earlier than the reign of Henry VIII. Next to him is a pope who exceeded his temporal, rather than his religious, authority. As he supports a globe, this pope's classical prototype on a visual level is closer to Atlas than to Phlegyas. Finally, there is the Covenanter holding the scroll marked 'Solemn / League & Covenant', who again has misused religion in imposing his will on others, a will whose purpose in 1643 was in part to eradicate Catholicism from Britain's shores.

Barry, 1784, *Addenda* to 2nd edition of *Account* (not reprinted in *Works*), pp. 243–9:

After these pictures were exhibited last year, a new character has been introduced into Tartarus; it is one of those people who from pride, laziness or malevolence, give themselves up to the government of envious or other

malicious whisperers, and proceed to dislikes and hostility from what they hear, without doing the justice either to themselves or others of taking the trouble to examine with the necessary attention whether what is reported to them be a calumny or not. The figure is represented blindfolded, as he lived, with a dagger in each hand, and vipers pulling him down by the ears. Noxious as this character is, and frequently as we meet it in life, yet I should have omitted and passed it by, as I have many others, were it not for an unlucky adventure which I did not seek, but which sought me during the exhibition.

[Barry describes at length his version of an altercation with his fellow Royal Academician, Rev. Matthew William Peters. Shortly after the exhibition of Barry's murals had opened in 1783, Peters had written to him requesting that the Duke of Rutland be added to his list of subscribers for the proposed prints reproducing the paintings. Receiving no reply, Peters wrote a second time, and still getting no response he then called on the artist. Barry's defence for not responding to the letters and for refusing to place Rutland on his list was that Peters was acting on his own without the duke's knowledge.]

[…]

Six weeks after this, when I happened to call at Dr. Burney's, Mrs. Burney asked me to give her some account of my reasons for treating the Duke of Rutland in the unhandsome manner I had done; that it was reported all over the town that his Grace had very obligingly wished to have his name on the list of my Subscribers, and had commissioned Mr. Peters, a Member of the Academy, to propose it to me; but that instead of complying with his Grace's desire, I told Mr. Peters I would have no such paltry fellows as Dukes upon my list of subscribers, with a great deal of other similar unbecoming language; that this story had been long in circulation; that she heard it in a large company at Mr. Strange's; and that it made many people of condition afraid to subscribe, least they should meet with some insult. I was shocked, as may be supposed, at so infamous and malicious a lie; but the mischief it was intended to effect was done; it was then too late to contradict it by any advertisement, as I had already notified in the public papers that my exhibition would close the next day … However my interest might have suffered, I have contented myself (after stating the fact in my own necessary justification) with converting this nasty business to a moral use, by introducing into Tartarus an abstract or general figure of those who wickedly lend their ears to scandal, without making use of their eyes to discover how far it ought to be depended upon.

Barry, 1793, in *Works*, vol. 2, p. 431:

Next him [the Spendthrift] is one with vipers pulling him by the ears, a dagger in each hand, and a bandage over his eyes, representing one of those wilfully blind miscreants who gratify pride, envy, and malignity, by the facility with which they receive and give currency to whatever may tend to lower, defile, and obliterate excellence: his necessary instrument, the literary hireling, is in the same line.

Envy takes on such importance for Barry that this deadly sin now requires two figures. Anonymous Scandal represents those who hiss their venom into the world, whereas the new figure represents those who all too gladly seize on and disperse this poison. Wearing a blindfold, indicative of his wilful ignorance, and with vipers envenoming his ass's ears, this figure flails about with two daggers. His strong jaw and thick nose may be intended as an oblique reference to Barry's fellow academician Rev. William Matthew Peters, which would give Peters the dubious distinction of being the only person with the possible exception of Henry VIII to have his portrait introduced into *Tartarus*.[38]

Of the seven deadly sins, envy is the one most closely related, albeit in a negative way, to the great men presented in *Elysium*. In his later illuminated book, *The Marriage of Heaven and Hell*, William Blake, who, as we shall see, appears to have known Barry well, penned lines that could form an appropriate motto for the entire mural. One of Blake's devils, a representative of imaginative energy,

proclaims the following: 'The worship of God is. Honouring his gifts in other men each according to his genius. and loving the greatest men best, those who envy or calumniate great men hate God, for there is no other God.'[39]

The 1792 print

Elysium and Tartarus or the State of FINAL RETRIBUTION

The artist's commentary is reprinted in Barry, 1793, in *Works*, vol. 2, pp. 425–36. Parts of this text have already been incorporated into the discussion of the painting. A full list of the identifiable figures in the print can be found in Pressly, no. 22.

In his print, Barry plays more aggressively with illusion and reality. The inscriptions to the other prints in this series are placed in the lower margin, although in *Crowning the Victors in Olympia* the text box is inserted into the image itself. But in this instance, Barry gives the text box a strong three-dimensional presence as it projects into the viewer's space, with the scene of *Elysium and Tartarus* behind it. This illusion is even more forcibly presented at the left, where the classical cornice thrusts outward, with the clouds of *Elysium* spilling out along its side. The pedestal bearing the Pelican and its young rests on this projecting cornice. Now added to the movement of up in *Elysium* and down in *Tartarus* is the sense of a welcoming extension toward the viewer on the side of *Elysium*, and a recession away from the viewer on the side of the damned. More forcibly than before, the viewer is invited to embrace virtue over vice. Yet few of the figures in *Elysium* look out at their audience. They are lost in their own thoughts, and perhaps because the image is in black and white, their expressions seem even sadder than before.

Barry's ordering of his discussion of the figures unfolds slightly differently from the description of the painting. He begins as before with the left-hand group of scientists and philosophers, and

Fig. 28 James Barry, *Elysium and Tartarus or the State of Final Retribution*, 1792. Etching and engraving, 419mm x 924mm. © The Trustees of the British Museum, London

Detail from Pl. 6 James Barry, *Elysium and Tartarus or the State of Final Retribution*, 1777–84, 1798 and 1801. Oil on canvas, 360cm x 1278cm. Royal Society of Arts, London

then moves on to the group around the Glorious Sextumvirate to which he has added Hippocrates as a classical counterpart to the modern men of medicine. He concentrates the group of legislators and wise rulers by dropping Solon and Zaleucis, and he replaces Minos with Titus, perhaps because Minos, so prominently displayed in Michelangelo's Sistine Chapel fresco *The Last Judgement*, was too closely associated with the regions of hell. Titus Vespasianus' story, on the other hand, invokes memories of Shakespeare's Prince Hal: after having lived a debauched life as a young man, Titus transformed himself into a model of virtue on becoming emperor of Rome in AD 79. The motivation for the artist having introduced this figure into the print may have been the hope that the Prince of Wales on becoming king might follow Titus' example just as he had up to that time by living a dissolute life. Lorenzo de' Medici and Alexander the Great are no longer present with the other patrons. Barry introduces Cosimo de' Medici in Lorenzo's place, even though he cites him in his discussion of the artists rather than the patrons.

At this point in his narrative, Barry jumps to the artists, whose ranks have been greatly reduced, but the most significant change in this part concerns Apelles. The viewer, left to imagine its content, can now only see the back of Apelles' canvas. The end of his brush also touches the circumference of the solar system behind him. No angel is shown supporting this particular globe; it is the artist who, unaided, best encapsulates universal meaning.

The ranks of the poets and writers are also pruned. Barry moves the supporters of peace to the left side above the Glorious Sextumvirate, and to their number he adds the Irish philosopher Bishop George Berkeley and Juan de Marianna, the Jesuit, who was best known for his history of Spain. While Barry's interest in Spanish history, particularly that country's involvement in its American colonies, was a growing fascination, inspired largely by his friendship with General Francisco Miranda, he was even more attracted to Marianna's book *De Rege et Regis Institutione*, a work that will be discussed in the context of his 1793 print, *Lord Baltimore*. The virtuous pagans Brahma, Confucius and Manco Capac extend this group to the left. Returning to the print's central foreground, Barry concludes his account of identifiable figures with the theologians Pascal and Butler, who are still prominently positioned above the Judging Angel. By putting them last in his description, the artist reaffirms their importance.

In *Tartarus*, the dramatic lightning bolt that passes through the head of the lion is perhaps intended as a political statement prompted by the French Revolution. The lion in the mural, who inflicts misery upon the sinners, now must himself suffer. Perhaps Barry is alluding to the British lion, which the Almighty rebukes for its counter revolutionary bias.

A Catholic perspective

In describing her visit to Barry's house on 26 October 1779, Susan Burney mentions seeing 'a representation of Elysium, & another of Tartarus', subjects that he had yet to introduce into the mural in the Great Room. Her further remarks make clear that these two preparatory images were for a single design:

– the concluding Piece is however far advanced – this we saw at His own House – it represents Elysium – In a Groupe sit the younger Brutus, Sir Thos More, Cato, the Elder Brutus, Socrates, & Epaminondas – the idea of introducing Sir Thos. More in company wth. all these ancients Mr. Barry says he borrow'd from some passage in Swift's works, but I know it not – Locke, Boyle, Shaftesbury & many more compose another groupe – in a 3d. appear 2 angels unveiling an Orrery to Sir Isaac Newton, Copernicus, Bacon &c – Above are Angels incensing the Creator, who however is invisible – but the idea seems a little catholic – a groupe of Poets are merely

sketched – the Bards of all nations & ages will be here assembled from <u>Homer</u> down to <u>Gray</u>. – the Painters & sculptors occupy another place, among whom are Phidias and Apelles. – to conclude the scene a representation of Tartarus strikes one – not as you will believe in the most pleasing manner in the world – Fire is ascending from a Pitt into which a <u>Warrior</u> is tumbling headlong, a Gamester with Cards in his hands – a Miser wth. a bag of money grasp'd in his hands – a Nobleman whose face is not seen but whose Star & Garter distinguish him &c – [40]

Burney begins her description with the Glorious Sextumvirate and then discusses two groups that proceed from right to left before concluding with the poets and artists. Assuming Barry's arrangement at that point was in accord with his final resolution, the important group of legislators goes unmentioned. Perhaps the surprise of the artist's use of a relatively obscure passage in Swift made that group Burney's starting point. She also states the obvious – the 'Angels <u>incensing</u> the Creator' is an idea that 'seems a little catholic' – yet she curiously is the only commentator to suggest a Catholic bias in the treatment of the subject matter. Possibly such a detail stood out more in the smaller confines of the studio sketch than it does in the actual mural.

Another reason that the religious imagery has been so frequently overlooked is that at first glance the mural appears to be an exclusively humanist programme with the angels merely suggesting an otherworldly setting. From this vantage point it is through humanistic study and critical enquiry, not through faith, that man realises his full potential. But as we saw in the section 'Angels and theologians: Christian symbolism at the mural's core', Christian imagery permeates the design.

In addition to the guardian angel already discussed, Barry alludes to another Catholic precept that would have proven even more offensive to Protestants. Given the inflammatory nature of its content, he makes the allusion even more discreet. All of the figures in *Elysium* are dispersed among the clouds, with the sole exception of Gabriel/Christ, who sits upon a piece of rock next to the craggy cliff. A large key lies at his feet, adjacent to which is the padlock that secures the chain sealing off Tartarus from Elysium. In more than one passage in the Book of Revelation, angels are associated with the key to hell, as in 'I saw a star fall from heaven unto the earth: and to him was given the key of the bottomless pit' (9:1). But the combination in Barry's mural of the rock with the key also recalls Christ's charge to Peter, a charge that forms the basis for papal authority:

> And I say also unto thee, That thou art Peter, and upon this rock I will build my church; and the gates of hell shall not prevail against it.
> And I will give unto thee the keys of the kingdom of heaven: and whatsoever thou shalt bind on earth shall be bound in heaven: and whatsoever thou shalt loose on earth shall be loosed in heaven.
> (Matthew 16:18–19)

St Peter traditionally greets souls at Heaven's gate, and the conflation of him with the Gabriel/Christ figure requires little effort on the part of the perceptive Catholic viewer.

Overall Barry's experience of Rome underlies his conception. One thinks back to the impressive rows of portrait busts of emperors and philosophers lined up on shelves in the Capitoline Museum or the lines of Roman patricians carved in relief on the Ara Pacis. Then, too, as in the Vatican's *Stanza della Segnatura*, the mural concentrates heavily on the ancients and the moderns. It is as if the figures in Raphael's *School of Athens* have joined those of an up-to-date *Disputa*. But the greatest influence of all, one that is never mentioned, is to be found in the myriad ceilings and domes throughout the Eternal City, where a host of biblical figures and saints populate elaborate cloudscapes. In these

ubiquitous ceilings of Baroque Rome, glorifying a Catholic heavenly kingdom, one finds the primary source of inspiration. Furthermore, the Judging Angel performs a psychostasis, the weighing of souls, and the entire composition evokes the Last Judgement, with the saved on the left and the damned on the right. Barry even took into account the Great Room's actual orientation: God's light is seen in the mural's upper-left corner on the room's east side, whereas *Tartarus* occupies the lower-right corner on the room's west side. Taken in its entirety, *Elysium and Tartarus* shows not only a Christian Last Judgement but one that, as we have seen, is viewed through a Catholic lens. In addition, as we shall see in terms of the artist's later alterations, whether in the creation of new print details or in proposed and actual changes to the murals themselves, his emphasis on Catholicism became increasingly more pronounced. Yet even in the 1783 conception, one barely has to scratch the surface to see a Catholic tincture to his narrative, a perspective that sets the stage for approaching the hidden meaning discussed in part two.

RECEPTION

CHAPTER NINE

Art in a Commercial Society

Going public

The Society of Arts opened its doors for the first exhibition of Barry's murals on Monday 28 April 1783, the same day that the Royal Academy commenced its own annual exhibition.[1] The artist would have welcomed comparison with this rival exhibit, his murals providing examples of the kind of high-minded historical compositions that the Academy was failing to foster. Until this moment, he had kept his series largely inaccessible, showing it only to a select few. The first recorded instance of his showing his work in progress, as already mentioned, occurred on 26 October 1779, when he gave a tour of both his studio and the Great Room to the Burney party, which consisted entirely of women. Another occasion occurred shortly before 1 May 1782, the date of a letter recording the visit of a distinguished group of three learned and intellectually curious men: 4th Earl of Bristol, Frederick Hervey, art collector and, as bishop of Derry, noted Irish patriot; Patrick Brydone, the Scottish traveller and writer; and the antiquary Sir John Cullum, the author of the letter describing the visit:

The next morning Mr. Brydone & myself took an early ride with my Lord [Bristol] & went first to the Society of Arts house in the Adelphi where we were entertained with a suite of paintings by Mr. Barry a travelled Irishman, who read us a long dissertation to explain all their parts & designs. They exhibit mankind in different states of cultivated life beginning with their first improvements under Orpheus, & concluding with a representation of all the illustrious persons who have encouraged or cultivated the arts & sciences, placed in various groups in Elysium. The whole appears a most noble design & well-executed – two of the pictures are 42 feet long.[2]

Thus a year before the first exhibition, Barry felt the works could be shown to knowledgeable and

important visitors, and it is of interest that not only had he completed a draft of his account, but he also felt the need to stick to his script. He clearly wanted feedback on the description he was preparing to put before the public, but he also had no desire to reveal any insights beyond his official text. He hoped that the murals would provoke prolonged discussion, but he was never willing to partake in this discourse beyond his written account. In this regard, the murals were intended to speak for themselves.

In the following year, Barry enlisted the help of Arthur Young, who appears in *The Distribution of Premiums*, to read the manuscript of his *Account*. Presumably Young, who was Charles Burney's brother-in-law, had also seen the murals. Typically Barry urges Young in his remarks to 'in charity spare not the rod as it may save the Child', even after having rebuffed him earlier in this same letter: 'I expect to find you on a wrong sent [*sic*] in what you call <u>my violence</u> and wch you may think <u>has been carried too far</u>, and I shall have a pleasure in setting you right as to that matter the first time we meet: You will find nothing has arisen from resentment, nothing from a desire of retaliating nothing from paultry interested views, such motives 'tho I might be inclined to make allowance for them in others I should reprobate in myself.'[3]

For the most part, the critical response was approving but under-whelming. The Society, whose members had enjoyed a private viewing on the Saturday before the opening, published its own resolution of 26th April in the *Public Advertiser*, characterising the series as 'a Work of great Execution, and classical Information, and must be deemed a national Ornament, as well as a Monument of the Talents and Ingenuity of the Artist'.[4] This same newspaper was to echo these same sentiments, even if it allowed a 'perhaps' to qualify its assessment, ranking the work as 'among the first in the first Class – accomplishing the chief Purposes of the Art, and perhaps nationally creditable, while it produces the fair Fame of the individual Artist who achieves it!'[5] Although his knowledge of painting was deplorably deficient, Samuel Johnson deserves the last word, because he instantly grasped the murals' intellectual complexity: 'Whatever the hand may have done, the mind has done its part. There is a grasp of mind there which you find no where else.'[6]

In a commercial society, the audience votes with its purse strings. In this instance 6,541 attendees paid to see Barry's murals. Just two years earlier, in 1781, when John Singleton Copley had exhibited his painting *The Death of the Earl of Chatham* at Spring Garden, almost twenty thousand customers had filed through the exhibit by the end of the first six weeks.[7] In portraying the earl's collapse in the House of Lords on 7 April 1778, Copley appealed to popular taste by focusing on a recent, dramatic moment of national history. This single picture had triple the attendance enjoyed by Barry's six murals. The Royal Academy's rival 1783 exhibition garnered 55,357 patrons, each paying a shilling. Samuel Johnson wrote to his close friend Hester Thrale in early May, commenting on the Academy's success and speculating on the extreme density of the crowds: 'On Monday, if I am told truth, were received at the door, one hundred and ninety pounds, for the admission of three thousand eight hundred Spectators. Supposing the show open ten hours, and the Spectators staying one with another, each an hour, the rooms never had fewer than three hundred and eighty justling [*sic*] each other.'[8] Judged by these standards, Barry's exhibition was an extreme disappointment. The public proved relatively indifferent to his murals on classical subjects. After he had continued to work on the murals during the following year, the Society held for him a second exhibition in 1784, when the gate came to 3,511. The artist's profits for both exhibitions totalled only £503 12s 0d, a paltry sum considering Reynolds could receive as much as two hundred guineas for a single full-length portrait.

Unlike Copley's and the Royal Academy's exhibitions, which were temporary, Barry's paintings remained on permanent view. In order to make the works more accessible to the casual viewer, the Society published in its *Transactions* of 1785 an abridged description made by its secretary,

Samuel More, from Barry's *Account*.[9] Then beginning in 1792, the Society periodically published this abbreviated account in the form of the pamphlet, *A Description of the Series of Pictures painted by James Barry ... preserved in the Great Room of the Society of the Encouragement of Arts, etc.*,[10] which, given its easy portability, proved effective in reaching a wide audience. After riding in a stagecoach from Baltimore to Washington DC, on 9 November 1818, the American artist Charles Willson Peale recorded in his diary how he was introduced to Barry's achievement when a fellow passenger produced a copy.[11] For Peale, as for many others, it was the magnitude of Barry's achievement despite so little support that most impressed.

The murals were Barry's greatest achievement by far, and he never fully relinquished working on the Great Room. He still, of course, needed to secure a sitting from the Prince of Wales in order to complete his portrait in the *Distribution*; and on 13 January 1790, after making this last addition, he wrote to the Society that the work was entirely finished. But, as we shall see in part three and in the two appendices, he continued in both prints and in the murals themselves to alter details in his compositions in an effort to modify and improve their content. In addition, he still hoped to substitute his own paintings for the portraits by Reynolds and Gainsborough over the fireplaces.

From the beginning, the Great Room was a monumental achievement. The Society honoured the artist's efforts by voting him on 16 January 1799 a gold medal and two hundred guineas and made him a perpetual member not subject to contributions.[12] Barry died on 22 February 1806, and after his body had lain in state in the Great Room, he was also accorded the honour of being buried in the crypt of St Paul's Cathedral next to Reynolds, another acknowledgment of the respect in which his series was held.[13] Respect, however, does not necessarily translate into comprehension. The series was more admired, and that somewhat tepidly, than understood.

The public's failure, then and now, to comprehend the artist's intent: they seeing see not, neither do they understand

In her book of 1842, the art historian Anna Jameson unequivocally acknowledged Barry's murals as the finest of their type by an artist of the English school: 'they are up to this time the greatest historical works of the English school.'[14] But no one quite knew how to assess their content and purpose. A decade earlier Allan Cunningham had cleverly skewered the murals for being irrelevant to British culture: 'But the heathen gods on Barry's canvass appealed to no popular sympathy – to no national belief – to no living superstition: the mob marvelled what they meant, and the learned had little to say.'[15] In their later survey of artists of the British school, published in 1866, the brothers Richard and Samuel Redgrave were like-minded, deploring the fact that Barry had not chosen a religious subject, having instead pursued a personal programme with little to communicate to his intended audience:

Barry, who, from his religious opinions and influences, and the great admiration he expressed of Raphael and Michelangelo, might have been expected to apply himself to religious art, was led away by classic influences while abroad, and at home by the only opportunity afforded him of exhibiting his powers. He devoted his life to a work on social culture, of which the heathen myths and sports are made to form the principal groundwork, and a half-classic Elysium the object and end. He, no doubt, owed his enthusiasm and devotion to art to the noble works of the master minds of Italy; and he toiled on, under good and evil report, at a work which, if too high for his art-power or mental culture, was yet treated in a manner of his own, and with little obligation to the inventions of the great painters whom he revered; he thus completed an epic in art, unique of its kind, the first, and, so far, the last which his country has produced.[16]

The Redgraves give Barry high marks for originality, but again the result is failure, albeit a bold one.

More recent criticism also finds fault with the nature of the attempt. The enterprise was doomed from the start because history painting itself was an anachronism in a commercial society. Such a culture valued only art that catered to private tastes, such as portraiture and landscape, rather than the high-minded rhetoric of the grand style. More interested in private consumption, this society was ill-suited for the transplantation of a Continental model based on an elite system of patronage relying on Church and state. Given the irrelevance of attempting a category of painting that was paid lip service but was fundamentally without an audience, it is no wonder that in 2006 Julian Bell detected in the murals only 'graceless bombast'.[17] Earlier in his 1995 book *Landscape and Memory*, Simon Schama, focusing on *The Triumph of the Thames* (admittedly the series' least successful painting), would also seem to have dismissed the artist's entire enterprise:

While he [Barry] echoed Joshua Reynolds (and Winckelmann) in asserting the classical maxim that 'the principal merit of painting as of poetry is its address to the mind', it was precisely in the conceptual department that he fell so woefully short. His *Commerce; or, The Triumph of the Thames*, one of six large paintings produced unsolicited for the society and exhibited in 1777 [*sic*], is a lamentable mishmash of allegory, history, and fluvial landscape that topples over into unintended comedy.[18]

In Schama's eyes, the unsupervised nature of the patronage is a damning weakness, but this book argues that the absence of collaboration and control opened up new possibilities for public art. His subsequent assertion that in this picture 'Barry's failure was as much of the imagination as of technique' is not only dismissive of allegory as a genre but also fails to grasp the Thames' role within the series' epic structure.[19] As part two will demonstrate, the Adelphi murals do not lack for imagination, but the extreme complexity of their visual and literary allusions do require a great deal from the viewer if he or she is to comprehend their grand, mythic dimensions.

Those who have praised Barry's endeavours have often concentrated on the nobility of his motives and the extraordinary personal sacrifice that went into his attempt. This theme was struck early and often, and no one stated it better than William Blake:

Who will Dare to Say that [*Fine*] <Polite> Art is Encouraged, or Either Wished or Tolerated in a Nation where The Society for the Encouragement of Art. Sufferd Barry to Give them, his Labour for Nothing A Society Composed of the Flower of the English Nobility & Gentry – [*A Society*] Suffering an Artist to Starve while he Supported Really what They under pretence of Encouraging were Endeavouring to Depress. – Barry told me that while he Did that Work – he Lived on Bread & Apples.[20]

In one sense, the greater his failure, the more poignant was his sacrifice.

This book advances a different argument. Although difficult to discern, the artist's message is not bombastic or conceptually deficient. There is a majestic, overarching vision that has never been addressed, albeit one that is extremely difficult to uncover, the artist having taken pains to conceal his message, in part because his meaning was unpalatable to the majority of the British as well as to those in positions of power. As already noted in the introduction, he hoped that the Great Room would become a meeting place for engaged viewers who would continually examine and discuss his pictures. As we also saw, this model accords well with Jürgen Habermas' analysis of the rise of the public sphere as a political arena in eighteenth-century urban societies. For the artist, his murals formed a cornerstone (from his grandiose point of view probably a capstone as well) for this ongoing civic debate. Although there might be variations in his viewers' responses, they would eventually arrive

at the same essentials in understanding the Secret Wisdom. In the process, a group identity would be forged, an identity, however, that is about more than fellowship. It is meant to be transforming, leading to social, political and religious change.

No major work in a public venue has been as misunderstood as this one. What will emerge in the following chapters is a more complete understanding of Barry's own statement as to his approach: 'The majesty of historical art requires not only novelty, but a novelty full of comprehension and importance.'[21] In demonstrating the validity of this pronouncement as applied to the Adelphi murals, this book will show that his series belongs among the great monuments of the Romantic imagination.

PART 2

THE HIDDEN AGENDA

CHAPTER TEN

Art as a Universal Language

Inverting Habakkuk's vision: Barry as a modern prophet

Barry repeatedly insists that his text to the murals is only introductory. The murals' address to the mind is intended to be difficult and thought-provoking:

It is an absurdity to suppose, as some mechanical artists do, that the art ought to be so trite, so brought down to the understanding of the vulgar, that they who run may read: when the art is solely levelled to the immediate comprehension of the ignorant, the intelligent can find nothing in it, and there will be nothing to improve or to reward the attention even of the ignorant themselves, upon a second or third view.[1]

In this declamation, the artist's paraphrasing of the Old Testament prophet is revealing. Habakkuk quotes God as telling him, 'Write the vision, and make *it* plain upon tables, that he may run that readeth it' (Habakkuk 2:2). In the United States at the turn of the last century, God's mandate to Habakkuk was frequently quoted as being particularly applicable to mural painting. In 1896, the critic William A. Coffin praised Robert Reid's nine panels recently unveiled in the Library of Congress in Washington, D. C.: 'It is gratifying to record the fact that his meaning is so plain that he who runs may read.'[2] Writing a few years later in 1913, the muralist Edwin Howland Blashfield approvingly echoed such sentiments: 'the decoration in a building which belongs to the public must speak to the people, to the man in the street. It *must* embody thought, and that so plainly that he who runs may read.'[3] In Barry's own time, the poet William Cowper echoed Habakkuk's meaning in his poem 'Tirocinium', which, begun in 1782, was completed in 1784. After denouncing truths that are too dearly bought because they are obscure, requiring too much in the way of 'philosophic pains' to unravel their

'pompous strains', he praises that which shines forth:

> But truths on which depends our main concern,
> That 'tis our shame and mis'ry not to learn,
> Shine by the side of ev'ry path we tread
> With such a lustre, he that runs may read.[4]

In his murals, Barry, a modern prophet, has written his vision for all to see, but significantly when he paraphrases Habakkuk, it is to reverse the prophet's meaning. He purposefully stands the tradition on its head, arguing for complexity over simplicity.

Barry is wedded to a well-established tradition that is the polar opposite of Habakkuk's view. William Blake pithily invoked this contrary tradition when replying in 1799 to Rev. Dr John Trusler, who had returned with numerous criticisms the first of the watercolours he had commissioned:

I feel very sorry that your Ideas & Mine on Moral Painting differ so much as to have made you angry with my method of Study. If I am wrong, I am wrong in good company … But you ought to know that What is Grand is necessarily obscure to Weak men. That which can be made Explicit to the Idiot is not worth my care. The wisest of the Ancients consider'd what is not too Explicit as the fittest for Instruction, because it rouzes the faculties to act. I name Moses, Solomon, Esop, Homer, Plato.[5]

Blake's list of names relies on Old Testament and Greek figures. It leaves out an important antecedent, the Egyptians, who with their hieroglyphic writing were thought to embody the principle of concealment. Furthermore, Christ himself stands at the head of this tradition. When the disciples asked him why his meaning was not readily apparent, he replied, 'Therefore speak I to them in parables: because they seeing see not; and hearing they hear not, neither do they understand' (Matthew 13:13). In pursuing this ancient hermeneutical tradition, Barry is following in Christ's footsteps as well as those of the Egyptian priests, the biblical prophets, and the Greek writers and philosophers.

Despite the difficulty of the tradition, Barry assures his viewers that no specialised knowledge is required to understand his meaning. He recognises that the eighteenth-century Englishman lacks a strong critical tradition in the visual arts, but this should not deter the viewer possessed of a solid general education from trusting his abilities to comprehend the paintings' message. He remarks that the examination of the series 'would be attended with less difficulty than people seem to be aware of, as it would be wholly free from the perplexities of picture jargon, and requires little more than liberal manly information, and some patience and attention'.[6] The murals conceal as much as they reveal. This goes to the heart of their meaning. The following chapters attempt to articulate the hidden subtext that, for the artist, is at the core of their meaning.

It is noteworthy that none of the artist's contemporaries recorded his intent; the hidden agenda remained well concealed. Presumably they did not record it because a portion of the message itself was too politically explosive. But before addressing the hidden meaning in the Adelphi murals, it would be helpful to sketch some of the traditional assumptions on which Barry relied for support in creating his own mythic narrative.

Based on the biblical account, Barry, as did his contemporaries, collapsed the creation of the world into a relatively short time frame. Such a perspective fostered a sense of a closely interconnected past that allowed for greater cohesion among disparate cultures, particularly Western ones. Within this telescoped world view, God had played an active part. From the beginning he was thought to have revealed himself to mankind, his earliest revelations being the most fundamental and therefore

the most important to reconstruct. The evidence that needed to be reconstituted was contained not only in the scriptures but also in the writings of ancient pagan authors. Together this body of material, known as the Ancient Wisdom or *prisca theologia*, was interpreted through a syncretic lens that emphasised continuity rather than difference. The pagan writings were thought either to have foreshadowed biblical truth or to have actually been derived from the Hebrew scriptures. Thus, the Ancient Wisdom both gave 'proof' of the Bible's veracity and demonstrated that religion's basic tenets were everywhere and at all times virtually the same. D.P. Walker gives a helpful overview of how the *prisca theologia* was seen as uniting pagan philosophy with Christian theology:

If a Christian wishes to believe in the existence of a series of Ancient Theologians who in some measure foreshadow the Christian revelation, he must assume or accept as historical fact the following:

Either that the only or main pre-Christian revelation was the Jewish one; but that this filtered through to the Gentiles, the usual channel of communication being Egypt, where Moses had taught the priests or left books.

Or that there were partial pre-Christian revelations other than that given to the Jews.

These are not mutually exclusive, since a Gentile revelation may be supposed to be reinforced or completed by a Jewish one. The first assumption is evidently more surely orthodox, since it safeguards the unique authority of the Old Testament, and this is the assumption adopted by the [Church] Fathers and the more cautious Renaissance syncretists.[7]

By placing Moses in *Elysium* in greater glory nearer to God, Barry acknowledged his extreme reverence for this figure.[8] Thus for the artist, Moses, an Egyptian born-and-bred prophet, must have been one of the primary founts from which knowledge flowed to the Greeks. Through him, the God-given revelations granted to the Hebrews were, at least in part, imparted to the pagan philosophers. The revered Hermes Trismegistus was thought to be a student of Moses, and the Greek Orpheus was next in line, having travelled to Egypt to learn, in his turn, from Hermes Trismegistus. In the sixteenth century, Philippe Du Plessis Mornay sketched out Orpheus' importance in bringing back the Ancient Wisdom to Greek civilisation (Pythagoras was soon to follow in his footsteps by also travelling to Egypt) and in affirming how much Orpheus' message was in accordance with biblical teachings, proving, as in his book's title, 'the trunesse of Christian Religion': 'Orpheus the ancientest of the Greekes, had been in Aegypt as hee himselfe saith, that there hee learned, That there is but one God … I sing (saith he) of the darke confusion, I meane the confusion that was in the beginning, how it was disfigured in divers natures, and how the Heaven, the Sea, and the Land were made, And what more? I sing (saith he) of Love, even of the Love that is perfect of it selfe, of more antiquity than all these things.'[9]

Walker outlines how this stream of Ancient Wisdom continues on to Plato and his followers:

From either or both these assumptions [that of a primarily Jewish revelation or an independent Gentile one] derive the lists of Ancient Theologians, all teaching the same religious truths, some of them with texts attached to their names, some without. A typical list, but fuller than any I have actually found, would run (the textless Theologians are in brackets): (Adam, Enoch, Abraham, Noah), Zoroaster, Moses, Hermes Trismegistus (the Brahmins, the Druids), David, Orpheus, Pythagoras, Plato, the Sibyls … The series culminates in the New Testament; but, since the main intention is to provide a Christian Platonism, it can be continued to include the Neoplatonists, as valuable interpreters of Plato.[10]

The Renaissance's interpretation of the writings of Plato and his followers (more the writings of the Platonists than of Plato himself) gave rise to Neoplatonism, which continued to make the important

Fig. 29 J. Collyer after James Barry, *Universal History*, late 1770s (?). Etching, 174mm x 104mm (image). Collection of William L. Pressly

linkage between Plato's teachings and Christianity, a linkage that becomes indisputable if one accepts as fact the fanciful assertion that his philosophy descends from the revelations contained in the Hebrew scriptures, which also become the foundation blocks for Christian belief. Numenius, the Platonic philosopher of the second century AD, summed up this connection in a single sentence when he asked the rhetorical question, 'What is Plato but Moses talking Attic Greek?'[11]

An engraving by J. Collyer[12] after a design by Barry documents the artist's belief, which was hardly exceptional, that the Bible best reveals mankind's historical record, with pagan accounts reflecting, rather than contradicting, its veracity. Unfortunately the publication for which this print was executed is still unknown,[13] but its meaning is clear. History, as seen in Cesare Ripa's emblem,[14] is personified as a woman writing in a large book. In Barry's image, in a flowing script she inscribes the phrase 'Universal History'. In the background on the left Father Time with his scythe slices off the top of an Egyptian obelisk. A bust of Solon, the statesman who is credited with having laid the foundations of

Athenian democracy, occupies the upper-right corner. Next to him are Corinthian columns, part of a temple, which, like the obelisk, have suffered the ravages of time. At the lower right is a slab inscribed 'ARUNDELIAN / MARBLES', a reference to the Earl of Arundel's collection of classical sculptures.[15] The names of four historians are inscribed on the books in the lower-left corner. The oldest is the history by 'SANCHONIATHO', the Phoenician sage who is said to have written his account before the Trojan War. Propped against this book is one by 'HERODOTUS', who is often called the father of history. These books rest atop two others, the first of which is by 'THUCYDIDES', the Athenian historian, and this volume lies on a book inscribed 'JOSEPHUS', referring to this author's first-century-AD history of the Jews.[16]

The primary focus is the exchange between the figure of History and the angel, who holds the Bible in one hand and either a medallion or a mirror in the other. The mirror is the more likely reading, as the image in the oval appears to be that of History herself, a reference to History's obligation to reflect truth. The Bible trumps all of the other accounts, but these other histories should not be seen as in opposition to the Bible, rather as in support of it, each, even if imperfectly, expressing aspects of the divine plan that runs through earthly affairs.[17] The earlier frontispiece to the 1707 edition of Bossuet's *Universal History* illustrates much the same argument, as the personification of History, ensconced in a library full of books, looks to Time, who pulls back the shutter and curtains to reveal biblical scenes illustrating that History's main concern is Christian revelation.[18]

Barry's imagery in his murals at the Royal Society of Arts relies on the tradition that purports to link Moses to Orpheus to Plato to Neoplatonism in a chain that transmits God's own message, with Barry himself being the latest in this long line of truth tellers. The fact that he works in a different medium, with images instead of words, is far from a liability. In evoking the phrase 'the universal language of art',[19] Barry was again echoing a traditional argument. With a myriad of languages, both ancient and modern, there is no one text that can reach all, but visual imagery is not only universal, it is also capable of expressing more than can be put into words. An image has the overwhelming power of immediacy, hitting the mind's eye with a single, forceful impact. Its compressed message is simultaneously more direct and more profound than the written word, as after the initial encounter it invites meditation that reveals ever deeper levels of meaning. It, too, is a language in the sense that it has its own vocabulary, a system of symbols and myths that convey deeper truths. In lecture 4, delivered in his role as professor of painting at the Royal Academy, Barry insisted that artists should adhere to traditional imagery, relying on the standard types of the received language rather than partaking in fanciful departures of their own: 'But the student cannot be too often reminded, that … he must in nowise indulge himself in any silly, unwarranted conceits of his own fancy. His invention must consist in the disposition of old, and not in the creation of new things. The figures and symbols he employs, must address the spectators in the language received, and well understood, and not in any short-lived emblematic jargon.'[20] Yet, while insisting on the old forms, his use of these conventions is extremely creative. Despite Christ's parable to the contrary,[21] he succeeds in his efforts to pour new wine into old bottles. The word most commonly used by art historians for this culturally based language is iconography, 'The representation of abstract ideas and concepts through a system of symbolic imagery'.[22] If one defines the history painter as an author composing in mankind's most exalted language, then from Barry's perspective, Samuel Johnson was unwittingly right after all when he wrote, 'The chief glory of every people arises from its authours' [sic].[23]

The Renaissance demonstrated a new passion for Egyptian hieroglyphics, which were considered to be an enigmatic image-script that encoded divine mysteries. Here again one hears reverberations of the Ancient Wisdom both in terms of this image-script's content and how that content was expressed.

In the introduction to his *Hieroglyphia sive de Sacris Aegyptiorum*, first published in 1556, J.P. Valeriano relates how hieroglyphics are closely related to the Bible:

I find that there is a likeness between this hieroglyphic way of teaching and our divine Scriptures; thus, everything that Moses, David and the other prophets uttered, inspired by the heavenly Spirit, they uttered with a certain mystic meaning. Indeed, in the New Testament, when our Deliverer [Jesus Christ] says: I will open my mouth in parables, and I will talk in ancient enigmas, what else does He mean than: I will speak hieroglyphically, and bring forth allegorically the ancient memorials of things?[24]

The fascination with emblems also grows out of this belief in an erudite play with image and text, which demands from the viewer/reader an extreme intellectual effort in order to divine its moral. In 1593 Cesare Ripa published *Iconologia*, his first handbook offering explanations of emblems that expressed complex thoughts. This type of book proved popular, and a 1709 English edition explains the supposed origins of Ripa's didactic emblems:

The Invention of this Science [iconology] is ascrib'd to the *Egyptians*, from whence *Pythagoras* brought it from the farthest part. *Plato* took the greatest part of his Doctrine from those Hieroglyphic Figures: The Prophets themselves veil'd their sacred Oracles with Enigma's: and our Saviour himself compris'd most of his divine Mysteries under Similitudes and Parables. These Emblems are very properly drawn under human Figures, since Man, being the measure of all things, so likewise his exteriour Form ought to be lookt upon as the measure of the Qualities of his Soul.[25]

Valeriano's assessment of hieroglyphics is in harmony with Ripa's concerning the purpose of emblems. In addition, Barry, along with his contemporaries, wholeheartedly agreed that the human form alone could express complicated, abstract ideas.

Revisiting the list of names that Blake offered to Rev. Dr John Trusler of the wisest of the ancients ('I name Moses, Solomon, Esop, Homer, Plato.'[26]), one sees the degree to which he honoured the lineage of the Ancient Wisdom in his beginning with Moses and ending with Plato. The history of veiled meaning, which can be seen so clearly in the context of hieroglyphics (or at least as they were then interpreted) and emblems, applies to history painting itself (what Blake refers to as 'Moral Painting'). In Raphael's *Stanze* or Michelangelo's Sistine ceiling, one encounters a complex and sophisticated use of iconography, in which biblical stories and scenes drawn from the past resonate with a deep symbolism expressing profound truths that the viewer is invited to 'read'. Barry's murals or history paintings, executed within the same iconographic tradition that was employed by the old masters, are equally demanding. Barry's English forerunners, such as Sir James Thornhill, employed sophisticated iconographical programmes in their allegories adorning such structures as Greenwich Hospital, and even Thornhill's son-in-law, William Hogarth, although illustrating commonplace contemporary narratives, also alluded to motifs drawn from the old masters not just for their idealising forms but also for their meaning, their iconography adding another layer of interpretation. For example, Leonardo's *Last Supper* provides not only a structure for Hogarth's print *The Cockpit* but also adds to its meaning in highlighting the gulf between the modern victim and his biblical forerunner. Barry's audience, while perhaps not fully conversant in the 'science' of iconology, would not have found it totally foreign to the ways in which they were encouraged to approach pictures.

Teaching a veiled, syncretic wisdom: *The Education of Achilles*

Barry's painting *The Education of Achilles*, exhibited at the Royal Academy in 1772, offers insights into how one should approach his later series. *The Education of Achilles'* narrative is simply told, but its meaning, encoded in a Greek inscription as well as in its imagery, belongs to a larger, demanding tradition that, embodying the principle of concealment, requires a certain level of knowledge to appreciate its message's mysterious power.

Barry's point of departure for this subject was the fresco of Chiron and Achilles unearthed in the excavations at Herculaneum, a work he saw on his trip to Naples in the winter of 1769–70. The recently rediscovered classical towns of Herculaneum and Pompeii, which had been buried in the 79 AD eruption of Mount Vesuvius, gripped the eighteenth-century imagination as they continue to do today. Although from 1709 to no later than 1716, Emmanuel Maurice de Lorraine, known as the Prince d'Elbeuf, oversaw the initial exploration at Herculaneum, excavations did not begin in earnest until October 1738, when the property was in the hands of Charles VII, the ruler of the Two Sicilies. These treasures were to form a cornerstone in the king's campaign to elevate Naples' status within the context of European culture. Digging proved arduous as the town was buried under a deep layer of compacted mud and ash, and the explorations were undertaken as a series of exploratory tunnels. Herculaneum provided a time capsule that only surrendered its objects as the diggers stumbled across them, the work being undertaken more in the spirit of a treasure hunt. No sooner was a valued object found than it was unearthed to be placed in the adjacent Royal Palace at Portici, where the king was to add rooms known as the Museo Ercolanese, whose floors were composed from the mosaics acquired

Fig. 30 James Barry, *The Education of Achilles*, *c.* 1772. Oil on canvas, 1029mm x 1289mm. Yale Center for British Art, Paul Mellon Collection, New Haven

Fig. 31 *'Chiron and Achilles' and Two Roundels.* Engraving by Roccus a Puteo Romanus Regius after a drawing by Francesco La Vega, 340mm x 243mm. Plate 8 in vol. 1 of *Le Pitture Antiche d'Ercolano*, 1757. Beinecke Rare Book and Manuscript Library, Yale University, New Haven

in the excavations. Barry encountered the fresco of Chiron and Achilles along with other works in this museum setting. Many visitors were particularly impressed by the utilitarian, household items, the kinds of utensils of daily life that do not normally survive, and Barry was no exception.[27] But the frescoes, too, were a highlight of the visit. Anna Riggs, Lady Miller, who was in Naples shortly after Barry, remarks on these works, 'The collection of antique paintings found at Herculaneum, painted on the walls, are conserved with the greatest care in glass-cases fitted to their size and shape. The pieces were sawed out with the utmost attention, having been previously secured from breaking, by frames of wood exactly of their size, contrived to hold them tight, and prevent the plaister from cracking in detaching them from the walls'.[28] Because the frescoes' exposure to air led to changes in the colouring, the works were varnished, a solution that produced its own set of problems. This was a wondrous opportunity to see a range of paintings from antiquity, with the Chiron and Achilles usually mentioned in the collection's first rank. Because visitors were not permitted to sketch or take notes, recorded impressions, both written and engraved, often contain inaccuracies, but in the case of Chiron and Achilles, the 1757 engraving after it offered a precise record of its composition.

The fresco was discovered on 28 November 1739. Found in a semi-circular niche, it is slightly curved. Unfortunately because the excavation notes are less than thorough, its exact relationship to other works is unknown.[29] Nearby a fresco of Medea had also been uncovered,[30] a picture that may have inspired Barry's missing painting of Medea, which he exhibited at the Royal Academy at the same time as his *Education of Achilles*. It is crucial, however, to recall that at the time Barry saw the fresco of Chiron and Achilles, it was most commonly described as having come from a temple of Hercules.[31] Later in the eighteenth century, the building was described as a basilica,[32] but at the time Barry encountered this work it was seen within a religious context, the same context in which his own painting should be viewed.

While on the grand tour, the poet Thomas Gray noted on 16 June 1740 that the Chiron and Achilles was 'one of the most considerable' of the frescoes, remarking on the boy's 'perfectly genteel figure' and how Chiron's hair and beard were 'very great, & bold in a Style like Rafael'.[33] In his description of two years later, published in 1748, James Russel declared that 'Chiron teaching Achilles to play on the harp' was 'one of the finest painted, and best preserved of any'.[34] These commentators, however, along with others, also found faults in the execution.[35] There was an awareness that these pieces did not represent antiquity's finest artistic expressions, an observation brutally articulated by Barry himself:

… I honestly think the large pictures of Chiron, and Achilles, and the other large pictures, which are the most talked of, are the least valuable: perhaps they might appear so much inferior to the rest, as they are brought nearer to the eye, than the painter intended they should be, which makes the inaccuracies of them so striking: but as you well know that these were but paintings upon the walls in a village, and were to be considered in no other light than as ornaments contributing to the coup d'oeil, of a room, so there is no danger that the works of the ancient painters (which were always portable, and on wood) will suffer in the least from any objections these may be open to.[36]

Such a negative assessment gave Barry the psychic distance he needed to compete with his classical source, its perceived mediocrity offering him more of an opportunity to improve on the rendering of so important a subject.

In his picture, Barry followed the fresco in making Chiron more massive and imposing than the adolescent Achilles, but for his primary inspiration for Chiron he turned to the celebrated Furietti Centaurs in the Capitoline Museums in Rome, combining the elongated torso of the more youthful

centaur, who also has a lion skin draped over his arm, with the imposing bearded head of his older companion.[37] In the case of Achilles, he emphasised the youth's effeminate delicacy. He retained the figure's nudity, an attribute of heroes, but increased this effect by foregoing his sandals, while at the same time adorning his head with an ennobling fillet.[38]

As in the Herculaneum fresco, Barry shows Chiron, one of antiquity's most renowned teachers, instructing Achilles on the lyre. But he adds a number of other attributes. He shows the centaur teaching philosophy, with the three extended fingers of his right hand forming a rhetorical gesture for the enumerating of points. Military prowess also forms an important part of Achilles' education, as Chiron, who himself wears a sword, points with his left hand to the spear, which leads the eye to the accompanying shield. Also sketched on the ground is one of Euclid's theorems. This world of art and science, pushed off-centre to the right, is set apart from the sheltered domestic scene on the left of the nursing centauress, who holds her infant to her breast while resting on the ground.

In his painting, Barry rejects the fresco's use of an architectural setting, creating instead one of his most evocative landscapes. The brooding and ominous mood demonstrates that the striving after wisdom involves a perilous journey. The landscape is dark, made all the more so by the cloud of divine wisdom descending on the left. The spiky, dead limbs of trees frame the sides, and the ground is flecked with blood-like reds. The left hand of Chiron pointing to the spear casts a shadow, the shadowy hand of death that points directly to Achilles. The viewer knows the hero's fate, and Achilles' milky-white, seductive body poignantly hides the vulnerable heel that will seal his doom when pierced by an arrow.

Barry's attraction to subject matter that highlights feet in peril prompted John Barrell to write at length regarding this emphasis in terms of fetishism.[39] The reasons, however, for his recurring interest in the injured foot is not born just from a private obsession but also out of a concern for the public's welfare, because it reflects his belief in a universal, mythic dimension driving human knowledge. In this regard, his 'foot subjects' can be seen as variations on the divine revelation to be found in Genesis, one of the books of the Bible said to have been written by Moses. Barry's first exhibited picture in London, *The Temptation of Adam* (National Gallery of Ireland, Dublin), shown at the Royal Academy in 1771, alludes to this prophecy by depicting the head of the beguiling serpent close to Eve's right foot with its elevated heel. After the Fall of Man, God placed a curse on both the serpent and on Adam and Eve's progeny, who are locked in perpetual, mortal combat:

And the Lord God said unto the serpent, Because thou hast done this, thou *art* cursed above all cattle, and above every beast of the field; upon thy belly shalt thou go, and dust shalt thou eat all the days of thy life:

And I will put enmity between thee and the woman, and between thy seed and her seed; it [her seed] shall bruise thy head, and thou shalt bruise his heel.
(Genesis 3:14–15)

The struggle between mankind and his sinful nature is played out in the symbolism of the attacking and attacked foot.[40] In Barry's first surviving history painting, *The Baptism of the King of Cashel by St Patrick* (Terenure College, Dublin), the king's foot is pierced by the saint's crozier, as St Patrick spikes it into the ground to free up his hands for the baptism. Thinking this was part of the ritual, the king remains motionless as a serpentine trickle of blood exits his wound.[41] But for Barry the accident mirrors reality, encapsulating the original curse. The baptism enacted by St Patrick at the top of the king's head is intended to wash away those sins symbolised by the king's lowest extremity, his bruised foot. The picture *Philoctetes on the Island of Lemnos* (Pinacoteca Nazionale di Bologna), painted in 1770, depicts a Greek warrior whose temporarily incurable wound is caused

by the bite of a serpent, an example of the biblical prophecy carried out in a classical context. The dove pierced by the arrow lying beside Philoctetes' right foot, next to the serpentine bow, is another religious allusion to this earthly combat. Returning to *The Education of Achilles*, one can see that the reference to the hero's vulnerable heel is pregnant with meaning that again is part of a larger discourse.

The enmity God decreed between mankind and the serpent also informs the subject on the shield showing the infant Hercules strangling the serpents that a jealous Juno had sent to destroy him. This was another subject treated in the frescoes recovered from Herculaneum,[42] and its later Christian associations are unmistakable. In his book *Polymetis*, which was first published in 1747, Joseph Spence makes explicit the Christian subtext, a subtext that was hardly original to Barry. He relates how a certain bishop who 'had found out most of the mysteries of the christian religion, in the very earliest writers among the Chinese' had continued this pursuit in terms of 'the remains of the Greek and Roman artists'. On one occasion, the bishop was present when Cardinal Melchoir de Polignac was showing to a group of friends a sculpture that he had just purchased of 'a young Hercules strangling the serpents'. When the cardinal turned to the bishop after the assembly had commented on such details as expression and attitude, the bishop unhesitatingly gave a Christian reading: 'I think of it … what I doubt not your Eminence must have thought of it, long since; it is most evidently, a representation of the great hero [Christ]; destroying the old serpent; by his being born into the world.'[43]

As in the case of Achilles, Barry's painting invites the viewer to reflect on Hercules' death. Hercules, too, had been instructed by Chiron, but his later contact with another centaur, Nessus, proved deadly. Nessus had tried to rape Hercules' wife Deianeira when carrying her on his back across a river, but Hercules, already on the farther bank, slew him with an arrow that had been dipped in the poisonous gall of the Hydra, the multi-headed serpent that Hercules had earlier slain. The dying Nessus, knowing that his blood was now contaminated with the Hydra's poison, tricked Deianeira into believing she should collect his blood as a powerful love potion. Later, in order to reforge her bonds with her straying husband, she sent him a tunic soaked with this potion. When he put it on, Hercules went mad from the Hydra's poison, dying an agonising death. His ultimate triumph, however, occurs when in death he crushes the serpent's head with his heel, as in the painted statue seen in *Crowning the Victors at Olympia*, bringing one back to God's original prophecy. Christ-like intimations are already present in the pose of the Infant Hercules, which echoes that of the Crucifixion, and the stark contrast between dark and light on the shield denotes the Manichean nature of this struggle between good and evil.

Looming behind the two main protagonists is a monolithic, cropped herm that ends in the sphinx-like head of a woman with an enigmatic smile and a veil across the upper part of her face. The herm represents Minerva, the goddess of wisdom, who, in this context, is synonymous with the Egyptian goddess Isis. Barry derived his conception from Plutarch's characterisation of the religion and philosophy of the ancient Egyptians as delineated in his treatise 'Of *Isis* and *Osiris*'. Plutarch describes how, after having been elected, the Egyptian king would be 'admitted unto the College of priests, and unto him were disclosed and communicated the secrets of their Philosophy, which under the veil of fables and dark speeches couched and covered many mysteries, through which the light of the truth in some sort though dimly appeareth'. Here there were no plain truths, for 'all their Theology containeth under ænigmatical and covert words, the secrets of wisdome'. Plutarch goes on to describe a Minerva that is the inspiration for Barry's herm: 'In the city of *Sais*, the image of *Minerva* which they take to be *Isis*, had such an inscription over it, as this: I am all that which hath been, which is, and which shall be, and never any man yet was able to draw my veil.'[44] Barry's Greek inscription on his herm, which translates into English as 'All Things: One and in One', harmonises

with the inscription described by Plutarch. The herm's impressive head, cropped by the picture frame, is draped with the veil that no man has lifted. Only in the afterlife, as seen in *Elysium*, will man be fully able to discern truth.

While Plutarch's treatise formed a textual source for the herm's presence, Barry's trip to Naples would also have provided a visceral experience of the importance of the Egyptian goddess. In 1764 a Temple of Isis was uncovered at Pompeii, marking the first time an Egyptian temple had been found intact. Again its major frescoes were whisked away to be displayed in the palace at Portici. Barry would have seen these works at the same time he viewed the *Chiron and Achilles*,[45] and he may well have visited the temple itself. The ash covering Pompeii was much less thick and compact than that at Herculaneum, and the entire structure of the temple, minus its roof, could be visited. This rediscovery of an intact Iseum, complete with the bodies of its priests and the remains of their last meal, caused a sensation that led to an early wave of Egyptomania throughout Europe. Barry would not have been immune to the excitement generated by this discovery,[46] and again, like others before him, he would have seen a Christian parallel with the myth of Isis and Osiris.[47]

Barry shows Chiron as a versatile teacher with wide-ranging knowledge, but, as in the fresco, the central lesson is to be found in the mastery of the lyre, an eleven-stringed instrument in the fresco that is reduced to four in the painting. This lesson represents not only the mastery of music but also of epic poetry for which it provides the accompaniment. In the painting's subsequent titles, this emphasis on music is paramount. When the work was put up for sale in 1792, it bore the title *The Centaur Chiron Instructing Achilles in Music*.[48] When later in 1808 the earl of Buchan was negotiating to purchase the picture from the artist Ozias Humphry, Buchan described it with even greater specificity as 'the excellent chef d'oeuvre of Chiron instructing the Young Achilles in the Hymns of Orpheus'.[49] These hymns were thought to contain the knowledge that Orpheus had acquired in Egypt and that, in their turn, laid the foundation for the Greek Eleusinian Mysteries. In his book *The Divine Legation of Moses Demonstrated*, volume one of which was first published in 1737, Bishop William Warburton describes one of Orpheus' revelatory hymns:

We now come to the HYMN celebrating the unity of the godhead, which was sung in the *Eleusinian mysteries* by the hierophant [priest], habited like the CREATOR. And this, I take to be the little ORPHIC poem quoted by Clemens Alexandrinus and Eusebius; which begins thus: 'I will declare a SECRET to the Initiated; but let the doors be shut against the profane. But thou, O Musæus [Orpheus' disciple], the offspring of bright Selene [the moon goddess], attend carefully to my song; for I shall deliver the truth without disguise. Suffer not, therefore, thy former prejudices to debar thee of that happy life, which the knowledge of these sublime truths will procure unto thee: but carefully contemplate this divine oracle, and preserve it in purity of mind and heart. Go on, in the right way, and see THE SOLE GOVERNOR OF THE WORLD: HE IS ONE, AND OF HIMSELF ALONE; AND TO THAT ONE ALL THINGS OWE THEIR BEING. HE OPERATES THROUGH ALL, WAS NEVER SEEN BY MORTAL EYES, BUT DOES HIMSELF SEE EVERY ONE.'[50]

That Barry's inscription on the herm, 'All Things: One and in One', accords well with this revelation as well as with that of Isis/Minerva is hardly surprising in light of the fact that Orpheus, as we have seen, reiterates the *prisca theologia* he had learned in Egypt, a lineage that is passed down and summarised in Neoplatonic thought. Man's spirit temporarily resides in a fleshly body, but his true home is in the divine world beyond the senses. In pointing to Achilles' head, the shadow of Chiron's index finger highlights the word in the inscription for the transcendent One that embodies the one-in-many. This One forms the eternal archetypes of all that exists. The lyre, which Achilles strokes with a plectrum, symbolises the divine harmony underlying all. Although the rubbed surface of the painting makes

it difficult to be certain, the inscription appears to be encircled by a snake with its tail in its mouth, the traditional symbol of eternity, which signified for the artist an even deeper meaning: 'the circle formed by the serpent with his tail in his mouth … was actually intended to typify the eternity of the supreme mind or intellect.'[51]

While the figure of Isis/Minerva, which is representative of the most profound wisdom, and the Orphic hymns, which convey this wisdom, fuse ancient Egyptian with classical learning, this same spirit invoked by 'All Things: One and In One' is present, as we have seen, in Christianity. One can hear it echoed by St Paul in his Letter to the Colossians: 'Christ *is* all, and in all' (Colossians 3:11). Barry's painting gives testimony to there being a seamless truth, for those who can see it, that unites Egyptian and classical priests with those of the Christian religion.

In the world of myth, all things are indeed one and in one, every part being related to and animated by a greater whole. Its universal language is not a limiting, reductive vocabulary, but rather its images resonate with transforming glimpses of the divine mind or soul in ways that are far more powerful than mere words could ever be. In his mind Barry had recreated the kind of ancient prototype for which the provincial fresco offered only a faint shadow. In using the fresco as a point of departure, he, too, was creating a sacred image, but unlike the fresco, his work is densely packed with multiple, rich allusions available only to those who could read myths in a syncretic fashion. Such a mindset provides a model for how best to approach his murals. In addition, the subject of Orphic hymns as providing the best instruction leads directly into the Adelphi series' first painting showing Orpheus himself accompanied by his lyre instructing primitive listeners.

The erotic power of Barry's art: the myth of androgynous unity

In his art, Barry enthusiastically embraced Greek conventions of the heroic male nude and those of the enticing female, their idealising forms exhibiting a high-minded, moral component. In *Crowning the Victors*, Hercules is the physical embodiment of fortitude and courage, and the athletes of austere discipline. Venus in *Venus Rising from the Sea* (National Gallery of Ireland, on loan from Dublin City Gallery The Hugh Lane) is made up of those soft, gently undulating curves that Edmund Burke so articulately defined as embodying the beautiful in his *Philosophical Enquiry into the Origin of Our Ideas of the Sublime and Beautiful* of 1757. Admittedly Barry's early attempt to encapsulate female beauty is somewhat perfunctory, a by-the-book approximation of the Medici Venus in the Uffizi, but other invitations to ponder the passive female form are indeed bewitching. The Nereid reclining on her back in *The Thames* is a seductive siren, and Pandora's pose in the painting *The Birth of Pandora* (see fig. 40) is also languorously inviting. But as the picture *Jupiter and Juno* (Sheffield City Galleries) cautions, women's dangerous power is not to be trusted – a reminder, if one was needed, that Pandora's beauty is intended solely as a trap for hapless man.

In terms of his biography, Barry seems to have been conflicted over his feelings of sexual desire, the enticing female, as in his art, being simultaneously desirable and dangerous. Although he enjoyed the company of women, there is no record of his having engaged in any serious courtships in London. However, the only letter he apparently had bothered to save when travelling in Italy reveals his unrequited passion for an Italian woman, who was too carefully chaperoned by her mother. In the company of his fellow painter John Francis Rigaud, Barry had set out from Rome on 22 April 1770 in order to visit a number of northern Italian cities on his way back to London.[52] In Bologna the two men met the English portraitist and expatriate William Keable,[53] who, born in 1714, was almost the same age as 'Athenian' Stuart, another of Barry's mentors. Keable was instrumental in getting his protégé

accepted into the Accademia Clementina, and after Barry had left for Parma, Keable wrote him a letter that reads in part:

My Dear Barry.

I recd. your dolefall Letter two days after its arrival in which you tell me of your damn'd Melancholly, and that you are also half dead wth cold, that in your present state you can compare yourself to no other object so like as that of a poor languishing Fly, who on a Chimney-piece is crawling upon his last Legs. If this is truly your present Case I own it is very deplorable, yet I'm convinced youl get the better of it, because I remember you in a situation as I think much worse, when not far from a certain Chimney you play'd the part (gia per forza d'Incantesimo) [already under the spell of sorcery] of an Insect much more abject than a Fly (cioe) [namely] that of a wretched bewildered Piatoli [crab-louse] who in the seems of a Wollen Pettecoat had lost his way, and tho' within the smell of his cara Partria [beloved homeland since 'Patria' is the intended word] such was his dappocaggine [ineptitude] that he never arrived there …

– methinks I hear you exclaim the Devil fire the Black-guard he will not write me one word of news – patience old Friend – dammè [damn it] but I would have begun my Letter wth news if I had had any, I have been two or three times to the wonted Grotto where I allways found the dear Object and Authur of your present qualms of tenderness, unaccompanied, as Cold, Insipid, Indeferent, and Industrous as when she was at the Side of her Pastor fido [faithful shepherd]. dice che Barry è veramente un buon uomo, e la Mamma responde si, è vero, è un buon Figliuolo, e che hanno avuto gran piacere che se ne parti cosi eroicamente [she says Barry is truly a good man and the mother responds yes, truly a good fellow, and they were quite pleased that he left so heroically]. Truly my dear Barry this is all the news I can send you in regard to them.[54]

Keable's bawdy letter says more about him than Barry, but the depth of the Irishman's passion is unmistakable.[55]

While seductive women populate Barry's art, so do enticing males. Barry's homoerotic *The Education of Achilles* shows a different type of bonding, that between a Greek *erastes*, or senior partner, and an *eromenos*, his submissive junior partner. The contrast in skin tones between Chiron and Achilles is marked: the darker skin of the former juxtaposed with the milky-white flesh of the latter mimics the formula normally employed for contrasting males and females. Chiron is a masculine, dominating presence, who despite his considerable erudition and knowledge still embodies aspects of the wild barbarity associated with centaurs, even if Barry chooses to hide his pointed ears within his crown of hair. Achilles, on the other hand, is the 'effeminised', passive recipient of his mentor's attentive instructions. His body is soft and yielding, his hair composed of seductive, wavy, golden ringlets. Immature and innocent, youthful, naked and vulnerable, this ephebe is both warrior and woman, an androgynous figure inviting male desire.[56] He is similar to the adolescent Cupid in Barry's *Birth of Pandora*. This Cupid is not a lustful suitor for Pandora's hand – rather theirs is representative of a spiritual love, striving for a divine union. While Achilles' genitals are hidden from view, the lyre, on which he plays Orphic hymns, protrudes from his lap. These hymns, revelatory of life's mysteries, give him his other-worldly potency. The viewer, who, as is traditional, is presumed to be male, does not wish so much to make love to him as to become him, embracing his example of a self-contained, refined and delicate love that combines both male and female.

The figure of Orpheus in the first mural of the Adelphi series shares in this effeminate portrayal of the male form as do the attenuated athletes in *Crowning the Victors*. These athletes are Barry's attempts, like a modern Pygmalion, to bring classical sculpture to life. The marmoreal surfaces of such androgynous statues as the *Belvedere Antinous*, the *Apollo Belvedere*, the Vatican's *Meleager*, the *Capitoline Antinous* and the Uffizi's *Apollino* become in the mural palpable, soft flesh.[57] Barry's

athletes embody an androgynous aesthetic that is simultaneously masculine (well-muscled, sublime exemplars of awe-inspiring divinity) and feminine (beautiful passivity, exhibiting the sensual pleasures of voluptuous, pliant flesh). As such, they hold out the promise of a psychic wholeness, the lost perfection of a primal unity. Representing the quest for spiritual and intellectual enlightenment, such figures as these embody a narcissistic dream of self-sufficiency and total fulfilment. In them, ones sees, and thereby achieves, the path to the Platonic fulfilment of one and in one, resolving in a rapturous, mystical, cosmic union those troubling tensions found in this all-too-worldly flesh.

CHAPTER ELEVEN

The Classical World's Christian Allegory

When Barry first conceived his programme for the murals at the Society of Arts, three depictions of the Olympic Games were to occupy half of the entire room not already occupied by the two portraits over the fireplaces. As will be shown, *Crowning the Victors at Olympia* contains a Christian subtext in which the celebration of Diagoras is analogous to a papal procession. In this telling, the sacred, pagan games provide a foundation for the Roman Catholic Church. At this time, the mural *Orpheus* formed the sole lead into this subject, the room's climactic focal point. As an appropriate introduction to this Christian subtext in *Crowning the Victors*, Barry relied on the traditional association of Orpheus with Christ, thereby having Christ's ministry prepare the way for the Church's apotheosis. But when he dropped the idea of having subjects from the Olympic Games spill into the two adjacent walls, he created instead *A Grecian Harvest-home* as an intermediate stage between *Orpheus* and *Crowning the Victors*. In this new configuration, *A Grecian Harvest-home* alludes to the Nativity as well as intimating the Eucharistic sacrifice. At this point, the Orpheus/Christus analogy in the introductory painting became chronologically out of sequence; if Orpheus is intended to prefigure the preaching of the adult Christ, then the prefiguration of the Saviour's birth and childhood in the next painting is out of place. In order to make the painting *Orpheus* fit the final conception, Barry associated Orpheus with St John the Baptist, thereby introducing Christ's forerunner before introducing Christ himself in *A Grecian Harvest-home*.

First conception: Orpheus as a classical prefiguration of Christ

The best-known example of the early Christians associating a pagan mythological figure with Christ is that of Orpheus. This tradition began early and continued to flourish,[1] but it was in the seventeenth century that it burst with a new force into European consciousness with the rediscovery of the frescoes of Orpheus/Christus in the Roman catacombs. From the end of the second century to the beginning of the fifth, many of the early Christians were buried underground in labyrinthine cemeteries, often on multiple levels, cut into the soft tufa rock in and around Rome. These catacombs are filled with *loculi*, which are rectangular, horizontal cuts made for one or more bodies that would then be sealed over. There are also *cubicula*, or underground chambers, often with elaborate fresco decoration. Beginning in the sixth century with the removal of the martyrs' relics to churches, the sites ceased to be destinations for pilgrims, and these underground cities of the dead slipped virtually into oblivion. By the Renaissance, very few were still known, and it was not until 1578 that the first catacomb to be found since antiquity was accidentally discovered by workmen.[2] Antonio Bosio (1575–1629) was the individual who did the most in recovering this lost world, earning in the nineteenth century the title 'the Christopher Columbus of the Roman catacombs'.[3] In 1593, while still a teenager, Bosio discovered Domitilla's catacomb,[4] and in all he was responsible for uncovering around thirty new complexes. Of greater significance was his posthumous publication *Roma Sotterranea*, which first appeared in 1632 and was profusely illustrated with engravings of frescoes, sarcophagi, and inscriptions. This publication was reissued in 1651 in an expanded Latin edition titled *Roma Subterranea Novissima*, which proved popular enough to go through several more editions. Barry was familiar with Bosio's achievement: in the first book he published, which appeared in 1775, he cited the Italian edition of Bosio's work as a valuable resource for those interested in pursuing the decline of the arts from the time of Constantine.[5]

Fig. 32 *Orpheus in the Catacomb of Domitilla*. Engraving, 213mm x 318mm. In Antonio Bosio, *Roma Sotterranea*, Rome 1632, p. 255. Beinecke Rare Book and Manuscript Library, Yale University, New Haven

One of the rooms prominently featured in Bosio's work is the *cubiculum* of Orpheus in Domitilla's catacomb. On the wall opposite the entrance, the most important of the four sides, in the recessed lunette of the *arcosolium* (or arched tomb) is a depiction of the poet/priest Orpheus with his lyre amidst tame and wild animals from which the *cubiculum* gets its name. The engraving only barely indicates the large tomb that lies beneath, having moved the fresco that occupies its back wall to its front edge, and the recessed horizontal cuts pictured at the top and bottom of the engraving are *loculi* that were later dug into the walls without concern for the decoration's integrity.[6] On the *arcosolium* façade are, from left to right, the Old Testament prophet Micah pointing to a city,[7] a seated Mary with Christ in her lap, a defaced portion that may have shown the Three Wise Men, and Moses striking the rock. But it is Orpheus, wearing a Phrygian cap and a long tunic, who commands the primary focus. Seated, he plays the lyre with his left hand while pointing heavenward with his right. The animals on the left are two camels, an ox, and a dove and peacock in a tree; on the right are four doves in a tree with two lions beneath.

Orpheus' associations with Christ are on multiple levels. He is an example of the Good Shepherd, and his playing the lyre underscores his eloquence as a teacher who can impart an understanding of the universe's fundamental harmonies, thereby introducing mankind to the civilising arts of culture and peace. His later death at the hands of the Thracian women foreshadows Christ's sacrificial death, and his lyre is itself, according to Bosio, a symbol of the cross.[8] Particularly relevant to funerary art, he is honoured as a psychopomp, a leader of souls out of hell as he had done when attempting to rescue his wife Eurydice. With the positioning of the fresco above the main tomb. Orpheus/Christus, a resurrection figure, rises from out of the grave,[9] and the *loculum* that was later cut into the fresco's base only reinforces this concept. On the centre of the *cubiculum*'s ceiling is a fresco of Christ himself,[10] underscoring his presence within the Orpheus narrative.

Catholics seized on this early Christian imagery as, in their minds, strengthening the Catholic Church's claims to authority. Counter-Reformation propaganda used these decorated labyrinths to remind believers of the antiquity of the Church's heritage with its apostolic succession extending back to St Peter himself. English tourists were often reluctant to acknowledge these spaces as holy sites, arguing that slaves as well as Christians were buried there, and deriding the idea that the dead were necessarily martyrs. On a trip undertaken in 1770 and 1771, just after Barry had left Rome, Lady Miller mentions her visit to the catacombs, and her tale is told entirely in the mode of Gothic horror. She likens this gloomy, damp world, 'a labyrinth of very narrow passages, turning and winding incessantly', to 'the veins in the human body'.[11] At one point, finding herself alone, she attempted to leave, only to be held tight after her dress, unbeknownst to her, had been snagged by an iron bar from a grate: 'My heart, I believe, ceased to beat for a moment, and it was as much as I could do to sustain myself from falling down upon the ground in a swoon'.[12] Finally, reunited with her party, she underwent yet more terror: 'as we were retiring, the poor guide, whom my imagination had represented as an assassin, told me, that there was a pit amongst the Catacombs, of which the bottom could never be discovered; and he had been told, that formerly a great many people had been abused, robbed, and flung into it'.[13] Lady Miller wisely concluded, 'I determined within myself that this visit to the Catacombs should be my last'.[14] During his long stay in Rome, Barry surely would also have visited the catacombs, and such a first-hand experience would have proven equally indelible even if the conclusions he drew would have differed from those of Lady Miller. At the very least, he knew the engravings in Bosio's book, and the marriage of classical pagan iconography with Christian iconography in the Orpheus fresco in Domitilla would have, for him, offered further confirmation of his belief in a syncretic Ancient Wisdom.

The sacrificial lamb at the lower right of Barry's *Orpheus* offers another Christian allusion. The artist goes out of his way to provide a lamb instead of a bull or heifer, a mature sheep, goat, swine or

Fig. 33 Gaspard Dughet with Guillaume Courtois, *Landscape with St John the Baptist among the Animals*, 1652–53. Oil on canvas, 276cm x 378cm. © Arti Galleria Doria Pamphilj s.r.l.

another animal that would be equally suitable for a classical, pagan sacrifice. For his audience, the lamb would unfailingly invoke Christ, 'the Lamb of God, which taketh away the sin of the world' (John 1:29). Furthermore, the smoking censer, while appropriate to a classical sacrifice, would, in a Christian context, have been associated only with Catholic ritual, the Anglican Church at this time having abandoned such a papist practice.[15]

Final conception: Orpheus as St John the Baptist

The addition of *A Grecian Harvest-home*, with its own Christological references, required Barry to alter the way in which Orpheus was interpreted in a Christian context. The artist shifted the emphasis from Christ to St John the Baptist, Christ's forerunner. Primarily, he invokes this association through Orpheus' pose. As early as 1842, the perceptive nineteenth-century art historian Anna Jameson remarked on the similarity of Orpheus' pose with that of the traditional iconography for St John the Baptist: 'The figure of Orpheus is taken, I suspect, from the St. John Preaching in the Wilderness, of Raphael – but borrowed and applied, as Raphael himself applied the ideas of others.'[16] Barry's figure is even closer to Reynolds' *St John in the Wilderness* (Wallace Collection, London).[17] In this context, it is explicitly critical of Reynolds' light-hearted creation, returning its rhetoric to the type of grand and serious subject matter for which it was intended. Jameson argues that this type of borrowing is what one would expect of an academic artist, and need not imply any meaning beyond the skilful and appropriate adoption of a pose suitable for an orator addressing sacred subjects from one figure, St John, to another, Orpheus. Yet Barry's sophisticated use of iconography to convey hidden meanings suggests there is more here than meets the eye.

Some aspects of Orpheus' story even fit better with John than with Christ. Both preached in the wilderness, and both were, at times, identified with a strong misogynistic bias. Sir Francis Bacon's characterisation of Orpheus, in fact, sounds a lot like St John the Baptist: 'Orpheus falling into a deep melancholy [after losing Eurydice], became a contemner of Women kind, and bequeathed himself, to a solitary life in the Desarts.'[18] Subsequently both, too, were beheaded because of women: in Orpheus' case the Thracian women decapitated him after tearing him apart, and in John's case he was beheaded at the behest of Salome and her mother Herodias. Other references associable with John are the water for baptism in the middle distance in Barry's picture and the sacrificial lamb in the foreground. The lamb stands for Christ, but it is John who utters the words, 'Ecce Agnus Dei' ('Behold the Lamb of God'), thereby introducing Christ's mission to the world.

There is as well a visual reference in which Orpheus is associated with St John the Baptist, or, more accurately stated, St John the Baptist is associated with Orpheus. In Barry's lifetime, as now, Gaspard Dughet's painting Landscape with St John the Baptist Among the Animals, executed in collaboration with Guglielmo Cortese (Guillaume Courtois), hung in the Palazzo Doria Pamphilj in Rome. This large picture is one of seven religious subjects commissioned by Camillo Pamphilj and executed in 1652–53 that form an upper band around the walls of the grand entrance room to the palace.[19] In each case, Dughet executed the landscapes with Courtois supplying the figures. In St John the Baptist Among the Animals the placement of the saint within a context associated with the subject of Orpheus charming the animals with his music creates an unusual iconography. The main reason for this surprising conceit arises from the picture's function within the Pamphilj collection. The vast majority of the animals are borrowed from another painting in the collection, Jan Breughel the Elder's Earthly Paradise, in which the temptation of Adam takes place in the background while the primary focus spotlights the large variety of animals peacefully populating the Garden of Eden just before the Fall.[20] In St John the Baptist Among the Animals, the Baptist announces the coming of Christ, who is to redeem the world from the consequences of the Original Sin unfolding in Breughel's painting, but in this picture situated in the palace's entrance he also points the way to the rest of the collection. In his mural painting for the walls of the Society of Arts, Barry was only too happy to adopt for his own purposes the idea of this conflation of Orpheus and St John the Baptist, which he would have known from his years in Rome.

The Bible describes the Baptist as 'clothed with camel's hair, and with a girdle of a skin about his loins' (Mark 1:6). In the Pamphilj picture, while a camel-hair garment lies next to the Baptist on the rock on which he leans, he is draped instead in a cloth that is again more in keeping with Orpheus. Barry prefers as well an ennobling cloth tunic for his Orpheus/St John in order to differentiate him from his savage brethren. Yet the Orpheus/Christus figure is never entirely eliminated, even if this figure's principal function here is to announce the coming of Christ in the next picture.

Christ's advent in *A Grecian Harvest-home*

The reading of *A Grecian Harvest-home* as embodying a harmonious period in the development of classical civilisation is both satisfying and complex on its own terms, but Barry invites the viewer to see as well an alternate narrative. The Christian content in this image is insistent and unmistakable. The cluster of images to the left of the circling dancers have numerous elements common to the related scenes of the Nativity and the Holy Family (a detail of this part of the mural is reproduced as the frontispiece to the Contents). In this context, the seated young mother is Mary with the Christ Child on her lap. The Infant Christ plays with a bird on a string, a motif with a long iconographic history that

Fig. 34 Francisco de Zurbarán, *The Virgin and Child with St John the Baptist*, 1658. Oil on canvas, 1368mm x 1038mm. Gift of Anne R. Amy and Irene Putnam, The San Diego Museum of Art, San Diego

alludes to Christ's eventual death and soaring resurrection.[21] One impressive example of this motif is Francisco de Zurbarán's depiction of 1658, where the young St John the Baptist offers a goldfinch tied to a string to the Christ Child, whose agitated response testifies to his awareness of the bird's symbolism. Within Barry's rendering, the slightly older boy straddling the dog is St John the Baptist, and Joseph appears as the freedman standing in the rear of this Holy Family grouping.

In a review of the book of Barry's writings published after his death, Richard Payne Knight savagely criticised the artist's inclusion of the peacock atop the rustic shed, comparing it unfavourably to a work in Turin which he attributed to Rembrandt:

In the small picture of Rembrandt, which he [Barry] did not deign to notice – probably not to look at – in the palace at Turin, is a peacock; an object which he found expedient, not perhaps with strict propriety, to introduce in this large picture. But, in the work of the Dutch artist, it is most skilfully and judiciously employed to fill up the scale of rich and complicated harmony; while, here, it only produces a harsh glaring spot, which attracts the eye merely to offend it. Such is the effect of despising mean familiar objects, and Dutch imitators of them![22]

Unquestionably the peacock's size and colour make it intrusive, but its prominence alerts the viewer that it is more than a decorative accessory. As we saw, this bird is not to be found in Virgil's *Georgics*, the work's primary textual source, but, as 'the symbol of immortality … derived from the legendary belief that the flesh of the peacock does not decay',[23] it is frequently encountered in Nativity scenes, one example of which is Fra Angelico's and Fra Filippo Lippi's *Adoration of the Magi*.[24] The ox and ass do appear in Virgil, but they are also standard participants in paintings of the Nativity in keeping with Isaiah's verse, 'The ox knoweth his owner, and the ass his master's crib' (Isaiah 1:3).

Fig. 35 Fra Angelico and Fra Filippo Lippi, *The Adoration of the Magi*, c. 1445. Tempera on panel, 1372mm. diameter. Samuel H. Kress Collection, National Gallery of Art, Washington DC

In light of these visual clues linking this stage of classical civilisation with the coming of Christ, the emphasis on Ceres and Bacchus can be seen in a religious context as well. The two deities, whose gifts to mankind are grain (i.e. bread) and wine, allude to the Eucharist, an association that Barry is hardly the first to make. In the print (see fig. 9), while the scale and role of the peacock and the Holy Family have been reduced, the addition of the bunch of grapes spilling over the sheaf of grain is another means by which the image's Eucharistic message is conveyed. In the painting a large bowl of wine and in the print a pitcher are being brought up to the musicians, and the container of wine in each is superimposed on the wagonload of grain. In terms of the harvest, there is a movement from left to right: the prominent apples hanging at the far left symbolise the Fall, which the grain and wine will now redeem. Finally, by splitting in the margin of the print Dryden's four lines of his Virgil 'translation', Barry places the most crucial pair directly beneath the title:

> Bacchus and Fostring Ceres Pow'rs Divine
> Who gave us Corn for Mast for Water Wine.
> (*Georgics I*, lines 9–10, as rendered in the print)

Thus, not only the painting's iconography but also its presumed Eucharistic textual source all underscore the picture's concealed narrative of Christ's birth and its meaning for humanity.

The most celebrated example of Virgil's supposed affinity to Christianity was not to be found in the *Georgics* but rather in his *Fourth Eclogue*, in which he was thought to have prophesied the birth of Christ, a prophecy that was based on writings of the Cumaean Sibyl. The Emperor Constantine in his *Oration to the Convention of the Saints* appears to have been the first to put forth the contention that this eclogue, written around 40 BC, contained a Christian meaning.[25] By the time Dryden published his translation, this thesis was axiomatic. Dryden's 'Argument' to his translation affirms this 'truth': 'Many of the Verses are translated from one of the Sybils [the Cumaean], who prophesie of our Saviour's Birth.'[26] In the eighteenth century, Alexander Pope wrote his poem 'Messiah', to which his 'Advertisement' again confirms that Virgil's poem, based on a sibylline prophecy, foretells the coming of Christ and furthermore is related to the writings of the Old Testament prophet Isaiah.[27] Given *The Fourth Eclogue*'s prominence as the prime source for Virgil having anticipated the coming of the Christ Child, it seems likely that Barry, in evoking the Latin poet in a Christian context in terms of the *Georgics*, was counting on the viewer also to make this well-known, self-evident connection.[28] *The Fourth Eclogue* foretells the descent of 'A golden Progeny from Heav'n' (line 10), resulting in a 'glorious Birth' (line 12) that will usher in a new era of virtue, peace and plenty. Again, the linkage of grain and grapes (lines 33–4) provide Eucharistic overtones. The boy's mother is interpreted as Mary, and a sentence such as 'The Serpents Brood shall die' (line 28) also dovetails nicely with a Christian reading. The poem even links up with the preceding mural: 'Not *Thracian Orpheus* should transcend my Layes' (line 66). As seen in the first mural, Orpheus, too, had foretold of Christ's coming, but even his songs are not to outstrip the one Virgil now sings.

It is important to recall that the word 'Eucharist' is derived from the Greek word for 'thanksgiving'. In this regard, it refers not only to the consecrated bread and wine but also to the rite itself – a solemn thanksgiving celebration – the main subject of Barry's picture. The mural encapsulates both the coming of Christ and the thanksgiving communion instituted by him at the Last Supper. The pensive, sweet sadness of the dancers shows their sympathetic awareness of the sad fate that awaits the Christ Child, the painful sacrifice that must be endured before his final victory over death.

Papal primacy and papal powers: The Donation of Constantine, the Magna Carta of the See of Rome

In *A Grecian Harvest-home*, Barry borrowed the motif of the child astride the dog from the Vatican fresco *The Donation of Constantine*, a design often credited to Raphael even though executed after his death by Giulio Romano and Gianfrancesco Penni. In the fresco, this motif occupies a prominent place: positioned in isolation in the foreground directly beneath the principal scene of the emperor kneeling before the pope, it is difficult to overlook. In their descriptions of the Vatican *Stanze*, Giorgio Vasari and the Richardsons, father and son, all mention this detail.[29] No one, however ascribes to it a meaning. It is rather a delightful diversion, helping to animate and draw the viewer into the foreground. In appropriating this motif, Barry relies not on iconography to convey his message but on synecdoche, where he uses a part to conjure up the whole. While the iconography of the Holy Family associates the boy with St John the Baptist, the artist's borrowing from *The Donation of Constantine* operates on a different level.

The Vatican fresco memorialises the moment in the fourth century when the Emperor Constantine supposedly granted to Pope Sylvester and his successors not only spiritual supremacy but also temporal dominion over the Western world.[30] Even when the fresco was executed, this claim was controversial, Laurentius Valla in 1440 having already demonstrated that the document recording the donation was a forgery. The fresco was intended as a bold statement bolstering the papal claim against such detractors. As Jonathan Richardson Sr and Jr expressed it for their English readers in 1722, the donation was 'a sort of *Magna Charta* [*sic*] of the See of *Rome*'.[31] Thus Barry subtly introduces into his painting a detail that would recall for the attentive viewer a story of papal supremacy over secular power. Just as on the level of the classical narrative the figures wrestling in the background of *A Grecian Harvest-home* prepare the viewer for the next picture showing the Olympic Games, on the level of the Christian allegory the boy on the dog prepares the viewer for the next picture's focus on the Roman Catholic Church.

Fig. 36 Giulio Romano and Gianfrancesco Penni, *The Donation of Constantine*. Fresco. Scala/Art Resource, NY, Sala di Costantino, Vatican

The Olympic Games and the Roman Catholic Church: a continuum

In the preface to his eighteenth-century ancient history, Charles Rollin writes concerning the observance of classical religion, 'Games and combats made a part of the religion, and had a share in almost all the festivals of the ancients'.[32] The Greek Olympic Games and the Roman Secular Games were important components of those societies' religious traditions. Furthermore there is a long-standing tradition of Christianity identifying with the image of the pagan athlete. In his First Epistle to the Corinthians, the Apostle Paul makes the analogy between pagan contests and the Christian's journey through this world, when he compares the crowning of the winner of the foot-race and the crowning of the boxer or pancratist to that of a Christian victor:

Know ye not that they which run in a race run all, but one receiveth the prize? So run, that ye may obtain.

And every man that striveth for the mastery is temperate in all things. Now they *do it* to obtain a corruptible crown; but we an incorruptible.

I therefore so run, not as uncertainly; so fight I, not as one that beateth the air:

But I keep under my body, and bring *it* into subjection: lest that by any means, when I have preached to others, I myself should be a castaway.

(1 Corinthians 9:24–27)

In his history, Rollin refers to Paul's analogy, but he goes on to point out how Tertullian, an early Church father, had extended it to apply as well to martyrs:

St. Paul, by an allusion to the Athletæ, exhorts the Corinthians, near whose city the Isthmian games were celebrated, to a sober and penitent life. *Those who strive*, says he, *for the mastery, are temperate in all things: Now they do it to obtain a corruptible crown, but we an incorruptible.* Tertullian uses the same thought to encourage the martyrs. He makes a comparison from what the hopes of victory made the Athletæ endure. He repeats the severe and painful exercises they were obliged to undergo; the continual anguish and constraint, in which they passed the best years of their lives; and the voluntary privation which they imposed upon themselves, of all that was most affecting and grateful to their passions.[33]

For St Paul and Tertullian the spiritual value embodied in classical games also illuminates the course and conduct of the Christian life.

Extending the traditional analogy between the classical athlete of virtue and the committed Christian, Gilbert West in his *Odes of Pindar … To which is Prefixed a Dissertation on the Olympick Games* provides a lengthy comparison between the Olympic Games and the foundations of the Roman Catholic Church:

the great Dignity and Authority of the *Hellanodicks* was founded solely upon this Power of Excommunication; …Whether the Thunders of the *Vatican* were forged in Imitation of those of *Olympian Jupiter*, I will not determine; tho' I must take notice, that many of the Customs and Ordinances of the *Roman* Church allude most evidently to many practised in the *Olympick Stadium*, as *Extreme Unction*, the *Palm*, and the *Crown* of Martyrs, and others; which may be seen at large in *Faber's Agonisticon*.[34]

In alluding to 'others', West affirms that the connections are numerous, and one presumes among their number he would have included the insistence on a male hierarchy. In citing Petrus Faber's sixteenth-century book *Agonisticon*, he is also at pains to ground his observation within a larger Renaissance

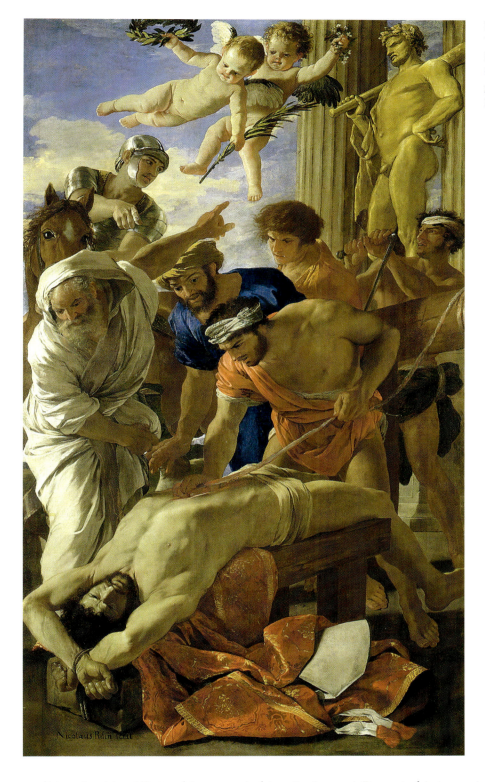

Fig. 37 Nicolas Poussin, *The Martyrdom of St Erasmus*, 1628–29. Oil on canvas, 320cm x 186cm. Pinacoteca, Vatican

tradition. In citing West as his source in his 1783 *Account*, Barry, in his turn, signals his awareness of this argument that the Olympic Games could be interpreted as having laid the foundations for the Catholic Church. A closer look at the artist's imagery places it within this tradition.[35]

Barry's interpretation of the lesser judge handing a palm to the foremost victor at the same time he places a laurel-like crown on his head alludes to the imagery of Italian Baroque art inspired by the Counter-Reformation, where martyrs are frequently shown being awarded palms and crowns. Nicolas Poussin's well-known *Martyrdom of St Erasmus*, executed for St Peter's Basilica in 1628–29, is one such example, where an angel hovers overhead holding a palm branch and a laurel crown, while his companion is about to throw flowers.[36] Although the crowns of the victors at Olympia consisted

of olive leaves, which is how Barry correctly identifies the wreaths in his text, in the painting he shows something closer to the laurel crowns that are associated with Christian martyrs. By facing the crown downwards he also differentiates it from the laurel crown Pindar wears as a poet. It is no accident that one of Barry's preparatory studies for these athletes was in the twentieth century misidentified as an Ecce Homo, an identification that, while technically incorrect, gets to the heart of his conception.[37]

In his writings as well as his art, Barry connects Olympic practices with Catholic ones, extending the analogies made by Gilbert West, who had demonstrated how sports in the classical period were imbued with important cultural, political and religious concepts. In his book of 1793 on his prints after the murals, Barry writes of the popes' invaluable contributions to European culture, citing this as a defence, despite gross excesses, for the continued existence of the Papal States:

those arts which have civilized and polished Europe were the consequence of that culture derived from the independence and even to say the worst criminal affluence of the Roman Pontiffs, which could never have been expected, had that see depended on the emperors. After all this, when it be recollected that the affairs of religion, like every thing else in this world, are committed to the hands of men, and not of angels, and that every man is answerable but for the use or abuse of his part of it, there is no great matter for complaint. Christian charity may be admirable and amply exercised on all sides, and what remains to the popes at present (like the sacred territory of the Eleans) is nothing more than sufficient to preserve that decorum and becoming exterior which for the honour of Europe it should not want: and a speculator upon the quantum of political happiness in this age of inquiry and effort for civil improvement might, every thing fairly considered, be justified in supposing that the portion of territory which the church possesses in Italy, could not be in better hands than those of the literate, peaceful, exemplary veterans in which it is placed.[38]

Fig. 38 Giorgio Vasari and Workshop, *Pope Gregory XI Returns to Rome from Avignon in 1376*, 1573. Fresco. Sala Regia, Vatican

A 'truce of God' had protected the territory of the Eleans, where the games were held, permitting all participants to attend in safety regardless of which Greek states might then be at war. Barry advocates extending this Olympic custom to the papal territories, another instance of continuity between the classical culture and the Christian one. In his *Letter to the Dilettanti Society* of 1798, he returns to this refrain: 'what could any man say of the sacred territory of Elis, which might not be affirmed ... of the papal government at Rome?'[39] He reiterates the special relationship between the papacy and the arts: 'The infinite importance of such a government as the Papal to the arts which humanize society, has been long an object of my deepest meditation.'[40]

For the modern viewer stepping back and viewing the composition as a whole, the full extent of Barry's radical scheme becomes clear: in terms of the Christian narrative the classical procession is to be seen as a papal progress. Such a connection between Olympic and papal processions would have come naturally to him in light of West's linkage of Olympic rituals with Catholic ones. The pope carried in his *sedia* is the central motif for numerous illustrations of papal processions,[41] and little imagination is required to associate images such as that of Pope Gregory XI being carried along in

Fig. 39 Raphael, *The Expulsion of Heliodorus*, 1511–12. Fresco. Alinari/Art Resource, NY, Stanza d'Eliodoro, Vatican

his *sedia* supported by graceful attendants with that of Diagoras borne aloft by his sons. There is also a close visual analogy between Barry's Diagoras borne in triumph on his sons' shoulders and Pope Julius II in Raphael's Vatican fresco *The Expulsion of Heliodorus*, where the pope is supported in his *sedia* by young male attendants, one of whom is Raphael himself. Given Barry's constant citing of the Vatican frescoes as the closest forerunner of his own attempt, he intends the viewer to make this connection.

Barry's inscription in the margin of his 1792 print (see fig. 13) records that Diagoras was descended from a still greater antecedent:

The famous Diagoras of Rhodes carried on the shoulders of his two Victorious Sons amidst the joy & exultations of the Nations assembled at Oly[m]pia. Pausanias relates that this illustrious family the Diagorides were descended from ARISTOMENES the Messenian, whose whole life appears a brilliant texture of the noblest Services rendered to his Country & whom the Delphic Pythia pointed out as the best & most distinguished Man of all the Greeks.

In the classical narrative, Diagoras looks back to Aristomenes; in the Christian narrative he looks back, as do all the popes, to St Peter. In one sense on entering the Great Room, the dominant focal point is the artist's newly minted Pope Diagoras, the Holy Father who is borne in triumph on the shoulders of his children, the sons of the Church.[42]

The mural contains other Christian allusions. Within the long history of the Games, the number of judges varied from one to a maximum of twelve, but no source gives the number as three.[43] The

three enthroned judges at the far right are a reference to the Holy Trinity; a commanding Christ is the principal figure, and to the left (Christ's right) is the white-bearded profile of God the Father, while a saturnine Holy Spirit sits at the right.[44] The artist closely juxtaposes God the Father's head with Christ's, and he positions the Holy Spirit's left arm in such a way that it can be confused with Christ's left arm; all these features are elements that help to underscore the doctrine of the Three-in-One.[45] In the classical account, the central judge instructs the attentive scribe to inscribe the victor's name into the Olympiad; in the Christian account, Christ directs that the saint's name be recorded in the Book of Life.

As discussed earlier in 'Raphael as forerunner: when the centre no longer holds', the strict symmetry of Raphael's frescoes, the artist's stated model for his own series, is a reminder that Barry went out of his way to decentralise all six of his compositions. Raphael's works, executed for the pope, embody fixed, immutable principles, but for Barry the contemporary world had lost sight of these ideals. Only when British culture again embraces those truths embodied in its Catholic heritage will a harmonising symmetry again be possible. Although in *Crowning the Victors* the main group of Diagoras and his sons is off-centre, it is still worth remembering that Socrates occupies the exact centre of both the painting and the 1792 print. Socrates is frequently seen as a classical counterpart to Christ; both died for the highest principles after refusing to reject the cup placed to their lips. Again, in *Crowning*, Barry embeds another hidden Christian analogy. Although Socrates/Christ's placement is central, his presence is still understated; in terms of modern life his importance and centrality are, as here, too often and too easily overlooked.

Barry reaffirmed the mural's purpose in his concluding remarks describing the 1792 print. As shown in chapter 4, he closed with lines from Fénelon's *Les Aventures de Télémaque* (*The Adventures of Telemachus*) that offer an eloquent plea for political unity resulting from the awareness of the brotherhood of man. Such a state of affairs will bring with it 'an everlasting bond of perfect amity and concord'. Implicit in the future archbishop of Cambrai's call for peaceful harmony brought about by the consolidation of social institutions is a return to one unifying Church. The procession of the Olympic Games, which brings together all of Greece, transforms into the establishment of its heir, the Roman Catholic Church, which is that institution that can best unite all mankind. At the core of its mission is the promotion of the arts within the same rules of fairness as established by the Olympic Games. When one perceives that the painting's meaning is that the classical world forms a foundation for Christianity with the Catholic Church, properly understood, embodying the finest aspects of that tradition one can understand why Barry placed so much emphasis on this picture and why he needed as well to disguise its overarching significance.

Barry was not suggesting that the Olympic Games should be reconstituted in eighteenth-century London. What he attempted to resurrect was the Games' religious and social underpinnings. He envisioned the reconstitution of a social order based on competition where the envious mediocre were not allowed to suppress those exhibiting true merit because authority, be it the Games' original judges or the papal government of modern times, ensured the promotion of excellence. One also witnesses the continuity of civilisation, classical Greece here anticipating the contemporary Roman Catholic Church. England was outside this cultural mainstream, and the mural's English audience remained ignorant of its larger meaning.[46] Few, if any, would have recognised Diagoras as a classical prototype for the papacy. Yet for the discerning, at civilisation's apex is the artist's celebration and defence of Catholicism.

Because there was no way that the Society of Arts would have accepted a painting extolling the Catholic Church, the artist had to conceal this part of his meaning. Barry, however, did not invent the traditions on which he relies, that of the virtuous pagan athlete or the connection between the rigours of athletic training and those undergone by the Christian martyr. His echoing of Counter-Reformation imagery is also more than mere coincidence. In addition, his primary textual source – Gilbert West's treatise on the Olympic Games, one that he references in his own text – evokes correspondences between the sacred nature of the Games and the Catholic Church, its modern heir. But West's textual analogies between the Games and the Church, along with the artist's own analogies, both textual and visual, proved for his audience to be insufficient. The problem lay not so much in the obscure nature of the references as it did in the seemingly irrelevant nature of the analogy. His audience simply was unprepared to see a relationship between the classical Games and Catholicism. Even those who had read West's account would have been unlikely to recall his brief, offhand remarks. Rather than reject Barry's analogy, his public was simply oblivious to its existence.

How could Barry, who did not die until 1806, continue to keep his secret? Would not the tension between the need to conceal and the desire to reveal have proven too great? The answer is that his frustration over his audience's lack of comprehension did indeed provoke him to even greater revelations. As appendices one and two repeatedly document, he continued to emphasise a Catholic agenda in the large print details he executed after the murals and in the changes he made to the murals themselves. It is worth repeating here one of the more telling of the texts of the later prints. In his inscription, added sometime between 2 May 1798 and June 1800, to *Detail of the Diagorides Victors* (see fig. 64), Barry, more clearly than ever before, chose to tip his hand, although significantly he resorted to composing his inscription in Italian. In English translation, it reads, 'This group of Diagoras and his children taken like a little bouquet of flowers from the painting of the Olympic victories and in testimony of the deepest and most affectionate veneration and thanks is painted to adorn the exemplary and triumphant course of the papal government of Rome, mother and gracious protectrice of the praiseworthy creative arts by James Barry'. Here he boldly equates the classical procession with 'the exemplary and triumphant course of the papal government of Rome'. Despite this blunt assertion, albeit one made in Italian, his contemporaries continued to turn a blind eye to his meaning. Unlike the artist, they did not comprehend history painting's exalted purpose and consequently never devoted to the murals the careful scrutiny that they required.

Modern life and institutions

Barry's two paintings of modern society, *Commerce or The Triumph of the Thames* and *The Distribution of Premiums*, were not part of the original plan he had conceived in Rome, and he added them because of their relevance to the Society of Arts. But they also comment on aspects of the modern world that have improved on the civilisation of the ancients. Modern scientific instruments have led to advances in navigation that promote commerce as an agent for global enlightenment, and in the painting of the Society, women enjoy a more prominent position than they had in any of the earlier pictures, highlighting their role in social progress. All in all, however, these modern advancements are essentially minor – all we truly need to know is contained in the type of religious and social order encapsulated in the classical narrative. The ideal civic identity is to be found in ancient Greece, whose heritage continues into modern times in the governance of the Roman Catholic Church. The origin of St Paul's Cathedral seen over the parapet in *The Distribution of Premiums* is Catholic, and Christopher Wren's dome, the part of the current cathedral seen in the mural, was inspired by Michelangelo's dome

to St Peter's in Rome and François Mansart's dome to the church of Val-de-Grâce in Paris, both of which adorn Catholic sanctuaries. In this way the spirit of the 'true' Church hovers over London in the background.

On one level much of the series' content can be experienced from a sensitive reading of the stories themselves, but this visual language, like any language, also requires a learning process. In the *Distribution*, the painting hanging on the massive pier showing St Michael casting down Satan is intended to recall the classical counterpart of Jupiter with his thunderbolts casting down the offending giants. In the modern world, the earlier formula is reversed; now a Christian subject refers to its classical counterpart. Barry's modern audience must relearn the pagan lore in light of God's revealed truth within a larger, syncretic vision. To appreciate the climactic painting *Elysium and Tartarus*, this knowledge of the veiled meanings underlying both pagan and Christian teachings, at least as interpreted by Barry and his modern sources, is essential if one is to grasp this level of the work's content.

Elysium and Tartarus: the contributions of two Anglican bishops

The final mural, *Elysium and Tartarus* continues and completes what the first half of the series had begun. There is now only a thin veneer between the classical narrative and the underlying Christian one; the Christian Heaven and hell have supplanted the classical Elysium and Tartarus in everything but name only. In the foreground of *Elysium*, although Barry carefully avoids portraying biblical figures with the exception of a remote Moses, they are still thought of as being present – closer to God's radiant being, they are distanced from the viewer's sight. In *Tartarus*, the Christian seven deadly sins are featured, barely disguised with different wording. In the large print detail *The Angelic Guards* (see fig. 69), the pretence is dropped altogether as one of the archangels has a cross emblazoned on his diadem.

Arguing by analogy: *Elysium*'s Bishop Butler

The central foremost figure in *Elysium and Tartarus* helps to unlock one of the sources of inspiration for Barry's conception. Just above the doorway and closest to the discoursing angel stands Bishop Joseph Butler, clutching to his breast his book *The Analogy of Religion, Natural and Revealed, to the Constitution and Course of Nature*, published in 1736.[47] According to Edward Fryer, Edmund Burke had introduced the artist to this book at a time of spiritual crisis. Fryer maintains that for a time after his trip to Italy the artist's belief in revealed religion faltered, until Burke induced him to read Butler.[48] By the phrase 'revealed religion' Fryer means the belief that God has directly intervened in the affairs of men, showing them his will through the miracles, prophecies and the life of his son as set forth in the scriptures.

In its assault on revealed religion, natural religion or deism had proved a potent force in English thought in the first half of the eighteenth century, flourishing in a climate of opinion that had placed traditional Christianity on the defensive. For one thing, bitter conflicts among a seemingly endless stream of religious denominations had led some to doubt the validity of revealed religion. Because there had been so many disputes over what exactly had been revealed, the doctrine of revelation was itself called into question. In addition, the scientific advances being made by men such as Sir Isaac Newton challenged supernatural events as a plausible explanation for the course of human history. Nature no longer seemed so mysterious or forbidding but was now conceived as a great machine operating according to natural laws. It was also felt that man not only could perceive the Creator in

this external world, but he had only to look within to find God's laws inscribed in the human heart. Although the Bible with its supernatural framework had been discarded, natural religion did not challenge Christianity's basic premises: the deists were in agreement that there was but one God, that his laws were righteous, and that mankind would be rewarded or punished in a future existence according to their conduct in this world.

If Fryer was right, Barry's intense experience of Rome was the crucial event that had shaken his faith. In this city both the classical heritage and the Christian stood side by side. For some, Rome was the physical embodiment of how the Christian experience had been enriched by the pagan world, Christian churches literally growing out of classical temples. For them Christianity had not rejected what was valuable in the earlier civilisation but had incorporated it into a still greater truth. Others, however, were inclined to view the two worlds as antithetical, many churchmen throughout the centuries having viewed pagan culture with suspicion and hostility. But in Barry's day there were a growing number of influential writers who held up classical civilisation as a superior epoch that could be used in the war on a barbarous Christianity. In this regard philosophers such as Voltaire frequently employed the pagan classics to attack the Church, and of course it was under the inspiration of Rome that Edward Gibbon undertook his epic history *The Decline and Fall of the Roman Empire*, in which Christianity is viewed as one of the principal culprits in Rome's subversion. Through the many translations that were available to him, Barry knew intimately the great works of classical literature, and on arriving in Rome he gloried in the visual remains of this monumental civilisation: 'really and indeed I never before experienced any thing like that ardour, and I know not how to call it, that state of mind one gets on studying the antique. – A fairy land it is, in which one is apt to imagine he can gather treasures, which neither Raffael nor Michael Angelo were possessed of.'[49] It is no wonder that the contrast between this ancient splendour and the less than glorious reality of modern Rome must have shaken his faith, the pagan civilisation having apparently outstripped the Christian even within the pope's own city.

Butler's book, one of the most profound theological treatises of the eighteenth century, provides one of the intellectual foundations for Barry's construct. First of all, it should be noted that Butler was in agreement with the arguments made in favour of natural religion, asserting that because natural laws were of divine origin, God's will is discernible in the course of nature, and reason is to be accepted as a guide to life. He stresses, however, that man's knowledge is woefully incomplete as he can never know the entirety of God's plan. Since God is the author of nature and since much that is in nature is inexplicable to man, then it follows that if God were to choose to reveal himself directly to man, much of the revelation would be equally obscure. Therefore our experience of nature demonstrates the probability of revealed religion, for the difficulties found in the constitution of nature are analogous to the difficulties found in the scriptures. This celebrated analogy of natural religion with revealed religion leads us to infer the truth of the Bible, because our experience of the first confirms the probability of the latter.

Barry, following Butler's lead, also argues by analogy. He in effect resolves the tension between the pagan world and the Christian by retelling the Christian story in a classical vocabulary. *Orpheus* announces the coming of the Messiah; *A Grecian Harvest-home* introduces him in his youthful innocence while at the same time foreshadowing his tragic destiny; and *Crowning the Victors at Olympia* establishes the Catholic Church as that institution which carries on his ministry. Through the method of analogy, the classical world is seen to offer a Christian paradigm. At the same time it provides a strong foundation on which the Church could build. For the artist, however, the classical world should not be confused with a deist perspective. It, too, shared in divine revelation, as can be seen in the heavenly cloud that descends in the first mural to touch Orpheus' head in order to inform and inspire his understanding.

Barry also would have responded sympathetically to Bishop Butler's stress on man's ignorance in this world, a gloomy assessment that was unusual in an age noted for its optimistic response to mankind's potential. Man is the only one of God's creatures who is called upon to complete his own nature. Natural law and revelation are purposefully obscure, since if all were known or knowable, fulfilment would require little or no effort on man's part. Unlike many of the deists, neither Bishop Butler nor Barry was guilty of underestimating the effort required to struggle toward the realisation of God's will for man. Fryer's characterisation of Barry's painting *Elysium and Tartarus* is entirely accurate; he pointed out that though the figures are variously grouped, the action is uniform and that action is 'the acquisition and discussion of *reserved* knowledge'.[50] In this life it is impossible to perceive the whole, but the principal joy of heaven consists in acquiring that knowledge reserved for the next.

If the pursuit of an elusive happiness through knowledge is the principal theme of these murals, one of its primary metaphors is that of light. In the dawn of *Orpheus*, mankind is shown as emerging from darkness into light; the twilight of *A Grecian Harvest-home* marks the closure of a harmonious moment in civilisation's progress; and a golden sky illuminates civilisation's apex in *Crowning the Victors at Olympia*. *Elysium*, on the other hand, is eternally flooded with those rays emanating from God, while *Tartarus* is cast in a gloom as dark as *Elysium* is bright. Such imagery is of course commonplace, and the very phrase for this period – the Enlightenment – makes use of this archetypal symbolism. It was a time during which the penetrating light of reason was perceived as purging society of those superstitions and errors that had for centuries shackled its most brilliant minds. But it again should be emphasised that Barry's series does not reflect the sense of a brave new world that was a commonplace of Enlightenment aspirations. Rather his murals stress the difficulties and danger that are implicit in the painful struggle from darkness to light. One should be reminded that Orpheus, the hero of the first painting, was torn limb from limb by the Maenads, and of course St John the Baptist, who in the Christian narrative is present in this figure of Orpheus, also died a violent death. Christ, who is literally the light of the world, is present in the second canvas, and he, too, died at the hands of men who could not tolerate his illuminating message. In *Crowning the Victors at Olympia*, Aristophanes mocks the great statesman Pericles, and the victorious athletes who solemnly receive the palms are purposefully meant to recall the sacrifice and dignity of Christian martyrs. Throughout these paintings there is a pensive, sober quality that suggests that the pursuit of happiness is indeed a melancholy affair.

Interpreting Virgil's *Aeneid*: Bishop Warburton and the Eleusinian Mysteries

Another Anglican bishop whose writings also engage a deist objection to Christianity was William Warburton, bishop of Gloucester. Warburton's book *The Divine Legation of Moses Demonstrated on the Principles of a Religious Deist* (2 vols., 1737 and 1741), passages from which have already been quoted, is critical for understanding Barry's mural *Elysium and Tartarus*. Although Warburton obligingly died in 1779 in time for inclusion in the mural itself, Barry, despite his indebtedness to the bishop's argument, refrained from including him alongside Butler. Presumably Warburton's stiff opposition to Roman Catholicism made him less than an ideal candidate for joining the elect.[51]

As Warburton points out, the deists and Christians were in agreement on the importance of a belief in the afterlife that will mete out either rewards or punishments as merited by the conduct of each individual's life. In this regard, religion and civil society were seen as going hand in hand. Religion, with its emphasis on a future state, is essential to curbing private vices, thereby providing a restraint that makes civil government possible. The deist and Christian attitudes toward a final retribution underpin Barry's mural, being incorporated into the full title of the work itself.

The two views diverged, however, in that deists argued that natural religion is all that is required

for the proper understanding of God's grand scheme for mankind. Additionally, deists debunked revealed religion by observing that Moses, the author of the Pentateuch, nowhere argues for an afterlife of rewards and punishments, proving that the cornerstone of the Hebrew and Christian scriptures is not divinely inspired. Turning the tables, Warburton paradoxically argued that Moses' silence on an afterlife proved instead that his writings could not be the work of a human legislator. For the bishop, the absence of the injunctions of a future state demonstrated that God had to have been directly and continually revealing himself to the Jews, thereby making the overt teaching of final retribution unnecessary. Revelation was continuously granted to the Jews up until the final dispensation of Christ's coming. Once again, as with Butler, this summary hardly does justice to Warburton's sophisticated erudition.[52] What is significant here is that deists and Christians are seen as agreeing on the requirement of a divine system of rewards and punishments imposed in the afterlife.

Of even greater import, Warburton's radical and controversial analysis of Book 6 of Virgil's *Aeneid* provides not only the primary source for Barry's organisational principles in *Elysium* but also the intellectual scaffolding for his classical narrative as a whole. Warburton, following Virgil's account of Aeneas' journey to Elysium's blessed fields, charts the Trojan hero's encounter with four principal groups in descending order of importance:

1. The first place, in these happy regions, is assigned to the LAWGIVERS, *and those who brought mankind from a state of nature into society*:

> Magnanimi Heroës, nati melioribus annis.
> ['… old Heroick Race;
> Born better times and happier Years to grace.'
> (Virgil/Dryden, *Aeneid*, Bk 6, lines 882–3)]

At the head of these is Orpheus, the most renowned of the European lawgivers; but better known under the character of poet: for the first laws being written in measure, to allure men to learn them, and, when learnt, to retain them, the fable would have it, that by the force of harmony, Orpheus softened the savage inhabitants of Thrace:

> Threicius longa cum veste sacerdos
> Obloquitur numerius septem discrimina vocum.
> ['The *Thracian* Bard, surrounded by the rest,
> There stands conspicuous in his flowing Vest.
> His flying Fingers, and harmonious Quill,
> Strike sev'n distinguish'd Notes, and sev'n at once they fill.'
> (Virgil/Dryden, *Aeneid*, Bk 6, lines 878–81)]

But he has the first place; because he was not only a Legislator, but the bringer of the mysteries into that part of Europe.

2. The next is allotted to PATRIOTS, *and those who died for the service of their country*:

> Hic manus, ob patriam pugnando vulnera passi.
> ['Here Patriots live, who, for their Countries good,
> In fighting Fields, were prodigal of Blood:'
> (Virgil/Dryden, *Aeneid*, Bk 6, lines 896–7)]

3. The third to *virtuous and pious* PRIESTS:

> Quique sacerdotes casti, dum vita manebat;
> Quique pii vates & Phœbo digna locuti.
> ['Priests of unblemish'd Lives here make Abode;
> And Poets worthy their inspiring God:'
> (Virgil/Dryden, *Aeneid*, Bk 6, lines 898–9)]

For it was of principal use to society, that religious men should lead holy lives; and that they should teach nothing of the Gods but what was agreeable to the divine nature.

4. The last place is given to the INVENTORS OF ARTS *mechanical and liberal*:

> Inventas aut qui vitam excoluere per artes:
> Quique sui memores alios fecere merendo.
> ['And searching Wits, of more Mechanick parts,
> Who grac'd their Age with new invented Arts.'
> (Virgil/Dryden, *Aeneid*, Bk 6, lines 900–1)

The order is exact and beautiful. The first class is of those who FOUNDED society, heroes and lawgivers: the second, of those who SUPPORTED it, patriots and holy priests: and the third, of those who ADORNED it, the inventors of the arts of life, and the recorders of worthy actions.[53]

In terms of the importance of their positioning, Barry's groups reflect this same order: in the first rank are the legislators and wise rulers, with Orpheus having already been given the honour of inaugurating the series as a whole; the second most important group is the Glorious Sextumvirate, consisting of patriots who had died for liberty; in the third are theologians and supporters of peace; and in the fourth, the practitioners of mental and creative arts, a broad category encompassing scientists and philosophers, poets and writers, and artists. Dryden in his translation expanded on Virgil's account of those who were foremost in the ranks of the blessed by adding the following two lines:

> Those who, to worth, their Bounty did extend;
> And those who knew that Bounty to commend.
> (Virgil/Dryden, *Aeneid*, Bk 6, lines 902–3)

Barry follows Dryden's lead in also giving a place of prominence to patrons despite their having gone unmentioned in Virgil's Latin text.

Warburton's summary, in which he condenses the classes of the elect from four to three by combining patriots and priests, also provides the scaffolding for the Great Room's first three murals. *Orpheus* corresponds to the first class, consisting 'of those who FOUNDED society, heroes and lawgivers'. It is also worth recalling that Orpheus is the first person Aeneas encounters on entering Virgil's Elysium, making him all the more appropriate as the series' first subject. *A Grecian Harvest-home* reflects the second class, composed 'of those who SUPPORTED it, patriots and holy priests'. No one is holier than Christ, and he as well as Orpheus/St John the Baptist gave their lives in carrying out their missions. Finally, *Crowning the Victors at Olympia*, with its assemblage of artists, statesmen, writers, philosophers, scientists, and historians, embodies 'the inventors of the arts of life, and the

recorders of worthy actions'.[54] Thus the first three paintings in Barry's series foreshadow the groupings in *Elysium*, while presenting them in their proper sequence of heroic lawgivers, promoters of the religious values of virtue and peace, and proponents of mental, physical and creative excellence.

Warburton's overall framing of the meaning underlying Book 6 is his most daring and controversial contribution. He interpreted this book as a political allegory based on the rituals of the Eleusinian Mysteries.[55] Aeneas' descent into the underworld is his initiation into the Mysteries, an initiation that is necessary if he is to fulfil his destiny as a great lawgiver and leader. The hero progresses through the Lesser Mysteries until he arrives at the Greater Mysteries reserved only for a select few:

Accordingly, Æneas now enters on the GREATER MYSTERIES, and comes to the abodes of the blessed:

> Devenere locos lætos, & amœna vireta
> Fortunatorum nemorum, sedesque beatas:
> Largior hic campos æther, & lumine vestit
> Purpureo: solemque suum, sua sidera norunt.
> ['… they took their Way,
> Where long extended Plains of Pleasure lay.
> The verdant Fields with those of Heav'n may vye;
> With *Æther* vested, and a Purple Sky:
> The blissful Seats of Happy Souls below:
> Stars of their own, and their own Suns they know.'
> (Virgil/Dryden, *Aeneid*, Bk 6, lines 868–73)]

These two so different scenes explain what Aristides meant, when he called the shews of the *Eleusinian* mysteries, *that most shocking, and, at the same time, most ravishing representation.*[56]

Warburton emphasises the dramatic nature of the divine light as recorded by other writers. Barry's scene is quietly pastoral, even if he exchanges the green fields for a cloudscape, as well as overwhelming in its upper register in terms of shining splendour and a dazzling cosmic order.

Warburton reveals what he felt was 'the famous SECRET of the *mysteries*, THE UNITY OF THE GODHEAD'.[57] Christian and pagan are again united in a seamless whole. The Cumaean Sibyl, who had been leading Aeneas through this initiation, is another example of the merging of the two traditions. Within Christianity the sibyls were seen as counterparts of the Old Testament prophets as in Michelangelo's Sistine ceiling, where five sibyls alternate along the sides with seven prophets. Just like the prophets, they are forerunners of the revealed truth to be found in the New Testament.

Warburton continues to explicate the doctrine of the unity in terms that are echoed in Barry's work:

Musæus, therefore, who had been *hierophant* at Athens, takes the place of the Sibyl (as it was the custom to have different guides in different parts of the celebration) and is made to conduct him [Aeneas] to the recess, where his father's shade opens to him the hidden doctrine of perfection, in these sublime words;

> Principio cœlum, ac terras, camposque liquentes,
> Lucentemque globum Lunæ, Titaniaque astra
> SPIRITUS INTUS ALIT, totamque infusa per artus
> MENS agitat molem, & magno se corpore miscet.

Inde hominum pecudumque genus, vitæque volantum,

Et quæ marmoreo fert monstra sub æquore pontus.

['Know first, that Heav'n, and Earth's compacted Frame,

And flowing Waters, and the starry Flame,

And both the Radiant Lights, one Common Soul

Inspires, and feeds, and animates the whole.

This Active Mind infus'd through all the Space,

Unites and mingles with the mighty Mass.

Hence Men and Beasts the Breath of Life obtain;

And Birds of Air, and Monsters of the Main.'

(Virgil/Dryden, *Aeneid*, Bk 6, lines 981–8)]

This was no other than the doctrine of the old Egyptians, as we are assured by Plato; who says they taught that Jupiter was the SPIRIT WHICH PERVADETH ALL THINGS.[58]

Warburton's characterisation of the hidden doctrine of perfection reminds one of Barry's *Education of Achilles*, which links Grecian culture through Orpheus' teachings to an older wisdom whose veiled meanings are expressions of Neoplatonism.

In Book 5 of the *Aeneid*, Virgil relates how Aeneas, after arriving in Sicily with his band of Trojans, instituted funerary games to honour his deceased father, Anchises. Various contests were organised with prizes offered. Warburton sees in this circumstance another reference to the Eleusinian Mysteries, pointing out that the celebration of the Mysteries 'was accompanied with the Grecian GAMES. On which account too, perhaps it was that, in the disposition of his [i.e. Virgil's] work, his *fifth* book is employed in the *games*, as a prelude to the *descent* in the *sixth*'.[59] Thus Barry's classical narrative is, to a large extent, inspired by Warburton's analysis of Virgil's epic. It points the way to beginning his series with Orpheus and extends to *Crowning the Victors*, which can be seen as the games that are a prelude to entering *Elysium and Tartarus*. Furthermore, through all is intertwined a parallel Christian content. The pagan account represents its own strand of revelation, which, though, dovetails with the Christian one as both derive from the same Godhead.

Warburton has his own explanation for why Virgil's underworld differs in some particulars from the Christian heaven and hell. Because the poet's description is an initiation into the Mysteries, it is concerned with tracing out the various stages that lead to final enlightenment, and should not be read in all its parts as concerned solely with the afterlife. The initiate is first taken through 'A RUDE AND FEARFUL MARCH THROUGH NIGHT AND DARKNESS' filling him or her with horror and dread. Then comes 'A MIRACULOUS AND DIVINE LIGHT' revealing 'SHINING PLAINS AND FLOWERY MEADOWS', appropriate to the imparting of the sublime doctrines of sacred knowledge.[60] The final result reads a lot like the scene presented in Barry's painting: 'AND NOW BECOME PERFECT AND INITIATED, THEY ARE FREE, AND NO LONGER UNDER RESTRAINTS; BUT CROWNED AND TRIUMPHANT, THEY WALK UP AND DOWN THE REGIONS OF THE BLESSED; CONVERSE WITH PURE AND HOLY MEN; AND CELEBRATE THE SACRED MYSTERIES AT PLEASURE.'[61]

As Warburton points out, there is a distinction to be made between actually dying, with its accompanying descent into the infernal regions, and an 'INITIATION, where the representation of those regions was exhibited'.[62] Aeneas undertakes the latter progress, as does the viewer of Barry's murals. Accordingly other elements are also featured to help initiates to comprehend more clearly their present condition. The doctrine of metempsychosis, or the transmigration of souls, and the idea

of Purgatory were introduced, according to Warburton, as a way of ameliorating the fact that a future state of rewards and punishments does not address the objections raised by the existence of gross inequalities in this life.[63] Thus Book 6 is to be read as a progress toward comprehension in this world and not just the blueprint for life after death.

Looking at Book 6 as a whole, Aeneas can be seen to undergo a religious rite of passage, which, as interpreted by Warburton, reproduces the Eleusinian Mysteries. This initiation prepares him for the culmination of his role as a great leader and 'fir'd his Mind to mount the promis'd Throne' (line 1230). Aeneas then returns to the land of the living through the Gate of Ivory instead of Horn.

> Two Gates the silent House of Sleep adorn;
> Of polish'd Iv'ry this, that of transparent Horn:
> True Visions thro' transparent Horn arise;
> Thro' polish'd Iv'ry pass deluding Lies.
> (Virgil/Dryden, *Aeneid*, Bk 6, lines 1236–9)

Aeneas' departure through the gate of lies rather than true vision strikes an ominous chord. But Warburton interprets the ivory gate as a reminder that Aeneas has not actually died but has instead undergone that vision provided by the Greater Mysteries. Horn is reserved for 'the *reality* of another state', and ivory is 'the *shadowy* representations of it in the shews of the *mysteries*'. Of the things shown to Aeneas, 'the scenes of them only, were false; as they lay not in HELL, but in the TEMPLE OF CERES'.[64] The ivory gate itself was 'no other than that sumptuous door of the temple, through which the *initiated* came out, when the *celebration* was over'.[65]

In his account, Warburton makes an interesting distinction between Homer's Elysium as described in the *Odyssey* and Virgil's Elysium. In describing Ulysses' visit to the underworld (Book 11 of the *Odyssey*), Homer had made Elysium 'so dark and joyless a landscape' that no one would have any desire to go there. Better to be a day labourer in this world, than command in the regions of the dead. Virgil, on the other hand, 'whose aim … was the good of society', in his Elysium exalts reputation, fame and glory as a spur to virtue. In doing so, Virgil, in contrast to Homer, copies 'the amiable paintings of Elysium, as they were represented in the *mysteries*'.[66] While Warburton is using 'paintings' metaphorically, Barry chose to see this as a literal accounting, his own mural providing an actual painting of Elysium, and his classical scenes, taken as a whole, unfolding the Mysteries for all to behold.

The viewer does not enter the afterlife but only sees it represented in order that, having been initiated into the divine plan, he or she can go forth from the Great Room to live a life infused with a heightened awareness of mankind's purpose and potential. The Great Room is indeed a sacred space, a recreation of the arcane wisdom to be found in the cave of the Cumaean Sibyl or in the *cella* of the Temple of Ceres at Eleusis. As such the murals offer a transforming message that encapsulates and inculcates a coherent and magisterial world view. To 'see' the murals is to experience a rite of passage involving an initiation into the Eleusinian (and Christian) Mysteries, with the artist, rather than the sibyl, as one's guide. Each painting represents a different stage, and each accordingly stands in isolation as one proceeds through this initiation. *Elysium and Tartarus* is the grand crescendo of this epic, spiritual journey for which the other paintings are preparatory.

The Eleusinian Mysteries, which composed the most revered ritual celebration of ancient Greece, were shrouded in secrecy, the initiates having pledged, on pain of death, not to reveal their secrets. By focusing on Book 6 of the *Aeneid* as the blueprint for understanding the initiation, Bishop Warburton offered a window into the Mysteries' rituals. As we have seen, all four of Barry's Greek subjects are indebted to Warburton's overall structure. The bishop, however, felt no need to dwell on the Mysteries' core meaning, but this, too, further establishes a relationship between the rites at Eleusis and those of Christianity. The Greater Mysteries were intimately involved with harvest rituals, being performed annually roughly in September. Their meaning revolved around the story of Ceres and her daughter Proserpine, primarily as told in Homer's *Hymn to Ceres*. The beautiful Proserpine, having attracted the attention of Pluto, lord of the underworld, was seized by him to reign at his side in the subterranean world as his queen. A grief-stricken Ceres refused to let crops grow, turning corn-bearing fields into barren plains, until Jupiter intervened. The final arrangement allowed for Proserpine to return to her mother and the world at large for two thirds of every year, the remaining third, the time of fallow winter, spent back in the underworld with Pluto. Thus the Mysteries centred on issues of fertility and the harvest, of death and rebirth. As had many before him, Barry would have perceived a number of significant relationships between the Eleusinian and Christian Mysteries. Foremost, both were centred on high-minded communal worship concerned with the profound issues of death and resurrection. As devotional thanksgiving celebrations, they placed each participant in the presence of awe-inspiring divinity. Furthermore, one of the pagan rites was the drinking of the *kykeon*, a beverage primarily composed of barley meal and water, a sacramental communion with the deity reminiscent of the drinking from the chalice during the Mass. One of the principal purposes of both the pagan and Christian rituals was to reassure its participants that a blessed immortality awaited that would avoid the horrors of Tartarus or hell in favour of the bliss of Elysium or heaven.

For Warburton, the most important commonalities between the Mysteries and Christianity were their shared belief in the unity of the Godhead and their shared Neoplatonic vision. He also mentions a specific relationship between preparation for the Mysteries and one of the sacraments of the Roman Catholic Church: 'it was required in the *aspirant* to the *Mysteries*, that he should be of a clear and unblemished character, and free even from the suspicion of any notorious crime. To come at the truth, he was severely interrogated by the priest or hierophant, impressing him with the same sense of his obligation to conceal nothing, as is now done at the roman Confessionnal.'[67] Yet Barry, far more than Warburton, would have responded to the nature of the ritual presentations. The Eleusinian rites progressed through various stages, as is the case with the murals themselves. At Eleusis, dazzling theatrical effects were employed, the rites being held at night in the Temple of Ceres, with initiates plunged into confounding darkness, accompanied by horrific noises and apparitions, eventually to be exposed to bright torchlight or even daylight, with their ordeal climaxing in a beatific vision as in Barry's concluding mural. Thus both rites relied heavily on the concept of an initiation involving the presentation and enactment of exalted, dramatic narratives, either, as in the case of the Eleusinian Mysteries, as theatrical spectacles, or, as in the case of Christianity, as sacred paintings or statuary. In Catholicism, participation in the Liturgy of the Mass was for all believers, but the artist keenly felt that at Christianity's core was, as in the Eleusinian Mysteries, a secret wisdom reserved only for a few, one that required a hierophant (more specifically a history painter) to impart its message.

The Birth of Pandora: the relationship of Barry's greatest easel painting to the murals

Measuring over 274cm x 518cm, *The Birth of Pandora* is not only Barry's largest and most ambitious easel painting, but his fascination with this subject also spanned his entire career. He conceived this

work in the late 1760s when studying in Rome but did not complete this project until 1804, shortly before he died.[68] As with the Adelphi murals, part of the problem, then as now, is that his intention has been misinterpreted. Like the Royal Society of Arts murals, at its heart is an elaborate underlying Christian subtext.[69] Thus even during his student years in Rome, Barry was thinking in terms of a syncretic vocabulary that combined the pagan classical world with the Christian.[70] In this regard *The Birth of Pandora* and *A Series of Pictures on Human Culture* are cut from the same cloth. They both draw, as well, inspiration from Bishop Warburton, with each emphasising different aspects of the Eleusinian Mysteries.

The textual source for the birth of Pandora is Hesiod's *Works and Days* and *The Theogony*. In order to wreak havoc on mankind for Prometheus' theft of fire, Jupiter ordered Vulcan to create Pandora, the first woman, with the members of the Olympic assembly participating by bestowing on her their individual gifts. After her fashioning, Pandora was sent down to Epimetheus, Prometheus' brother. Accompanying her was a box that mankind was forbidden to open. Unable to resist temptation, Pandora opened the lid releasing all the ills of the world, with only hope remaining. In his notes to his translation of *The Works of Hesiod*, Thomas Cooke did not bother to belabour the obvious biblical parallel: '*Pandora*'s box may properly be took in the same mystical sense with the apple in the book of *Genesis*; and in that light the moral will appear without any difficulty.'[71]

Barry's earliest conception of this subject to have survived is a print by Louis Schiavonetti, published in 1810, after a lost drawing, probably dating to the early 1770s.[72] This composition, with its carefully constructed clusters of figures, which spread out from left to right, resembles that of a classical frieze. In this regard Barry was attempting to recreate Phidias' celebrated relief on the base of the statue of Minerva in the Parthenon, for which only a cursory textual description survives. The 1804 painting on the other hand departs from the chastity and purity of the neoclassical style of the Schiavonetti print to evoke the same Baroque thunder encountered in *Elysium and Tartarus*. In the 1804 painting, having contracted the figures into a semicircle, the artist employs strong colours and bold use of light and dark to create an electrifying impact. Jupiter's red overgarment and the intense blues of Juno's robe and Minerva's tunic provide strong accents. Just as in *Elysium and Tartarus*, a pulsing light bursts from the upper left, with the composition descending into the dark clouds at the lower right. Fittingly Apollo, the sun god, is at the far left, with Diana, the moon goddess, at the extreme right. The viewer follows Aurora's soaring path up and out into the dazzling light of the dawn, and the direction of the two main figures flying overhead in the composition's centre likewise creates a strong leftward pull. The right-hand side as well is anchored by a few massive figures, and although the left-hand side has twice the number as the right, their smaller size and concentration in the lower register in no way hinders the accelerated pace that bursts through the frame at dawn's early light.

A bright platform of clouds supports this assembly, with a much darker cloud barrier anchoring the composition's bottom. This barrier breaks beneath Mercury at the lower right, where it permits the viewer to enter into this majestic world. The artist thus fittingly positions Mercury, the messenger of the gods, as the intermediary between mortals and the immortals. Higher above this break in the dark cloud barrier sits Jupiter, who, because of his monumental size, is the picture's main focus despite being off-centre. He and his consort Juno dominate. A kneeling Hebe, cup-bearer to the gods, holds the tray from which Jupiter takes the nectar-filled kylix. Aligned next to Jupiter to his right (the viewer's left) are Neptune with his trident and a brooding Pluto with his pitchfork. The Three Fates are in the background between Jupiter and Juno.

Behind Hebe, Minerva holds up in her left hand a tapestry showing the gigantomachy, or Fall of the Giants. This tapestry is the sacred state robe, or peplos, which, woven anew in Athens each time the Panathenaic Festival was held, was draped on the statue of Minerva in the Erechtheum. The peplos was

Fig. 40 James Barry, *The Birth of Pandora, c.* 1791–1804. Oil on canvas, 279cm x 519cm. © Manchester City Art Galleries, Manchester

of such importance to the festival that it formed the climax of the decoration on the Parthenon frieze, where the folded cloth, held by a priest, appeared on the part of the frieze directly above the east door. In the frieze the goddess seated next to the peplos is Minerva herself, but it is of interest that James 'Athenian' Stuart thought this figure might be Ceres,[73] a misidentification that more closely associates Panathenaic rites with those of the Eleusinian Mysteries. For Barry, weaving was synonymous with the art of painting, because it, too, created images on what is basically a two-dimensional surface. His knowledge of Raphael's work would have strengthened such an association. The two principal frescoes in the loggia at the Villa Farnesina are, after all, fictive tapestries. Although the Nine Muses were associated with a variety of the arts, the majority of which represented different forms of poetry, painting was not among them. For Barry, this meant that the Greeks had held painting in even higher regard than poetry or music, because they had associated painting through tapestry with Minerva, the goddess of wisdom, who was superior to any muse. Minerva and her tapestry enjoy a place of honour: the tapestry she holds occupies the painting's central axis. Painting therefore should be seen as playing the central role in educating and guiding mankind. History painting, painting's most exalted category, is the highest achievement of human expression, requiring supreme intelligence. Pandora's lassitude recalls that of Michelangelo's Adam in *The Creation of Adam* on the Sistine ceiling. Both Pandora and Adam are mortals, who, still in the process of creation, await the divine spark, the last and supreme gift of their animating soul. In Michelangelo's fresco, God the Father is about to bestow this gift. Barry, on the other hand, assigns this sacred task to the art of tapestry/painting as Minerva extends to Pandora a spindle. Pandora, seated on a plush, red, gold-trimmed cushion, turns her attention solely to the goddess. In receiving knowledge of the art of painting, she will be able to achieve the divinity within.

The Three Graces alternately anoint Pandora's hair with ambrosia, plait her locks, and tie her sandal in a grouping that is inspired by Guido Reni's *The Toilet of Venus*.[74] Hymen, holding his marriage torch, to which he points, stands between the second of the Three Graces and Minerva. At the left of the group around Pandora stand Venus and Cupid. A reluctant Venus, who has difficulty tolerating rivals, gingerly offers her cestus, or girdle of beauty, to her son to give to Pandora. Apollo, playing a seven-string lyre, anchors the far-left group. Both his tresses and laurel crown are golden, as he sings an entrancing hymeneal song. An equally comely Bacchus, now holding a spear instead of a thyrsus, and a rustic Pan listen attentively. Between Pan and Venus is Mars, the god of war, who looks up at Venus, his lover. Since this scene eschews violence, Mars' role is downplayed in the painting, and in the print after the painting he is almost squeezed out of the composition altogether.[75]

Vulcan, the creator of Pandora's form, holds a hammer in his right hand and a butterfly, Pandora's animating soul (or psyche) in his left. Beside him are images of creation and metamorphosis from a lower form to a higher, 'which might be supposed to have resulted from the experiments for his masterwork of Pandora',[76] which in their turn can be seen as variations on the 'Orphic doctrine of the seed or egg'.[77] An eaglet emerges from the cracked egg warming on the brazier; a bunch of grapes have the potential of fermenting into wine; a frog emerges from a vase of water with tadpoles; the vase is encircled by a snake, 'the Egyptian Cneph or Cnuphis',[78] with an egg emerging from its mouth, a symbol of creation and regeneration; farther to the right plants spring up from seeds; and the butterfly is lifted from a chrysalis. Even the egg and dart pattern in Pandora's lotus-like chair suggests fertility and new life, which the artist links to 'the fertile, universal, terrestrial mother, the same as the Isis of the Egyptians'.[79]

What Raphael's Vatican *Stanze* are to the Society of Arts murals, Raphael's Loggia of Psyche in the Villa Farnesina at Rome, executed about 1518, is to Barry's *Birth of Pandora*. In each case, the Italian old master provided the model to be emulated and challenged. The story of Cupid and Psyche is related in Lucius Apuleius' book *The Golden Ass* or *Metamorphoses*, which was written in the second century AD.

After the narrator Lucius is transformed into an ass for his foolish indulgence in magic, he undergoes many adventures before finally resuming his human form when he converts to the worship of Isis and joins her priesthood. At the book's centre, Lucius in the form of an ass hears the story of Cupid and Psyche as told by an old woman. Psyche's remarkable beauty attracted the ire of Venus, who sent her son Cupid to humble this mortal upstart, only to have him fall in love with the object of his mother's scorn. Because of Cupid's injunction that Psyche, a mortal, should never see him, the couple were blissfully united only at night. Egged on by her jealous sisters, a curious Psyche lighted a lamp to look upon her sleeping lover, but when her trembling hand spilled oil from the lamp, she wounded Cupid, who immediately departed. In an effort to regain her lost love, a desperate Psyche undertook four seemingly impossible tasks imposed on her by Venus, the last of which was to descend into the underworld to ask Queen Proserpine to place within a box a small portion of her beauty to bring back to Venus. On her return, Psyche, unable to resist taking for herself a little of the beauty placed in the box, opened it, only to fall into a Stygian sleep. Having recovered from his wound, Cupid flew out to discover the prostrate Psyche, and returning the cloud of sleep to the box, he awakened his love. Next Cupid pleaded with Jupiter on his wife's behalf. Calling a council of the gods, Jupiter delivered his verdict that Cupid and Psyche should be forever united. Mercury was instructed to bring Psyche into the assembly, where she drank from a cup of nectar that made her an immortal. A great celebration was then held for their wedding.

All of Raphael's scenes from Apuleius' tale involve what transpires in the celestial realm, the presumption being that the terrestrial scenes, never executed, were intended for the lunettes and walls below. The ceiling, executed for Agostino Chigi's villa in Rome's Trastevere district about 1518, was particularly fitting for this rich banker, who in 1519 was to marry his mistress, thereby associating their love with this heavenly one. The story as recounted by Raphael, who would have been assisted by the patron and his advisers, was complex in that it was tailored to suit as closely as possible Chigi's personal circumstances. Drawing on a variety of sources, the cycle's full meaning was not intended for the uninitiated, being reserved instead only for the patron and his intimate circle.

Although the loggia's narrative was closely attuned to Chigi's personal situation, the story was always seen to have a larger moral dimension. Psyche is both an individual and, on a higher plane, as the name suggests, a representative of the human soul. Cupid is both the human emotion of love, as well as the god of love, in which a heavenly love supplants an earthly one. In this context the myth can be read as the soul in search of divine love, leading to immortality. There is as well a biblical resonance to this tale. Psyche or mankind, living in a world resembling the Garden of Eden, possesses love, only to lose paradise by disobeying a divine injunction. After the Fall, trials and tribulations follow as the soul seeks to reunite with the ecstasy that comes from being in the presence of the divine. As in the biblical account, envy plays a leading role. Psyche was brought low by the envy of her sisters, who plotted against her. And Psyche herself, envious of the beauty she thought she was bringing to Venus in Proserpine's box, fell into a profound sleep after disobeying Venus' stern command not to open it.

In the parallel story of Pandora, the chain of events is set into motion by man's envy of the gods' possession of fire. After Prometheus had stolen fire, the gods created Pandora/Eve as mankind's punishment. She is sent to earth along with the box she has been given to marry Epimetheus/Adam. The world she encounters is akin to the Garden of Eden: 'Mortals at first a blissful earth enjoy'd' (Hesiod/Cooke, *Works and Days*, line 134). Despite the gods' express prohibition, Pandora could not resist opening the box, thereby releasing horrific and dreaded ills into the world that resulted in a calamitous fall from grace. But in depicting the birth of Pandora, Barry, like Raphael, focused solely on the celestial aspects of the narrative.

Both Raphael's cycle devoted to Cupid and Psyche and Barry's image of the birth of Pandora are at their core celebrations of marriage. In Barry's design, at the far left 'Apollo is singing the Hymeneals',[80]

and at the far right the scene on Juno's diadem in Barry's print after his painting is of the *dextrarum iunctio*, the sacred handclasp of a couple, with Juno presiding over their marriage. In the painting Barry even introduces Hymen, the god of marriage, next to Minerva to make this emphasis unmistakable. Like Raphael, Barry visualises the epithalamium, the wedding-hymn performed in honour of a bride and groom. In Raphael's case the two on an earthly plane who are being united are Agostino Chigi and his mistress; in Barry's case, they are Epimetheus and Pandora. But the celestial plane is the more exalted and important, and in Raphael's case the blessed couple is Cupid and Psyche. Although not mentioned by Hesiod, the male who is attentively at Pandora's side in all of Barry's compositions is Cupid. He is, as in the parallel story of Cupid and Psyche, the heavenly bridegroom. In the story of Pandora, an earthly love is rent asunder by disobedience, leading to all manner of ills. Redemption is achieved only through a long, arduous struggle. In the end, however, the hope is that Pandora, the human soul, will be reunited with Cupid, her divine love. As interpreted by Barry, the narrative indeed parallels Apuleius' story, just as his design parallels in composition and content Raphael's frescoes *The Council of the Gods* and *The Marriage of Cupid and Psyche* on the loggia's ceiling.

The Christian symbolism in *The Birth of Pandora* also goes far deeper than the labelling of Pandora as the heathen Eve and her casket as symbolic of the forbidden apple. As in the Royal Society of Arts murals, classical and Christian meanings are throughout closely intertwined. In his uncompleted essay on the subject of Pandora, Barry makes plain his intention to incorporate classical sources into a Christian framework. Having described the classical gods and goddesses as 'fabulous productions of the imagination' and as 'visionary beings',[81] he asserts, 'These vestiges of paganism, like their temples, may be consecrated and made use of for good and Christian purposes'.[82] Just as the Pantheon had been converted into a Christian structure, the philosophical underpinnings of the classical world can be made 'subservient to the cause of Christian piety and virtue'.[83]

In Hesiod's accounts, the Seasons or Horae adorn Pandora in *Works and Days* with a garland of flowers (lines 113–4), and Minerva crowns her in *The Theogony* with a garland followed by 'a glitt'ring crown of gold' (line 861). Barry, however, in accord with Raphael's *Marriage of Cupid and Psyche*, shows one of the Three Graces anointing her with the contents of a small urn or bottle. Such an anointing has both classical and biblical connotations, and the suggestion here is that a sacramental function, akin to baptism, is being performed. In addition, Pandora's extended left leg, exposing her vulnerable heel, is intended to recall God's prophecy of the enmity between the serpent's head and mankind's heel: Pandora is indeed the heathen Eve.[84] The story of the Fall of the Giants on Minerva's tapestry has its Christian counterpart in the Fall of Satan, and the male and female figures flying overhead more closely resemble angels than they do the Horae or amoretti.

In Christian symbolism, the number three is closely associated with the Trinity, and this number is repeated throughout the design. Such groupings as the Three Graces and the Three Fates are in no way remarkable, but why show only three horses of the sun chariot's quadriga, and why only feature three of the nine muses in the lower-left foreground? Furthermore the red, three-leaf shamrock motif in the head scarf of the anointing Grace is an Irish symbol of the Holy Trinity, said to have originated with St Patrick. Finally, the Trinity itself – God the Son, God the Father, and God the Holy Ghost – appears in the painting in the form of Jupiter as Christ, Neptune as the Father, and Pluto as the Holy Ghost. This configuration replicates that of the judges seen in *Crowning the Victors at Olympia*, where a black-bearded, youthful Christ is foremost, God the Father is a white-bearded old man, and the Holy Spirit is a brooding, saturnine figure. In *The Birth of Pandora*, the figure of Pluto/Holy Ghost is a particularly sublime portrayal, with his agitated, flame-like hair, craggy eyebrows and wild-eyed stare.

A Christian reading also explains the otherwise inexplicable. In the story of Pandora, the fatal box plays a crucial role, yet Barry places the lidded jar in the background, focusing instead on the kylix

that Hebe is handing to Jupiter. This emphasis led Dora and Erwin Panofsky to mistake the kylix for Pandora's box: 'the "fatal vessel", presented to Zeus on a platter, is a kylix enormously magnified and transposed into metal but admirably correct in shape; the modern beholder may find it somewhat difficult to imagine it closed, but should remember the fact that Barry's contemporaries were accustomed to seeing the kylix form adopted for covered dishes and soup tureens.'[85] Hebe of course is not offering Jupiter the fatal box or vessel but rather a golden cup filled with nectar, the drinking of which, as seen in Raphael's *Council of the Gods*, confers immortality. In a Christian context, Barry identifies the nectar with the consecrated wine of the Eucharist, which also bestows life everlasting. In his English translation of Homer, Alexander Pope had already done the same thing, translating the Greek word for nectar as red wine, thereby making the two synonymous:

> And now *Olympus*' shining Gates unfold;
> The Gods, with *Jove*, assume their Thrones of Gold:
> Immortal *Hebè*, fresh with Bloom Divine,
> The golden Goblets crowns with Purple Wine:
> (Homer/Pope, *Iliad*, Bk 4, lines 1–4)

In his discussion, Barry describes Jupiter as seemingly about to hand the kylix to Juno.[86] Pandora's/Eve's creation foreshadows the Fall, and Jupiter/Christ takes up the redemptive cup, as he prepares to hand it to his consort. This is a solemn occasion in which the kylix represents the holy chalice rather than Pandora's casket. Christ fittingly wears an inner garment of white purity and innocence over which is a Eucharistic, blood-red covering. In addition, although the composition is framed by Apollo, the sun god, and Diana, the moon goddess, the next framing pair is Bacchus and Ceres, who, as in *A Grecian Harvest-home*, strike another Eucharistic note. Finally, Hebe is at the painting's centre, and her scarf is unlike any other; in administering the sacrament she appears to wear a priest's stole.

Juno wears the Virgin Mary's traditional blue mantle, symbolising truth and her role as Queen of Heaven, but an identification of Juno with Mary does not fit the context of Christ and Mary as Jupiter and Juno are man and wife. Minerva is more suited as Mary's classical counterpart. In the painting, like Mary, she wears a blue robe, and her status as a virgin goddess makes her an appropriate choice. It is no coincidence that when the Parthenon was converted to a church, the building was first dedicated to St Sophia or Holy Wisdom but soon thereafter to the Virgin Mary. In Barry's painting Minerva/Mary has a special relationship with Pandora/Eve. Of these heavenly beings, Mary is most closely associated with humanity. The serpents on her aegis and the one on her helmet demonstrate her redemptive power, a reminder of Christ's injunction, 'be ye therefore wise as serpents' (Matthew 10:16). The serpent that brought mankind low can now, through Mary's divine agency, lead to redemption.

But still the question remains as to Juno's Christian identity. The bride of Christ is the Church. St Paul makes the analogy explicit in describing the relationship between Christ and the Church as that of man and wife: 'For the husband is the head of the wife, even as Christ is the head of the church' (Ephesians 5:23). In the painting, Christ is about to hand the redemptive, consecrated wine to the members of the universal Church, who, from the drinking of it, will enjoy eternal life.

Looking at *The Birth of Pandora* as a whole, it is clear that, as in the Royal Society of Arts murals, there are multiple levels of interpretation with a Christian subtext underlying its every facet. Once again the pagan myths support a Christian or, more specifically, a Catholic reading, both traditions giving witness to immortal truths. The painting documents the process of beautiful creation, foretells the fall from grace, and provides for the ultimate redemption to come. This larger story is told as the

backdrop for each individual's search for union with the divine. The viewer witnesses the preparations for a marriage, which is ultimately between the soul and Cupid. Barry, however, is careful to make the distinction that Cupid is not Venus' son, 'but was, according to Hesiod, the eldest born of things, that spirit of desire moving or brooding on the face of the waters,'[87] a deliberate echoing of the biblical verse 'And the Spirit of God moved upon the face of the waters' (Genesis 1:2). The soul's great passion is to unite with that divine spirit that was there at the beginning and animates all life: 'All Things, One and in One'.

Having documented the Christian reading at the core of both *Pandora* and the Adelphi murals, one can point to Bishop Warburton as the *éminence grise* behind both projects. In *The Divine Legation of Moses*, Warburton saw two texts as emphasising different aspects of the Eleusinian Mysteries. On the one hand was the story of Cupid and Psyche, which, according to Barry, was closely related to the myth of the birth of Pandora, and on the other Virgil's account of Aeneas' descent into the underworld, the most important text for understanding the paintings in the Great Room. Warburton links these texts in the following manner:

We have seen in general, how fond and tenacious ancient paganism was of this extraordinary Rite [the Eleusinian Mysteries], as of an institution supremely useful both to SOCIETY and RELIGION. But this will be seen more fully in what I now proceed to lay before the reader; an examination of two celebrated pieces of antiquity, the famous *Sixth book of* VIRGIL'S *Æneis*, and the *Metamorphosis of* APULEIUS: The first of which will shew us of what use the mysteries were esteemed to SOCIETY; and the second, of what use to RELIGION.[88]

In the case of Apuleius' tale, Psyche's struggle fits the model of redemption and enlightenment through an arduous initiation into a larger understanding of life's mysteries. In her final ordeal, following in the footsteps of such figures as Orpheus and Aeneas, not to mention Christ's Harrowing of Hell, Psyche journeys to Hades. In this regard Bishop Warburton sees Virgil and Apuleius as having much in common. The two ancient authors wrote of a descent into darkness as a means of finally being ushered into dazzling light. Both, too, were ardent followers of Platonic philosophy and were sympathetic to the principles underlying the Eleusinian Mysteries as well as the mysteries of Isis and Osiris, to which the Eleusinian Mysteries were indebted. Although Apuleius, who lived a century and a half after Christ's birth, rejected Christianity in name, he was in tune with its spirit, at least according to Warburton's interpretation.[89] Thus Barry's response to Warburton's analysis lies at the heart of both *Pandora* and his Adelphi series.[90] Drawing his inspiration for his *Pandora* from Raphael's Psyche Loggia, he interpreted his story along the lines laid down by Warburton for Cupid and Psyche. When formulating the subject matter for his murals in the Great Room, he turned again to the other of Warburton's essential texts, Book 6 of Virgil's *Aeneid*. In accordance with Warburton's organisation, the story of Pandora and the narrative underlying the Adelphi murals are mutually reinforcing; each illuminates aspects of the Eleusinian Mysteries, *Pandora* being concerned primarily with religious matters and the murals with society's optimal organisational principles.

Given his close personal friendship with the artist, Fryer deserves the last word on this subject. In his biographical comments, he affirms that Barry's purpose in *Pandora* was to inaugurate a study of 'theological science': 'at Rome he began his design of Pandora, which was to eclipse Raffael's Marriage of Cupid and Psyche before an assembly of the gods in the little Farnese palace, and to serve the first in a series of theological science.'[91] When discussing the Adelphi murals, Fryer claims that this series was also conceived in Rome and that Raphael's work in the Vatican was not only its genesis but was also in dialogue with its meaning: 'In the stanzas of the Vatican sprung this vast conception in the mind of young Barry, and what is singular, in front of the pictures of Raffael, intended by that immortal

painter to represent part of the same subjects.'[92] Fryer had already characterised the murals' content as an unparalleled epic:

These objects [i.e., the desire to achieve 'great things'] in a mind so creative, ardent, and richly fraught as Barry's, rose like the Epics of Homer and Milton, into one vast and sublime, yet connected and systematic whole … This subject, which we state as the most comprehensive ever considered or undertaken by painter or poet, was no less than the complete history of the human mind in its various stages from barbarity to refinement, both with respect to its multiplied relations of man with man, and its more solemn relations of man with God; and in the final retribution awarded to all in a future world.[93]

Pandora and the Adelphi murals can thus be seen to form part of the same grand design. Although Barry did not embark on the most ambitious project of his career until 1777, he had already conceived the germ of his subject matter in Rome in conjunction with *The Birth of Pandora*. By combining social science with 'theological science', the murals continue and expand on the meaning underlying the painting of Pandora's birth. Together they exhibit a philosophical system that is derived from Raphael's Roman frescoes as seen through a Warburtonian lens.

CHAPTER TWELVE

Virgil's Guiding Spirit

Virgil as a Christian prophet

While Barry makes reference to numerous texts in *Elysium and Tartarus*, both in the mural itself and in his description of it, Book 6 of Virgil's *Aeneid*, interpreted in a Christian context, provides the work's organising structure. The series' other classical scenes also reference a variety of texts (Lucretius and Horace are essential to understanding *Orpheus*; Thomson's *Seasons* permeates *A Grecian Harvest-home*; and Gilbert West's treatise on the Olympic Games and Pindar's Odes underlie *Crowning the Victors*), but Virgil's texts provide the thread that binds together all four classical scenes, to which *Thames* and *Distribution* compose an interlude. He is the overarching guide for Barry's series, and it is not just his *Aeneid* but his *Georgics* and *Eclogues* as well. In this regard, seeing him as a Christian prophet is an integral part of his works' meaning.

During the medieval period, as Domenico Comparetti demonstrated at length in his book *Vergil in the Middle Ages*, the Latin poet was perceived as both 'the chief representative of the classical tradition' and as the pagan who had approached nearest to the Christian faith.[1] The best example of Virgil's attunement to Christianity was his *Fourth Eclogue*, in which he was thought to have prophesied the birth of Christ. Virgil ascribed his prophecy to the Cumaean Sibyl, who is also Aeneas' guide to the underworld in Book 6 of the *Aeneid*. As a result, the poet and the sibyl became linked, and Virgil came to be seen as the most significant voice of Christian prophecy in the pagan world. Dante, in making Virgil his guide in the *Inferno*, ensured the Latin poet's position as the premier Christian prophet of the pagan classical world, a man who, forty years before Christ's birth, foretold of his coming. As John Ogilby succinctly wrote in 1654 in his notes to his translation of Virgil's *Fourth Eclogue*, 'Virgil *was a Christian, even without Christ*'.[2]

Obviously Bishop Warburton was hardly the first to see Virgil as a precursor of Christianity, but his analysis of Book 6 of Virgil's *Aeneid* as based on the Eleusinian Mysteries was extraordinarily original and daring. Yet although this analysis provided the artist, in large part, with his intellectual framework, Barry's trip as a young man to Naples provided him with something just as important; Virgil's landscapes and narratives became, for him, an internalised, lived experience.

Experiencing at first-hand Virgil's haunted ground: descending in order to ascend

Before the discoveries of Herculaneum and Pompeii, the visitor to Naples encountered the most impressive classical ruins to the west of the city. Like the region around Vesuvius, this area was the site of intense volcanic activity, and in the first century AD Pliny the Elder had christened one part *campi phlegraei* (the Phlegraean Fields or 'fields of fire').[3] In 1538 volcanism created overnight the Monte Nouvo, which overshadowed Vesuvius as the region's volcano that attracted the most attention until Vesuvius started its modern string of eruptions beginning in 1631. To the eighteenth-century visitor, this scenery of natural splendour and marvellous classical remains could be imagined as having been scarcely contaminated by modern life. In a letter written after he had arrived in Naples, Barry commented on how the virtuous simplicity of classical customs, now a forgotten inheritance, had survived into the present day:

blessed be the poverty of this people, and long may it continue to their latest posterity. It has preserved them, (though in the state of ignorance) the elegant notions of their forefathers; it has kept it out of their power to flaunt about after the deliriums and new fangled whims of fashionable people in great cities, and you shall not be able in your Londons, Paris, Romes, &c. to cull me out such an object as one of these women, standing near a fountain, with her sweet antique formed vase on her head.[4]

While the area west of Naples had been home to numerous famous figures from antiquity, such as Cicero, Julius Caesar and Nero,[5] its primary association was with Virgil, who not only was said to have written his *Eclogues*, *Georgics* and part of the *Aeneid* there but had also, on his deathbed in Brundisium, requested that he be buried in Naples. Virgil was the landscape's presiding genius, with even place names bearing his imprint, the name Cape Misenum[6] having been derived from Misenus, who was Aeneas' mourned trumpeter in the *Aeneid*, and the naming of the Elysian Fields also having been derived from the same epic. While Lake Avernus' name goes back to the Greeks, who are said to have derived its name from 'without birds' to signify the deadly powers of its sulphurous fumes, Book 6 of the *Aeneid* provides the full context and meaning for it and its accompanying Cave of the Cumaean Sibyl.

Although Virgil was the dominant author, Homer, too, was often invoked, this area forming a microcosm of Greco-Roman culture. Writing on 8 October 1757, Madame du Bocage reported meeting a canon named Martolemeo, who was writing a book, 'the design of which was to prove that the country about *Naples* gave occasion to all the fables of the *Odyssey*, and *Æneid*'.[7] Furthermore, the Apostle Paul had set foot in this same area, as related by him in Acts (28:13–14): 'we came the next day to Puteoli [Latin name for Pozzuoli]: Where we found brethren, and were desired to tarry with them seven days: and so we went toward Rome', an itinerary that mimicked Aeneas' own travels. The tourist visiting Pozzuoli and its environs was following in the footsteps of both Aeneas and the apostle, yet in the eighteenth century, no matter how many guidebooks to this region had been written (and they were indeed numerous), Virgil's own writings remained the primary text. In his account published

in 1730, Edward Wright eloquently described his preparation: 'On the other side of *Naples*, about *Pozzuoli*, *Baiæ*, *Cumæ*, &c. there is a very entertaining Scene of Antiquities and Curiosities. We took a *Virgil* along with us in this Tour, and with a great deal of pleasure read such Passages in his sixth *Æneid*, &c. as referr'd to some of these Places, in the Places themselves.'[8]

Virgil, too, dominated how one literally entered this landscape. His supposed tomb, a pilgrimage site, rose above the entrance of the tunnel – most often referred to as the grotto of Posillipo – that enabled the road from Naples to pass through the high ridge impeding access to this western region. While long celebrated as Virgil's tomb, having even been visited as such by Petrarch, its association with Virgil had rightly been called into question.[9] One of the most influential sceptics was Joseph Addison, who near the beginning of the eighteenth century wrote, 'It is certain this Poet [Virgil] was buried at *Naples*; but I think it is almost as certain, that his Tomb stood on the other side of the Town, which looks toward *Vesuvio*. By this Tomb [i.e. the one that had been incorrectly identified as his] is the Entry into the Grotto of *Pausilypo*. The common People of *Naples* believe it to have been wrought by Magic, and that *Virgil* was the Magician; who is in greater Repute among the *Neapolitans* for having made the Grotto than the *Æneid*.'[10] Some, however, were reluctant to give up the tomb's association with Virgil. In his book of 1768, Edward Holdsworth advanced the argument that 'we may reasonably conclude that this road, as being the most public, would be allotted for the monument of so great a man … There would be some propriety also in Virgil's being buried by that very road, which leads directly towards Misenum, the lake Avernus, and the Sibyl's Grotto; the very spot of ground which he had chosen for the scene of one of the most beautiful books of his Aeneid.'[11] But no matter how sceptical the visitor, in passing through the tunnel or grotto of Posillipo, one could not help but be in a Virgilian frame of mind. The grotto itself was long, dark, and dusty, best undertaken by torchlight. It provided a liminal threshold with the traveller journeying through this birth canal only to be reborn on the far side. The English traveller John Evelyn, writing in February 1645, eloquently captured the transformative nature of this experience: 'The Way [through the grotto] is pav'd under foote; but it dus not hinder the dust, which rises so excessively in this much frequented passage, that we were forc'd at mid day, to make use of a Torch; & so at length, with no small astonishment we were deliver'd from the bowels of the earth into one of the most delicious, and incomparable Plaines in the World.'[12]

While the beckoning landscape contained great beauty in which were situated majestic ruins, it also supplied, with its volcanic activity, scenes of terror. In the case of the Cave of the Cumaean Sibyl, where Aeneas made his descent on the shore of Lake Avernus, it even encompassed the gateway to hell itself.

> Deep was the Cave; and downward as it went
> From the wide Mouth, a rocky rough Descent;
> And here th' access a gloomy Grove defends;
> And there th' unnavigable Lake extends.
> O're whose unhappy Waters, void of Light,
> No Bird presumes to steer his Airy Flight;
> Such deadly Stenches from the depth arise,
> And steaming Sulphur, that infects the Skies.
> From hence the *Grecian* Bards their Legends make,
> And give the name *Avernus* to the Lake.
> (Virgil/Dryden, *Aeneas*, Bk 6, lines 338–47)

A drawing by Barry of Lake Avernus, which was originally contained in a sketchbook of views made in Italy, has survived.[13] As with the other landscapes from this sketchbook, he reduced the view to

Fig. 41 James Barry, *Lake Avernus*, c. 1769. Pencil, pen and ink, 148mm x 422mm. Yale Center for British Art, Paul Mellon Collection, New Haven

a few schematic lines in pen over pencil, and in this instance the scene is entirely depopulated. The viewpoint is from the southern shore looking toward the ruin on the east bank. This structure is the remains of a bath complex, but in the eighteenth century it was usually referred to as a temple, sometimes of Pluto, Neptune, or Mercury, but most often as of Apollo.[14] Barry condenses the view by situating the mouth of the cave, which is on the lake's north-west side, closer to the 'temple' than it is in reality.[15] Behind can be seen Monte S. Angelo, atop which are the Arcangel San Michele church and convent, Monte Gauro (also called Barbaro for its lack of vegetation at one period), which Barry labels 'Falern' after the Falernian wine that is produced in this region.[16]

Writing back to the Burkes from Naples, the artist specifically mentions his drawing of Lake Avernus:

I shall say but little of the ruins of Baia, the fine views, taking in Ischia, Caprea, Pausilippo, Vesuvius, &c. the Appian way, and the ruins of palaces, seen under and above the water, and the fine temples of Mercury, &c. on the sides, and the mount Falernum, and the other mountains which enclose the lake Avernus. I have on the sides of the lake, made a sketch, which takes in the temple of Apollo, (as they call it) the lake and the Cumean Sybil's grotto. This grotto is a most dreadful place, being regularly hewn through the rock into the bowels of the great mountain, God knows how far; through small passages on the sides you go into chambers, out of which there are other passages, some choaked up with earth, others filled with water; but on throwing in stones, the disturbed waters gulp, and rebellow, from one recess to another, seemingly without any end to it; and supposing these passages to have gone, in the direction they seem to have, but a very little way farther, one must unavoidably come into the sulphurous fumes and hell-like stufas of Nero, in which I have almost sweated to death; they are in the mountain, next door to this Sybil's cave. I must confess, I was struck with this notion on the spot, that art and nature could never have united in forming a more proper theatre than this must have been to act Virgil's hell in; and it is not impossible but the ancient priests and priestesses might have been inclined to jugling.[17]

The *Stufe di Nerone*, which are the 'stoves' or sweat holes carved out of the rock that take advantage of the extensive thermal systems created by hot springs, are not far to the south of Lake Avernus, halfway to the town of Baia. These sweating rooms were a favourite tourist site, with many remarking on how unbearably hot the deepest chamber was, while speculating on how many slaves lost their lives in digging these rooms for the cruel and callous Emperor Nero.[18] Barry was right in surmising

that this region was honeycombed with 'diabolical' passageways, and for him hell was indeed here. In describing the priests and priestesses as inclined to juggling, he was employing this word in its sense of using trickery and artifice. As he states, no better stage could be found for performing the theatre of hell, and the vividness of his description testifies to the extent that he had internalised Virgil's characterisation.

Although Lake Avernus' shoreline had long ago been stripped bare of the gloomy groves described in Virgil, in his drawing Barry includes some vegetation, particularly around the cave's mouth, whose dark opening does not invite the casual tourist to enter. The lake's once-toxic waters are ominously still. The 'temple' of Apollo, the god of light, backed by a grape-bearing mountain and a mountaintop church and convent, offers some relief to this mysterious, silent scene, a sacred landscape that gives access to another world.[19]

Having secured the golden bough in the grove of Lake Avernus, Aeneas descends with the Cumaean Sibyl into the jaws of hell. In his eighteenth-century analysis, Joseph Spence distinguishes five divisions of Virgil's underworld, the first three of which are more pagan than Christian.[20] Once through these frightening regions, the road splits into two paths. At this point a different philosophical conception takes over, one that is far closer to a Christian conception and which is the one portrayed by Barry in his mural. On one side is Tartarus, where the wicked endure horrific torments; on the other side is Elysium, the abode of the blessed. Then Musaeus, Orpheus' disciple, takes Aeneas to his father Anchises, who instructs his son in the Platonic vision of one common soul.

As we have just seen, Barry had himself followed in Aeneas' footsteps into this same cave. One suspects that his knowledge of the Roman catacombs was similarly based on first-hand experience and not just on his reading of Antonio Bosio's *Roma Sotterranea*. The art of the catacombs took on special resonance in that it gave the viewer the sense of being in touch with the early Christians. Given its proximity to the Saviour's own lifetime, the early Church had an aura of authenticity, and Catholics, as we have seen, were only too happy to link this sanctified past with the present through the line of popes stretching through the ages. Equally important was the bonding of Orpheus, a classical figure, with a Christian one. The two traditions were viewed as mutually reinforcing, the classical and the Christian harmoniously revealing the same grand, universal truths.

The experience of the nature of the descent into the dark, dangerous tunnels of the catacombs parallels Aeneas' descent into the Cave of the Cumaean Sibyl. Barry would not have been alone in making this connection. In the middle of the eighteenth century, the English tourist Sacheverell Stevens wrote of his hair-raising visit to the Catacombs of St Agnes outside the walls of Rome. As an Englishman, Stevens was suspicious of some of his Roman guide's claims; he did not believe that the tunnels extended for 30 miles or that they were used for the burial of martyrs and that the primitive Christians had fled to them for refuge, assertions that Catholics wholeheartedly embraced. Yet for Stevens the experience was a telling one. Both he and his guide were equipped with a large wax candle, and, as he relates, at the beginning of the journey 'we crept thro' a very narrow passage on our knees'.[21] Beyond this point they could stand, and the exploration was a dangerous undertaking: 'we were obliged to fix a piece of white paper at the corner of every turning for fear of mistaking the way in our return back again; for want of such a precaution, several who have been so venturesome, as to advance too far into these dark subterraneous passages, have never found their way back.'[22] At this

point in his narrative, he makes the association with Aeneas' descent into the Cave of the Cumaean Sibyl:

this brings to my mind a beautiful passage in Virgil, applicable to this circumstance.

> ————*facilis descensus averni,*
> *Sed revocare gradum, superasque evadere ad auras,*
> *Hoc opus, hic labor est.*————
> [Smooth the Descent, and easie is the Way:
> But, to return, and view the chearful Skies;
> In this the Task, and mighty Labour lies.
> (Virgil/Dryden, *Aeneid*, Bk 6, lines 193–5)][23]

Stevens was happy to have survived the suffocating tunnels, concluding, 'we got out of this dismal abode to my great joy, as the consequence might have been fatal to us, had the damps or any other accident extinguished our lights'.[24] While Stevens was out of sympathy with Catholic sentiments surrounding the catacombs, he instinctively made the connection between a sacred Christian space and a pagan one. In these dark, threatening interiors, the responsive pilgrim could experience profound, sacred revelations. Furthermore, as Warburton argued in the case of Aeneas, the descent itself signifies an initiation into the Mysteries.[25] With Virgil as his guide, Barry had made such descents not just in his mind's eye, while reading literary and historical sources, but also in the flesh, as he scrambled through the Sibyl's Cave and presumably as well the tunnels of the catacombs.

The murals as a series of progressions: a pilgrim's progress

This section summarises five interrelated progressions that are to be found in *A Series of Pictures on Human Culture*, but before pursuing these themes one needs to clarify what is meant by 'progress' and 'progressions'. In 1779 Susan Burney, who had a short time earlier been shown the series by Barry himself, recorded its title as *The Progress of Society & Cultivation*.[26] Given the artist's emphasis on culture, a title such as *The Progress of Human Culture* seems apt. One, however, might recall Ralph Willett's characterisation of his pictures at Merly House as *The Rise and Progress of Knowledge*.[27] Willett's argument is that from rudimentary beginnings, civilisations advance to ever higher states of excellence. Different civilisations advance at different rates, but Western culture, despite regressions, is in modern times continuing its ascending trajectory. Willett's usage of progress is in accord with Samuel Johnson's third definition of this word when used as a noun: 'Intellectual improvement; advancement in knowledge.'[28] In his first three paintings, Barry also charts improvements in knowledge as Greek culture advances in well-defined stages. Yet, unlike Willett, Barry does not believe that modern times in the essentials are even equal to, more less surpass, the accomplishments of ancient Greek civilisation. While *Thames* and *Distribution* demonstrate ways in which classical civilisation can be and is being improved upon, overall the ancient Greek world remains unequalled. His main argument is that if one wants to go forward in terms of cultural advancement, then it is essential to go back, to return to those fundamental 'truths' revealed to man by God. The viewer undergoes the various progressions through the series in order that he or she and society itself may be improved, but, in part, this progression forward is based on regaining what has formerly been lost. The Enlightenment's optimistic sense of progress, in which modern times were continuing to surpass

the cultural achievements of the ancients, plays a much lesser role in Barry's series than it does in a series such as Willett's.

Taking the murals as a linear, chronological progression, the activities depicted and the framework of the stages of civilisation go hand in hand. *Orpheus*, showing man in a primitive state, depicts inspired instruction as providing the means for society's advancement. The next image, *A Grecian Harvest-home*, shows social harmony and a thankful, worshipful attitude within an agrarian culture. Next in *Crowning the Victors* comes a fully matured society participating in sacred games that nurture and promote excellence by honouring the truly deserving in all spheres of life. *Thames*, the first of the two modern subjects on the east wall, argues for expanding through global commerce Britain's cultural advantages. The second modern subject, *The Distribution of Premiums*, highlights the beneficial role that national institutions can play in society's advancement as well as the softening, ameliorating influence derived from women's participation in the politics of culture. The last mural closes with the final revelation of the rewards and punishments meted out in the afterlife. Together these images provide both the ways and means for civilisation's advancement as well as offering incentives for pursuing these goals.

The stages of civilisation are told largely in a classical Greek context, with only two modern subjects focusing on contemporary British concerns. Yet the entire series can also be read in a British context, detailing its civilisation's stages of development. In the first painting, *Orpheus*, the ancient Greeks and the early inhabitants of Britain are easily conflated, an association warranted by their both having derived their sacred rites and beliefs from the same source, the Egyptians.[29] The second mural looks back to English rural life as glorified in Thomson's *Autumn*, which, in its turn, relies heavily on Virgil's idyllic pastoral in the *Georgics* praising the virtues of country life in its harmony with nature. *A Grecian Harvest-home* as a paean to the theme of Georgian retirement then introduces the competitive world that is the subject of *Crowning the Victors*. The *Thames* is explicitly about British commerce, just as the *Distribution* focuses on British national institutions. Finally, because there are so many British historical figures in *Elysium and Tartarus*, this mural emphasises native culture more than any other civilisation.

Another underlying progress within the series is the popular trope of civilisation's westward advance, as it supposedly follows the path of the sun. The *Aeneid* also supports such a reading; here the true understanding of religion and civic values moves westward from Troy and Greek civilisation to Rome. The Cumaean Sibyl, located in the environs of Naples, was thought as well to prophesy events that were still to take place in the Holy Land, whose impact would shift westward over time. This cultural progress is also in Barry's conception for the Great Room in that the movement is from Greece's Olympic Games in Olympia, to Rome and the Roman Catholic Church, then to modern English society. In the murals the sun stops at England's shores, but in his earlier print *The Phœnix or the Resurrection of Freedom*, published in December 1776, Barry had articulated an even more complex pattern, with liberty and the arts progressing from Greece to Rome to Florence to England and then to America. But wherever the sun is said to have stopped in modern times, its westward advance is a given.

On another level the murals are executed in what the viewer first experiences as a bewildering variety of styles and genres. But these changes on reflection can be seen to form another progression. *Orpheus* consists of a rough, mostly barren landscape, and taking its cue from Renaissance art its main protagonist's pose is derived from a supposed Raphael. *A Grecian Harvest-home*, an essay in the elegiac pastoral, owes its primary stylistic inspiration to Poussin's seventeenth-century classicism. *Crowning the Victors* in terms of both its statuesque, epicene athletes and its frieze-like composition is an up-to-date rendition of late-eighteenth-century neoclassicism. In this progression, one advances

from the period of the High Renaissance to the mid-seventeenth century to contemporary times. The two paintings of modern subjects, befitting their status as an interlude before the final scene, are not only in different styles but also genres. *Thames* is a more monochromatic allegory, punctuated with a few enlivening spots of blue, while *Distribution* employs the brighter colours appropriate to a heroic group portrait. Then comes the crescendo of *Elysium and Tartarus*, where the grand changes in scale, the sweeping cosmic vistas, and pulsating golden light orchestrate a resonating conclusion to the entire series. The viewer experiences this variety of ever-changing styles and modes, a constant shifting of perspective, until finding release in an operatic crescendo.

In a fifth progression, which is primarily contained within the four classical murals, one encounters the brilliant unfolding of a Christian allegory. Barry infused Warburton's critique of Virgil, which charts a path from wise rulers and legislators to those who had died for liberty and peace, to mankind's creative elite, with a dynamic and highly original Christian narrative. *Orpheus* announces the Coming of Christ; *A Grecian Harvest-home* introduces the Christ Child within the context of a solemn thanksgiving ritual celebrating the Eucharist's redeeming self-sacrifice; *Crowning the Victors* asserts the authority of Christ's Church on earth; and *Elysium and Tartarus* provides the final Christian revelation of the hereafter. The paralleling of the Christian with the classical serves too to demonstrate the compatibility of these two traditions, whose messages, derived from the same divine source, are so intertwined as to be inseparable.

Together all five progressions – the surface narrative of the stages of classical civilisation, the suggested stages of British civilisation, culture's westward progression, the stages of varying styles and genres, and, most important of all, the hidden religious content – constitute an initiation. Just as Warburton saw Book 6 of the *Aeneid* as detailing Aeneas' initiation into the Eleusinian Mysteries with the Cumaean Sibyl as his guide, Barry, in the murals in the Great Room, establishes his own initiation for those who would follow in Aeneas' footsteps. Just as Aeneas is the hero of Virgil's epic, the viewer, who undertakes this pilgrim's progress, is the hero of Barry's. In *Orpheus*, the pilgrim acquires the knowledge to comprehend and anticipate the coming of Christ. In the second picture, he or she shares in the joy of his birth and in the sorrow of his earthly mission with its sacrifice. In the third painting, the pilgrim participates not only in celebrating the Church by acknowledging the pope as its supreme head but also in acknowledging the arduous dedication required in the running of life's race even to the point of martyrdom. Having now acquired in the first three murals the main outlines of the meaning of life from infancy to death, the initiate turns to the two paintings on the east wall, which articulate a contemporary national vision for British society. *Thames* celebrates an imperialistic economic expansion that, in Barry's telling, will greatly benefit all parties. The pilgrim then views in *Distribution* how native institutions can serve in this grand scheme of achieving a society where the best thinkers and leaders (i.e. history painters) are allowed to emerge and be listened to. At the heart of this model of behaviour is the concern that cliques of jealous inferiors will conspire to bring down the great man, witness the ending to the lives of Orpheus/St John the Baptist in the first picture, Christ in the second, and the potential martyrs in the third. Yet the pilgrim making the spiritual and intellectual journey through this series will know the truth of where to look for guidance, whom to honour and to heed in this life. In this regard, *Elysium and Tartarus* supplies the pilgrim not just with an incentive to follow the right path but also with an organisational structure of how society should value greatness. Lawgivers form the foundation of a pyramid at whose apex are the creative geniuses. As is traditional, Barry places literary figures at the top, even though by this point the pilgrim knows that artists compose in a visual language superior to all other forms of expression. It is no accident that artists comprise the last group in *Elysium* that Barry discusses – in terms of his text, they, not the poets, form the picture's climax.

Fig. 42 Giovanni Lorenzo Bernini, *Aeneas, Anchises and Ascanius Fleeing Troy*, 1619. Marble. Scala Art Resource, NY, Galleria Borghese, Rome

Given Aeneas' importance as a model for the Christian pilgrim, it is surprising to observe that he appears nowhere in the murals. His presence, however, is implied. Barry sets up a visual analogy between the three male generations of the major protagonist of the *Aeneid* with the three male generations of the major protagonist of his version of the Olympic Games. A favourite illustration from the *Aeneid* is of Aeneas fleeing the burning city of Troy while supporting his father Anchises on his shoulder and with his son Ascanius at his side. Paintings of this subject frequently show Aeneas' trailing wife Creusa,[30] who is soon lost in the confusion and killed by the marauding Greeks, reducing the family to the three males. By disposing of the wife so early in the story, Virgil ensures that Aeneas has a legitimate son to carry on the line, while still being unburdened by marital ties. Aeneas is thus freed to have his dalliance with Dido, but more importantly he can fully embrace the role of the unencumbered warrior-pilgrim. Sculpture, in any case, could better accommodate depicting only the three males, and the best known representation of this group is Bernini's sculpture in the Villa Borghese showing in effect the Three Ages of Man.[31] Clad in a lion's skin, a thoughtful Aeneas precedes with his father Anchises on his shoulder. Anchises holds in his hand two seated household gods, becoming a father in the ecclesiastical sense, a priest or hierophant carrying sacred images. Clinging to Aeneas' side, his son Ascanius holds a burning lamp to light the way.

In the mural, the counterpart to this grouping is Diagoras on the shoulders of his sons with his grandson at the side. When he later made a print detail of this group (see fig. 64), Barry remarked on how this conception could form the subject for a great sculptural grouping.[32] This is his companion to Bernini's sculpture. The Baroque work shows the beginning of the epic journey, with Aeneas as the hero, while Barry's 'statue' shows its end, with Diagoras as the primary protagonist. Diagoras, as we have seen, is intended to represent the pope. Thus Barry's grouping relies on and completes Bernini's conception, the warrior-pilgrim now having aged into the role of the paterfamilias, who represents divine authority.

Aeneas undertakes his expedition into the underworld in order to consult his deceased father Anchises. On meeting the sibyl, the hero succinctly states his purpose:

> Conduct me thro' the Regions void of Light,
> And lead me longing to my Father's sight.
> (Virgil/Dryden, *Aeneid*, Bk 6, lines 162–3)

This is the purpose of the murals as well: to lead the viewer, as had Virgil his reader, through the stages of an initiation that ends in a final revelation. Ultimately the series attempts to unite the pilgrim/viewer with the Holy Father.

The viewer's experience of the murals is just like that of Aeneas in the *Aeneid*. He or she learns in this world the lessons of the next. Just as Aeneas found his father, we are to discover our own heavenly father. From this experience, Aeneas garnered the strength and wisdom to lay the foundation for one of the world's great empires. From our experience, we, too, are to go forth to shape our lives and the course of our society in light of this transforming vision. Outside of William Blake, there is no other artist of this period who created such an original and intellectually intricate narrative, and Barry, unlike Blake, had the opportunity to do this on a grand scale. In British art this monumental series has no peers.

PART 3

THE IMPORTANCE
OF BEING IRISH

PROLOGUE

B Y 1793 BARRY HAD COMPLETED all aspects of the series: the book describing the murals had been published in 1783 to accompany the first exhibition, only to be reissued a year later with an enlarged appendix on the occasion of the second exhibition; the artist completed the last detail to the murals themselves in 1790 when he added the portrait of the Prince of Wales to the *Distribution*; the prints after the murals had finally made their appearance in 1792, including a plate giving the intended seventh and eighth pictures in the series; and Barry's description of this series of prints, *A Letter to the Right Honourable the President, Vice-Presidents, and the Rest of the Noblemen and Gentlemen, of the Society for the Encouragement of Arts, Manufactures, and Commerce*, appeared in 1793. With this great effort behind him, he could now reap the rewards and see what his monumental series, distributed far and wide in prints and in descriptive accounts, might germinate. Yet no sooner had he tied up all the loose ends in seeing this project through to its completion than he was already at work amending its content. He felt compelled to edit his encyclopedic history of human culture beyond the minor variations he had introduced in his 1792 series of prints reproducing the paintings. This editing and refining was in the beginning confined to the execution of the large print detail *Lord Baltimore*, which appeared in time for the inclusion of his description of its content and purpose in his 1793 book describing the 1792 print series. Presumably this print was conceived as a single addendum, but, as it turned out, it inaugurated a series of its own of major and minor adjustments. The story of these seven large print details, six amending the foreground of *Elysium* and one the Diagorides victors from *Crowning the Victors at Olympia*, is told in appendix one. A thread that runs through all of these later works is Barry's attempts to reassert the central role Catholicism, as the leading representative of the universal Church, should play in the progress of human culture. The artist also turned to the murals themselves in making alterations in 1798 and 1801 that helped refine both his argument and its presentation, changes that are explored in appendix two.

Barry gives as his reason for his emendations to the series the need to correct 'inaccuracies', such as his having featured William Penn over Lord Baltimore as the first champion of civic and religious liberties in America. Behind such concerns to update his content were two primary motivations. Although the series gave a grand overview of mankind's historical progress, its general lessons were intended to be applied to the shaping of contemporary affairs. In 1798 he lauded the murals' address to social improvement in the here and now: 'If ever I could have doubted of the wisdom and eligibility of honestly applying and devoting art to utility and social improvement, such doubt would have been long since satisfied, when I see, and have seen, so many great events daily occurring, which afford an illustrious comment on the truth and efficacy of the principles pursued in that work.'[1] But he also felt

compelled by the very unfolding of these new events to tweak his imagery in an effort to address with as much specificity as possible the new political realities. There was indeed no more major event than the French Revolution, which, begun in 1789, had by 1792 led to the foundation of a republic in place of the Bourbon monarchy. This development, which continued to reverberate throughout Europe and beyond, was a strong factor in motivating Barry to respond in his art to such seismic changes. The second motivating factor, which was related to the first, was his presumed frustration over his hidden meaning having not only gone unheeded but, worse still, undetected. On the one hand, he had to make his message obscure, building in plausible denial since his endorsement of the blessings of Catholicism would have been repugnant to his audience, but, on the other hand, somewhat illogically, he still wanted that message to percolate and ultimately to convince. Many of the changes effected in the print details were intended to foreground more boldly this subtext, which had remained, to his chagrin, too well hidden.

Because Barry, like the eighteenth-century French *philosophes*, had looked back to the classical past for models for contemporary civic and cultural conduct, it is not surprising that his series should have espoused values and symbols that were subsequently adopted by the French revolutionaries, as they had been inspired by the same Enlightenment sources. It would be even more surprising if Barry did not feel responsible for having helped advance this discourse that had blossomed into revolutionary ardour. While there is no evidence that the French at this time were students of his series, he most likely took points of similarity as proofs of influence. Certainly much in the French experience was in step with his own reading of history and how the present should respond to his particular reconstruction of the past. The French avidly adopted such classical symbols as the liberty cap, and they as well attempted to revive their version of classical games as part of a patriotic repertoire. A print *Fête de la fondation de la République*, depicting one such festival that took place on *1er Vendemiaire An 5* (22 September 1795), shows simultaneously a chariot race, foot-races, and a horse race within a space evoking an ancient circus. The speech delivered on this occasion praised such creative figures as poets and musicians at the same time as the names of the winners in the competitions were also recorded for posterity.[2] To take another example, the print *Fête dédiée à la vieillesse*, reproducing Pierre Alexandre Wille's depiction of a festival dedicated to the theme of virtuous old age, harmonises with Barry's print *A Grecian Harvest-home*, where, in both, a seated old couple at the far right is honoured at a country fête.[3]

Although Barry enthusiastically responded to France's promotion of republican values, one needs to address the elephant in the room. The French revolutionaries were, for the most part, less than thrilled with the Catholic Church and certainly saw the pope as an arch-enemy. The French National Assembly, even before the creation of the republic, outlined the nature of the conflict between Church and state. The government confiscated all Church properties, and the clergy was to answer to the government rather than to the pope in Rome. The French also were solely responsible for the election of priests and bishops, whose salaries were now paid by the state. The pope condemned this new state of affairs, which went beyond the old 'Gallican liberties' that had traditionally curbed papal power in France, and ended up condemning as well the revolution itself. The Assembly, in its turn, required the clergy to swear an oath of loyalty to the constitution, which incorporated the new relationship of the French church to the state. Those clergy who refused to acquiesce became known as the 'refractory'

clergy, a large group, approximately half of the whole, and they proved to be as staunchly counter-revolutionary as the pope himself.

For a number of revolutionaries a restructured Church was insufficient, as they promoted an atheistic programme that gave rise to a de-Christianisation movement. In 1793, for example, a new revolutionary calendar was adopted, whose purpose in replacing the old Gregorian calendar was to eradicate Christian influence: all religious holidays along with Sunday itself were swept away, and the years themselves were no longer counted from the time of Christ's birth. A more 'rational' construct was substituted, and the numbering of the years began anew with 22 September 1792, the founding of the republic, inaugurating Year I. Churches were converted into temples, with the most famous example being that of the Cathedral of Notre Dame, which in November 1793 was transformed in an elaborate ceremony into a temple of reason. But Robespierre in 1794 chose to rein in some of the revolution's more radical tendencies. Introducing the 'Worship of the Supreme Being', he encouraged the veneration of a naturalistic deity and the acknowledgment of a hereafter. The government also extended toleration to those Catholics who were not opposed to the revolution, but peace with the papacy itself had to wait until 1801, when Napoleon signed the concordat with the Vatican.

Given this context in which the 'godless' French were for so long at odds with the papacy, how could Barry reconcile the view that the Roman Catholic Church represented the finest and wisest of social organisations with the view that the main thrust of the French Revolution was to be enthusiastically championed? For the artist the solution was simple – denial. First, Barry rejected the premise that the French entertained in any meaningful way strong atheistic beliefs. He viewed instead French atheism as only a rhetorical device by which to attack more efficiently the false Christianity that had been used to prop up the monarchy. In his book *A Letter to the Dilettanti Society*, first published in 1798, he praises religious sceptics, while at the same time castigating atheism as a pernicious and ultimately peripheral philosophical position:

D'Alembert, Diderot [editors of the *Encyclopédie*], and other great men, may have (and with a good conscience too) done every thing in their power to discredit and to destroy the wretched appearance, under the name of religion, which, like a stalking-horse, was fabricated and held up for political state purposes, by the Jesuit Tellier, the Cardinals Bissi and Du Bois, and their odious corrupt confederates, during the years of the dotage of Lewis XIV. and the worthless, dissipated Regent, his immediate successor … This surely, and no other, can be the reason for the little temporary credit given to atheistical opinions, as a battery for immediate use, the better to enable them to demolish this state engine of mock religion, no less injurious to the genuine, generous character of Christianity, than to the virtuous freedom, peace, and happiness of civil society. But as that work is now done, there is no longer any occasion for that atheistical battery; for, it is to be hoped, no man can be weak enough to believe, or to endeavour to make others believe, that the chilling torpors of Atheism, like the horrid, inert, deadly silence of the polar regions, can be of any use … Away, then, with Atheism! the men of France have wisely and becomingly thrown it aside; and let us hear no more of it in England: the philosophers but made an occasional use of it, and never intended that any well-ordered society should really be the *dupe* of such a pestilential opinion.[4]

As for the embittered relationship between the French government and the papacy, Barry's print

additions clarify that, in his mind at least, there was no conflict between supporting a Catholic reading of history while at the same time supporting French revolutionary principles. He denied that the conflict was based on issues of substance, steadfastly refusing to acknowledge any meaningful divide between the Vatican and France's republican values.

From the beginning, Barry's experiences as an Irish Catholic had been crucial in the formation of his vision of what lay at the heart of a transcendent civilisation. Even his support of republican France did not alter this view. The following chapter explores how his deeply rooted feelings concerning his native country more than ever came to the fore in his plans for altering and expanding his *Series of Pictures on Human Culture*. His support for the Act of Union of Great Britain and Ireland enacted in 1801 not only inspired the most significant of the details that he added to the *Distribution* but also prompted him to reconfigure the paintings he wished to substitute for Gainsborough's *Portrait of Viscount Folkestone* and Reynolds' *Portrait of Lord Romney*. The importance of Barry's background in shaping his world view cannot be overestimated. The importance of being Irish, which, in keeping with the artist's perspective, refers to its Catholic majority, also has another meaning. For Barry, Irish culture was far more in tune than Britain's with God's original revelation to mankind, and therefore offered the best promise of restoring humanity to its former glory. Britannia had more to learn from Hibernia than the other way around.

Rethinking the Great Room in Light of the Act of Union

From the start of his work on his series of paintings, Ireland's plight was never far from Barry's thoughts. Both *The Triumph of the Thames* and *Elysium and Tartarus* allowed him to ruminate on his native country's deplorable situation. At the beginning of his work on these murals, he even took the time to compose a lengthy letter to Richard Boyle, 2nd Earl of Shannon, an important member of the Protestant ascendancy in Ireland. Two drafts of this letter, which he may never have sent, survive in his Commonplace Book, and his heading for the more finished draft, which is dated 4 January 1778, reads, 'A Letter to Lord Shannon on the political situation of the Roman Catholicks of Great Britain & Ireland; in which the raising of Roman Catholic regiments is taken into consideration.'[1] Under the stresses arising from Britain's war with its American colonies, Ireland's ruling classes raised a home guard of volunteers not only to protect its shores but also its political interests. Barry wrote his letter as an argument for why Catholics should be included among these volunteer regiments. In making his case, he offered an elaborate defence of Catholicism and of papal power as being in no way antithetical to civil liberties. He also passionately restated the painful and deleterious history of England's domination of Ireland and in particular its oppressed Catholic majority. He defined what for him constituted the best form of government: 'the most just and desirable mode of a government is that which affords the greatest number of checks & restraints upon the unlawful passions of the few who govern, and which best pursues the interests of the majority of the people.'[2] In giving his version of English history, he argued that the Catholics were in both ancient and modern times the ones who most consistently championed the people's rights and liberties:

it must indeed be confessed that whatever liberties and priviledges the English could boast of and plead against Tyranny in the reigns of the Stuarts, they owe them to their popish Ancestors and to none other, for from the time of Henry ye 8th to those Stuarts, their [*sic*] appears not one law that took place, nor one priviledge that was obtained favourable to the liberties of the people: The very contrary was in fact the case, the Absurd, slavish and execrable notion of the <u>divine</u>, <u>indefeasible</u>, <u>uncontroulable</u> right of <u>Kings</u> and <u>the passive obedience</u> of <u>Subjects</u> was a doctrine first introduced by the Reformers and the sacred writings were by the perverse misconstruction of those (in this respect) novellists held out as the foundation of this doctrine. But the Catholicks on its appearance attacked it with all their might, and asserted the liberties and rights of the people, from whose will and choices alone Kings can derive any equitable or just pretensions.[3]

Far from being a hindrance to the establishment and practice of good government, Catholicism instead forms the firmest of foundations for creating and safeguarding a people's sacred rights and liberties.

Just as the American Revolution had fleetingly offered the promise of beneficial changes in Ireland's governance, the French Revolution, in its turn, encouraged many, Barry among them, to hope that Britain's oppressive yoke might be lifted.[4] When in the 1790s tensions with the existing state of affairs in Ireland continued to mount, the government, fearful of French support of local revolutionaries, began to adopt strong preventive measures. In Presbyterian Ulster, the outbreak organised by the radical middle-class United Irishmen was easily suppressed, and in the Catholic south an ill-disciplined yeomanry and militia imposed a ruthless terror that led to a widespread peasant rebellion which the better-equipped and better-organised Crown forces finally put down in 1798. French aid to the rebels proved to be too little too late. The Irish rebellion of 1798 did, however, encourage William Pitt the Younger, George III's prime minister, to press for a plan calling for the legislative union of Ireland with Great Britain followed by Catholic emancipation, a plan which most Catholics favoured. After stubborn resistance, the Irish Parliament agreed to the Act of Union on 28 March 1800, and the countries were officially united in one parliament on 1 January of the following year. Pitt wanted Catholic emancipation to follow this merger, because the Catholics could now become full citizens without arousing traditional fears of their subverting Anglican rule, since, although they formed a majority in Ireland, they were in a decided minority in the Union as a whole. Yet at this juncture, the king blocked any such proposal, and Pitt resigned in March 1801 rather than force the issue while England was at war with France.

This chapter's first section explores Barry's interest in the Act of Union as a subject for his art. He first conceived of a painting celebrating the Union independently of the Adelphi series but then attempted to introduce it into his larger programme. Had he proved successful, Ireland's presence within this series on human culture would have become ever more pronounced. The second section examines Barry's introduction of a new figure and models for medals and coins into *The Distribution of Premiums*. Although these additions were prompted by the Society's request for designs for a new medal, embedded within them, both the one he inserted into the *Distribution* and in his final design for the Society's medal, are further allusions to the Act of Union. The third and final section examines the artist's crushing disappointment over the failure not only of the Act of Union to achieve its goals but also to his having been prevented from participating in any significant way in the critical discourse surrounding this event. Two images, one a drawing presumably preparatory to a print and the other an etched frontispiece, give voice to his dejection over the country's debased condition by rendering a world of depraved vices, violent oppression and torturous death.

The proposed fireplace additions of 1801

Barry's enthusiasm for the Union was such that he embarked on designs for a painting that was to commemorate this event and, at the same time, offer his commentary on what he felt was the intent of this legislation, which he characteristically interpreted in an unrealistically optimistic fashion. Hoping to receive a commission from the government, he wrote two letters to William Pitt not long before the prime minister was to resign, one of which included a petition to the queen urging the

Fig. 43 James Barry, *Study for 'The Act of Union Between Great Britain and Ireland',* c. 1801. Pen and brown and grey ink wash over black chalk, 709mm x 524mm. Ashmolean Museum, Oxford

acceptance of his project.[5] Failing to get a reply from the government, he then decided to introduce this subject into his Adelphi series. On 31 March 1801 he wrote to the Society again proposing that the portraits by Reynolds and Gainsborough be removed so that he could replace them with his own compositions.[6] Barry planned to place his painting of the Union in the centre of the east wall, where it would be flanked by *The Triumph of the Thames* and *The Distribution of Premiums*, the other paintings focusing on contemporary subjects.

The artist's earliest surviving conception for his proposed painting of the Act of Union between Great Britain and Ireland is a drawing in the Ashmolean Museum, which is probably the version of the design he referred to when he first wrote to Pitt that his work on a painting and engraving of this 'Holy Union' was 'accompanied with more venustas, unction, and happy adaptation, than will be found in any thing else which I have hitherto done.'[7] The sisterly figures of Britannia and Hibernia, watched by a presiding angel, tenderly embrace and together hold a book containing the Gospels inscribed 'Holy / Evangelists', a reference to the first four books of the New Testament authored by the Four Evangelists, Matthew, Mark, Luke and John. The scene on the altar is Aesop's 'fable of the father, his Sons & ye bundle of sticks, wch could not be broken whilst in a bundle',[8] proving that in union there is strength. The parliamentarians positioned at the right are particularly appropriate for a design intended for the government. The mace of Parliament lies on the table in front of the venerable scribe, and the standing figure behind him, who ticks off on his fingers the benefits of the political marriage, is presumably Pitt. The figure seen in profile on the left end of the row of legislators, who is responding to the Speaker, may be Charles James Fox, one of the artist's liberal heroes. Between the raised left hand of the angel and his left wing can be glimpsed a long-haired figure, who holds thunderbolts in his outstretched right hand. This avenging figure is determinedly routing a group of vices. Behind the balustrade at the lower left is Folly, with his belled fool's cap and ass' ears. Then come Destruction brandishing torches, followed by Envy accompanied by his self-consuming serpent. Next to Envy is Deceit, with flame-like hair and a mask, and cropped by the right-hand margin comes War, represented by bayonets.

In 1707 Scotland had joined with England to form the United Kingdom of Great Britain. The addition of Ireland in its turn created the United Kingdom of Great Britain and Ireland. This nomenclature not only allowed Barry to represent the three kingdoms as two allegorical figures (Wales is to be considered as having been subsumed into England),[9] but Hibernia, who stands in the foreground in front of the altar, is also the more prominent. She cradles the Gospels in her right hand, while Britannia supports the book's back. Hibernia's left arm is around Britannia's shoulders, with their left hands clasped together, while both gaze into each other's eyes. The symbols in the lower-right corner, Britannia's shield and the Irish harp, again reduce the political marriage to two emblems, with Ireland's symbol given equal weight to Britain's.

As to the religious beliefs to be found in the three kingdoms, Anglicans predominated in England, Presbyterians in Scotland, and Catholics in Ireland, but all embraced Christianity as the one true faith, albeit with profound cultural differences. By introducing the book 'Holy Evangelists', Barry places the Gospels at the core of this union and, in the process, gives a religious tinge to the design's other imagery. Thus at the top, the dove indicates the presence of the Holy Spirit as well as signifying peace. The angel with the scales of justice, an echo of St Michael, points heavenward as the source of authority and instruction. The figure with the thunderbolts is as much a reference to St Michael or Christ himself as it is to a thundering Jove. The heart pierced by the arrow inside the triangle emanating rays refers to the concept of 'Love conquers all',[10] a reference in this context to the spirit of divine love in which this union is to be undertaken. Although the triangle is not equilateral, it recalls the Trinity. Yet, on the other hand, overall the altar has a strong classical bias: its primary decoration

Fig. 44 James Barry, *Study for 'The Act of Union Between Great Britain and Ireland',* c. 1801. Pen and brown ink and grey wash over black chalk, 696mm x 497mm. British Museum, London;

is derived from one of Aesop's fables; rams' heads decorate its corners; and the representations of King George and Queen Charlotte in the medallion employ classicising profiles and attire. Barry, too, refers to the strip of fringed cloth that accompanies the kingdom's crown and royal sceptre atop the cushion on the altar as a fillet: 'Perhaps my first thought was better vizt., a larger medallion on

Fig. 45 James Barry, *Study for 'The Act of Union between Great Britain and Ireland',* c. 1801. Pen and brown ink and grey wash over black chalk, 696mm x 494mm. British Museum, London

Fig. 46 James Barry, *Study for 'Minerva Instructing her Rural Companions'*, *c.* 1801. Pen and brown and grey ink and grey wash over black chalk, 654mm x 384mm. Ashmolean Museum, Oxford

ye face of ye altar (aa) & ye subject to be ye fable of the father, his Sons & ye bundle of sticks, wch could not be broken whilst in a bundle, & ye heads of ye King & Queen on medals suspended or attached to ye fillet (b) wch binds on ye Crown & also on medals suspended from ye necks of ye two figures Brittania & Hibernia.'[11] In none of the drawings of this subject does this 'fillet' bind any of the medallions, which are instead supported by festoons, nor would it have proved suitable for the other tasks Barry assigns to it. In appearance the cloth more closely resembles a stole or maniple, Barry again alluding to Catholicism's brand of Christian worship even while misdirecting the viewer to conceive this imagery primarily in classical terms. Even the ram's head can also be viewed as a reference to a biblically inspired sacrifice. The scribe at lower right pauses to observe Hibernia's and Britannia's embrace, centred on the Gospels. As in the artist's earlier illustration *Universal History* (see fig. 29), what the scribe prepares to record is in conformity with the Holy Scriptures.

Once Barry decided to place *The Act of Union* on the east wall of the Great Room between the other two paintings of contemporary subjects, he altered his first conception, deleting the parliamentarians

in the other two designs to have survived. He had been criticised for having introduced portraits of specific personages into his allegorical composition *The Triumph of the Thames*, and, in deleting the parliamentarians, he eschewed mixing a more mundane reality with exalted symbolism. The excising of the portraits along with much of the emblematic clutter also allowed him to create a more simplified, idealised and heroic image. In both of the late designs, the composition is reversed. By placing Hibernia on the right, her pose echoes that of the Prince of Wales in the adjoining *Distribution*, suggesting a special bond between Ireland and the next monarch, a bond that in any case could be no worse than the current one with George III. This reversal of the composition to a right-to-left orientation is also in keeping with the overall format in the Great Room, where the modern subjects switch over from the traditional left-to-right orientation of the first three murals.

While it is difficult to be certain of the ordering of the two later designs, if one assumes Barry continued to work toward a more grand and unified solution, then figure 44 would have preceded figure 45, with Barry in the final version deleting in the heavens the scale with hearts and the figure of Folly below. In addition in figure 45, the beams of light radiating from the heavenly dove are so strong that they obliterate the head of the avenging angel, only his out-thrust right hand remaining. In figure 44, the artist covered over the recording angel's wing at the lower left with a piece of paper, but if this suggested order is correct, in figure 45 he reintroduced this wing while at the same time excluding Folly.

In both of his later designs, Barry excises the overt religious reference to the 'Holy Evangelists'. The presiding angel also no longer points heavenward, as he is occupied holding the Irish harp and Britannia's shield. The former scribe has been turned into a more timeless figure. This heroic, pensive old man, who is perhaps Father Time, dictates to the recording angel, and the fact that he covers his mouth with his hand suggests his is a secret wisdom. Ireland's role, however, becomes even stronger. The heart on the altar clasped by two hands, which signifies friendship, is of Roman origin, but in Ireland it would have been associated with the Claddagh ring, dating to the seventeenth century, which depicts two hands (friendship) clasping a heart (love) surmounted by a crown (the sovereignty of love or, once again, 'Love conquers all').[12] The crown is present in Barry's design atop the altar just above the heart, a subtle juxtaposition that would only have been available to those familiar with Irish customs. Then, too, the fleurs-de-lis decorating the crown look more like shamrocks than lilies. The relationship of the two allegorical figures has also changed. Britannia still longingly looks at Hibernia, but Hibernia now pensively gazes heavenward. She is the reflective and wise leader within this new union. While some might fear that Ireland's national identity could become subordinated to, and ultimately submerged within, the larger framework of the Union, Barry, with his characteristically wilful idealism, refused to see this as a case of Ireland losing her own soul in joining in Britain's general prosperity. For him, Ireland, whose uncontaminated spirit was still motivated by immortal and universal truths, was to lead the way for her sister kingdoms to recover their former selves. From his standpoint, Ireland was the first among equals.

Once Barry had chosen the Great Room as the site for the painting commemorating the Union, he needed to conceive a second work to occupy the space above the opposite fireplace on the west wall. In this spot between *Orpheus* and *A Grecian Harvest-home*, he wrote to the Society that he intended a picture showing 'the most classical & important matters respecting the manufactures of the ancient world'.[13] The preparatory drawing for this subject, *Minerva Instructing her Rural Companions*, shows the goddess, delicately poised on a descending cloud, directing the gaze of Pan and a ploughman heavenward, much like the attending angels in *Elysium*. In the centre of the composition stand Bacchus and Ceres, the principal deities of the adjacent canvas, *A Grecian Harvest-home*. In the sense that Minerva is the protector of the arts, she is involved with manufactures, but in truth the design

Fig. 47 Sir Peter Paul Rubens, *The Union of the Crowns of England and Scotland* with (left) *Hercules crushing Discord* and (right) *Minerva overcoming Ignorance*, 1632–4. Oil on canvas. Banqueting House, London

focuses exclusively on agricultural matters. The drawing's elongated format is also more suitable for the space it was designed to inhabit than the format of *The Act of Union*, whose composition had originally been conceived independently of the Great Room additions.

While Minerva, who is the most prominent of the figures, is the protector of the arts, the artist identified her specifically with the art of painting.[14] In maintaining that painting had played the key role in the development of Greek civilisation, mankind's noblest epoch, he suggests that it should hold an equally exalted station in modern life. Such a position bolsters his claim that his painting of the Union designed for the opposite wall should be seen as a contribution to, not just a commemoration of, the new political order. Bacchus and Ceres repeat and reinforce the Eucharistic symbolism of the neighbouring *A Grecian Harvest-home*. At the bottom right sits the rural Pan with his pipes and shepherd's crook. At bottom centre is the composition's sole mortal, an example drawn from Virgil's *Eclogues* of the simple rustic who aspires to a life of virtuous and harmonious labour. In front of him, the plough and yoke refer to the planting of grain, while the pruning hook to the right refers to the harvesting of grapes, reinforcing yet again the Eucharistic allusion embodied in the grouping of Bacchus and Ceres.

Vying with an old master: Rubens' *The Union of the Crowns of England and Scotland*

Rubens had depicted an earlier political union in his ceiling painting *The Union of the Crowns of England and Scotland* of 1632–4. Although it was in 1707 that the two separate parliaments of England and Scotland were merged into one to form the Kingdom of Great Britain, the coming together of the two countries had been forged earlier in 1603, when James VI of Scotland, after the death of Elizabeth I, became, as James I, the monarch of both countries, uniting for the first time the two kingdoms under one crown. Rubens' work, prominently displayed in the great hall of the Banqueting House located at Whitehall, was not far from the Society's headquarters. Comparisons between two

paintings on such similar themes would have been unavoidable, and Barry, never one to shy away from a challenge, would have welcomed the competition.

Inigo Jones' Banqueting House, completed in 1622, was England's first public building in the Palladian style. The ceiling, measuring 3353cm x 1676cm, offered an imposing opportunity for a grand statement in Britain's capital. Charles I, James' son who had ascended to the throne on his father's death in 1625, wanted to entrust so important a commission only to an artist of Rubens' stature, an artist of the first rank who had mastered the Italianate conventions of large decorative programmes, a type then unfamiliar to English audiences. Rubens received instructions on the nature of the ceiling's content, but given his distinguished reputation, he also had a great deal of latitude in determining the final design. After visiting London in 1629–30, when he was knighted by the king, he and his workshop completed the canvases in his Antwerp studio in 1634.

At the southern end of the hall, above the throne, Rubens installed the rectangular canvas *The Peaceful Reign of James I*. In the large central oval, he placed *The Apotheosis of James I*, and the *Union* was located in the north end of the room above the hall's entrance. In the corners of the ceiling, flanking the two large rectangular canvases, were scenes of Virtues triumphing over Vices, and flanking the central oval were two long rectangular canvases showing processions of putti and animals. Although this grand design has experienced over the centuries changes in orientation, it has remained *in situ*, allowing Barry and his contemporaries to experience at first-hand its compelling drama.[15]

The three central images all feature James I as the major protagonist in a creative mixture of historical and allegorical figures. Rather than focus on specific events, the paintings offer a generalised account of the benefits arising from James I's emphasis on peace and prosperity. Rubens' pictorial language is highly sophisticated, relying largely on a classical vocabulary of allegorical and mythological figures to convey thematic issues related to peace and good government. Even the *Union*, which is based on James' greatest political accomplishment, is rendered in abstract terms. Rubens shows the king at the right seated in his red state robes on a throne beneath an impressive red baldachin. The monarch points with his sceptre to an allegorical grouping commemorating the two countries' union. Minerva, who is tying together the two crowns, forms the apex of this group. To the left is the female personification of England and to the right that of Scotland. Between them is a nude child, presumably Cupid, who symbolises the love that, along with Minerva's wisdom, motivates and blesses this union.[16] The scene unfolds within a grand rotunda, whose classical architecture recalls the Pantheon. At the lower left a putto sets fire to the paraphernalia of war, and two putti overhead support the new coat of arms surmounted by the Imperial Crown. A soldier in classical costume stands in the lower-right corner. At his feet sits a sergeant-at-arms holding a mace. In the background seen beneath the king's sceptre stand two figures, who, like the monarch himself, would seem to be specific portraits, thereby introducing another note of historical specificity within this allegorical setting, a formula Barry expanded on in his first conception of the Act of Union.

Barry adopted the same language as Rubens, relying on didactic allegory and personifications to convey the main message with the introduction of a few contemporary figures. In Rubens the vocabulary is almost exclusively classical, although there is no mistaking the underlying Christian nature of James' rule. In his *Union*, for example, a cross tops the orb that the king holds, and crosses and fleurs-de-lis decorate both the monarch's crown and the Imperial Crown. Barry, on the other hand, brings Christian elements more to the fore, empowering the religious symbolism to permeate the classical vocabulary.

In the lower-right corner of his drawing *Passive Obedience* (see fig. 53), which is part of his response to the failure of the Union of 1801 to achieve Catholic emancipation, Barry specifically attacks both James I and Rubens. The image of a crowned James in his state robes adorned with a

chain is based on Rubens' *Union*, as are his gestures of holding a sceptre in his right hand with his left resting on an orb. Behind him Rubens cradles a scroll inscribed 'Whitehall' and 'apotheosis of Mary of Medicis', references to his grand commissions for Charles I and the French monarch Marie de Médicis. Barry condemns the artist specifically for his having prostituted his art to flatter royalty. The ceiling paintings in the Banqueting Hall are adulatory in the extreme, and in addition to promoting the virtues of peace, they are designed to express the sentiments inscribed on the ribbon tied around James' sceptre in Barry's drawing, 'Divine right [of kings]' and 'passive obedience [of subjects]'. Both James I and Charles I were fierce proponents of the divine right of kings, the same principle invoked by George III in refusing to support Catholic emancipation. Not only did such a stance demand the unchallenged obedience of their subjects, but it also was intended to counter papal authority, making the monarch answerable to God alone. In his own designs commemorating the Act of Union of 1801, Barry plays down the role of royalty, with the king and queen presented only within a small medallion. In the first conception, even the parliamentarians overshadow the monarch, but in all the designs the personifications of the sister kingdoms and the presiding angel dominate. In Rubens' conception, the king is God's viceroy on earth, whereas in Barry's designs divine elements such as the presiding angel and the celestial thunderbolts overshadow any earthly power.

Each artist is concerned to persuade his audience to his point of view. Yet their audiences differ. Rubens was painting for a select few: the king, his court and those foreign dignitaries who would be introduced to the king when he was enthroned in the great hall. Barry aimed at a broader constituency, the enlightened citizen who might visit the Society's Great Room. Although in the series as a whole, he did not hesitate to conceal his message, in the *Union* his main content is more direct and comprehensible. When taking on a contemporary, political issue, he was at pains to make his message clear even within the ennobling, abstract rhetoric of high art. For Barry, religion, not the ruler, supplies the necessary social cohesion that guides the governing principles of the state. Obviously it follows that the more uniform the religion, the more cohesive and unified the society. Since Barry, albeit subtly, gives Ireland the leadership role, the implication is that the predominant form of Christian worship should be Catholicism. Presumably if the message of Barry's *Union* is heeded, not to mention that of the series as a whole, this result is only a matter of time.

The Society's refusal: Barry's Jacobinical, levelling intentions

Although a majority of the Society's members approved Barry's proposed additions, a determined few, including the Duke of Norfolk, who was then president, and the heirs of Lord Romney and Lord Folkestone, objected strongly to the removal of the portraits on the grounds that it would be disrespectful to alter their original locations. Argument was useless in the face of this powerful opposition, and on 6 May 1801 Barry wrote to the Society withdrawing his proposal.[17] The Duke of Norfolk also had a more compelling, unstated reason for blocking this scheme, for along with his fellow Whigs he disapproved of Pitt's plan. James Gillray created an unforgettable image of the Opposition drowning its sorrows over the formation of the Union, where the corpulent Duke of Norfolk is shown prominently sprawled on the floor in the centre foreground.[18]

Barry must have expected some opposition to his subject matter, for when he first proposed introducing these new designs into the Great Room, he cryptically referred to the content of the painting commemorating the Union simply as 'matter the most pertinent, patriotic & moral, which could not fail being exceedingly popular, as it is in great measure called for by the circumstances of the time & most perfectly congenial with the views of the Society'.[19] His later acknowledgment that his proposal 'was but darkly hinted to the Society' proves that the obscure wording was deliberate.

Fig. 48 Laurent Guyot and J. Le Roy after Lagrenée, *Declaration of the Rights of Man and the Citizen*, 1793. Etching and engraving, 420mm x 280mm. Bibliothèque nationale, Paris

He was obviously aware that his subject matter was controversial, and he hoped to win approval of his scheme without having to be too specific. He went on to maintain that the refusal to permit him to add the *Union* to his series was politically motivated, and he wished to publish the correspondence over this affair to discredit the conspiracy he saw ranged against him. It never occurred to him, however, that Whigs might oppose his work on the grounds that it was too pro-government. He saw the attack coming from a different quarter. In this same letter to the Society of 6 January 1803, he found it necessary to declare that there was nothing in his proposal that was 'traiterous, seditious or derogatory to the Nobility of the Country' despite 'certain lying reports'.[20] Almost two years later, he was still repeating the charge that his request had been 'whisperingly converted into a Jacobinical levelling intention of degrading the Noble or Aristocratical part of our Government'.[21]

Barry's well-earned reputation for being a republican sympathiser could have been enough reason for his detractors to attempt to block his proposed submissions.[22] Yet if any members of the opposition had actually seen his designs, they would indeed have had cause for alarm, particularly in terms of the imagery found in the first version (see fig. 43). The French revolutionary emphasis on '*liberté, égalité,*

Fig. 49 Antoine
Quatremère de Quincy,
*Sculpture of the French
Republic for the Pantheon*,
1792. Coloured aquatint,
395mm x 277mm.
Bibliothèque
nationale, Paris

fraternité' was known to all. In England, liberty was claimed by all parties. The belief in the free-born
Englishman remained strong, and, at least initially, the English could perceive the French embrace
of liberty as a sign that the French were becoming more like themselves. The other two categories of
equality and brotherhood were more threatening. The concept that all men are equal indeed signified a
levelling intention that was decidedly at odds with Britain's oligarchical society. In republican imagery,
the carpenter's level was the ubiquitous symbol for equality, but scales could also serve this function.
The hearts in the pans of the scale in one of the later versions of the *Union* (see fig. 44) again emphasise
that equality is the overarching principle, the hearts of Britannia and Hibernia being judged as equal.

The 1793 French engraving *Declaration of the Rights of Man and the Citizen* shows at its top an
abstract version of a level, where the equilateral triangle, composed of the trinity of *Unité*, *Indivisibilité*
and *Égalité* (the all-seeing eye of Providence is at its centre) has its arms extended all the way down to
the block on which it rests, composing yet another, larger sacred symbol of equality. An earlier French
print of 1792 depicting a statue of the French Republic intended for the Panthéon in Paris contains
another rendering of a level. This revolutionary altarpiece, the creation of Antoine Quatremère de

Quincy, shows the French Republic, whose conception is based on that of Minerva, flanked by a female personification of Liberty and a male personification of Equality. This last figure, like a young, winged angel, tramples on a serpent, in this instance a symbol of the poisonous machinations of the counter-revolution.[23] Of interest here is the simplified version of the carpenter's level that the Republic holds above the figure of Equality. Like Barry's triangle on the altar above the Aesop fable (see fig. 43), it is not equilateral, the base being longer than the two sides. While recalling the sacred associations with the Trinity, it is first and foremost a carpenter's level. Barry executed his triangle at a time when the carpenter's level had fallen out of favour in France, as the Napoleonic government had no use for symbols of democratic rule that were contaminated with associations of 'mob' violence. Barry revives in a British context this once ubiquitous image of equality. With its emanating rays of light and the image of divine love at its centre, it still retains a religious aura, but for those who knew revolutionary iconography, it unmistakably enshrines the republican principle of equality even within an altar on whose top rests a crown and sceptre.

Where the artist fully gives the game away is in his choice and characterisation of Aesop's fable. Before the advent of the French Revolution, there was nothing inherently radical in this fable's content. In fact, the full title of one of the eighteenth-century editions edited by Samuel Richardson explicitly denies a political sectarian meaning to any of the 240 illustrated fables: *Æsop's Fables. With Instructive, Morals and Reflections, Abstracted from all Party Considerations, Adapted to all Capacities; and design'd to promote Religion, Morality, and Universal Benevolence.* In fable 53, a father instructs his contentious sons how to work in harmony by first having them try to break a rod composed of multiple twigs. After failing in this attempt, once the rod was unbound they could easily snap the twigs one by one, leading to the reflection 'A divided Family can no more stand, than a divided Commonwealth; for every Individual suffers in the Neglect of a common Safety'. This moral's political application supports the status quo: instead of 'pecking at one another, till, one by one, they all are torn to Pieces', men should consider 'the Necessity and Benefits of Union'.[24] Better to join in mutual support of the government one has than engage in squabbling over individual concerns; national unity trumps party politics. The French revolutionaries, however, were to transform the image of the bundle of sticks, politicising its generalised meaning. For them, the rods bound into a single unit referred back to the fasces of the Roman Republic, thereby exclusively symbolising this form of government along with the linked virtues of unity, equality and justice. For example, in the *Declaration of the Rights of Man and the Citizen* (see fig. 48), the bundle appears twice, in the lower centre as a large fasces with the accompanying axe heads symbolising the state's power to exercise capital punishment, and in the oval vignette above, showing Hercules, in an adaption of Aesop's fable, as unable to break a bundle of rods. The words in the triangle above the vignette stress unity, indivisibility and equality. In its turn, the inscription next to Hercules, *vincit concordia fratrum* ('concord among brothers triumphs') enshrines *fraternité*. The radicalisation of Aesop's archetypal imagery can also be seen in an English context. In 1795 the London Corresponding Society, which was founded in 1792 to further republican aims in Britain, produced a token showing the Aesopian father instructing his three sons that a single stick is easily broken, while the unbreakable bundle lies at their feet.[25] In his rendering of Aesop's fable, Barry makes the theme of brotherhood unmistakable by placing three young men, literally a band of brothers, clasping hands directly behind the two sons attempting to break the bound sticks. This motif of figures clasping hands as a gesture of brotherhood and equality is carried over into the two later designs of the *Union* in terms of the allegorical figures of Britannia and Hibernia themselves. While the earlier, generalised interpretation of Aesop's fable offered Barry a fig leaf for plausibly denying a politically charged meaning, in the 1790s the fable had become so politicised that the meaning of this leaf was now transparent.

Although Barry damped down the inflammatory political rhetoric inspired by the French Revolution in his later two designs, this message is still present. For him, the British should adopt the principles of revolutionary France. Yet, at the same time, his images assert that Ireland should be the dominant partner in this new marriage, a message that would have been equally unsettling. There was more than one reason for the Society to conclude that Barry's versions of *The Act of Union* were unacceptable adornments for its Great Room.

A new medal for the Society: continuing to celebrate the three kingdoms

Letter of 26 November 1801, from Barry to the Society, in Barry, 1801, pp. xxviii–xxix and xxxi:

Mr. Barry has exemplified his idea for the improvement of Medals and Coins, originally suggested in a letter to His Majesty's Most Honourable Privy Council, dated July 31, 1798 (see Letter to the Dilletanti Society, p. 218, 8vo edn) by introducing into the Picture of the Society two models for Medals or Coins; the one, a more than profile female head, with the imperial shield of Great Britain and Ireland suspended from her shoulder; the other, a head of Alfred, the great improver and founder: the latter of which he adopted from necessity not from choice, as he had no portrait of his present Majesty with which he was satisfied. He was particularly desirous to shelter this improvement under the wings of the Society, as he thought it probable that the noble relievo, and the security of that relievo exemplified in those heads, would be imitated in our coinage; and, from its obvious utility and dignity, be adopted all over Europe: and, in an object of such importance as the conservation of the portraiture and inscription, two points of the highest *desiderate*, the lead would be taken by a Society which has given rise to so many others, and has been so long remarkable for its exemplary, patriotic, and philanthropic conduct. [...]

Fig. 50 Detail of James Barry's *The Distribution of Premiums in the Society of Arts*, 1774–84, 1801. Royal Society of Arts, London

The better to elucidate these two models, Mr. Barry introduced an aged figure stooping over them looking very intently on a medal and holding in his other hand a letter or paper on which is written, 'On the guosto of Medals and Coins, and the best mode of preserving them from injuries by friction,' the identical wish expressed by the Privy Council to the Royal Academy, and which produced Mr. Barry's letter before referred to. On the same paper is also introduced the necessary section of such a coin.

On 19 June 1801 the Society's Committee of the Polite Arts approved a proposal to request five artists to submit designs by 1 August for dies for a new medal.[26] This medal was intended to replace the old one created by James 'Athenian' Stuart, which the Society had been bestowing as an award since 1758.[27] The five artists solicited were Barry, John Flaxman, J.C.F. Rossi, Robert Smirke and Thomas Stothard. Barry, as did Flaxman and Smirke, declined to participate in this competition,[28] and the Society had to wait

Fig. 51 Warner after Barry, *Design for a New Medal of the Society of Arts*. Etching, image is 98mm in diameter. Frontispiece to vol. 2 of *The Works of James Barry*, London, 1809. British Museum, London

until 1806 before obtaining a new medal.[29] On two occasions Barry gave lengthy accounts of his involvement with this project. On 25 October 1801 he read a letter of that same date to the Society discussing the additions he had made to his series of paintings in the Society's Great Room during the summer recess.[30] Then he provided a second letter, dated 26 November 1801, for publication in the Society's *Transactions*, polishing and expanding material contained in the first.[31] In these accounts Barry explained that when he had first been approached for a new design, he had not realised it was to replace Stuart's medal. Stuart, who had died in 1788, had been his first employer on his arrival in London in 1764. When he learned on meeting with the committee in late June 1801 that Stuart's original medal was being 'utterly discarded without ceremony, without any previous discussion in the Society' and that furthermore he was expected 'to enter the lists [of those competing to replace it], not with the great artists of Europe, nor even with those eminent natives of the country, but with such artists as our architects were in the habit of directing and employing for their ornaments and other subordinate internal decorations', he quit the committee 'without making the communication he had intended'.[32] What he had hoped to show were two drawings for the medal's obverse and reverse: 'One a head of his Majesty, more than profile, the other a female head of the united kingdom of Great-Britain and Ireland, with the imperial shield suspended from her shoulder.'[33]

The day after his disappointing meeting, Barry went to the Society's Great Room, where he introduced his intended models into the lower-left corner of his fifth mural, *The Distribution of*

Premiums in the Society of Arts, 'only changing the design for the king's head into that of Alfred, as he had no portrait of his Majesty'.[34] In his letter of 26 November, he expanded on his statement, saying that he chose Alfred over George III because 'he had no portrait of his present Majesty with which he was satisfied'.[35] Because the artist had had no difficulty in introducing the king's portrait into his designs for the Act of Union, his excuse rings hollow. Closer to the truth is that he vastly preferred the medieval king to the modern one, and by using Alfred, he tied the *Distribution* more closely to its neighbour *Elysium and Tartarus*, where Alfred is prominently positioned at the right of the cluster of illustrious legislators in the painting's foremost rank near its centre.

The design for the reverse, which is cropped by the picture's frame, shows the head of Britannia wearing a laurel crown and bearing a shield with the Cross of St Andrew on her back. The shamrock at the top of the shield refers to the United Kingdom's newest links with Ireland in the Act of Union of 1 January 1801. This shamrock, accompanied by England's rose at the bottom of the shield, is the artist's reference to the Union with its promise of a new political, social, and religious order.[36]

Barry had been writing to Charles Jenkinson, 1st Earl of Liverpool, who was head of the government committee on coinage, with suggestions on how the royal mint could improve its product. He also intended that his additions to the *Distribution* should address directly this government committee. In the lower left-hand corner of the painting, above the obverse and reverse of the medal, he inserted an old gentleman closely observing a beribboned medallion (the blue ribbon indicates it has been awarded as one of the Society's prizes) while holding a scroll that reads, 'on the Gousto of Medals & [/] Coins & the Mode of Preserving [/] them from Injury by [/] Friction'. As he wrote to Lord Liverpool on 3 July 1801, this scrolled paper contains 'the identical patriotic wish of his Majesty's Most Honourable Privy Council, so gracefully and exemplarily, though unsuccessfully, communicated to the Royal Academy'.[37] In addition, beneath this inscription on the scroll is the cross section 'of such a coin as was required [by this committee]'.[38] In his letter, Barry invites Lord Liverpool to visit the Great Room to see for himself these additions,[39] and one suspects that the engrossed gentleman who holds the scroll is none other than Liverpool himself, who at the time was seventy-two years old. By adding this painted proxy, the artist ensured that, at least within the fictional space of the canvas itself, his models and his arguments would be carefully examined.

Because the two sides of the medal added to the *Distribution* perform a variety of functions, such as harmonising with the content of other paintings in the series and demonstrating numismatic principles, it is not surprising that the result fails to address practically the Society's needs. On reflection Barry soon conceived a new obverse, which in a modified form the Society was eventually to adopt.[40] His drawing as engraved by Warner appears as the frontispiece to volume two of *The Works of James Barry*. Obviously pleased with this new conception, Barry requested and received permission to introduce it into *The Distribution of Premiums*,[41] but he never followed through on this initiative. Barry described how this design was meant as both an improvement on, and homage to, James Stuart's medal of 1757.[42] On the obverse of his medal, Stuart had employed three full-length figures: a seated Britannia at the right receiving Mercury, who holds his caduceus in one hand and a purse in the other, and Minerva, who holds a laurel crown in her left hand and her spear in her right. By focusing only on the heads of Minerva and Mercury, Barry achieved a grandeur that Stuart had not. He had already employed overlapping heads in the double-profile portraits of George III and Queen Charlotte that he had inserted in his studies for his commemoration of the Act of Union. This arrangement of a male ruler's head trumping that of his consort is traditional, but in his medal for the Society Barry inverted the conventional ordering of the genders, placing the female deity above the male one. This shift also reverses the power relationship seen in Stuart's medal, where Mercury, representing Commerce, dominates; Mercury occupies the centre and is the one who

interacts with Britannia. In his design Barry gave Minerva, in her role as the patroness of the arts, pre-eminence.

In contrast to Stuart, Barry dropped Britannia, replacing her with another political symbol, which was one of his own creation. In his 1792 print showing the two paintings that he then wished to add above the Great Room's two fireplaces (see fig. 24), he provided his portraits with elaborate frames that contain at their bases the rose representing England on one side and the thistle representing Scotland on the other. In the Society's medal executed soon after the Act of Union, the Irish shamrock joins these two plants to weave a wreath around the medal's rim. Barry thereby created a new dynamic that gives Ireland her full due, and he included his own initials on a leaf of the shamrock at the lower right. All are equal in this organic, vital image of the three kingdoms. In two of the compositions commemorating the Act of Union an angel clasps the Irish harp together with Britannia's shield. In the Society's medal, the intertwined plants encircling the rim symbolise a similar coming.ing but in a more distilled and subdued format that hopefully would not arouse the opposition that had been directed at the earlier composition. Barry's design for the Society's new medal not only proclaimed the fundamental importance of the promotion of the arts over that of any of the Society's other concerns but also saw this encouragement taking place within a new imperial order in which the three kingdoms of England, Scotland and Ireland were bound together as equals.

Barry carried over his intense interest in the union of Ireland with England and Scotland into his painting *The Birth of Pandora*, completed in 1804.[43] Of the Three Graces, the scarf tied around the head of the Grace anointing Pandora's hair is decorated with red shamrocks. Presumably he chose to make the shamrocks red instead of green in order to make the association with Ireland less obvious and also as a reference to Ireland's troubled and bloody history and its revolutionary ardour. By associating one of the Graces with Ireland, he suggests that together the Three Graces represent the three kingdoms. Next to this Irish Grace, the second of the Three Graces also attends to Pandora's hair. Her own coiffured hair is richly adorned with a strand of pearls. In this political reading she represents England, the most prosperous of the three countries. Yet, as in the designs commemorating the Union, Ireland is given the more prominent and important task. Scotland, as the lesser of the three kingdoms, or so Barry would have it, is by default the Grace absorbed in tying Pandora's sandal.

The Birth of Pandora's message is timeless, harking back to Phidias' classical relief. But even within this conveyor of eternal, universal truths, there is room for current events. The whole point to the relevance of immutable truth is its application to the here and now. The attentive observer of Barry's last great design was meant to come away with another lesson on the importance of Ireland's role within the course and conduct of imperial Britain. This timeless image conveys an up-to-the-minute commentary on current affairs.

The message unheeded: *Passive Obedience* and *Minerva Turning*

The promise of the Act of Union was not to be realised. While it is to be regretted that none of Barry's projected commemorations of this political event ever came to fruition, his disappointment led to the creation of both a remarkable drawing and a print (see fig. 54) that expand on the Union's issues and imagery.

The drawing *Passive Obedience* is one of Barry's most radical compositions, creatively extending into the category of history painting some of the conventions found in satirical art. There are dizzying

OPPOSITE PAGE: **Fig. 52** Detail of James Barry's *The Birth of Pandora*, c. 1791–1804. © Manchester City Art Galleries

Fig. 53 James Barry, *Passive Obedience*, *c*. 1802–05. Pen and brown ink with grey wash and black chalk, 427mm x 584mm. Art Museum, Princeton University/Art Resource, NY

changes in scale; the figures are cut radically at the edges of the composition with no foreground plane by which the viewer can enter; bizarre metamorphoses unfold as if in a dreamscape; and a dark void occupies the composition's centre. Overwhelmed by the folly, tyranny and brutality surrounding him, a heroic male, on his knees and wearing only a loincloth, recoils into the arms of a consoling angel at upper left. This virtuous hero resonates with Christlike connotations. In particular his situation recalls the Agony in the Garden, where Christ recoils in the face of his agonising fate. In Luke's account, a lone angel strengthens him in his resolve to fulfil his painful destiny. In addition, scenes depicting Christ in the Garden of Gethsemane often show Judas approaching in the distance with the multitude that has come to seize the Saviour; such a detail recalls the menacing figures crowded together in Barry's design. Barry forcefully expresses the agony that the good man, in harmony with his Christlike destiny, must experience in a sinful and fallen world.

At the lower left, four figures in fool's caps swear an oath over an altar, which is itself a parody of the earlier altars in the illustrations to the Act of Union, chains having now replaced festoons and a human skull the ram's head. The fringe of these fool's caps resembles crowns; this is a monarchial fraternity, the anti-type of the brotherhood extolled in the *Union* drawings. These royal fools pledge their fidelity to a social order rooted in enslavement and death.

Oppressors and those creative figures who supported and flattered them inhabit the lower-right corner. As already noted, James I brandishes a sceptre in his right hand, to which is tied a ribbon with the phrases 'passive obedience [of subjects]' and 'Divine right [of kings]'. A bishop holds the ends of the ribbon, making explicit the unholy alliance between Church and state. Rubens stands behind James, cradling a scroll that reads 'Whitehall' and 'apotheosis of Mary of Medicis', reminders of his sycophantic glorification of two monarchs. The female who grasps the other end of James' sceptre holds up a mask in her other hand as a sign of her deceitful nature. Because Edmund Spenser is beside her, pointing to

his book labelled, 'Fairy Queen', this woman is Elizabeth I, whom Spenser flattered in his epic, which Barry had criticised for being an intentionally abstruse allegory limited to a select few.[44] In his *Letter* of 1793, the artist had made the argument that Henry VIII had first introduced the vile notions of divine right and passive obedience. When mentioning Cardinal Pole, whom he had introduced into the print *Lord Baltimore* and who was Henry's implacable foe, Barry wrote, 'The [figure] next to him [Chichele] is Reginald Pole, the last English cardinal, and, as far as my knowledge extends, the first writer, who to the new-fangled doctrines of *the divine right and irresistible power of kings, and the passive obedience of subjects*, opposed those sacred *rights of the people*, from whence he nobly derives the delegated, legitimate powers which give sanction and just authority to the exercise of royalty'.[45] Thus the Stuarts were only following the insidious doctrines promulgated by the Tudors, and James I and Elizabeth I, supported by a corrupt clergy and artistic establishment, assault the sensibilities of the virtuous man. Above the two monarchs and their minions is a judge, holding up another sceptre on which is perched a severed head. The power structure has also co-opted the judiciary in a world in which justice has been perverted to serve the ruling class. Behind the judge's head protrudes a shepherd's crook and a mace, another linkage of the authority of Church and state. The mace, which had appeared in the earliest design dedicated to the Act of Union, refers to Parliament's role in this cruel and oppressive system.

The centre-middle ground shows fighting on land and sea. Closest to the viewer are two hooded, hanging figures with their hands tied behind their backs. Behind them a skeleton remains grotesquely splayed on the wheel on which the person had been broken. Farther in the distance are skulls mounted on pikes atop a tower, while a battle rages on a breached, crenelated battlement. More carnage is seen in the distance, behind which a naval battle is enjoined off the coastline. In the sky at the upper right, a slave driver whips his struggling charges, above which unfolds a mournful scene of spectral forms lamenting over the burial of rows of the dead.

Barry may have well intended to execute this drawing as a print. If in doing so the composition were reversed, then the viewer, reading the image from left to right, would have his or her eye climax on the figure of the recoiling virtuous man. Barry had chosen his cast of characters from the sixteenth and seventeenth centuries presumably because he was fearful of making too explicit a statement against Britain's current government. Although in his 1793 text, when he praised Cardinal Pole's opposition to Henry VIII, he was willing to rail against the abuses that occurred when the divine right of kings and the passive obedience of subjects overwhelmed the sacred rights of the people, he was unwilling to publish *Passive Obedience*, which cut too close to the bone. The execution of the drawing itself had to prove sufficient.

In general terms, *Passive Obedience* shows a long history of repression since the time of the Tudor dynasties. It is an impassioned indictment of the corrupt form of government that had been instituted by Henry VIII and that, despite such efforts as the Glorious Revolution of 1688, was being maintained in the present day. The depiction of the slave-driver, an example of colonial atrocities, indicates the global reach of this savage culture. The suffering giant is the contemporary British nation, which, as a collective body, continues to groan under the assault of tyrannical misrule. As the drawings commemorating the Act of Union demonstrate, although Barry had no difficulty introducing George III and Queen Charlotte (of course, too, the artist had little choice), he was against a form of monarchy that threatened the sacred rights of the people. Because these rights were seen to encompass liberty, equality and justice for all, as well as the brotherhood of man, it would appear that, in essence, although there was room for a monarch, it was only one who supported expansive freedoms. In his indictment, too, of how quickly creative figures, such as Spenser and Rubens, could be seduced by the patronage of the powerful, Barry may be hinting that artistic reforms were also needed; perhaps, as in France, 'Royal' should be dropped from the Royal Academy, with the Academy's organisation and

Fig. 54 James Barry, *Minerva Turning from Scenes of Destruction and Violence to Religion and the Arts*, *c*. 1805. Etching, 197mm x 121mm. British Museum, London

purpose reconfigured. *Passive Obedience* shows the spiritual malaise and suffering arising from the current oppressive, anti-republican system, a system that was also contrary to divine will represented in the form of the anguished, administering angel.

The horrific scenes in the background can also be seen as having been inspired by current events, in particular the violent reactions of the counter-revolution in the context of the Irish rebellion of 1798 and the ongoing wars with France. In Ireland the stated principles of the American and French Revolutions had increased the longing for greater political representation and social justice. Some revolutionaries, such as Wolfe Tone, hoped to unite their disaffected countrymen in order to achieve independence, whereas others wished to wrest more control from England without completely severing long-standing ties. The kind of imagery shown by Barry reflects the types of horrors visited on Ireland during the rebellion of 1798. The rebels planned for a general uprising that was to begin in Dublin on 23 May 1798, but the government, abetted by spies and with the liberal use of flogging, was able to thwart the full impact of this threat directed at the capital. The ensuing fighting in such areas as County Wexford quickly turned to savagery, with the rebellion degenerating into sectarian conflict as Catholics and Protestants turned on one another. Arson, looting, murder and massacres were commonplace, and opponents were often hung or piked. In retaliation the government forces were not to be outdone in the barbaric cruelty of their response. The fact that Barry shows his hanged men as having first been hooded suggests these 'executions' were carried out by government authorities.

In his addition of the Naval Pillar to the *Thames* in 1801, Barry praised the successes of the British navy, but the duelling ships in the background of *Passive Obedience* may again refer to Ireland's particular situation. One of the best hopes for those who wanted to see an independent Ireland was the possibility of French intervention. The French republican government attempted on several occasions to instigate and support insurrection. At the end of 1796, General Hoche and his French army were unable to land after the French fleet was dispersed by a storm. In 1797, the British prevented another large contingent of French troops from reaching Ireland, when on 11 October they defeated a Dutch fleet, France's ally, at Camperdown off the coast of Holland. In 1798 the French mounted three more expeditions, but it was a case of too little too late, with these attempts fizzling out in the north-west counties.[46] One involved a naval battle in which a small French fleet was forced to surrender off Lough Swilly to Admiral Warren on 12 October 1798. One of the government's prisoners on this occasion was Wolfe Tone, who later committed suicide rather than face the ignominy of being hanged as a common criminal. Barry's small-scale naval battle close to shore may refer to this engagement, even if the specific is translated into the general among a catalogue of multiple disasters spread over time and space.

In 1805 Francis Burroughs published a tribute to the artist titled *A Poetical Epistle to James Barry, Esq*. For this book, Barry etched the frontispiece, a print that addresses issues similar to those in *Passive Obedience* but in a more discreet fashion. The concept of Minerva descending on clouds recalls his earlier design *Minerva Instructing her Rural Companions* (see fig. 46). As Burroughs delineates in the footnotes accompanying his verse 'explaining' the print, the artist characterises Minerva in a specific role. As Minerva Erganè, she 'was supposed to preside over the arts, and to have been the inventor of tapestry [i.e. the art of painting]'.[47] He further elaborates:

Minerva, among the Greeks, was the general symbolical expression of pure intellect, as it issued from the head of Jove, and they added Erganè, to designate more particularly that peculiar species of intelligence which operates in bringing to perfection the works of genius, and conducts us to a state of refined and exalted civilization, independent of materialism, and uncontaminated by the dregs of gross sensuality, which overwhelms the faculties and plunges the soul into an abyss of misery and degradation.[48]

As stated in the verse, Minerva Erganè is the muse who inspires 'The pen or pencil [i.e. the artist's brush]' to forge 'human culture', making possible the advancement of mankind.[49]

Although the whereabouts of the preparatory drawing for the print is unknown, it was reproduced in the *Art Journal* in 1908.[50] The print reverses the drawing, Barry again being somewhat cavalier about the symbolism of left and right. In the drawing the positive imagery is found, as one would expect, on Minerva's right-hand side, the negative on her left, with the spiral of the Naval Pillar running in the same counterclockwise direction as in the painting. In the reversed image of the print the scenes of violence and degradation are now on Minerva's right, the left-hand side of the print. Much of this imagery echoes that of *Passive Obedience*: in the background are heads on pikes atop a crenellated fortification; next to that is a burning building; bound, hooded figures hang from a scaffold; and a phalanx of pikes, the crude weaponry of the rebellion, pursues desperately fleeing figures.[51] In the foreground a knife fight erupts over a card game, as a barking dog adds to the dissonance. Next to this group, a man gluttonously imbibes from a large bowl. The woman in front has collapsed in a stupor, still cradling the jug beside her, while the three discarded masks on the ground before her underscore her deceitful nature. In the preparatory drawing, her breasts are fully exposed, associating drunkenness with debauchery.

The print's right-hand side shows a world that has heeded Minerva Erganè's inspiring message. In the background, the Naval Pillar and St Paul's Cathedral recall the two paintings devoted to the contemporary world in the Society of Arts murals, the *Thames* in the first instance and the *Distribution* in the second. They also, however, are expressions of two major forms of religious architecture, both of which point to man's cosmic aspirations: the dome symbolises the overarching heavens, whereas the tower is an expression, dating to the Tower of Babel, of mankind's yearning for spiritual ascent. These religious forms fill the background, forming a stable, spiritual backdrop for the foreground groupings in contrast to the fire and smoke and the menacing and menaced architecture on Minerva's opposite side.

The Three Graces, symbolising the arts, dance in front of St Paul's, just as they had on America's shores when Barry had identified America as the land of liberty in his 1776 print, *The Phœnix or the Resurrection of Freedom*. The Three Graces represent one kind of trinity, a group that conjures up enlightened harmony, while on the other side are contrasting sinister trinities: three heads on pikes, three hanging bodies, and three masks on the ground. On the right-hand side between the outstretched arms of two of the Graces, two men are shown looking on, a portion of the band of brothers who flourish in such an environment. The singing figure, playing the Irish harp, is Hibernia. Again, the spirit of Ireland points the way, and tellingly she sits on the same cascade of clouds supporting Minerva. The brushes and palette symbolise painting, the mallet sculpture. The plough represents agriculture and the steering oar seaborne commerce, whereas the two books celebrate the life of the mind. Finally, the foremost, foreground item is a carpenter's level, missing its plumb line, a symbol of equality that is once again taken directly from the republican imagery of the French Revolution.

Burroughs concludes his introductory verse with the following couplet:

> The goddess, high exalts her heav'nly voice,
> Reveals the scene, and leaves us TO OUR CHOICE.
> (Burroughs, p. iv)

The trope is that of the Choice of Hercules, where the classical hero is forced to choose between virtue and vice, and underlying Barry's imagery is a work, such as Reynolds' *Garrick Between Tragedy and Comedy*,[52] which makes use of this allegory. As with Garrick, Minerva has made her choice, in this instance turning from the scenes of violence and debauchery toward religion and the arts, but as in

Burroughs' verse, she invites the viewer to make his or her choice. In this late image, Barry is offering his audience one last chance to heed his injunctions, but at this point he knows all too well what will be the likely outcome no matter how one chooses, given that the political system is unresponsive to the desires of the public. Unlike the goddess' appearance in *Minerva Instructing*, Minerva here wears a forlorn expression. In addition, her pose is as suggestive of a crucifixion as it is of a choice.

Conclusion

William Blake and James Barry as prophetic painters: would, God, that all the Lord's people were prophets

James Barry was not alone in attempting to promote the important role history painting should play in British culture, particularly with regard to religious subject matter. His was one of several religious series undertaken in late-eighteenth-century England. Around 1779, just two years after Barry had begun work at the Society of Arts, George III approached Benjamin West to decorate the Royal Chapel at Windsor Castle with religious paintings; this was the most important commission offered to an artist of the English school in the eighteenth century.[1] The project eventually grew to encompass thirty-five or thirty-six large pictures for an entirely new chapel to be built in Windsor's Horn Court. This undertaking was eventually to end in disappointment, but as West wrote on 25 May 1811, 'had it been completed, it would have marked itself as worthy of His Majesty's protection as a Christian, and a Patriot King, and all Christendom would have received it with affection and piety'.[2] Thus the content of the chapel was fit for the king, for the nation's welfare, and for all Christendom's delight and edification. West must have come to see its decoration, executed for the head of the Anglican Church, as having parity with the Sistine Chapel, executed for the head of the Catholic Church. In effect this was his opportunity to become the English Michelangelo. There were numerous factors contributing to the project's failure, but not least among them was the artist's hubris. Both West and Barry attempted to set mankind's historical narrative within a Christian framework. The difference in patronage, however, spelled doom for West. As he moved further away from the original conception – a visual accounting of St Paul's Sermon to the Gentiles which reinforced the conservative view of the king as God's anointed leader of his people – to a more grandiose plan – in which the chapel was to

unveil God's purpose for mankind as seen through the artist's eyes – his dream became increasingly untethered to reality and consequently increasingly more unacceptable to the only audience that mattered, the king himself. West was accorded the greater opportunity, but Barry produced the greater result.

In 1794 John Francis Rigaud, having been commissioned by Alderman John Boydell, executed four frescoes for the pendentives beneath the cupola of the Common Council Chamber in London's Guildhall.[3] Rigaud knew Barry well, the two having travelled together through northern Italy in 1770 and 1771 after having departed Rome. His series featured four allegorical women, representing Providence, Innocence, Wisdom and Happiness, with their various attributes. For the most part, on the surface they presented a secular moral discourse. Yet closer inspection reveals that they were infused with deeper Christian meanings that applied both to a single lifespan and to the unfolding of human history. Conceptually Rigaud's frescoes so closely paralleled Barry's methodology that one suspects he was influenced by his old friend's example. His message, however, was far from controversial. By obscuring his content, he wanted to challenge viewers to work out on their own the deeper meanings, one of which was to grasp the secret nature of God's power to shape mankind's destiny. His project, the most ambitious of his career, also ended in failure. Difficulties with the medium proved insurmountable, and the frescoes, which never dried properly, were removed only two decades after they had been created. Although Rigaud's vision was as expansive as Barry's, the space he was allotted was more limited, as was his intellect.

The other history painter who aspired to create monumental narratives resonating with grand philosophical, religious, social and political ideas is William Blake, who, however, worked, not necessarily by choice, in the different media of illuminated books and watercolour. Of all the Irishman's contemporaries, Blake is the one who most closely shared the breadth and profundity of his vision and the heroic vocabulary by which to express it. Born on 28 November 1757, Blake was sixteen years Barry's junior. In terms of their professional standings the two were far apart; until 1799 Barry was a Royal Academician and the Academy's professor of painting, whereas Blake, at least in the eyes of his contemporaries, never managed to rise above his position as a journeyman engraver. Yet both came from marginalised families that were not in the religious mainstream (Barry, an Irish Catholic, Blake, a London Dissenter); both were outsiders in London society; both were self-taught and were men of fierce intelligence and even fiercer opinions; and both were galvanised by a strong sense of social injustice and inequality. In addition, both saw history painting as the primary means by which to effect the profound cultural changes they felt were needed. As Martin Butlin affirms, Barry 'was one of Blake's idols', and a portrait sketch of Barry by Blake is attached to the inside of the front cover of Blake's copy of Barry's 1783 *An Account of a Series of Pictures, in the Great Room … at the Adelphi*.[4] Similarities in composition among works that could only have been seen in their studios demonstrate that they had visited one another, an intimacy the Irish painter allowed to few fellow artists.[5] On the back of the title page of his copy of *The Works of Sir Joshua Reynolds*, edited by Edmund Malone and published in 1798, Blake complained bitterly about the depressing effects Reynolds, in his promotion of portrait painting, had had on English art. Significantly Barry headed Blake's list of other artists, a group that also included John Hamilton Mortimer and Henry Fuseli in addition to himself, who had been severely injured by Reynolds' supposed machinations: 'Having spent the Vigour of my Youth & Genius under the Opression of Sr Joshua & his Gang of Cunning Hired Knaves Without Employment & as much as could possibly be Without Bread, The Reader must Expect to Read in all my Remarks on these Books Nothing but Indignation & Resentment[.] While Sr Joshua was rolling in Riches Barry was Poor & [*Independent*] <Unemployd except by his own Energy>.'[6]

Both artists not only viewed the means and ends of history painting in a similar light, they also

Fig. 55 William Blake, *Joseph of Arimathea Among the Rocks of Albion*, 1773–c. 1810. Engraving, 229mm x 118mm. British Museum, London

cast the role of the history painter in identical terms. Blake later adapted one of his earliest works as an apprentice engraver to make a statement about artistic identity. As the caption of the later state of the print reads, he first engraved this image in 1773, taking it from a drawing (more likely a print) after a figure by Michelangelo that had been abstracted from the lower right-hand corner of the fresco *The Crucifixion of St Peter* in the Cappella Paolina in the Palace of the Vatican. In his later reworking, Blake titled the image at the upper right, 'JOSEPH / of Arimathea / among The Rocks of Albion'. Joseph of Arimathea was witness to Christ's crucifixion and was the owner of the tomb in which the Saviour was buried. Blake's identification of the anonymous figure in his engraving with Joseph is far from arbitrary. The sad, bearded head beneath a Phrygian or Parthian cap is extremely similar to the figure that can plausibly be identified as Joseph of Arimathea supporting the body of Christ in Michelangelo's *Pietà* in the Duomo, Florence. Thus, as Blake would have it, Joseph travels westward. After having witnessed Christ's crucifixion in Jerusalem, he journeys to Rome, where he witnesses St Peter's crucifixion, and now finds himself on England's shores, again a plausible progression in light of the legend that he had founded the first church in England at Glastonbury.[7] Furthermore, both of Michelangelo's figures, the man in *The Crucifixion of St Peter* and the one in the Florentine *Pietà*, have been identified as self-portraits, images of the aging Michelangelo in a moment of extreme personal sorrow and profound meditation. In the inscription, Blake, alluding to the verses in Paul's Epistle to the Hebrews (11:37–38), identifies this figure of Joseph of Arimathea/Michelangelo with the self-sacrificing artists of the Middle Ages and subsequently of all periods: 'This is One of the Gothic Artists who Built the Cathedrals in what we call the Dark Ages / Wandering about in sheep skins & goat skins of whom the World was not worthy / such were the Christians / in all Ages.' As with Barry, the concept of being both an artist and a long-suffering martyr go hand in hand. Also, as with Barry, the allusions to the imagery and texts of earlier artistic traditions are rich and complex, creating from a thoughtful approach to the art of the old masters new, dynamic narratives of his own.

Another facet of Blake's kinship with Barry is their reverence for great men. Blake has already been quoted as supplying the most suitable inscription for *Elysium and Tartarus*: 'The worship of God is. Honouring his gifts in other men each according to his genius. and loving the greatest men best, those who envy or calumniate great men hate God, for there is no other God.'[8] Another passage from one of

Blake's Illuminated Books also supplies a remarkably apt expression of Barry's point of view, although Blake states his truth in the positive rather than in the negative:

I know of no other Christianity and of no other Gospel than the liberty both of body & mind to exercise the Divine Arts of Imagination[,] Imagination[,] the real & eternal World of which this Vegetable Universe is but a faint shadow & in which we shall live in our Eternal or Imaginative Bodies, when these Vegetable Mortal Bodies are no more ... What are the Treasures of Heaven which we are to lay up for ourselves, are they any other than Mental Studies & Performances? What are all the Gifts of the Gospel. are they not all Mental Gifts? ... O ye Religious discountenance every one among you who shall pretend to despise Art & Science! ... What is the Life of Man but Art & Science? ... What is Mortality but the things relating to the Body, which Dies? What is Immortality but the things relating to the Spirit, which Lives Eternally! What is the Joy of Heaven but Improvement in the things of the Spirit? ... Answer this to yourselves, & expel from among you those who pretend to despise the labours of Art & Science, which alone are the labours of the Gospel.[9]

For Barry, as for Blake, the mental pursuit of art and science is heeding the voice of God, which is that imaginative core within. Barry was in complete agreement with Blake's rhetorical question, 'What is the Joy of Heaven but Improvement in the things of the Spirit?' His Heaven is filled with leaders in mental pursuits, who continue to explore questions of art and science. The viewer is invited to join actively in this dialogue, but sadly most are not up to this task. Barry would have liked to have cried out with Moses, 'would God that all the LORD's people were prophets, *and* that the LORD would put his spirit upon them!' (Numbers 11:29).[10]

Many artists of this period, including Reynolds himself, paid lip service to history painting's exalted role, but Barry and Blake were among the few to act on this precept. Like Barry, Blake desperately wanted to create monumental works in public spaces. In his catalogue to a private exhibition of his work of 1809, he wrote of his ambition to create imposing, portable pictures for prominent public buildings: 'I could divide Westminster Hall [in Parliament], or the walls of any other great Building, into compartments and ornament them with Frescos [i.e. his version of tempera], which would be removable at pleasure.'[11] Later, in discussing four of his watercolours of religious subjects in the exhibition, he wrote, 'The above four drawings the Artist wishes were in Fresco, on an enlarged scale to ornament the altars of churches, and to make England like Italy, respected by respectable men of other countries on account of Art ... The times require that every one should speak out boldly; England expects that every man should do his duty, in Arts, as well as in Arms, or in the Senate.'[12] His conclusion to his introductory remarks could have just as easily been written by Barry: 'If Italy is enriched and made great by RAPHAEL, if MICHAEL ANGELO is its supreme glory, if Art is the glory of a Nation, if Genius and Inspiration are the great Origin and Bond of Society, the distinction my Works have obtained from those who best understand such things, calls for my Exhibition as the greatest of Duties to my Country.'[13] Again, art formed an important part of the national dialogue in defining and uniting a people as well as determining its future direction.

Because he could not secure public venues for his art, Blake turned to other means to disseminate his mythic narratives, publishing his Illuminated Books, which combine text and image on sheets of copper. What is important to recognise, however, is that these pages exhibit the same heroic vocabulary, derived from artists such as Michelangelo, as do large-scale history paintings. Blake's is a monumental art no matter the size of the page on which his images appear. By also turning to this format, he kept control of the means of production, freeing himself from the need to heed patrons or advisers.

Blake's Illuminated Books demarcate a startling break with past traditions. Benjamin West, for example, embarked, with advice from others, on a sophisticated interpretation of a biblical narrative

Fig. 56 William Blake, *Urizen on the Atlantic*. Relief-etching, colour-printed, 234mm x 168mm. Plate 10 of *Europe: A Prophecy*, Lambeth, London, 1794. Yale Center for British Art, Paul Mellon Collection, New Haven

based on one of St Paul's sermons. Building on earlier traditions, he did not depart from the conventional practices of history painting. Blake, on the other hand, created private myths that, while building on traditional iconography, transcend these sources. He chronicles apocalyptic struggles that have as their backdrop the grand sweep of politics, religion, culture and intense psychological tensions over the millennia, while at the same time tracing the conflicts taking place within each individual. Two pages drawn from his 1794 publication *Europe: A Prophecy* offer examples of this original and complicated approach.

Urizen on the Atlantic from *Europe*, an image of restricting symmetry, portrays one of mankind's ubiquitous oppressors. The enthroned figure is a mixture of a king and priest, a forbidding representation of state religion, who holds a copy of the brazen book mentioned in the lines at the bottom of the page. The porcine features are those of George III, and the papal tiara, Gothic throne and ecclesiastical dress imbue him with religious authority as the controlling and oppressive figurehead of England's state religion. In the title page to *The First Book of Urizen*, also of 1794, Urizen, the god associated with reason that has been perverted in a fallen world, sits on his brazen book while

Fig. 57 Anonymous, *Babel and Bethel: Or, The Pope in his Colours*, 1679. Broadside, letterpress and engraving, 174mm x 294mm (image), 464mm x 365mm (sheet). British Museum, London

scribbling on tablets. Behind and framing him are the twin Mosaic tablets, because all these writings are meant to command and restrict in an effort to deaden the poetic spirit within. The bat-like wings of the Urizenic king/priest in *Europe* have five ribs each, presumably again associating this negative authority figure with the Ten Commandments. The cloud on which George III floats against an inky backdrop of profound darkness is in its shape not unlike an inverted mirror image of the wispy cloud containing the text at the page's bottom. In this fallen world, each delusional construct reflects the other; what is at first glance a rigid, seemingly immutable order, which the symmetrical angels help to define and support, can in fact vanish in an instance.

David Bindman has astutely pointed to an earlier broadside as one of Blake's sources.[14] Here the artist draws on seventeenth-century popular imagery that formed part of a continuing English assault on Roman Catholicism. In this work, the pope is associated with the Whore of Babylon from the Book of Revelation, whereas Charles II, in contrast, is associated with Bethel, the 'House of God' located near Jerusalem. Blake, however, simply conflated the two pictures, combining the current English king and the pope as powers to be resisted rather than obeyed. Blake would have relished as well the fact that this anonymous broadside unintentionally makes the same point. The scenes of violence associated with the pope are despicable because they show Catholics mercilessly destroying Protestants, whereas the violent executions on the right are to be applauded because the tables have been turned. Yet visually nothing changes from one side to the other. Both show the powerful inflicting unimaginable tortures on anyone opposing their will. Thus even in the seventeenth-century broadside the images unwittingly conflate pope and king in an orgy of bloodlust.

Fig. 58 William Blake, *Los fleeing with his Daughters*. Relief-etching, colour-printed, 232mm x 165mm. Plate 15 of *Europe: A Prophecy*, 1794. Yale Center for British Art, Paul Mellon Collection, New Haven

While Blake and Barry were similar in their creative use of iconography, an iconography that they, with an abundance of unwarranted optimism, were counting on their public to recognise, the details of their message were obviously not always compatible. But if Blake did not see eye to eye with Barry on the papacy, even in this respect they had more in common than not. Blake had no objections to the support the papacy had given to artists, such as Raphael and Michelangelo, only to its claims to unquestioning obedience, claims that Barry chose to downplay or ignore in his view of the papal government as instigator and facilitator of creativity rather than as a tyrannical naysayer. Both men strongly denounced oppressive authority while championing the guiding spirit provided by the creative imagination. They were in complete agreement on the things that mattered.

Blake's final plate in *Europe* ends with lines in which Los, who represents the creative imagination, releases an earth-shattering cry that 'Call'd all his sons to the strife of blood', a war cry that begins the

revolutionary attempt to overthrow the world's despotic regimes. The image beneath these lines shows what appears to be a father fleeing the classical ruins of a burning city with his two daughters. As in his other designs, Blake intentionally invokes imagery drawn from earlier art, in this case looking to the high art of classical sculpture, conjuring up such heroic nudes as the *Horse Tamers* on Rome's Quirinal Hill. Some critics have also credited Blake with alluding to Aeneas' flight with his family from Troy.[15] Troy does offer an archetypal image of a city in flames, and it does not seem far-fetched to think Blake wants the viewer to associate his image with this famous scene from the *Aeneid*. This is Los or one of his sons, beginning, with remnants of his family, his long and arduous journey, which will end with the founding of a great city, in this instance the New Jerusalem rather than Rome.[16]

Blake and Barry were hardly alone in insisting on the importance of history painting, even if they were among the few to practise what they preached, but their similar approach to painting sets them apart from their contemporaries as kindred spirits. Iconography was a major building block for all artists of this period, but they, more than most, employed it as a universal language that could be adapted to their own voice in composing new interpretative narratives. Art of the past, be it pagan or Christian, was all part of this same sacred vocabulary. As Blake wrote in his 1809 exhibition catalogue,

The antiquities of every Nation under Heaven, is no less sacred than that of the Jews. They are the same thing as Jacob Bryant [in a book such as *New System of Ancient Mythology*, 1774–76], and all antiquaries have proved. How other antiquities came to be neglected and disbelieved, while those of the Jews are collected and arranged, is an enquiry, worthy of both the Antiquarian and the Divine. All had originally one language, and one religion, this was the religion of Jesus, the everlasting Gospel. Antiquity preaches the Gospel of Jesus.[17]

The two artists also exhibit similarities, as well as differences, in their use of texts. Although Barry often supplied canonical literary sources for his works, he, as in the Society of Arts series, did not 'illustrate' them but only used them as points of departure. He, too, supplied his own commentary on his work, but his writings are descriptive rather than independent creations. Blake in this regard is his own man; poet and painter, his texts are often in dialogue with his images, each at times providing competing points of view. Both artists also deliberately concealed their messages, not only to force the viewer to wrestle with their content but also in an effort to evade those who would censor their radical and unwelcome propositions.

Barry and Blake are most alike in their use of iconography to create private myths of their own, a philosophical stance that makes strenuous demands on the viewer. Theirs is an epic and prophetic vision of mankind's erratic and tortuous struggles. Although Barry at least offers a surface narrative, even if it is only the tip of an iceberg, Blake requires the viewer to dive head first into his perplexing mythic constructions. In this instance, paradoxically Blake provides the easier approach. One cannot escape the reality that the comprehension of his art is a demanding task. In Barry's case, for over two hundred years the surface narrative has sufficed, leaving the viewer with the impression that his work is confused, bombastic and marginal, unworthy of more intensive study.

Although both Barry and Blake qualify as prophets, few others among their contemporaries could claim to know, much less delineate in art, God's will and purpose for mankind. Who among Barry's and Blake's contemporaries did in fact understand their art? In Barry's case, the contemporary most likely to have perceived his intent was Blake. Their similarity in outlook and purpose and the likelihood of a close personal relationship suggest that Blake was aware of the Adelphi series' secret wisdom. He certainly adopted and expanded on the same approach in his own art. It takes a prophet to see and hear a fellow prophet, and although many are called, few are chosen.

Barry's portrayals as Timanthes in 1783 and 1803: embodying the artist's virtue

Barry created some of the most intriguing and arresting self-portraits of his generation. All five of his recorded self-portraits in oils have survived. The first three are his *Self-portrait with Paine and Lefèvre* (National Portrait Gallery, London), which he painted around 1767 when studying in Rome, his remarkable *Burke and Barry as Ulysses and a Companion Escaping from the Cave of Polyphemus* (see fig. 60), exhibited at the Royal Academy in 1776, and his haunting, 'unfinished' self-portrait of a few years later now at the Victoria and Albert Museum, London. His self-portraits in drawings and prints are equally gripping, particularly the late images showing him in the guise of Melancholy Genius.[18] But his most prominent self-portrait is the one he created for the murals. This and his later reworking of its concept, his Dublin self-portrait (see fig. 61), have the authority of an official image, his definitive statement on who he was as an artist and his place within the pantheon of genius.

With his insertion of himself as the Greek artist Timanthes into the mural *Crowning the Victors at Olympia*, Barry takes his place among the ancients. The artist had initially contemplated including other contemporary figures in this painting,[19] but in the end he only introduced himself into the mural along with the recently deceased William Pitt, the Earl of Chatham, who appears as Pericles. In his 1778 print commemorating Pitt,[20] Barry had already cast the statesman as an antique hero, inscribing the following on the pyramid within the image: 'The Secretary stood alone, modern degeneracy had not reached him, Original, and unaccomodating [*sic*]; the features of his character had the hardihood of Antiquity.' The artist now accords himself this same honour. In addition, he is the only figure in the mural to make eye contact with the viewer.

The question arises as to why Barry chose Timanthes as his classical persona. Apelles was the artist who enjoyed the acclaim of having been antiquity's greatest painter, but Barry had already reserved pride of place for him in *Elysium*. In his letter to Sir George Savile of 19 April 1777, the artist writes of his intention to include the artist Aetion among the onlookers at Olympia, which was an appropriate choice

Fig. 59 Detail of *Crowning the Victors at Olympia*, 1777–84. Royal Society of Arts, London

in that Aetion had been cited as having exhibited at the Olympic Games. Thus presumably at that time he was thinking of including himself as Aetion, but ultimately he settled on Timanthes, because the way this Greek artist's approach to art had been characterised best matched his sense of his own genius.

No paintings by Timanthes have survived, but Barry here recreates one of his most famous as described by Pliny, one that showed satyrs cautiously approaching a large, sleeping Cyclops in order to measure the size of his thumb with a thyrsus, a subject that might first appear as trivial. Yet the contrast between a trifling appearance and a profounder reality lay at the core of this subject's appeal. Pliny had singled out Timanthes for just this type of intellectual profundity: 'Indeed Timanthes is the only artist in whose works more is always implied than is depicted, and whose execution, though consummate, is always surpassed by his genius.'[21] In his book *The Painting of the Ancients*, published in 1638, Franciscus Junius, following in Pliny's footsteps, offered an early account in English of Timanthes' prowess:

There are also other proofes of his wit [i.e. his inventive intellect]: as namely a sleeping *Cyclops* in little [i.e. within a small format]: whose greatnesse when he studied to expresse, he painted some Satyrs hard by measuring his thumbe with the stalke of some kinde of hearbes. There is ever much more understood in his workes, then [*sic*] there is painted; and though the Art be great, yet doth his wit goe beyond the Art.[22]

Later in the seventeenth century, in his 1668 book *An Idea of the Perfection of Painting*, which had been translated from the French edition of 1662, Roland Fréart, sieur de Chambray, elaborated at length on why Timanthes' picture was held in such high esteem:

For he [Pliny] afterwards speaks of another *Work* of the same hand, which represented a *Polyphemus* sleeping; but in so narrow a compass, that the *streightness* of the *Table* [i.e. panel] hindered the *Painter* to design so *Gigantick* a body, as that prodigious *Cyclops* requir'd. But this *distress* gave *Timantes* occasion to shew the World, that his *Wit* and *Invention* was superiour to all the other rules of *Art*: He resolves therefore to supply this defect of *Matter*, and discover to the *eye* of the *mind* what he could not do to the eyes of the *body*.[23]

Chambray maintained that what raises the conception to the level of genius was the addition of satyrs around the snoring giant, some of whom were running away in fright, others showing a mixture of fear and admiration, whereas the hardiest approached him to measure one of his thumbs, for which purpose they used their thyrsi. He concludes: 'this *Invention* of our *Painter* was thought so *ingenious* and *new*, that it prov'd a great reputation to his *Piece*, which was else but very indifferent of it self, and of an inconsiderable *Subject*.'[24]

Chambray identified Timanthes' Cyclops with Polyphemus, the most famous of the Cyclopes from antiquity. Barry had already placed himself with Polyphemus in his earlier self-portrait of 1776, *Burke and Barry as Ulysses and a Companion Escaping from the Cave of Polyphemus*. In this instance the narrative was drawn from Homer's *Odyssey*, where the fierce Cyclops is a monster intent on cannibalising Ulysses and his men. In his book *A Philosophical Enquiry into the Origin of Our Ideas of the Sublime and Beautiful*, first published in 1757, Burke had cited this Polyphemus as an example of the horrific sublime:

The large and gigantic, though very compatible with the sublime, is contrary to the beautiful. It is impossible to suppose a giant to be the object of love. When we let our imaginations loose in romance, the ideas we naturally annex to that size are those of tyranny, cruelty, injustice, and every thing horrid and abominable. We paint the giant ravaging the country, plundering the innocent traveller, and afterwards goring with his half-living flesh: such are Polyphemus, Cacus, and others, who make such a figure in romances and heroic poems. The event we attend to with the greatest satisfaction is their defeat and death.[25]

Fig. 60 James Barry, *Edmund Burke and James Barry as Ulysses, and a Companion Fleeing from the Cave of Polyphemus, c.*
1776. Oil on canvas, 1270mm x 1008mm. © Crawford Art Gallery, Cork

Given the cautious nature of the satyrs' approach, elements of the terrifying power of Homer's
Polyphemus are also evident in Barry's recreation of Timanthes' painting. Yet Timanthes' Cyclops is
not the monster for whom Burke imagines a satisfying death. In his account, Chambray mentions in
glowing terms Giulio Romano's variation on Timanthes' theme in his fresco of Polyphemus in the Villa
Madama, which Barry would have seen during his long sojourn in Rome. In his interpretation, Giulio
looks to Ovid's description of Polyphemus in the *Metamorphoses* for clues as to his accoutrements,
taking from Ovid the enormous staff formed from an uprooted tree as well as rustic pan pipes.[26] In
addition, as detailed by Chambray, Giulio adds a greater number of satyrs engaged in a variety of antics

Fig. 61 James Barry, *Self-portrait as Timanthes*, *c*. 1780 and 1803. Oil on canvas, 760mm x 630mm. National Gallery of Ireland Collection, Photo © National Gallery of Ireland

designed to elicit a smile rather than a fearful shiver. He also replaces the measuring of the thumb with that of a big toe. In comparing the classical work with Giulio's interpretation, Chambray concludes,

The first, which is that of *Timanthes*, will shew us, that a small *Piece* may sometimes emerge a great and noble *Master-piece*, according as the *Idea* of the *Painter* is qualified and heightend, whence one may judge, that there is no *Argument* so poor and barren, but what may be inrich'd by an ingenious and fruitful *Invention* … For the other *Composition* of our modern *Julio Romano*, it does in effect shew us, that an ingenious *Imitation*, may equal, and even exceed the *original*.[27]

Barry creates his own 'imitation' in response to the account of Timanthes' original, and again the underlying concept is that invention or the idea underlying a work is of greater importance than the execution. The fact that in his self-portrait he holds a porte-crayon, with which one first lays down the outline or idea, rather than brushes and a palette, underscores this meaning. In the 1792 print 'reproducing' his mural (see fig. 13), Barry adds brushes and a palette at the base of the statue of Hercules on which he sits. Tellingly, a scrolled paper unfurls beneath the palette. Again painting is proclaimed an intellectual activity, equal, if not superior to, writing, and the unfurling paper recalls the scroll next to Orpheus. Barry, the painter, possessed of the intellectual profundity of a Timanthes, is seen to be part of a long, but highly select, line of instructive philosophers stretching back to Orpheus, the hero of the first mural with which the narrative begins. In contrast to Giulio's more playful response, he returns the subject matter to its more serious and high-minded roots

After the Society of Arts approached Barry in the spring of 1804 for a self-portrait that could serve as an engraved frontispiece to the next volume of its *Transactions*, the artist replied in the third person: 'The only portrait Mr Barry has of himself is the head which he painted many years since, & copied at the time into the picture of the Olympic victors. Notwithstanding the wear & tear in such a fragile thing as the human countenance, yet as Mr. Barry's friends thought it still like him, he without in the least touching the head, finished the rest of the picture sometime last summer by painting in the hands, drapery, cyclops &c.'[28] This canvas, his last painted self-portrait (begun *c.* 1780 and completed in 1803), updates and expands on the earlier image, in effect serving as his last will and testament. The radical compression is startlingly powerful, demanding the attention of the mesmerised viewer.

In his 1783 account of the mural, Barry writes, 'On the basement of this statue of Hercules, sits Timanthus the painter'.[29] Thus even in the mural he intends a close association of himself as Timanthes with this statue of Hercules treading on the Serpent of Envy. Despite the fact that visually the statue and Timanthes share only a tangential proximity, the association was always there, but in the 1803 rendition it becomes an inescapable and integral part of the self-portrait's meaning. In his highly condensed rendering, the radical juxtaposition turns the serpent's fanged, dragon-like head into a terrifying presence directly adjacent to the self-portrait's right ear. In his description of the mural, Barry cites Horace's *Epistle I* from his *Second Book of Epistles* as his textual source for the concept of Hercules treading upon Envy. Initially, Barry had considered introducing the Greek writer Prodicus as a witness at the Olympic Games in honour of his celebrated allegory of Hercules choosing between Virtue and Vice.[30] Hercules had chosen the former, going on to perform his heroic labours. Yet as sung by Horace, it was these very qualities and achievements that aroused the envy of others, who incessantly hissed their venomous attacks on his character. Philip Francis provides the eighteenth century's most popular English translation of the relevant passage in Horace's verse:

> Who crush'd the Hydra, when to Life renew'd,
> And Monsters dire with fated Toil subdu'd,
> Found that the Monster Envy never dies,
> 'Till low in equal Death her Conqueror lies;
> For he, who soars to an unusual Height,
> Oppressive dazles, with Excess of Light,
> The Arts beneath him: yet, when dead, shall prove
> An Object worthy of Esteem and Love.
> (Horace/Francis, *Epistle I* in *Second Book of Epistles*, vol. 2, p. 379)

An eighteenth-century prose translation gives an even clearer statement of Horace's theme: 'Even

the Hero who crushed the dreadful *Hydra*, and, by a Labour imposed on him by Fate, surmounted the Opposition of so many Monsters, found that Envy was only extinguished in Death. For whoever remarkably excels others, raises a Jealousy by this Superiority: yet no sooner is he removed from us, than his Memory begets a Veneration.'[31] Barry's citation of Horace's epistle as his textual source demonstrates that, when he describes in his 1783 *Account* the meaning underlying the Serpent of Envy, these haunting attacks come from without rather than from within:

by-the-bye, it is no doubt a good and a wise distribution, that Envy should continually haunt and persecute the greatest characters; though for the time, it may give them uneasiness, yet it tends on the one hand to make them more perfect, by obliging them to weed out whatever may be faulty, and occasions them on the other, to keep their good qualities in that state of continued unrelaxed exertion, from which the world derives greater benefit, and themselves in the end, still greater glory.[32]

Barry sees himself as continually harassed by his jealous colleagues and benighted critics, but listening to the serpent's hiss will only make him stronger. Yet such a paradigm ensured a life of painful isolation. The Royal Academy's annual exhibitions, in particular, provided a venue where greed and envy always trumped merit, or so Barry believed. In the murals, his self-portrait at the left of *Crowning the Victors at Olympia* faces the right-hand side of *Elysium and Tartarus*, where he depicts hell with his version of the seven deadly sins. For Barry the worst of these is envy, and by the second exhibition of the murals in 1784, he had even added a second figure to go with the first, showing a blindfolded man holding a dagger in each hand with vipers pulling at his ears. In his large print detail *The Angelic Guards* (see fig. 69), Tartarus, or hell, has been reduced solely to the vipers that swim like sharks through its Stygian depths.

Living with the constant assault of one's envious inferiors is bad enough, but as Horace says, and Barry reiterates, the only way Hercules could finally triumph over envy was to die, since then his superiority could no longer threaten the living. Barry's greatness itself is what has put him at risk, and ironically only death can rescue him from his contemporaries' venom.[33]

Despite Barry's having chosen Timanthes as his classical surrogate, there is also within his focus on the power of envy a link with Apelles, the artist from antiquity who enjoyed the highest reputation. The trampling of envy evokes one of Apelles' famous lost pictures. As related by Lucian, after having had malicious charges directed at him by a fellow artist, Apelles executed a work known as *The Calumny of Apelles*, which exposed this iniquitous assault on his reputation. In the opening to his book devoted to this subject, David Cast characterises this allegory's primary moral: 'It [calumny] is the result of envy, and envy to Renaissance moralists, as to their peers in antiquity, was an extraordinarily serious vice – even considered the source … of all the ills that afflict Man.'[34] As Cast points out, artists being identified with, or identifying themselves with, Apelles became commonplace.[35] Barry, though, avoids this cliché by identifying with Timanthes, but he still invokes an image that contains echoes of *The Calumny of Apelles*. He would, too, have been acutely aware that his predicament was far worse: Apelles had the support and patronage of Alexander the Great, whereas Barry had no august patron, such as George III, to protect him. As with the Society of Arts murals, he had to appeal to the public at large, making the consequences of the venomous attacks on his reputation all the more consequential.

In the mural, Barry shows himself in pseudo-classical attire, wearing a white undergarment over which is a bulky yellow-and-orange robe. Lying beside him, tumbling down the steps of the statue, is a red cloak. In the 1803 version, he is in modern dress with a white undershirt beneath a yellow vest. His bulky red coat, as with the earlier yellow-and-orange robe, adds to his impressive size. His modern attire also contains intimations of martyrdom. In the aftermath of the French Revolution, with its

introduction of the tireless guillotine, the black tie cord that cuts across his throat strikes an ominous chord as does his coat's blood-red colour.

As in the mural, Barry props up his recreation of Timanthes' work on his left-hand side (the viewer's right). Cropped and now within a rectangular frame, the composition of the painting-within-the-painting has undergone subtle but significant changes from its 1783 appearance. More clearly than before, it is as if the format of *Ulysses and a Companion* has been turned inside out; in contrast to the 1776 painting, the Cyclops now inhabits the foreground and the other figures are behind, with the foremost satyrs recalling the relationship between the older, cautioning Burke and his anxious companion. Yet the figures echoing Burke and Barry approach rather than flee the Cyclops, whose nature has also changed dramatically. In *Ulysses and a Companion*, he is the Polyphemus of Homer's telling, a violent, man-eating monster. Timanthes' Cyclops is more benign, if only because he is asleep. Giulio Romano's fresco based on Timanthes' picture had even turned him into a wellspring for humour rather than dread. Ovid's more humanised Polyphemus has supplanted Homer's savage. In the 1803 self-portrait, the serpent replaces Polyphemus as the picture's villain. The Cyclops in fact is now a heroic figure, a characterisation that in the 1783 mural was not so clearly pronounced. Radically cropped, one sees mostly his torso, where the visual source is the *Belvedere Torso*, one touchstone for the classical ideal. Barry, following well-established custom,[36] held the *Torso* in the highest regard.[37] The *Torso* was also thought, because of the lion skin on which it sits, to represent Hercules.[38] Barry has surrounded himself with this heroic figure: Hercules' foot is seen at the upper left, while Hercules' sublime *Torso* provides the model for the figure at the lower right. The composition's compression makes the artist himself appear all the more powerful. He metamorphoses into a modern-day Hercules, supported and enhanced by classical prototypes on both sides.[39]

These juxtapositions of the past with the present help to blur the distinctions between the classical and modern periods. The universal values that run through both are part of the eternal present, in which past and present are forever intertwined. At least for his own purposes, Barry had successfully resolved the battle of the ancients and the moderns, which had preoccupied so many, as to which age should be considered superior to the other. Within this debate, a favourite metaphor was that of giants and dwarfs, with, most frequently, antiquity being associated with the former and moderns with the latter. In a letter of 5 February 1675/76, to Robert Hooke, Sir Isaac Newton employed an oft-quoted variation on this theme when he wrote, 'If I have seen further it is by standing on ye sholders [*sic*] of Giants'.[40] The conclusion to be drawn from such statements is complex and ambiguous, but many agreed that in science, where Newton was a prime example, the moderns had bested the ancients, but in the arts the moderns were still considered as inferior.[41] Piranesi, for example, built a career on exaggerating the grandeur of Roman ruins in whose shadows scurry the less-than-imposing ragged figures of the contemporary world.

Various psychological strategies were adopted to attempt to lift the burden of the past off the shoulders of the moderns, and one of the most successful was the approach embodied in Edward Young's *Conjectures on Original Composition* of 1759. Young preached the virtues of original genius, arguing that one should look within for inspiration rather than becoming enslaved and oppressed by too great a reliance on imitating the works of antiquity. Cleverly adapting the giant-and-dwarf metaphor to his argument, he writes, 'Too formidable an Idea of their [the ancient authors'] Superiority, like a spectre, would fright us out of a proper use of our Wits; and dwarf our Understanding, by making a Giant of theirs. Too great Awe for them lays Genius under restraint, and denies it that free scope, that full elbow-room, which is requisite for striking its most masterly strokes'.[42] In number fifty of his long list of aphorisms, Barry's colleague Henry Fuseli, who was born in the same year as he, even refers to the content of Timanthes' picture when writing about the relationship of contemporary genius to the past masters:

50. Genius may adopt, but never steals.

Coroll[*ary*].–An adopted idea or figure in the works of genius will be a foil or a companion; but an idea of genius borrowed by mediocrity scorns the base alliance and crushes all its mean associates – it is the Cyclop's [*sic*] thumb, by which the pigmy measured his own littleness, – 'or hangs like a giant's robe upon a dwarfish thief'.[43]

The giant Cyclops or the spectre of the antique is always poised to crush the modern pygmy. Only genius can escape this fate.

In Homer's *Odyssey*, as translated by Alexander Pope, Polyphemus uses the imagery of giants and dwarfs when shouting after the fleeing Ulysses and his men:

> I deem'd some godlike Giant to behold,
> Or lofty Heroe, haughty, brave, and bold;
> Not this weak pigmy-wretch, of mean design,
> Who not by strength subdu'd me, but by wine.
> (Homer/Pope, *The Odyssey*, Bk 9, lines 601–4)

In *Ulysses and a Companion*, Burke and Barry win a dangerous round with this monster, as Ulysses had, but Polyphemus' insult suggests that they are still far from equals. In the painting-within-the-painting in the 1803 self-portrait, the counterparts of Burke and Barry from the 1776 painting are the two diminutive satyrs who marvel at the grandeur of the giant, but in terms of the central image – Barry's self-portrait – the artist himself takes on the mantle of greatness. His impressively large body, made all the more powerful by the intense compression of the space it inhabits, can easily fill out the giant's robes. He is now truly a coequal with the Cyclops, his porte-crayon, with its potent placement and angle, paralleling the Cyclops' staff. As the Cyclops' thumbs are cut by the frame, the only ones offered to the viewer are those of the artist himself. Just as the satyrs approach in amazement the mighty Polyphemus/Hercules to measure his thumbs, the viewer, their mirror image, approaches Barry with the same awestruck regard. The godlike artist is as formidable and dominating as any ancient; indeed, by the end of his career he has become one of them.

There are close parallels between the image of Hercules crushing underfoot the Serpent of Envy and Christian iconography, establishing once again a creative synergy between the two. As already seen in the discussion of *The Education of Achilles*, the Christian counterpart of a foot treading upon a serpent goes back to Genesis, where, in the Garden of Eden after the Fall of Man, God places a curse on the serpent: 'And I will put enmity between thee and the woman, and between thy seed and her seed; it shall bruise thy head, and thou shalt bruise his heel' (3:15). In his first painting exhibited in London, *The Temptation of Adam* (National Gallery of Ireland, Dublin), which appeared at the Royal Academy in 1771, Barry had alluded to this curse by juxtaposing the serpent's head with Adam's heel. Christ, the Second Adam, was sent finally to crush Satan in the form of the serpent, and Christian iconography, as in the print after Pietro Testa, shows the young Christ trampling with his foot on the serpent's head. In the classical relief at the right, Testa even relates Christ to Hercules in terms of the hero's second labour, in which he battles the Hydra, the multi-headed, monstrous serpent.[44] As in the self-portrait, the foot treading on the serpent is to be identified with both Hercules and Christ, the classical figure having been subsumed into the Christian one. As in the case of Orpheus, Hercules is another mythic, pagan figure interpreted through typology as having prefigured Christian subject matter.

In the Christian account, the sin of envy can be read as the primary cause of mankind's fall. When Satan in the form of the serpent tempts Eve to eat the apple, it is with the promise that she and Adam will become as gods: 'For God doth know that in the day ye eat thereof, then your eyes shall be

Fig. 62 Giovanni Cesare Testa, after Pietro Testa, *Christ Trampling the Serpent, c.* 1650–55. Engraving, 21cm x 25cm (trimmed). British Museum, London

opened, and ye shall be as gods, knowing good and evil' (Genesis 3:5). John Milton in *Paradise Lost*, Barry's primary text for *The Temptation of Adam*, also makes envy the central theme:

> Round the tree [bearing the forbidden fruit]
> All other beasts that saw, with like desire
> Longing and envying stood, but could not reach.
>> (Milton, Bk 9, lines 591–3)

Satan accuses God himself of having been motivated by envy in forbidding Adam and Eve the acquisition of knowledge:

> What can your knowledge hurt him, or this tree
> Impart against his will if all be his?
> Or is it envy, and can envy dwell
> In heav'nly breasts?
>> (Milton, Bk 9, lines 727–30)

Eve herself, just before she takes her fateful bite, rationalises that the serpent, who has already tasted of the fruit, shows no signs of an envious nature:

> ... yet that one beast which first
> Hath tasted, envies not, but brings with joy
> The good befall'n him, ...
> (Milton, Bk 9, lines 769–71)

Again, in Milton as in the biblical account, the main temptation is clear: 'and ye shall be as Gods' (Milton, Bk 9, line 708). Thus envy is not only a cardinal sin, it is also the Original Sin. Mankind's fall was the result of envying God's wisdom and knowledge, which man vainly hoped to acquire. Barry was tone deaf to the ironic implications of envy's corrosive power. Despite the fact that in his self-portrait he takes on the mantle of Hercules/Christ, himself becoming as a god, he is not the one who is guilty of envy – rather the guilty ones are those who envy his genius.

Isolated from almost all of his artistic colleagues and suffering from paranoia, Barry believed that his greatness had made him a target for his envious inferiors, but this ever-present promise of a martyr's death only sanctified his mission. In the murals he had identified with such classical figures as Hercules and Orpheus, both of whom, in their turn, are closely associated with Christ, who died for the sins of the envious multitude. In his self-portrait his expression of ingenuous simplicity gives him the poignant look of Christlike innocence.

At this point it would be worthwhile to revisit how envy acts as a spur to greatness. Interpreting the source of envy as coming from without rather than from within is counter-intuitive to what we know about Barry's conduct. Exploring further this dynamic helps crystalise the artist's intent. His writings contain frequent diatribes against those who were more successful than he, not the least of whom was Sir Joshua Reynolds. James Northcote relates how, during Barry's lectures at the Royal Academy that he gave in his role as professor of painting, Reynolds found it expedient to feign sleep or to absent himself because of the artist's intemperate remarks.[45] When it was his turn to deliver his *Discourses* as the Academy's president, Reynolds had to deal with Barry's expressing 'to those near Him His contempt for what Sir Joshua spoke'.[46] Barry's jealousy over Reynolds' success as a 'mere' portrait painter and a leader of the artistic community was so unconstrained that Northcote recorded Sir Joshua as saying, 'he thought it a very bad state of mind to hate any man, but that he feared that he did hate Barry'.[47]

In his 1954 article on Barry's 1803 self-portrait, Robert Wark, after mentioning the similarities between it and the self-portrait in the earlier mural, offered an explanation of its meaning: 'One may deduce from the correspondence between the mural and the [1803] Dublin portrait that the portion of a statue in the top left-hand corner of the smaller picture is the foot of Hercules crushing the Snake of Envy. And this too may have been conceived by the artist as a personal allusion. Certainly as far as wealth and worldly position were concerned, he had just cause to envy the fashionable portraitists of his day'.[48] In 1984 Robert Rosenblum was in agreement with Wark's interpretation: 'Above Barry's head, we see a huge foot, that of Hercules, crushing the serpent of Envy, a reference to his efforts to squelch his jealousy toward other more fashionable and successful painters who, unlike him, did not set their goals at so high an imaginative level'.[49] Because of the ambiguity of Barry's statement about his self-portrait in the mural, one can indeed interpret envy as coming from within rather than from without: 'it is no doubt a good and a wise distribution, that Envy should continually haunt and persecute the greatest characters; though for the time, it may give them uneasiness, yet it tends on

the one hand to make them more perfect, by obliging them to weed out whatever may be faulty'.[50] Although Barry's personal conduct would seem to substantiate that the envy he describes is from within, his self-definition, however deluded, actually confirms the opposite.

Barry always wrote eloquently and unrestrainedly about the dangers posed by his jealous inferiors: 'there is nothing which the Public ought so much and so cautiously to guard against, as the clamours and combinations of low Artists, who, whenever they are indulged, are and always have been so blinded by that self-love, envy, and desperate bitterness, as carry after them such a long *et cetera* of disgrace and mischief, as well public as private'.[51] In his letter to Richard Dalton published in his appendix of 1784, Barry makes clear that the external attacks directed at him served only to make him stronger: 'the ordeals I have occasionally passed, have laid me under the necessity of weeding out of my disposition many vicious and useless tendencies, and invigorated and improved whatever little talents and good qualities had been bestowed upon me'.[52] Thus in his writings there is no evidence that he viewed envy's spur as a two-way street, coming from within as well as from without. In any case, his textual source, Horace's *Epistle*, makes the meaning of the Serpent of Envy in the two self-portraits unmistakable: it is others' envy of him that gives witness to his genius. What can explain this disconnect between Barry's biography and his interpretation of self as exhibited so forcefully in his 1803 self-portrait? First of all, Barry was anything but self-aware; he was always seeing himself as the victim of jealous inferiors rather than seeing himself as the one who was envious of others' success. But, more significantly, his conception makes such a personal accounting completely beside the point: he is unconcerned with achieving anything approaching self-revelation. His image is not intended to be confessional in the manner of Jean-Jacques Rousseau. Rather his aspirations belong to a different approach, one that is rooted in classical and Renaissance conventions.

In the Renaissance, both the study of history and of biography conformed to classical rhetorical models. Indeed, biography, like history, was understood to be a type of rhetoric. In writing biography the author was not intent on giving an account of a private life but instead the creation of a public image. Accordingly, there are canonical topoi, anecdotes that are part of rhetorical conventions, which have been repeated about artists' lives down to the present day. As expressed by Carl Goldstein, 'what is important is not what someone is, personality as we understand it, but rather where that person fits in a set of cultural categories that are transhuman and, therefore, unchanging'.[53] He elaborates, 'The character *topoi* describe is an example or type, neither capable of individual action nor with an individual personality – nothing not "artistic". About the subject of the *Life* they tell us only: this was a great artist'.[54] These topoi are grounded in classical culture, where rhetoric played a central role in ancient civic life. In giving witness to a subject's virtue, they can rise to the level of 'panegyrical rhetoric', which celebrates virtue and makes 'an appeal for moral living according to the understanding of morality within ancient society'.[55] Such rhetorical performances are intended to inflame the viewer to imitate the great man. More than this, in the Renaissance and later one experiences the artist as a sacred figure, engaged in a spiritual undertaking:

The experience in question is, as it had been in pre-modern Europe, fundamentally religious; the work of art so understood contains a spark of divinity, the artist responsible for it an almost holy figure…[W]hile seeming to celebrate an individual of rare spirituality within the framework of a tradition that we think of as promoting personhood, the Renaissance tradition as deepened in post-Enlightenment Europe is fundamentally depersonalizing.[56]

The Self-portrait as Timanthes is not the record, as Wark and Rosenblum would have it, of the artist's personality but of his belonging to a type – that of the great man. The 1803 self-portrait is a remarkable

archetypal symbol that brilliantly reformulates old topoi. Barry shows himself as the heir to two of antiquity's great painters, with the subject matter of Apelles' *Calumny* alluded to on the left and the mental prowess of Timanthes celebrated on the right. The artist, a modern-day Hercules, sits between the 'sculpture' and the painting-within-the-painting. Not only does he share with Hercules a dedication to virtue, but he also imbues himself with a Christlike divinity. The characteristics of the great man defined here are the artist as alienated genius, as guileless martyr and as hero. The viewer not only approaches in awestruck wonder to measure Barry's thumbs but also to touch the eloquently extended forefinger of his left hand. He is a semi-divinity, who, as in Michelangelo's *Creation of Adam*, can infuse new, abundant life into our own tired, constricted selves.

After insisting on the fact that Barry's conscious intent was not to present his life as lived but only his life as perceived, one might, however, speculate that the haunting, nightmarish quality of the hissing serpent so close to his ear may indeed reveal, albeit subconsciously, more of his inner life than he had intended. In any case, this traumatic juxtaposition only adds to the painting's emotional potency. In this iconic image, Barry takes his stand among the old masters; the stunning originality and hypnotic power of his conception corroborates the aggrandising nature of his bold assertion.

The visionary power of images

The Great Room's secret wisdom: the revelation of religious mysteries

After this extensive analysis of the murals' meaning, one can better understand Barry's own assessment of the demands of history painting: 'The majesty of historical art requires not only novelty, but a novelty full of comprehension and importance.'[57] It would be difficult to imagine a series whose content is more original than the narrative that he puts forth in the Great Room. In addition, there is no arguing with the profundity of his thought and the depth of his knowledge. It is worth repeating as well Samuel Johnson's assessment: 'Whatever the hand may have done, the mind has done its part. There is a grasp of mind there which you find no where else.'[58] It seems doubtful that Johnson comprehended Barry's programme, but he had the good sense and intuition to know that there was far more here than meets the eye.

On the surface the murals present an Enlightenment programme. With the exception of those pictures on modern subjects – *The Triumph of the Thames*, *The Distribution of Premiums*, and the intended portraits of the king and queen, which were followed by the proposed celebration of the Act of Union – Barry sticks to a classical script. His approach to the classical heritage was that its texts and art embodied timeless truths. These eternal verities, however, were purposefully concealed, requiring immense effort on the part of the viewer to comprehend their meaning. His own classical narratives conceal an underlying Christian allegory. *Elysium and Tartarus*, even on its surface given its cast of characters, has a strong Catholic bias. In the artist's construct there is no conflict between reason and belief. Although he opposes superstition and ignorance, he, unlike a Voltaire, does not view Christian faith, properly understood, as antithetical to scientific progress and moral understanding. He embraces a syncretic vision in which the pagan and the Christian are part of one animating impulse, expressing the same eternal truths that are part of God's revelation. These truths are structured around seminal histories and myths drawn from ancient Mediterranean cultures, not only Greco-Roman but also Egyptian and Judeo-Christian. Isis-Athena-Minerva-Mary are all part of the same belief system, which is an unsurprising connection given that their meanings all derive from God himself. In their adaptation of these ancient traditions, the murals are unified at their deepest level by a soaring mythic grandeur in which the viewer is invited to experience a version of

the Eleusinian Mysteries, as it was perceived as having been embodied in Virgil's *Aeneid*, which, at its core, harmonises with biblical revelation. The Roman Catholic Church is the modern heir to these parallel and intertwined traditions.

The murals encapsulate a coherent world view: civilisation changes as its understanding and practise of life's core values wax and wane over time, but the values, as laid out by God himself, remain unchanged and unchanging. While classical Greek civilisation provides the model for understanding life's ultimate meaning, this culture is seen as embodying the same divine revelations that are contained in the scriptures. Furthermore, one of the prime interpreters of Christianity's divinely imparted knowledge, or so Barry and other commentators presumed, was the pagan Roman poet Virgil, who, through the revelations of the Cumaean Sibyl, was informed, before the fact, by a Christian understanding of God's purpose for mankind. The artist's purpose was to recover and express those values through an exposition of a universal history.

The series, executed in a variety of styles and genres, lacks an organic cohesion; the message is more important than aesthetic concerns. Conceived as an initiation into spiritual values, the Great Room itself should be perceived as a cave or the dark interior of a temple, an echo of the Temple of Ceres at Eleusis, that acts as a theatre for the unfolding of sacred rituals. Each painting is to be focused on in its turn. It is as if a spotlight is first on *Orpheus*, and then moves around the room one picture at a time, with each telling its own part of the story. In this progress the initiate experiences the various stages singly, even as each scene builds on what has come before. In putting together the intellectual programme, the viewer constructs the overall harmony; content rather than style provides the series' glue. The progress finally concludes in a cosmic cloudscape of pulsating light where one can participate in unending revelations with like-minded members of the elect.

The journey laid out by the artist is related to the Catholic ritual of pilgrimage. The very act of undertaking this intellectual, emotional and spiritual pilgrimage through the paintings is an essential part of grasping their truths. This journey also is based on a sacred geography, with each of the first three paintings containing dual locales. One begins in Orpheus' Thrace as well as St John the Baptist's wilderness, and then moves to the landscapes outside Eleusis as well as Bethlehem and Jerusalem, before climaxing in both Olympia and Catholic Rome. Next comes the interlude of London as the world's navel, followed by London as the location for the rebirth of civilisation. The final sacred site is a glimpse of the afterworld itself. On one level this journey is that of Aeneas, and on another level that of the Catholic pilgrim. In each case the movement is from east to west, and those who run to read will be unable to grasp the eternal vision.

From the murals' first exhibition in 1783, Barry continued to fine-tune his message, making it more intelligible, rethinking certain aspects, emphasising others, and making it responsive to such major contemporary developments as the French Revolution and the Irish rebellion. Through all this, however, the core argument remained the same. The Western classical tradition in lockstep with the Judeo-Christian heritage provided the underlying framework. Probably because of his contact with General Miranda, he became much more engaged with Mesoamerica and South America. When forced to contemplate cultures outside the Western mainstream, he, as with so many others, saw those ancient American civilisations, which had been completely unknown to the West before 1492, through a lens that corroborated his world view. Barry's reaching out to the more remote corners of the earth only confirmed for him the truth of his central vision: mankind derives from a single source, and although the remote areas of the earth retained some memory of God's revelation, the Western tradition continued to be the one that most closely reflected the divine plan.

In promoting his syncretic classical-Christian world view, Barry was confronted with the tension between representing timeless, universal truths and addressing the specific concerns of a particular

time and place, that of late-eighteenth-century Britain. On a macrocosmic level he is presenting a universal history of mankind, but on a microcosmic level, his audience is the inhabitants of the British Isles. The Society's own published statement concerning the exhibition of the series spoke of it in a nationalistic context, asserting that it 'must be deemed a national ornament'.[59] The Society's membership saw the murals as contributing to the sophistication of the nation's cultural heritage, thereby enhancing its status and patrimony. But Barry was not interested in adding an ornamental jewel to the country's elite artistic production, but rather in addressing national concerns in a public forum.

As has been repeatedly enumerated, the artist addresses issues concerning national affairs, particularly in the *Thames* and in the *Distribution*, but what concerns us here is his primary message for the British public, a message that contradicted the deeply held religious beliefs of the vast majority of his countrymen. Barry's unifying vision is, at heart, a call to heal the country's great religious schism. Running through the series is a championing of the Roman Catholic Church as the fountainhead of what should be valued most in civilisation. From his point of view, his Protestant countrymen had sold their birthright in order for Henry VIII to divorce his Spanish queen. Thus the Catholics in the British Isles were the ones who were most in tune with those eternal verities on which future progress should be based. Within the nation's boundaries, the Irish best represented the people's uncorrupted native soul. As such, they were the ones best situated to lead their benighted compatriots back to their former, true selves, engaging in the healing of a national trauma.

Barry is imagining a community based on what he feels are the divinely sanctioned values of the original inhabitants of the British Isles. It would be helpful, however, to distinguish his sense of an imagined community, a phrase that he did not specifically employ, to Benedict Anderson's use of this term in his seminal book, *Imagined Communities: Reflections on the Origin and Spread of Nationalism*. Anderson proposes the following definition of the nation as 'an imagined political community': 'It is *imagined* because the members of even the smallest nation will never know most of their fellow-members, meet them, or even hear of them, yet in the minds of each lives the image of their communion.'[60] In his formulation, 'imagine' should be defined as 'to form a mental image of something not present'. As applied to Barry's conception, 'imagine' is closer to an alternate definition: 'to form a notion of without sufficient basis'.[61] Barry's imagined community, which for him had existed in the British Isles from early times, was mostly a fanciful construct. For this reason, it is hard to pin down his beliefs in concrete terms or to identify him with a specific political party or faction. In his mind there is no contradiction between a deeply held admiration for the monarchical government of King Alfred and a conviction that government should be rooted in the republican principles of equality and justice for all. There is a sense in his approach that wishing will make it so. In religious matters, Quakers and Catholics are virtually indistinguishable. Even a staunch anti-Catholic, such as John Milton, belongs squarely with the elect, because, to paraphrase Blake, Milton, as a fierce freedom fighter, was of the Catholic party without knowing it.[62] Milton surely would have been surprised to learn that he was Catholic at heart, but perhaps no more so than to learn, as Blake argued, the hero of his epic was Satan. In making the case for a unified British Isles, Barry envisions a community that would return to what he perceived as its original values, a cultural system that in the present is represented by the Irish Catholics. The Irish, in effect, should on a spiritual and intellectual level now colonise the coloniser. The result would be a reborn community that, while enjoying its own national identity, would also fit comfortably within the larger construct of a universal Christendom.

As an Irish Catholic, Barry was an outsider in terms of Great Britain, but, far more than the English and Scots, an insider in terms of the grand sweep of European history. He was indebted to Italian culture, in particular to Renaissance syncretic philosophy, to Neoplatonic thought, and to the Counter-Reformation Catholic archaeology of classical and early Christian remains that saw the

ancient past as solidifying the claims of the apostolic Church. Barry, too, was an astute reader of eighteenth-century critical writings, taking, for example, from Anglican theologians those elements that reinforced and expanded on his own world view, all this in order to make sense of a fragmented world that needed to return to the imagined harmony and unity of an earlier pan-European, Catholic culture. But it is not the world view that impresses, rather the startling originality of its articulation in the murals.

Hearing the voice of God: history painting's modern audience

To address an audience of citizens in a society where public opinion could help shape national goals and priorities was all well and good, but what if the public could not take even the first steps toward comprehending the work's message? Barry was frustrated indeed by the incomprehension, worst still the indifference, with which his masterwork had been received. One of the problems, as already noted, was that the artist purposefully disguised his underlying meaning, because if the Society of Arts had perceived the connection with the Catholic Church, it would have rejected the series as a despicable betrayal of its trust in granting him permission to decorate its interior. But in keeping with his concept of great art, Barry also wished to challenge the viewer to uncover those deeper meanings that lie beneath the surface. In addition, as we have seen, a third, even more compelling, reason is that the artist is initiating the viewer/acolyte into hallowed mysteries, both those of Eleusis and of the Eucharist, which in their essence are one and the same, and the word 'mysteries' itself implies religious rites that are secret and difficult of access. Thus the murals require a great deal from its audience in terms of absorbing and analysing their content before arriving at a fuller understanding. The journey itself is part of their meaning. But if a mural series is created in the heart of London and no one understands it, has it really been seen?

There is a perplexing quandary at the heart of Barry's enterprise. On the one hand, he does not intend his series for a limited audience or agenda. He invites everyone to participate in this journey of discovery. In this regard, his ambitious and expansive programme is like that of the Gothic cathedrals, offering an inclusive summa of spiritual knowledge. But unlike the messages carved in stone and affixed in glass in the cathedrals, this vision is not easily accessible. One has the dilemma of a public message offered to all and intended for all but that can be comprehended only by a few.

Christ provides the model for this tension between inclusiveness and exclusivity. Like Christ's teachings, Barry's work is conceived as a parable in which a seemingly self-sufficient narrative illustrates an even profounder and richer message. A secret wisdom lies at the core of his content that must be uncovered in order to be understood. Earlier, Matthew's account of Christ's comments on seeing without seeing was quoted, but Mark's version is even tougher and more uncompromising:

And he said unto them [the disciples], Unto you it is given to know the mystery of the kingdom of God: but unto them that are without, all *these* things are done in parables:

That seeing they may see, and not perceive; and hearing they may hear, and not understand; lest at any time they should be converted, and *their* sins should be forgiven them.

And he said unto them, Know ye not this parable? and how then will ye know all parables?

(Mark 4:11–13)

Christ's harsh statement is followed by his parable of the sower of the word. After the sower sows the word, in some instances Satan comes immediately to take away the seed sown in people's hearts. In other instances the word falls on stony ground, where its roots are too shallow to sustain those who at

first embrace its truth only to relinquish their belief when confronted with difficulties. The word, too, falls among thorns, where the concerns of daily life and distracting desires choke off understanding. Finally, when the word is sown on good ground, its recipients bear abundant fruits.

The problem for Barry was that his message was not being perceived even when it fell on fertile soil. By its nature, history painting's parables are difficult to comprehend, but the artist's British audience had lost its ability to read this visual language, mankind's most sublime vocabulary, thereby rendering his narrative opaque. In a letter of 6 January 1803, when Barry discussed the last two prints in the large print series, *Divine Justice* (see fig. 68) and *The Angelic Guards* (see fig. 69), he made a revealing statement about the value of history painting and, more particularly, its relationship to its modern audience. According to him, while the general public instinctively senses history painting's exalted purpose, its members unfortunately are ill-equipped to comprehend its meaning. The 'experts', in their turn, muddle the terms of the debate in order to keep the general audience ill-informed and unsure of its own convictions:

… yet as to the publick at large who are unequal to the task of making this extraction [i.e. comprehending the possibilities of perfection in history painting of the present age], there is no Cui bono [i.e. useful advantage] for them; their time is idly & unpleasantly employed in search of what is wanting in almost all that they look for as of any importance to them: & ye disrelish of their dissapointed [*sic*] feelings of the truest & noblest kind, … this disrelish wch is indeed ye voice of God, speaking within them & calling out for melioration, is notwithstanding by the pedants of Art & Connoiseurship very unjustly & absurdly retorted back on them as a proof of their mauvaise gout & want of exalted feelings.[63]

In evoking the phrase 'ye voice of God', Barry echoes the Quaker principle that God's voice is within every individual, a corollary of which is that all men are equal. His view of the condition in which modern man finds himself is paradoxically both equalitarian (this voice of God is within everyman) and elitist (only a select few can fully appreciate what this voice is truly saying).

The reason that even the select few cannot 'see' the murals goes back to the first reason for the words perishing within the souls of men offered by Christ in his parable of the sower; Satanic forces, particularly those motivated by the sin of envy, actively work to extinguish enlightenment. Those so-called experts – in Barry's case the pedants of art and connoisseurship, whose purpose was to frustrate those viewers who were attempting to comprehend more fully those noblest of feelings aroused by the murals – were guilty of the crime of envying and calumniating a great man. To sabotage a work of genius is the unforgivable sin. As stated by both Barry and Blake, the primary sin can be reduced to this one error, that of envy, and Barry shows the Serpents of Envy as the vipers seen in Tartarus at the bottom of *The Angelic Guards*, forever swimming through the darkest recesses of the human psyche.

Those who would instruct the public in the secret wisdom at life's core are actively taking on Christ's mantle. Theirs is a messianic mission. Yet just as in the case of Christ, being a spiritual leader places one's life in danger – witness as well the deaths of Orpheus and St John the Baptist. The power elites, jealous to maintain their authority, conspire to extinguish the messengers along with their threatening messages. Martyrdom is often the price exacted for being a truth teller. As another messiah, Barry feared for his own life, desperately wanting his recondite content to be understood while at the same time fearful as to what might befall him once this should happen.

The artist as high priest and myth-maker

A theme that has run through this book is Barry's conviction that men of genius and, in particular,

history painters should play the leading role in all political, social and religious endeavours. One goal of the murals is to demonstrate how society can best promote and encourage the emergence of these creative figures. In order to go forward, contemporary civilisation must return to the ancient roots of Greek culture, reinstituting those social structures and attitudes that best nurture the pursuit of happiness and knowledge. As with the earlier scenes, the organisational principles that underlie the modern subjects of the *Thames*, an allegory, and *The Distribution of Premiums*, a heroic group portrait, ensure the emergence of men of genius. Too much in modern society favours the self-promoting, who are concerned primarily with their own welfare rather than with national advancement. To counter such corrupting and baneful influence, one needs political and social structures that encourage liberty and justice for all. Competition that is open and fair-minded leads to the rise of true genius in all aspects of the public arena. In contemporary Britain, private organisations can help circumvent an oligarchy that stifles individual creativity, whereas unfettered commerce and industry can offer benefits on a global scale. In addition, women should be encouraged to provide an ameliorating, softening influence on those conflicts and tensions that will arise in a world that puts a premium on masculine competition. The ensuing progress to be made in science and technology, in commerce and capitalism, and in the burgeoning industrial and agricultural revolutions will benefit all. Yet it is not Britain's politicians, scientists, or businessmen who should be leading this parade of progress. Rather they must take their cue from the cultural elite, at whose apex stand the history painters, the most important interpreters and moulders of national character and its destiny.

Barry viewed himself as a hierophant, a high priest overseeing the nation's course and conduct. The original hierophant was the chief priest who presided over the Eleusinian Mysteries. His modern counterpart is in many ways the pope, but the person who actually 'speaks' the sacred language connecting man with God is the history painter. In this regard the pope and the papal government facilitate rather than articulate; as in the past with such history painters as Raphael and Michelangelo, the pope should provide the means to achieve this greater end. Barry, as the creator of a new religious narrative, as the instigator of a sacred rite of passage, takes on the hierophant's mantle. In this role he is also a modern-day Orpheus; he is a teacher, a priest, a good shepherd, a philosopher, a musician in the sense that he is attuned to universal harmony, and an epic poet in terms of his creation of heroic imagery on a grand scale, imagery that speaks in a mode superior to words. As a psychopomp, a guide to the souls of the afterworld, he leads the viewer on a spiritual journey embracing a fully articulated world view. In many ways his role even surpasses that of high priest to take on the mantle of Christ himself.

Barry was so intently serious about his role as a history painter that he took up the duties of a hierophant with little regard for financial remuneration. Although he obviously wanted to be paid for his work, this was a secondary consideration. It is sobering to be reminded that of the ten history paintings that he exhibited at the Royal Academy from 1771 to 1776,[64] only one was commissioned, his *Antiochus and Stratonice*, which he painted for the 3rd Duke of Richmond. Only one other of these pictures, his *Education of Achilles*, can be identified as having been sold in his lifetime. In two instances, *The Jupiter and Juno on Mount Ida* of 1773 and the contemporary history painting *The Death of General Wolfe*, the provenance is unknown, and he gave his *Medea Making her Incantation after the Murder of her Children* to the Royal Academy as his diploma picture. All of the remaining five works – *The Temptation of Adam*, *Venus Rising from the Sea*, the 1774 *King Lear Weeping Over the Body of Cordelia*, *Mercury Inventing the Lyre* and *The Death of Adonis* – appeared, because unsold, in his posthumous sale. His largest easel painting *The Birth of Pandora* (see Fig. 40) also remained unsold during his lifetime, as did his late version of the subject of Jupiter and Juno. The condition for payment he set up for the Society of Arts series did not begin to provide adequate compensation for

the time and effort he expended. Again, the need to articulate his vision for a public that had lost its way outweighed any financial considerations.

The nature of the partnership between Barry and the Society of Arts also sets his murals apart from what is normally expected of history painting. As public art, history painting was intended to confirm and support the cherished opinions of its sponsors. It would be unimaginable to think that a sponsoring state, Church, institution or individual could conceive of the relationship in any other way. History painting was to elevate and improve the viewer, but it was to accomplish this by reinforcing the religious, political and social order within and for which it was created. In requiring that the Society of Arts give him artistic freedom in determining his subject matter, Barry broke dramatically with the traditional requirement that the content of works created for important public venues should be within the control of the patron. He paid a high price for his artistic independence, but this freedom allowed him to create a series that contradicted and corrected the trajectory of the society for which it was created. For him history painting's purpose was not just to provide heroic, uplifting subject matter, treated in an idealising style, that would elevate the viewer to a more exalted level of understanding, but rather its mission was truly transformative, intended to alter the viewer's fundamental perceptions of life's meaning and purpose. In terms of the history of art, this window of opportunity was a brief one. Barry took advantage of one of the earliest moments when the growing reverence for creative genius nurtured by the Romantic movement prompted a patron to grant an artist full control over his content. At the same time it was one of the last moments when an artist could have entertained an inclusive universal history on a global scale. Soon the fragmented nature of the modern world, with its bewildering array of cultures, past and present, and its loss of any central authority, fatally compromised other such attempts.

In inventing a narrative that is intended to reshape the viewer's understanding of the world, Barry demonstrates his supreme confidence in history painting's ability to effect profound changes. To 'read' the universal language of his murals is, for him, to be persuaded at the core of one's being. Paradoxically, the more he attempted to resurrect the neglected and increasingly moribund tradition of history painting, the more original and personal became his achievement. In looking backward to create a unifying, mythic vision that would summarise and explain everything of significance that was, is and will be, he created instead a complex epic whose originality continues to challenge his public. An inspired myth-maker on a heroic scale, he belongs with the greats of the Romantic movement alongside those poets and painters who fervently believed in the transforming power of the divine imagination.

APPENDIX 1

Addition and Subtraction in Prints

The large-print series: reasserting Catholic values

Barry executed seven large-print details, one illustrating the principal group of the Diagorides victors from *Crowning the Victors at Olympia*, and six from the foreground of *Elysium and Tartarus*. They were intended to complement the 1792 series of seven prints reproducing all the murals. He referred to these seven details as the large set, and the seven reproducing the entire series as the small set, a distinction that denotes his feelings about their respective merits as much as it does their relative size. On 31 March 1801, when commenting on the four large-print details he had executed up to that time, he specifically praised their ability to convey a more imposing message than had his 1792 series: 'as the figures come very large, near two feet high, (where all the details are fully comprehended,) [these prints] give a much more dignified & adequate idea of the moral application of the work, than the small sett of Prints.'[1] Yet this large series, the product of four distinct programmes, grew in stages, with each of the four programmes apparently at the time of its execution being conceived as the last. This appendix's four sections correspond to these four stages. Barry, too, while often appending lengthy texts in the margins to his prints, did not concern himself overly with succinct titles, and the titles given to these works in this chapter do not necessarily appear in this form in the prints themselves.

Barry's first print detail, *Lord Baltimore and the Group of Legislators* (see fig. 63), bears the publication date 23 February 1793. This work allowed him to introduce Cecilius Calvert, 2nd Lord Baltimore, into a place of prominence in *Elysium*'s cast of characters. Unwilling or unable to make

so significant a change in the painting itself, the print would suffice to update the painting's content. In addition to effecting this major alteration, Barry also used this opportunity to make a number of secondary changes, both additions and subtractions, on a lesser scale. As he was to write later, in the third person, about the print series as a whole, this opportunity to rethink content was the prime motivation for his issuing of these details:

his principal & main view in thus revising his subject, was to incorporate with ye important, gracefull matter of it, such second thoughts & improvements as time & more information might suggest; & as this could not be done in the painting with the same convenience & facility that it is done in the raw editions of Bookmaking; the pictures for the most part were suffered to remain without obliterating anything & the expedient of new Engravings on this enlarged scale was necessarily recurred to.[2]

Not long after publishing *Lord Baltimore*, Barry decided to return to this format, executing three large print details bearing the dates 1 May 1795, one from *Crowning the Victors at Olympia* (see fig. 64) and two from *Elysium and Tartarus* (see figs. 65 and 66). Writing in 1798, he gave as a motivating factor the need to make more visible important details in these large paintings that the 1792 prints reproducing them were incapable of achieving on so small a scale:

as the picture of Elysium, and its companion, the Victors at Olympia, were each forty-two feet in length, and the prints I had made of them were only three feet long, in order to be comprehended in a single sheet of paper, the details of the work, reduced to so small a compass, were unavoidably liable to be overlooked; and having another reason besides this, [a footnote here refers readers to the 1793 *Letter to the Society of Arts*] for making a separate print of this group of the Legislators in Elysium [*Lord Baltimore*], where, from the enlarged size of the figures, the details would become more apparent, I have been since induced to add three prints of other groups in the same enlarged size.[3]

Again, though, he took advantage of this opportunity to introduce new variations on these themes. In addition, this effort, too, was conceived as his last of this type: 'Some friends have wished me to make separate prints, on the same enlarged plan of other groups, in this and the other pictures, which are not without pertinence; but I am satisfied with what is already done, and will leave the rest to any one who may think it worth his pains.'[4]

In July 1800 Barry published a narrow strip (see fig. 67), which he referred to as 'a slip of copper', which allowed him to introduce more figures from Spain's contact with the New World, a subject that had come to hold a special fascination for him. This third stage provided a bridge between *Reserved Knowledge* and *The Glorious Sextumvirate*, and these three prints along with *Lord Baltimore* now formed a close-knit, continuous frieze of the foreground figures of *Elysium*, re-edited to conform to the artist's most recent musings. About two years later, Barry added the last two prints, *Divine Justice* (see fig. 68) and *The Angelic Guards* (see fig. 69), the fourth and final stage. Positioned to the right of *Lord Baltimore*, these prints continue the recasting of *Elysium*'s foreground right up to the abyss of Tartarus itself.

The six large details from *Elysium and Tartarus* should be read in their proper sequence within the painting (from left to right, figs. 65, 67, 66, 63, 68, 69). Barry ever writes of them as together forming a single concatenated print,[5] but when viewed in the order in which they were executed, one can see his growth as a printmaker. There is greater contrast in the prints of 1795 than in the *Lord Baltimore* of 1793, and the spindly figures of the earlier design are replaced with more compact groupings. The final two works, with their alternating zones of light and shadow, are particularly majestic, their

bolder sense of pattern generating greater force and clarity. Now, too, the monumental scale of the foreground angels effectively contrasts with the receding enclaves of the blessed, and an awesome, plunging abyss replaces the stabilising base of the earlier designs.

The lawgivers revisited in *Lord Baltimore*, 1793

Lord Baltimore and the Group of Legislators

For states and full inscriptions, see Pressly, no. 24.

Inscription in lower margin: In the Elysium one of the Series of Pictures on Human Culture in the Great Room of the Society for the Encouragement of Arts &c. at the Adelphi, a mistake was committed owing to [/] the delusion which has been so generally spread of considering Wm. Penn as the first Colonizer who established equal laws of Religious & Civil Liberty: this Design is therefore added to the [/] Series in order to rectify the mistake in the groupe of Legislators by making Lycurgus looking at those exemplary laws as placed in the hands of Cæcilius Calvert Baron of [/] Baltimore who was the original establisher of them in his Colony of Maryland many years before Wm. Penn & his Colony arrived in America to copy the worthy example. [/] Designed Engraved & published by James Barry. R. A. Professor of Painting to the Royal Academy. Feby 28. 1793 ['7' and '3' printed backwards]. L. D.

Barry, 1793, in *Works*, vol. 2, pp. 439–47:

The particular at which I am troubled is, the having committed a great mistake, or rather a great piece of injustice, which stands in a very conspicuous part of the picture of Elysium, and also of the print. It was not committed wilfully, I was misled by general fame, I had almost said, by the current opinion of the world, into a belief that William Penn was, in his Pensylvanian code, the first, the original author, of an establishment composed of the different denominations of christians, where the laws restricting property and liberty, civil and religious, were equally extended to all, where no particular denomination was permitted to take any lead or possess any advantages not enjoyed by the others.

… I shall now produce some sober manly information which has lately been put in my way, from which it will appear that Cæcilius Calvert, Baron of Baltimore, was really the man to whom all this praise and admiration truly and fairly belongs, and that whatever valuable was done in the way of legislation in Pensylvania, was but a copy taken from the original, executed in Maryland above thirty years before even the granting and signing of Penn's charter, which authorised him to collect his people for the intended colony in America.

… it is not now possible to alter that part of the picture of Elysium, nor of the print, they must remain as they are, a monument of the general delusion in which I have participated. But I have made a new design for that part, where the matter is as it should be, and I shall with God's blessing publish a print of it very shortly, which as the figures are two feet high, will make an agreeable addition of another print to the set.

In this new design, which consists of King Alfred and the other legislators, where Lycurgus is looking over the Pacific Code of Laws which is considered as the ultimatum of legislation for a mixt people, I have instead of Penn, placed those laws in the hands of Cæcilius, Lord Baltimore, whom Alfred leans on, and is as it were, exultingly producing, and who is affectionately looking back upon Alfred and pointing to him as the real source from whence issued the old common law, of which this code of Maryland is but an extension suited to the occasions of many instead of one people. As after all William Penn must be allowed the merit of having copied this excellent pacific example, I have honourably placed him with his Pensylvanian code next to Calvert, which keeps up an agreeable diversity in the forms, and is an additional weight to the moral of this part.

Fig. 63 James Barry, *Lord Baltimore and the Group of Legislators*, 28 February 1793. Etching and engraving, 743mm x 472mm. Tate Images

Barry, 1803, in *Works*, vol. 2, pp. 667–8:

… below pope Adrian, Lycurgus and Numa are looking at the perfect and proper code of laws for a mixt people, the first example of which was gloriously shewn by Lord Baltimore and his Roman catholics in Maryland in America; it is to be regretted, it is even scandalous, that such a fact should have been either wilfully or negligently overlooked by Raynal, Montesquieu, and others. On one side of Baltimore is William Penn, with his Pensylvanian code, which was a worthy copy of this of Maryland; and on the other side is M. Aurelius and King Alfred, who is affectionately leaning over the shoulder of Baltimore.

As the inscription elucidates, the print's primary purpose is to establish a Catholic as the first champion of civil and religious liberty in the New World, thereby replacing William Penn and his Quaker-inspired colony, a scenario that ignores Roger Williams and his still earlier founding of Rhode Island. Lord Baltimore, who holds a scroll that reads 'Religious & Civil Liberty [/] Established in Maryland [/] in 1649', is now the one who is on intimate terms with King Alfred, having pushed Penn into the background. In 1632 Cecilius Calvert, 2nd Lord Baltimore, received the charter for the proprietary province of Maryland from Charles I, a charter that had been initiated by his recently deceased father, George Calvert, 1st Lord Baltimore, who was a convert to Catholicism. The first colonists landed in 1634, and although the 2nd Lord Baltimore never set foot in America, he followed closely the province's development. His brother Leonard Calvert was the first governor, and from its founding the province provided a sanctuary for Catholics. Yet Protestants also were present in increasingly large numbers, and in 1649 the Maryland Assembly passed Lord Baltimore's 'Act Concerning Religion', which granted religious toleration for all Trinitarian Christians, thereby ensuring that Catholics would maintain equal rights with Protestants. This Act of Toleration is the one Barry celebrates in his print. even if religious turmoil in England eventually disenfranchised Maryland's Catholics.

Barry cites two French writers, Montesquieu and the Abbé Raynal, as having misled him into believing that William Penn deserved the honour of establishing civil and religious liberty in America. Voltaire, who preceded both in holding up Penn as an exemplum, is conspicuously absent, but this is perhaps only because Barry was writing in the early 1790s at a moment when he was extremely critical of those French revolutionaries who had adopted atheistic beliefs. He, in fact, mentions Voltaire later in his account but only in a negative vein: 'We may see this [the indulgence in corruption and depravity] verified at present in a valet de chambre or perruquier, who, without the trouble of intellect or information, can laugh along with Voltaire, shake an empty head at religion, and vote its abettors a [à] la lanterne [i.e. to be hanged from the lamp post].'[6] Benjamin West's painting *Penn's Treaty with the Indians* (see fig. 27) also goes unmentioned, but it, too, was another key document in the 'false' glorification of Penn's achievement.

Barry credits George Chalmers with having clarified the true nature of events, quoting and paraphrasing at length from his book *Political Annals of the Present United Colonies, from their Settlement to the Peace of 1763*, published in 1780. Chalmers, who had trained as a lawyer in his native Scotland, had practised law in Baltimore for about ten years before settling in London at the outbreak of hostilities between the colonies and Great Britain. A Marylander, at least for a time, he undercut the fame accorded Penn in favour of Lord Baltimore, but Barry took Chalmers' bias a step further. Following the lawyer's lead, he accurately mentions Penn's 'sketch of a patent, which he had chiefly copied from the charter of Maryland',[7] but as he had when executing the 1783 mural, the artist confuses the charter with the code of laws, leaving the reader to think that in the latter instance Penn was also dependent on Baltimore.

As for religious freedom, Lord Baltimore's colony indeed preceded Penn's, but here, too, the artist muddies the waters. Penn required of his citizens the belief in one God, while Baltimore had

extended toleration only to all sects of Trinitarian Christians. Another detail that Barry chose to overlook is the question of slavery. The Pennsylvania Quakers attempted to abolish this institution in their colony, while Marylanders supported it. Chalmers and Barry are right in giving Lord Baltimore and his American province its due, but the case for Baltimore over Penn is exaggerated. Yet these distortions allowed Barry to foreground Catholicism without qualification as the touchstone for peaceful toleration in the English-speaking New World.

As for civil government, Maryland's 1632 charter provided a feudal organisation for the colony, giving the proprietor all the powers enjoyed by the bishop of Durham, that is, those of an absolute lord nominally under the king's suzerainty. Over time the assembly slowly whittled away the proprietor's almost unlimited governmental rights, and unsurprisingly the feudal system proved unsuited for the colonisation of America. Yet in spirit Barry is indeed accurate in linking Lord Baltimore to King Alfred in a celebration of the continuation of an idealised vision of the past. In the print, Alfred's ermine-trimmed robe is covered with a generative floral pattern, and his cloak now hangs over the wing of the Judging Angel, hinting at the possible reading of this detail as Britannia's shield.

Ultimately it does not matter which model one takes – Penn's Pennsylvania as embodied in the 1783 mural or Baltimore's Maryland as embodied in the 1793 print detail – for, according to Barry, they represent virtually the same thing. Writing a few years after issuing the print *Lord Baltimore*, he conflates these two branches of Christianity: 'if Christianity can be supposed to predispose men to a predilection for any particular mode of government, it must be that of the greatest conceivable freedom, like that of the Quakers, and the difference between the Quakers and the other religious orders of St. Benedict, St. Francis, &c. is less than is vulgarly imagined; a very slight alteration, in one or two particulars, and they are the same.'[8] Taking the long view, Barry finds the roots of American liberty in King Alfred's administration. As for the short view, whether it be Quaker Pennsylvania or Catholic Maryland, the point is that America has fulfilled the perceived promise of Alfred's England far better than had the English themselves. Furthermore, the Catholic model takes precedence, even if the facts have to be massaged in order to make this claim.

Barry, 1793, in *Works*, vol. 2, pp. 449–51:

This upper group, consisting of those exalted truly christian dispositions, who were disposed to labour in conciliating, doing away differences, and restoring the primitive unity and peace of the christian church, begins with pope Adrian, who is seen over Lycurgus at a little distance, and by his action may be supposed to express to Grotius, Father Paul, and the others, that remarkable wish to reduce the temporalities of the papacy to the apostolic simplicity if it might obtain this pacific reconciliation. The figure on the right of Adrian is Chichele, Archbishop of Canterbury, in the reigns of Henry the fifth and sixth, who was so illustrious for the truly christian piety and fervour with which he asserted and maintained the rights and liberties of the church of England against foreign and domestic encroachments. The next to him is Reginald Pole, the last English cardinal, and, as far as my knowledge extends, the first writer, who to the new-fangled doctrines of *the divine right and irresistible power of kings, and the passive obedience of subjects*, opposed those sacred *rights of the people*, from whence he nobly derives the delegated, legitimate powers which give sanction and just authority to the exercise of royalty. Standing next to him is Mariana the Jesuit, who has discussed that question more at length, and of whose book 'De Rege & Regis Institutione', Peter Bayle gives the following character. [Barry goes on to quote passages from the French text which are summarised in the following analysis.] The capuchin friar who is next Mariana and Cardinal Pole, was introduced to fill up the chasm, and lead the eye on to that vigorous assertor and defender of every valuable right, Paul Sarpi the Venetian friar. The next characters are Dr. Benjamin Franklin, Barnevelt, Grotius, and Bishop Berkeley. The pacific graceful virtues so conspicuous in Berkeley, that

corrective for the shallow infidelity which would obtrude itself for philosophy, makes him a becoming part of this company, and nobody can wonder if the glorious John Olden Barnevelt, a politician so remarkable for his integrity, his abilities, and his ever memorable services to his unworthy country, should accompany his friend Grotius to such a meeting. Benjamin Franklin, who is next to Barnevelt, was much a similar character, more fortunate in the reflection of having served a more just people, who permitted him to die amongst them without the mortification of seeing them stained with ingratitude.

Barry, 1803, in *Works*, vol. 2, p. 667:
[Another listing of the cast of characters. The list of names is repeated in Barry, 1803, in *Works*, vol. 2, p. 667.]

In the 1792 print after the mural, Barry had moved several of the Christian conciliators and peacemakers to a position above and to the left of the legislators, and this cluster of five figures, showing Pope Adrian conversing with Bishop George Berkeley, Hugo Grotius, Fra Paolo Sarpi and a standing Juan de Mariana, is retained as the nucleus for the group he portrays in 1793, to which he adds Jan van Oldenbarnevelt, who had accompanied Grotius in the 1783 mural, Benjamin Franklin in a fur cap, a friar as an assistant to Sarpi, and the Englishmen Cardinal Pole and Archbishop Chichele. No ancients appear in this group: all the participants belong to a later, Christian era. Yet the pope's reclining pose, which resembles that of a participant in a classical symposium, suggests continuity.

In the text to the 1792 print, Barry had mentioned Henry Chichele,[9] but now he introduces him as the anchor to the right-hand side. Cardinal Pole, appearing on the other side of Pope Adrian's head, completes this important triumvirate of English ecclesiastics who had fought for the true principles underlying Catholic governance, which are to be seen as patriotic as well as progressive. In this scenario the Catholic Church is not a threat to English nationalism, rather it protects and nourishes national interests.

Benjamin Franklin, who had only recently died in 1790, is another important addition. Barry takes his portrait from Augustin de Saint Aubin's 1777 engraving, which shows Franklin as a man of simplicity wearing the shapeless cap of marten fur he had acquired on a trip to Canada.[10] But Barry discards Franklin's spectacles; no one wears glasses in this clear-sighted, enlightened community. Finally, Franklin's inclusion brings the narrative back to America as the best representative of modern liberty, even if Franklin, a Philadelphian, followed more in the tradition of William Penn (this did not deter him from fiercely opposing Thomas Penn's policies) than he did that of Lord Baltimore.

Barry, 1793, in *Works*, vol. 2, pp. 459–60:

In the angelic figure, strewing flowers over Alfred and the other legislators, I have introduced something of the character and resemblance of the amiable (and after so much unmerited injury, no doubt, the blessed) Mary Queen of Scotland, and the two heads appearing lower down on the other side, behind Numa and Lycurgus, are the famous Robert Boyle and William Molyneux, with his book of the Case of Ireland in his hand.

Barry, 1803, in *Works*, vol. 2, p. 667:

William Molyneux with his celebrated case of Ireland in his hand, is sitting low behind Lycurgus and Numa, and anxiously looking up towards Lord Baltimore and his Maryland code, which would have been so effectual a remedy for the almost unexampled miseries and distractions of his ill-fated country. Over Molyneux is the Hon. Robert Boyle.

In the mural, Barry had discreetly made the case that Britain's break from the Catholic Church under the Tudor monarchs Henry VIII and Elizabeth I had had disastrous consequences. In the print detail he continues even more vehemently his condemnation of these two monarchs.

The reference to Henry VIII is oblique but savagely explosive. In this context it becomes clear that the juxtaposition in the group of 'peacemakers' at upper left of the Jesuit Mariana with Cardinal Pole, who had heroically, though unsuccessfully, opposed Henry's claims to unlimited power, is intended to the careful viewer as an indictment of Henry. In his 1793 book describing the prints after the murals, Barry quotes three excerpts from Pierre Bayle's *Dictionnaire historique et critique*, first published in 1695–97, where Bayle discusses Mariana's proposition, made in his book *De Rege et Regis Institutione* of 1598, that it is lawful to overthrow, even by assassination, a tyrannical ruler. The artist first excerpts the lines giving Mariana's fundamental principle that the authority of the people is superior to that of kings; then the opposition's principle that only God can call a sovereign to justice; and finally Bayle's observation that Mariana had applied his maxim to all situations and not just to Catholics who wish to dispose of an unacceptable ruler.[11] However, these quotations hardly give an adequate idea of Bayle's characterisation of Mariana's book, which Bayle asserts presents a seditious and venomous doctrine. By placing the Jesuit among *Elysium*'s elite, Barry leaves no doubt that he, on the other hand, approves Mariana's argument. Furthermore, by now having Mariana looming over Pole's shoulder, he hints that the Jesuit's doctrine aptly applies to the cardinal's opponent, a monarch who should have been removed by any means, assassination among them. The fact that this had not been done was not only regrettable but was also reprehensible; justice, as defined by Mariana, had demanded it.

The attack on Elizabeth is more overt, Barry in his text referring to her as 'that fiend Elizabeth'.[12] In the print his introduction of Mary Queen of Scots in beatified form offers witness to Elizabeth's 'criminal' conduct. In signing the warrant for her 'innocent' cousin's execution, she not only murdered a rival but also dealt a severe blow to the Catholic cause in Britain. Twice, first in his discussion of the 1792 print and then in that of this 1793 print detail,[13] Barry cites approvingly two recent books that had attempted to rehabilitate Mary's reputation: William Tytler's *An Inquiry, Historical and Critical, into the Evidence Against Mary Queen of Scots*, first published in 1759, and John Whitaker's three-volume opus *Mary Queen of Scots Vindicated*, first published in 1788. Dressed in a Scottish tartan, Mary Stuart looks down on King Alfred; she, the great-granddaughter of Henry VII, rather than Elizabeth, who was tainted by grounds of illegitimacy, was the rightful heir to the British throne, the true (i.e. Catholic) embodiment of Britain's royal heritage.

When Barry executed this print detail, no others were then contemplated. Molyneux's message for Ireland was important enough that the artist split him off from the group of the Glorious Sextumvirate to squeeze him into the left-hand margin, with the head of Robert Boyle above. By prominently displaying Molyneux's book, the artist ensures that his audience should not forget that the historical abuses heaped on British Catholics continue to have a dire impact on contemporary Ireland.

Ancients and moderns: three 1795 details of *Crowning the Victors* and *Elysium*

Barry gives a publication date of 1 May 1795 for three of the large-print details: *Detail of the Diagorides Victors*, *Reserved Knowledge*, and *The Glorious Sextumvirate*. That date has been respected here, but it presumably refers to their inception rather than their completion. In a note of 2 May 1798, to the Society of Arts, written in the third person, he acknowledges not having yet etched the inscriptions now found in the margins to the final states: 'As Mr. Barry has not yet put the writing to the three large Prints of the separate Group from the Pictures of the Victors at Olympia and the Elysium … he is sorry they cannot accompany this Note, but when the writing is put to the Plates he will send

impressions of them to the Society with his sincere and affectionate respects.'[14] One assumes that he completed the inscriptions within the next eleven months, as it is unlikely he would have identified himself as professor of painting at the Royal Academy after his expulsion on 15 April 1799. Yet he did not donate the four prints, these three and *Lord Baltimore*, until June 1800, a delay that may have been due to the distraction arising from his fight with his fellow academicians rather than to his continuing to tinker with the prints themselves.

Detail of the Diagorides Victors

For states and full inscriptions, see Pressly, no. 28.

Inscription in image at lower left: The Laws of Olympia requiring that these Contested Strenuous Exertions should be accompanied with [/] the Conservation of Integrity as the only becoming & the True Victory, this Group &c

Inscription in the margin: Questo Gruppo di Diagoras e i suoi Figlioli preso dal Quadro dei Vittori Olympici comme un pic[c]olo mazzo di fiori ed intestimonio dal piu profondo e affectionatissimo Veneratione e gratitudine gettato per [/] ornare il Corso Exemplare & Trimphante del Governo Papale di Roma, Madre e graziosa Prottetrice delle Arti Laudabile e Ingenosi per Giacomo Barry [English translation given in following discussion] R. A. Professor of Painting to the Royal Academy & Member of the Clemen [/] tine Academy of Bologna Painted En[grave]d. & Publd. May. 1. 1795 by J. B.

Barry, 1798, in *Works*, vol. 2, p. 576:

… I have been since induced to add three prints of other groups in the same enlarged size [as seen in *Lord Baltimore*]; one, the group of Diagoras and his Sons, from the picture of the Victors at Olympia. These Diagorides afford a subject of such peculiar felicity for a group in sculpture, that I have often complemented myself by supposing that there must have been (notwithstanding the silence of Pausanias) something like this of mine set up in the Altis at Olympia; the characters of the men in their different stages of life – father, sons, and grandsons, such a race of heroes, where the naked occurred with such peculiar propriety, and so gloriously connected with ethics, and with all the duties of the good citizen, that I can recollect nothing remaining of the ancients, where the subject matter is more exemplary, more impregnated with that unction, spirit, and *venustas* [mental and moral beauty], which are the inseparable characteristics of Grecian genius.

This group of Diagoras and his sons is similar to that found in the painting and the 1792 print, but the dramatic framing alters its impact. The celebrants, their feet approaching the bottom margin, are brought closer to the picture plane, and with Diagoras receding slightly more than before, the figures tower above the awed viewer. By placing Diagoras to the left of centre, Barry opens up room for the group's rightward movement. The radical cropping of the figures at the sides, particularly the abrupt cutting of the advancing spear carrier, also enhances the sense of momentum. The heroic nudity of the three monumental competitors is itself an expression of ethics and good citizenship, and even Diagoras displays a bare midriff despite his expansive cloak and fur-trimmed buskins. On either side a celebratory pair of hands is upraised, having just thrown flowers into the air. The grandchild at lower right holding a floral wreath wears a medal around his neck, presumably a trophy his grandfather had won in an earlier contest or his own award won in a junior event. With two exceptions, the figures look either at Diagoras or at one another. Both of the exceptions gaze instead upward into the distance: they are the youngest, the exuberant grandson being carried at upper right, an example of

unburdened innocence, and the oldest, Diagoras himself, an example of wisdom manfully and hard won.

The background is remarkable for its bold, dramatic diagonals. The stadium, anchored at upper left with two small groups of figures, begins a dizzying descent toward the right. In the first group wedged into the corner, four figures listen to a fifth reading from a scroll, a reminder that the games are about mental as well as physical pursuits. The second group is composed of another five figures, one of whom is a child, who, having put aside his stick and hoop, joins the others in looking over the stadium wall. For those who know the mural, they are witnessing the sacred procession leading an ox to be sacrificed at the Temple of Zeus, the columns of which are glimpsed at the upper left.

Barry, not to mention Western civilisation as a whole, was presented with a different world view after the cataclysmic events of the French Revolution. The artist had been both a staunch supporter of liberty and, as the mural *Crowning the Victors* demonstrates, an equally staunch supporter of the papacy. But with the advent of republican France and Pope Pius VI's determined opposition to this government and its values, which side would Barry choose? Could his subsequent engagement with the mural continue to reconcile a belief in liberty, fraternity and equality with papal prerogatives?

In 1795 when Barry executed his large print detail of the Diagorides victors, Pius VI had long since declared on the side of the counter-revolution. In issuing this detail Barry continues to support the papacy, as the motif of Diagoras borne in triumph on its own conveys the mural's hidden narrative, where one witnesses a triumphant papal procession. Yet in the upper-left corner of the print, he shows a member of the group attending to the man reading from a scroll wearing a liberty cap. Although a rustic wears a liberty cap in the 1783 mural *A Grecian Harvest-home*, timing is critical. By 1795 such a cap had been thoroughly politicised; it cannot help but recall the *bonnet rouge*. Thus in the print detail Barry takes the long view; his sympathies continue to lie with both the papacy and republican values. Despite Pius' quarrel with the French republicans, Barry refuses to acknowledge any fundamental differences between what the papacy over the centuries had stood for and the French call for liberty and equality.

With time the struggle between the pope and France escalated, making it increasingly more difficult to ignore the conflict between the two. On 15 February 1798 the French General Berthier occupied Rome, proclaimed a republic, and within days forced Pope Pius VI into exile in Tuscany. Then, on 28 March 1799, the French carried the pope on a long journey that was to take him across the Alps to Valence, France, where, at age eighty-one, he died a prisoner on 29 August 1799.

The mural of 1783 is addressed primarily to an English audience, as is the 1792 print after it. Because of subsequent events, Barry in his 1795 print detail, at least in its later state, is more concerned with addressing the French and Italians. The message remains the same – the papacy forms a valued part of mankind's progress toward liberty and the arts – but given the unforeseen shift in contemporary affairs, the message more and more is redirected toward the Continent in an effort to foster reconciliation between the French and the papacy.

At some point between 2 May 1798 and June 1800, Barry added the inscription to the print detail. In appealing to an Italian audience, he signed himself as a member of the Academy Clementina in Bologna, the only one of the three prints in which he refers to this honour. He also provided a lengthy Italian inscription, which is intended not only to make his meaning accessible to Italians but also to make its controversial proposition less obvious, and thus less confrontational, to an English audience. In translation it reads, 'This group of Diagoras and his children taken like a little bouquet of flowers from the painting of the Olympic victories and in testimony of the deepest and most affectionate veneration and thanks is painted to adorn the exemplary and triumphant course of the papal government of Rome, mother and gracious protectrice of the praiseworthy creative arts by James Barry'. In this final state he reaffirms more pointedly than ever that the story of Diagoras and the Olympic Games is about the papacy as an indispensable component in the nurturing and promotion of the arts. At this same time, in his *Letter to the Dilettanti Society* of 1798, he addresses the French directly concerning their aggressive anti-papal posture. As he had earlier, he makes the connection between the papal government and the practices of the classical Greeks in setting apart Elis as an inviolate territory, an example the French should imitate:

one might hope there would be always found magnanimity enough in human nature to permit, as the Greeks had so gloriously, and for such a long time, permitted, a sacred territory apart governed by its own pacific laws, which were respected by all contending parties: There is nothing in all the Grecian story which can exhibit that very belligerent people in a more graceful, amiable, and becoming point of view, than their admirable, salutary, exemplary conduct in this particular: and yet, what could any man say of the sacred territory of Elis, which might not be affirmed (with many additional arguments of inexpressible advantage) of the papal government at Rome?[15]

He is optimistic that the French will take his advice since they are 'a wise and great people, who have been long distinguished by their predilection for those arts which humanize'.[16] From Barry's perspective, although the French were misguided in their suppression of the pope and the Papal States, there is no need to delete the *bonnet rouge* at the print's upper left. Ultimately, liberty and the papacy go hand in hand, and even if the clash between republican France and the papal government is regrettable, it need not be permanent. One may accuse the artist at the end of the century in engaging in wishful thinking by refusing to acknowledge political realities, but in the print detail the programme presented in the mural remains intact.

Reserved Knowledge

For states and full inscriptions, see Pressly, no. 29.

Inscription in margin: This Groupe Exhibiting the Future Enjoyment of Reserved Knowledge, where an Arch Angel is explaining a Solar System to the admiring Newton, Gallileo, Copernicus & Bacon is taken from the Picture of the State of Final- [/] -Retribution & with the most Respectful, Affectionate Regard is Dedicated to the Society for the Encouragement of Arts, Manufactures & Commerce by James Barry R. A. Professor of Painting to the Royal Academy …

Barry, 1798, in *Works*, vol. 2, p. 580:

The other print is the group adjoining, where angels are unveiling and explaining a solar system to Newton, Gallileo, Copernicus, and Bacon, whose admiration at what is communicated, intimates how much is reserved for a *hereafter*, which even the wisest could not otherwise have known. In the advanced group are Thales, Des Cartes, and Archimedes, and below them, the Friar, Roger Bacon, and his sagacious and excellent friend, Bishop Grouthead, with his letter to Pope Innocent IV. in his hand.

Barry, 1803, in *Works*, vol. 2, p. 664:

… I shall proceed here to mark out the arrangement in the prints of the large groups, beginning with the first, that of *reserved knowledge*. The first figure, sitting with the scroll on his lap, appears (by the doctrine of eclipses, the tropical and polar divisions, and the mode of calculating altitudes, by the lengths of proportionate shadows inscribed on it) to be Thales, who is said to have first disseminated this knowledge in Greece, and who is looking on a demonstration of more improved geometry, pointed out by Des Cartes, on which also Archimedes is looking with great attention. – The figure sitting below is the admirable friar Bacon, just opening his *Opus Majus*, and in deep conversation with Bishop Grouthead, who seems pointing or referring to something in that work. Even independent of Grouthead's commendable zeal for melioration and the removal of abuses, which occasioned him so much contest, there was reason enough to entitle him to a place in Elysium as the friend of Bacon, whose patronage followed him in all fortunes: it is indeed an argument of no small virtue in the great, to be able to suppress those selfish vanities and dispositions, which but too often accompany and enfeeble their friendships for men of great talents. The figures above Thales are Lord Bacon, Copernicus, Gallileo, and Newton, who notwithstanding all their knowledge here below, behold now with admiration and astonishment, what is discovered and pointed out by the Angelic or superior intelligence, on unveiling the real system of things.

Having already executed his *Lord Baltimore*, with the two prints *Reserved Knowledge* and *The Glorious Sextumvirate*, Barry completes the left foreground of *Elysium*. In his first published description of these

This Groupe Exhibiting the Future Enjoyment of Reserved Knowledge where an Arch Angel is explaining a Solar System to the admiring Newton, Galileo, Copernicus & Bacon is taken from the Picture of the State of Final Retribution is with the most Respectful & affectionate Regard is Dedicated to the Society for the Encouragement of Arts Manufactures & Commerce by James Barry R.A. Professor of Painting to the Royal Academy
Painted Engraved Publ. May 1. 1795 &. D.

Fig. 65 James Barry, *Reserved Knowledge*, 1795. Etching and engraving, 745mm x 478mm. Tate Images

APPENDIX 1 ❧ 323

two works in his *Letter to the Dilettanti Society* of 1798, he first discusses *The Glorious Sextumvirate* then *Reserved Knowledge*. This is perhaps a reflection of *The Glorious Sextumvirate* being directly adjacent to *Lord Baltimore*, but it may as well suggest that this print had for him a more important message, and he certainly gives it a more elaborate description than he does *Reserved Knowledge*. When, though, he discusses the large print details in the *Monthly Magazine* in 1803, he describes them from left to right within the composition as a whole, the order followed here.

To the mural *Elysium and Tartarus*, Barry added in 1798 flanking heads to either side of the prominent discoursing angel in order to suggest a greater concentration of superior intelligence. This is a detail that he also introduced into the third state of this print detail. This print also includes an angel delicately supporting a globe in the upper-left corner, a figure transplanted from the mural's system of systems, which here is another reference to the multiple mental universes still to be comprehended. The young angel assisting her mentor by removing the veil from the globe on which she is discoursing no longer resembles a portrait.

While Barry introduces minor modifications in the poses of the elect, his major change occurs in the introduction of Bishop Robert Grosseteste as a companion to Roger Bacon. He states in his descriptions that the reason for Grosseteste's inclusion is twofold. First, it allows him to give another example of an English ecclesiastic who did not hesitate to stand up for the independence of the English clergy even against the pope himself, demonstrating once again the artist's conviction that when the English Church was Catholic, the popes posed no credible threat to national interests. Second, together Grosseteste and Bacon offer an example of true friendship, much along the lines laid out by Cicero in his celebrated essay: 'it is characteristic of true friendship both to give and to receive advice and, on the one hand, to give it with all freedom of speech, but without harshness, and on the other hand, to receive it patiently, but without resentment.'[17] Thus another reason Roger Bacon is to be greatly admired is for his unwavering support of his talented friend; he did not allow resentful envy to stop him from promoting the greatness in others.

The Glorius Sextumvirate

For states and full inscriptions, see Pressly, no. 30.

Inscription in margin: This Colloquial Groupe of the Celebrated Sextumvirate, Epaminondas, Socrates, J Brutus, Cato, Sr Thos More & M Brutus with that Scene of Pious Reference in the Back-Ground, the only sure Root from whence Civil Liberty & every thing Social, [/] Graceful & Generous can derive Nutriment, vigor & Expansion is taken from the Picture of the State of Final Retribution & is recommended to the Serious consideration of the Disciples of the Modern Philosophy by James Barry R. A. Professor of [/] Painting to the Royal Academy …

Barry, 1798, in *Works*, vol. 2, pp. 576–80:

… the colloquial, adjoining group to that of the Legislators in the Elysium, consisting of the Sextumvirate; to which Swift says, all ages of the world have not been able to add a seventh, where Socrates is proving something to Epaminondas, Cato the younger, the elder Brutus, and Sir Thomas More. The effigies of Brutus, and those other generous advocates for civil liberty, have lately been much sought after, in the midst of this mighty struggle which is still agitating Europe, and I am happy to reflect, that in the print of this group of the heroes of civil liberty, what is passing in the back-ground, where angels are presenting and interceding for the imperfect legislators, Brumha, Confucius, and Mango Capac, tends to shew where all the various talents which insure

Fig. 66 James Barry, *The Glorious Sextumvirate*, 1795. Etching and engraving, 743mm x 474mm. Tate Images

beatitude centre, and that virtue, and all those generous qualities which reflect such lustre and true glory on the character of the good citizen, are but emanations from the higher principle of religion, and piety to God (the sovereign good, the essence of perfection, whose law is rectitude), where all the virtues root …

By way of border and ornament to Epaminondas's shield, which, near the feet of M. Brutus closes the circle of this colloquial group, it would come well (particularly as there is not portrait remaining of him) to write the following truly heroic advice, which this Theban general gave his countrymen, to dissuade them from enslaving the Orchomenians: '*A nation* (says he) aspiring to command the Greeks, ought to preserve by its humanity, what it acquired by its valour.' Plato and Aristotle, just behind this group of the sextumvirate, are going towards the group of the most perfect legislators in the other print, to whom Plato is pointing.

Addition of battle plan on shield, letter of 31 March 1801, in Barry, letter-book 2:

… this acquaintance [with General Miranda] very fortunately for me took place shortly after [his visit to the murals], & from my notion respecting ye military character, I was not a little astonished to find in the General,

the acquisitions and virtues of the Togati, so happily & in such an extraordinary degree blended once more with the profession of ye sword, as was ye case with the Romans in the time of their Scipio's & Agrippa's, & I can never forget the manly arguments he made use of in ye justification of defensive & necessary war for the obtaining & securing social peace & happiness in order to induce me to inscribe on the shield of Epaminondas that fine instance of military tacticks first employed in ye battle of Leuctra, by wch that virtuous Theban not less celebrated for his Philosophy than Generalship, was enabled to pull down that Spartan Power wch was so ill employed in subverting the Liberty & Happiness of the neighbouring States …

Barry, 1803, in *Works*, vol. 2, pp. 665–7:

The figure next to Columbus, in the next print, is Epaminondas, with the famous oblique movement inscribed on his shield, by which intellectual skill became superior to mere bodily force in the memorable battle of Leuctra, where the ferocious power of the Spartans (so often unjustly and ill-exercised) was so happily humbled. Next to this heroic Theban commander (so eminent for soldiership, philosophy, patriotism, and all the endearing, interesting virtues that adorn private life), Socrates, in his own gracefully-familiar, cogent way, is explaining something to J. Brutus, Marcus Cato, Sir Thomas More, and M. Brutus, which last holds in his hand the Treatise which he wrote upon the sufficiency of virtue. [Barry comments on the outstanding virtue of the younger Cato and speculates that Christian principles would have tempered the limitations of his Stoicism, thereby preventing his suicide. He relates that Socrates is discoursing on this point] Shaftesbury, John Locke, and Zeno, with two Vestals, are in the range above this sextumvirate. The next is Aristotle, looking at the group of the more perfect legislators in the next print, to which Plato is pointing, Dr. Harvey and Hippocrates come next. Over head angels are incensing, and as it were, interceding and supplicating for the deficiency of the more imperfect legislators, Brumha, Confucius, Mango Capac, &c. whom they are presenting; and they make part of a group which extends into the next print …

Through the rediscovered preparatory drawing and through the print's several states, one can trace how Barry altered *The Glorious Sextumvirate*'s secondary figures to accommodate the two flanking prints, *Reserved Knowledge* to the left and *Lord Baltimore* to the right.[18] In the drawing as in the 1783 painting, Columbus looks out at the viewer, whereas in the print, in an effort to link this image more closely to its neighbour *Reserved Knowledge*, he altered Columbus' gaze to look to the viewer's left. In addition, he supplied him with chains and handcuffs, a reminder of the explorer's difficulties with Spanish authorities, another example of how a great man suffered at the hands of envious inferiors. Relating *The Glorious Sextumvirate* to its neighbour to its right was of much greater concern. In order not to repeat characters who already appeared on the left-hand side of *Lord Baltimore*, he altered the right-hand side of the *Sextumvirate*. In the upper register of the early states, Barry had shown Hugo Grotius and the shoulder of Bishop Berkeley, but since they had already appeared in *Lord Baltimore*, he replaced them in the third and final state with scaled-down figures of what appear to be two monks conversing. In the lower register, Boyle and Molyneux, who also appear in *Lord Baltimore*, are dramatically altered. In the *Sextumvirate*, Boyle becomes a bearded, hooded figure, and a balding man with hand to head in the traditional pose of melancholy reflection replaces Molyneux, a portion of whose wig is introduced at the frame's extreme edge to connect with the remainder of his head in *Lord Baltimore*. The pensive, balding man now contemplates for eternity not so much the back of Molyneux's head but the 'spirit of Molyneux', which, as defined by Barry, encompasses the striving toward legislative independence and liberty for all the people of Ireland. Molyneux may have vanished from *The Glorious Sextumvirate* at this point, save for a sliver of his wig, but for the discerning viewer his position as the seventh man is secure, and accordingly so is his message of Irish liberty and justice for all.

The print as footnote: redeeming the image of Catholic Spain, 1800

Queen Isabella, Las Casas, and Magellan

For states and full inscriptions, see Pressly, no. 31.

Inscription in lower margin: As a Testimony of Veneration for the Integrity & [/] transcendent Abilities which for more than 20 years [/] have been, tho unsuccessfully, yet, vigorously, [/] uniformly & gracefully exerted in the [/] Publick Service: this little Slip of Copper which, as the [/] Key Stone of an Arch, binds together these Groupes & the Virtues [/] they commemorate is inscribed with the Honourable & Glorious [/] name of Charles James Fox [/] by his humble Servant James Barry. [/] July. 25. 1800

Letter of 31 March 1801, Barry, in letter-book 2:

I have since [June 1800] made another addition [to the large-print details of *Elysium*] on a slip of Copper, in consideration of some of the figures which I wished to introduce near Columbus, as they associate admirably in that part. The industrious & truly good Queen Isabella of Castile, not only pawned her Jewels to assist Columbus in going on the discovery of the New World but it further appears from the history of the time, that, her benevolent heart was ardently employed in protecting those newly discovered people from every outrage, & it was not until after her death, that the Spaniards let themselves loose in the exercise of those Cruelties & devastations which stiffen the reader with horror & which are faithfully recorded by the ever to be venerated Las Casas, who sits below Isabella, holding the very identical record of those brutalities under his arm, with another Tract or scroll of Laws for the protection of those poor unfortunate Indians, which after much dangerous bickering & contest & long solicitation at the Court of Spain, he at last happily obtained: Also the introduction of the first Circumnavigator the intrepid Magellanus, who is at some little distance, give a finish & completeness to this important part, the subject of Discovery, by which the two Hemispheres were united.

At the very time when I was engraving this Slip of Copper & as I could find no portraits of Isabella of Castile or of Las Casas, had accordingly disposed of them by turning their faces into ye picture so as not to err as to likeness & yet to identify their persons by some other means, a very happy incident took place wch furnished me with all the information that could be obtained respecting Las Casas, Isabella & whatever concerned ye discovery of America & even with a great deal more than perhaps I shall ever have occasion to make use of. An illustrious stranger Genl. Miranda having about that time seen my work at the Adelphi, & being much struck with ye comprehension & utility of its views & the family resemblance of its spirit & disposition with those immortal works of Rafaelle with wch he had been so well acquainted in ye Vatican, & being determined to be acquainted with ye painter of such a work (as he told ye Secretary & others who were present & who afterwards told me) this acquaintance very fortunately for me took place shortly after …

Barry, 1803, in *Works*, vol. 2, pp. 664–5:

On the small slip which unites this [*Reserved Knowledge*] with the next print [*The Glorious Sextumvirate*], are seated the two truly christian works, under the elbow of the ever admirable Las Casas; and the bandage, or instrument of acknowledgment for the pawn of the jewels, [which so] worthily binds on, and is suspended from the crown of Isabella of Castile, who appears talking with Columbus in the next print; near her is Magellan, the first circumnavigator, holding the chart of his voyage. [The print is also mentioned in Barry's letter of 6 January 1803. In addition, his notes related to the print's subject matter from Herrera's *General History of the Vast Continent and Islands of America* can be found in his commonplace book, pp. 20–1.]

Executed in 1800, this oddly shaped print, an elongated vertical intended to be sandwiched between *Reserved Knowledge* and *The Glorious Sextumvirate*, is at first glance a curious addition, but the artist felt it an important addendum to his series. He gives as his primary consideration the desire to introduce Queen Isabella of Spain next to Columbus, who occupies the left-hand margin of *The Glorious Sextumvirate*. The first reason that he offers is Isabella's munificence as a patron, having pawned her jewels to ensure the financing for Columbus' first voyage of discovery. This noble sacrifice is noted in 'the bandage or instrument of acknowledgment' that hangs from, as well as secures, her crown, a testimony to her deserving the responsibilities of her position. Barry had already mentioned the queen in this context in his description of *The Distribution of Premiums* in his *Account* of 1783,[19] but now he wishes to place her within the elite rather than provide her with only a textual allusion. King Ferdinand, her husband and co-ruler, is absent, as is the later Charles V, under whose reign Ferdinand Magellan, who stands between Isabella and Columbus, undertook his circumnavigation of the world. Isabella alone is given the credit for initiating the voyages that were to reveal and unite the entire globe.

John Manning has insightfully suggested that Isabella, whose face Barry turns in lost profile under the pretence he could not find a portrait, is intended to allude to the Duchess of Devonshire, another aristocratic lady who had given so much in the political arena, particularly in 1784 in support of the Whig candidate Charles James Fox.[20] The dedication of the print to Fox is one confirmation of this association,[21] as well as the ribbon, already mentioned, which, hanging from Isabella's crown, duplicates the luxuriant curl of hair hanging down behind the Duchess of Devonshire in *The Distribution of Premiums*.[22]

The other reason Barry gives for wanting to introduce Queen Isabella is to celebrate her benevolent intentions toward the peoples of the New World. Bartolomé de Las Casas, bishop of Chiapas, whom Barry was soon to introduce into the painting itself, is seated in front of Isabella contemplating what was to follow on the heels of Columbus' voyages. The book opened beside him is his 1552 defence of the Indians, *Brief Relation of the Destruction of the Indies*, and the scroll refers to his having helped in the drafting of laws for the court of Spain applicable to Mexico and Peru. In associating Las Casas with

Fig. 67 James Barry, *Queen Isabella, Las Casas and Magellan*, 1800. Etching and engraving, 713mm x 150mm. © The Trustees of the British Museum, London

Queen Isabella, Barry distances her from the atrocities of the 'Black Legend', the horrific evils greedy Spaniards inflicted on the subjected natives. Isabella's devotion to the Catholic faith earned her the surname *la Católica* (the Catholic), and in exalting her Barry wishes to make clear that such 'true' Catholics as the queen and the bishop stand in stark contrast to the exploiters who were Catholic in name only. For Barry, Isabella, like Mary Queen of Scots in *Lord Baltimore*, is the antidote to that vile Protestant queen, Elizabeth I, who had so severely infected the nation's bloodstream. In redeeming the historical image of Catholic Spain, Barry is also arguing for the future redemption of British civilisation. Once the British perceive the nature of Catholicism as espoused by a ruler who was Catholic to her core, they cannot help but embrace their former religion, while at the same time rejecting the poisonous divisions introduced by Henry VIII and his perfidious daughter. A page in Barry's commonplace book, entitled 'Christianity unconnected with Politicks (mundane)', contains the artist's summary of the lessons to be learned from Spain's engagement with the New World. He laments how Christianity was too often 'unfairly, wickedly blended with sinister interests so utterly alien & contradictory to its pure & spiritual nature'. This 'Antichristian mundane Spirit' goes back to the conversion of the Roman Empire, when the interests of the Church and of secular rulers became thoroughly intertwined. But he more optimistically concludes, 'This Antichristian spirit ye coming of wch was so inevitable & so clearly predicted is however easily distinguished in all times & places & cannot vilify ye Sacraments & usuages of the Christian & Catholick Church whether administred by Saint or Sinner'. The real danger is in allowing one's disappointment over institutional imperfections 'to form scisms & seperation'. Because the word 'catholic' means universal, it goes without saying that 'the Christian & Catholick Church' by its very nature should be undivided. The print may be only a footnote, but it is a footnote that is in the form of an exclamation point.[23]

The climactic sublime: the concluding prints of *c.* 1802

The two prints, Divine Justice (fig. 68) and The Angelic Guards (fig. 69), continue and complete the series of large-print details across *Elysium*'s foreground. Barry takes pains to link *Divine Justice*'s left-hand margin with its neighbour *Lord Baltimore*, showing Mary Queen of Scots' cloak in the upper-left corner, the back of King Alfred beneath, and other figures, such as the boy holding the harp, resolutely looking to the viewer's left. Even so, stylistically and thematically these images can stand alone, together forming a cohesive pair. Aesthetically, with their masterful handling of lights and darks, they are the most powerful of the works in this series. Barry boldly plays off the light ground of Elysium with the dark cliff face of Tartarus, and such radical abstractions as the patterning on the helmet of the angel pointing into Tartarus enhance these images' dynamic vibrancy. Despite their role in anchoring the series of six large-print details of *Elysium*, even Barry could not refrain from speaking of them as a pair apart:

let it suffice to observe that, as the infernal region just commences & the Elysium terminates in this last print [*The Angelic Guards*], so both the prints joined exhibit in their advanced parts, that grand centre of the picture where the Angelic Minister of Divine Justice, weighing the good & the evil of life & the figures of the Angelic Guards stretching along to the extremity, form a mass, that for ye association of ye utile & dolce [practical and graceful], for grandeur & sublimity of action & form & for classical intellectual sentiment may be very safely committed to ye judgment of a liberal, indulgent Publick.[24]

On 3 May 1802 Barry wrote to the Earl of Buchan that he was 'nearly finished' with the completion of these two works,[25] yet he did not donate impressions to the Society of Arts until 2 May 1804. The delay

was the result of his waiting to find 'any Inscription adequate to the comprehensive & very ethical occasion which should be engraved on the vacant space of the rocks which extends thro' both the prints', submitting the pair only after none was forthcoming. At this time he wrote of his frustration in this regard:

Nothing could come more happily in that place, than such an Inscription as would intimate some idea of that parent generating source of good, from whence issued all those rivulets which afford necessary nutrition to the beautiful, the perfect, & the interesting which have so gracefully, & variegatedly fertilized the composition with the admirable characters which are exemplarily associated with the several groups of those prints, or rather concatenated print. The famous Inscription over the entrance of Dante's Inferno ['Leave all hope, you who enter in.'], altho' indeed truly sublime would be much too vague, & has neither the extension, nor the utility desirable.[26]

Despite Barry's desire, one is grateful the rock remains 'uncarved'.

Divine Justice

For states and full inscriptions, see Pressly, no. 33.
Barry, 1803, in *Works*, vol. 2, pp. 667–8:

Just behind Alfred [in *Lord Baltimore*], and in the next print, is the excellent and so justly celebrated St. Charles Borromeo, cardinal and archbishop of Milan, Trajan, Titus, Peter the Great of Russia, Henry IV. of France, Andrea Doria, the Great Scipio, the *pater patriæ* old Cosmo de Medicis, Alexander of Macedon, (*See Letter to the Dilettanti Society*) Louis XIV. and Julius II. Bossuet, bishop of Meaux, in the group below, with one hand leaning over the shoulder of Origen, and the other stretching to bishop Butler, between whom are Pascal and Antony Arnauld, is as it were, embracing and sanctioning the whole, as consistent with the catholic exposition in his hand. Of the angel who is elucidating something to them, and that below, weighing *good* and *evil*, and the lesser or guardian angel, who with clasped hands is regretting the perdition of his ward, nothing need be said …

Addition of Scipio, letter of 6 January 1803, in Barry, letter-book 2:

… a place has been found amongst ye promoters & Patrons of Art, for that illustrious Roman. P. C. Scipio, who as well before as after his Asiatic expedition contributed so much towards ye glory & the polish of his Country from whose envy & ingratitude, even so much worth was driven to ye necessity of banishing itself. But however 'tis consoling to know that everything essential, all the constituent parts of a great character naturally attach it, & the little its enemies can describe it of is hardly worth the mention, nay, ye enemies of a truly great man, as enemies to ye publick advancement, want shelter for themselves & can only find it in their concealment, publick detestation & indignation follow them when they are discovered …

Substitution of Cosimo de Medicis for Lorenzo, letter of 6 January 1803, in Barry, letter-book 2:

… & after what has been aduced in the Letter to the Dilletante respecting L. da Vinci, no wise or honest man will wonder to see the Magnifico, the mock Patron but real obstructer of Art, Lorenzo de Medicis driven away from amongst the Encouragers of Art in ye Elysium, in order to make room for the truly illustrious Scipio: But as justice is due to all & that no man is araignable for the faults of another happily one of those Medici is still saved & retained, it is old Cosmo, the pater patriae of his age, whose wisdom & integrity was so well employed

in ye publick service by selecting to that end ye greatest & most-proper artists of his time & who accordingly brings grace & ornament to ye situation in wch he is placed between Scipio, Alexander & Louis 14.

In the case of the central group of theologians, Barry had added Bishop Bossuet to the mural in 1801, but Bossuet's presence in this print detail is even more imposing as he dominates the quartet below him. To this quartet, Barry introduces Antoine Arnauld (1612–1694), squeezing him between Blaise Pascal, whose friend he was, and Bishop Butler. Arnauld, an ardent supporter of the Jansenists, is best known for his controversial writings against opponents such as the Calvinists, Jesuits and others who held different convictions. Notwithstanding that Butler is still closest to the discoursing angel, he is not as prominent as before, a part of the steady erosion of the Protestant presence in favour of a Catholic one.

Of the new patrons in the upper row of figures, the most prominent is Scipio Africanus. As with Agrippa in the companion print, his addition reinforces the presence of the ancients within the ranks of the moderns. At the same time the bald-headed general, who had also supported important

artistic contributions to his countrymen, provides another example of a great man persecuted by an ungrateful public. Next to him is Cosimo de' Medici. In his print of 1792 (although not in the mural itself), Barry had already made the substitution of Cosimo for Lorenzo de' Medici, but now Cosimo takes his rightful place among the patrons rather than the artists. In 1798 Barry had also substituted Cassiodorus for Pope Leo X in the mural. Yet in order to maintain a representative of the Renaissance popes who had done so much to patronise the arts, he now includes Leo X's predecessor Julius II, the supporter of Bramante, Raphael, and Michelangelo, to the right of Louis XIV. What appear to be papal tiaras and bishop mitres are ranged behind Julius II, suggesting that it is the Church as a whole, rather than just a few select individuals, that has done so much to champion artists.

At the left of the upper row of figures Barry inserts the profile of St Charles Borromeo into the ranks of the wise rulers. This sixteenth-century cardinal and archbishop of Milan, who had been canonised in 1610, was a zealous reformer and a prominent leader of the Counter-Reformation. Unlike the patrons Cosimo and Scipio, he assumes his place with little fanfare, Barry choosing to be more circumspect when introducing militant Catholics.

The Angelic Guards

For states and full inscriptions, see Pressly, no. 34.
Barry, 1803, in *Works*, vol. 2, p. 668:

… nor of those angelic guards in the next print who so sublimely group with them and over-see what is done in the entrance from the world below. Charles I. Colbert, Francis I. and the illustrious Roman, M. Agrippa, range with and appear part of the group of the patrons of art, Julius, Lewis, Alexander, &c. in the former print. In the opening between Colbert and Francis I. appear Cassiodorus and another monk inspecting the plan for the convent of Viviers, (*See Letter to the Dilettanti*). Overhead are Sir Joshua Reynolds, Giles Hussey, Annibal Carrache, Dominichino, &c.

Addition of Agrippa, letter of 6 January 1803, in Barry, letter-book 2:

… behind Francis I. who is talking with Colbert & Charles 1st another ancient Roman is introduced, whose love for the Arts appears to have arisen from the true springs, out of the higher virtues of character & who was probably the real author or occasion of the greatest part of the splendor & magnificence of the Augustan Age of Rome. As this illustrious Roman M. Agrippa had also written upon the arts, the following extract from a Letter of Mr. Barry's to the Earl of Buchan, may afford some illustration of that writing of Agrippa. 'For after all & notwithstanding the serious loss of my little salary wch was to have been the reward of so much previous labour of my Lectures in the Royal Academy, yet after all the rancour & brutal violence of this invidious, unexampled business, it must be evident to any intelligent, liberal observer that the substance matter of that Letter of mine to the Dilletante Society, from the beginning to the end of it & all its views, direct & colatteral, must have been of similar material & texture, (however defective in the other respects of oratory,) with that oration wch Pliny so emphatically commemorates "Extat certe ejus oratiae magnifica & maxumo Civum digna" which I have exhibited in the hands of M. Agrippa, whom I have in this last print associated with Francis I. Colbert & other characters of similar disposition, whose honest, wise & patriotic views of ye importance of ye Arts to ye culture & happiness of Society, would never suffer those useful monuments of genious & ability in what is emphatically called the Belle Arti, to be criminally exiled to country villas & the Houses of private possessors, "detabulis omnibus signisque publicandis: quod fieri satius fuisset, quam in villarium exilia pelli." as ye honest & intelligent Pliny expresses it.'

Contrasts in light and dark, a radical play with scale, and a progression in depth enhance this print's drama. The viewer's eye moves from the dark abyss of Tartarus to the lights and darks of the monumental angelic guards, to the dark row of patrons, and finally to the bright upper region inhabited by artists. The dark row of patrons is itself punctuated with the much brighter, huddled figures of Cassiodorus and his companion, who, although recessed, appear purer in motive in consequence of their being spotlighted in contrast to their more worldly peers.

Agrippa, at the far right of the row of patrons, is the new member of the elite. It may well have been George Turnbull's 1740 praise of Agrippa that prompted Barry to include him in Elysium. Turnbull writes how first the Greeks and then the Romans took great care 'to preserve the Memory of great Men and their virtues, and thereby to promote, and maintain the Love of true Glory'. But in time the Romans began to remove such 'Memorials of Merit' from public buildings to ornament private homes, and Agrippa's oration was written to oppose this latter custom by insisting that art 'ought to be exposed to the Publick in order to call forth Genius, and to be studied by Artists desirous of improving themselves and the fine Arts'.[27] Barry compares his *Letter to the Dilettanti Society* to Agrippa's treatise,

but more importantly, while these texts advocate a public art that inculcates virtue, his murals and his prints after them actually supply this desideratum.

The group of artists differs considerably from the earlier choices. The likes of Apelles, Raphael and Michelangelo are no longer present, and they give way to figures who, although present in the mural, did not make the cut in the 1792 print (Sir Joshua Reynolds, because he was alive at that time, was ineligible). On the left Barry introduces the two English artists Reynolds and Giles Hussey, and on the right the Italians, Annibale Carracci and Domenichino. Reynolds now gestures toward the expansive heavens rather than to his predecessor Michelangelo, indicating the cosmic nature of the artist's mission. Hussey is furnished with an indoor cap that echoes the form of a liberty cap, a not so subtle reference after the events of the French Revolution to republican principles. A vestal and an angel engage with Hussey in regarding either a manuscript or a drawing, again underscoring Elysium as a place of continuing intellectual exchange. The unidentified young man to the right of Carracci and Domenichino is presumably a student who learns at the feet of these two great academicians, perhaps a stand-in for Barry himself. In his *Letter to the Dilettanti Society* of 1798, he characterises himself as a follower of Carracci, and in this he sees himself as continuing the efforts of Hussey to introduce their reforms into England.[28]

In this print detail a fully articulated cross replaces the star motif seen in the diadem of the angel seated at the centre of the monumental trinity. This is the first and only time that Barry makes an unambiguous reference to his Elysium as a Christian Heaven, rather than as an afterworld that happens to include a large number of Christians.

Musings on *Elysium*'s elite: three small prints, *c.* 1800–05

The set of seven prints, known as the small series, reproducing the six paintings plus the two intended royal portraits, and the set of seven details, known as the large series, reproducing the principal group in *Crowning the Victors* and six groups from *Elysium and Tartarus*, together form Barry's public record in prints of his monumental cycle. But even the creation of these fourteen works did not satisfy his need continually to tinker with this his greatest achievement. Late in his career he executed another print of those scientists and philosophers inhabiting the lower left-hand corner of *Elysium*, an area he had already treated in the large-print detail *Reserved Knowledge* (see fig. 65). He turned as well to two small prints of heads, *Pensive Sages* (see fig. 71) and *Blessed Exegesis* (see fig. 72), which are meditations on the figures in *Elysium*.

These three works, executed on a different scale and in a different key from the small and large series, apparently were lumped together, along with three other plates, in a single lot in the artist's posthumous sale: 'Six ditto [i.e. 'copperplates, some laid with mezzotinto ground'], *Descartes* [presumably *Scientists and Philosophers*], a portrait [presumably Barry's mezzotint self-portrait], two studies of heads [*Pensive Sages* and *Blessed Exegesis*], and a small mezzotinto portrait of a youth [*Bust of a Young Boy* after Reynolds].'[29] The artist's contemporaries did not value these works; the entire lot of six sold for only £2 5s 0d, one of the lowest sums for any of the lots in this section of the sale. In addition, no impressions are recorded as having accompanied any of these plates. Either impressions were considered too inconsequential to be worth mentioning or Barry never accumulated any stock, another indication that their primary purpose was not commercial in nature. Furthermore, none of these works were included in the posthumous publication of the 1808 book *A Series of Etchings by James Barry, Esq. From his Original and Justly Celebrated Paintings, in the Great Room of the Society of Arts, Manufactures, and Commerce, Adelphi*, which contains the other fourteen prints. With the

exception of the initialled plate (see fig. 71), they may well have never been intended for the public at large. Contrary to one's expectations for prints, where the possibility of multiple impressions assumes a wider audience, the three works discussed in this chapter appear to be more in the nature of private musings on *Elysium*'s elite.

Caves as portals to the eternal mysteries: *Scientists and Philosophers*

Unconcerned with creating a polished image, Barry executed his unnamed print of the lower left-hand corner of *Elysium*, now christened *Scientists and Philosophers*, on an imperfect copperplate containing a nick in the centre of its left-hand edge (the right side of the print itself).[30] The print's square format and smaller size (337mm x 327mm) also sets it apart from his earlier works devoted to the Society of Arts murals. His technique is more varied and less precise than in the preceding fourteen prints. In places there is a bold disdain for finish; the hatching on the plinth, for example, is cursorily done,

imparting a raw vitality. Still, why did he feel the necessity to return to this small corner of *Elysium*? The answer lies more in content than in technical departures.

Within the print there are minor variations on earlier themes. No divine agents are present in this reduced cast of characters. The head of the angelic boy seen over Thales' shoulder in both the painting and the print *Reserved Knowledge* becomes that of a mature bearded man with a classical fillet. This figure's gaze also now directs the viewer's attention toward the main grouping. Descartes is still at the centre, but rather than address the contents of a book in his lap, he pauses, still looking at us, while employing a compass on a sheet of paper placed on a firm support. Thales, who points to Roger Bacon in the lower-right corner, is more prominent than before.

Barry also introduces a fully articulated mouth of a cave beneath the ledge on which Thales sits. It recalls the most famous cave in literature, Plato's allegory in Book 7 of *The Republic*, where he creates a dialogue between Socrates and Glaucon in which the philosopher compares man's lot to chained figures in a cave whose only knowledge of the larger world comes from shadows cast by a fire onto the wall before them, a land of shadows that they mistakenly perceive as reality. If one of these unfortunates was unchained and made to face the light, before his eyes could adjust he would see the actual objects less clearly than he had formerly seen their shadows. Once, though, he had absorbed this reality he might then be forced up into the sunlight – for Plato a metaphor for the region of the intelligible – and here with time his knowledge would expand still further. But upon returning to his chained companions, his eyes would again need to readjust, and those he had left behind would find him more confused and uninformed than he had been before he had undertaken his journey. They would laugh at him, and resisting any attempt to make the ascent themselves, they would even kill anyone who should try to free them to embark on a similar voyage of discovery. Thales and his companions are shown as having emerged into the full light of revealed knowledge, and given Barry's numerous pessimistic statements made throughout his life, he would have been particularly responsive to Plato's melancholy warnings that the progress of the mind from ignorance to enlightenment was a painful one, and that those who then attempted to lead their fellow men toward the light placed their own lives in jeopardy. In *Scientists and Philosophers*, the cave's arched top harmonises with the curve of the celestial sphere above and behind it. These spherical worlds inhabited by the viewer's imagination keep expanding as he or she progresses from darkness to light. Bacon's slumped, meditative pose in the lower-right corner is a reminder that the journey is often a solitary and sad affair.

Barry's oeuvre is filled with a number of caves that symbolise the movement from the darkness of ignorance to the bright light of knowledge. Ulysses' escape from the cave of Polyphemus (see fig. 60) chronicles just such a journey from darkest despair to sunshine's freedom. Often the experience of the cave is itself a necessary step toward enlightenment. Aeneas must descend into the Cave of the Cumaean Sibyl before reaching the revelations that await him. Barry himself descended into this cave both through the pages of Virgil's epic as well as through the actual cave's mouth on the banks of Lake Avernus. The experience of the catacombs would have provided another such revelation, and the tunnels excavated at Herculaneum offered a modern version of a subterranean descent in order to recover intellectual treasures. In his description of *The Birth of Pandora*, Barry writes that the Fates are in a cave of clouds,[31] and Chiron, the great teacher, used a cave for his shelter. In his idiosyncratic *A New System, or, An Analysis of Ancient Mythology*, Jacob Bryant pointed out the power of caves. In his chapter beginning, 'Of Worship paid at Caverns', he writes, 'Men repaired in the first ages either to the lonely summits of mountains, or else to caverns in the rocks, and hollows in the bosom of the earth; which they thought were the residence of their Gods'.[32] He went on to link these caves to the *cellas* of temples: 'the innermost part of the temple was denominated the *cavern*'.[33] The Society of Arts' Great Room, like the dark interior of the Temple of Ceres, in which the rites of the Eleusinian Mysteries

were performed, is itself another dark cavern/*cella* in which the initiate experiences the illuminating flashes of insight offered by the murals on the walls.

The print *Scientists and Philosophers* provides another telling variation or refinement on the earlier depictions of this corner of *Elysium*. Despite his advanced age, Thales is shown as a heroic nude, no figure in *Elysium*, including himself, having been previously rendered in such a fashion. Furthermore his features are those of the artist.[34] This conflation of the modern artist with ancient heroes is explored more fully in the conclusion, but it is of decided interest that, at least in this print, he takes his stand not with the many artists represented in *Elysium* but with the great thinkers. Here he chooses to see himself as another Thales rather than Apelles. Barry as Thales now holds the scroll that had earlier spilled from his lap, pointing with his index finger at Francis Bacon. In pointing to his soon-to-be animated companion, he recalls Michelangelo's energising God in *The Creation of Adam* on the Sistine ceiling. His godlike power is also alluded to in the diagram on the scroll, where Barry as Thales becomes the source of the light that casts the moon's shadow onto the earth. Barry as the philosopher artist is the sun itself, with the murals of the Great Room blazing out his message.

Experimental heads: *Pensive Sages* and *Blessed Exegesis*

Pensive Sages (fig. 71) and *Blessed Exegesis* (fig. 72), Barry's smallest prints (81mm x 90mm and 64mm x 89mm, respectively), depict the type of brooding philosopher encountered in his *Elysium*.[35] Yet unlike *Scientists and Philosophers*, neither reproduces a particular section of *Elysium*'s composition. Rather each is a variation on the theme of its meditating geniuses – a virtually all-male intellectual elite engaged in the never-ending quest for meaning.

In *Pensive Sages*, the bare shoulders of the foremost figure suggest a heroic nude, not unlike that of Thales as he appears in *Scientists and Philosophers*. The figure at the left peering over his companion's shoulder is reminiscent of one of Barry's late self-portraits.[36] In addition, the placement is similar to that of an earlier self-portrait, where in his print *The Phœnix or the Resurrection of Freedom* the artist stands at the far right in a group of the illustrious dead looking over the shoulder of Andrew Marvell.[37] Even if, unlike in *Scientists and Philosophers*, he no longer identifies with a lead figure, in *Pensive Sages* he hardly minimises his importance: here the foremost figure with inclined head contemplates for eternity the artist's own initials.

Fig. 71 James Barry, *Pensive Sages*, c. 1800. Etching, 81mm x 124mm. Collection of William L. Pressly

Fig. 72 James Barry, *Blessed Exegesis*, *c.* 1800. Etching and aquatint, 63.5mm x 89mm. Collection of William L. Pressly

On the left side of *Blessed Exegesis*, a bearded philosopher, wearing what is surely a monk's cowl, ponders an open book, the upper right-hand corner of which is held firmly by his right hand. He closely resembles Barry's other portrayals of Roger Bacon, particularly as visualised in the lower-right corner of *Reserved Knowledge*, but perhaps in this instance a specific identification is not the artist's intent. On the right side are young, beardless soldiers. The principal helmeted figures in Barry's *Elysium* are the angelic guards, and like other angels in the larger composition, these figures instruct: the mouth of the one in profile at the far right is opened as if in the act of speaking, while one of the two raises an expository finger. It is a tightly compressed image, made all the more dense by the print's small size. Its uneven aquatint wash provides the greatest contrast with *Pensive Sages*. Barry applied it in a single biting, as he achieved the contrast in light and dark tones across the surface of the plate through the varying density of the etched lines. The effect is like that of a photographic negative, the image possessing a haunting, hallucinatory power as the faces of the soldiers swim in and out of view.

In *Pensive Sages* and *Blessed Exegesis*, working on a small scale and on a familiar subject, Barry was freer to experiment than in the fourteen 'public' prints on the murals. In their creation, he was as interested in process as he was in product. In the case of the unsigned *Blessed Exegesis*, clearly an experimental effort, the artist may have intended this work for an audience of one – himself.

APPENDIX 2

Real and Imagined
Alterations in Paint

The engraved details discussed in appendix 1 afforded Barry the opportunity to make substantial changes to the murals without retouching the paintings themselves. Yet he also twice reworked the murals. The first modifications, made in 1798, involved limited tinkering with *Elysium*. The 1801 modifications were more extensive, involving all three murals from the second half of the series. The changes almost always involved additions, although in one instance in *Elysium* the artist made a substitution, replacing Pope Leo X with Cassiodorus and a companion. Sometimes the reasons had more to do with aesthetic considerations than they did with content, as he attempted to achieve a more harmonious composition.

Changes to the murals, 1798

Proposed introduction of two new portraits into *The Distribution of Premiums*

Letter of 1 October 1798, in Barry, *Works*, vol. 2, p. 639:

However, as our satisfaction is never to be complete, (at least here below) a blemish has, partly from the suggestion of others, lately occurred to me … The unlucky blemish is in the fifth Picture of the Series, where the Society are occupied in the distribution of Premiums, and where so much occurs of what is great and respectable as to rank and talents: there is nothing to specify the City of London, except the view of St. Paul's in

the distance. Had I introduced the Lord-Mayor of that City, which has always been so remarkably distinguished for its numerous Hospitals, Schools, and for whatever could best denote the most truly citizen-like and generous publicity, I had then done it a justice which would be in strict unison with the other parts of the work …

As without putting out any thing, there is in that picture good space for the introduction of two portraits, I should feel happy in receiving the Society's command for filling that space with a portrait of a Lord Mayor of London, and also with a portrait of the truly noble personage, both as to rank and talents, who is at the head of Presidency; and I am not a little gratified in this opportunity of saying so, as among the number of public attacks that have been made upon my reputation and interest, one of the latest has been a lying story that his Grace the Duke of Norfolk had done me the honour to desire his portrait at my hand, and that with the most underbred brutality I instantly shut the door on his Grace, bidding him to look out for somebody else.

The 'good space' Barry had in mind for his insertion of the two new portraits was presumably above the head of Keane Fitzgerald in the space next to Rev. Dr Stephen Hales. Charles Howard, 11th Duke of Norfolk, who had become president in 1794, would also presumably have been shown, like his two predecessors, wearing a hat. By introducing a lord mayor, Barry intended to highlight his focus on private institutions, such as hospitals and schools, which, like the Society of Arts and the Royal Academy, promote the advancement of the general welfare. These proposed changes, however, were never made. Perhaps, despite Barry's denials, there was some friction between him and the Duke of Norfolk. It is also possible that his choice of a lord mayor, once known, could have proved controversial. His phrasing 'of a Lord Mayor of London' suggests he did not have in mind the current occupant, and he may have been contemplating introducing the famous or infamous, depending on one's point of view, John Wilkes, a man whom the artist greatly admired and who had been voted to this position in 1774. Wilkes' ongoing struggle against the powers of Parliament in favour of voters' rights, the freedom of the press, and freedom from arbitrary arrest would have made him an excellent representative for Barry's promotion in the mural of the authority derived from middle-class and local institutions in opposition to governance by an oppressive, centralised state. The fact that Wilkes had recently died on 26 December 1797 would have made such a posthumous honour even more timely. However, one can see how, if this was the case, such a choice, given Wilkes' radical political following, would have proved unacceptable to many of the Society's members.

First modifications to *Elysium*

In his *Letter to the Dilettanti Society* of 1798, Barry mentions his returning to work on the murals, making adjustments that had more to do with visual effect than with content: 'with God's blessing, I mean to leave that work as perfect as I can … With the subject matter of it I am perfectly satisfied, and see nothing to alter, to add, or to take away; but I am eager and anxious to add more energy to its effect, and to the execution of several parts.'[1] *Elysium* was the area to which he devoted his attention. In contradiction to his statement about content, he added four figures, three of whom are portraits and none of whom had appeared in any of the prints up to this time. He also introduced six more angels, who do indeed help impart a grandeur that gives 'more energy' to the whole.

Addition of six angels or superior Platonic intelligence, letter of 1 October 1798, in Barry, 1798, *Works*, vol. 2, pp. 641–2:

I have indeed, in the last picture, the state of Final Retribution, introduced something new, which gives a further extension, and a more weighty impression to the old matter. Behind the Superior Intelligence, who is discoursing

upon the Solar System to the admiring Newton, Galileo, Copernicus and Bacon, I have introduced two similar intelligences, which necessarily intimates a Platonic mass of superior intellect in that part. Also, over the centre group, the general arrangement is assisted by another angel strewing flowers; and by introducing three more angelic characters among the guard in the advanced part of the Elysium, I have answered the double purpose of adding, by those three large ideal figures, something more to the dignity of that part where so many portraits of mere individuals occurred, and without introducing any thing new into Tartarus, the action and way in which those guards are employed, necessarily leads the attention into that part, and consequently furnishes another link for uniting those two stages of final retribution, which form the subject of the picture.

The addition of the six angels occurs in three distinct parts of *Elysium*. In the first instance, which consists of the two heads at the far left flanking the head of the large angel discoursing on the solar system, Barry had first tried out this addition beginning in his second state of the 1795 print *Reserved Knowledge* (see fig. 65). However, in the mural he swapped their positions and modified the number and position of the wings, but the head of the angel on the left has either been removed or painted over.[2]

In the second instance, Barry added the angel just above the heads of Solon and Numa in the group of legislators. This figure, who holds a basket of flowers in her left hand, now assists and reinforces the Raphaelesque angel above King Alfred. Barry refers to the legislators as the centre group, which is truer of their position within the foreground of *Elysium* than of the mural as a whole, but this characterisation of them as central underlines their importance.

The third addition is more impressive still. Along the rim to *Tartarus* Barry introduced three new male guards. The 1792 print (see fig. 28) compresses and alters the mural's composition, but it nonetheless offers a guide to the mural's pre-1798 appearance. Barry added the guard at lower right, who points with both hands into *Tartarus* while looking back up at the massive figure of the seated archangel. Continuing up the rim, a second guard, also equipped with a large spear, looks thoughtfully into *Tartarus'* depths. The most likely identity of the third angel that Barry added along the rim in 1798 is the head in shadow that backs up the head of this second figure. This head is prominently featured in the print *The Angelic Guards* (see fig. 69), where all three of these guards are lined up together.

As the 1792 print demonstrates, the dangling feet at upper right were present from the beginning even if this angel in the mural is more radically cropped than in the engraving. In the print, an angel, who is also dramatically cropped, stands next to the dangling legs, with his right hand resting on a shield. In the painting this companion is below, and, resting his left hand on his shield, he looks back up at the angel, with the dangling legs calling attention to his imposing presence. Because this angel differs substantially from the configuration in the 1792 print, one could argue that he is the third angel that Barry added in 1798, choosing in his description not to count the lesser shadowy head. More likely, however, he was there from the beginning, with the 1792 print, as is often the case, offering a variation on the original placement. However one configures the three angels added to the rim, the additional figures enhance the painting's sense of awesome grandeur.

Addition of Mendelssohn, letter of 1 October 1798, in Barry, 1798, *Works*, vol. 2, p. 642:

Happening within these three years to meet some of those truly noble works translated from the present race of the literary heroes of Germany, a most extraordinary and admirable character of the true old Grecian leaven, has fortunately come to my knowledge, and after a long and fruitless search for a portrait of him, by the luckiest accident imaginable, only a fortnight since, just as I had terminated what I was about in the Great Room, a very fine medal was brought to me, by which I have been enabled to enrich my Elysium with another portrait, which would have ranged admirably near the eye, in that group with Plato, behind Sir Thomas More, had it not been

that the vacant space was there necessary for the composition as a totality of easy and agreeable comprehension to the sight: however Moses Mendelssohn, the illustrious character I allude to, was blessed with such various and graceful talents, that it was easy to find in such a society, a station and company which he would relish, and where he might give, as well as receive lustre; I have therefore placed him shaking hands with Addison, near Thompson, Dryden, and Pope. 'Tis curious, though melancholy to reflect, that such a character as Moses Mendelssohn, with all his virtues, could not have become entitled to the citizenship of London, even though he were born here, (without which he probably would not do,) having previously attempted, aided, or abetted the spilling of human blood, by firing at some enemy. However, I may safely rely on God and good men for my justification in spurning all such brutal conditions for his admission to that Elysium, where he makes so graceful an ornament. Constraint, encouragement, principle, – although these words may pass without any meaning with – but reasoning is out of its place, and thrown away upon certain matters, – Surely one cannot help cursing that baneful, destructive hypocrisy, which by artfully contrived oppressions, prevents any part of the human race from emerging into science and virtue, and then diabolically attempts to justify its conduct by the very barbarism which those oppressions naturally occasion. Let God almighty deal with them and us, with Jews and Christians, according to his own wise and beneficent though inscrutable *designs*: this can furnish no reason for our wicked and impious interference, in officiously tormenting each other, to the utter subversion of all those charities that ought to grace our common nature.

Responding to such works as Moses Mendelssohn's *Phädon* of 1767, which was modelled on Plato's dialogues of the same name, Barry had first contemplated inserting the modern author, who had died in 1786, with the philosophers, but for aesthetic reasons he rejected filling the vacant space between the heads of Zeno and Aristotle. Instead he positioned Mendelssohn among the writers, showing him wearing a purple yarmulke and extending a bony left hand, while clasping with his right the hand of Joseph Addison, another celebrated essayists. Mendelssohn is the only modern Jew included among the elect. (Moses and other Old Testament figures are far removed, present, but largely unseen, in the distant parts of the picture.) By including Mendelssohn, Barry hopes not only to honour him but also to foster a more inclusive spirit, a part of his increasing emphasis on the necessity of cultivating religious and political toleration.

Addition of Cassiodorus and a monk, letter of 1 October 1798, in Barry, 1798, in *Works*, vol. 2, pp. 642–3:

But to get to something less agitating: Amongst those personages who have been dignified with the title of patrons of the arts, and just behind Francis I. and Lord Arundel, I have introduced a bald-headed friar, holding a large scroll of parchment, which by the writing on it appears to be the plan of the illustrious Cassiodorus, for his convent at Viviers in Calabria. This graceful, really patrician vestige of the ancient nobility of Rome, had, under Theodoric, and the other Gothic Princes, employed the most unremitting industry and wisdom in directing that power with which he was entrusted by those ferocious strangers, in the manner best calculated to mollify, and give some alleviation to the deplorable miseries of his times: and when after many years of the best possible administration, and from the horrible disorder and confusions of changes, and new conflicting hordes of these barbarians, it was no longer in his power to be useful to the existing generation, he piously retired to this convent, which he had previously formed, and furnished with whatever could be obtained of ancient wisdom and literature, to digest, to teach, or at worst to copy, multiply, disseminate, and preserve it, for more happy times, when it might again germinate. From these store-houses, as from another *Ark*, the world had again been replenished with sciences and arts: and as to our own arts of painting and sculpture, we may truly and confidently say, that Europe would at this day be blind and dead to all feeling for the perfections of ancient, even of Grecian art, were it not for the long course of education in those arts, which the piety of those

convents afforded during the whole career, from Cimabue to Raffael and the Carraches. This reasoning will hold true of the Greeks themselves; that perfection they had superinduced upon mere human nature, arose from a higher principle than the listless, cold-blooded apathy of materialism, which can love nothing, because it leaves nothing worth loving, and, fairly left to itself, exert but to destroy.

In the place first occupied by Pope Leo X, between Colbert and Francis I, Barry inserted Cassiodorus along with a fellow monk. The scroll at which Cassiodorus and his companion are looking continues out to the viewer's right to occupy the former position of one of Phidias' sketches. Barry effectively fills what space he could reclaim from the first design, but in this new configuration Cassiodorus must stretch in order to support the top of the scroll with his left hand. The rolled part of the scroll is inscribed 'Cassiodorus', Plan [/] Viviers'. The unfurled portion that is visible shows the drawing of a church. Barry honours Cassiodorus for his sixth-century founding of monasteries, in this instance Vivarium, which helped preserve sacred and profane knowledge during the barbarian invasions. The inclusion of Cassiodorus also forms part of Barry's efforts to give more emphasis to the medieval period when Catholicism was the dominant religion. In *Lord Baltimore* (see fig. 63) he had added Henry Chichele to this group; in *Reserved Knowledge* of 1795 (see fig. 65) he had added Robert Grosseteste; and in *The Glorious Sextumvirate*, also of 1795 (see fig. 66), he had substituted two monks for George Berkeley and Father Sarpi.

Addition of Reynolds, letter of 1 October 1798, in Barry, 1798, *Works*, vol. 2, p. 643:

I have also had the satisfaction of introducing, near Rubens and Vandyke, the portrait of our own Sir Joshua Reynolds; and, agreeable to the sentiment expressed in his last discourse, I have made him pointing to M. Angelo, whom he so much admired. This great city of London would have enjoyed more advantage from Sir Joshua's fine talents, had there been remaining in it some of those exploded, old, and happily fashioned convents, where those fine talents might have taken wing. Alas! How much it is to be wished that our neighbours on the continent would think seriously and deeply about this matter, whilst it is yet time. Epicurism will be, as it always has been, barren with respect to excellence. These our neighbours have been long distinguished for their love of art, and they will never be able to find any generous principle of sufficient general interest, to call out, to concentrate, and give efficacious existence to the abilities of their artists, but by the preservation of religion, and wisely separating whatever it affords of admirable, amiable, and consoling, from those illiberal, mean, mischievous perversions, by which, from its occasional, accidental mixture with wretched, political artifices, and mere low, mundane concerns, it has been often so much defiled.

Despite their having quarrelled in life, after Reynolds' death in 1792, Barry was quick to revere both the man and his work. He shows the first president of the Royal Academy pointing to Michelangelo as the most illustrious of his predecessors, and this gesture, as Barry states, recalls Reynolds' famous declaration in the conclusion to his final *Discourse*: 'I reflect not without vanity, that these Discourses bear testimony of my admiration of that truly divine man, and I should desire that the last words which I should pronounce in this Academy, and from this place, might be the name of – MICHAEL ANGELO.'[3] Here in *Elysium*, Barry shows Reynolds proclaiming for eternity his admiration.

Concerning his relationship to Michelangelo, Reynolds had also said in the conclusion to his last *Discourse*, 'Yet however unequal I feel myself to that attempt, were I now to begin the world again, I would tread in the steps of that great master'.[4] While Reynolds sees Michelangelo as the best model for emulation, Barry offers a more ambitious agenda. In his text he again refers to the villainy of Henry VIII, in this instance to Henry's dissolution of London's great monastic institutions. Had that

Catholic culture survived, there would have been ample opportunity for Reynolds to have achieved his full potential as a painter: Church patronage leads to religious pictures that inspire and elevate. Thus Barry's addition of Cassiodorus and his addition of Reynolds are related. In the first instance, a monastic system was created that could protect and promote the arts, whereas in the second instance one sees the unfortunate consequences of this system having been abolished. Reynolds, born into a commercial society dedicated to pleasure, never received the encouragement he needed to achieve Michelangelo's stature. In showing Reynolds in *Elysium* pointing to his predecessor, Barry suggests that new Michelangelos are possible, but only if the culture that nourished this great Italian old master can also be resurrected. For Reynolds and other artists of the English school to follow in Michelangelo's footsteps, one must first reconstitute society itself, not only reintroducing monastic institutions but also the papal government that had provided Michelangelo with his greatest opportunities.

Missing unidentified male figure:

An unnamed man in Elizabethan attire occupied the spot next to Edmund Spenser (fig. 73), but, like the angel's head, this figure disappeared sometime between 1979 and 1996.[5] Perhaps the conservator who worked on the murals *in situ* in the mid-1980s targeted both the now missing man and the angel's head because they had been superimposed over the original layer of paint. Barry never mentioned this figure in any of his writings, and if it was an addition, it could date from either 1798 or 1801. Because it is almost a doppelgänger for Spenser, perhaps it was intended to suggest other illustrious, early English poets, just as the addition of the angel's head was intended to increase the intelligence quota in that part of the picture. There is another possibility as well. In his 1783 description to *The Distribution of Premiums*, Barry had lamented over the fate of Thomas Chatterton, who in 1770, as a young man of only seventeen years of age, had committed suicide. Perhaps Barry intended the unidentified figure as Chatterton in his role as Thomas Rowley, the fabricated sixteenth-century poet-

Fig. 73 Detail of *Elysium and Tartarus* from an A.C. Cooper photograph taken in the 1950s. Collection of William L. Pressly

priest who was his principal persona. Chatterton had already become a subject for artists as early as 1780, and since he was on Barry's mind and since no portrait of him had survived, the somewhat nondescript head may have been in homage to this remarkable youth who, more and more, was being exalted as a poet worthy of any age.[6]

Changes to the murals, 1801

Proposed fireplace additions (see chapter 13)

From Mercury to Mars: adding a Naval Pillar to the *Thames*

Letter of 26 November 1801 in Barry, 1801, pp. xlix–lxi:

Another matter which Mr. Barry is happy in offering to the attention of the Society, is a Naval Pillar which he has introduced in the picture of the Thames, or Triumph of Navigation. This design occurred to his mind at the time when his Royal Highness the Duke of Clarence, and other Noblemen and Gentlemen, associated for the purpose, advertised their idea of obtaining designs for a Naval Pillar, or other trophy, which might serve for the commemoration of great national achievements. In consequence, however, of the dark and mysterious opposition which had so long followed him, and of which he has had such frequent reason to complain, Mr. Barry laid aside the design till its connexion with the subject of this picture of the Thames, pressed upon him with accumulated and irresistible force; and finding nothing had been done, which would answer the intended purpose, to his satisfaction, he rolled the scaffold to the picture, and began such a trophy of a mausoleum, observatory, or lighthouse, as is no where else in existence before. Nothing can have more simplicity and *naïvité* than the idea of it as a totality; the British Tars so well and obviously typified by the naval Gods, the Tritons, upon sea-horses, dashing up the sides of a rock, upon the top of which they erect this trophy to the first Naval Power. [Here appears a lengthy paragraph on the harm done to the artist by the publication in his name of a supplement which grossly abuses the king in Rev. Matthew Pilkington's 1798 edition of *The Gentleman's and Connoisseur's Dictionary of Painters*.]

In the year 1792, it appeared that Mr. Barry had occasion to offer another (though much more limited) scheme for a national Mausoleum (see page 28, Letter to the Dilettanti), where the subjects sculptured in the round and in basso-relievo, being all near the eye, afforded to the spectator every opportunity of considering them with convenience, pleasure, and utility, the want of which was so deeply regretted by all of who had seen the fine column at Rome, erected to commemorate the victories of Trajan; the greatest part of these fine sculptures being to every purpose of desirable inspection, as much lost and buried in the air, as if they had been so many feet under ground. [Barry goes on to discuss Trajan's column in more detail, regretting that it did not admit 'of an exterior ascent'. He also mentions the column of Antoninus, the great column of Constantinople, and Pompey's pillar at Alexandria. He then turns his attention to the Egyptian pyramids and the Chaldaic temple of Belus, which prompts an extended discussion of Mexican temples.]

But when one reflects that [on top of the great temple of Mexico] the victims were human, and that 72,344 of them were sacrificed on this platform, in one festival of four days continuous, at the dedication of this temple [see Clavigero, vol. 1, p. 201; Barry quotes extensively from Clavigero in his commonplace book, pp. 1–11], it is not to be wondered that the Spaniards demolished, and suffered not a stone of it to remain standing. And yet it had been better, perhaps, to have adopted a different conduct, and to have suffered the temple to remain; and, in lieu of the former horrid butchery, to have performed in the presence of the misguided people, their own christian unbloody sacrifice, which, to its relation to the oblation at Calvary of that lamb which was slain from the beginning, had happily atoned for all, and precluded the necessity of any other sacrifice ... Let so much

then suffice, as it will sufficiently authorize the observation, that the British Pillar, in the picture of the Thames, possesses every advantage enjoyed in those famed pyramidal, obeliscal, or columnal fabrications of Egypt, Chaldea, Rome, or America, with advantages peculiar to itself, of still higher value than all that it may have in common with those celebrated vestiges of antiquity. This British Naval Pillar, Mausoleum, Observatory, Lighthouse, or whatever it may be called, as they are all united in the same structure, which, by a very legitimate flight of classical imagination, these Tritons, or sea-gods, have erected to the first Naval Power, will admit of whatever advantages may be obtained from altitude; and, if the settling of snow would permit, it may be raised high enough to see (as Saussure did) the moon and constellations moving in a jet black vault at noon day; whilst the easy unembarrassed road all the way up, might feast the eye, the mind, and the heart, with all desirable national, ethical, or other exemplary useful information. Although this building is at too great a distance in the picture to afford accurate inspection of detailed particulars, yet it is near enough for a general view, as is sufficiently apparent from the group of figures on the basement, looking at one of the basso-relievo's, which, by the fleet of ships and the distant pyramids, might represent the brave Nelson's victory at the Nile; whilst some more youthful characters appear eagerly attentive to what is said with so much energy, as would appear by the action and stretched-out hands of the speaker. At the end of the bridge which connects this building with the chalky shore, is a triumphal arch, through which processions might pass; and, at some distance, under the bridge is seen a more humble, though not less endearing prospect of a village church steeple and fishing boats, with the men pulling in their nets. A seventy-four gun ship is to windward of the Naval Pillar, stretching out to sea, and a fleet just appearing in the offing. [Also see letter of 25 October 1801 transcribed in secretary's hand in letter-book 2, published in *Works*, vol. 2, pp. 647–61.]

In 1801 Barry returned to *Commerce, or The Triumph of the Thames*, retouching the painting itself by adding the large Naval Pillar at the right. Surprisingly, despite the substantial nature of this intrusion, it does not unbalance the design, helping instead to anchor the right-hand side. The bright blue drapery above the row of Nereids at the right may have been added at this time as a visual barrier to aid in the transition from the foreground figures to the distant colossus.

Barry's design for a Naval Pillar grew out of an earlier competition. In 1799 a government committee, responding to the public's enthusiasm over the navy's impressive string of victories in the continuing war with France, organised a competition after the Battle of the Nile for a design for a commemorative column. This memorial was never built, but it was the occasion for a remarkable proposal on the part of the sculptor John Flaxman, who took the unusual step of publishing a pamphlet *A Letter to the Committee for Raising the Naval Pillar, or Monument* (London, 1799) with engraved illustrations by his friend William Blake. Flaxman reviewed six of the basic types of memorials from antiquity, the majority of which could be adapted to the committee's call for a column. Plate 3 of his publication gave examples of each type: the Egyptian Obelisk of the Sun, the Column of Antoninus Pius, the Meta of the Circus at Rome, the Arch of Titus, the Pharos or lighthouse at Alexandria, and one of the temples at Paestum. After giving reasons for rejecting all these types, he proposed instead to erect a colossal statue of Britannia, 70 metres high, on the summit of Greenwich Hill. The diminutive sculptor's oversized vision was rejected, with one waggish critic remarking, 'There is to be a show at Greenwich of *little* Flaxman and *big* Britannia'.[7]

Flaxman's failure did not deter Barry in presenting his own colossal entry in the form of his painted, conical tower, which rests on a huge platform supported by the sculpted forms of three Tritons on horseback. A bridge, under which ships can pass, gives access to the lower part of the extensive base beneath the platform. At the far right a triumphal arch frames the entrance to this bridge, sounding a victorious note at the beginning. Once the platform is reached, a spiralling ramp ascending the narrowing pillar gives access to reliefs along the side, with the pyramids commemorating Nelson's

Fig. 74 Detail of *The Triumph of the Thames*. Royal Society of Arts, London

victory at the Battle of the Nile being visible at its base. Moving in a counterclockwise direction,[8] the exhausted visitor eventually reaches the pavilion at the top, with its large telescope pointing heavenward.

The artist's addition of the Naval Pillar introduces a more martial note to the painting's original call for the promotion of peaceful world trade, but the structure also serves other ends. It is a mausoleum, presumably intended for naval heroes, although one suspects Barry wished it might house his own remains, and it could function as well as a lighthouse, surpassing even John Smeaton's celebrated construction of the Eddystone lighthouse, one of the eighteenth-century's great engineering feats.[9] Each of these two functions looks back, as had Flaxman's historical summary, to classical prototypes,

with each referencing one of the Seven Wonders of the Ancient World: the Mausoleum at Halicarnassus in the first instance and the Pharos at Alexandria in the second.

In 1803 Barry qualified his proposal by saying, 'This Naval Pillar is susceptible of any altitude, proportion &c. & any Number of these Colossal Cavalier Tritons may be employed in its erection, the proportion here adopted was merely to exhibit ye Idea, without disturbing ye other parts of ye composition wch were previously established'.[10] Thus although its size could be constructed on a more modest scale, it could also be made larger by increasing the number of supporting Tritons. Barry's proposal that the tower also function as an astronomical observatory placed above the stratosphere elevates his design in truly mind-boggling fashion, putting one in direct touch with the system of systems. In dreaming the impossible dream he cites Horace Bénédict de Saussure's experience atop Mont Blanc in seeing at noon the moon and stars moving across the black sky. Apparently he had misremembered the expedition's 1788 account in which the moon, appearing in an ebony night sky, had cast so much reflected light on the snow that only the brightest stars were visible, a case of night becoming day rather than the other way around.[11] The artist's megalomaniacal aspirations make Flaxman's proposed statue of Britannia a dwarf in comparison.

In his summary of ancient precedents, Barry touches on all of the Four Continents: 'those famed pyramidal, obeliscal, or columnal fabrications of Egypt [Africa], Chaldea [Asia], Rome [Europe], or America'.[12] The pyramids in relief at the base of his tower are not only intended to commemorate Nelson's victory at the Battle of the Nile but also presumably could initiate a historical unfolding of the great monuments from the past. Thus in its form and presumably as well in its sculpted content, the Naval Pillar evokes the Four Continents. By echoing the allegory of the Four Continents on the mural's left-hand side, it further underscores the painting's relevance for the entire world.

In looking at the similarities in structures from around the globe that best express mankind's aspirations to ascend to the divine, Barry was seeking the architectural equivalent of the Ancient Wisdom, in this case a grand, syncretic aesthetic that embodies an unaltering, central truth of man's straining after divinity. At this vision's unspoken core is the Tower of Babel. After the Flood, 'the whole earth was of one language, and of one speech' (Genesis 11:1), and the members of this unified civilisation said to themselves, 'let us build us a city and a tower, whose top *may reach* unto heaven' (11:4). Such hubris proved unpleasing to God, who confounded the children of men by introducing multiple languages and scattering 'them abroad upon the face of all the earth' (11:9). If one accepts the Hebrew scriptures as fact, then the appearance of pyramids and ziggurats in earlier cultures throughout the world is the product of a distantly remembered, shared past, echoes of the archetypal Tower of Babel, rather than the result of civilisations having discovered independently of one another a basic building type that permits height with stability.[13]

In his description Barry lavishes the most attention on the architecture of the Americas. His point is that the Indians basically understood the principles of an architecture that aspired to ascend to divinity itself, their design expressing the best of sacred beliefs. Unfortunately, what transpired on top of these monumental forms had perverted their underlying meaning. Because the Indians had not received the final revelation of Christ's sacrifice, they had resorted to out-of-control, ritual killings on an almost unimaginable scale. Yet their architecture did not require destruction or modification. The simple placement of a surmounting cross would express and fulfil the structures' sacred intent, derived, as it was, from the primordial archetype.

Barry would have been hardly alone in seeing biblical accounts reflected in, and confirmed by, evidence found in the Americas. Significantly, Francesco Clavigero, who was one of his primary sources, alludes to a biblical story in the sentence immediately following the part quoted by Barry of the abbé's ascent on horseback of the pyramid of Cholula, which then resembled more of 'a natural

eminence than an edifice': 'This is that famous hill about which so many fables have been feigned, and which Boturini [Lorenzo Boturini Benaducci] believed to have been raised by the Toltecas as a place of refuge in the event of another deluge like Noah's.'[14] Later, Clavigero, who in this was in agreement with other scholars, argued that accounts found in the Old Testament are also to be found in Mexico's own history: 'the polished nations of the new world, and particularly those of Mexico, preserve in their traditions and in their paintings the memory of the creation of the world, the building of the tower of Babel, the confusion of languages, and the dispersion of the people.'[15]

Barry's own design has most in common with those towers that hark back to the spiral minaret of the Great Mosque at Samarra in Iraq, constructed in AD 852, which was the type commonly thought to most closely resemble that of the Tower of Babel.[16] Rising from a square base, the cone-shaped minaret ascends in a spiralling clockwise direction to a columned pavilion at its top. In following such a model, only reversing the direction of the spiral, Barry again attempts to move forward by returning to an ancient archetype that he sees as having been echoed throughout all the cultures scattered to the earth's four corners.[17] His syncretic, architectural vision is meant once again to ascend to the heavens, but this time in a more reverent frame of mind that will find favour with the Almighty. Yet the British tars, whom this pillar is meant to commemorate, seem lost in the magnificence of the undertaking, and Barry is as guilty of prideful megalomania as any of the Tower of Babel's original builders.

The lower left-hand corner of *The Distribution of Premiums* (see chapter 13)

The lower right-hand corner of *The Distribution of Premiums*

Addition of the tea urn in *Distribution,* letter of 6 January 1803, in Barry, letter-book 2:

The Vase or Tea Kitchen in the other corner of this picture is offered as an improvement in the form & rationale of those in general use, wch in many respects have been so vulgarly & ill contrived, so complicated & tasteless as to shock every intelligent eye, resting as they generally do, on pedestals with additional feet to them, handles equally unaccounted for, stuck on merely for the purpose, & the water issuing from an odious, insulated & consequently feeble conveyance, stuck in like a spigot in a barrel in lieu of all this tasteless, complicated vulgarity. This Vase in the picture of the Society is of the simplest & least complicated kind, & if any idea results from its general appearance, it is the Sublime suggestion of the Grecian Cosmogony. The primæval Egg of Ancient Mother Night, suspended between two mysterious serpents, the principle of regenerating vitality, the convolution of whose bodies flung in the air, naturally furnish the handles & their tails afford the stable, circular foot or basis on wch ye whole rests; whilst the passage for the water of life within is controuled by the little Psyche or button in ye Centre of ye bottom where the heads of those serpents meet. Perhaps there is nothing in ye immense collection of antique vases in Passeri or Sr. Wm. Hamilton so elevated, classical & compleately Grecian as this Idea, whilst it is certain that nothing can be more compleately adapted to every purpose of security & utility.

On his visit to Naples in the winter of 1768–69 when he had been a student in Rome, Barry wrote back to Edmund and William Burke, his two sponsors, about his enthusiastic reaction to some of the everyday items that had been uncovered in the excavations at Herculaneum:

I find the love of antiquity growing upon me every day. Good God, what will become of me by and bye, when I leave Italy? but I will not run away from my subject. At Herculaneum I saw that the moderns, with all their vapouring, have invented nothing, have improved nothing, not even in the most trifling articles of convenient

household utensils; our candlesticks are poor things compared with the stands for their lamps, and there is even an antique kitchen, (tea urn) such as we use on tea tables to hold boiling water, with a place in it for the fire. The deuce abit is there any thing new in the world!¹⁸

In the right-hand corner he introduces a tea urn, which, in its design, looks back to the Grecian cosmogony outlined on the scroll Orpheus holds in the mural directly opposite. In this scroll the mundane egg issues from the god's mouth. In the case of the urn its dark colour evokes night; its egg-shape the universe's primeval beginnings; and its serpents evoke regeneration, while the life-giving water is metaphorically turned on and off by the animating soul. Barry elevates this type of minor art, which the Society of Arts was encouraging, to the level of high art, in which its forms engage in the same high-minded discourse normally reserved for history painting. Although he returns to the antique for inspiration, he does attempt to introduce something new, or at least improved, into the world that would not have been seen in Herculaneum, nor would it have been found on contemporary English tea tables. Yet its message, encoded in what for him was a universal language, would have been available for all.

Barry's design for this tea urn had already been present in embryo in his print reproducing *The Thames or the Triumph of Navigation* (see fig. 16), where he had introduced a less radical variant of the urn held by one of the Nereids at the right. By adding his more fully developed conception of the tea urn to the *Distribution*, he not only reaffirmed his advocacy of elevating the content level of commonplace manufactures but also more closely linked the subject matter of the *Distribution* with that of the *Thames*.

Addition of scrolls in *Distribution*, letter of 6 January 1803, in Barry, letter-book 2:

As the Views of the Society are widely & laudably extended to most things where the interest & satisfaction of mankind may be concerned, there are introduced near this Tea Vase, large scrolls of paper wch it would be very desirable to have realized if any premium or bounty in ye power of ye Society could effect it. One appears by its inscription to contain accurate drawings & necessary measurements of the many statues & the monothelite buildings wch accompany them, wch are situated on ye borders of the mysterious lake in the country of Peru & wch many respectable writers mention as of the remotest antiquity & cannot be ascribed to any known people of that Continent. The other scroll contains such accurate drawings & measures as may be necessary toward forming a just idea of the Pyramids &c in & about the valley of Mexico. One might have expected that in all this time of near 300 years since the settlement of Europeans in these parts of America, that the seeds of European Arts would have fructified at least sufficently to convey to our world (in pictures, prints or drawings) some idea of the many monuments of ingenuity & industry wch might have been remaining as honourable testimonies of the skill & civilization of the original or old inhabitants: but also, there was no vivification, nothing good could have been hoped for amidst the contracted, sordid pursuits of morbid gain & the sinister jealous politicks of mischievous imperious ignorance when thus permitted to tyrannize & oppress. Our minute Philosophers (as Berkley calls a certain species of idle, shameless reasoners.) might well have spared a good part of the Zeal & vehemence of their fulminations respecting the bigotry & superstitious ignorance of the Christian clergy, nothing could have been more unjust & absurd that the direction of such censures to this quarter: for it is impossible not to remark here, that, the only information of any worth, that has reached us is owing originally, not to say almost entirely to the Ecclesiasticks settled in those countries, before the policy of Courts had time to employ those allurements or terrors, necessary for corrupting them to their views. & from the same respectable source of Ecclesiastic information another scroll of important desiderata might be added to this corner of the picture by adverting to the immense ancient Column erected in 33.10. south latitude called the Giganti of 150

feet in height, inscribed with unknown Characters, somewhat resembling those of the Chinese, the mention of wch with another inscribed monument occur in that most excellent, admirably written 8vo tract entitled, Compendio della Storia Geographica, Naturale, e Civile del Regno del Chile, del Abbate Molini, Ex Jesuita

Inscriptions on the two scrolls to lower right of tea urn: 'the Pyramids & other [/] Teotihuacan near [/] Mexico.' and 'Accurate Drawing[s] [/] Antiquities near [/] Lake of Titiaca [/] Peru v'

Barry's first job as a young man in London, secured for him by Edmund Burke, was to work for James 'Athenian' Stuart, who had published on important Greek ruins. In his additions of the inscribed scrolls to the *Distribution*, Barry is calling for a similarly serious approach to the methodical examination of ancient American architecture and artifacts. One of the scrolls mentions the city of Teotihuacan, which, about thirty miles north of Mexico City, contained numerous temples, including the Pyramid of the Sun, one of the largest such structures in the New World. We have already seen how such temple architecture had inspired the artist when conceiving his Naval Pillar. His scroll indicating the need for studies of this region is in line with his intellectual curiosity over the structures and monuments of this early American metropolis.

On the other scroll Barry mentions the antiquities near 'Lake of Titiaca', a misspelling of Peru's Lake Titicaca, which is the mysterious lake he refers to in his description. Herrera recounts some of the tales told about the inhabitants of an island in this lake, one of which concerns 'a white Man of a large Stature, and a venerable Aspect', who could work miracles, bringing down mountains and raising valleys, and who taught men to be good and love one another.[19] Another white man came sometime afterwards who healed the sick. Despite this, some people were about to stone him, but on his knees he lifted up his hands to heaven calling down fire that scared the would-be executioners into submission. Some Spaniards had conjectured this last man was one of the Apostles, but Herrera was more inclined to discountenance this, because only devil worship was practiced in the temple erected in his honour.[20] No wonder Barry was eager to put the examination of these earlier civilisations on a firm, scientific footing. In his mind, they must have held out the promise of discoveries of astonishing consequence.

Inscription on scroll at the base of the tea urn and behind the harpoon: 'from upper Canada to [/] South Sea'

Although when Christopher Columbus first stepped ashore in the New World in 1492 he thought he had arrived in the East Indies, it soon became apparent that the American continents blocked easy access to Asia's wealth. Embarking in 1519 on his expedition to become the first man to circumnavigate the world, Ferdinand Magellan pioneered the way around the southern end of South America through the straits that now bear his name, thereby giving Europeans access to Asia via a western route. However, the hope for a more direct route by means of a North-west Passage still haunted the imaginations of European explorers and their imperial sponsors. Captain Cook undertook his third and final voyage of discovery in 1776 in an attempt to settle the question of whether such a passage existed by probing the western coast of North America at the same time as other ships were attempting a passage of the northern latitudes from the Atlantic side of the continent. After a cursory beginning, Cook was killed in 1779 when refitting in Hawaii, but a little over a decade later, in 1792, George Vancouver began for the British government his three-year exploration of North America's west coast from San Francisco to the Bering Sea.

At approximately this same time, the Scot Alexander Mackenzie undertook two Canadian expeditions to find an overland river passage to the Pacific Ocean. In 1789 he explored the river in

western Canada that now bears his name, which turned out to flow northward into the Arctic Ocean instead of the Pacific. Then in a second expedition, begun in 1792, Mackenzie became the first white man to traverse the continent north of Mexico, arriving, after having overcome great obstacles, on 22 July 1793 at the mouth of the Bella Coola River in British Columbia just weeks after Vancouver had sailed along this part of the coast. A dozen years before Lewis and Clark, Mackenzie had accomplished an epic transcontinental journey that, although not finding an easy passageway from east to west, did open up vast new territories for British exploration and exploitation.

The Society of Arts had shared in the renewed enthusiasm surrounding the search for the long-sought North-west Passage, offering in 1792 the premium of a gold medal 'to the person who should first discover a Passage by Land from the North-West parts of Upper Canada to the South Sea'.[21] In 1800 the Society awarded this medal to Mackenzie, who was to enjoy even greater international acclaim the following year on the publication of his book detailing his two expeditions, *Voyages from Montreal, on the River St Laurence, through the Continent of North America, to the Frozen and Pacific Oceans; in the Years 1789 and 1793*.

In his mural Barry does not mention Mackenzie by name. Instead, by echoing the Society's phrasing for its 1792 premium in his six-word inscription on the scroll, 'from Upper Canada [/] to South Sea', he honours the explorer's remarkable achievement in relationship to the Society's 1800 Gold Medal. Barry lionises Mackenzie along with others of his illustrious predecessors who are present in the adjacent picture the *Thames*, in particular Captain Cook, whose last task Mackenzie had helped to complete. But the artist is not only interested in Mackenzie as another in a long line of intrepid British explorers. The Scot was first and foremost a fur trader, even beginning his book of 1801 with an essay on the fur trade.[22] Mackenzie's achievement was intricately linked to the promotion and encouragement of British imperial commerce, a core value that again harks back to the contents of *The Triumph of the Thames*.

Second modifications to *Elysium*

In terms of *Elysium*, the additions of 1801 continue the same pattern established in 1798. Barry returned to the angelic guards to enhance their imposing presence, while adding identifiable figures to the elect. In the case of Las Casas, he had already introduced him in the print *Queen Isabella* (see fig. 67), and his placement of this Spanish friar in a remote area of the mural has more to do with content than with composition.

Addition of two angels, in Barry, letter-book 2:

The last Grand Scene of Elysium or final Retribution has had its central mass of colossal Guards improved & dignified by more Figures & a Weight & importance has been given to the Group which the single contemplative Angel did not unsupported possess.

In the 1792 print 'the single contemplative Angel' sits alone, presumably an accurate reflection of his disposition in the painting as it had appeared since the first exhibition of 1783. Barry now adds the two equally monumental figures behind him. All three pensive archangels are deeply imposing, but the new middle figure is the most impressive of all in terms of his accoutrements. He wears a starred diadem, whose rays suggest a cross given the dominance of the vertical and horizontal beams (in the later print detail [see fig. 69] the cross is made explicit). In the diadem as seen in the mural, a beam extends from the star's diagonal ray in the lower-right quadrant, recalling the ray of light that

accompanies Gabriel in paintings of the Annunciation. In the context of the Annunciation, the ray symbolises the Incarnation, the moment of Christ's conception when the Word is made flesh. Here the inspired ray emanating from the archangel points in the direction of Reynolds and Hussey, whom Barry honours as having revelation directly bestowed upon them. In addition, this archangel holds a sceptre, another common attribute of Gabriel in Annunciation scenes.

In the mural's 1783–84 appearance there was reason to believe that the solitary angel was Gabriel. With Gabriel's identity being transferred to the newly created second archangel, St Michael whose attributes were latent in the first figure in terms of the armour he wears and his link with the judging scales, now becomes fully identified with the original figure. The partially glimpsed, brooding, saturnine figure behind Gabriel completes this trio of archangels. Any attempt to name the archangels obscures the more important point that Barry now has expanded the single figure to a group of three. Just as Christ formed part of the identity of the 1783–84 archangel, the three archangels together allude to the Trinity. One is reminded of the judges who represent the Trinity on the right-hand side of *Crowning the Victors at Olympia*. The Christian component is strengthened in *Elysium and Tartarus* at the same time as the mural is even more closely linked to its counterpart, the other forty-two-foot-long (1280cm) mural on the wall opposite.

Addition of Bossuet, in Barry, letter-book 2:

Behind the Circle where Pascal & Butler are attending to the Exposition of an Angel of Light, Bossuet is introduced in an energetic attitude expressive of the Force of his peculiar Eloquence ... The Figure behind Pascal & Butler with his Arms stretched out & advancing with so much Energy is that Ornament of our later Ages the graceful the sublime Bossuet Bishop of Meause, the uniting Tendency of the paper he holds in that Hand resting on the Shoulder of Origen would well comport with those pacific Views of the amiable Grotius for healing those discordant Evils which are sapping the Foundations of Christianity amongst the Nations of Europe, where in other respects it would be & even is happily & so well established.

An earnest and dynamic Jacques Bénigne Bossuet joins the group of pre-eminent theologians.[23] All four of these figures are accompanied by an example of their writings (only Origen's scroll, beneath and to the left of his elbow, lacks an inscription). In Bossuet's case, Barry inscribes his scroll 'I. B. Bossuet's [/] Expos'. Bossuet published his *Exposition de la foi catholique*, a masterful call for religious toleration, in 1670. Bareheaded with flowing grey hair, Bossuet, bishop of Meaux, has removed his mitre, which can be seen beside Origen's scroll and behind the Judging Angel's large wing.

Addition to Epaminondas, in Barry, letter-book 2:

The portrait of Epaminondas has been especially designated by tracing upon his Shield the plan of that Chef-d'oeuvre of military Tactics the battle of Leuctra the adoption of which by the greatest modern Commanders has best demonstrated the skill of its original Inventor.

The addition of the plan of battle on Epaminondas' shield updates the painting with a detail that had already appeared in the print *The Glorious Sextumvirate* (see fig. 66).

Addition of Las Casas and American Indians, in Barry, letter-book 2:

In the more advanced part, just bordering on this blaze of light (where those female figures are almost absorbed)

is introduced a groupe of the poor native west indian females, in the Act of Adoration preceded by Angels incensing & followed by their good Bishop, his face partly concealed by that energetic hand wch holds his Crozier or pastoral staff may notwithstanding by the word Chiapa inscribed on ye front of this mitre, be identified with the glorious Friar Bartolomeo de las Casas Bishop of the place. This matter of friendly intercourse continued beyond life, is pushed still further in the more advanced part of the same groupe by the male adoring Americans & some Dominican friars where the very graceful incident occurs of one of those Dominican friars directing the attention of an astonished Caribb to some circumstance of that Beatitude the enjoyment of wch he had promised to his Caribb friend. Much of this endearing, heartfelt intercourse might well be supposed to have happened during that intercourse & unexampled confidence wch subsisted between those friars & ye Caribbs, until it was unfortunately interrupted by ye coming of the Spanish commissioned adventurers. – and the dreadful instance of ye destruction & massacre of a whole Convent of the Dominicans, who as Herrera informs us had indiscreetly pledged themselves to the Indians for ye good conduct of their military countrymen, only shews, how much confidence had been obtained, & a most illustrious proof of the many felicities, temporal as well as spiritual wch would infallibly have resulted had these Friars with their Las Casas's, actuated by ye mild, gratious, truly beneficent spirit of Christianity been suffered to operate unconnected & uncontrolled by ye brutality & treacheries of mere mundane base politicks under ye semblance of allegiance & state interest. [Barry continues by extolling the Jesuits' enlightened policies in South America in opposition to government chicanery.]
[…]
In the Crowd who are employed in contemplating the Effulgence of light which marks the Seat of Deity, the same liberal Spirit which before admitted Confucius & Brahma to their merited Share of the holy Emanation, has added to the Group several native South Americans, & the diffident downcast Look of one of them is directed by a Dominican Friar to the heavenly Source of all Things. The venerable Bishop Las Casa / himself of the Dominican Order / is introduced in the Act of Adoration, & these two Religious are intended as a proper Tribute of praise to the well meant though unsuccessful Endeavours of their Society to arrest the Barbarity of the Spaniards after the Conquest of Mexico.

Barry added Las Casas behind and to the left of the angel interceding on behalf of the three non-Western figures, Brahma, Confucius and Manco Capac. To indicate his position as bishop of Chiapa, Barry shows Las Casas wearing a mitre and holding a crozier. In the foreground to the right of this group, the artist also introduces a reclining Dominican friar offering guidance to the Indian seated beside him. Two more dark-skinned men are seen in advance of the group just to the right of the added angel's wings. The body of the man nearest the wing is bowed in despair, with his head on his hand. Behind him his companion raises his hands and head in supplication in repetition of the African slave in *The Triumph of the Thames*, another reminder of the barbarity visited on the American Indians as well as on Africans. Las Casas, who had fought his entire career to overturn the injustices imposed by colonial rule, along with his Dominican companion again represent, for Barry, Catholicism's authentic voice.

Proposed change, 1805

Commemorating Lord Nelson in the *Thames*

Viscount Nelson, the great British naval hero, died at the Battle of Trafalgar on 21 October 1805. Less than a month later, on 13 November, William Meredith tabled a motion at the Society of Arts that Barry be requested to place a portrait of Nelson 'among those worthies whose final retribution in Elysium holds out glorious examples for the emulation of posterity'.[24] Barry's compliance with this request is

recorded in the minutes of 4 December, in which, however, he maintains that 'the most proper and advantageous situation for this commemoration is the Picture of Navigation'.[25] The artist died before being able to return to the mural. According to the obituary in the *Gentleman's Magazine*, Barry 'had lately undertaken to paint a whole-length portrait of the late lamented Lord Nelson, for the Society of Arts',[26] yet it seems doubtful that he intended to show Nelson full-length within this composition. Presumably the admiral would have been treading water along with his illustrious precursors.

Nelson's presence would have continued the tilt toward the emphasis on maritime warfare rather than trade. Yet since Barry did not himself initiate this proposal, his failure to introduce Nelson into the picture does not mean his vision remained unfinished. The mural's 1801 appearance, the state in which it is seen today, can be said to express the artist's full intentions.

NOTES

Introduction

1 As discussed in the preface, Barry did not concern himself unduly with titles, letting the images speak for themselves. With regard to his murals, in his 1777 letter to Sir George Savile he wrote, 'I mean to ground the whole work upon one idea, viz. Human Culture' (letter of 19 Apr. 1777, in *Works*, vol. 1, p. 254). In his *Account* he introduced his paintings as 'a series of Pictures, on the subject of human culture' (Barry, 1783, p. 303). In *A Letter to the Society* he called it 'the series of pictures on human culture' (Barry, 1793, p. 419), and gave the same title, 'the Series of Pictures on Human Culture', in the margin to his print *Lord Baltimore* (see fig. 63). In *Letter to the Dilettanti Society* he referred to 'my work on the necessity of human culture' (Barry, 1779, p. 599), 'such a work as that on Human Culture' (vol. 2, p. 635), and 'my Work on Human Culture' (vol. 2, p. 638). Nowhere does he employ the phrase 'The Progress of Human Knowledge and Culture', which has become popular as the series' title. Although this last phrase is more poetic, I have reverted to his most common usage. For a discussion of the appropriateness of the word 'progress' as it applies to the paintings, see the section entitled 'The murals as a series of progressions' in chapter 12.

2 Anna Jameson, *A Handbook to the Public Galleries of Art in and Near London* (London: John Murray, 1842), p. 509. In 1953, in his authoritative survey of British painting, Sir Ellis Waterhouse also praised this series, characterising it as 'the most considerable achievement in the true "grand style" by any British painter of the century'; Ellis Waterhouse, *Painting in Britain, 1530–1790* (London, Melbourne, and Baltimore: Penguin Books, the Pelican History of Art, 1953), p. 199.

3 Barry, 1775, p. 248. The version in *Works*, quoted here, substitutes 'every people' for 'any people', which can be found on page 132 of the original book.

4 William Duff, *An Essay on Original Genius* (London: printed for Edward and Charles Dilly, 1767), p. 259.

5 Samuel Johnson, *A Dictionary of the English Language*, 2nd edn (2 vols, London, 1755 and 1756), vol. 1, p. x.

6 This is not the only time that Barry challenged Johnson's authority. His 1774 *King Lear Weeping over the Body of Cordelia* is, in part, a response to Johnson's Shakespeare criticism; see William L. Pressly, *The Artist as Original Genius: Shakespeare's 'Fine Frenzy' in Late-eighteenth-century British Art* (Newark, Delaware: University of Delaware Press, 2007), pp. 140–1. Writing to Hester Thrale on 24 August 1780, Fanny Burney also mentioned how much the artist enjoyed being in Dr Johnson's company: 'Dr. Johnson was very sweet & very delightful, indeed I think he grows more & more so, – or at least I grow more & more fond of him. I really believe Mr. Barry found him almost as amusing as a fit of the Tooth ache! –'; Betty Rizzo (ed.), *The Early Journals and Letters of Fanny Burney*, vol. 4 (Montreal and Kingston, London, Ithaca: McGill-Queen's University Press, 2003), p. 225.

7 Benedict Anderson, *Imagined Communities: Reflections on the Origin and Spread of Nationalism* (rev. edn, London and New York: Verso, 2006), p. 13.

8 See ibid. p. 14.

9 Ibid. pp. 15–16.

10 Ibid. p. 19.

11 Barry, 1798, p. 585.

12 On the vexed question of word versus image, one should consult W.J.T. Mitchell's *Iconology: Image, Text, Ideology*, a book that also contains a chapter dedicated to the theories of Edmund Burke, the artist's mentor. Barry, however, did differ with Burke, as he, unsurprisingly, privileged painting over poetry.

13 Barry, 1783, p. 404.

14 Although the 1792 set of prints is another of the incarnations this series was to assume, in an effort to keep a long book from being even longer, these prints, as already stated, have been incorporated into part 1's discussion of content. As a result, they are given less attention than they deserve, but their abbreviated treatment allows the main focus to remain on the series' overall meaning.

Chapter 1

1 For an account of Barry's early years and his family background, see Peter Murray, 'James Barry: the Cork background', in Tom Dunne (ed.), Cork: Crawford Art Gallery, *James Barry, 1741–1806: The Great Historical Painter* (2005–06), pp. 19–25.

2 Edward Fryer's biography in *The Works of James Barry* provides the 'official' account, but, relying on information that appeared in the *European Magazine* for April 1806, his date of 1763 for the young man's arrival in Dublin appears to be in

error (see *Works*, vol. 1, pp. 7–9). As reported by Tom Dunne, Gitta Willemson has found evidence suggesting that Barry had been a student at the Dublin Society Drawing Schools as early as 1760; see Dunne (ed.), *James Barry, 1741–1806*, p. 122 n. 35.

3 Barry, 1793, p. 437.

4 The books in Barry's library are listed in the posthumous sale held at Christie's on 11 April 1807. This list can also be accessed online (Barry's Correspondence).

5 See Fryer's comments in *Works*, vol. 1, p. 305.

6 *Works*, vol. 1, pp. 332–3.

7 Ibid. pp. 334 and 333 respectively.

8 See William L. Pressly, *The Life and Art of James Barry* (New Haven and London: Yale University Press for Paul Mellon Centre for Studies in British Art, 1981), p. 137.

9 See ibid. pp. 11, 14, 200, 223 n. 5.

10 Barry, 1783, 311–12.

11 Ibid. p. 408.

12 An account of the details surrounding the St Paul's project can be found in Martin Postle, *Sir Joshua Reynolds: The Subject Pictures* (Cambridge: Cambridge University Press, 1995), pp. 161–7.

13 Reynolds to Thomas, 2nd Baron Grantham, 20 July 1773, in John Ingamells and John Edgcumbe (eds), *The Letters of Sir Joshua Reynolds* (New Haven and London: Yale University Press for Paul Mellon Centre for Studies in British art, 2000), p. 45.

14 From an account of the events surrounding the St Paul's project quoted in James Northcote, *The Life of Sir Joshua Reynolds*, 2nd edn (2 vols, London: Henry Colburn, 1818), vol. 1, p. 309.

15 [William Shipley], *Proposals for Raising by Subscription a Fund to be Distributed in Præmiums for the promoting of Liberal Arts and Sciences, Manufactures, &c.* (Northampton, 1753), reproduced in D.G.C. Allan's manuscript at the Royal Society of Arts, 'A chronological history of the Royal Society for the Encouragement of Arts, Manufactures and Commerce', 1998, p. 14.

16 For an excellent introduction to the Society's early years, to which this account is indebted, see Celina Fox, 'Art and trade: from the Society of Arts to the Royal Academy of Arts', in Sheila O'Connell, with contributions by Roy Porter, Celina Fox and Ralph Hyde, London: British Museum, *London 1753* (2003), pp. 18–27.

17 In the next century, the creation of the Victoria Embankment from 1864–70 distanced the river.

18 James and William were not as fortunate as their brothers. The two small streets named after them were later combined into the single thoroughfare Durham House Street, which runs north from John Adam Street and then takes a right turn to run behind the Strand houses.

19 Minutes of the Society of Arts, 27 Apr. 1774.

20 Valentine Green introduced Barry's proposal on 5 March 1777. Barry, however, did not reveal his name until the following day. The estimate for the colours and stretched canvases came to £100, and Barry thought £30 sufficient for the models and said he was willing to undertake this last expense if the Society preferred; see Minutes of the Committee of Polite Arts, 14 Mar. 1777. The Society in the end paid a total of £45 for the cost of the models.

21 See Barry, 1783, p. 315.

22 Duff, *An Essay on Original Genius*, p. 5.

23 Barry, 1783, p. 323.

24 Ibid. pp. 313–14.

25 Barry to Sir George Savile, 19 Apr. 1777, in *Works*, vol. 1, pp. 254–5.

26 Barry, 1783, p. 414.

27 For an account of Aetion's painting, see Thomas Francklin (ed.), *The Works of Lucian*, trans. from Greek (2 vols, London: printed for T. Cadell, 1780), vol. 1, pp. 377–8. The subject was well known in Renaissance art. Gavin Hamilton had included it in his book of engravings after famous Italian pictures. The 1772 engraving *Alexandri et Roxanæ Nuptiæ*, executed by Giovanni Volpato, is after a painting said to be by Raphael, an attribution that has since been discounted; see *Schola Italica Picturae* (Rome, 1773), pl. 10. In addition, Sodoma's fresco *The Marriage of Alexander and Roxana*, then as now, could be seen in Agostino Chigi's bedchamber in the Villa Farnesina.

28 Barry to Savile, 19 Apr. 1777, in *Works*, vol. 1, pp. 255.

29 Ibid, pp. 255–6.

30 See *Works*, vol. 1, p. 251. Joseph Farington, whose source was Joseph Nollekens, recorded on 25 February 1805 the remarkably similar sum of 17s 6d; see Kathryn Cave (ed.), *The Diary of Joseph Farington* (17 vols: vols 1–6 eds Kenneth Garlick and Angus Macintyre; vols 7–16 ed. Kathryn Cave; vol. 17 (index) Evelyn Newby; New Haven and London: Yale University Press, 1978–98), vol. 7, p. 2524.

31 Benjamin Robert Haydon, *The Diary of Benjamin Robert Haydon*, ed. Willard Bissell Pope (9 vols, Cambridge, Mass.: Harvard University Press, 1963), vol. 5, p. 116.

32 Edward Dayes, *The Works of the Late Edward Dayes* (London, 1805), p. 317.

33 Minutes of the Society of Arts, 5 May 1779.

34 *New Monthly Magazine*, vol. 5, Mar. 1816, p. 134.

35 Burney manuscript, p. 19v.

36 Haydon, *Diary*, vol. 5, p. 116. To every rule there are exceptions. In an undated letter, which Timothy McLoughlin surmises was written in September 1778 (see Barry's Correspondence), Barry invited Joseph Bonomi to see the 'nearly finished' *Crowning the Victors at Olympia* and *A Grecian Harvest-home*. As an architect and architectural draughtsman, Bonomi was not in competition with Barry. He was also a close personal friend. In addition, there is another item that supports Barry having shown his work to other artists. A notice in the newspaper *Morning Herald* of 14 March 1782 states, 'The artists who have seen it [the series at the Society of Arts], pronounce Mr. Barry's work to be one of the most capital that this country ever saw' (p. 2). However, this comment is presumably no more reliable than the accompanying statement that patriotic members intended to exhibit the paintings for two years at their expense. This puff piece was intended to excite rather than inform.

37 See Barry, 1793, p. 463. Samuel More, the Society's secretary, recorded the following expenditures on the part of the institution: £315 2s 0d 'For canvas, colours, frames, and other incidental charges', and £224 0s 0d for 'Expense of two exhibitions, including catalogues'; Barry, 1785, p. 135.

38 Barry, 1783, pp. 318–19.

39 Ibid. pp. 316–17.

40 Ibid. pp. 317–18

41 Ibid. p. 317.

42 See ibid. p. 318.

43 Ralph Willett, *A Description of the Library at Merly in the County of Dorset* (London: printed for the author by John Nichols, 1785), p. 1. The first edition, which was not illustrated, was published in 1776. If Barry did not visit Dorset, he would have known of the scheme only from this 1776 text, which, however, offers a full description. There are only minor differences between the texts of the two editions, and, unless stated otherwise, the 1785 quotations cited here also appear in the 1776 version. The project is discussed in Tim Knox, '"A mortifying lesson to human vanity": Ralph Willett's library at Merly House, Dorset', *Apollo*, vol. 152 (July 2000), pp. 38–45. David Alexander entitles his note drawing attention to Knox's article 'Anticipating Barry's *Progress of Civilization*', making implicit the connection between Willett's scheme and Barry's; see *Print Quarterly*, vol. 9 (Mar. 2002), pp. 55–6.

44 Ralph Willett, 'Dedication to King', in Willett, *Description of the Library at Merly*, no pagination but follows title page and only appears in the 1785 edn.

45 Ibid. p. 6.

46 Ibid. p. 7.

47 'Milton is standing, and leans against the Chair of Sir Francis, with his Face lifted up to Heaven; whether averting his Eyes from Majesty, or invoking the Aid of his Urania, the Designer hath left uncertain–'; ibid. p. 12.

48 Ibid. p. 11.

49 Ibid. p. 12.

50 Barry, 1783, p. 404.

51 Ibid. p. 405.

52 Ibid. p. 314.

53 Ibid. p. 404.

54 Barry, 1784, p. 249.

55 See Barry's 'Broadside' in Barry's commonplace book.

56 This generation of artists also could look back to Hogarth's example, but Hogarth offered a different trajectory, that of a printmaker who had become proficient in painting.

57 See 'Catalogue of prints', nos. 1–14, in Pressly, *Life and Art of James Barry*.

58 Barry, 1793, p. 419.

59 Rev. Matthew Pilkington, *A Dictionary of Painters* (London, 1810), p. 30.

60 J.T. Smith, *Nollekens and his Times* (London, 1828), vol. 1, p. 9.

Chapter 2

1 Joseph Spence, *Polymetis: or, An Enquiry Concerning the Agreement Between the Works of the Roman Poets, and the Remains of the Antient Artists*, 2nd edn (London, 1755), p. 281.

2 Robert Wood, *An Essay on the Original Genius and Writings of Homer* (London, 1775), p. 269.

3 These lines from the print can be found in Rev. Philip Francis (trans.), *A Poetical Translation of the Works of Horace with the Original Text*, 3rd edn, trans. into English with notes (2 vols, London: A. Millar, 1749), vol. 2, p. 477.

4 Francis, *Poetical Translation of the Works of Horace*, vol. 2, p. 476, footnote to line 391.

5 Barry, 1783, p. 324.

6 *Public Advertiser*, 2 May 1783, p. 2.

7 John Smith, *Choir Gaur … Commonly called Stonehenge* (Salisbury, 1771), pp. 70–1. For several modern explications of the mundane egg, see W.K.C. Guthrie, *Orpheus and Greek Religion*, 2nd edn (London: Methuen & Co., 1952), pp. 92–104, where 'the World-egg' is also referred to as 'the Orphic Egg'; Peter Dronke, *Fabula: Explorations into the Uses of Myth in Medieval Platonism* (Leiden and Cologne: E.J. Brill, 1974), pp. 79–99; and Martin Persson Nilsson, *The Dionysiac*

Mysteries of the Hellenistic and Roman Age (New York: Arno Press, 1975), pp. 140–3.

8 Barry quotes only a portion of West's rendition of Pindar's ode: the opening lines and Decade III; see Gilbert West, *Odes of Pindar, with Several Pieces in Prose and Verse, Translated from the Greek. To which is Prefixed a Dissertation on the Olympick Games* (London: printed for R. Dodsley, 1749), pp. 79, 81. There are minor differences in punctuation and capitalisation.

9 For a helpful introduction to Lucretius and Hesiod, see Stephanie Moser, *Ancestral Images: The Iconography of Human Origins* (Ithaca: Cornell University Press, 1998).

10 As early as the abbreviated description of 1785 published in the Society's *Transactions*, an intellectual progression was noted: 'The countenances of those savages, who are supposed to have profited by the divine lessons of Orpheus, are happily contrasted with those of another group, who have not yet attended to his doctrine, and shew, with peculiar energy, the effect of those benefits which accrue to mankind from philosophy and religion'; Barry, 1785, pp. 114–15.

11 Titus Lucretius Carus, *Of the Nature of Things*, trans. Thomas Creech (2 vols, London: Printed for Daniel Browne, 1743), vol. 2, p. 191.

12 Ibid. p. 193.

13 Ibid.

14 Ibid. p. 191.

15 Claire Richter Sherman, 'Introduction', in Carlisle, Penn., the Trout Gallery, and Washington, DC, the Folger Shakespeare Library, *Writing on Hands: Memory and Knowledge in Early Modern Europe* (2000–01), p. 13. The entire catalogue provides an interesting introduction to hand imagery and its meaning. Martin Kemp's essay 'The handy worke of the incomprehensible creator' offers a particularly thoughtful assessment (pp. 22–7).

16 Lucretius, *Of the Nature of Things*, vol. 2, pp. 193–5.

17 Ibid. p. 197.

18 Burney manuscript, p. 19v.

19 Ibid.

20 Lucretius, *Of the Nature of Things*, vol. 2, pp. 187–9.

21 Burney manuscript, pp. 19v–20r.

22 George Richardson, *Iconology; or, A Collection of Emblematical Figures* (2 vols, London, 1779), vol. 1, p. 36. Richardson added that the swan 'was also consecrated to Venus, probably on account of its extreme whiteness'.

23 Lucretius, *Of the Nature of Things*, vol. 2, p. 211.

Chapter 3

1 *Virgil*, trans. into English by H. Rushton Fairclough (2 vols, Cambridge, Mass., and London: Harvard University Press and William Heinemann Ltd., 1967), vol. 1, p. 81.

2 The conception of this portion of the picture is not unlike William Kent's frontispiece to *Autumn* in James Thomson's *The Seasons* (London, 1730), although in Barry's design the deities are not so prominent and are engaged with the mortals below.

3 The overwhelming majority of the prints used to illustrate Dryden's translation were taken from the earlier 1654 English translation of Virgil's works by John Ogilby; see *The Works of Publius Virgilius Maro*, trans. into English by John Ogilby (London: printed by Thomas Warren for the author, 1654). Modifications were confined largely to the dedicatory inscriptions in the margins. The illustrations in this book are taken from their first appearance in the Ogilby edition.

4 *Public Advertiser*, 3 May 1783, p. 2. The critic was confusing Barry's remarks about the disorderly and mean nature of the group of figures at the left with the dancers. He was quick to apologise for his remarks after Barry had obviously objected (see *Public Advertiser*, 7 May 1783). His complaint, though, that Barry 'might have finished them [the dancers] more highly, without any Detraction from the Subject of characteristic Flatness, and unamiable Rusticity' suggests that Barry did work on improving his rendering of these figures from the time of the 1783 exhibition until the exhibition of the following year.

5 Barry, 1808, text to *Orpheus*.

6 See John Dryden, *The Works of Virgil: Containing his Pastorals, Georgics, and Æneis*, 2nd edn, trans. into English verse by John Dryden (London: Jacob Tonson, 1698; 1st edn 1697), *Georgics I*, plate facing p. 112.

7 '& in a corner slaves joining in the general Festivity by indulging themselves in drinking' (Burney manuscript, p. 20r).

8 See Dryden, *Works of Virgil*, *Georgics II*, plate facing p. 134. One of Barry's drawings of a male model shows the figure naked except for a cap, whose uppermost extension hangs backwards; Pressly, *Life and Art of James Barry*, p. 257, no. 78.

9 Barry's republican sympathies are discussed at greater length in chapter 13.

10 See Maren-Sofie Røstvig, *The Happy Man: Studies in the Metamorphoses of a Classical Ideal*, 2nd edn (2 vols, Trondheim: Norwegian Universities Press, 1962). Examples of this longing for rural retirement, as in the following passage, are provided in Thomson, *Seasons*:

> OH knew he but his happiness, of men
> The happiest he! who far from public rage.

> Deep in the vale, with a choice few retir'd,
> Drinks the pure pleasures of the RURAL LIFE.
> (*Autumn*, lines 1134–9)

11 Barry, 1808, text to *Orpheus*.

12 Ibid.

13 In 1984 I argued that the sun imagery in the series as a whole showed a certain consistency: rising in *Orpheus*, a little higher in the heavens in *Harvest-home*, and a golden sky in *Victors*; see William Pressly, 'A chapel of natural and revealed religion: James Barry's series for the Society's Great Room reinterpreted', *Journal of the Royal Society of Arts*, vol. 132 (July–Sept. 1984), pt 2, p. 637. I now agree with Fryer's reading that the time of day is evening. This is in keeping with the view, as will be argued later, that the murals, while marking a progression, also are intended to stand alone, each being focused on in its turn as a separate, self-contained experience.

14 Burney manuscript, p. 20r.

Chapter 4

1 Barry to Sir George Savile, in *Works*, vol. 1, pp. 254–5.

2 In his piece 'Herodotus, or Etion', the classical Greek writer Lucian identifies both Prodicus and Aetion as having followed Herodotus' example in choosing the Olympic Games as a propitious moment for addressing an assembly of all the Greeks. See Francklin (ed.), *Works of Lucian*, vol. 1, pp. 376–8.

3 West, *Odes of Pindar,* preface, p. xii.

4 Ibid. pp. cci–ccii.

5 Edward Croft-Murray, *Decorative Painting in England, 1537–1837* (2 vols, London: Country Life Books, 1970), vol. 2, p. 68. Barry also may have had in mind Rubens' use of Hercules and Minerva as flanking figures in the Banqueting Hall ceiling at Whitehall, where *Hercules Crushing Discord* and *Minerva Overcoming Ignorance* frame *The Union of the Crowns of England and Scotland*. He would have also been aware of Mantegna's grand processional paintings at Hampton Court depicting the triumph of Julius Caesar; see Andrew Martindale, *The Triumphs of Caesar by Andrea Mantegna in the Collection of Her Majesty the Queen at Hampton Court* (London: Harvey Miller Publishers, 1979). Clusters of blaring trumpets appear three times in Mantegna's lengthy procession, including at its beginning a curved trumpet along with straight ones; see *Canvas I: Trumpeters, Bearers of Standards and Banners*, reproduced in colour, ibid. p. 21.

6 This detail is discussed at length in the conclusion.

7 For the translation of this word as courage, see West, *Odes of Pindar*, p. lxxxvi. Professor Hugh Lee at the University of Maryland has suggested 'excel' as a more accurate translation.

8 Ibid. p. cxxxii.

9 The leaves of the 'olive' crown in *Crowning the Victors* replicate those of the laurel crowns worn by Orpheus in *Orpheus*, by Pindar in *Crowning* and by Britannia in the painted coin in the *Distribution*. In *Crowning* on the side of the chariot, the scrawny leaves on the branch of the olive tree held by Minerva do not resemble those composing the victor's crown.

10 Ibid. pp. cxxxi–cxxxii.

11 Martin Kemp (ed.), *Dr. William Hunter at the Royal Academy of Arts*, (Glasgow: University of Glasgow Press, 1975), p. 25.

12 J.J. Winkelmann [Winckelmann], *Reflections on the Painting and Sculpture of the Greeks*, trans. from German by Henry Fusseli [Fuseli] (London, 1765), p. 5.

13 West, *Odes of Pindar*, p. 47.

14 Ibid. p. cxxxvii.

15 Ibid. pp. 63–4, footnote. For Cicero's and Plutarch's accounts, see *M. Tully Cicero's Five Books of Tusculan Disputations* (London, 1715), p. 56, and *Plutarch's Lives* (6 vols, Edinburgh, 1763), vol. 2, p. 356.

16 See West, *Odes of Pindar*, p. 63, footnote.

17 David Allan offers an alternative identification, casting this figure as the Spartan. See David G.C. Allan (ed.), *The Progress of Human Knowledge and Culture: A Description of the Paintings by James Barry in the Lecture Hall or 'Great Room' of the RSA in London, Written by the Artist* (Basingstoke, England: Basingstoke Press, 2005), with intro. and keys, p. 23, key no. 4.

18 See West, *Odes of Pindar*, p. 63, footnote.

19 Barry, 1798, p. 576.

20 West, *Odes of Pindar*, pp. lxxxix–xc.

21 I am indebted to Peter Murray for this observation.

22 West, citing Pausanias, offers a more sensational account of how Callipatiera, his name for Aristopatera, disguised herself as a man in order to attend the games; see West, *Odes of Pindar*, pp. 124–5 and p. 124 n. 31. Her name is also spelled as Callipitera in ibid. p. 63 n. 11. Barry, however, gives a more straightforward account of her participation in Barry, 1802, p. 151, footnote.

23 Rubens had made the broad-brimmed black hat with its associations with melancholy genius a celebrated trope in his well-known self-portrait now in the Royal Collection of Queen Elizabeth II.

24 West, *Odes of Pindar*, p. ccvi.

25 Although Plato, as we have seen, is not named among the figures in *Crowning*, he surely is the young boy next to Socrates

in the mural (this boy is dropped from the print). The mature Plato appears in *Elysium*, but his appearance in *Crowning* is so closely tied to his relationship to Socrates that it seems reasonable to maintain Socrates' distinction as being the only figure to appear in a significant way twice. The phrase 'in a significant way' is meant to exclude Solon and Lycurgus, who appear only as medallion heads in *Crowning*. Hippocrates, on the other hand, does not appear in the mural *Elysium*, even if he managed to be inserted into a large-print detail.

26 Burney manuscript, pp. 20r–20v.

27 One is reminded of the derisive comment directed at Barry's painting *The Temptation of Adam*, the first work he had exhibited at the Royal Academy in 1771: 'The only objection to this piece is, an insufficiency of drapery; a fault common to most young painters, immediately after the tour of Italy, on account of the difference of climate'; *The Gazetteer*, 8 May 1771.

28 Barry had already painted Baretti's portrait, a work that he exhibited at the Royal Academy in 1773; reproduced in Dunne (ed.), *James Barry, 1741–1806*, p. 101. Each man had a volatile temper, and their friendship was eventually to rupture over one of Barry's outbursts. Fanny Burney refers to this occasion when writing to her sister Susan on 11 November 1781: 'The History of the quarrel of Barry & Baretti was really frightful – how can Barry appear again amongst you? – I am very sorry indeed he has given this glaring specimen of that violence & ungovernable rage which from Time to Time he has even himself hinted at'. Rizzo (ed.), *Early Journals and Letters of Fanny Burney*, vol. 4, p. 503.

29 I am using the spelling employed by Barry and Baretti rather than *Sæculare*.

30 Joseph Baretti, *The Introduction to the Carmen Seculare* (London, 1779), p. 9.

31 Francis, *Poetical Translation of the Works of Horace*, vol. 1, p. 485. Baretti mentions using Francis' translation for his own work.

32 Barry presumably would not have classified the beribboned palm borders as frames. He had said his solution of a continuous frieze of paintings would save the Society the necessity of purchasing frames, but from the beginning he must have envisioned some type of surround.

33 See Barry, *c.* 1802.

34 Wheler's book *A Journey into Greece* was published in 1682. Dr Spon, who was from Lyons, had already published his French account in 1678.

35 For an introduction to these five major games, see Panos Valavanis, *Games and Sanctuaries in Ancient Greece: Olympia, Delphi, Isthmia, Nemea, Athens*, trans. from Greek by David Hardy (Los Angeles: Getty Publications, 2004).

36 It is of interest that Barry's painting *Venus Rising from the Sea*, which he exhibited at the Royal Academy in 1772, is a subject that can also be related to these religious festivals – in this case, the activities surrounding the preparations for the Eleusinian Mysteries. As remarked on by Winckelmann, 'Phryne [a beautiful courtesan] went to bathe at the Eleusinian games, exposed to the eyes of all Greece, and rising from the water became the model of Venus Anadyomene [a painting executed by Apelles]'. Winckelmann goes on to associate classical nudity, male and female, with early Christian practices: 'the christians of the primitive church, both men and women, were dipped together in the same font'; Winkelmann [Winckelmann], *Reflections on the Painting and Sculpture of the Greeks*, p. 11.

37 Barry to Savile, in *Works*, vol. 1, p. 255.

38 Barry to Chatham, 27 Dec. 1777, Chatham Papers, Public Record Office, London, 30/8/18, pt. 2.

39 Barry, 1793, pp. 438–9.

40 In his discussion of *The Distribution of Premiums*, Barry regrets having been unable, due to 'want of time and room', to add General Paoli to 'the picture of the Grecian Victors'; Barry, 1783, p. 341.

The Modern World

1 Barry to Sir George Savile, 19 Apr. 1777, in *Works*, vol. 1, p. 255.

2 See letter-book 1, p. 18.

3 Burney manuscript, p. 20v.

4 Barry to Sir George Savile, 19 Apr. 1777, in *Works*, vol. 1, p. 255.

5 Sir James Thornhill, *An Explanation of the Painting in the Royal Hospital at Greenwich* (poss. London: by order of the hospital's directors, *c.* 1727–30), p. 8.

6 Ibid. p. 10. For the suggestion that the old philosopher is Galileo, see Ann Stewart Balakier and James J. Balakier, *The Spatial Infinite at Greenwich in Works by Christopher Wren, James Thornhill, and James Thomson* (Lewiston, Queenston and Lampeter: Edwin Mellen Press, 1995), p. 59.

Chapter 5

1 Joseph Addison in *The Spectator*, vol. 69 (19 May 1711), in Donald F. Bond (ed.), *The Spectator*, with an introduction and notes (5 vols, Oxford: Clarendon Press, 1965), vol. 1, pp. 292–3.

2 Among the paintings are John Vanderbank's *Britannia Receiving the Commerce of the World*, *c.* 1720, which still decorates the stairwell at 11 Bedford Row, London, and Sir James Thornhill's *London with Pallas Athena*, commissioned in 1727

for the ceiling of the Aldermen's Court Room at Guildhall and which is still in its collection. The most prominent of the sculptures is the grand pediment decoration of 1752 to the Mansion House by George Dance the Elder, showing London triumphant in the social arts of trade and commerce. Michael Rysbrack created an impressive chimney piece and overmantel for the East India Office showing Britannia receiving the riches of the Orient. Executed *c.* 1730, it now decorates the India Office Council Chamber in the Foreign and Commonwealth Office, London. Another marble fireplace ornament, *Britannia Reviver of Antique and Prompter to Modern Arts*, was presented by the sculptor J.F. Moore to the Society of Arts in 1766; it is still in the Society's possession. Even in the early seventeenth century, London's commercial dominance was being affirmed in artistic publications. When Claes Jansz. Visscher's view of London was published in Amsterdam in 1616, it bore a Latin heading that translates as 'London, Most Flourishing City of Britain and Marketplace Celebrated Throughout the World'; see Malcolm Warner, with contributions by Brian Allen, John House, Robin Spencer and Samuel F. Clapp, London, Barbican Art Gallery, *The Image of London: Views by Travellers and Emigrés, 1550–1920* (1987), p. 103.

3 See Ralph Hyde's essay, 'Portraying London Mid-century: John Rocque and the Brothers Buck', in O'Connell et al., *London 1753*, pp. 28–38.

4 Only Africa, because of his dark skin, is easily identifiable. Interestingly, John Vanderbank had employed a similar lackadaisical approach to the Four Continents in his mural at 11 Bedford Row, where Europe, crouching before Britannia, embraces a large bale.

5 The Society of Arts had already demonstrated an interest in the theme Barry undertook. In 1759, when it decided to offer prizes for history painting, it initially wanted to restrict the subjects that artists could submit to six themes, three of which were drawn from classical history, two from English history, and the last to illustrate the following allegory: 'The Birth of Commerce as described by Mr. Glover in his Poem called London'; quoted in John Sunderland, 'John Hamilton Mortimer: his life and works', *Journal of the Walpole Society*, vol. 52 (1986), p. 13. Richard Glover's *London: or, The Progress of Commerce* of 1739 celebrates commerce as a civilising force that from ancient times has been closely tied to maritime trade, with London being its most recent beneficiary. Following Sir Isaac Newton's speculation that 'letters were first invented amongst the trading parts of the world' (Glover, 1739, p. 12, footnote), Glover credits commerce, personified as a goddess, with making possible mankind's finest achievements:

> Thou gav'st him letters; there imparting all,
> Which lifts th' ennobled spirit near to heav'n,
> Laws, learning, wisdom, nature's works reveal'd
> By godlike sages, all Minerva's arts,
> Apollo's music, and th' eternal voice
> Of Virtue, sounding from th' historic roll,
> The philosophic page, and poet's song.
>
> (lines 200–6)

6 'Explanation of the allegoric Picture … representing the East-Indian Provinces paying Homage to Britannia'; *Gentleman's Magazine*, vol. 48 (1778), p. 628.

7 The portrait of George II rests on Britannia's knee, and in the right background one sees Hawke's ship, the *Royal George*, defeating the French ship, the *Soleil Royal*; see Brian Allen, *Francis Hayman* (New Haven and London: Yale University Press, 1987), p. 68.

8 Barry, 1783, p. 332.

9 In his description of the decoration at Greenwich, Thornhill mentions that, on the left-hand side of the painted arch one sees on exiting the hall, the figure of Commerce holds 'a *Rudder* the *Emblem* of NAVIGATION'; Thornhill, *An Explanation of the Painting in the Royal Hospital at Greenwich*, p. 20.

10 Patricia Fara places the navigational compass in Barry's mural in a fuller context and also points out that it 'illustrates the concept of a compass rather than a specific contemporary model'; 'The attraction of national interest: navigational compasses as cultural artefacts', *British Journal for Eighteenth-century Studies*, vol. 20 (autumn 1997), pp. 133–5.

11 The portraits of Raleigh with his feathered hat and Drake are lifted from Thomas Birch, *The Heads of Illustrious Persons of Great Britain, Engraven by Mr. Houbraken and Mr. Vertue with their Lives and Characters* (2 vols, London: printed for John and Paul Knapton, 1747 and 1752) vol. 1, facing pp. 53 and 47 respectively, whereas Cook is adapted from Nathaniel Dance's portrait (National Maritime Museum, Greenwich).

12 Horace Walpole to Rev. William Mason, 11 May 1783, in W.S. Lewis, Grover Cronin, Jr. and Charles H. Bennett (eds), *Horace Walpole's Correspondence*, (1937–83), with index, (48 vols, New Haven: Yale University Press, 1955), vol. 29, p. 300.

13 Barry's commonplace book, p. 89.

14 Sir Joshua Reynolds, *Discourses on Art*, ed. Robert R. Wark (New Haven and London: Yale University Press, 1975), Discourse VII, 10 Dec. 1776, pp. 128–9.

15 *Public Advertiser*, 1 May 1783.

16 The Wedgwood medallion is reproduced in David Bindman, *Mind-Forg'd Manacles: William Blake and Slavery* (London: Hayward Gallery, 2007), p. 42.

17 Barry, 1798, p. 572.

18 Ibid. pp. 572–3.
19 Molyneux, William [spelt 'Mollyneux' in this edn], *The Case of Ireland Being Bound by Acts of Parliament*, p. vi.
20 Ibid. p. vii.
21 Ibid. p. xvii.

Chapter 6

1 Barry, letter-book 1, p. 18.
2 Minutes of the Society, vol. 24, 18 Nov. 1778.
3 Ibid., 9 Dec. 1778.
4 David Allan supplies a helpful list of the officers and committee chairmen of the Society from 1755 to 1800 in appendix 1 of D.G.C. Allan and John L. Abbott (eds), *The Virtuoso Tribe of Arts & Sciences: Studies in the Eighteenth-Century Work and Membership of the London Society of Arts* (Athens, GA., and London: the University of Georgia Press, 1992), pp. 359–64. Keane Fitzgerald died in 1781 after the painting was well begun but before the first exhibition.
5 The Prince of Wales first sat to Barry on 28 June 1789, with the artist taking his canvas to Carlton House. Soon thereafter he painted in the prince's head in the mural in the Great Room. However, the prince sat to Barry a second time on 7 December 1789, allowing the artist to retouch the portrait in the mural on 7 January 1790; see *Works*, vol. 2, pp. 464–8 (note that the correct date for the letter on p. 466 is 23 December 1789 and not 3 December 1780).
6 Edward Edwards, *Anecdotes of Painters who have Resided or been Born in England* (London, 1808), p. 308.
7 Barry, 1783, p. 413.
8 The prince's portrait is reproduced in Dunne (ed.), *James Barry, 1741–1806*, p. 109.
9 For a full list of these items, see Pressly, *Life and Art of James Barry*, p. 291.
10 Just as Barry inserted Charles Burney, presumably without his knowledge, into *The Triumph of the Thames*, he may here be honouring Fanny in a similar fashion, although in this case anonymously. Fanny was twenty-five years old in 1777, and the likeness, after allowing for idealisation, is a distinct possibility. For a reproduction of her brother's portrait of her, executed *c.* 1784–85, see Elizabeth Eger and Lucy Peltz, London: National Portrait Gallery, *Brilliant Women: 18th-century Bluestockings* (2008), p. 25.
11 For discussions of Elizabeth Montagu and Samuel Johnson in the context of this mural, see Morris R. Brownell, *Samuel Johnson's Attitude to the Arts* (Oxford: Clarendon Press, 1989), pp. 69–72; Norma Clarke, *Dr. Johnson's Women* (London and New York, 2000), p. 229; Dunne (ed.), *James Barry, 1741–1806*, p. 110; and Eger and Peltz, *Brilliant Women*, pp. 39–40.
12 See the Hales entry in the *Oxford Dictionary of National Biography* [*ODNB*], vol. 24, p. 555.
13 Barry's individual portrait of Hooper is reproduced in Dunne (ed.), *James Barry, 1741–1806*, p. 113.
14 Barry gives his name as 'Locke', thereby associating him with the philosopher John Locke, for whom he was sometimes said, apparently incorrectly, to have been descended; see his entry in the new *ODNB*, vol. 34, p. 214. Barry had featured John Locke in his 1776 print *The Phœnix or the Resurrection of Freedom*.
15 Barry's independent portrait of the duke is reproduced in Dunne (ed.), *James Barry, 1741–1806*, p. 107.
16 Barry, 1783, p. 341.
17 *Royal Academy Exhibition Catalogue*, 1778, no. 319.
18 See Barry to the Burkes, n.d., in *Works*, vol. 1, p. 178.
19 John Knowles, *The Life and Writings of Henry Fuseli* (3 vols, Millwood, NY: Kraus International Publications, and Liechtenstein: Nendelin, 1982; repr. of 1831 London edn), vol. 3, p. 92. Barry is also recorded as having painted an oil of this subject in the manner of Rembrandt: 'The Grecian mother is a noble painting. It is the property of W. Jerdan, Esq., Editor of the *Literary Gazette*, and would, we understand, be sold; the price asked is a long one, but, doubtless, not more than its value. The picture, we understand, was produced in a fit of indignation, and in the style of Rembrandt; no more than two or three colours were used in its composition, for that great master loved to work his miracles in the fewest possible colours. Brown was his favourite one'; *The Nation*, 2 Dec. 1843, p. 12, repr. from *Southern Reporter*. I am most grateful to Claire E. Lyons for bringing this notice to my attention.
20 St Paul's Cathedral also appears in Gainsborough's portrait of Lord Folkestone, which originally hung on the Great Room's west wall. Presumably, the switch was made with Reynolds' portrait on the east wall so that the two depictions of the cathedral could match up, perhaps a good idea from a decorator's point of view but nonetheless an egregious violation of the room's original layout.
21 See, for example, the section 'The new Rome' in Warner et al. *Image of London*, pp. 125–8. The two works mentioned here, the painting by Joli and the print by Piranesi, are nos. 68 and 76 in this catalogue. For an informative discussion as to the important role that Virgil played in the late seventeenth century and in the first half of the eighteenth century in establishing Augustan Rome as a model for the English, see Angus Ross, 'Virgil and the Augustans', in Charles Martindale (ed.), *Virgil and His Influence: Bimillenial Studies* (Bristol: Bristol Classical Press, 1984), pp. 141–67.

Chapter 7

1 *Morning Chronicle*, 5 May 1783.
2 William Blackstone, *Commentaries on the Laws of England*, 6th edn (4 vols, London, 1774), vol. 1, pp. 267–8. Blackstone amended the king's speech by changing it from the first person to the third. It is transcribed as delivered in the House of Commons Journal, vol. 28 (1751–61), p. 1093. I am grateful to Liz Carless, House of Commons Information Office, for this citation. In acknowledging Blackstone as a legal authority, Barry also did not hesitate to speak for him, later maintaining that were Blackstone, who had died in 1780, still living he would no longer support the penal statutes against Catholics because of the doctrine of papal supremacy: 'there is no doubt but he [Blackstone] would eagerly, and with pleasure, dash his pen across what he had said … respecting the doctrine of the pope's supremacy, as subversive of all civil government, and as a reason for continuing the penal statutes'; Barry, 1793, p. 458.
3 Reproduced in Pressly, *Life and Art of James Barry*, p. 83, fig. 60.
4 Barry, 1793, p. 436.

Chapter 8

1 I am glad for this opportunity to be able to acknowledge the error in my key to the central figures of *Elysium and Tartarus* published in my *The Life and Art of James Barry* (New Haven and London: Yale University Press for Paul Mellon Centre for Studies in British Art, 1981). Unwittingly, I had given photographs showing the two halves of the mural to John McCrillis, the key's draughtsman, not realising that the photos failed to meet in the middle. Thus McCrillis had an imperfect model from which to work, and I would hope the error is so obvious as to have caused minimal confusion.
2 Barry, 1783, p. 361.
3 *St James's Chronicle*, 13–15 May 1783.
4 Richard Payne Knight, 'Review of *The Works of James Barry*', *Edinburgh Review*, vol. 16 (Aug. 1810), p. 306.
5 Barry, 1793, p. 430.
6 Cæsar Ripa, *Iconologia: or Moral Emblems* (London: Benjamin Motte, 1709), p. ii.
7 Grinling Gibbons also carved a pelican with its young at its breast in the reredos of St James' Church, Piccadilly, which is an easy walk from the Society of Arts in a westerly direction.
8 Xenophon, *The Memorable Things of Socrates*, 2nd edn, trans. Edward Bysshe (London, 1722), p. 57.
9 See Thomson, *Seasons*, lines 1039–41 of *Winter*. In his commonplace book, Barry wrote, 'Inscription or Motto for Elizium to be written on ye base of the Pelican feeding its young, must express this Idea, that Elysium is ye recompence of those who make their chief happiness to consist in dooing good to others'; Barry's commonplace book, p. 234. In the preceding pages he also considered other quotations besides those of Xenophon and Thomson: he copied out in Latin lines 660–4 from *The Aeneid* (p. 230) (see Dryden, *Works of Virgil*, lines 895–900); he quoted Ecclesiasticus 44:7 and 14: 'All these were honour'd in their generations, and were the glory of their times[.] their bodies are ['are' written over 'were'?] buried in peace, but their name liveth for evermore' (p. 232); and he cited Pindar's *First Nemean Ode* (see Epode 4 in West, *Odes of Pindar*, pp. 104–5), lines that refer to Hercules' arrival in Heaven, to which the artist appended, 'the passage there applying to many persons instead of our Hercules' (p. 232). On the verso he added, 'The general meaning of the passage, is They enjoy isfor [*sic*] ever tranquillity in the houses of the blest, the reward peculiar to great labours' (p. 233).
10 Perino's frescoes for the *Stanza della Segnatura* are listed in Elena Parma Armani, *Perin del Vaga: L'anello mancante* (Genova: Sagep Editrice, 1986), page 287, and a colour reproduction of the wall containing *The School of Athens* is reproduced on page 192.
11 Manning noted this connection between the lesser angel and the Duchess of Devonshire when giving his talk, published in Susan Bennett (ed.), *Cultivating the Human Faculties: James Barry (1741–1806) and the Society of Arts* (Bethlehem, Penn.: Lehigh University Press, 2008).
12 [Jonathan Swift], *Travels into Several Remote Nations of the World … By Lemuel Gulliver*, 2nd edn (Dublin, 1727), p. 179.
13 *Lucan's Pharsalia*, 3rd edn, trans. into English verse by Nicholas Rowe (2 vols, London, 1753), vol. 2, book ix, lines 972–3.
14 Ibid. vol. 1, book ii, lines 592–3, 604–7.
15 Barry, 1803, p. 666, repr. of *Monthly Magazine*, vol. 16 (1 Sept. 1803), p. 106.
16 See Barry, 1793, p. 437.
17 The engraving of Harvey's portrait, dated 1739, appears in Birch, *Heads of Illustrious Persons of Great Britain*, vol. 1, facing p. 83.
18 Molyneux, *Case of Ireland Being Bound by Acts of Parliament*, p. vi.
19 Ibid. p. vii.
20 Ibid. p. xiv.
21 Daniel Owen Madden, *The Speeches of the Right Hon. Henry Grattan* (Dublin, 1853), p. 70.
22 Barry, 1793, p. 427.
23 This title is from the 1726 London edition. The title page lists the author as 'By his Great Grandson, Thomas More', even though his name was Cresacre More. This work was first published in France about 1631.
24 Barry, 1793, p. 436.

25 An overview of the Penn family's motives as well as those of the artist can be found in Ann Uhry Abrams, 'Benjamin West's Documentation of Colonial History: *William Penn's Treaty with the Indians*', *Art Bulletin*, vol. 64 (Mar. 1982), pp. 59–75. Abbé Raynal's lengthy account of the colony's founding, cited in note 28, may have provided the catalyst for the commission.

26 Voltaire, *Letters Concerning the English Nation*, trans. from French by John Lockman (London, 1733), pp. 29–30.

27 In John Galt's biography, in which West was deeply involved, he tells of how the Indians taught the young boy to paint when they showed him how 'to prepare the red and yellow colours with which they painted their ornaments'; John Galt, *The Life, Studies, and Works of Benjamin West* (2 vols in 1, London, 1820), vol. 1, p. 18.

28 In his text to *The Distribution of Premiums*, Barry mentions Lady Juliana among those 'to whom I have had the honour of being in some measure known in the course of this work'. Charles Coleman Sellers plausibly argues that Lady Juliana was the instigator of West's commission, even if Thomas Penn, for propriety's sake, was the one who approached the artist in 1771; see Philadelphia, the Pennsylvania Academy of the Fine Arts, *Symbols of Peace: William Penn's Treaty with the Indians*, 1976. Barry's contact was of course only with Lady Juliana, as Thomas had died in 1775.

29 Abbé Raynal, *A Philosophical and Political History of the Settlements and Trade of the Europeans in the East and West Indies*, trans. from French by J. Justamond (4 vols, London, 1776; first published 1770), vol. 4, p. 261.

30 Charles Montesquieu, *The Spirit of Laws* (2 vols, London, 1750), vol. 1, pp. 50–1.

31 Item 33 is concerned with what factors or correspondents owe their employers should they wrong them.

32 *A Collection of the Works of William Penn*, with a life written by Joseph Besse (2 vols, London, 1726), vol. 1, p. 33.

33 Barry, 1793, pp. 426–7.

34 Theologically speaking, angels have no gender, but like Milton, Barry defines them as male and female. In this instance, characterising an archangel as female is an even bigger departure from tradition.

35 For a reproduction of J. Faber's engraving after van Loo, see David Piper, *The Image of the Poet* (Oxford: Clarendon Press, 1982), fig. 73.

36 Barry, 1793, p. 430.

37 One is reminded of Jasper Johns' 1963 painting *Periscope (Hart Crane)* (The Menil Collection, Houston), in which the artist's arm and hand extend across a cosmic globe to touch its circumference.

38 For a portrait of Peters, see the detail from an engraving by William S. Leney reproduced in Lady Victoria Manners, *Matthew William Peters, R.A.: His Life and Work* (London: Bemrose & Sons for *The Connoisseur*, 1913), pl. xiiib. After Barry had specifically been attacked for having condemned the Duke of Richmond to Tartarus, because His Grace's leg in *The Distribution of Premiums* resembles that of the Ambitious Man, the artist gave a statement of principle that he had made no references to individuals in Tartarus; see Barry, 1793, p. 462. While one believes his declaration that no linkage with the duke was intended, he may well have had Peters in mind when adding in 1784 his new figure to Tartarus.

39 William Blake, *The Marriage of Heaven and Hell* (Lambeth, London, c. 1790–93), pls 22, 23.

40 Burney manuscript, pp. 20v–21r.

Chapter 9

1 Barry had even hoped to start his exhibition slightly ahead of the Academy's but was unable to meet this deadline; see *Morning Chronicle*, 18 Apr. 1783.

2 Letter from Sir John Cullum, 1 May 1782, in William S. Childe-Pemberton, *The Earl Bishop; The Life of Frederick Hervey, Bishop of Derry, Earl of Bristol* (2 vols, London [1924]), vol. 1, p. 283.

3 Letter from Barry to Young, BM Add MSS 35,126 ff. 240. While the letter is undated, it appears between letters dated 23 April 1783. Presumably the book was still being worked on at the time of the opening. On 10 July 1783 the Society of Arts council recorded its thanks to Barry for a copy.

4 *Public Advertiser*, 28 Apr. 1783, p. 3. The resolution was repeated the following day in the *Morning Chronicle and London Advertiser* and in the *Morning Herald and Daily Advertiser*. In later publications, perhaps due to Barry's insistence, the phrase 'a Work of great Execution, and classical Information' was expanded to 'a work of great excellence of Composition, masterly execution, and classical Information'; see *Morning Herald*, 1, 7 May 1783, and *Morning Chronicle*, 12, 31 May 1783.

5 *Public Advertiser*, 2 May 1783, p. 2.

6 G.B. Hill (ed.), *Boswell's Life of Johnson*, rev. L.F. Powell (6 vols, Oxford: Clarendon Press, 1971; first published 1934), vol. 4, p. 224. Johnson made these remarks to Boswell on 26 May 1783, when at tea with Fanny Burney.

7 See Jules David Prown, *John Singleton Copley* (2 vols, Cambridge, Mass.: Harvard University Press for the National Gallery of Art, Washington, 1966), vol. 2, p. 284.

8 Quoted in C.S. Matheson, '"A shilling well laid out": the Royal Academy's early public', in David H. Solkin (ed.), *Art on the Line: The Royal Academy Exhibitions at Somerset House, 1780–1836* (New Haven and London: Yale University Press for Paul Mellon Centre for Studies in British Art and the Courtauld Institute Gallery, 2001), p. 44. One should also note John Barrell's article, in which he discusses the difficulties encountered by Barry in attempting a public, civic art in a commercial and divided society; 'The function of art in a commercial society: the writings of James Barry', *The Eighteenth Century*, vol. 25 (spring 1984), pp. 117–40.

9 See Barry, 1785.

10 The various editions of this pamphlet are discussed in Pressly, *Life and Art of James Barry*, p. 303. To the dates given there (1792, 1800, 1803 and 1817), one should add editions of 1808 and 1815. Beginning with the 1803 edition, material supplied by the artist and edited by the secretary, Dr Charles Taylor, was added to reflect changes to the murals. It should also be noted that in 1812 the minutes of the Society record that another two thousand copies were ordered, although I have not seen a pamphlet with that date.

11 Lillian B. Miller (ed.), *The Selected Papers of Charles Willson Peale and his Family* (4 vols, New Haven and London: Yale University Press for the National Portrait Gallery, Smithsonian Institution, 1983), vol. 3, p. 613. I am grateful to Ellen Grayson at the National Portrait Gallery for bringing Peale's entry to my attention.

12 Minutes of the Society of Arts, 16 Jan. 1799.

13 Barry's funeral procession from the Society of Arts to St Paul's Cathedral took place on Friday 14 April 1806. Rev. Dr Henry Fly, senior minor canon of the cathedral, performed the Anglican burial service as set out in the Book of Common Prayer, a service that was held in the cathedral's northwest corner (now known as St Dunstan's Chapel), after which the artist's body was interred in the crypt; see David G.C. Allan, *Barry's Death and Funeral*, Occasional Paper 7 (Ruislip, Middlesex: William Shipley Group for RSA History, 2009), p. 5. In 1819 Dr Edward Fryer and a Dr Clarke were instrumental in seeing that a memorial bust in Coade stone was placed on the wall of the crypt close to Barry's tomb; see Alison Kelly, 'A bust of James Barry for the Society of Arts', *Journal of the Royal Society of Arts*, vol. 123 (Nov. 1975), pp. 819–22, and Alison Kelly, *Mrs Coade's Stone* (Upton-Upon-Severn, Worcs.: Self Publishing Associations Ltd, 1990), pp. 138–9. Kelly makes a case for Dr Clarke being Dr James Stanier Clarke, a naval chaplain, but he is Rev. Dr Thomas Brooke Clarke, DD (1757–1833), who in 1806, along with Dr Fryer, was one of the executors of Barry's estate (Timothy McLoughlin provides the relevant biography in Barry's Correspondence, appendix E, n. 9). The plan to erect a bust began early, and the delay arose from securing permission from the Dean and Chapter of St Paul's (letter in private hands from Dr Fryer to an unnamed recipient, presumably George Tennant, who was overseeing matters at the Society related to Barry, 24 May 1809). At the lower left of Barry's tomb slab is a worn monogram that is repeated at the base of the bracket supporting the artist's bust. This monogram would seem to consist of the following four letters: T, E, O, R. Because these letters are superimposed, they can be arranged in any order. While a great deal of manuscript material was destroyed in the 1940 bombings of the Chapter House, Joseph Wisdom, the cathedral's librarian, doubts that the archives ever contained any explanation for the monogram's meaning, it having posed a challenge from the beginning; I am grateful to both Joseph Wisdom and Wendy Hawke, senior archivist of the London Metropolitan Archives, for their assistance in this matter. McLoughlin has already suggested to the author one possible reading: 'Oramus Tibi Ei Requiem' ['We pray you (Lord to grant) him rest'].

14 Jameson, *Handbook to the Public Galleries of Art in and near London*, p. 509.

15 Allan Cunningham, *The Lives of the Most Eminent British Painters, Sculptors, and Architects* (6 vols, London: John Murray, 1829–33), vol. 2, p. 89. To make matters worse, in another section of his book Cunningham quotes James Northcote's argument that historical painting is incompatible with British culture: 'As to lofty history … our religion scarcely allows it. The Italians had no more genius for painting, nor a greater love of pictures, than we; but their church was the foster-mother of the fine arts … The genius of Italian art was nothing but the genius of popery; every thing at Rome is like a picture – is calculated for show'; ibid. vol. 6, p. 66.

16 Richard and Samuel Redgrave, *A Century of British Painters* (Oxford: Phaidon, 1981; first published 1866), p. 81. For a more detailed treatment of the murals' reception history up until the time of the Redgraves, see David Solkin, 'From oddity to odd man out: contesting James Barry's critical legacy, 1806–66', in Tom Dunne and William L. Pressly (eds), *James Barry, 1741–1806: History Painter* (Farnham, Surrey, and Burlington, Vermont: Ashgate, 2010), pp. 11–22.

17 Julian Bell, 'British art: the showcase', *New York Review of Books*, 19 Oct. 2006, p. 51.

18 Simon Schama, *Landscape and Memory* (New York: Alfred A. Knopf, 1995), p. 357.

19 Ibid. p. 359.

20 William Blake, 'Annotations to *The Works of Sir Joshua Reynolds*, edited by Edmond Malone. London, 1798', in David V. Erdman (ed.), *The Poetry and Prose of William Blake* (Garden City, New York: Doubleday & Company, 1970), p. 626.

21 Barry, 1783, p. 314.

Chapter 10

1 Barry, 1783, pp. 314–5.

2 William A. Coffin, 'Robert Reid's Decorations in the Congressional Library, Washington, D.C.', *Harper's Weekly*, vol. 40 (17 Oct. 1896), p. 1029. I am indebted to Marian Wardle for bringing to my attention this and the citations in the following two notes.

3 Edwin Howland Blashfield, 'Mural painting in America', *Scribner's Magazine*, vol. 54 (Sept. 1913), p. 362.

4 'Tirocinium', in John D. Baird and Charles Ryskamp (eds), *The Poems of William Cowper* (2 vols, Oxford: Clarendon Press, 1995), vol. 2, p. 273.

5 William Blake to Rev. Dr Trusler, 23 Aug. 1799, in Geoffrey Keynes (ed.), *The Letters of William Blake* (Cambridge, Mass.: Harvard University Press, 1970), p. 29.

6 Barry, 1783, p. 321.

7 D.P. Walker, *The Ancient Theology: Studies in Christian Platonism from the Fifteenth to the Eighteenth Century* (Ithaca, N.Y.: Cornell University Press, 1972), pp. 19–20. The following are also among the many helpful books on this topic: Frances A. Yates, *Giordano Bruno and the Hermetic Tradition* (New York: Vintage Books, 1969); Désirée Hirst, *Hidden Riches: Traditional Symbolism from the Renaissance to Blake* (New York: Barnes & Noble, 1964); and Ingrid D. Rowland, *The Culture of the High Renaissance: Ancients and Moderns in Sixteenth-century Rome* (Cambridge: Cambridge University Press, 1998).

8 See Barry, 1793, p. 430.

9 Philip of Mornay [Philippe Du Plessis Mornay], *A Worke Concerning the Trunesse of Christian Religion*, trans. from French by Sir Philip Sidney Knight and Arthur Golding (London, 1617), pp. 124–5. The French publication had appeared in 1581. The typeface uses *u* for both the letters *u* and *v*, but I have transcribed *u* as *v* where appropriate.

10 Walker, *Ancient Theology*, p. 20. The square brackets are mine; the parentheses and ellipses are Walker's.

11 Quoted in ibid. p. 12.

12 Two engravers are candidates for J. Collyer: John (1708–86) and his son Joseph (1748–1827).

13 I would like to thank Maria Rossi, senior curatorial assistant in Rare Books and Manuscripts at the Yale Center for British Art, for her extensive efforts to locate this print's source. In her book *The Theory and Practice of Neoclassicism in English Painting* (New York and London: Garland Publishing, 1988), Ann M Hope dates the print to 1775 (p. 187), but apparently this date is derived only from the fact that an impression is to be found in the Anderdon interleaved Royal Academy catalogue for that year at the Royal Academy of Arts, London. The date and the source unfortunately still remain unknown.

14 See Cesare Ripa, *Baroque and Rococo Pictorial Imagery: The 1758–60 Hertel Edition of Ripa's 'Iconologia' with 200 Engraved Illustrations*, intro., trans. and commentaries by Edward A. Maser (New York: Dover Publications, 1971), no. 122.

15 Two books devoted in part to this collection, the last of which is profusely illustrated, had already been published: Humphrey Prideaux, *Marmora Oxeniensia* (Oxford, 1676) and Richard Chandler, *Marmora Oxoniensia* (Oxford, 1763).

16 Suffice it to say here that all five of the figures from classical antiquity – Solon, Sanchoniatho, Herodotus, Thucydides and Josephus – play roles in Bishop William Warburton's discussion of the Eleusinian Mysteries; see William Warburton, *The Divine Legation of Moses*, 4th edn (2 vols, London: printed for J. and P. Knapton, 1755). The relevance of this observation will become clearer in the following chapter, where the Mysteries are linked to Christianity.

17 It is noteworthy that Barry executed his prints *Job Reproved by his Friends* and *The Conversion of Polemon* as pendants, although the first subject was from Hebrew scripture and the second from classical Greece.

18 The second volume repeats as a frontispiece the same print, with a battle scene replacing the biblical subjects seen through the window.

19 Barry to Charles James Fox, 5 Oct. 1800, in *Works*, vol. 1, p. 286.

20 Barry, 1782 (Lecture IV), p. 470.

21 'And no man putteth new wine into old bottles; else the new wine will burst the bottles, and be spilled, and the bottles shall perish' (Luke 5:37). See also Matthew 9:17 and Mark 2:22.

22 Mervyn Levy (ed.), *The Pocket Dictionary of Art Terms* (Greenwich, Conn.: New York Graphic Society; and London: Studio Books, 1961), p. 61.

23 Johnson, vol. 1, p. x.

24 Quoted in English (trans. from Latin) in Walker, *The Ancient Theology*, p. 122. Walker footnotes as his source the 1575 Basle edition.

25 Cæsar Ripa, 'To the reader', in *Iconologia: or Moral Emblems* (London: Benjamin Motte, 1709), no pagination. Under the entry 'Iconography and iconology', *The Dictionary of Art* offers the following clarification concerning these two terms: 'In the modern sense iconography involves the collection, classification, and analysis of data, from which the theme or subject of a work of art is deduced. Iconology, on the other hand, starting from the results of iconography, attempts to explain the very basis for the existence of a work of art and its entire meaning.' It goes on to point out that the term 'iconology' as employed by Ripa 'later came to be understood as iconography'; Jane Turner (ed.), *Dictionary of Art*, 34 vols. (New York: Grove, 1996), vol. 15, p. 89.

26 William Blake to Rev. Dr Trusler, 23 Aug. 1799, in Keynes (ed.), *Letters of William Blake*, p. 29.

27 See Barry to the Burkes, n.d., in *Works*, vol. 1, p. 110.

28 Lady Anna Miller ('an English Woman'), *Letters from Italy, Describing the Manners, Customs, Antiquities, Paintings, &c. of that Country in the Years MDCCLXX and MDCCLXXI to a Friend Residing in France*, letter of 9 Feb. 1771, vol. 2, p. 195. The painted architectural decoration and other 'minor' pieces were often destroyed.

29 In her dissertation, Tina Najbjerg offers one possible scenario. She suggests that *Chiron and Achilles* may have been positioned high in its niche above another, larger fresco, *Hercules Finding his Son Telephos*, a counterpart to its twin niche in which *Marsyas and Olympus* would have been positioned above *Theseus Rescuing the Children from the Minotaur*; Tina Najbjerg 'Public painted and sculptural programs of the early Roman Empire: a case-study of the so-called Basilica in Herculaneum', Ph.D thesis, Princeton University, 1997, p. 285.

30 Reproduced as an engraving in *Pitture Antiche d'Ercolano*, vol. 1, p. 73, pl. xiii.

31 See for example, J.J. Winckelmann's *Critical Account of the Situation and Destruction By the First Eruption of Mount Vesuvius, of Herculaneum. Pompeii, and Stabia* (London, 1771), where he mentions *Theseus, Hercules and Telephus, Chiron and Achilles*, and *Pan and Olympus* (now identified as *Marsyas and Olympus*) as coming from 'a temple, of

a round figure, which it is believed, was dedicated to Hercules' (p. 32). One should also be reminded that not only was Herculaneum named after Hercules as its presumed founder, but also that Pompeii was named after a procession (*Pompa*) that he was thought to have made on this site.

32 For an introduction to this site at Herculaneum, see Tina Najbjerg, 'From art to archaeology: recontextualizing the images from the porticus of Herculaneum', in Victoria C. Gardener Coates and Jon L. Seydl (eds), *Antiquity Recovered: The Legacy of Pompeii and Herculaneum* (Los Angeles: J. Paul Getty Museum, 2007), pp. 59–72. Najbjerg refers to the building as a porticus, and the label for *Hercules and Telephus* in the exhibition *Roma: La Pittura di un Impero* (Rome: Scuderie del Quirinale, 2009–10) identified it more specifically as an Augusteum, 'a building with a central courtyard and lateral arcades which was used among other things for imperial worship'.

33 Duncan C. Tovey (ed.), *Gray and his Friends: Letters and Relics in Great Part Hitherto Unpublished* (New York: Kraus Reprint Co., 1968; from Cambridge University Press edn of 1890), pp. 255–6. Gray incorrectly records that drapery covered the boy's middle, and the two were positioned in front of a porticoed temple.

34 [James Russel], *Letters from a Young Painter Abroad to his Friends in England* (London, 1748), p. 216.

35 See, for an influential example, Charles Nicolas Cochin and Jérôme Charles Bellicard, *Observations sur les antiquités de la ville d'Herculanum*, 2nd edn (Paris, 1755), p. 41.

36 Barry to the Burkes, n.d., in *Works*, vol. 1, p. 111.

37 Reproduced in Francis Haskell and Nicholas Penny, *Taste and the Antique* (New Haven and London: Yale University Press, 1981), figs. 91, 92. The use of sculpture was doubly fitting, as the fresco was said itself to have been based on an important sculptural composition.

38 An early sketch for Barry's composition of Chiron and Achilles survives (see Pressly, *Life and Art of James Barry*, p. 245, no. 3), a work that he probably executed on his trip to Naples or soon thereafter, because it is on paper bearing the same watermark as those in his Italian sketchbook of views in and around Rome and outside Naples; for a discussion of this sketchbook, see William L. Pressly, 'On classic ground: James Barry's "Memorials" of the Italian landscape', *Record of the Art Museum: Princeton University*, vol. 54 (1995), pp. 12–28. The drawing's composition, though reversed, more closely interlocks the two protagonists. A more finished, signed preparatory drawing that still differs in significant details from the painting appeared in the sale '"Galleria Portatile": the Ralph Holland Collection', Sotheby's, London, 5 July 2013, lot 354.

39 See John Barrell, *The Birth of Pandora and the Division of Knowledge* (Philadelphia: University of Pennsylvania Press, 1992). In his index he has multiple pages listed under 'feet' for the category 'endangered and fetishised'.

40 Another combat between mankind's feet and sinister forces has already been quoted in chapter 8: 'Thou shalt tread upon the lion and adder: the young lion and the dragon shalt thou trample under feet' (Psalms 91:13).

41 This painting is discussed in Pressly, 'James Barry's *The Baptism of the King of Cashel by St. Patrick*', *Burlington Magazine*, vol. 118 (Sept. 1976), pp. 643–6.

42 The fresco *The Infant Hercules Strangling the Serpents* was uncovered on 2 December 1739; see Najbjerg 'Public painted and sculptural programs of the early Roman Empire', p. 322. It is reproduced in the engraving in *Le Pitture Antiche d'Ercolano*, vol. 1, p. 37, pl. vii. In the nineteenth century, Ingres considered it worthy for inclusion on the rear wall of the room depicted in his painted versions of Antiochus and Stratonice.

43 Spence, *Polymetis*, p. 125.

44 Plutarch, *The Philosophy Commonly Called, the Morals*, trans. from Greek into English, and conferred with the Latin and French translations by Philemon Holland (London: printed by S.G., 1657), p. 1050. Barry cites Plutarch's account in his book *A Letter to the Dilettanti Society* of 1798 (see Barry, 1798, p. 591). He quotes the inscription as 'I *am* whatever *was, is*, and *will be*, and my vail no mortal hath raised'. I have not been able to locate the source for this particular translation.

45 One of the frescoes shows a crouching boy (presumably Horus, the son of Isis and Osiris) between two serpents raised up on their tails; reproduced in V. Tran Tam Yinh, *Essai sur le culte d'Isis à Pompéi* (Paris: Editions E. de Boccard, 1964), pl. vii, no. 3. One suspects Barry saw in this design an Egyptian parallel to the Greco-Roman story of Hercules and the serpents. Another fresco, this time from Herculaneum, shows an Isiac ceremony, with sphinxes flanking the temple's entrance; reproduced in *Le Pitture Antiche d'Ercolano*, vol. 2, p. 321, pl. ix.

46 One of the more celebrated instances of the effect the discovery of the Temple of Isis had on a creative contemporary concerns Mozart's visit to Naples, when he was only fourteen years old, in May and June 1770, just months after Barry's visit. As in Barry's case, one cannot be entirely certain that Mozart went to the temple site, but he would have been acutely aware of the excitement generated by its discovery. The impact of this exposure to the mysterious worship of Isis, particularly in the context of Freemasonry, burst forth two decades later in his opera *The Magic Flute*.

47 Isis' brother and husband Osiris was murdered and dismembered at the hands of the satanic Seth. After lamentations and wanderings, in which she collected his remains, the goddess was able to resurrect Osiris, ensuring that the world of light was able to defeat Seth's world of darkness. Not only in this telling is Osiris a Christlike figure, but there are also numerous parallels between Isis and Mary. After a lengthy rendition of such associations, R.E. Witt offers this encapsulating summary: 'The Egyptian goddess [Isis] who was equally "the Great Virgin" (*hwnt*) and "Mother of the God" was the object of the very same praises bestowed upon her successor. Mary, Virgin Mother of Jesus, could gradually (and silently) replace the Graeco-Roman Isis-Sophia [i.e. Minerva or Wisdom]'; R.E. Witt, *Isis in the Ancient World* (Ithaca, N.Y.: Cornell University Press, 1971), p. 273. Furthermore, in classical times the Pompeian temple had been a restricted site reserved only for those who had been initiated into the cult of Isis, and its profound mysteries included purification rites that could be associated with baptism. Through these initiations that nurtured reverence for a supreme

being, one could look forward to redemption and an afterlife.

48 London: European Museum, *Fourth Exhibition and Sale* (1792), no. 271.

49 Earl of Buchan to Ozias Humphry, 1 Jan. 1808, in Royal Academy of Arts, *Original Correspondence of Ozias Humphry R.A.* (London), vol. 7, letter 1.

50 Warburton, *Divine Legation of Moses*, vol. 1, bk 2, sect. 4, pp. 176–7.

51 Barry, 1798, p. 592.

52 See Stephen Francis Dutilh Rigaud, 'Facts and recollections of the XVIIIth century in a memoir of John Francis Rigaud Esq., R.A.', abridged and edited with intro. and notes by William L. Pressly, *Journal of the Walpole Society*, vol. 50 (1984), p. 49.

53 As often is the case in the eighteenth century, spelling can be erratic. In dictionaries of English artists, the spelling is given as 'Keeble', but I am using the spelling with which he signed his letter to Barry. At any rate, either of these renditions is preferable to 'Ghibel', the phonetic spelling given to him when he was living in Naples; see Ellis Waterhouse, *The Dictionary of British 18th Century Painters in Oils and Crayons* (Antique Collectors' Club, 1981).

54 Letter from William Keable to Barry, n.d., James Barry Papers and Letters, Lewis Walpole Library, Yale University, Farmington, Connecticut. The letter is addressed to 'Mr James Barry chez Messrs. Maumary e fil Banquier [at the bankers Maumary and son] Parma'. Presumably the letter dates to before 17 January 1771, when Barry and Rigaud departed Parma for Turin.

55 What I take to be unconscious imagery in Barry's *c.* 1790 additions to his print *Philoctetes on the Island of Lemnos* literally raises more troubling issues (reproduced in Pressly, *Life and Art of James Barry*, p. 25, fig. 16). The subject is from the painting he executed as his diploma picture for the Accademia Clementina. In this late version Barry adds a gnarly tree to the right of Philoctetes. Near the trunk's bottom spiky branches painfully spurt from the protruding, phallic limb, suggesting conflicted feelings over his sexual urges. I am aware that my assertion that Keable's remarks may reveal more about him than about his friend, in this instance, can also be applied to me, but I still think the artist is the one with the problem.

56 Barry's aesthetic owes a great deal to the writings of J.J. Winckelmann. For a succinct and insightful analysis of the German philosopher's responses, see the section entitled 'Winckelmann: the beautiful boy as aesthetic icon' in Catriona MacLeod, *Embodying Ambiguity: Androgyny and Aesthetics from Winckelmann to Keller* (Detroit: Wayne State University Press, 1998), pp. 29–46. As she points out, 'Winckelmann's most adored androgynes, as commentators have frequently noted, are modeled after adolescent boys, puberty being the critical moment of sexual indeterminacy and liminality' (p. 40).

57 These five sculptures are reproduced in Haskell and Penny, *Taste and the Antique*, as nos. 4, 8, 60, 5 and 7, respectively.

Chapter 11

1 For helpful background material, see John Block Friedman, *Orpheus in the Middle Ages* (Cambridge, Mass.: Harvard University Press, 1970); Sister Charles Murray, *Rebirth and Afterlife: A Study of the Transmutation of Some Pagan Imagery in Early Christian Funerary Art* (Oxford: BAR International Series 100, 1981); and John Warden (ed.), *Orpheus: The Metamorphoses of a Myth* (Toronto, Buffalo, London: University of Toronto Press, 1982).

2 This catacomb, discovered on 31 May 1578, is now known as the 'Catacomba Anonima' of Via Anapo; see Vincenzo Fiocchi Nicolai, 'The origin and development of Roman catacombs', in Vincenzo Fiocchi Nicolai, Fabrizio Bisconti and Danilo Mazzoleni, *The Christian Catacombs of Rome* (Regensburg: Schnell & Steiner, 1999), p. 11.

3 The nineteenth-century scholar G.B. De Rossi christened Bosio with this name; see ibid.

4 See Carlo Pavia, *Il Labirinto delle Catacombe* (Udine: Carlo Lorenzini, 1987), p. 54.

5 See Barry, 1775, p. 181. I would like to thank Suzanne May for pointing out in a seminar paper this reference to Bosio, which, as she maintained, helps to establish the linkage of Orpheus to Christ within Barry's painting.

6 Colour reproductions of the entrance wall to the cubiculum and the wall shown in the engraving along with a detail of the Orpheus fresco can be found in Pavia, *Il Labirinto delle Catacombe*, pp. 142–4.

7 The identification of this figure as Micah is made by Pavia in ibid. p. 68.

8 See Murray, 'James Barry', p. 52 n. 35.

9 As the following chapter will demonstrate, Virgil's writings are fundamental to comprehending Barry's programme, and one should mention here Virgil's own identification of Orpheus as a resurrection figure in *Georgics IV*, where the story of Orpheus and Eurydice is told within the framework of the gods' restoration to Aristæus of his once plentiful bees.

10 Reproduced in Antonio Bosio, *Roma Sotterranea* (Rome, 1632), p. 253. Cross-sections of the room appear on p. 251.

11 Miller, *Letters from Italy*, vol. 3, p. 40.

12 Ibid. p. 41.

13 Ibid. p. 42.

14 Ibid. p. 43.

15 Incense was not used ceremonially in the Anglican Church until 1854 and even then was a rarity; see Geoffrey K. Brandwood, '"Mummeries of a Popish Character": the Camdenians and early Victorian worship', in Christopher Webster and John Elliott (eds), '*A Church as it Should be*': *The Cambridge Camden Society and Its Influence* (Stamford: Shaun Tyas, 2000), p. 87. I am grateful to Colette Crossman for this reference.

16 Jameson, *Handbook to the Public Galleries of Art in and near London*, pp. 519–20. Raphael's picture, now attributed to Giulio Romano, was important enough that it forms the centrepiece in Johan Zoffany's painting of the treasures of the Uffizi executed just before Barry's picture was begun (*The Tribuna of the Uffizi*, Royal Collection of Queen Elizabeth II).

17 See Pressly, *Life and Art of James Barry*, p. 92.

18 Sir Francis Bacon, *The Wisdom of the Ancients* (London, 1696; first published in Latin in 1609), p. 42.

19 All seven pictures are catalogued in Marie-Nicole Boisclair, *Gaspard Dughet: sa vie et son œuvre (1615–1675)* (Paris: Arthéna, 1986), nos. 117–23. In the *Guide to the Doria Pamphilj Gallery* (Rome: Arti Doria Pamphilj, 1997), the year of execution is given as 1656 (p. 21).

20 While sheep appear in Breughel's picture, in this instance the lamb beside the Baptist, which is essential to the Christian iconography, departs from those in the earlier composition.

21 See Herbert Friedmann, *The Symbolic Goldfinch* (Washington, D.C.: Pantheon Books, 1946), and Dorothy C. Shorr, 'The child's preoccupation with a bird', in Dorothy C. Shorr, *The Christ Child in Devotional Images in Italy During the XIV Century* (New York: G. Wittenborn, 1954).

22 Payne Knight, 'Review of *The Works of James Barry*', p. 306.

23 George Ferguson, *Signs & Symbols in Christian Art* (New York: Oxford University Press, 1959), p. 9. This belief that the peacock's flesh does not decay is given as fact in medieval bestiaries. It derives, at least in part, from St Augustine's early-fifth-century account of an experiment he conducted on a portion of a peacock's breast which resisted corruption; see St Augustine, *The City of God*, trans. Gerald G. Walsh and David J. Honan (Washington, DC: Catholic University of America Press, 1954), vol. 8, bk 21, chap. 4, p. 345.

24 Given the popularity of the peacock as a motif, it is unsurprising that Sandro Botticelli created at least two paintings in which this bird is on display in a Nativity: see *The Adoration of the Magi* in the National Gallery, London, and *The Adoration of the Magi* in the Uffizi, Florence. Also see Domenico Veneziano's *Adoration of the Magi*, c. 1439–41, in the Gemäldegalerie, Berlin, where the large peacock perched above the Holy Family on top of the shed is similar to Barry's with the exception of its tucked neck. Because the peacock as a symbol of immortality had already appeared in the art of the catacombs, Barry presumably saw this as additional confirmation of the linkage of the practices of the modern Catholic Church with those of the early Christians.

25 For 'The Emperour Constantine's Oration, which he entitled to the Convention of the Saints', see Eusebius Pamphilus and Evagrius Scholasticus, *The History of the Church from Our Lord's Incarnation to … 594*, 2nd edn (London, 1709), pp. 635–62.

26 Dryden, *Works of Virgil, Pastoral* or *Eclogue IV*, p. 59.

27 Alexander Pope, *The Works of Alexander Pope Esq.* (9 vols, London, 1766), vol. 1, p. 38.

28 Although Barry did not refer to *The Fourth Eclogue* in his writings, he may have introduced into the mural visual references to this famous poem. If he did, the references are too subtle to be certain, but again to be certain is to give the game away. In the mural (although not in the print), the patriarch at the far right is dramatically cut by the frame, only a portion of his profile being visible. Consequently, the emphasis is on his aged wife, who, by appearing virtually alone, is perhaps intended to refer to the Cumaean Sibyl. She indeed in her crone-like features and hooded veil resembles the sibyl in Raphael's fresco *Sibyls and Angels* (Chigi Chapel, Santa Maria della Pace, Rome), who sits next to the tablet inscribed with a line from Virgil's *Fourth Eclogue*: 'IAM/ NO[VA]/ PRO/ GE[NIES]' ('now a new generation …') (line 7). In this reading, the luminous, angelic boy beneath her in Barry's mural is the prophesied child who looks toward his own realised self, and in the younger woman below him he is again accompanied by his mother, the Virgin Mary. If this is the case, *A Grecian Harvest-home* is Janus-like: it looks to the past in terms of the Sibylline prophecy and to the future, as we shall see, in terms of the reference to the Donation of Constantine.

29 Vasari singles out the boy playing with a dog in his *Lives* under Giulio Romano. Jonathan Richardson, Sr. and Jr., mention 'a boy astride on a Dog' in their *An Account of the Statues, Bas-reliefs, Drawings and Pictures in Italy, France, &c.*, 2nd edn (London, 1754; 1st edn published in 1722 as *An Account of Some of the Statues …*), p. 249.

30 'The Edict of Constantine to Pope Silvester' can be found in *Constantine and Christendom*, trans. with notes and intro. by Mark Edwards, Translated Texts for Historians Series (Liverpool: Liverpool University Press, 2003). vol. 39.

31 Richardson and Richardson, *Account of the Statues*, p. 248.

32 Charles Rollin, *The Ancient History of the Egyptians, Carthaginians, Assyrians, Babylonians, Medes and Persians, Macedonians, and Grecians*, 6th edn (London, 1774), vol. 1, p. xlix.

33 Ibid. p. liv. Gilbert West also quotes St Paul's exhortation to the Corinthian converts at length; see West, *Odes of Pindar*, pp. clxxxix–xcx.

34 West, *Odes of Pindar*, pp. xl–xli.

35 I have previously discussed Barry's *Crowning the Victors at Olympia* in two earlier essays, which offer similar versions of my argument in this section; see 'Crowning the Victors at Olympia: the Great Room's primary focus', in Dunne and Pressly (eds), *James Barry, 1741–1806*, pp. 189–210, and 'James Barry's *Crowning the Victors at Olympia*: transmitting the values of the classical Olympic Games into the modern era', in Barbara Goff and Michael Simpson (eds), *Thinking the Olympics: The Classical Tradition and the Modern Games* (London: Bristol Classical Press, 2011), pp. 122–40.

36 In the first half of the eighteenth century, the painting was replaced by a mosaic after it, but Barry would have known both the mosaic and the picture itself, which was removed to the Vatican's Pinacotecca.

37 Reproduced in Dunne (ed.), *James Barry, 1741–1806*, p. 213, DR60.

38 Barry, 1793, pp. 434–5.

39 Barry, 1798, p. 526.

40 Ibid.

41 Multiple examples of papal processions are reproduced in Maurizio Fagiolo dell'Arco's *La Festa Barocca* (Rome: De Luca, 1997). See in particular Giovanni Orlandi's 1605 print of the procession of Pope Leo XI (p. 199) and Giovan Battista Falda's 1676 print of the procession of Pope Innocent XI (p. 506). J.I. Van Swaneburg's painting *Ceremonial Procession of the Pope in St Peter's Square* of 1628 also gives a good sense of the colourful pageantry observed on such occasions (reproduced in colour in Jörg Garms, *Vedute di Roma dal Medioevo all'Ottocento* (Naples: Electa Napoli, 1995), p. 43). There is little difference between these papal processions and the *Roman Triumph* reproduced in Charles Rollin, *History of the Arts and Sciences of the Ancients*, 2nd edn (3 vols, London, 1768), vol. 2, facing p. 34, where the victor rides in a chariot instead of a sedia.

42 Possibly Barry intended to show the pope held up by two Churches, the Roman Catholic Church, which looks up with reverence at him, and the Greek Orthodox, which has been distracted from full acknowledgment of its true leader. The third of Diagoras' sons, seen at the left holding one of his brother's hands, is perhaps representative of the Protestant Churches, which stand even further apart from the papacy. His boots and garment suggest he is an equestrian, but if nudity is equated with truth, then his clothing also may be intended to suggest he does not possess the same degree of purity as his brothers.

43 The number of judges was at first one, then two, and at the 103rd Olympiad it was increased to twelve in accordance with the number of the tribes of Elis. (In this chapter on classical and biblical parallels, the symmetry between the twelve tribes of Elis and the twelve tribes of Israel should not go unremarked.) However, in the next Olympiad, the number of judges was reduced to eight but then increased to nine and finally to ten; see John Potter, *Archæologia Græca, or, The Antiquities of* Greece, 2nd edn (2 vols, London, 1706), vol. 1, pp. 447–8. After this detailed accounting, Potter, however, opens the door for there having been three judges when he describes a dispute with two judges ruling for one candidate, and the third for another; see ibid. vol. 1, p. 448. One presumes the three were judging a specific event and only represented a portion of the whole.

44 If Barry intended these judges to represent the Trinity, then it seems unlikely, to say the least, that he ever contemplated introducing any of his contemporaries into the role of these three judges. Either he was not thinking in terms of the Trinity in the early stages of his conception or, more likely, he was planning to introduce his contemporaries in the figures of the lesser judges.

45 I am grateful to Quint Gregory for this observation. However, not everyone agrees with this interpretation. Suffice it to say here, the only other explanation for the left arm that can be read as an extension of two different bodies is the artist's clumsiness.

46 In the second half of the nineteenth century, the artist Frederic Leighton, for one, took inspiration from some elements of *Crowning the Victors at Olympia*. In particular, his processional picture *The Daphnephoria* (Lady Lever Art Gallery, Port Sunlight) of 1874–76 is akin to Barry's mural in composition and subject. While executing *The Daphnephoria*, Leighton conceived his famous sculpture *An Athlete Struggling with a Python* (Tate Britain, London), and in this instance, too, the source for the idea both of a heroic, virtuous athlete and a combat with a serpent can be found in Barry's painting.

47 Much of the following account is taken from Pressly, 'A chapel of natural and revealed religion'.

48 See *Works*, vol. 1, p. 6. Fryer's statement that while Barry was on the Continent he had doubted the existence of revealed religion requires qualification. The evidence of a work such as *The Birth of Pandora*, which was conceived in Rome, suggests that even then he believed in divine intervention in human affairs.

49 Barry to Dr Sleigh, Nov. 1767, in *Works*, vol. 1, p. 139.

50 *Works*, vol. 1, p. 324.

51 To give one example, in 1768 the bishop founded the Warburtonian lecture at Lincoln's Inn, which was 'to prove the truth of revealed religion … from the completion of the prophecies of the Old and New Testament which relate to the Christian Church, especially to the apostacy of Papal Rome'; *Encyclopædia Britannica*, 11th edn (29 vols, Cambridge: University of Cambridge Press, 1911), vol. 28, p. 318.

52 For an overview of Warburton's life and writings, see Robert M. Ryley, *William Warburton* (Boston: Twayne Publishers, 1984).

53 Warburton, *Divine Legation of Moses*, vol. 1, bk 2, sect. 4, pp. 275–6.

54 Ibid., p. 276.

55 An introduction to ancient mystery cults, in which the Eleusinian Mysteries occupy the first chapter, can be found in Hugh Bowden, *Mystery Cults of the Ancient World* (Princeton and Oxford: Princeton University Press, 2010). Although the soon-to-be-renowned historian Edward Gibbon heaped derision on Warburton's argument in his short retort *Critical Observations on the Sixth Book of the Æneid*, published in 1770, Barry chose to ignore Gibbon's objections.

56 Warburton, *Divine Legation of Moses*, vol. 1, bk 2, sect. 4, p. 272.

57 Ibid. p. 277.

58 Ibid. pp. 277–8.

59 Ibid. p. 275. Of interest here is Gilbert West's linkage of the Olympic Games and the Eleusinian Mysteries, asserting that, according to Pausanias, of all the many Greek spectacles, these two, transacted with religious pomp and care, were the most solemn; see West, *Odes of Pindar*, p. xii.

60 Warburton, *Divine Legation of Moses*, pp. 280–1. In this passage Warburton is quoting from an unidentified ancient writer whose words were recorded by Stobæus.

61 Ibid. p. 281.

62 Ibid. p. 280.

63 See ibid. p. 279.

64 Ibid. p. 284.

65 Ibid. p. 285.

66 Ibid. p. 274.

67 Ibid. p. 143.

68 Because the painting's surface shows varying degrees of finish, one might argue that while the composition is complete, its degree of polish is uneven. For a fuller treatment of this painting, see my article, 'James Barry's syncretic vision: the fusion of classical and Christian in his *Birth of Pandora*', *British Art Journal*, vol. 14 (winter 2013–14), pp. 27–35.

69 For a different approach to interpreting this painting, see 'The birth of Pandora and the origin of painting', in Barrell, *Birth of Pandora*, pp. 145–220.

70 In the British Museum catalogue of drawings, Laurence Binyon entitled a Barry drawing as *Christianity Overthrowing Idolatry*. Another version of this same subject has also survived; see 'Catalogue of drawings' in Pressly, *Life and Art of James Barry*, pp. 248–9, nos 23, 24. In light of a syncretic reading of Barry's work that combines classical and Christian, Binyon's title should be discarded. For the moment the subject is unidentified.

71 *The Works of Hesiod*, trans. from Greek by [Thomas] Cooke, 2nd edn (London, 1740), p. 15, footnote.

72 Reproduced in Pressly, 'James Barry's syncretic vision', p. 27, Fig. 2.

73 See James Stuart and Nicholas Revett, *The Antiquities of Athens* (London, 1787 [1790]), vol. 2, pl. 23 and p. 12. The reason for the identification of the goddess as Athena can be found in Ian Jenkins, *The Parthenon Frieze* (Austin: University of Texas Press, 1994), p. 79.

74 Reproduced in Pressly, *Life and Art of James Barry*, p. 28, fig. 19. This painting in the National Gallery, London, is now thought to be possibly only from Reni's studio. Barry describes two of the Three Graces as pouring ambrosia and plaiting Pandora's hair in Barry, *c*. 1802, p. 153.

75 Reproduced in Pressly, 'James Barry's syncretic vision', p. 31, Fig. 4.

76 Barry, *c*. 1802, pp. 154–5.

77 Ibid. p. 156.

78 Ibid. p. 155.

79 Ibid. p. 157.

80 A letter by Barry published in the *Morning Chronicle*, 1 May 1775, on the occasion of Barry's having exhibited a drawing of the birth of Pandora at the Royal Academy.

81 Barry, *c*. 1802, pp. 147 and 148 respectively.

82 Ibid. p. 147.

83 Ibid. p. 148.

84 This configuration of a baptism on top with a vulnerable or wounded foot at bottom is similar to the symbolism played out in *The Baptism of the King of Cashel*.

85 Dora and Erwin Panofsky, *Pandora's Box: The Changing Aspects of a Mythical Symbol*, 2nd edn (New York: Bollingen Foundation, 1962), pp. 89–90.

86 Barry, *c*. 1802, p. 153.

87 *Works*, vol. 2, p. 146.

88 Warburton, *Divine Legation of Moses*, vol. 1, bk 2, sect. 4, p. 210. The Eleusinian Mysteries also involved the drinking of the *kykeon*, a barley-based beverage that some commentators characterised as a religious sacrament, thereby providing another parallel with Christianity. See George E. Mylonas, *Eleusis and the Eleusinian Mysteries* (Princeton: Princeton University Press, 1961), pp. 259–60. Although Mylonas disagrees with this interpretation, he provides a summary of sources arguing in its favour.

89 Warburton argues that Apuleius' devotion to the Mysteries as the sole path to virtue naturally had led him to oppose Christianity, the chief threat to making the Mysteries obsolete. Furthermore a personal injury inflicted on him by a Christian accuser had made him even more antagonistic. See Warburton, *Divine Legation of Moses* vol. 1, bk 2, sect. 4, pp. 298–303.

90 One of Barry's notations confirms his identification of aspects of his painting *Pandora* with the Eleusinian Mysteries: 'for the Serpent round ye vase of water in ye Pandora see Eleusin. Mist. 112'; Barry's commonplace book, p. 428. This may be a reference to [Thomas Taylor], *A Dissertation on the Eleusinian and Bacchic Mysteries* (Amsterdam: printed for J. Weitstein [1790?]). On page 112 Taylor writes in the context of Ceres' search for her daughter, 'as these animals [serpents and dragons] put off their skins, and become young again, so the divisible life of the soul, falling into generation, is rejuvenized in its subsequent progression'. Taylor approved of Warburton's reading of Book 6 of *The Aeneid* as representing the rites of the Eleusinian Mysteries, even as he criticised him for interpreting these initiations as being Christian in nature, but Barry would have welcomed Taylor's confirmation that the snake represents rejuvenating transitions. It is worth pointing out that the entry in Barry's commonplace book just before this one reads, 'Isis is all ye Gods. See Apuleius. Eleus. Mist 77'. Taylor also discusses Apuleius' many identifications of Isis under the names of other

goddesses (pp. 73–8). Although Taylor's book postdates Barry's primary engagement in his paintings with Warburton and the Eleusinian Mysteries, these entries demonstrate the artist's continuing interest in this subject and prove as well his association of elements of *Pandora* with the Mysteries.

91 *Works*, vol. 1, p. 318.
92 Ibid.
93 Ibid. p. 317.

Chapter 12

1 Domenico Comparetti, *Vergil in the Middle Ages* (Hamden, Conn.: Archon Books, 1966; repr. of 2nd edn of 1908), pp. 96–7.
2 *Works of Publius Virgilius Maro*, trans. Ogilby, p. 19.
3 For a helpful overview, see Sean Cocco, 'Natural marvels and ancient ruins: volcanism and the recovery of antiquity in early modern Naples', in Gardener Coates and Seydl (eds), *Antiquity Recovered*, pp. 15–35.
4 Barry to the Burkes, n.d., in *Works*, vol. 1, p. 109.
5 See John H. D'Arms, *Romans on the Bay of Naples: A Social and Cultural Study of the Villas and their Owners from 150 B.C. to A.D. 400* (Cambridge, Mass.: Harvard University Press, 1970).
6 As was the case in the eighteenth century, the spelling of place names here will be inconsistent. The Latin 'Misenum' in Italian is 'Miseno'. In eighteenth-century literature, although the Latin 'Baiae' is more frequently used than the Italian 'Baia', I have used the latter as it is the spelling adopted by Barry. The Latin 'Cumae' is often used in place of 'Cuma', but in the case of the town Pozzuoli the Italian spelling is almost always used over the Latin 'Puteoli'. 'Herculaneum' of course is the Latin name of the modern 'Ercolano', another example of the interchangeability of classical and modern terms.
7 Madame du Bocage, *Letters Concerning England, Holland and Italy* (2 vols, London, 1770), vol. 2, p. 83.
8 Edward Wright, *Some Observations Made in Travelling Through France, Italy, &c. in the Years 1720, 1721, and 1722* (2 vols, London, 1730), vol. 1, pp. 173–4.
9 For an account of reactions to Virgil's tomb over time, see J.B. Trapp, 'The grave of Vergil', *Journal of the Warburg and Courtauld Institutes*, vol. 47 (1984), pp. 1–30 and illus. pp. 1–14.
10 Joseph Addison, *Remarks on Several Parts of Italy, &c. in the Years 1701, 1702, 1703* (London, 1761), p. 132.
11 Edward Holdsworth, *Remarks and Dissertations on Virgil* (London, 1768), p. 504.
12 E.S. De Beer (ed.), *The Diary of John Evelyn* (6 vols, Oxford: Clarendon Press, 1955), Feb. 1645, vol. 2, p. 338. While improvements were made in the eighteenth century, the passage through the grotto was still an adventure. More than two decades after Barry had made his visit, Henry Swinburne wrote: 'The dust is here intolerable in summer, and the scantiness of light at all times distressing … I never could accustom myself perfectly to this subterraneous road, but with hasty steps sought to leave it as the seat of noise, gloom, dust, and unwholesome damps'; Henry Swinburne, *Travels in the Two Sicilies*, 2 vols (London, 1783 and 1785), vol. 2, p. 55.
13 This sketchbook is discussed in Pressly, 'On classic ground', pp. 12–28.
14 Lady Miller, writing at the time of Barry's visit, did not hesitate to associate it with the Temple of Apollo described in Book 6 of *The Aeneid*: 'We determined to continue our course, after having first taken a view of the famous Temple of Apollo, probably that so beautifully described by Virgil, and which is situated on the borders of the lake, opposite the Sybil's cave'; Miller, *Letters from Italy*, vol. 2, p. 248.
15 Over the centuries the location of the Sibyl's Cave has been disputed. Commentators realised that the cave on the lake's north-west side had originally formed the entrance to a passageway that extended all the way to Cuma. This tunnel has sometimes been referred to as the Grotta della Pace after the Spanish captain Pietro de Pace, who plundered this site in the early sixteenth century, and sometimes as the Grotta di Cocceio after the first-century BC Roman architect who oversaw its construction. In the intervening centuries, collapses had blocked portions of the passage, but the eighteenth-century visitor could still encounter a large room with mosaics as well as three smaller chambers, all assigned to the sibyl. Edward Wright's comment of 1730 gives a judicious summary: 'Whether this was really a *Sibyl's* Grotta or no, 'tis generally agreed to have been that from whence *Virgil* took his Idea; so that 'tis at least the *Grotta* of the *Æneid*'; Wright, *Some Observations Made in Travelling Through France*, vol. 1, p. 181. In the nineteenth century, a 'cave' on the lake's south bank, the entrance to another man-made tunnel constructed by the Romans to link Lake Avernus with Lake Lucrinus, was designated the Sibyl's Cave. With the discovery in 1932 of the impressive corridor on the acropolis at Cuma, the site of the Sibyl's Cave was again relocated.
16 Edward Wright again offers a helpful summation: 'The *Monte Gauro*, once so Famous for its Wines, afterwards became (thro' Earthquakes, &c.) in a great measure barren, and continued so for some time, insomuch that it obtain'd the Name of *Monte Barbaro*, but has since been cultivated and planted, and is at this time very fertile in some parts of it. Hereabouts they say was produced the famous *Falernian* wine'; Wright, *Some Observations Made in Travelling Through France*, vol. 1, p. 177. In my earlier discussion of this drawing, I misidentified these mountains as Barbaro and Monte Nuovo. It required standing on the shores of the lake itself, aided by the local inhabitants, to secure the correct identifications.
17 Barry to the Burkes, n.d., in *Works*, vol. 1, pp. 111–12.
18 In 1730 Edward Wright remarked on the making of these sweating rooms: 'There are in these Parts abundance of Baths,

and Sweating-places; one among them they call *Cicero*'s, at *Baiæ*; another *Nero*'s; to him are ascrib'd those famous ones of *Tritoli*, which could indeed be made by none but an Emperor, and such a one too as did not value the Toil, or indeed the Lives of his Slaves, who must have work'd hard where the Heat was so suffocating, that we were scarce able to stand'; Wright, *Some Observations Made in Travelling Through France*, vol. 1, p. 179. In writing of Nero's hot baths, James Russel reported, 'My guide assured me, that no one can bear the heat of these Baths above a quarter of an hour: so that a great number of people must needs have perished, in carrying on and finishing so difficult and tedious a work'; [Russel], *Letters from a Young Painter Abroad*, p. 103.

19 John Evelyn records in his diary concerning Lake Avernus, 'Eustatius [of Matera] affirmes that our B:[lessed] Saviour ascended from those Infernal regions in this very place'. De Beer (ed.), *Diary of John Evelyn*, vol. 2, p. 346.

20 See Spence, *Polymetis*, p. 258.

21 Sacheverell Stevens, *Miscellaneous Remarks Made on the Spot, in a Late Seven Years Tour Through France, Italy, Germany and Holland* (London [1756]), p. 215.

22 Ibid. p. 216.

23 Ibid.

24 Ibid. p. 217.

25 See Warburton, *Divine Legation of Moses*, vol. 1, bk 2, sect. 4, p. 282. Earlier Warburton had made the same argument: 'For, the descent of Virgil's hero into the infernal regions, I presume, was no other than a figurative description of an INITIATION'; ibid. pp. 210–11. One should not forget how important Orpheus' descent was to this formulation. Warburton could not resist wildly speculating, 'Had an old poem, under the name of Orpheus, intituled, *A descent into hell*, been now extant, it would, perhaps, have shewn us, that no more was meant than Orpheus' *initiation*; and that the idea of this sixth book [of *The Aeneid*] was taken from thence'; ibid. p. 233.

26 Burney manuscript, p. 19v.

27 See chapter 1, the first paragraph of the section entitled 'A contemporary precedent: charting the progress of civilisation at Merly House'.

28 Johnson, vol. 2, no pagination. His fourth definition for 'progressions' is the same: 'Intellectual advance'.

29 Warburton, for one, asserts that the early Britons, as had the Greeks, derived their sacred rites from the Egyptians: 'The sages who brought them [the Mysteries] out of Egypt, and propagated them in Asia, in Greece, and Britain, were all kings or lawgivers'; Warburton, *Divine Legation of Moses*, vol. 1, bk 2, sect. 4, p. 205. In Britain's case this meant the Druids. Earlier, Warburton had argued that the Druids had introduced into Britain the Orgies of Bacchus, even before these rites had been introduced into Greece; see vol. 1, p. 140.

30 The Villa Borghese, for example, contains Federico Barrocci's 1598 painting *Aeneas' Flight from Troy*, but the most famous painted version is in Raphael's Vatican *Stanze*. In *The Fire in the Borgo*, the escaping family at the left pays homage to Virgil's description of Aeneas and his family fleeing the flames of Troy. Barry would also have known the book illustration of this celebrated scene in the Virgil/Ogilby and Virgil/Dryden engravings. Barry had himself executed this subject before leaving Cork. Fryer lists five canvases that hung in his father's house, all of which were of biblical subjects, with the exception of *Æneas Escaping with his Family from the Flames of Troy*; see *Works*, vol. 1, p. 7.

31 Bernini's skilful articulation of the Three Ages is best seen in the backs of the figures: Ascanius' flesh is soft and plump, Aeneas' physique is heroic and muscular, while Anchises' flesh sags alongside a well-defined backbone.

32 See Barry, 1798, p. 576.

Part 3

1 Barry, 1798, p. 580.

2 I am indebted to Lois Berdaus for introducing me to this and the following image by Wille in her 'Forging a new iconography: the French revolutionary festivals in Paris, 1789–1799', Ph.D thesis, University of Maryland, 2003, fig. 75. Two examples of this print after Abraham Girardet can also be found in the videodisc, *Images of the French Revolution*, gen. dir. Laure Beaumont-Maillet, a co-publication of the Bibliothèque Nationale, Paris, and Pergamon Press, London and Oxford, 1990, figs. 18853 and 18866.

3 See Berdaus, fig. 87, and *Images of the French Revolution* videodisc, fig. 18780.

4 Barry, 1798, pp. 578–9.

Chapter 13

1 This letter, which is in Barry's commonplace book (pp. 154–88), is published under its date in Barry's *Correspondence*.

2 Barry's commonplace book, pp. 155, 157.

3 Ibid. p. 159.

4 This account incorporates portions of my earlier discussion in Pressly, *Life and Art of James Barry*, pp. 175–8. Also see William L. Pressly, 'James Barry's proposed extensions for his Adelphi series', *Journal of the Royal Society of Arts*, vol. 126 (Apr. 1978), pp. 296–301.

5 Barry mentions the two letters to Pitt in his letter to the Society written on 6 January 1803, in Barry, letter-book 2. An excerpt from one of the letters is printed in *Works*, vol. 1, p. 284.

6 Barry to the Society, 31 Mar. 1801, in Barry, letter-book 2.

7 Excerpt from letter from Barry to Pitt, in *Works*, vol. 1, p. 284.

8 From an inscription on the drawing in the British Museum reproduced here as fig. 45.

9 The official Act of Union of Wales with England had taken place in 1536 in the reign of Henry VIII. When Barry talks of the three kingdoms (England, Scotland and Ireland), Wales is not of the company as a separate entity.

10 This phrase from Virgil's *Pastoral* or *Eclogue X* (Dryden, *Works of Virgil*, line 99) has already been quoted in chapter 11 under the discussion of *The Birth of Pandora*.

11 The inscription is to be found in the lower-right corner of the drawing reproduced here as fig. 45. The last line of the inscription is so severely cropped, it is impossible to cipher without anticipating the words '& Hibernia'.

12 I want to thank Lyrica Taylor for pointing out to me this symbolism.

13 Barry to the Society, 31 Mar. 1801.

14 See the discussion on *The Birth of Pandora* in chapter 11.

15 For analyses of Rubens' paintings, see Fiona Donovan, *Rubens and England* (New Haven and London: Yale University Press, 2004), and Gregory Martin, *Rubens: The Ceiling Decoration of the Banqueting Hall*, Corpus Rubenianum Ludwig Burchard XV (2 vols, London: Harvey Miller, 2005).

16 The child also alludes to James' then youthful heir, who was to succeed him as Charles I.

17 Barry to the Society, 6 May 1801, in Barry, letter-book 2.

18 Reproduced in Pressly, 'James Barry's proposed extensions for his Adelphi series', p. 300, fig. 4.

19 Barry to the Society, 31 Mar. 1801, in Barry, letter-book 2.

20 Barry to the Society, 6 May 1801, in Barry, letter-book 2.

21 Barry to the Earl of Buchan, 21 Dec. 1804, National Portrait Gallery, London.

22 For informed and differing discussions of Barry's political beliefs, see John Barrell, 'Reform and revolution: James Barry's writings in the 1790s', in Dunne and Pressly (eds), *James Barry, 1741–1806*, pp. 127–43, and Tom Dunne, 'Painting and patriotism', in Dunne (ed.), *James Barry, 1741–1806*, pp. 119–37.

23 This print is discussed at length in Claudette Hould, Quebec: Musée du Québec, *Images of the French Revolution* (1989), catalogue, p. 365.

24 *Æsop's Fables*, ed. Samuel Richardson (London [1760?]), fable 53, 'A father and his sons', p. 43. The inventory compiled after Barry's death lists two copies of the fables, one of which was the John Ogilby edition; see 'Inventory of Barry's estate', Lewis-Walpole Library, Farmington, CT. McLoughlin records both books in his section 'James Barry's library' in Barry's Correspondence.

25 Reproduced in David Bindman, London: British Museum, *The Shadow of the Guillotine: Britain and the French Revolution* (1989), catalogue, p. 55, fig. 195i. On the obverse, framed by the motto 'UNITED FOR A REFORM OF PARLIAMENT', is the dove of peace with an olive branch, recalling the dove, *sans* olive branch, in Barry's drawings.

26 Minutes, 19 June 1801. Much of the material in this section comes from my essay. 'Barry's medal for the Society of Arts: a celebration of the three kingdoms', in Bennett (ed.), *Cultivating the Human Faculties*, pp. 131–41.

27 Stuart's medal is reproduced in Bennett (ed.), *Cultivating the Human Faculties*, p. 132, fig. 38.

28 See the minutes of 3 Nov. 1801 for the report concerning the response of the five artists. At that time the committee resolved to advertise for other submissions.

29 John Flaxman eventually created the new medal, following, on the recommendation of the Committee of the Polite Arts, 'the principles suggested by Mr. Barry on this subject in the 19th Vol. of their Transactions'; see Minutes, 3 Dec. 1805. Flaxman's medal is reproduced in Pressly, *Life and Art of James Barry*, p. 294, fig. 148.

30 Barry's letter of 25 Oct. 1801, to the Society of Arts is in Barry, letter-book 2. It was published in *Works*, vol. 2, pp. 647–61.

31 See Barry, 1801.

32 Letter of 25 Oct. 1801, in *Works*, vol. 2, p. 648.

33 Ibid. pp. 647–8.

34 Ibid. p. 648.

35 Letter of 26 Nov. 1801, in Barry, 1801, p. xxviii.

36 The engraved head of Britannia with her shield is reproduced in *Works*, vol. 2, p. 474. This image, however, omits any botanical imagery.

37 Letter to Lord Liverpool (3 July 1801), reprinted in the body of a letter to the Society of Arts, 25 Oct. 1801, in *Works*, vol. 2, p. 652. While the letter itself is undated, Barry gives its date in his letter of 26 November 1801.

38 *Works*, vol. 2, p. 652.

39 Barry hopes that his letter to Lord Liverpool will entice at least one official to visit the Great Room: 'your lordship, or whoever you may send there, will see immediately, on the slightest glance at those models …' (ibid. p. 651).

40 One presumes that Barry did not concern himself with designing a new reverse because he anticipated that its primary function would be as a ground for commemorative inscriptions.

41 See Minutes, 25 Nov. 1801.

42 See Barry, 1801, pp. xxxvii–xxxviii. A portion of Barry's comments is quoted in the introduction to this section.

43 Fintan Cullen has insightful comments on how Barry associated *Pandora*'s Minerva with Ireland. See Fintan Cullen,

Visual Politics: The Representation of Ireland, 1750–1930 (Cork: Cork University Press, 1997), pp. 34–6. His book in general does an excellent job of situating Barry within an Irish context.

44 See Barry, 1782 (Lecture IV), pp. 466–8.

45 Barry, 1793, p. 449. This is the same argument, more temperately stated, that he had made in his letter to Lord Shannon of 4 January 1778.

46 The first of two landings took place on 22 August 1798, when the French General Humbert disembarked with his troops at Killala Bay. He was able to make some headway before surrendering on 8 September. The other landing was an anticlimax. No sooner had he landed near Donegal with rebel leaders in tow, Napper Tandy departed on 17 September after learning of Humbert's defeat.

47 Francis Burroughs, *A Poetical Epistle to James Barry, Esq.* (London: printed by S. Gosnell for J. Carpenter, 1805), p. iii, footnote.

48 Ibid. p. iv, footnote.

49 Ibid. p. iii.

50 *The Art Journal* (London), 1908, p. 317.

51 The preparatory drawing for the print makes clear that these are bayonets rather than pikes or lances.

52 Reproduced in colour in Paris, Grand Palais, and London, Royal Academy of Arts, *Reynolds*, 1985–86, p. 115, fig. 42.

Conclusion

1 For an account of this project, see my essay 'Benjamin West's Royal Chapel at Windsor: who's in charge, the patron or the painter?', which is to be published in *Transatlantic Romanticism: An Anthology*, Andrew Hemingway and Alan Wallach (eds), forthcoming.

2 Draft of letter of 25 May 1811, from West to H. Rowland interleaved in folio edition of John Galt, *The Life, Studies, and Works of Benjamin West* (London, 1820), vol. 5, p. 43, in the collection of the Historical Society of Pennsylvania, quoted in Nancy Pressly, San Antonio Museum of Art, *Revealed Religion: Benjamin West's Commissions for Windsor Castle and Fonthill Abbey* (1983), catalogue, p. 15.

3 For an account of this project, see my essay 'Inoculating the public against French infection: John Francis Rigaud's 1794 frescoes in London's Guildhall', which is to be published in the *British Art Journal*.

4 Martin Butlin, *The Paintings and Drawings of William Blake* (2 vols, New Haven and London: Yale University Press for Paul Mellon Centre for Studies in British Art, 1981), vol. 1, p. 492, no. 68. The portrait (reproduced in vol. 2, no. 904) shows Barry as irascibly intense. In his biography, Peter Ackroyd points out that at one point Blake even contemplated writing 'an epic poem in three books entitled simply *Barry*'; Peter Ackroyd, *Blake* (New York: Alfred A. Knopf, 1996), p. 68.

5 See Pressly, *Life and Art of James Barry*, pp. 149–51.

6 'Annotations to the works of Sir Joshua Reynolds', in Erdman (ed.), *Poetry and Prose of William Blake*, p. 625.

7 Blake's print *Joseph of Arimathea Preaching to the Britons* is reproduced in David Bindman, *The Complete Graphic Works of William Blake* (New York: G.P. Putnam's Sons, 1978), no. 320.

8 Blake, *Marriage of Heaven and Hell*, (Lambeth, London, *c.* 1790–93), pls 22, 23.

9 Blake, *Jerusalem: The Emanation of the Giant Albion*, pl. 77, reproduced in vol. 1 of *Blake's Illuminated Books*, ed. David Bindman (Princeton: Princeton University Press in conjunction with the William Blake Trust, 1991).

10 Blake used the quote, 'Would to God that all the Lords people were Prophets', in his preface to his 1804 *Milton*; see 'Supplementary illustrations' in *William Blake: Milton a Poem*, vol. 5 of *Blake's Illuminated Books*, ed. David Bindman (Princeton: Princeton University Press in conjunction with the William Blake Trust, 1993), p. 94, pl. 2.

11 'Blake's exhibition and catalogue of 1809', in Erdman (ed.) *Poetry and Prose of William Blake*, p. 518.

12 Ibid. p. 539.

13 Ibid. pp. 518–19.

14 David Bindman, 'William Blake and popular religious imagery', *Burlington Magazine*, vol. 128 (Oct. 1986), pp. 712–18.

15 D.W. Dörrbecker provides a summary of some of the critical responses to this image in *William Blake: The Continental Prophecies*, vol. 4 of *Blake's Illuminated Books* (Princeton: Princeton University Press in conjunction with the William Blake Trust, 1995), pp. 205–6.

16 Another visual source for this image also refers back to *The Aeneid*, where Virgil tells the story of the death of the priest Laocoön and his two sons. The sculpture of this group as later engraved by Blake (reproduced in Bindman, *Complete Graphic Works of William Blake*, no. 623) recalls elements in the earlier design. The young hero's torso in *Europe* is modelled on that of the priest. In addition, although Laocoön is seated, Blake adapts the figure to a striding pose. The left leg of each forms an identical diagonal, and Blake even makes the bent right leg of Laocoön splay out more than it does in the original, thereby bringing it closer to the 1794 image. Finally, the otherwise inexplicable drapery that spills down behind the young hero echoes that of the sculpture, even if the two sons have been transformed into two daughters.

17 'Blake's exhibition and catalogue of 1809', in Erdman (ed.), *Poetry and Prose of William Blake*, p. 534. See also Blake's illuminated book *All Religions Are One*.

18 These three oils are reproduced and discussed in Dunne (ed.), *James Barry, 1741–1806*, nos. P1–P3. The late drawings and prints are reproduced as nos. DR49, DR50, PR40.

19 See the section entitled 'Enriching the work with contemporary portraits' in chapter 4.

20 Reproduced in Dunne (ed.), *James Barry, 1741–1806*, PR17.

21 Pliny, *Natural History*, trans. H. Rackham (10 vols, Cambridge, Mass.: Harvard University Press, and London: William Heinemann Ltd., 1968), vol. 9, book XXXV.xxxvi.74 (p. 317).

22 Franciscus Junius, *The Painting of the Ancients* (London: Richard Hodgkinsonne, 1638), p. 243.

23 Roland Freart, Sieur de C[h]ambray, *An Idea of the Perfection of Painting*, trans. from French by J.E. (London, 1668), pp. 86–7.

24 Ibid. p. 88.

25 [Edmund Burke], *A Philosophical Enquiry into the Origin of our Ideas of the Sublime and Beautiful* (London: printed for R. & J. Dodsley, 1757), pp. 162–3.

26 Equally unforgettable is Giulio Romano's fresco of Polyphemus, alluding to his unrequited love for Galatea, in the Palazzo del Te, Mantua. Annibale Carracci also gave Polyphemus a prominent place in his frescoes at the Palazzo Farnese, Rome, where the Cyclops attempts to serenade on his pan pipes the waterborne Galatea.

27 Chambray, p. 92.

28 Barry to the Society of Arts, 2 May 1804, copied in Minutes, 6 June 1804.

29 Barry, 1783, p. 331.

30 See Barry's letter to Sir George Savile of 19 Apr. 1777, in *Works*, vol. 1, p. 255.

31 *The Works of Horace*, begun by David Watson and revised and enlarged by S. Patrick, 4th edn (2 vols, London, 1760), vol. 2, pp. 314, 316.

32 Barry, 1783, p. 331.

33 Valentine Green, who in 1772 had published a mezzotint after Barry's painting *Venus Rising from the Sea* and who was a go-between for the artist and the Society, employed Horace's trope of Hercules conquering envy only in death at the same time as Barry in terms of the attacks of the cognoscenti on painters: 'But enough, surely, has been sacrificed to the supercilious vanity of our half-formed *Conoscenti*, in the run they have been pleased to make on the Modern Professors of the Arts … To read the scurrility with which they are attacked, to mark the venom and inveteracy with which they are aspersed, one cannot but turn aside from them with indignant horror, and bewail the baseness of the principles on which such depraved sentiments are founded … To become eminent in the Arts is an Herculean task; and many secret and open Hydras are to be encountered on the way … though true prophets, their report is not to be believed, nor can they hope to obtain justice till out of the reach of envy, and mixed with the dust of the earth, they receive it in the incense of an impartial and grateful Posterity'; Valentine Green, *A Review of the Polite Arts in France, at the Time of their Establishment under Louis XIVth, Compared with their Present State in England … in a Letter to Sir Joshua Reynolds* (London, 1782), pp. 66–8. In using a phrase such as 'Professors of the Arts', Green signals that Barry was among those he had in mind.

34 David Cast, *The Calumny of Apelles: A Study in the Humanist Tradition* (New Haven and London: Yale University Press, 1981), p. 1.

35 According to Cast, Petrarch seems to have been the first to compare an artist to Apelles, in this instance Simone Martini; see ibid. p. 167. The first artist to take the compliment upon himself in a self-portrait was Antonio Moro in 1588; see ibid. p. 169.

36 Since the Renaissance, the *Belvedere Torso*'s reputation had benefitted from Michelangelo's admiration for it; see Haskell and Penny, *Taste and the Antique*, no. 80. In describing a cast of the *Torso* in the Royal Academy, Barry's friend Giuseppe Baretti made the by then commonplace linkage of this classical work with the Renaissance artist when he referred to 'the famous colossal *Torso of Michelangelo*, so emphatically [*sic*] called, because Michelangelo termed it His School, thinking it the very best remain of Greek Sculpture that the World could show'; Joseph Baretti, *A Guide Through the Royal Academy* (London: T. Cadell, 1781), p. 28.

37 In his lectures as professor of painting at the Royal Academy, Barry twice described the *Belvedere Torso* as above all other works of art, calling it in Lecture I an 'unparalleled piece of excellence', and again reaffirming this assessment in Lecture III: 'The Torso of the Belvedere, is as to perfection really *unique*. There is nothing that can be put into the same class with it'; Barry, 1782, pp. 368 and 447, respectively.

38 In discussing the *Torso*, Baretti repeats the identification of the subject with Hercules: 'By the Lion's skin under it, 'tis reasonably supposed to have represented an Hercules'; Baretti, *A Guide Through the Royal Academy*, p. 28.

39 Barbara Stafford offers a reading of this painting that either ignores or is ignorant of the artist's own statements. She maintains that the figure of the Cyclops in the painting within the painting alludes to 'the about-to-be-flayed Pan', who 'hides his face to express the intensity of corporeal suffering, not through wracked features but through the Belvedere twist of the torso alone'; Barbara Maria Stafford, *Visual Analogy: Consciousness as the Art of Connecting* (Cambridge, Mass., and London: MIT Press, 1999), p. 35. This painting-within-the-painting is also incorrectly described as leaning against an easel.

40 Newton's letter is reproduced as the frontispiece to Robert K. Merton, *On the Shoulders of Giants* (New York: Free Press, and London: Collier-Macmillan, 1965), and is quoted on pages 9 and 31.

41 For the most part, the debate centred around writers as the visual arts were considered of lesser importance. In the case of painting, there was little basis for comparison, but what was said about writers and poets could easily be extended to creative figures in general.

42 Edward Young, *Conjectures on Original Composition* (Leeds: Scolar Press Facsimile, 1966), p. 25.

43 Knowles, *Life and Writings of Henry Fuseli*, vol. 3, p. 79, no. 50.

44 In Caravaggio's *The Madonna of the Serpent* (Borghese Gallery, Rome), the Virgin and the youthful Jesus together stomp on the writhing serpent's head.

45 See James Northcote, *Memoirs of Sir Joshua Reynolds* (London, 1813), p. 302.

46 28 Mar. 1819. See Cave (ed.), *Diary of Joseph Farington*, vol. 15, p. 5343. Farington was recording remarks made to him by Dr Thorpe at a dinner party.

47 Northcote, *Memoirs of Sir Joshua Reynolds*, p. 317.

48 Robert R. Wark, 'The iconography and date of James Barry's self-portrait in Dublin', *Burlington Magazine*, vol. 96 (May 1954), p. 154.

49 Robert Rosenblum (painting) and H.W. Janson (sculpture), *19th-century Art*, revised and updated edn (Upper Saddle River, N.J.: Pearson Prentice Hall, 2005), p. 57 (in 1984 edn p. 63). In 2007, the last year of his life, Rosenblum was still echoing these sentiments: 'he [Barry] includes a cropped view of Hercules crushing the serpents of envy, a projection of his own efforts to suppress his personal and professional jealousies'; Robert Rosenblum, 'Portraiture: facts versus fiction', in *Citizens and Kings: Portraits in the Age of Revolution, 1760–1830* (London, Royal Academy of Arts, and Paris, Galeries Nationales du Grand Palais, 2007), p. 22.

50 Barry, 1983, p. 331.

51 Letter of 1 Oct. 1798, in *Works*, vol. 2, p. 641 footnote.

52 Barry, 1784, p. 238.

53 Carl Goldstein, 'The image of the artist reviewed', *Word & Image*, vol. 9 (Jan.–Mar. 1993), p. 14. The literature on canonical rhetorical conventions as applied to artists is sizable, but Goldstein offers a succinct summation.

54 Ibid. p. 17.

55 Ibid. p. 12.

56 Ibid. p. 15.

57 Barry, 1783, p. 314.

58 Hill (ed.), *Boswell's Life of Johnson*, vol. 4, p. 224.

59 *Morning Chronicle*, 29 Apr. 1783, p. 4.

60 Anderson, *Imagined Communities*, p. 6.

61 These definitions are from *Webster's New Collegiate Dictionary*.

62 Blake writes in *The Marriage of Heaven and Hell*, 'Note. The reason Milton wrote in fetters when he wrote of Angels & God, and at liberty when of Devils & Hell, is because he was a true Poet and of the Devils party without knowing it'; Blake, *Marriage of Heaven and Hell,* pl. 6. In his print *Milton Dictating to Ellwood the Quaker*, Barry rejected the traditional subject of the poet dictating to his daughters. His linkage of Milton to a Quaker allowed him to show the poet in sympathy with a religion that, in the artist's mind, was closely aligned with Catholicism.

63 Barry to Society, 6 Jan. 1803, in Barry, letter-book 2.

64 The details on the provenance of these ten pictures can be found in 'The catalogue of paintings', Pressly, *Life and Art of James Barry*, nos. 5, 7, 9–11, 13–15, 17–18.

Appendix 1

1 Barry to Society, 31 Mar. 1801, in Barry, letter-book 2.

2 Barry to Society, 6 Jan. 1803, in Barry, letter-book 2.

3 Barry, 1798, pp. 575–6.

4 Ibid. p. 580.

5 Barry to the Society, 2 May 1804, in Minutes, vol. 49, 6 June 1804, pp. 267–70.

6 Barry, 1793, p. 454.

7 Ibid. p. 444. George Chalmers comments on the patent having been 'chiefly copied from the charter of Maryland' in George Chalmers, *Political Annals of the Present United Colonies, from their Settlement to the Peace of 1763* (London: printed for the author, 1780), p. 636.

8 Barry, 1798, pp. 577–8.

9 See Barry, 1793, p. 432 footnote.

10 St Aubin's print after Charles Nicolas Cochin the Younger's drawing is reproduced and discussed in Charles Coleman Sellers, *Benjamin Franklin in Portraiture* (New Haven and London: Yale University Press, 1962), pp. 109, 227–30, fig. 10a.

11 For Bayle's statements in English translation, see Peter Bayle, *The Dictionary Historical and Critical*, 2nd edn (London, 1737), vol. 4, pp. 128a, 128b, 130a respectively.

12 Barry, 1793, p. 428. Barry was not alone in his condemnation of Queen Elizabeth. In a letter of March 1766, while on the grand tour, Samuel Sharp related the following Neapolitan encounter: 'A certain Catholick Lady informed me, that last year she was at church, when a celebrated Jesuit told the following story. – "That Queen *Elizabeth*, so famous throughout the world for her heresy, made a compact with the Devil, that if he would indulge her in all she desired, and suffer her to reign so many years, she would surrender her soul at the conclusion of that term." Accordingly, the day she died, there

was a great black cloud ascended from the *Thames*, which drew the attention of an infinite number of spectators, who, at last, heard a voice from the cloud pronounce these words, *I am the soul of Queen* Elizabeth, *now going to the Devil for the sins I have committed'*. Samuel Sharp, *Letters from Italy, Describing the Customs and Manners of that Country, in the Years 1765, and 1766*, 3rd edn (London: Henry and Cave, n.d.), pp. 181–2.

13 See Barry, 1793, pp. 427, 446.

14 Barry, letter-book 1, p. 136.

15 Barry, 1798, pp. 525–6.

16 Ibid. p. 526.

17 *Cicero: De Senectute, De Amicitia, De Divinatione*, trans. William Armistead Falconer (London: William Heinemann; and Cambridge, Mass.: Harvard University Press, 1938), p. 199.

18 See William L. Pressly, 'A preparatory drawing for Barry's *Glorious Sextumvirate* rediscovered: the search for the seventh man', in Bennett (ed.), *Cultivating the Human Faculties*, pp. 119–30.

19 See Barry, 1783, pp. 344–5.

20 See John Manning, '"This slip of copper": Barry's engraved detail of *Queen Isabella, Las Casas and Magellan*', in Bennett (ed.), *Cultivating the Human Faculties*, pp. 110–18.

21 For Barry's letter to Fox, which was accompanied by an impression of this print, along with Fox's somewhat bewildered reply, see *Works*, vol. 1, pp. 285–8.

22 As noted in chapter 8, Barry had alluded to the Duchess of Devonshire in the mural *Elysium and Tartarus* in the form of the young angel assisting the superior angel by unveiling the globe at the lower left of the composition, but she had vanished from the large-print series; in *Reserved Knowledge* this assisting angel no longer exhibits portrait-like features. However, the duchess, in the form of Queen Isabella, now returns to the foreground figures in *Elysium*.

23 Barry's commonplace book, p. 18.

24 Barry, 6 Jan. 1803, in Barry, letter-book 2.

25 Barry to Buchan, 3 May 1802, Osborn Collection, Beinecke Rare Book and Manuscript Library, Yale University, New Haven.

26 Barry to Society, 2 May 1804, in Minutes, vol. 49, 6 June 1804, pp. 267–70.

27 George Turnbull, *Treatise on Ancient Painting* (London, 1740), p. 120. Based on Pliny's *Natural History*, 35.11.

28 See Barry, 1798, p. 575.

29 London, Christie's, 11 Apr. 1807, lot 57.

30 This work was first discussed in William L. Pressly, '*Scientists and Philosophers*: a rediscovered print by James Barry', *Journal of the Royal Society of Arts*, vol. 129 (July 1981), pp. 510–15.

31 See Barry, 1802, p. 153.

32 Jacob Bryant, *A New System, or, An Analysis of Ancient Mythology*, 2nd edn (3 vols, London, 1775–76), vol. 1, p. 217.

33 Ibid. vol. 1, p. 218.

34 See the self-portrait drawing reproduced in Pressly, '*Scientists and Philosophers*', fig. 5.

35 These two prints are discussed in William L. Pressly, 'James Barry and the print market', in Elise Goodman (ed.), *Art and Culture in the Eighteenth Century: New Dimensions and Multiple Perspectives* (Newark: University of Delaware Press, and London: Associated University Presses, 2001), pp. 142–56; and in Pressly, '*Elysium*'s elite: Barry's continuing meditations on the Society of Arts Murals', in Bennett (ed.), *Cultivating the Human Faculties*, pp. 98–109.

36 This self-portrait in the Ashmolean Museum, Oxford, is reproduced in Goodman, *Art and Culture in the Eighteenth Century*, fig. 40, and Bennett (ed.), *Cultivating the Human Faculties*, fig. 27.

37 Reproduced in Goodman, *Art and Culture in the Eighteenth Century*, fig. 41, and Bennett (ed.), *Cultivating the Human Faculties*, fig. 28.

Appendix 2

1 Barry, 1798, pp. 580–1.

2 For a discussion as to when the head disappeared, see the subsection entitled '*Missing unidentified male figure*' at the conclusion of this section on the 1798 changes.

3 Reynolds, *Discourse XV*, p. 282.

4 Ibid.

5 The figures were present when Douglas Smith photographed the paintings in 1979 for the Paul Mellon Centre for Studies in British Art. They no longer appear in photographs taken just before the International Fine Art Conservation Studios in Bristol removed the works for conservation in the summer of 1996. However, another conservator had worked on the murals *in situ* from 1984–87, and this seems the most likely period when the editing occurred. I would like to thank Richard Pelter, a director of IFACS, and Evelyn Watson, archivist at the RSA, for their help in determining when these changes might have taken place. These two missing figures appear in David Alan's keys to the painting, as he apparently was unaware they were no longer present when he published his 2005 book; see Allan (ed.), *Progress of Human Knowledge and Culture*, key 18, no. 5, for the angel's head, and key 19, no. 13, for the Elizabethan figure.

6 For an introduction to early images of Chatterton, see Pressly, *Artist as Original Genius*, pp. 165–83.

7 Quoted in Cunningham, *Lives of the Most Eminent British Painters*, vol. 3, p. 324.

8 When the Naval Pillar was added to the print, Barry did not bother to reverse the spiral on the plate, so that it prints in a clockwise direction. The thinner proportions of the tower in the print also correspond to the pentimento in the painting, which demonstrate that he later thickened the tower's proportions in the mural.

9 See John Smeaton, *A Narrative of the Building and a Description of the Construction of the Edystone Lighthouse with Stone*, 2nd edn (London: printed for G. Nicol, 1793).

10 Barry to the Society, 6 Jan. 1803, in Barry, letter-book 2.

11 See [Thomas Martyn], *An Appendix to the Sketch of a Tour Through Swisserland, Containing a Short Account of an Expedition to the Summit of Mont Blanc, by M. De Saussure, of Geneva, in August last* (London: printed for G. Kearsley, 1788), p. 107.

12 Letter of 26 November 1801 in Barry, 1801, p. lix.

13 Barry writes of his belief in an ancient civilisation 'now buried in the remoteness of antiquity', which had provided 'a body of very extensive and complete knowledge' that had been dispersed throughout the world to other nations (Barry, 1798, p. 583). This lost civilisation was presumably Atlantis, which he thought had been located in the Atlantic off the coast of Africa (see Fryer's comments in *Works*, vol. 1, p. 309).

14 Abbé D. Francesco Saverio Clavigero, *The History of Mexico*, trans. from Italian by Charles Cullen (2 vols, London, 1787), vol. 1, p. 268. Barry had copied out this passage in his commonplace book, p. 10.

15 Ibid. vol. 2, p. 202 (page incorrectly printed as 210). In his commonplace book, Barry records assertions, made by John Francis Gemelli Careri in 1698, that the builders of the Mexican pyramids had come from Atlantis and were influenced by the Egyptians, their structures probably dating from 'not much later than ye flood'. The contact apparently was a two-way street as Egyptian obelisks in their turn contain carvings of birds and animals from another world; Barry's commonplace book, p. 13, from *A Collection of Voyages and Travels* (compiled from the library of the late Earl of Oxford) (6 vols London, 1745), vol. 4, p. 514.

16 For a photograph of the minaret of the Great Mosque at Samarra, see Metropolitan Museum of Art, New York, *Art of the First Cities: The Third Millennium B.C. from the Mediterranean to the Indus*, eds. Joan Aruz and Ronald Wallenfels (New York, 2003), fig. 121. Reproduced on that same page is Athanasius Kircher's engraving *The Tower of Babel*, whose design is based on that of the minaret. However, the more modest tower that Kircher introduces in the distance at the right, whose design is also related to the minaret, is particularly close to Barry's Naval Pillar.

17 The Chinese-like characters that Barry mentions on the column in Chile (see his text quoted on pp. 350–1) would again have suggested for him the interconnectedness of the world's far-flung civilisations.

18 Barry to the Burkes, n.d., in *Works*, vol. 1, p. 110.

19 Antonio de Herrera [y Tordesillas], *The General History of the Vast Continent and Islands of America*, trans. from Spanish by Capt. John Stevens, 2nd edn, (6 vols, London: Wood and Woodward, 1740), vol. 4, pp. 284–5.

20 Ibid. pp. 285–6. In his notes Barry recorded the following from Clavigero's *The History of Mexico*: '3. A long & learned dissertation on ye announcing of ye Gospel in Anahuac; wch was done there, as he [Carlos de Siguenza e Gongora] believed, by ye Apostle St Thomas, supporting his opinion on traditions of ye Indians, crosses found, & formerly worshipped in Mexico & other monuments'. Barry's commonplace book, p. 3, from Clavigero, *History of Mexico*, vol. 1, p. xxii.

21 *Transactions of the Society*, vol. 18 (London, 1800), p. 289. This account details what was required to fulfil the 1792 premium and provides the documentation confirming Mackenzie's accomplishment of this task.

22 The book's lengthy title concludes with the subtitle *With a Preliminary Account of the Rise, Progress, and Present State of the Fur Trade of that Country*. The essay itself is entitled, 'A general history of the fur trade from Canada to the northwest'. The essay is now thought to have been written by Alexander's cousin Roderick Mackenzie, who worked with him in the fur trade; see *ODNB*, vol. 35, p. 553.

23 For an excellent discussion of Barry's involvement with Bossuet, see Daniel R. Guernsey's essay 'Barry's Bossuet in *Elysium*: Catholicism and Counterrevolution in the 1790s', in Dunne and Pressly (eds), *James Barry, 1741–1806*, pp. 211–31.

24 Minutes, vol. 51, pp. 36–7. The entry only cites Meredith's last name, and I am grateful to Susan Bennett for this identification with William Meredith, who had been elected a member of the Society on 12 November 1793.

25 Ibid. p. 64.

26 *Gentleman's Magazine*, vol. 76, 1806, p. 286. The *Universal Magazine* (1806) also mentions that he left unfinished a portrait of Lord Nelson (p. 270).

SELECTED BIBLIOGRAPHY

Primary Sources

Note: References to the writings of James Barry collected in James Barry, *The Works of James Barry, Esq., Historical Painter*, ed. and with a life by Edward Fryer (2 vols, London: J. M'Creery for T. Cadell and W. Davies, 1809) (abbreviated to *Works*), are in the text and endnotes abbreviated to 'Barry' followed by the year of publication (e.g. Barry, 1775).

Barry, 1775: *An Inquiry into the Real and Imaginary Obstructions to the Acquisition of the Arts in England* (London: Printed for T. Becket, 1775) (in *Works*, vol. 2, pp. 167–299)

Barry, 1782: *Lectures on Painting, Delivered at the Royal Academy* (*Works*, vol. 1, pp. 339–558). In 1782 Barry was appointed professor of painting, and the year 1782 is used here for the sake of convenience. His lectures were composed and delivered over a number of years, beginning in 1784.

Barry, 1783: *An Account of a Series of Pictures, in the Great Room of the Society of Arts, Manufactures, and Commerce, at the Adelphi* (London: printed for the author by William Adlard, and sold by T. Cadell and J. Walter, 1783) (in *Works*, vol. 2, pp. 301–415)

Barry, 1784: *An Account of a Series of Pictures ...* Same title page as for Barry, 1783, and with the same date of 1783 but reissued with an addition to the appendix for the second exhibition of 1784.

Barry, 1785: 'An account of the proceedings of the Society respecting the pictures painted by James Barry, Esq. R.A. and professor of painting to the Royal Academy, for the decoration of their Great Room, with a description of the several subjects of those pictures', *Transactions of the Society, Instituted at London, for Encouragement of Arts, Manufactures, and Commerce*, vol. 3 (1785), pp. 103–36. The text by Samuel More, the secretary of the Society, is based on Barry's *Account*.

Barry, 1793: *A Letter to the Right Honourable the President, Vice-presidents, and the rest of the Noblemen and Gentlemen, of the Society for the Encouragement of Arts, Manufactures, and Commerce, John-Street, Adelphi* (London: printed for the author by Thomas Davison, 1793) (in *Works*, vol. 2, pp. 417–74)

Barry, 1798: *A Letter to the Dilettanti Society, Respecting the Obtention of Certain Matters Essentially Necessary for the Improvement of Public Taste, and for Accomplishing the Original Views of the Royal Academy of Great Britain* (London: printed for J. Walker, 1798). (*Works*, vol. 2, pp. 475–600). In 1799 a second edition of this book was published 'with an Appendix, Respecting the Matters lately agitated between the Academy and the Professor of Painting' (*Works*, vol. 2, pp. 601–45). Although the version in the *Works* is based on this second edition, I have chosen to use the 1798 date because I do not quote from the appendix.

Barry, 1801: letter of 26 Nov. 1801 from Barry to the Society, *Transactions of the Society, Instituted at London, for Encouragement of Arts, Manufactures, and Commerce*, vol. 19, 1801, pp. xxvii–lxiii (the pagination is given here as printed, though the numbering repeats that of the preceding ten pages).

Barry, *c.* 1802: 'Fragment on the story and painting of PANDORA' (in *Works*, vol. 2, pp. 141–66)

Barry, 1803: letter from Barry to Cooper Penrose, 15 July 1803, *Monthly Magazine*, vol. 16 (1 Sept. 1803), pp. 105–7 (in *Works*, vol. 2, pp. 661–70)

Barry, 1808: *A Series of Etchings by James Barry, Esq. from his Original and Justly Celebrated Paintings, in the Great Room of the Society of Arts, Manufactures, and Commerce, Adelphi* (London, 1808). Edward Fryer based his text on Barry's descriptions in his 'life' of Barry in *Works*: *The Works of James Barry, Esq., Historical Painter*, ed. and with a life by Edward Fryer (2 vols, London: J. M'Creery for T. Cadell and W. Davies, 1809).

Barry's commonplace book: on loan to Special Collections, Boole Library, University College, Cork. The page numbers offered in the endnotes are approximations as the book is a compilation of various writings bound together. I am grateful to Colleen O'Sullivan of the Crawford Art Gallery for supplying me with images of some of the more important pages, and my numbers are based on those given in the videodiscs.

Barry's Correspondence: online publication entitled *The Correspondence of James Barry*, ed. Timothy McLoughlin. This comprehensive resource includes such materials as a critical introduction and appendices, as well as an edited list of the books in Barry's library at the time of his death.

Barry, letter-book 1, 'Papers on Barry's pictures', Royal Society of Arts, London

Barry, letter-book 2, 'Letters from James Barry Esq. & papers relative thereto since October 1798', Royal Society of Arts, London

Burney manuscript: Susan Burney's letter journal, entry for 1 Nov. 1790, London, British Library, Egerton MS 3691, ff. 19 verso–21 recto (page numbers in ink: pp. 537–40). The transcription of this entry by Philip Olleson, director of the Susan Burney Letters Project, has been published in Susan Bennett (ed.), *Cultivating the Human Faculties: James Barry*

(1741–1806) and the Society of Arts (Bethelehem, PA: Lehigh University Press, 2008), pp. 145–50.

Committee minutes of the Society of Arts, Royal Society of Arts, London

Minutes of the Society of Arts, Royal Society of Arts, London

Works: *The Works of James Barry, Esq., Historical Painter*, ed. and with a life by Edward Fryer (2 vols, London: J. M'Creery for T. Cadell and W. Davies, 1809)

Secondary Sources

Books and Articles

Allan, David G.C. (ed.), *The Progress of Human Knowledge and Culture: A Description of the Paintings by James Barry in the Lecture Hall or 'Great Room' of the RSA in London, Written by the Artist* (Basingstoke, England: Basingstoke Press, 2005)

Anderson, Benedict, *Imagined Communities: Reflections on the Origin and Spread of Nationalism*, rev. ed. (London and New York: Verso, 2006)

Barrell, John, *The Political Theory of Painting from Reynolds to Hazlitt* (New Haven and London: Yale University Press, 1986)

————, *The Birth of Pandora and the Division of Knowledge* (Philadelphia: University of Pennsylvania Press, 1992)

Bennett, Susan (ed.), *Cultivating the Human Faculties: James Barry (1741–1806) and the Society of Arts* (Bethlehem, PA: Lehigh University Press, 2008)

Bindman, David, *The Complete Graphic Works of William Blake* (New York: G.P. Putnam's Sons, 1978)

Birch, Thomas, *The Heads of Illustrious Persons of Great Britain, Engraven by Mr. Houbraken and Mr. Vertue with their Lives and Characters* (2 vols, London: printed for John and Paul Knapton, 1747 and 1752)

Burroughs, Francis, *A Poetical Epistle to James Barry, Esq.* (London: printed by S. Gosnell for J. Carpenter, 1805)

Cave, Kathryn (ed.), *The Diary of Joseph Farington* (17 vols: vols 1–6 eds Kenneth Garlick and Angus Macintyre; vols 7–16 ed. Kathryn Cave; vol. 17 [index] Evelyn Newby; New Haven and London: Yale University Press, 1978–98)

Clavigero, Abbé D. Francesco Saverio, *The History of Mexico*, trans. from Italian by Charles Cullen (2 vols, London, 1787)

Cullen, Fintan, *Visual Politics: The Representation of Ireland, 1750–1930* (Cork: Cork University Press, 1997)

Cunningham, Allan, *The Lives of the Most Eminent British Painters, Sculptors, and Architects* (6 vols, London: John Murray, 1829–33)

De Beer, E.S. (ed.), *The Diary of John Evelyn* (6 vols, Oxford: Clarendon Press, 1955)

Duff, William, *An Essay on Original Genius* (London: printed for Edward and Charles Dilly, 1767)

Dunne, Tom and William L. Pressly (eds), *James Barry, 1741–1806: History Painter* (Farnham, Surrey, and Burlington, Vermont: Ashgate, 2010)

Eaves, Morris, *The Counter-arts Conspiracy: Art and Industry in the Age of Blake* (Ithaca and London: Cornell University Press, 1992)

Erdman, David V. (ed.), *The Poetry and Prose of William Blake* (Garden City, New York: Doubleday & Company, 1970)

Gardener Coates, Victoria C. and Jon L. Seydl (eds), *Antiquity Recovered: The Legacy of Pompeii and Herculaneum* (Los Angeles: J. Paul Getty Museum, 2007)

Guernsey, Daniel R., *The Artist and the State, 1777–1855: The Politics of Universal History in British and French Painting* (Aldershot and Burlington: Ashgate, 2007)

Haskell, Francis and Nicholas Penny, *Taste and the Antique* (New Haven and London: Yale University Press, 1981)

Herrera [y Tordesillas], Antonio de, *The General History of the Vast Continent and Islands of America*, 2nd edn, trans. from Spanish by Capt. John Stevens (6 vols, London: Wood and Woodward, 1740)

Hesiod/Cooke: *The Works of Hesiod*, trans. from Greek by [Thomas] Cooke, 2nd edn (London, 1740)

Hill, G.B. (ed), *Boswell's Life of Johnson*, rev. L.F. Powell (6 vols, Oxford: Clarendon Press, 1971; first published 1934)

Homer/Pope: *The Iliad of Homer*, trans. Alexander Pope (6 vols, London: W. Bowyer, 1715)

————, *The Odyssey of Homer*, trans. Alexander Pope (5 vols, London: Henry Lintot, 1758)

Horace/Francis: Rev. Philip (trans.), *A Poetical Translation of the Works of Horace with the Original Text*, 3rd edn, trans. into English with notes (2 vols, London: A. Millar, 1749)

Jameson, Anna, *A Handbook to the Public Galleries of Art in and near London* (London: John Murray, 1842)

Johnson, Samuel, *A Dictionary of the English Language*, 2nd edn (2 vols, London, 1755 and 1756)

Knowles, John, *The Life and Writings of Henry Fuseli* (3 vols, Millwood, NY: Kraus International Publications, and Liechtenstein: Nendelin, 1982; repr. of 1831 London edn)

Kriz, Kay Dian, *The Idea of the English Landscape Painter: Genius as Alibi in the Early Nineteenth Century* (New Haven and London: Yale University Press for Paul Mellon Centre for Studies in British Art, 1997)

Le Pitture Antiche d'Ercolano: the two volumes cited in this book form part of a series of eight known as *Le Antichità di Ercolano Esposte*, produced by the Accademia Ercolanese di Archeologia, Naples; vol. 1: 1757; vol. 2: 1760

Lenihan, Liam, *The Writings of James Barry and the Genre of History Painting, 1775–1809* (Farnham, Surrey, and Burlington, Vermont: Ashgate, 2014)

Lucian: Thomas Francklin (ed.), *The Works of Lucian*, trans. from Greek (2 vols, London: printed for T. Cadell, 1780)

Lucretius/Creech: Titus Lucretius Carus, *Of the Nature of Things*, trans. Thomas Creech (2 vols, London: Printed for Daniel Browne, 1743)

Miller, Lady Anna ('an English Woman'), *Letters from Italy, Describing the Manners, Customs, Antiquities, Paintings, &c. of that Country in the Years MDCCLXX and MDCCLXXI to a Friend Residing in France* (3 vols, Dublin, 1776)

Milton, John, *Paradise Lost. A Poem, in Twelve Books* (London, 1751)

Molyneux, William [spelt 'Mollyneux' in this edn], *The Case of Ireland Being Bound by Acts of Parliament in England, Stated* (London, 1770)

Myrone, Martin, *Bodybuilding: Reforming Masculinities in British Art, 1750–1810* (New Haven and London: Yale University Press for Paul Mellon Centre for Studies in British Art, 2005)

Oxford Dictionary of National Biography [*ODNB*], eds H.C.G. Matthew and Brian Harrison (60 vols, Oxford: Oxford University Press, 2004)

Payne Knight, Richard, 'Review of *The Works of James Barry*', *Edinburgh Review*, vol. 16 (Aug. 1810), pp. 293–326

Pressly, William L., *The Life and Art of James Barry* (New Haven and London: Yale University Press for Paul Mellon Centre for Studies in British Art, 1981)

————, 'A chapel of natural and revealed religion: James Barry's series for the Society's Great Room reinterpreted', *Journal of the Royal Society of Arts*, vol. 132 (July–Sept. 1984), pts 1–3, pp. 543–6, 634–7, 693–5

————, 'On classic ground: James Barry's "Memorials" of the Italian landscape', *Record of the Art Museum: Princeton University*, vol. 54 (1995), pp. 12–28

————, *The Artist as Original Genius: Shakespeare's 'Fine Frenzy' in Late-eighteenth-century British Art* (Newark, Delaware: University of Delaware Press, 2007)

————, 'James Barry's syncretic vision: the fusion of classical and Christian in his *Birth of Pandora*', British Art Journal, vol. 14 (winter 2013–14), pp. 27–35

Reynolds, Sir Joshua, *Discourses on Art*, ed. Robert R. Wark (New Haven and London: Yale University Press, 1975)

Rigaud, Stephen Francis Dutilh, 'Facts and recollections of the XVIIIth century in a memoir of John Francis Rigaud Esq., R.A.', abridged and edited with intro. and notes by William L. Pressly, *Journal of the Walpole Society*, vol. 50 (1984), pp. 1–164

Rizzo, Betty (ed.), *The Early Journals and Letters of Fanny Burney*, vol. 4 (Montreal and Kingston, London, Ithaca: McGill-Queen's University Press, 2003)

Schama, Simon, *Landscape and Memory* (New York: Alfred A. Knopf, 1995)

Scott, John Beldon, *Images of Nepotism: The Painted Ceilings of Palazzo Barberini* (Princeton: Princeton University Press, 1991)

Spence, Joseph, *Polymetis: or, An Enquiry Concerning the Agreement Between the Works of the Roman Poets, and the Remains of the Antient Artists*, 2nd edn (London, 1755)

Thomson, James, *The Seasons* (London, 1730)

Thornhill, Sir James, *An Explanation of the Painting in the Royal Hospital at Greenwich* (poss. London: by order of the hospital's directors, c. 1727–30)

Virgil/Dryden: *The Works of Virgil: Containing his Pastorals, Georgics, and Æneis*, 2nd edn, trans. into English verse by John Dryden (London: Jacob Tonson, 1698; 1st edn 1697)

Virgil/Ogilby: *The Works of Publius Virgilius Maro*, trans. into English by John Ogilby (London: printed by Thomas Warren for the author, 1654)

Warburton, William, *The Divine Legation of Moses*, 4th edn (2 vols, London: printed for J. and P. Knapton, 1755)

West, Gilbert, *Odes of Pindar, with Several Pieces in Prose and Verse, Translated from the Greek. To which is Prefixed a Dissertation on the Olympick Games* (London: printed for R. Dodsley, 1749)

Winkelmann [Winckelmann], J.J., *Reflections on the Painting and Sculpture of the Greeks*, trans. from German by Henry Fusseli [Fuseli] (London, 1765)

Exhibition Catalogues

Dunne, Tom (ed.), Cork: Crawford Art Gallery, *James Barry, 1741–1806: The Great Historical Painter* (2005–06)

Eger, Elizabeth and Lucy Peltz, London: National Portrait Gallery, *Brilliant Women: 18th-century Bluestockings* (2008)

Kear, Jon and Ben Thomas, Canterbury: University of Kent, *In Elysium: Prints by James Barry* (2010)

O'Connell, Sheila, with contributions by Roy Porter, Celina Fox and Ralph Hyde, London: British Museum, *London 1753* (2003)

Pressly, William L., London: Tate Gallery, *James Barry: The Artist as Hero* (1983)

Warner, Malcolm, with contributions by Brian Allen, John House, Robin Spencer and Samuel F. Clapp, London: Barbican Art Gallery, *The Image of London: Views by Travellers and Emigrés, 1550–1920* (1987)

INDEX

Note: illustrations are indicated by page numbers in bold.